Bruno Ernst
The Magic Mirror
of M.C. Escher

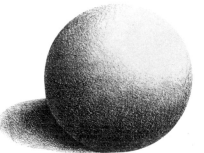

Bruno Ernst The Magic Mirror

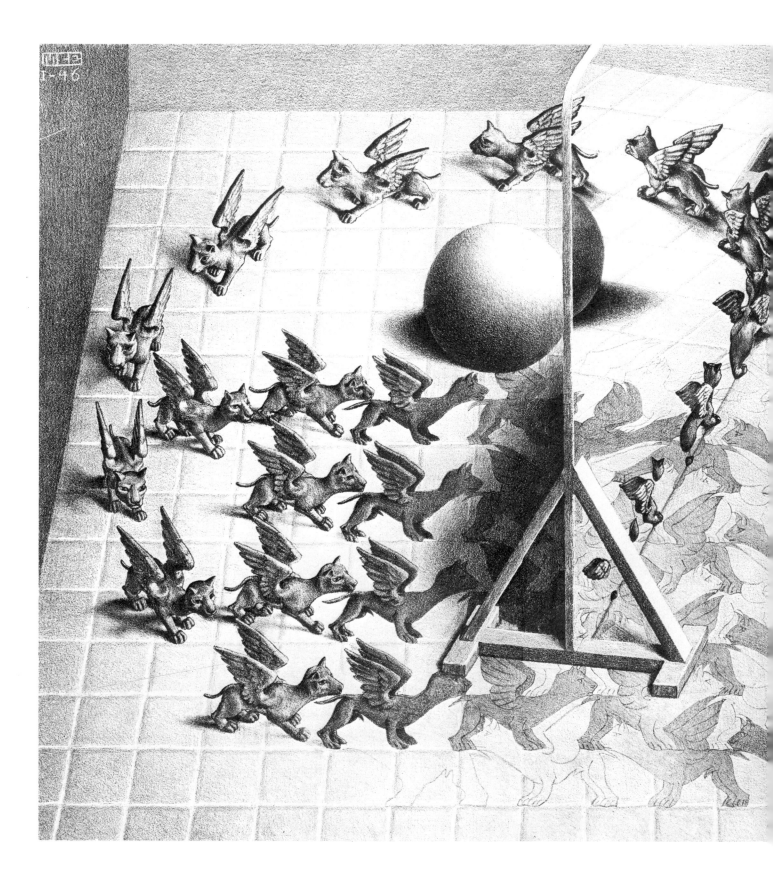

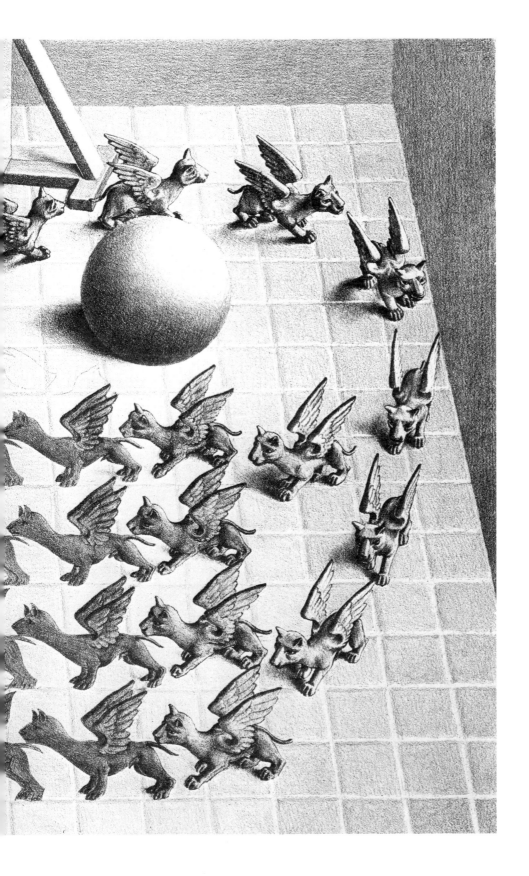

Taschen

This book was printed on 100 % chlorine-free bleached
paper in accordance with the TCF standard.

© 1978 by Bruno Ernst
© 1994 for this edition:
Taschen America L. L. C.

We are grateful to Cordon Art B. V., Baarn, Holland, for
permission to reproduce the pictures and sketches by
Escher in this book.

Many diagrams and explanatory drawings were first
published in *Pythagoras*, a journal for mathematics students,
and we are grateful to Wolters-Noordhoff B. V., Groningen,
Holland, for permission to reproduce these. We are also
indebted to the Bank of the Netherlands, Amsterdam, for
their permission to reproduce the banknotes designed by
Escher.

Cover design: Mark Thomson, London
Translated from the Dutch by John E. Brigham

Printed in Germany
ISBN 1-886155-00-3
GB

Contents

Part One: Drawing is deception

Part Two: Worlds that cannot exist

De clematis-omranking van de „balken" op mijn prententoonstelling zou ongetwijfeld fraai zijn. Evenwel zijn die balken gedacht als spanningen van buiten. Tevens heeft waarschijnlijk het „middenstuk" van zulk een voorstelling al zó veel van mijn energie geëist, dat ik te afgestompt was om later aan aesthetische eisen te voldoen. Deze prenten (die trouwens geen van allen ooit gemaakt werden met het primaire oogmerk „iets moois" te maken) kosten mij gewoonweg hoofdbrekens. Dat is dan ook de reden, dat ik mij, te midden van mijn grafici-collega's, nooit volkomen op mijn plaats voel: zij streven, in de eerste plaats „schoonheid" na (al is dat begrip deze zienswijze, ook voor hen, sinds de 17ᵉ eeuw!) Misschien streef ik wel uitsluitend verwondering na en tracht ik dus ook uitsluitend verwondering bij mijn toeschouwers te wekken. Met de „schoonheid" is het soms kwalijk gesteld.

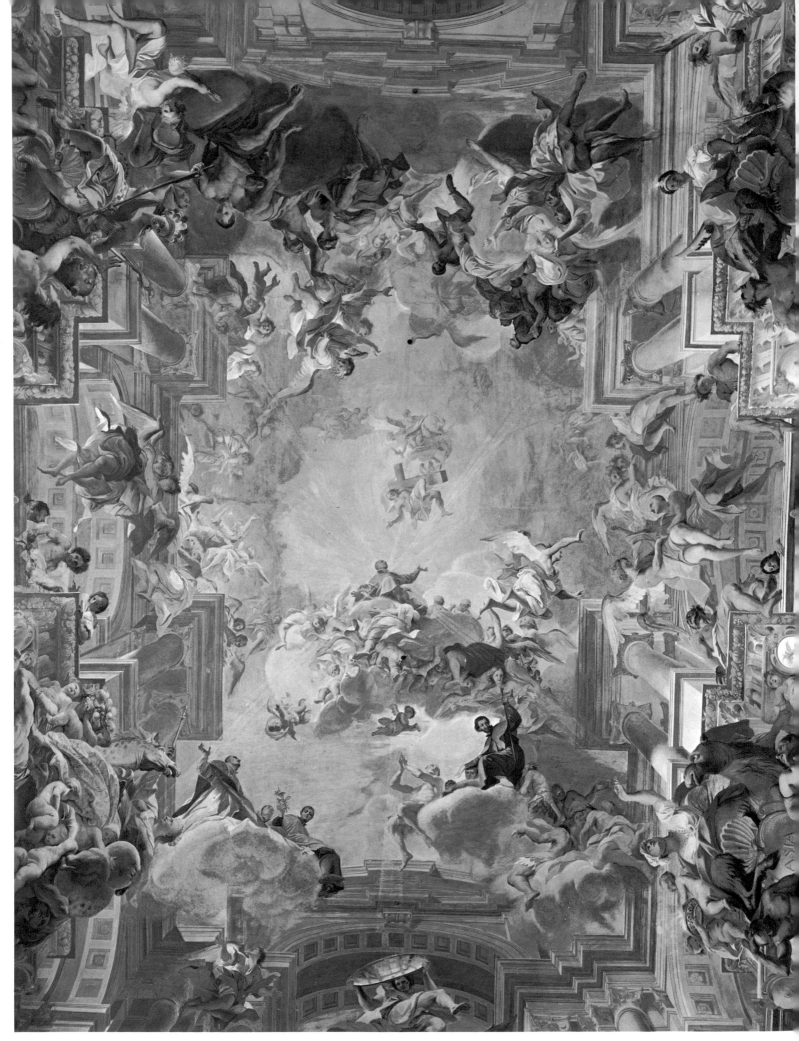

1. Baroque ceiling, St. Ignazio's Chapel, Rome, by Andrea Pozzo. (Photograph by F Fratelli Alinari, Florence)

4

Part One: Drawing is deception

1 The Magic Mirror

"As the emperor gazed into the mirror his visage became first a blood red blob and then a death's head with slime dripping from it. The emperor turned away from it in alarm. 'Your Majesty,' said Shenkua, 'do not turn your head away. Those were just the beginning and the end of your life. Keep on looking, and you shall see everything that is and everything that may be. And when you have reached the highest point of rapture, the mirror will even show you things which cannot possibly be.'"

—Chin Nung, "All about Mirrors"

When I was a young man I lived in a seventeenth-century house on the Keizersgracht in Amsterdam. In one of the larger rooms there were *trompe-l'oeil* paintings above the doors. These mural paintings, carried out in many combinations of varying shades of gray, achieved so plastic an impression that one could not escape the conviction that they were marble reliefs—a deception, an illusion that never ceased to astonish. And perhaps even more skillful still are those ceiling paintings in churches in central and southern Europe where two-dimensional paintings and three-dimensional sculpture and architecture pass over from one to the other without any visible joins.

This playful exercise has its roots in the representational methods of the Renaissance. The three-dimensional world had to be reproduced as faithfully as possible on the flat surface, and in such a way that image and reality might be indistinguishable to the eye. The idea was that the painting should conjure up warm, voluminous reality.

In the case of the *trompe-l'oeil* paintings, ceiling paintings, and those portraits which keep on staring at one from whichever point one looks at them, it is a question of playing the game for the game's sake.

It is no longer a matter of representational verisimilitude in the things that are being portrayed, but of downright optical illusion, of superdeception in the service of deceit. The painter takes a delight in this deceit, and the viewer is determined to be deceived willy-nilly, deriving therefrom the same sort of sensation as when he is being taken in by a magician. The spatial suggestion is so strong, so exaggerated, that nothing short of actual touch can

2. Pieter de Wit, "Trompe l'oeil" painting (the Rijksmuseum, Amsterdam)

5

reveal to us that we are dealing with pictures on a flat surface.

A great deal of Escher's work is related to this supersuggestion of the spatial to which we have just referred. However, the suggestion itself is not what he is primarily aiming at. His prints are much rather the reflection of that peculiar tension inherent in any flat representation of a spatial situation. In many of his prints he causes the spatial to emerge from the flat surface. In others he makes a conscious attempt to nip in the bud any spatial suggestion that he may have brought about. In the very highly developed wood engraving *Three Spheres I* (1945), which we shall discuss more fully at a later stage, he carries on a discussion with the viewer: "Now, isn't that one at the top a splendid round globe? Wrong! You are quite mistaken—it is completely flat! Now, just look, in the middle I have drawn the thing folded over. So you see it really must be flat, or I could not have folded it. And at the bottom of the print I have laid the thing down horizontally. And in spite of this, I guess your imagination will go and turn it into a three-dimensional egg. Just satisfy yourself about this with the touch of your fingers over the paper—and feel how flat it really is. Drawing is deception; it suggests three dimensions when there are but two! And no matter how hard I try to convince you about this deception, you persist in seeing three-dimensional objects!"

With Escher, optical illusion is achieved by means of a representational logic that hardly anyone can evade. By his method of drawing, by his composition, he "proves" the genuineness of the suggestion that he has brought into being. And the fascinated viewer, on coming to his senses, realizes that he has been taken in. Escher has literally conjured up something before his eyes. He has held before him a magic mirror whose spell has been cast as a compelling necessity. In this Escher is an absolute master, and unique at that. Let us take the lithograph *Magic Mirror* (1946) to illustrate this. By standards of artistic criticism, perhaps it is not a successful print. It is set before us like some tangled skein. There is certainly something taking place, but what it is is far from clear. There is obviously a story in it, but both beginning and end remain so far unrevealed.

It all begins at a very inconspicuous spot. At the edge of the mirror nearest to the viewer, immediately underneath the sloping bar, we can perceive the tip of a small wing, together with its reflection. As we look further along the mirror, this develops into a complete winged hound and its mirror image. Once we have allowed ourselves to be inveigled into accepting the wing-tip as a possibility, we now have to swallow the compelling plausibility of the whole strange setup. As the real dog turns away from the mirror toward the right so his reflection turns to the left, and this reflection looks so real that it is no surprise whatever to us to see him continue walking away behind the mirror, quite undeterred by the mirror frame. And now winged hounds move off to left and right, doubling themselves twice en route; then they advance upon each other like two armies. However, before an actual confrontation takes place, there is a falling off in their spatial quality and they become flat patterns upon the tiled floor. If we watch closely, we see the black dogs turning into white ones the moment they pass through the mirror, doing this in such a way that they exactly fill up the lighter spaces left between the black dogs. These white gaps disappear and eventually no trace of the dogs remains. They never did exist anyway—for winged dogs do not come to birth in mirrors! And yet the riddle is still there—for in front of the mirror stands a globe, and in the mirror, sloping away at an angle, we can still see just a portion of its reflection. And yet there also stands a globe behind the mirror—a real enough object in the midst of the left-hand mirror-world of the dogs.

Who is this man that possesses this magic mirror? Why does he produce prints like this one, obviously without any consideration of aesthetics? In chapters 2, 3, and 4 we shall discuss his life story and throw some light on his character, insofar as this emerges from his letters and his personal conversations. Chapter 5 gives an analysis of his work as a whole. And the following chapters discuss in detail the inspiration, working methods, and the artistic results of this unique talent.

2 The Life of M.C.Escher

Not Much of a Scholar

Maurits Cornelis Escher was born in Leeuwarden in 1898, the youngest son of a hydraulic engineer, G.A. Escher.

In his thirteenth year he became a pupil of the high school in Arnhem, a town to which the family had moved in 1903. He could hardly be described as a good student. The whole of his school days was a nightmare, the one and only gleam of light being his two hours of art each week. This was when he made linocuts, together with his friend Kist (later to be a children's-court judge). Twice Escher had to repeat a grade. Even so he failed to obtain a diploma on leaving, having achieved only a number of grade fives, a few sixes, and—a seven in art. If anything, this result gave more distress to his art teacher (F. W. van der Haagen) than it did to the candidate himself. Such work as has survived from Escher's school days clearly indicates a more than average talent; but the bird in a cage (the set piece for his examination) was not highly thought of by the examiners.

Escher's father was of the opinion that his son ought to be given a sound scientific training and that the most suitable plan for the boy to aim at—for after all, he was really quite gifted artistically—would be to become an architect. In 1919 he went to Haarlem to study at the School of Architecture and Decorative Arts under the architect Vorrink. However, his architectural training did not last very long. Samuel Jesserun de Mesquita, a man of Portuguese extraction, was lecturing in graphic techniques. It took no more than a few days to show that the young man's talents lay more in the direction of the decorative arts than in that of architecture. With the reluctant agreement of his father (who could not help regarding this as being probably inimical to his son's future success) young Maurits Escher changed courses and de Mesquita became his main teacher.

Work from this period shows that he was swiftly mastering the technique of the woodcut. Yet even in this Escher was by no means regarded as outstanding. He was a keen student and worked well, but as for being a true artist . . . well, no, he was certainly not that. The official college report, signed by both the director (H.C.Verkruysen) and de Mesquita, read: ". . . he is too tight, too literary-philosophical, a young man too lacking in

3. Maurits Escher as a fifteen-year-old boy, spring, 1913

4. Escher in Rome, 1930

to Spain on a cargo boat, and Escher was able to go with them, as "nursemaid" to their children. After a short stay in Spain he boarded another cargo boat at Cadiz, en route for Genoa, and the winter of 1922 and the spring of 1923 were spent in a pension in Siena. It was here that his first woodcuts of Italian landscape were produced.

One of the pension guests, an elderly Dane who had taken note of Escher's interest in landscape and architecture, inspired him with an enthusiasm for southern Italy, and told him in particular, that he would find Ravello (to the north of Amalfi, in Campania) to be bewitchingly beautiful. Escher traveled there and did indeed discover and take to his heart a landscape and an architecture in which Moorish and Saracen elements were attractively interwoven.

In the pension where he was staying he met Jetta Umiker, the girl whom he was to marry in 1924. Jetta's father was Swiss and, prior to the Russian Revolution, had been in charge of a silk-spinning factory on the outskirts of Moscow. Jetta drew and painted, and so did her mother, although neither of them had had the benefit of any training in these arts.

The Escher family came over from Holland for the wedding, which was held in the sacristy and town hall of Viareggio. Jetta's parents set up house in Rome and the young pair went to live with them. They rented a house on the outskirts of the city, on the Monte Verde. When their first son, George, was born, in 1926, they moved to a larger dwelling, where the third floor became their living quarters and the fourth floor was made into a studio. This was the first place in which Escher felt that he could work in peace.

Until 1935 Escher felt quite at home in Italy. Each spring he would set off on a two-month journey in the Abruzzi, Campania, Sicily, Corsica, and Malta, usually in the company of brother artists whom he had come to know in Rome. Giuseppe Haas Trivero, a former house painter turned artist, accompanied him on practically every one of these journeys. This Swiss friend was about ten years older than he and also lived on Monte Verde. Robert Schiess, another Swiss artist, and member of the Papal Guard, sometimes went too. In the month of April, when the Mediterranean climate begins to be at its loveliest, they would set off by train, but mostly they would travel on foot, with rucksacks on their backs. The purpose of these journeys was to collect impressions and make sketches. Two months later they would return home, thin and tired but with hundreds of drawings.

Many an anecdote could be told about this period; a few morsels of traveler's tales must suffice here, to sketch in the atmosphere a little.

A journey through Calabria brought the artists to Pentedattilo, where five rocky peaks rise out of the landscape like giant fingers. The company was more numerous than usual, for a Frenchman called Rousset, who was engaged in historical research in southern Italy, was also with them. They found a lodging in the tiny hamlet—one room with four beds. Meals consisted mainly of hard bread (baked once a month) softened in goat's milk; also honey and goat's-milk cheese. At this period Mussolini had already taken power firmly into his hands. A Pentedattilo woman asked the travelers if they would take a message to Mussolini on behalf of the village. "If you see him, tell him we are so poor here we have not got a well, or even a plot of land where we can bury our dead."

After a stay of three days they tramped the long road back to Melito station on the south coast. A man on horseback came toward them on the narrow, rocky path, and, seizing his enormous camera, Rousset started to film the rider. The man dismounted, and with southern courtesy pressed the travelers to go with him to his home in Melito. He proved to be winegrower and had a very fine cellar. This last was not merely inspected but was so long and so excessively sampled that, a few hours later,

feeling or caprice, too little of an artist."

Escher left in 1922, after two years of study in the art school. He had a good grounding in drawing and, among graphic techniques, he had so mastered the art of the woodcut that de Mesquita had reached the conclusion that the time had come for him to go his own way.

Until early 1944, when de Mesquita, together with his wife and family, was taken away and put to death by the Germans, Escher maintained regular contact with his old teacher. From time to time the former pupil would send the master copies of his latest pieces of work. It was in reference to *Sky and Water I* (1938), which de Mesquita had pinned up on the door of his studio, that the teacher recounted without the slightest tinge of jealousy how a member of his family had exclaimed with admiration, "Samuel, I think that is the most beautiful print you have ever made."

Looking back on his own student days, Escher could see himself as a rather shy young man, not very robust in health but with a passion for making woodcuts.

Italy

When he left art school in the spring of 1922, Escher spent about two weeks traveling through central Italy with two Dutch friends; and in the autumn of that same year he was to return there on his own. A family with whom he was friendly was going

5. Color sketch of Amalfi, south of Italy

6. Photograph taken by the author of the same spot, March 1973

the travelers arrived in a remarkable state of reckless abandon at the station at Melito. Schiess took his zither from its case and began to play just as the train was due to leave. Out got the passengers and so did the engine driver. Even the stationmaster was so enthusiastic that he started to dance to the music.

Later Rousset recalled the memories of the journey in a letter to Escher and commemorated the incident in this epigram:

Barbu comme Appollon, et joueur de cithare,
Il fit danser les Muses et meme un chef-de-gare.

Sometimes the zither playing caused astonishment. It seemed to be a better means of communication than eloquent speech or anything else, as instanced in a travel story which Escher himself once published (in the *Groene Amsterdamer,* April 23, 1932).

Usually the only connecting link between the unknown mountain eyries in the inhospitable interior of Calabria and the railroad which runs right along the coast is a mule-path. Anyone wishing to pass this way has to go on foot if he has no mule at his disposal. One warm noontide in the month of May, at the end of a tiring tramp in the blazing sun, the four of us, loaded up with our heavy rucksacks, sweating profusely and pretty well out of breath, came through the city gate of Palazzio. We strode purposefully to the inn. It was a fairly large, cool room, with light streaming in through the open doorway, and smelled of wine and its countless flies. We had long been accustomed to the dourness of the people of Calabria, but never before had we met with such an attitude of antagonism as we sensed on this occasion. Our friendly questions brought forth only gruff and incomprehensible replies. Our light hair, strange clothing, and crazy baggage must have evoked considerable suspicion. I am convinced that they suspected us of

gettature and *mal occhio.* They literally turned their backs on us and barely managed to put up with our presence among them.

With a glum expression and without a word spoken, the innkeeper's wife attended to our request for wine. Then, calmly and almost solemnly, Robert Schiess took his zither out of its case and began to strum, very softly at first, as though he were immersed in and carried away by the magic that was coming from the instrument. As we watched him and the men around us, we witnessed the wonderful way in which the evil spell of enmity was broken. With a great deal of creaking a stool was turned around; instead of the back of a head, a face came into view . . . then another and another. Hesitatingly the landlady approached, step by step, and stood there with her mouth open, one hand on her hip and the other smoothing her skirt. When the strings went mute and the zither player raised his eyes, there stood around him a deep rank of onlookers who burst into applause. Tongues were loosed: "Who are you? Where do you come from? What have you come here for? Where are you going next?" We were pressed to accept wine, and we drank much too much of it, which was very pleasant, and our good relationship was even further increased.

The Abruzzi mountains are impressively somber in comparison with other Italian landscapes. In the spring of 1929, Escher went there entirely on his own in order to sketch. He arrived rather late in the evening in Castrovalva, found a lodging, and went straight to sleep. At five in the morning he was awakened by a heavy thumping on his bedroom door. *Carabinieri!* Whatever could they be wanting with him? He was ordered to go to the police station with them. A great deal of argument was required in order to persuade the constable to postpone the hearing until seven o'clock. In any case he impounded Escher's passport. When Escher arrived at the police station at seven o'clock, it appeared

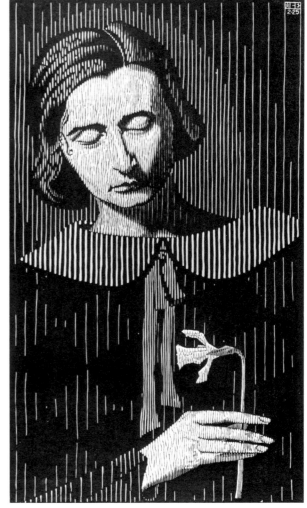

7. Sketch of Jetta

8. *Woman with Flower* (Jetta), woodcut, 1925

that the inspector was not up yet; and it was almost eight before this official put in an appearance. There was certainly a serious accusation; Escher was suspected of having made an attempt on the life of the king of Italy. The incident in question had occurred the previous day in Turin—and Escher was a foreigner, he had arrived late at night, and he had taken no part in the procession that had been held in Castrovalva during the evening. A woman had noted that he had an evil expression *(guardava male)* and had reported this to the police.

Escher was furious about this crazy story and threatened to make a row about it in Rome, with the fortunate result that he was swiftly set at liberty.

What is more, Escher made some sketches for one of his most beautiful landscape lithographs, *Castrovalva* (1930), so impressive in its breadth and height and depth. He himself has said of it, "I spent nearly a whole day sitting drawing beside this narrow little mountain path. Up above me there was a school and I enjoyed listening to the clear voices of the children as they sang their songs." *Castrovalva* is one of the first of his prints to draw high praise from several critics: "In our judgment the view over Castrovalva in the Abruzzi can be regarded as the best work Escher has so far produced. Technically it is quite perfect; as a portrayal of nature it is wonderfully exact; yet at the same time there is about it an air of fantasy. This is Castrovalva viewed from without, but even more so it is Castrovalva from within. For the very essence of this unknown place, of this mountain path, these clouds, that horizon, this valley, the essence of the whole composition is an inner synthesis, a synthesis which came into

being long before this work of art was made . . . it is on this imposing page that Castrovalva has been displayed in all its fearsome unity." (Hoogewerff, 1931)

At this period Escher was not very well known. He had held a few small exhibitions and illustrated one or two books. He hardly sold any work in its own right, and to a great extent he remained dependent on his parents. Not until many years later, in 1951, did a portion of his income derive from the production of his prints. In that year he sold 89 prints for a total of 5,000 guilders. In 1954 he sold 338 prints for about 16,000 guilders— but by this time he had become well known, not for his landscapes and town scenes but for graphic representations of the most appealing concepts that had occurred to his mind up to then.

What a pity it was that his father, the very one who had made it possible for his son to evolve so tranquilly and to reach a stage at which his work bore the stamp of exceptional originality, was never able to appreciate fully the value of this work! Escher senior died in 1939, in his ninety-sixth year. The print *Day and Night* (1938), the first great synthesis of his son's new world of thought, made scarcely any impression on him. It is significant that Escher's own sons also, who had experienced at such close quarters the creation of so many prints, have but little of their father's work hanging in their homes. Escher's comment on this was, "Well, yes, *Ripple* does hang in my son's house in Denmark, and when I see it there, I think it is quite a nice picture, really."

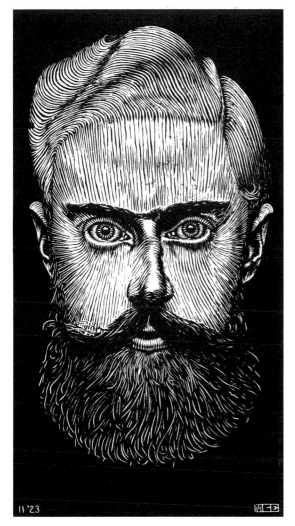

9. *Self-Portrait*, **woodcut, 1923**

Switzerland, Belgium, The Netherlands

In 1935, the political climate in Italy became totally unaccept-able to him. He had no interest in politics, finding it impossible to involve himself with any ideals other than the expression of his own concepts through his own particular medium. But he was averse to fanaticism and hypocrisy. When his eldest son, George, was forced, at the age of nine, to wear the Ballila uniform of Fascist Youth in school, the family decided to leave Italy. They settled in Switzerland, at Chateau d'Oex.

Their stay was of short duration. Two winters in that "horrible white misery of snow," as Escher himself described it, were a spiritual torment. The landscape afforded him absolutely no inspiration; the mountains looked like derelict piles of stone without any history, just chunks of lifeless rock. The architecture was clinically neat, functional, and without any flights of fancy. Everything around him was the exact opposite of that southern Italy which so charmed his visual sense. He lived there, even taking ski lessons, but he remained an outsider. His longing to be free from these frigid, angular surroundings became almost an obsession. One night he was awakened by a sound like that of the murmur of the sea . . . it was Jetta combing her hair. This awoke in him a longing for the sea. "There is nothing more enchanting than the sea, solitude on the foredeck of a little ship, the fishes, the clouds, the ever-changing play of the waves, the constant transformations of the weather." The very next day he wrote a

10. **Travel snapshots in central Italy**

11

11. Escher and a colleague at an exhibition both held together in Switzerland

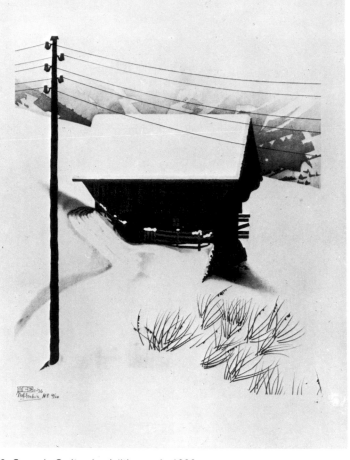

13. *Snow in Switzerland*, lithograph, 1936

12. *Marseilles*, woodcut, 1936

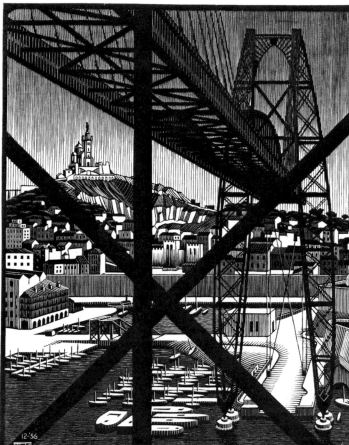

letter to the Compagna Adria in Fiume, a shipping line that arranged voyages in the Mediterranean region on cargo vessels with a limited amount of accommodation for passengers. His proposal is noteworthy: he wanted to pay the price of the cruise, for himself and his wife, with forty-eight prints; that is, four copies each of twelve prints, which he would make from sketches made en route. The shipping company's reply is even more noteworthy. They accepted his offer. Nobody in the company knew Escher, and it is even open to question whether a single member of the management had any interest in lithographs. A year later Escher made this note in his account book:

> 1936. Jetta and I made the following voyages on freighters of the Adria Line:
> I, from April 27, 1936, to May 16, 1936, from Fiume to Valencia.
> I, from June 6, 1936, to June 16, 1936, from Valencia to Fiume.
> Jetta, from May 12, 1936, to May 16, 1936, from Genoa to Valencia.
> Jetta, from June 6, 1936 to June 11, 1936 from Valencia to Genoa in exchange for the following prints which I executed during the winter of '36–'37.

Then follows a list of prints, among which we find *Porthole*, *Freighter*, and *Marseilles*. These are bracketed together with the figure of 530 guilders, and Escher has added the note: "Value of the voyages received to the tariff charges of the Adria Line, plus an amount of 300 lire which I received to cover expenses."

So there was once a period when the value of a print by Escher could be assessed according to the passenger fares of a cargo boat!

15. *Self-Portrait*, lithograph, 1943

14. *Portrait of G. A. Escher*, the artist's father, in his ninety-second year, lithograph, 1935

This journeying, partly comprising travels in the south of Spain, had a profound influence on Escher's work. He and his wife visited the Alhambra in Granada, where he studied with intense interest the Moorish ornamentations with which the walls and floors were adorned. This was his second visit. This time with his wife, he spent three whole days there studying the designs and copying many of the motifs. Here it was that the foundation was laid for his pioneering work in periodic space-filling.

It was also during the course of this Spanish journey that, because of a misunderstanding, Escher found himself under arrest for a few hours. In Cartagena he was drawing the old walls that straddle the hills there. A policeman regarded this as highly suspicious; here was a foreigner making drawings of Spanish defense works . . . he must surely be a spy. Escher had to accompany him to the police station and his drawings were confiscated. Down in the harbor there sounded the hooter of the cargo boat on which Escher was traveling: the captain was giving warning of departure. Jetta went back and forth as courier between ship and police station. An hour later he was allowed to leave, but he never got his drawings back. It still made him angry when he sat discussing it thirty years later.

In 1937 the family moved to Ukkel, near Brussels, Belgium. The outbreak of war seemed imminent and Escher wanted to be near his homeland. War did come, and residence in Belgium became psychologically difficult for a Netherlander. Many of the Belgians tried to escape to the south of France, and among those who remained behind there grew a tacit resentment of "foreigners" who were eating up the diminishing food supplies.

In January, 1941, Escher moved to Baarn, Holland. The choice of Baarn was determined primarily by the good name of the secondary school there.

In spite of the none-too-friendly climate in Holland, where cold, damp, and cloudy days are dominant and where sun and warmth come as a pleasant bonus, it was in this country that the richest work of the artist quietly flourished.

Outwardly there were no more events or changes of importance. George, Arthur, and Jan grew up, completed their studies, and made their way in the world.

Escher still went on several freighter voyages in the Mediterranean region, but these did not afford any further direct inspiration for his work. However, new prints came into being with clockwork regularity. Only in 1962, when he was ill and had to undergo a serious operation, did production cease for a while.

In 1969 he made yet another print, *Snakes*, and it proved that there was no diminution in his skill; it was a woodcut which still indicated a firm hand and a keen eye.

In 1970 Escher moved to the Rosa-Spier Home in Laren, North Holland, a home where elderly artists can have their own studios and at the same time be cared for. There he died on the 27th of March, 1972.

3 An Artist Who Could Not Be Pigeonholed

Mystics?

"A woman once rang me up and said, 'Mr. Escher, I am absolutely crazy about your work. In your print Reptiles you have given such a striking illustration of reincarnation.' I replied, 'Madam, if that's the way you see it, so be it.'"

The most remarkable example of this *hineininterpretieren* (hindsighted interpretation) is surely the following: it has been said that if one studies the lithograph *Balcony* one is immediately struck by the presence of a hemp plant in the center of the print: through the enormous blow-up toward the middle Escher has tried to introduce hashish as a main theme and so point us to the psychedelic meaning of the whole work.

And yet, that stylized plant in the middle of *Balcony* has no connection with a hemp plant, and when Escher made this print, the word hashish was to him no more than a word in a dictionary. As far as any psychedelic meaning to this print is concerned, you can observe it only if you are so color-blind that black looks white and white black.

Hardly any great artist manages to escape from the arbitrary interpretations people give to his work, or from their attachment to meanings that were never, even in the slightest degree, in that artist's mind; indeed, which are diametrically opposed to what the artist had in mind. One of Rembrandt's greatest creations, a group-portrait of the Amsterdam militia, has come to be called "Night Watch"—and not only in popular parlance either, for even many art critics base their interpretations of the picture on a nocturnal event! And yet Rembrandt painted the militia in full daylight—indeed, in bright sunshine, as became obvious when the centuries-old yellowed and browning layers of smoke-stained varnish had been removed.

Quite possibly the titles that Escher gave to some of his prints, or for that matter the very subjects that he used, have given rise to abstruse interpretations quite unconnected with the artist's intentions. For this reason he himself regards the titles *Predestination* and *Path of Life* as being really too dramatic, as is also the death's-head in the pupil of the print *Eye*. As Escher himself has said, one must certainly not try to read any ulterior meaning into these things. "I have never attempted to depict anything mystic; what some people claim to be mysterious is nothing more than a conscious or unconscious deceit! I have played a lot of tricks, and I have had a fine old time expressing concepts in visual terms, with no other aim than to find out ways of putting them on to paper. All I am doing in my prints is to offer a report of my discoveries."

Even so, it remains a fact that all of Escher's prints do have something strange, if not abnormal, about them, and this intrigues the beholder.

This has been my own experience. Nearly every day for a number of years I have looked at *High and Low*, and the more I have delved into it the more strangely has the lithograph affected me. In his book *Graphic Work*, Escher goes no further than a bald description of what anyone can see for himself. ". . . if the viewer shifts his gaze upward from the ground, then he can see the tiled floor on which he is standing, as a ceiling repeated in the center of the composition. Yet at the same time its function there is that of a floor for the upper portion of the picture. At the very top the tiled floor is repeated once again, but this time only as a ceiling." Now this description is so obvious and so straightforward that I said to myself, "In that case, how does all this fit together, and why are all the 'vertical' lines curved? What are the basic principles hiding behind this print? Why did Escher make it?" It was just as though I had been vouchsafed a glimpse of the front surface of a complicated carpet pattern, and the very pattern itself had given rise to the query, "What does the reverse side look like? How is the weave put together?" Because the only person who could enlighten me on this point was Escher himself, I wrote and asked him for an explanation. By return mail I received an invitation to come along and talk it over with him. That was in August, 1951, and from then onward I visited him regularly. He was extremely happy to be questioned on the background of his work and about the why and the wherefore; he always showed great interest in the articles which I wrote on the subject. When I was preparing this book in 1970, I had the privilege of spending a few hours with him each week throughout practically the whole year.

At that period he had only just recovered from a serious opera-

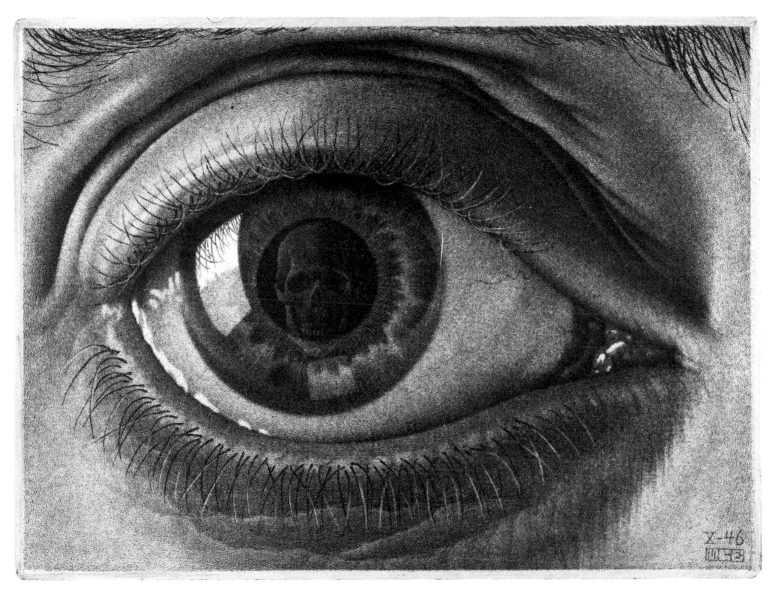

16. *Eye*, mezzotint, 1946

17. "If only you knew the things I have seen in the darkness of night . . ."

17. "If only you knew the things I have seen in the darkness of night . . ."

tion and sometimes these conversations were extremely tiring for him. Yet he wanted to go through with them, and he felt a need to explain how it was that he had come to produce his prints, and to expound their origin with the help of the many preparatory studies for them, which he still kept.

Art Critics

Until recently almost all Dutch print collections had omitted to build up any fair-sized section of Escher's work. He was simply not recognized as an artist. The art critics could not make head or tail of him, so they just ignored his work. It was the mathematicians, crystallographers and physicists who first showed great interest. And yet . . . anyone who is willing to approach his work without preconceived ideas will derive enjoyment from it, whereas those whose only approach is through commentaries

provided by art historians will discover that these latter are no more than a hindrance.

Now that the tide has turned and the public at large seems captivated by Escher's work, official art criticism is bringing up the rear and showing an interest. It really was quite pathetic to see how, on the occasion of the great retrospective exhibition at The Hague, held to commemorate Escher's seventieth birthday, an attempt was made to establish historical parallels. It did not succeed; Escher stands apart. He cannot be slotted in, for he has totally different aims from those of his contemporaries.

It is not fitting to ask of a modern work of art what its meaning is supposed to be. It is presumed that there *is* meaning and that the questioner is therefore an ignoramus. Far better to keep one's mouth shut about it, or to confine oneself to such remarks as "A nice bit of carving," "A clever piece of work," "Isn't that fascinating?" "It does something to one, doesn't it?" and so on.

It is quite a different story with Escher's work. Perhaps this is the reason for his own reluctance to reply when asked what his place is in the present-day world of art. Before 1937, a reply would not have been so difficult to give, for at that time his work was, generally speaking, entirely pictorial. He sketched and drew whatever things he found to be beautiful and did his best to depict them in woodcuts, wood engravings, and lithographs.

Had he continued in this vein he would have attained a comfortable place among the graphic artists of his time. As far as work of this period is concerned one would have no trouble in writing about an artist whose landscapes were at once poetic and attractive, who was capable of producing portraits with a remarkably literal likeness (although, apart from himself, he made portraits only of his father, his wife, and his children). He was clearly an artist with a mastery of technique and great virtuosity. The whole of that well-worn jargon with which the art critic normally tries to introduce an artist's work to the general public could have been easily and aptly used when writing about all his work.

After 1937 the pictorial became a matter of merely secondary importance. He was taken up with regularity and mathematical structure, by continuity and infinity and by the conflict which is to be found in every picture, that of the representation of three dimensions in two. These themes haunted him. Now he was treading paths which no others had yet trodden and there was an infinity of discoveries to make. These themes have their own underlying principles which have to be ferreted out and then obeyed. Here chance holds no sway; here nothing can come into being in any way other than that in which it does come. The pictorial is an extra bonus. From this time onward art criticism can get no purchase on his work. Even a critic who is very sympathetic expresses himself with a certain skepticism: "The question which continually comes up in regard to Escher's work is whether his more recent efforts can come under the heading of art . . . he usually moves me deeply, yet I cannot possibly describe all his work as good. To do so would be ridiculous, and Escher is wise enough to realize this." (G. H. 'sGravesande, *De Vrije Bladen,* The Hague, 1940.) It is worthy of note that this was said about work which we have now come to hold in the highest esteem. This same critic went on to say, "Escher's birds, fishes, and lizards defy description; *they call for a mode of thought which is only to be found among few people.*"

Time has proved that 'sGravesande underestimated his public, or maybe he was thinking only of that tiny group of people who faithfully tramp the galleries and the exhibitions, and never miss a single concert.

It is astonishing how Escher himself, apparently unmoved by the criticism of his work, forged ahead on his chosen way. His work was not selling well, official art criticism passed him by; even his closest associates thought little of it, and yet he still went on making pictures of the things that possessed his mind.

Cerebral

To those who regarded art as the expression of emotions, the whole of Escher's post-1937 work will be a closed book. For it is cerebral both in aim and in execution, although this does not take away from the fact that, alongside the message, alongside the intellectual content which he is aiming to display, the thrill of discovery comes over also, often in the panache (though not sentimental) of the picture. Yet all the critics who admire Escher try to avoid using the word cerebral. In music, and even more so in the plastic arts, this word is almost synonymous with antiart. It really is rather odd that the intellectual element should be so rigorously excluded. The word cerebral hardly ever plays any part in dissertations on literature, and it is certainly not a term which indicates disapproval or rejection. There it is quite obviously mainly a question of getting a thought content across, but of course in such a form as to fascinate, and to stir the emotions. In my view, it is irrelevant whether a work is called cerebral or not. The simple fact is that at the present time, artists are not sufficiently concerned with thought content to be able to draw on it for inspiration for their work. What matters most is that the artist should be able to give unique form to whatever it is that has taken hold of his mind, so that which cannot be expressed in words will come across pictorially. In Escher's case these ideas center on regularity, structure, continuity, and an inexhaustible delight at the way in which spatial objects can be represented on a flat surface. Such ideas he cannot put into words but he certainly can make them explicit in pictures. His work is cerebral to a high degree in the sense that it is of the mind—a pictorial representation of intellectual understanding.

The most important function of an art critic is to talk about a work in such a way as to help the viewer make contact with it, so to direct his attention to it that the work of art itself begins to speak to him.

With Escher's work, in one respect the critic would seem to have a remarkably easy time of it. He has to give an accurate description of what is to be seen in the print; he does not have to display his own subjective emotions. And for a preliminary acquaintance this is more or less all that is needed to get almost any viewer close enough to the print for the "understanding" of the print to be coupled with the excitement of discovery. It was this excitement that formed the kernel of Escher's own inspiration, and the whole aim of the print has been to transmit the excitement his own discovery brought him.

However, most of the prints have something more than this to offer. Every one of Escher's prints is (albeit temporarily) an end phase. Those who wish to understand and enjoy this end phase in any but a purely superficial way will have to be confronted with the total context. His work bears the character of a quest. He is using the print to make a report, a statement of provisional findings. This is where the critic's task becomes more difficult, for now he has to delve into the general underlying problem postulated by the print, and show how the print fits into it. And if the solution arrived at is on a constructional level, then he will have to throw some light on the mathematical background of the print, through a study of the many preparatory sketches that Escher made.

If he does this then he will help the viewer to see the print in all the fire of its creation, thus adding a new dimension to his viewing. Only then can the print become a living experience, its richness and variety harmonizing with its original inspiration.

Speaking of this inspiration, Escher has said, "If only you knew the things I have seen in the darkness of night . . . at times I have been nearly demented with wretchedness at being unable to express these things in visual terms. In comparison with these thoughts, every single print is a failure, and reflects not even a fraction of what might have been."

4 Contrasts in Life and Work

Duality

Escher's predilection for contrast of black and white is paralleled by his high regard for dual concepts in thought.

Good cannot exist without evil, and if one accepts the notion of God then, on the other hand, one must postulate a devil likewise. This is balance. This duality is my life. Yet I'm told that this cannot be so. People promptly start waxing abstruse over this sort of thing, and pretty soon I can't follow them any further. Yet it really is very simple: white and black, day and night — the graphic artist lives on these.

In any case it is obvious that this duality underlies his whole character. Over against the intellectuality of his work and the meticulous care that goes into the planning of it, there is the great spontaneity of his enjoyment of nature's beauty, of the most ordinary events of life, and of music and literature. He was very sensitive and his reactions were emotional rather than intellectual. For those who did not know him personally perhaps this can best be illustrated with a few extracts from the many letters he has written to me.

October 12, 1956

. . . meanwhile I am annoyed that my writing should be so shaky; this is due to tiredness, even in my right hand in spite of the fact that I draw and engrave with my left. However, it seems that my right hand shares so much in the tension that it gets tired in sympathy.

The refraction effect of the prisms is so amazing that I should like to try my hand at one or two. [I had sent him a couple of prisms and had drawn his attention to the pseudoscopic effect that can be achieved with them.] As far as my experiments with them have gone, the most striking effect is that of the way in which the far distance comes forward. The farthest branches, half in the mist, suddenly appear smack in front of the tree close at hand like a magic haze. How is it that a phenomenon like this should move us so? Undoubtedly a good deal of childlike wonder is necessary.

And this I do possess in fair quantity; wonderment is the salt of the earth.

November 6, 1957

To me the moon is a symbol of apathy, the lack of wonderment which is the lot of most people. Who feels a sense of wonder any more, when they see her hanging there in the heavens? For most people she is just a flat disc, now and then with a bite out of her, nothing more than a substitute for a street lamp. Leonardo da Vinci wrote of the moon, *'La luna grave e densa, come sta, la luna?'* *Grave e densa* — heavy and compact one might translate it. With these words Leonardo gives accurate expression to the breathless wonder that takes hold of us when we gaze at that object, that enormous, compact sphere floating along up there.

September 26, 1957

Home once more, after a six-and-a-half-week voyage by freighter in the Mediterranean. Was it a dream, or was it real? An old steamship, a dream-ship, bearing the name of *Luna*, bore me, its passenger bereft of will, right beyond the sea of Marmora to Byzantium, that absolutely unreal metropolis with its population of one and a half million Orientals swarming like ants . . . then on to idyllic strands with their tiny Byzantine churches among the palms and agaves. . . .

I am still under the spell of the rhythmic dreamswell which came to me under the sign of the comet Mrkos (1957d). For a whole month and more I followed it, night after night, standing on the pitch-dark deck of the *Luna* . . . as in the glittering heavens, with its slightly curved tail, it displayed itself fiercely and astonishingly . . .

December 1, 1957

As I write, there, immediately in front of my large studio window I can watch a fascinating performance, played out by a highly proficient troupe of acrobats. I have stretched a wire for them a few feet away from my window. Here my acrobats do their balancing act with such consummate skill, and get such enjoyment out of their tumbles that I can scarcely keep my eyes off them.

My protagonists comprise coaltits, bluetits, marshtits, long-tailed tits, and crested tits. Every now and then they are chased away by a pair of fierce nuthatches (blue back and orange belly), with their stubby supporting tails and woodpecker type of beak. The shy little robin redbreast (although as intolerant and selfish as any other individual among his own family) can muster up only enough courage to peck the odd seed from time to time, and clears off the moment a tit lays claim to the bird table. I have not seen the spotted woodpecker yet; normally he does not arrive until later in the winter season. The simple, innocent blackbirds and finches stay on the ground and content themselves with the grains that fall down from above. And quite an amount does fall; the nuthatches especially are as rough, ill-mannered and messy as any pirate; so the seed comes raining down on the ground when they are tucking in on the bird table. Every year the tits have to go through the process of learning how to hang head downward so as to peck the threaded peanuts. To start with they always attempt to remain balanced, with flapping wings about the swinging peanut pendant. But it seems that it is impossible for them to peck while flapping or to flap while pecking. And so at last they make the discovery that the best position for pecking at peanuts is hanging upside down.

Fellow Men

My work has nothing to do with people, nor with psychology either. I have no idea how to cope with reality; my work does not touch it. I'm sure this is all wrong . . . I know you are supposed to rub shoulders with folk, and to help them so that everything turns out for the best for them. But I do not have any interest in humanity; I have got a great big garden for the express purpose of keeping all these folks away from me. I imagine them breaking in and shouting, "What's the big idea of this huge garden?" They

are quite justified of course, but I cannot work if I find them there. I am shy and I find it very difficult to get along with strangers. I have never enjoyed going out. . . . With my work one needs to be alone. I can't bear to have anybody go past my window. I shun both noise and commotion. I am psychologically incapable of making a portrait. To have someone sitting there right in front of me is inhibiting.

Why have we got to have our noses rubbed in all this wretched realism? Why can't we just enjoy ourselves? Sometimes the thought comes to me: "Ought I to be going on like this? Is my work not serious enough? Fancy doing all this stuff, while on TV there is this terrible Vietnam affair . . ."

I really don't feel all that brotherly. I don't have much belief in all this compassion for one another. Except in the case of the really good folk; and they don't make a song about it.

All these rather cynical utterances come from an interview with a journalist from the magazine *Vrij Nederland*. They could be supplemented by many comments taken from personal conversations, ranging from the deceit that is practiced by those who persist in talking people into having religious feelings, through Escher's opinion that all men are at each other's throats and that the strongest always wins, to his views on suicide (viz., if you have had enough you ought to be able to decide for yourself whether or not you want to disappear).

When Escher gave vent to these thoughts he meant them from the bottom of his heart, but here too there emerges a remarkable dichotomy. In his dealings with others he was a truly gentle and kindly person who could not possibly do ill to any man nor dream of harming anyone.

In the same interview in which he expressed his disgust over the fact that there are still people who sacrifice their lives to a false idea by living in monasteries, he showed me with great enthusiasm a newspaper article containing the report of a nun who had dedicated herself entirely to the relief of suffering in Vietnam.

Escher never had money troubles, but if the need arose his father would always give him financial help. When, after 1960, he began to earn large sums for his work, he showed no interest whatsoever in the money. He continued to live frugally, just as he always had, and that means *very* frugally, not far short of asceticism. It gave him pleasure to think that his work should sell so well, and he regarded success as a sure sign of appreciation. The fact that his bank balance was increasing as a result left him cold. "At the moment I am able to sell an incredible amount of my work. If I had assistants in my studio I could be a multimillionaire. They could spend the whole day running off woodcuts to satisfy the demand. I have no intention of doing any such thing; I wouldn't dream of it!"

"That would be no better than a bank note; you just print it off and get so much cash for it." In a personal interview he said, "Do you realize I worked for years on a design for the 100-guilder note, on commission from the Netherlands Bank? That did not come to anything, but nowadays I'm turning out my own five-hundred-dollar bills by my own primitive method!"

When, in later years, he became less financially dependent on his parents and his work suddenly started to bring in a great deal of money, he went on living frugally and gave away much of his earnings to help others who were in difficulties. And all this in spite of his notion that every man ought to fend for himself and that the sufferings of others were really no concern of his.

This ambivalence is a permanent part of his character. Perhaps one can explain the conjunction of such contrasting elements in the one personality by Escher's aversion to all compromise and by his thirst for honesty and clarity. He was aware of his lack of involvement, and that he therefore missed out on a certain something which might have helped him to be more at ease with his fellow men. On the other hand he was never willing to put up any pretense. He was far too absorbed in his work and in those

ideals which are exclusively connected with the sphere of his art to be able to concern himself with the weal and woe of the great family of man. Because he was so well aware of this, and indeed sad about it, he could avoid the admission that the sufferings of others did not concern him. Nevertheless, when he did feel obliged to take to heart the lot of others, he refused to fall back on words only, but helped with deeds.

All this may give the impression that he had no need of any fellow feeling for his work, or that positive and negative criticism alike left him cold. It is true that he found his own direction and style, in spite of the minimal interest in it which he had to endure. But the fact is that his entire way of working was oriented toward widespread distribution. He made no once-for-all prints. Nor did he ever limit the number of impressions. He printed off slowly and carefully, and then only as the requests came in. And when I asked him if I might have six full-sized prints published, so that they could be offered at cost price to young readers of the mathematical magazine *Pythagoras*, he did not have the slightest objection. When the bibliophile De Roos Foundation asked him to write and illustrate a short book, he wrote to me thus:

. . . it has a magnificently precious cover (in my opinion far too splendid, but then so are all these half-baked bibliographies), in a limited edition of 175 copies, destined exclusively for members of De Roos — who have to pay through the nose for the privilege. This whole preciousness of theirs is quite foreign to my nature and I thoroughly deplore the fact that the majority of the copies will come into the hands of people who set more store by the form than by the contents and who will read little or nothing of the text. . . . I always feel a little scornful and aggravated when books are brought out in a limited edition for a so-called select group.

Escher was very proud when Professor Hugh Nichol, in 1960, wrote an article about his work and entitled it *Everyman's Artist*.

It affected him deeply when people whom he knew to have little money purchased his prints: "They save up their precious pennies for them and that speaks volumes; I only hope they get inspiration in return." And happily and tenderly he once showed me a letter he had received from a group of young Americans; underneath a drawing, they had written, "Mr. Escher, thank you for being."

It is sometimes claimed that Escher was a difficult man to get on with; yet I can call to mind very few men more friendly than he. But he resented being approached by people who had no real appreciation of his work, who simply wanted to be able to say that they had once spoken to Escher, or people who wanted to make use of him. He regarded his time as being too valuable to waste on sycophants.

His prints and his work took precedence over everything else. Yet he had the capacity to look at it all from the angle of an outsider, and in relation to the whole output of mankind. While he was actually engaged in making a print, it was to him the most important thing in all the world, and during this time he would not tolerate the slightest criticism, even from the most intimate friends. This would simply have served to take the heart out of any further work on it. Yet once the print reached its final form, then he himself would adopt an attitude of extreme criticism toward it and become open to criticism from others. "I find my work to be the most beautiful and the most ugly!"

His own work was never found in his house, or even in his studio; he could not bear to have it around him.

What I produce is not anything very special. I can't understand why more people don't do it. People ought not to get infatuated by my prints; let them get on and make something for themselves; surely that would give them more enjoyment.

While I am on with something I think I am making the most beautiful thing in the whole world. If something comes off well, then I sit there in the evening gazing lovingly at it. And this love is far greater than any love for a person. The next day, one's eyes are opened again.

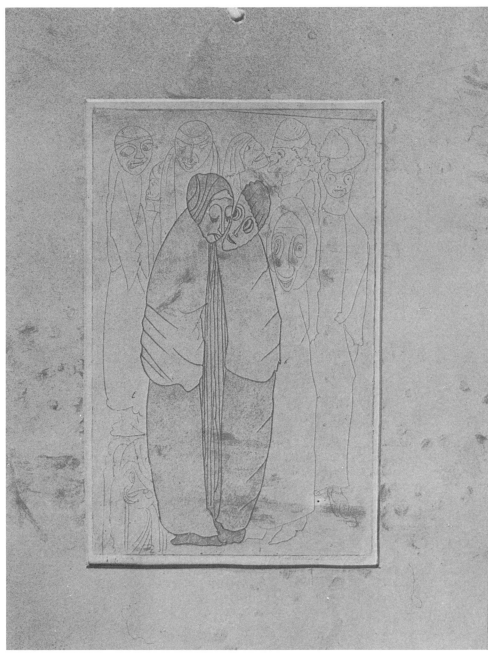

18. Jesserun de Mesquita

19. Print by de Mesquita, trampled by a German army boot

Escher and Jesserun de Mesquita

It is characteristic of Escher and of his faithfulness and gratitude to his teacher in the art of the woodcut, Jesserun de Mesquita, that he always kept a photograph of his teacher pinned on a cupboard door in his studio. When I asked him if I might have a reproduction made of it, he agreed so long as he could have it back within a week. Escher had a similar attachment to one of Mesquita's prints which he had found in the deserted house after Mesquita had been taken away to a German concentration camp. The words which Escher wrote on the back of this print, in 1945, testify, with his usual precision, to an underlying intensity of emotion:

"Found at the end of February, 1944 at the home of S. Jesserun de Mesquita, immediately behind the front door, and trampled on by German hob-nailed boots. Some four weeks previously, during the night of January 31 to February 1, 1945, the Mes-

quita family had been hauled out of bed and taken away. The front door was standing open when I arrived at the end of February. I went upstairs to the studio; the windows had been smashed and the wind was blowing through the house. Hundreds of graphic prints lay spread about the floor in utter confusion. In five minutes I gathered together as many as I could carry, using some pieces of cardboard to make a kind of portfolio. I took them over to Baarn. In all there turned out to be about 160 prints, nearly all graphic, signed and dated. In November, 1945 I transferred them all to the Municipal Museum in Amsterdam, where I plan to organise an exhibition of them, along with such works of de Mesquita as are already being kept there, and those in the care of D. Bouvy in Bussum. It must now be regarded as practically certain that S. Jesserun de Mesquita, his wife and their son Jaap all perished in a German Camp.

November 1, 1945. M. C. Escher."

19

5 How His Work Developed

Themes

Viewing Escher's work as a whole, we find that, in addition to a number of prints which have primarily southern Italian and Mediterranean landscape as their theme, and which were nearly all made prior to 1937, there are some seventy prints (post-1937) with a mathematical flavor.

In these seventy prints Escher never repeats himself. He indulged in repetition only if he was working on a commission. From his free work one can see that from first to last he is engaged in a voyage of discovery and that every print is a report on his findings. In order to gain an insight into his work one must not only make a careful analysis of each separate print but also take all seventy prints and read them as a logbook of Escher's voyage of discovery. This voyage spans three areas—that is to say, the three themes that can be discerned among the mathematical prints.

1. *Spatial structure.* Viewing his work as a whole, one can observe that even in the pre-1937 landscape prints it was not so much the picturesque that was being aimed at, but rather, structure. Wherever this latter feature was almost entirely lacking, as in ruins, for instance, Escher had no interest in the scene. In spite of his ten-year sojourn in Rome, all among the remains of an ancient civilization, he scarcely devoted a single print to it, and visits to Pompeii have left no trace whatsoever in his work.

After 1937 he no longer dealt with spatial structure in an analytical way. He no longer left space intact just as he found it but produced a synthesis in which differing spatial entities came together in one, *and in the same* print, with compelling logic. We see the results of this in those prints where different structures interpenetrate. Attention to strictly mathematical structures reaches its height at a later stage and originates in his admiration for the shapes of crystals. There are three categories of this spatial structure theme:

a. Landscape prints.
b. Interpenetration of different worlds.
c. Abstract, mathematical solids.

2. *Flat surface structure.* This begins with an interest in regular tessellations (i.e., identical or graduated surface divisions), stimulated in particular by his visits to the Alhambra. After an intensive study, by no means an easy task for a nonmathematician, he worked out a whole system for such periodic drawings.

Finally the periodic drawing turns up again in his approaches to infinity, although in this case the surface is filled up not with congruent figures but with those of similar shape. This gives rise to more complicated problems and it is not until later that we find this kind of print appearing.

Thus flat surface structure studies can be basically divided into these categories:

a. Metamorphoses.
b. Cycles.
c. Approaches to infinity.

3. *The relationship between space and flat surface in regard to pictorial representation.* Escher found himself confronted at an early stage with the conflicted situation that is inherent in all spatial representation—i.e., three dimensions are to be represented on a two-dimensional surface. He gave expression to his amazement about this in his perspective prints.

He subjects the laws of perspective, which have held sway in spatial representation ever since the Renaissance, to a critical scrutiny, and, having discovered new laws, illustrates these in his perspective prints. The suggestion of three dimensions in flat-picture representation can be taken to such lengths that worlds which could not even exist in three-dimensional terms can be suggested on a flat surface. The picture appears as the projection of a three dimensional object on a flat surface, yet it is a figure that could not possibly exist in space.

In this last section too we find three groups of prints:

a. The essence of representation (conflict between space and flat surface).
b. Perspective.
c. Impossible figures.

Chronology

Careful analysis of the post-1937 prints shows that the different themes appear at different periods. That this fact has not been

1. Spatial structure

Landscape prints **Interpenetration of different worlds** **Abstract, mathematical solids**

Town in Southern Italy

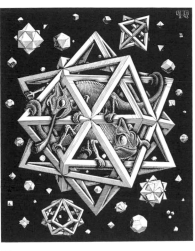

Hand with Reflecting Sphere

Stars

2. Flat surface structure

Metamorphoses **Cycles** **Approaches to infinity**

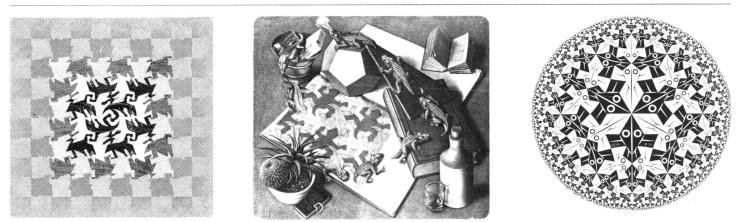

Development I *Reptiles* *Circle Limit I*

3. Pictorial representation of the relationship between space and flat surface

The essence of representation **Perspective** **Impossible figures**

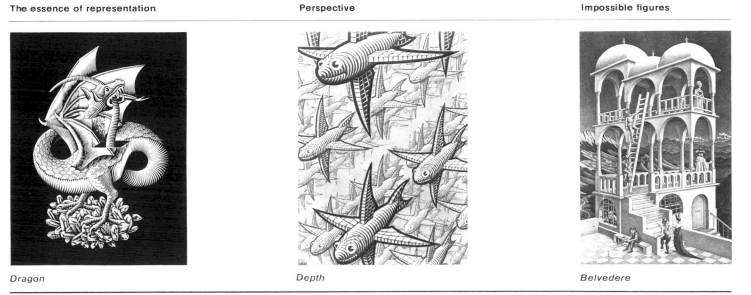

Dragon *Depth* *Belvedere*

21

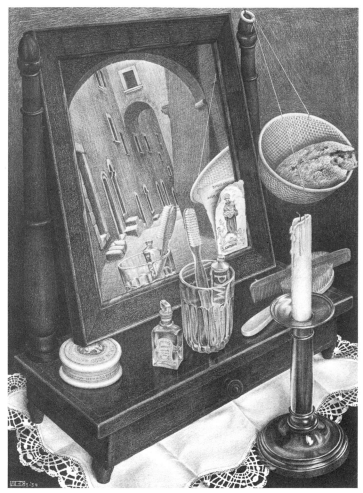

23. *Still Life with Mirror*, lithograph, **1934**

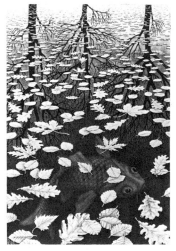

24. *Three Worlds*, lithograph, **1955**

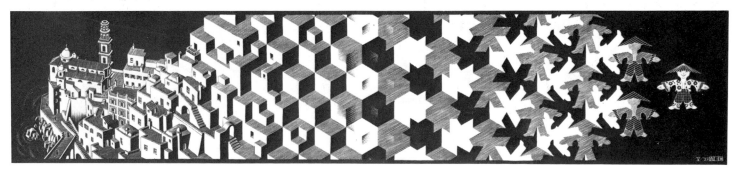

25. *Metamorphosis I*, woodcut, **1937**

noticed sooner is probably due to the difficulty of analyzing the prints and to the fact that in any given period a number of themes occupied Escher's mind simultaneously. Moreover, each period had its time of predevelopment, and so did not announce its arrival very clearly; what is more, a particular theme might very well turn up again even when the time of full attention to that theme had passed.

We shall try to assign years to the various periods, marking their beginning and end with certain prints. We shall also try to state which print, in our view, may be regarded as the highest point of the period in question.

1922–1937 Landscape Period

Most of these prints depict landscapes and small towns in southern Italy and the Mediterranean coastal areas. Apart from that, there are a few portraits and some plants and animals. A high point was undoubtedly reached with *Castrovalva* (1930), a large-sized lithograph of a small town in the Abruzzi. A new line of thought was showing itself in 1934, in the lithograph *Still Life with Mirror*, in which the mingling of two worlds was achieved by the reflection in a shaving mirror. This theme, which can be seen as a direct continuation of the landscape prints, is the only one which is not tied to any particular period. The last print of this type, which incidentally we might count as the high point, and which appeared in 1955, was *Three Worlds*, a lithograph full of calm, autumn beauty; and the unsuspecting viewer can scarcely realize what a triumph it was for Escher to succeed in representing here three different worlds in the one place, and so realistically too.

1937–1945 Metamorphoses Period

The print which heralds this period, *Metamorphosis I* (1937), shows the gradual transformation of a small town, through cubes, to a Chinese doll.

It is not easy to point to any high-water mark in this period. I will pick out *Day and Night* (1938) for this. All the characteristics of the period are to be found in it; it is a metamorphosis and at the same time a cycle, and, what is more, we can observe the change-over from two-dimensional forms (via ploughed fields) to three-dimensional ones (birds). The final metamorphosis-cycle print of this period *(Magic Mirror)* appeared in 1946.

The essence of representation that is already implicitly enunciated in the first of the metamorphosis prints (i.e., transformation from the two-dimensional to the three-dimensional) is explicitly stated only at the latter end of the period, in the print *Doric Columns* (1945). In 1948 there came the most beautiful print, *Drawing Hands*, and the very last print on this theme was made in 1952 *(Dragon)*. These last-mentioned prints extend chronologically far into the following period.

With the making of *St. Peter's, Rome* in 1935 and the *Tower of Babel* in 1928, all Escher's special interest in unconventional standpoints came to the fore. Already it was not so much a question of what one was trying to depict in the picture but rather of the idiosyncracies of the perspective that was being used in it. But it was in 1946 that the great quest really began into the regions beyond the traditional rules of perspective. The mezzotint *Other World* (1946), though not wholly successful as a print, introduced a point which was simultaneously zenith, nadir, and vanishing point. The best example of this period is undoubtedly *High and Low* (1947), in which in addition to a relativity of vanishing points we note bundles of parallel lines depicted as convergent curves.

At the close of this period there is a return to traditional perspective *(Depth)* when Escher is aiming at suggesting the infinity of space.

During this same period Escher's interest in straightforward geometrical spatial figures, such as regular multisurfaces, spatial spirals, and Moebius strips, came to the fore. The origin of this interest is to be found in Escher's delight in natural crystal shapes. His brother was a professor of geology and wrote a scientific handbook on minerology and crystallography. The first print was *Crystal* (1947). *Stars* (1948) is almost certainly the high point. In 1954 the last of the prints entirely devoted to stereometric figuration *(Tetrahedral Planetoid)* was made.

We do meet with a few more spatial figures in later prints, but then only as incidental ornamentation, such as the figures standing on the corner towers in *Waterfall* (1961).

In spite of the fact that they appeared at a later stage, the Moebius prints really belong to this period. Such figures were completely unknown to Escher at the time, but as soon as a mathematician friend of his pointed them out to him, he used them in prints, almost as if he wanted to make good an omission.

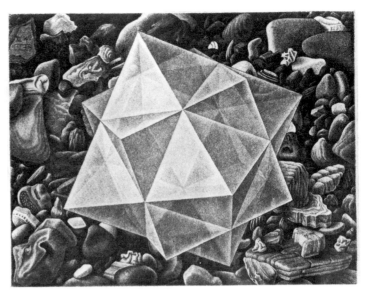

26. *Crystal*, mezzotint, 1947

1956-1970 Period of Approaches to Infinity

This period started off in 1956 with the wood engraving *Smaller and Smaller I*. The colored woodcut *Circle Limit III* (1959) was, even in his own opinion, much the best print dealing with this subject. Escher's very last print, in the year 1969 *(Snakes)*, is an approach to infinity.

In this period also the so-called impossible figures appeared, the first being *Convex and Concave* (1955) and the last *Waterfall* (1961).

The cleverest and most impressive print of this period, without doubt a highlight in the whole of Escher's work, is *Print Gallery* (1956). If one were to apply to it the same aesthetic standards as to art of an earlier time, then one could find a great deal of fault with it. But what applies to every one of Escher's prints applies here: an approach through the senses would miss entirely the deepest intentions of the artist. Escher's own opinion was that in *Print Gallery* he had reached the furthest bounds of his thinking and of his powers of representation.

Prelude and Transition

The remarkable revolution that took place in Escher's work was between 1934 and 1937. This transition definitely coincided with a change of domicile, although it is in no way explained by it. As long as Escher remained in Rome he continued to be entirely oriented toward the beauty of the Italian landscape. Immediately after his move, first to Switzerland, and then to Belgium

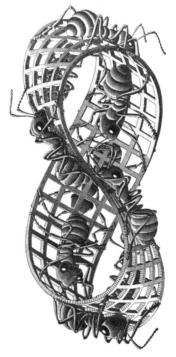

27. *Moebius Strip II*, wood engraving, 1963

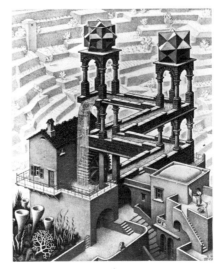

28. *Waterfall*, lithograph, 1961

29. *St. Bavo's, Haarlem*, India ink, 1920

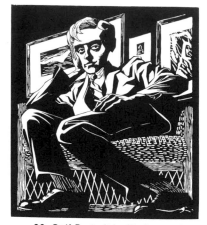

30. *Self-Portrait in Chair*, woodcut

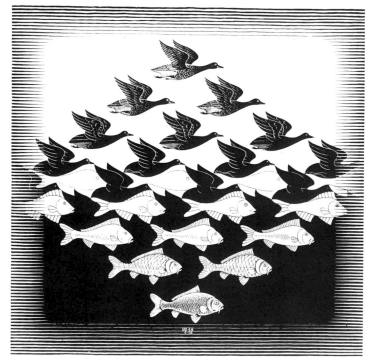

31. *Sky and Water I*, woodcut, 1938

and Holland, an inward change took place. No longer could he find the same inspiration in the outer visual world, but rather in mental constructions which can be expressed and described only mathematically.

It is obvious that no artist can experience such an abrupt transformation out of the blue. Had there not been a predisposition for it, the mathematical turn in his work could never have come about. However, it would be wrong to look for this predisposition in any scientifically mathematical interest. Escher bluntly declared to all who were willing to listen that he was a complete layman in the sphere of mathematics. He once said in an interview, "I never got a pass mark in math. The funny thing is I seem to latch on to mathematical theories without realizing what is happening. No indeed, I was a pretty poor pupil at school. And just imagine—mathematicians now use my prints to illustrate their books. Fancy me consorting with all these learned folk, as though I were their long-lost brother. I guess they are quite unaware of the fact that I'm ignorant about the whole thing."

And yet, this is indeed the truth. Anyone who tried to get a mathematical statement out of Escher, at any rate one which goes beyond what the merest secondary-school student knows, had the same sort of disappointment as that experienced by Professor Coxeter, who was fascinated by Escher's work because of its mathematical content. He took the artist along to attend one of his lectures, convinced that Escher would surely be able to understand it. Coxeter's lecture was about a subject that Escher had used in his prints. As might have been expected, Escher did not understand a thing about it. He had no use for abstract ideas, even though he agreed that they could be very brilliant, and admired anyone who felt at home among abstractions. But if an abstract idea had a point of contact with concrete reality then Escher was able to do something about it, and the idea would promptly take on a concrete form. He did not work like a mathematician but much more like a skilled carpenter who constructs with folding rule and gauge, and with solid results in mind.

In his earliest work, even when he was still at college in Haarlem, we can detect a prelude, although these recurring themes will be revealed only to those who really do know his later work. He did a large pen-and-ink drawing in St. Bavo's Cathedral, in 1920, on a sheet measuring more than a meter square. An enormous brass candelabrum is, so to speak, imprisoned in the side aisles of the cathedral. But in the shining sphere underneath the candelabrum we can see the whole cathedral reflected, and even the artist himself! Here, already, is an involvement with perspective and with the intermingling of two worlds by means of a convex reflection.

Self-portraits are usually made in front of a mirror, but in one of the self-portraits of this period (a woodcut) the mirror, although obviously being used, is invisible. Escher has placed the mirror at an angle at the edge of the bed, and so achieves an unusual viewpoint for this portrait.

A woodcut made in 1922, very early in his career, shows a large number of heads filling the entire surface. It was printed by the repetition of a single block on which eight heads had been cut, four of them right-side up and four upside-down. This sort of thing was not in the program of his teacher, de Mesquita. Both the complete filling up of the surface and the repetition of theme by making imprints of the same block next to each other were done on Escher's own initiative.

After he had visited the Alhambra for the first time, we can see a new attempt to make use of periodic surface-division. A few sketches of this, together with a few textile-design prints, have survived from 1926.* They are somewhat labored and awkward efforts. Half of the creatures are standing on their heads, and the little figures are primitive and lacking in detail. Surely these attempts serve to show very clearly how difficult any exploration in this field was, even for Escher!

After a second visit to the Alhambra, in 1936, and the subsequent systematic study of the possibilities of periodic surface-division, there appeared, in quick succession, a number of prints of outstanding originality: in May, 1937, *Metamorphosis I;* in November *Development;* and then in February, 1938, the well-known woodcut *Day and Night,* which immediately made a vital impact on those who admired Escher's work and which, from that moment onward, was one of the most sought-after of his prints. In May, 1938, the lithograph *Cycle* appeared, and in June more or less the same theme as in *Day and Night* was taken up again, in *Sky and Water I.*

The south Italian landscape and town scenes had now disappeared for good. Escher's mind was saturated with them and his portfolios were filled with hundreds of these sketches. He was to make use of them later, not as main subjects for prints, but rather as filling, as secondary material for prints with totally different types of content. In 1938 G. H. 'sGravesande devoted an article to this new work, in the November number of *Elsevier's Monthly Magazine:* "But the never-ending production of landscapes could not possibly satisfy his philosophical mind. He is in search of other objectives; so he makes his glass globe with the portrait in it a most remarkable work of art. A new concept is forcing him to make prints in which his undoubted architectural propensities can join forces with his literary spirit. . . ." Then there follows a description of the prints made in 1937 and 1938.

At the end of an article written, once again, by 'sGravesande, we read, "What Escher will give us in the future—and he is still a comparatively young man—cannot be predicted. If I interpret things aright, then he is bound to go beyond these experiments and apply his skill to industrial art, textile design, ceramics, etc., to which it is particularly suited." True enough—no prediction could be made, by 'sGravesande or even by Escher himself.

Escher's new work did not result in making him any more widely known; official art criticism passed him by entirely for ten whole years, as we have already seen. Then in the February, 1951, issue of *The Studio,* Marc Severin published an article on Escher's post-1937 work. At a single blow, this made him widely known. Severin referred to Escher as a remarkable and original artist who was able to depict the poetry of the mathematical side of things in a most striking way. Never before had so comprehensive and appreciative an appraisal of Escher's work been made in any official art magazine, and this was heart-warming for the fifty-three-year-old artist.

An even more outspoken and perceptive critique appeared in an article by the graphic artist Albert Flocon, in *Jardin des Arts* in October, 1965.

His art is always accompanied by a somewhat passive emotion, the intellectual thrill of discovering a compelling structure in it and one which is a complete contrast to our everyday experience, and, to be sure, even calls it in question. Such fundamental concepts as above and below, right and left, near and far appear to be no more than relative and interchangeable at will. Here we see entirely new relationships between points, surface, and spaces, between cause and effect, and these go to make spatial structures which call up worlds at once strange and yet perfectly possible.

Flocon placed Escher among the thinkers of art—Piero della Francesca, Da Vinci, Dürer, Jannitzer, Bosse-Desargues, and Père Nicon—for whom the art of seeing and of reproducing the seen has to be accompanied by a research into fundamentals. "His work teaches us that the most perfect surrealism is latent in reality, if only one will take the trouble to get at the underlying principles of it."

In 1968, on the occasion of Escher's seventieth birthday, a great retrospective exhibition of his work was held in the municipal museum at The Hague. As far as the numbers of visitors were concerned this exhibition did not fall behind the Rembrandt Exhibition. There were days on which one could scarcely get near the prints. The onlookers stood in serried ranks in front of the display walls, and the fairly expensive catalogue had to be reprinted.

The Netherlands Minister for Foreign Affairs commissioned a film about Escher and his work. This was completed in 1970. Inspired by Escher's prints, the composer Juriaan Andriessen wrote a modern work which was performed by the Rotterdam Philharmonic Orchestra, together with a synchronized projection of Escher's prints. The three performances, toward the end of 1970, drew full houses, with audiences especially of young people. Enthusiasm was so great that large sections of the work had to be repeated.

Now Escher is more widely known and appreciated as a graphic artist than any other member of his profession.

32. Tile mural, (First) Liberal Christian Lyceum, The Hague, 1960

6 Drawing Is Deception

If a hand is drawing a hand and if, at the same time, this second hand is busy drawing the first hand also, and if all this is illustrated on a piece of paper fixed to a drawing board with thumb tacks . . . and if the whole thing is then drawn again, we may well describe it as a sort of superdeception.

Drawing is indeed deception. We are being persuaded that we are looking at a three-dimensional world, whereas the drawing paper is merely two-dimensional. Escher regarded this as a conflict situation and he tried to show this very closely in a number of prints, such for instance as the lithograph *Drawing Hands* (1948). And in this chapter we shall deal not only with those particular prints but also with some in which this conflict appears as a secondary incidental feature.

The Rebellious Dragon

At first sight, the wood engraving *Dragon,* made in 1952, merely depicts a rather decorative little winged dragon, standing on a clump of quartz crystals. But this particular dragon is sticking his head straight through one of his wings and his tail through the lower part of his body. As soon as we realize that this is happening, and in a peculiar mathematical way at that, we arrive at an understanding of what the print is all about.

We would not give a second thought to a dragon like the one in figure 35; but then it is worth bearing in mind that in this case, as with all the pictures, the dragon is flat. He is two-dimensional! Yet we are so accustomed to pictures of three-dimensional things expressed in the two dimensions of drawing paper, photograph, or movie screen, that we do in fact see the dragon in three dimensions. We think we can tell where he is fat and where he is thin; we could even try estimating his weight! An arrangement of nine lines we immediately recognize as a spatial object, *i.e.,* a cube. This is sheer self-deception. This is what Escher tried to demonstrate in this *Dragon* print. "After I had drawn the dragon [as shown in figure 35] I cut the paper open at *AB* and *CD,* folding it to make square gaps. Through these openings I pulled the pieces of paper on which the head and the tail were drawn. Now it was obvious to anybody that it was completely flat. But the dragon

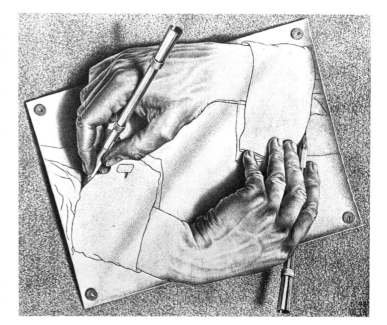

33. *Drawing Hands,* lithograph, 1948

didn't seem too pleased with this arrangement, for he started biting his tail, as could only be done in three dimensions. He was just poking fun—and his tail—at all my efforts."

The result is an example of flawless technique, and when we look at the picture we can scarcely realize how immensely difficult it has been to achieve so clear a representation of the conflict between the three dimensions suggested and the two dimensions available for doing it. Fortunately, a few preparatory sketches for this print have been preserved. Figure 36 shows a pelican sticking his long beak through his breast. This particular subject was rejected—because it did not offer enough possibilities.

In figure 37 we find a sketch of the dragon in which all the essential elements of the print are already present. Now comes the difficult task of getting the cut-open and folded part into correct perspective, so that the viewer will unmistakably recognize the gaps. For Escher can suggest that the dragon is completely flat only if he depicts the two incisions and the foldings very

realistically—that is to say, three-dimensionally. The deception is thus revealed by means of another deception! The diamond shapes in figure 38 will help us to follow this perspective more easily. In figure 39 the dragon is really and truly flat, cut, and folded. Finally, figure 40 introduces a possible variation; in this case the folds are not parallel but are at right angles to each other. This idea has not been worked out any further.

And Still It Is Flat

The upper section of the wood engraving *Three Spheres I* (1945), consists of a number of ellipses, or, if one prefers it that way, a number of small quadrangles arranged elliptically. We find it

practically impossible to rid ourselves of the notion that we are looking at a sphere. But Escher would like to get it into our heads that no sphere is involved at all; the whole thing is flat. So he folds back the topmost section and re-draws the resultant figure beneath the so-called sphere. But still we find ourselves given over to a three-dimensional interpretation; we can now see a hemisphere with a lid! Right, so Escher draws the top figure once again but this time lying flat. Yet even now we refuse to accept it, for what we see this time is an oval, inflated balloon, and certainly not a flat surface with curved lines drawn on it. The photograph (figure 42) illustrates what Escher has done.

The engraving *Doric Columns*, made in the same year, has precisely the same effect. It really is too bad that we cannot be convinced of the flatness of the print; and what is worse, the very means that Escher uses are exactly the same as the malady that

36. A pelican did not offer enough possibilities

37.

39.

38.

40.

Preparatory studies for the wood engraving, *Dragon*

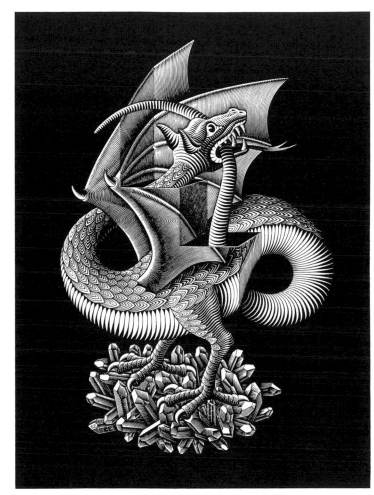

34. *Dragon*, wood engraving, 1952

35. The paper Dragon

27

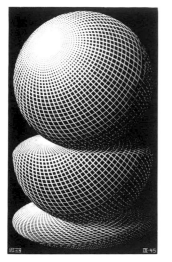

41. *Three Spheres I,*
wood engraving, 1945

**42. Photograph of three spheres—
not spheres, but flat circles**

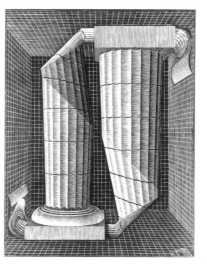

43. *Doric Columns,* **wood engraving, 1945**

he is trying to cure. In order to make it appear that the middle figure is on a flat drawing surface, he makes use of the fact that such a surface can be used to give an impression of three dimensions.

Both from a structural point of view and as a wood engraving, this print is incredibly clever. In earlier days this would have been regarded as a master test for a wood engraver.

How 3-D Grows Out of 2-D

Because drawing is deception—i.e., suggestion instead of reality—we may well go a step further, and produce a three-dimensional world out of a two-dimensional one.

In the lithograph *Reptiles* (1943) we see Escher's sketchbook, in which he has been putting together some ideas for periodic drawings. At the lower left-hand edge the little, flat, sketchy figures begin to develop a fantastic three-dimensionality and

thereby the ability to creep right out of the sketch. As this reptile reaches the dodecahedron, by way of the book on zoology and the set square, he gives a snort of triumph and blows smoke from his nostrils. But the game is up, so down he jumps from the brass mortar on to the sketchbook. He shrivels back again into a figure and there he remains, stuck fast in the network of regular triangles.

In figure 45 we see the sketchbook page reproduced. The remarkably interesting thing about this surface division is the existence of three different types of rotation point. These are: where three heads come together, where three feet touch, and where three "knees" meet. If we were to trace the design on transparent paper, and then stick a pin through both tracing paper and drawing at one of the above named points, we could turn the tracing paper through 120 degrees, and this would make the figures on the tracing paper fit over those of the drawing once again.

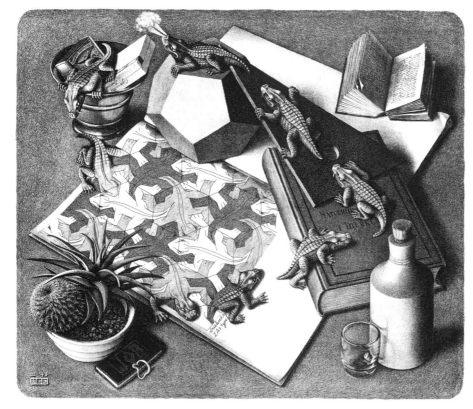

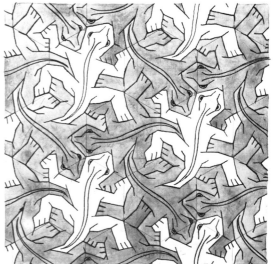

45. Sketch for *Reptiles,* **pen, ink, and watercolor,
1939**

44. *Reptiles,* **lithograph, 1943**

28

46. Sketch for *Encounter*, pencil, 1944

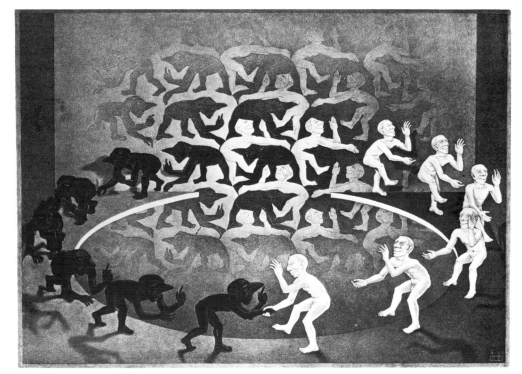

48. The periodic space-filling that was the basis for *Encounter*, pencil and India ink, 1944

White Meets Black

In the lithograph *Encounter* (1944) we can see a periodic drawing division consisting of black and white figures painted on a wall. At right angles to the wall there is fixed a floor with a large circular hole in it. The little men seem to sense the proximity of the floor, because as soon as they get near to it they step down from the wall, take on a further dimension in doing so, and then shuffle in rather a wooden fashion along the edge of the chasm. By the time the black and white figures meet, the transformation into real people is so far advanced that they are able to shake hands. The first time this print was reproduced an art dealer rather hesitated to put it on display because the little white man resembled Colijn, a popular Dutch prime minister! Escher had not intended this in the least; the figures had, so to speak, evolved spontaneously out of the periodic division of the surface.

This periodic drawing has two different axes of glide reflection, running vertically. By using tracing paper one can easily find them. We shall return to this in the next chapter.

Day Visits to Malta

On his cargo-boat voyages through the Mediterranean Escher called at Malta on two occasions. These were only short visits and lasted hardly a whole day, just long enough for the ship to load and unload. A sketch of Senglea (a little harbor town on Malta) has been preserved, dated March 27, 1935. In October of that same year Escher made a three-colored woodcut from it. This print is reproduced here, because it is not very well known and because he was later to use several important elements from it for two other prints.

A year later (June 18, 1936), when Escher escaped from Switzerland to make the Mediterranean tour which was to have so

47. *Encounter*, lithograph, 1944

great an influence on his work, the ship called once again at Malta and Escher sketched practically the same part of the little harbor town.

There must have been something very fascinating about the structure of this backdrop of buildings, because ten years later, when he was looking for a lively, well-balanced, rhythmic grouping of buildings for a print in which the center could be subjected to expansion *(Balcony)* his choice fell on this 1935 Malta print. And after yet another ten years he used the same sketch again for his unique print *Print Gallery* (1956). In this we can recognize not only the various groups of houses and the rocky coastline (as in *Balcony*) but this time the freighter as well.

Blow-up

In *Balcony* the center of the print is enlarged four times relative to its edges. We shall look presently at the method Escher used to achieve this effect. The result is a splendid bulge. It is as though the print had been drawn on a sheet of rubber and then inflated from behind. Details that hitherto had been of altogether minor importance have now been transformed and become the center of our attention. If we compare the print with the working sketch that was made for it, and in which the same scene is shown in its undeveloped form, then this particular balcony is not all that easy to find; it is in fact the fifth balcony from the bottom. In the working sketch the four lowest balconies are almost equidistant from each other, whereas in the print the distances between those nearest the bulge have been very considerably

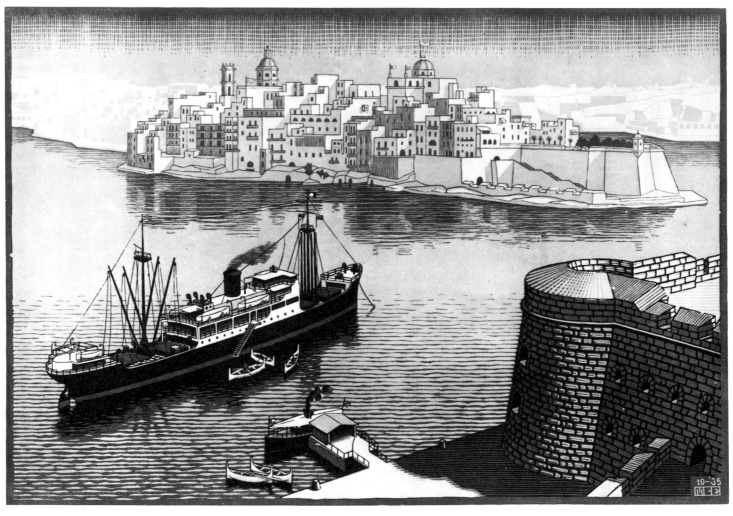

50. *Senglea*, woodcut, 1935

49. Sketch for Malta

compressed. For the inflation of the central area has got to be compensated for somewhere else, because the total content of the scene is the same in both working sketch and final print.

In figure 52 we see a square divided up into small squares. The broken circle marks the boundary of the above-mentioned distortion. The vertical lines PQ and RS and the horizontal lines KL and MN reappear in figure 53 as curved lines. In figure 54 the center is inflated. A, B, C, and D are displaced toward the edge and take up the position A', B', C', and D'. And it is possible to reconstruct the whole network in this way, of course. So we find that an expansion has taken place around the center of the circle and a squeezing together at its circumference; the horizontal and vertical lines have been, so to speak, pressed outward toward the edge of the circle. Figures 51 and 55 show the pictorial contents deformed and undeformed. And that is how the enormous blow-up in the center of *Balcony* has been brought about.

Growing 256 Times Over

Print Gallery arose from the idea that it must also be possible to make an annular bulge. First of all, let us approach the print as an unsuspecting viewer. At the lower right-hand corner we find the entrance to a gallery in which an exhibition of prints is being held. Turning to the left we come across a young man who stands looking at a print on the wall. On this print he can see a ship, and higher up, in other words in the upper left-hand corner, some houses along a quayside. Now if we look along to the right, this row of houses continues, and on the far right our gaze descends, to discover a corner house at the base of which is the entrance to a picture gallery in which an exhibition of prints is being held. . . . So our young man is standing inside the same print as the one he is looking at! Escher has achieved the whole

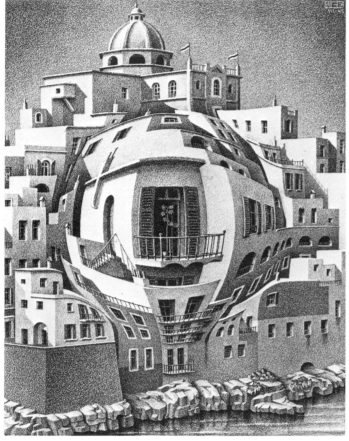

51. *Balcony*, lithograph, 1945

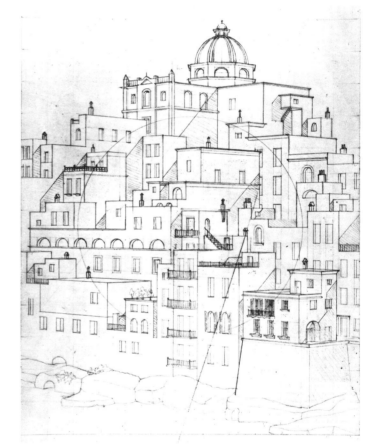

55. Sketch before the center was blown up

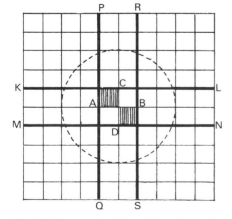

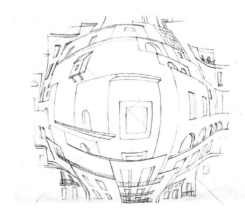

52.–53. The construction of the grid for the blow-up of the center

54. The blown-up center

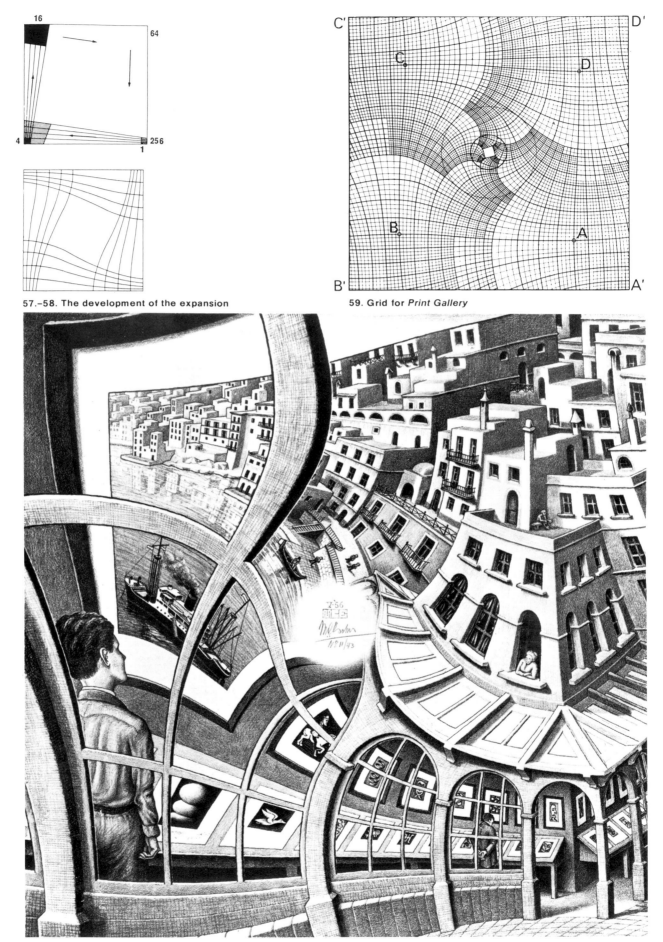

57.–58. The development of the expansion

59. Grid for *Print Gallery*

56. *Print Gallery*, lithograph, 1956

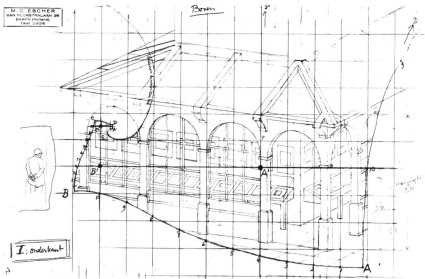

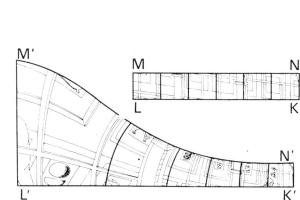

60. Print Gallery before the expansion

61a,b. How the circular expansion was obtained

of this trickery by constructing a grid that can be used as a framework for the print, marking out a bulge in a closed ring formation and having neither beginning nor end. The best way to gain an understanding of this construction is to study a few schematic drawings.

At the lower right of the square, figure 57, a small square has been drawn, and as we move along the bottom edge toward the left we note that this figure keeps increasing in size, until at the left-hand edge it has reached a fourfold enlargement. The dimensions of the original figure have now become four times as great. Passing upward along the left-hand edge we find a further fourfold increase, thus multiplying the original dimensions by sixteen. Go to the right along the top edge and the dimensions are sixty-four times as great as the original ones; keep on down the right-hand side and the enlargement is 256 times by the time we arrive back at the exit. What originally measured 1 centimeter in length has now become 2 meters 56! It would of course be quite impossible to carry out this exercise in full in the whole picture. In the actual figure we do not get any further than the first two stages (or indeed only one full stage, for at the second enlargement only a small section of the already enlarged figure is used).

At first Escher tried to put his idea into practice using straight lines, but then he intuitively adopted the curved lines shown in figure 58. In this way the original small squares could better retain their square appearance. With the aid of this grid a large part of the print could be drawn, but there was an empty square left in the middle. It was found possible to provide this square with a grid similar to the original one, and, by the repetition of this process a few more times, the grid shown in figure 59 came into being. *A'B'C'D'* is the original square and *ABCD* is an outward expansion that was a necessary consequence and a logical outcome. This marvelous grid has astonished several mathematicians, and they have seen in it an example of a Riemann surface.

In our figure 58 only two stages of the enlargement are shown. This is in fact what Escher has done in his print. We can see the gallery getting larger from right to left. The two further stages could not possibly be carried out within the square, because an ever-increasing area is required to represent the enlargement of the whole. It was a brilliant notion of Escher's to cope with the last two stages by drawing attention to one of the prints in the gallery, for this print itself can be enlarged within the square. Another invention of his was to illustrate within the aforementioned print a gallery that coincided with the gallery he started with.

Now we must find out how Escher, starting out as he did with a normal drawing, was able to transfer this onto his prepared grid. We shall concentrate on only a small part of this rather complicated process. Figure 60 shows one of the detailed drawings, that of the gallery itself. A squared grid was placed over the drawing. We come across the points *A, B*, and *A'* again of figure 59. And we also find there the same grid but this time in an altered form—that is to say, becoming smaller to the left. Now the image of each little square is transferred to the equivalent square on the grid. In this way the enlargement of the picture is automatically achieved. For example, the rectangle in figure 61a, *KLMN*, is transferred thus to *K'L'M'N'* in figure 61b.

I watched *Print Gallery* being made, and on one of my visits to Escher I remarked that I thought the bar to the left of the center horribly ugly; I suggested that he ought to let a clematis grow up it. Escher returned to this matter in a letter:

> No doubt it would be very nice to clothe the bars of my *Print Gallery* with clematis. Nevertheless, these beams are supposed to be dividing bars for window panes. What is more I had probably used up so much energy already on thinking out how to present this subject that my faculties were too deadened to be able to satisfy aesthetic demands to any greater degree. These prints, which, to be quite honest, were none of them ever turned out with the primary aim of producing "something beautiful," have certainly caused me some almighty headaches. Indeed it is for this reason that I never feel quite at home among my artist colleagues; what they are striving for, first and foremost, is "beauty"—albeit the definition of that has changed a great deal since the seventeenth century! I guess the thing I mainly strive after is wonder, so I try to awaken wonder in the minds of my viewers.

Escher was very fond of this print and he often returned to it.

> Two learned gentlemen, Professor van Dantzig and Professor van Wijngaarden, once tried in vain to convince me that I had drawn a Riemann surface. I doubt if they are right, in spite of the fact that one of the characteristics of a surface of this kind seems to be that the center remains empty. In any case Riemann is completely beyond me and theoretical mathematics are even more so, not to mention non-Euclidian geometry.
>
> So far as I was concerned it was merely a question of a cyclic expansion or bulge, without beginning or end. I quite intentionally chose serial types of objects, such, for instance, as a row of prints along the wall and the blocks of houses in a town. Without the cyclic elements it would be all the more difficult to get my meaning over to the random viewer. Even as things are he only rarely grasps anything of it.

Bigger and Bigger Fish

In 1959, Escher used the same idea and almost the same grid system for a more abstract woodcut, *Fish and Scales.* On the left we see the head of a large fish; the scales on the back of this fish gradually change, in a downward direction, into small black and white fish, which in turn increase in size. They form two schools swimming in among each other. We can almost exactly see the same thing happening if we start with the big black fish on the right. Figure 63 shows the scheme for the lower half of the print, and we find the upper half if we turn figure 64 through 180 degrees about the center of the drawing (small black block)— except that in the upper half the eyes and mouth are reversed in such a way that not a single fish is to be found upside down. Arrows indicate the directions in which the black and white fish are swimming.

Then we find that the scale *A,* swelling into a little fish at *B,* goes on to *C* and grows into the big black fish in the top half of the print. If we draw in lines above and below the swimming directions and then carefully extend this same system of lines to left and right, a rough outline appears of the grid that is used in the print. Thus we can get a much better understanding of what is happening. We can start at *P,* where we find a scale belonging to the big black fish on the right moving upward. This scale grows and changes into the little fish at *Q.* If we move to the left, this little fish goes on increasing in size until it has turned into the big black fish on the left. Now, if we should wish to move downward from *R,* this fish would have to be succeeded by still larger fish, and this is impossible within the compass of this print. Therefore, just as in *Print Gallery* he switched over from the gallery to the print as soon as available space became too small, so now Escher has selected one of the scales from the large fish so as to continue the enlargement process from *R* to *S.* The large fish plays her part in this, for before she has even reached her full size, she bursts open and brings forth some new little fish. In this way the enlargement continues without a break from *S* onward. The little fish at *S* swells up into the big fish on the right, from which once again we can select a scale—and so on.

It will be quite obvious that the grid for *Fish and Scales* is a mirror image of the one for *Print Gallery.*

Now, in *Fish and Scales* two further favorite themes of Escher's are brought out—i.e., periodic drawings and metamorphosis (from scales to fish).

Drawing is deception. On the one hand Escher has tried to reveal this deception in various prints, and on the other hand he has perfected it and turned it into superillusion, conjuring up with it impossible things, and this with such suppleness, logic, and clarity that the impossible makes perfect sense.

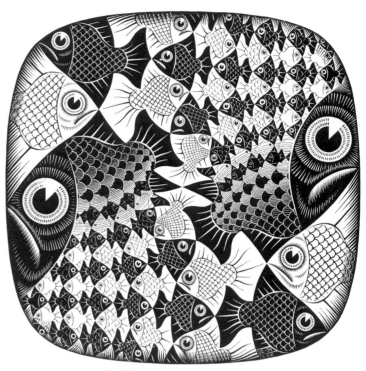

62. *Fish and Scales,* woodcut, **1959**

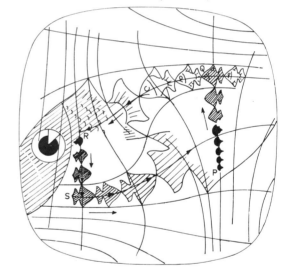

63. From scale into fish

64. Grid for *Fish and Scales*

34

7 The Art of the Alhambra

65. First attempt at regular division of a plane, with imaginary animals (detail), pencil and watercolor, 1926 or 1927

The Stubborn Plane

No theme or topic lay closer to Escher's heart than *periodic drawing division*. He wrote a fairly extensive treatise on the subject, going into technical details. There is only one other theme about which he has written—although by no means at such length—and that is *approaches to infinity*. What he says on the latter subject can perhaps be applied with even more justice to periodic drawing. It is a question of confession:

I can rejoice over this perfection and bear witness to it with a clear conscience, for it was not I who invented it or even discovered it. The laws of mathematics are not merely human inventions or creations. They simply "are"; they exist quite independently of the human intellect. The most that any man with a keen intellect can do is to find out that they are there and to take cognizance of them.

He also writes (in this instance in regard to regular tessellation): "It is the richest source of inspiration that I have ever tapped, and it has by no means dried up yet."

We can see how very much predisposed Escher was to the discovery and application of the principles of tessellation, even in the earliest work reproduced here, done when he was still studying under de Mesquita in Haarlem. The most detailed and fully developed production of this period is certainly the woodcut *Eight Heads* (1922). Eight different heads are cut on the one wood block, four of them right way up and four upside down. Here, in figure 66, we see the block printed four times over. These thirty-two heads have a certain theatrical air about them, false, unreal, *"fin de siècle."*

Neither the covering of the entire surface with recognizable figures nor the repeated printing from the one block to produce a rhythmic repetition of the motif (in this case the eight heads form a single motif) were due to the influence or the inspiration of de Mesquita.

Until 1926 it looked as though these efforts were to be confined to a youthful period and could not be regarded as a bud of promise destined later to come into full bloom. In 1926, having already had some acquaintance with the Alhambra on the occa-

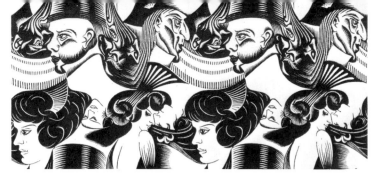

sion of a brief visit, Escher made tremendous efforts to express a rhythmic theme on a plane surface, but he failed to bring it off. All he could manage to produce were some rather ugly, misshapen little beasts. He was particularly annoyed at the stubborn way in which half of these four-footed creatures persisted in walking around upside down on his drawing paper (figure 65).

It would not have been surprising if Escher, after the failure of all these serious attempts, had come to the conclusion that he was not going to achieve anything in this sphere. For ten whole years space-filling was out for him—until, in 1936, accompanied by his wife, he paid another visit to the Alhambra. For the second time he was impressed by the rich possibilities latent in the rhythmic division of a plane surface. For whole days at a time he and his wife made copies of the Moorish tessellations, and on his return home he set to work to study them closely. He read books about ornamentation, and mathematical treatises he could not understand and from which the only help he got was to be found in the illustrations; and he drew and sketched. Now he could see clearly what it was he was really searching for. He built up a wholly practical system that was complete, in broad outline, by 1937, and which he set out in writing in 1941 and 1942. But by that time he was busy assimilating his discoveries in metamorphosis and cycle prints. The full story of how Escher struggled with this stubborn material and how he conquered it so well that, as he said later, he himself did not have to think up his fishes, reptiles, people, houses, and the rest, but the laws of periodic space-filling did it for him—all this would itself call for more space than the whole of this present book. We shall have to content ourselves with a short introduction, in the hope that it will give the reader a greater insight into this important (in Escher's view the *most* important) aspect of his work.

Principles of Plane Tessellations

In figure 68 we see a simple design: the entire surface is covered with equilateral triangles. Now we must discover in what ways this design can be "mapped onto" itself—that is, brought to coincide with itself. For this purpose we must make a duplicate of it by tracing it on transparent paper, and then laying it over the original pattern so that the triangles cover each other.

If we shift the duplicate over the distance *AB* it will cover the underlying pattern once again. This movement is referred to as *translation*. Thus we can say that the design maps onto itself by translation.

We can also turn the duplicate through 60 degrees about the point *C*, and we find that once again it covers the original pattern exactly. Thus this design can be said to map onto itself by *rotation*.

If we draw in the dotted line *PQ* on both the original pattern and the duplicate, and then remove the duplicate from the figure, turn it, and lay it down again in such a way that the dotted lines coincide, we shall notice that once more duplicate and original cover each other. We term this movement *reflection* on the mirror axis *PQ*. The duplicate is now the mirror image of the original figure, and yet it still coincides with it.

Translation, rotation, reflection, and—to be considered later—glide reflection; these are the possible shifts whereby a pattern can be made to map onto itself. There are some patterns that admit only of translation and there are others that are susceptible of both translation and reflection, and so on.

If we categorize the patterns according to the kinds of shifts whereby they map onto themselves, we discover that there are seventeen different groups. This is no place to list them all or even to summarize them, but we may at least point to the remarkable fact that Escher discovered all these possibilities without

66. *Eight Heads*, woodcut, 1922

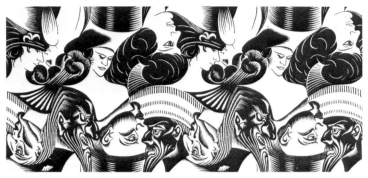

The same print, turned 180°

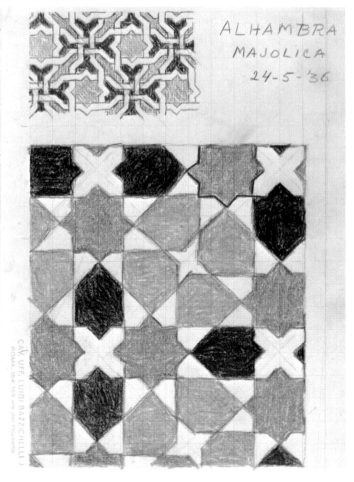

67. Sketches made in the Alhambra, pencil and colored crayon, 1936

68. Possible movements in a flat surface

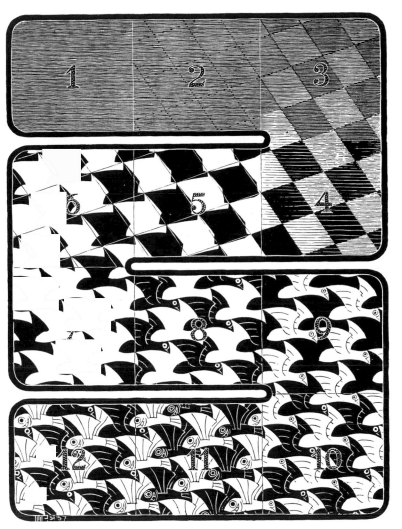

69. In this drawing Escher shows the creation of a metamorphosis

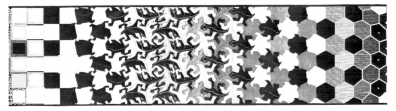

Detail of *Metamorphosis II*

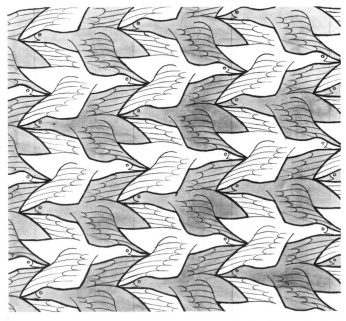

70. The periodic space-filling that forms the basis for *Day and Night*

the benefit of any appropriate previous mathematical knowledge. In her book *Symmetry Aspects of M. C. Escher's Periodic Drawings* (published in 1965 for use by students of crystallography), Professor C. H. McGillavray speaks of her astonishment at the fact that Escher even discovered new possibilities whereby color too might play an important role, and which had not been mentioned in scientific literature before 1956.

A particular characteristic of Escher's tessellations (and in this he is well-nigh unique) is that he always selects motifs that represent something concrete. On this subject he writes:

> The Moors were masters in the filling of a surface with congruent figures and left no gaps over. In the Alhambra, in Spain, especially, they decorated the walls by placing congruent multicolored pieces of majolica together without interstices. What a pity it was that Islam forbade the making of "images." In their tessellations they restricted themselves to figures with abstracted geometrical shapes. So far as I know, no single Moorish artist ever made so bold (or maybe the idea never dawned on him) as to use concrete, recognizable figures such as birds, fish, reptiles, and human beings as elements of their tessellations. Then I find this restriction all the more unacceptable because it is the recognizability of the components of my own patterns that is the reason for my never-ceasing interest in this domain.

Making a Metamorphosis

Escher always regarded periodic surface-division as an instrument, a means to an end, and he never produced a print with this as the main theme.

He made the most direct use of periodic surface-division in connection with two closely related themes: the metamorphosis and the cycle. In the case of the metamorphosis we find vague, abstract shapes changing into sharply defined concrete forms, and then changing back again. Thus a bird can be gradually transformed into a fish, or a lizard into the cell of a honeycomb. Although metamorphosis in the sense described above also appears in the cycle prints, nevertheless the accent is more on continuity and a return to the starting point. This is the case, for instance, with the print *Metamorphosis I* (1937), a typical metamorphosis print in which no cycle appears. *Day and Night* is also a metamorphosis print in which scarcely any cyclic element is found. But most of the prints display not only metamorphosis but also a cycle, and this is because Escher derived more satisfaction from turning the visual back upon itself than from leaving his picture open-ended.

In his book *Plane Tessellations* (1958), he shows us in a most masterly way, by both text and illustration, how he brings a metamorphosis into being. We give a brief resume of his argument by means of figure 69.

At 4 the surface is divided into parallelograms, distinguished from each other by virtue of the fact that a white one is always bounded by a black.

In 5 the rectilinear nature of the black-and-white boundaries is slowly changing, for the boundary lines curve and bend in such a way that an outward bulge on the one side is balanced with an equal-sized inward bulge in the opposite side.

In 6 and 7 the process continues, in the sense that there is a progressive alteration, not in the nature or in the position of the outward and inward bulges, but in their size. The shape arrived at in 7 is maintained up to the end. At first sight nothing remains of the original parallelogram, and yet the area of each motif stays exactly the same as that of the original parallelogram, and the points where the four figures meet are still in the same positions relative to each other.

In 8, details are added to the black motifs to signify birds, so that the white ones become the background, indicating sky.

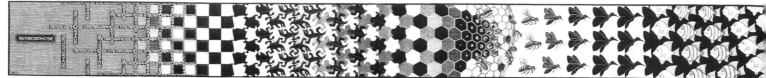

71. *Metamorphosis II*, woodcut, 1939-40

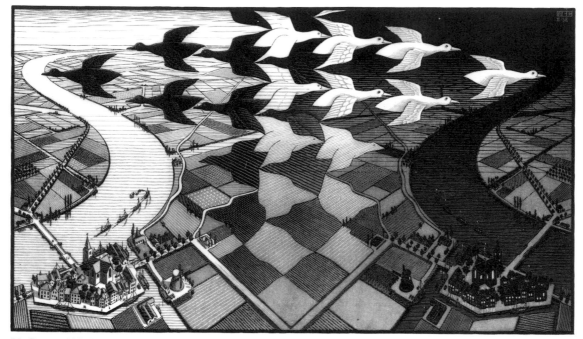

72. *Day and Night*, woodcut, 1938

9. This can be just as easily interpreted the other way round, with white birds flying against a dark sky. Night has fallen.

10. But why not have white *and* black birds simultaneously covering the whole surface?

11. The motif appears to allow of two different interpretations, for by drawing into the tails of the birds an eye and a beak, and turning the heads into tails, the wings almost automatically become fins, and from each bird a flying fish is born.

12. Finally, of course, we may just as well unite the two sorts of creature in one tessellation. Here we have black birds moving to the right and white fishes to the left — but we can reverse them at will.

The refinement with which Escher was so soon able to develop the metamorphosis can be seen in the woodcut *Metamorphosis II* (1939–40), the largest print Escher ever made. It is 20 centimeters high and 4 meters long! And later, in 1967, he added a further three meters when the print, greatly enlarged, was to be used as a mural for a post office. It is not so much the change-over, say from honeycomb to bees, that is of interest (for these depend more on the association of ideas); but when squares change, by way of lizards, into hexagons, he displays a tremendous virtuosity in the handling of his material. There is also *Verbum* (1942), not reproduced here, which comes definitely within the category of metamorphosis, and which is taken to its furthest possible extreme. In later prints we find a decline in the exercise of virtuosity for its own sake; and the metamorphoses come to be more subservient to other representational concepts, for instance in *Magic Mirror*.

The Most Admired Picture of Them All

Figure 70 illustrates one of the simplest possibilities of surface-filling. The pattern of white and black birds maps onto itself by translation only. If we shift a white bird over to the right and upward, the same pattern is found there again. There would be more possibilities if the white bird and the black bird were congruent. Escher used this type of tessellation in the woodcut *Day and Night* (1938) which is, to date, the most popular of all Escher's prints. This print definitely introduces a new period, as was clear even to the critics of that time. From 1938 to 1946 Escher sold 58 copies of this print, up to 1960 the total rose to 262, and in 1961 alone he sold 99! The popularity of *Day and Night* exceeded that of the other much-sought-after prints *(Puddle, Sky and Water I, Rippled Surface, Other World, Convex and Concave, Belvedere)*, so much so that we may safely conclude from this that Escher has succeeded, in this print more than in any other, in putting across to the viewer his sense of wonderment. In the center above us we see much the same tessellation as in figure 70, but this does not provide the basis for *Day and Night* — that is to be found in the center below the print. There one finds a white, almost diamond-shaped field, and our gaze is automatically drawn upward from it; the field changes shape, and very swiftly at that, for it takes only two stages to turn into a white bird. The heavy, earthy substance is suddenly whisked aloft to the sky and is now quite capable of flying to the right, flying as a bird high above a little village by the riverside, enveloped in the darkness of the night.

We could just as easily have chosen one of the black fields down there, to the right and left of the center line. And as it too rises in the air it turns into a black bird and flies away to the left, up above a sunny Dutch landscape which, in a most remarkable way, turns out to be a mirror image of the nocturnal landscape on the right!

From left to right there is a gradual transformation from day to night and from below upward we are slowly but surely raised

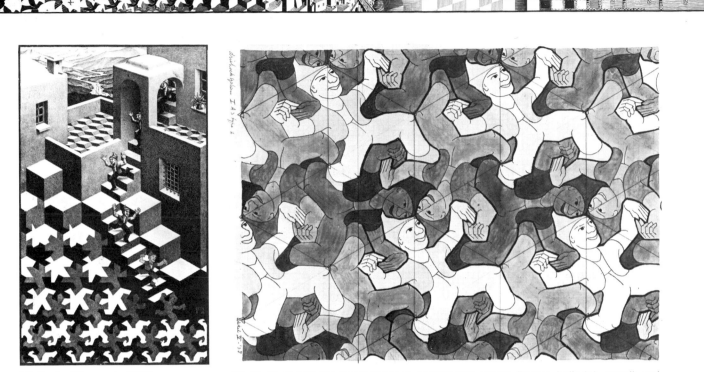

73. *Cycle*, lithograph, 1938

74. Study of periodic space-filling of a plane with human figures, India ink, pencil, and watercolor, 1938

toward the heavens . . . and the fact that this can be achieved through the vision of the artist explains, in my view, why this print appeals to so many people.

The Stone Lad

In *Cycle* (1938) we see a quaint little fellow emerging, gay and carefree, from a doorway. He rushes down the steps, oblivious of the fact that he is about to disappear down below and become dissolved into a whimsical geometric design. At the bottom of the print we come across the same pattern as in figure 74, about which more anon. It turns out to be this lad's birthplace.

This metamorphosis from human figure to geometric pattern is, however, not the end of the affair, for at the top left the pattern gradually changes to simpler, more settled shapes, until these achieve a diamond form; then the diamonds go to make up a block that is used as building material or as the pattern of the tiled floor of the little walled courtyard.

Thereupon, within some secret chamber of the house, these lifeless shapes seem to undergo a further transformation, being turned back into little men, for we see that cheerful young fellow leaping out of his doorway once again.

The periodic pattern used here has three axes of symmetry, and these are of three different types: that in which the three heads meet, that with three feet coming together, and one where three knees touch. At each one of these points the whole pattern can be mapped onto itself by rotation through an angle of 120 degrees. Of course, the little men will change color with each rotation.

Angels and Devils

The same kind of space-filling is basic to the print *Reptiles* (figure 44) and *Angels and Devils*.

In figure 75 we see a periodic space-division with fourfold symmetry. At every point where wing tips touch we can turn the whole pattern through 90 degrees and cause it to fit over itself. Yet these points are not equal. The point of contact of the wing-tips in the center of the picture at A and the points B, C, D, and E are not the same. However, the points P, Q, R, and S do have exactly the same context as A.

Now we can draw horizontal and vertical lines through the body axes of all the angels and devils (in the sketch these lines are indicated by the letter m). These lines are mirror axes. Lastly, there are still axes of glide reflection, which make angles of 45 degrees with the reflection axes. They are also the lines we can draw through the heads of the angels, labelled g in the figure 76. The only way in which we are likely to be able to prove that axes of glide reflection are present is to carry out an actual glide-reflection shift. For this purpose, trace the outlines of the angels onto transparent paper and at the same time the axes of reflection g. Now rotate the tracing paper and lay it down again in such a way that g' on the tracing coincides with g of the original. If you take care, at the same time, to ensure that the head of the angel furthest to the left coincides with its original, you will have effected a reflection.

It can be seen that with this reflection the traced pattern does not cover the original one. However, if you shift the tracing diagonally upward along the axis of reflection you will notice that both patterns map onto each other the moment you get the traced angel head onto the next angel head in the original—something you might not have expected.

It was not because of any aesthetic excellence that I chose

39

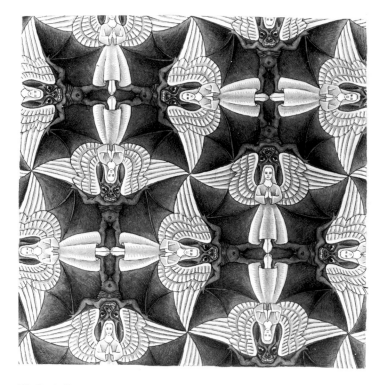

75. Periodic space-filling in *Angels and Devils*, pencil, India ink, crayon, and gouache, 1941

76. Rotation points, mirror axes, and glide-reflection axes in the flat pattern of *Angels and Devils*

figure 75 out of all the others — indeed, the angels might well have stepped straight out of some pious print of the thirties. But it is astonishing that such detailed figures as these can fill up the entire surface without leaving any gaps whatever, and in such a wide variety of orientations, and yet can still map onto themselves in so many different ways.

Escher never made use of the above version of his angels and devils, but at a later date, in 1960, he did make a circular print of them (figure 77). For a description of the circle limit prints, see chapter 15. Here we have not only fourfold axes but threefold as well. This can be seen where three angels' feet come together.

At a later date the same angel-devil motif was adapted to a spherical surface. On commission from Escher's American friend, Cornelius Van S. Roosevelt, who has one of the biggest collections of his work, and by means of instructions and drawings that Escher furnished, two copies of an ivory ball were produced in Japan by an old *netsuke* carver. The entire surface of the little sphere is filled by twelve angels and twelve devils. It is interesting to note how, in the hands of the old Japanese carver, the facial characteristics of the little angels and devils have taken on a typically Oriental look.

Thus Escher has made three variations of this surface-filling:

1. On a boundless flat surface, there is an interchange of double and quadruple axes.

2. On the (bound) circle-limit we find triple and quadruple axes.

3. On the spherical surface the same motif is used again, with double and triple axes.

A Game

When dealing with periodic space-filling I cannot refrain from describing a game that took Escher's fancy in 1942, and to which he attached no importance beyond that of a private diversion. He never reproduced it or made use of it in any more serious work.

Escher carved a die shown by figure 79a. On each side of the square, three corresponding connections are possible. If one prints from this stamp a number of times, so that the imprints come next to each other, then the bars form continuous lines throughout the whole figure.

Because the stamp can be printed off in four different positions, and because Escher cut the figure again in its mirror image (once again capable of being printed in four positions), it is possible to use it to conjure up a large number of interesting designs. In figure 79b you can see a few examples, and in figures 80 and 81 two of the many designs Escher colored in.

A Confession

The significance periodic space-division has had for Escher is difficult to overestimate. In this chapter we have shown something of it with just a few, indeed all *too* few, examples. This restriction does not tally with Escher's own view of his work.

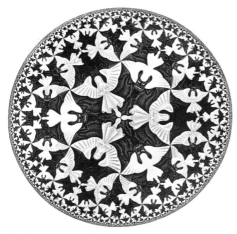

77. *Circle Limit IV*, woodcut, 1960

79a. Stampform for flat patterns

79b. Possible positions of the stamp and its mirror image

78. *Sphere with Angels and Devils*, stained maple, 1942 (diam. 23.5 cm.)

So let us allow Escher to have the last word in this chapter:

. . . I wander totally alone around the garden of periodic draw-
ings. However satisfying it may be to possess one's own domain,
yet loneliness is not as enjoyable as one might expect; and in this
case I really find it incomprehensible. Every artist, or better every
person (to avoid as much as possible using the word art in this
connection), possesses a high degree of personal characteristics
and habits. But periodic drawings are not merely a nervous tic,
a habit, or a hobby. They are not subjective; they are objective.
And I cannot accept, with the best will in the world, that some-
thing so obvious and ready to hand as the giving of recognizable
form, meaning, function, and purpose to figures that fill each other
out, should never have come into the head of any other man but me.
For once one has crossed over the threshold of the early stages
this activity takes on more worth than any other form of decorative
art.

Long before I discovered a relationship with regular space-
division through the Moorish artists of the Alhambra, I had al-
ready recognized it in myself. At the beginning I had no notion of
how I might be able to build up my figures systematically. I knew
no rules of the game and I tried, almost without knowing what I
was about, to fit together congruent surfaces to which I tried to
give animal shapes . . . later the designing of new motifs gradually
came with rather less struggle than in the early days, and yet this
has remained a very strenuous occupation, a real mania to which I
became enslaved and from which I can only with great difficulty
free myself.

— M. C. Escher, *Regelmatige Vlakverdeling
(Periodic Space-Filling)*,
Utrecht, 1958

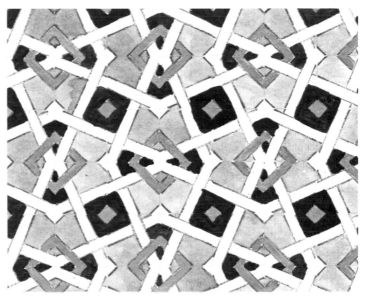

80. Stamped and colored ornament I

81. Stamped and colored ornament II

8 Explorations into Perspective

Classical Perspective

From the very first moment that man started to draw and
paint he represented spatial reality on a flat surface. The objects
which the primitive cave-dweller wanted to reproduce were quite
definitely spatial—bison, horses, deer, etc., and he painted them
on a rock wall.

But the common method of representation we now call per-
spective came into being only in the fifteenth century. We can
see that Italian and French painters wanted to make their pic-
tures duplicates of reality. When we are looking at the illustra-
tion we are supposed to get exactly the same image on our ret-
ina as when we are looking at the actual object that is being
illustrated.

In earlier days this was done intuitively, and many mistakes
were made, but as soon as a mathematical formula for this meth-
od of representation had been worked out, it became clear that
both architect and artist approached space in the same way.

We can define the mathematical model as in figure 84: the
eye of the beholder is situated at O; some distance in front of
him we are to imagine a perpendicular plane, i.e., the picture.
Now the area behind the picture is transferred to it point by point;
in order to do this a line is drawn from point P to the eye, and
the point of intersection of this line with the picture is the point
P', at which P is depicted.

This principle was well demonstrated by Albrecht Dürer (1471–
1528) who took great interest in the mathematical side of his
craft (figure 82). The artist has a glass screen in front of him
(i.e., the picture) and he draws the man sitting behind the screen
point by point. The extremity of a vertical bar fixes the position
of the artist's eye.

Of course it is not at all feasible for any artist to work like this.
Indeed Dürer's apparatus was used only to solve difficult prob-
lems of representation. In the majority of cases the artist relied
on a number of rules which could be deduced from the mathe-
matical model.

Here are two important rules:

1. Horizontal and vertical lines running parallel to the picture
are to be depicted as horizontal and vertical lines. Like distances
along these lines in reality are to be shown as like distances in
the picture.

2. Parallel lines that recede from us are to be depicted as lines
passing through a single point, i.e., the vanishing point. Like dis-
tances along these lines are not to be depicted as like distances
in the picture.

Escher meticulously concurred with these rules of classical
perspective in the construction of his prints; and it is for this
reason that they are so suggestive of space.

In 1952 there appeared a lithograph called *Cubic Space Division*

82. Dürer's demonstration of the principles of perspective

in which the sole aim was to depict an infinite extent of space,
and no means were used other than the laws of classical per-
spective. It is true that we can see this infinite extent of space
through a square window, as it were, but because this space is
divided up into completely similar cubes by bars running in three
directions, a suggestion of the whole of space has been achieved.

If we project the vertical bars they appear to meet at a single
point, which is the footprint or nadir. There are two further van-
ishing points, and these can be obtained by projecting the bars
that point upward to the right and the bars that point upward
to the left. These three vanishing points lie far beyond the area
of the drawing, and Escher had to use very large sheets of draw-
ing paper for the construction.

The aim of the wood engraving *Depth* (1955) was much the
same, but in this case the small cubes marking the corners of
the large ones were replaced by what look like flying fish, and
the joining bars are nonexistent. Technically, this problem was
much more difficult, for the fish had to be drawn decreasing
in size, with very great accuracy; also, in order to enhance the
suggestion of depth, the further away they got the less contrast
had to be shown. This would have been fairly simple in a litho-
graph, but it is much more difficult with a woodcut because every
bit of the print must be either black or white, and therefore it

83. Intuitive perspective—all lines running away from the spectator should converge in the same vanishing point

85. *Cubic Space Division*, lithograph, 1952

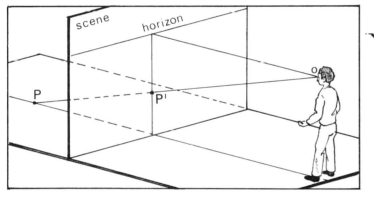

84. The principles of classic perspective

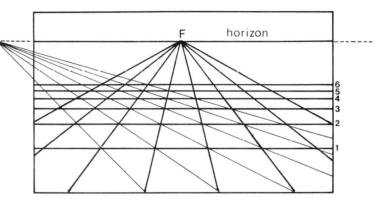

is impossible to achieve contrast by using gray. However, by using two colors Escher has managed to introduce what is known as light-perspective as a means of increasing the suggestion of space, beyond the considerable limitations imposed by geometric perspective. Figure 87 shows how exactly Escher worked out in perspective the situation around each grid-point.

The Discovery of Zenith and Nadir

Classical perspective lays it down that sets of parallel lines also running parallel with the picture are to be depicted as parallel lines themselves. This means that these sets of lines have no vanishing point, or, in the terminology of projective geometry, their point of intersection is at infinity. Now this would seem to belie our own experience; when we are standing at the bottom of a tower we see the rising vertical lines converging toward one point, and if we look at a photograph taken from this same viewpoint it becomes clearer still. However, the rules of classical perspective are in fact being followed, for the simple reason that our picture is no longer perpendicular to the ground. If we lay

the picture down horizontally and look down on it, then we shall see all the vertical lines converging toward a single point under our feet—in other words, the nadir. Escher took up just such an extreme viewpoint in an early woodcut *Tower of Babel* (1928), in which we can see the tragedy of the great confusion of tongues as described in the Bible played out on each of the terraces. In the wood engraving *St. Peter's, Rome* (1935) Escher has had a "personal experience" of the nadir, for here we have a case not merely of construction but of reality perceived. He spent hours on the top-most gallery of the dome sketching the scene that lay below him, and when tourists inquired, "Say, don't you get giddy up here?" Escher's laconic reply was, "That's the whole point."

The first time he consciously used the zenith as a vanishing point was in 1946 when he was making a small engraving for the Netherlands Ex-Libris Club. This print showed somebody clambering out of a deep well into the light of day. The caption ran. "We will come out of it"—a reference, this, to the aftermath of World War II.

Figure 91 shows how the zenith comes to be the point of intersection for the vertical lines. The photographer or painter lies on the ground and looks straight ahead and upward. The parallel lines *l* and *m* now appear at l^1 and m^1 in the picture, and they intersect at the zenith immediately above the observer.

43

86. Jean Fouquet, *The Royal Banquet* (detail) (the Bibliotheque Nationale, Paris). A natural impression is achieved notwithstanding the incorrect perspective

87. Preliminary study for *Depth*, pencil, 1955

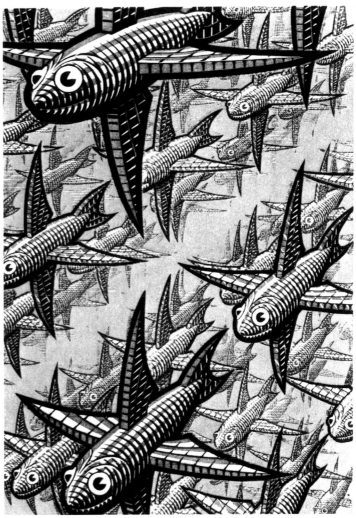

88. *Depth*, wood engraving, 1955

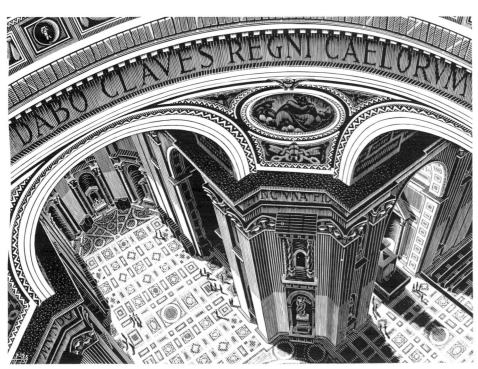

89. *St. Peter's, Rome*, wood engraving, 1935

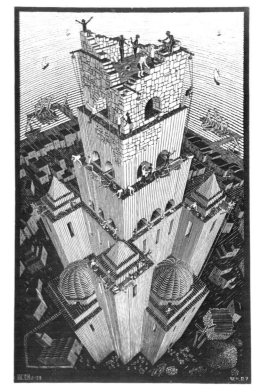

90. *Tower of Babel*, woodcut, 1928

91. The zenith as vanishing point

The Relativity of Vanishing Points

If we draw a number of lines converging on a single point, then this point can represent all kinds of things, including zenith, nadir, point of distance, and so on. Its use depends entirely on its context. Escher was trying to demonstrate this discovery in the prints *Other World I* and *Other World II*, in 1946 and 1947.

In the 1946 mezzotint we see a long tunnel with arched openings. This tunnel runs, in rather hazy darkness, to a point that may be used, according to the context, as zenith, nadir, or distance point. If we look at the tunnel wall on the right and on the left, then what we observe is a lunar landscape lying horizontally. And the tunnel's arches are so drawn that they fit into the horizontal aspect of this landscape. In this context the vanishing point of the tunnel limits takes on the function of distance point.

However, if we turn to the upper part of the picture, we now find ourselves looking straight down on a lunar landscape, and we see a Persian man-bird and a lamp from above. (This sculpture is called a *simurgh* and was a present from Escher's father-

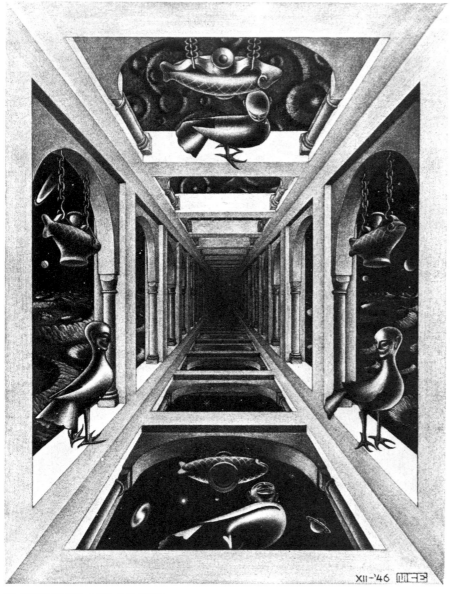

92. *Other World*, mezzotint, 1946

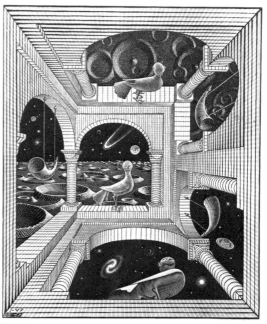

93. *Other World*, wood engraving, 1947

94. Bookmark with zenith as vanishing point (We Will Come Out of It), woodcut, 1947

in-law, who had bought it in Baku, Russia). So now this same vanishing point has changed to the nadir.

The final use for this vanishing point is that of zenith for the lower part of the print, for this time we are looking up into the heavens and seeing the bird and the lamp from below.

Escher himself was not at all happy with this print; the tunnel had no clear limits, the vanishing point was shrouded in darkness, and it took *four* planes to represent three landscapes.

A year later he produced a new version, in which he eliminated these (to him) irritating shortcomings. This four-colored wood-cut holds together in a most ingenious way. The long tunnel has disappeared and we find ourselves in a strange room where "above," "below," "right," "left," "in front," and "behind" can be interchanged at will, according to whether we decide to look out of one or another of the windows. And he has thought up a very clever solution of the problem of how the threefold function of the single vanishing point can be suggested by giving the building three pairs of *almost* equal-sized windows.

In each of these *Other World* prints there is only one vanishing point. However, in *Relativity*, a lithograph made in 1953, there are three vanishing points lying outside the area of the print, and they form an equilateral triangle with sides two meters in length! Each of these points has three different functions.

Relativity

Here we have three totally different worlds built together into a united whole. It looks odd, yet it is quite plausible, and anybody who enjoys modeling could make a three-dimensional model of this print.

The sixteen little figures that appear in this print can be divided into three groups, each of which inhabits a world of its own. And for each group in turn the whole content of the print is *their* very own world; only they feel differently about things and give them different names. What is a ceiling to one group is a wall to another; that which is a door to one community is regarded by the other as a trapdoor in the floor.

In order to distinguish these groups from each other let us give them names. There are the Uprighters—for instance, the figure to be seen walking up the stairs at the bottom of the picture; their heads point upward. Then come the Left-leaners, whose heads point leftward, and the Right-leaners with their heads pointing to the right. We are incapable of taking a neutral view of these folks, for we obviously belong to the community of the Uprighters.

There are three little gardens. Upright number 1 (lower center)

95. *Relativity*, lithograph, 1953

can reach his garden by turning to the left and walking up the stairs. All we can see of his garden is a couple of trees. If he stands beside the archway leading to his garden he has a choice of two stairways leading upward. If he takes the left-hand one he will come across two of his companions; up the right-hand stairway and along the landing, he will find the two remaining Uprighters At no point are we able to see the ground on which the Uprighters are standing, but quite large areas of their ceiling are visible in the upper part of the print.

In the center of the print, and up against one of the Uprighters' side walls, a Left-leaner sits reading. If he were to look up from his book he would see an Uprighter not far away from him. He would think this other's position very odd indeed, for he would appear to be gliding along in a recumbent pose. If he were to stand up and climb the stairs on his left, he would discover another remarkable figure skimming along over his floor, a Left-leaner this time; and the latter is quite convinced that he is on his way out of his cellar with a sack over his shoulder.

The Right-leaner goes up the stairs, turns to the right, and climbs a further stairway, where he meets up with one of his colleagues. There is someone else on this stairway—a Left-leaner who, in spite of the fact that he is moving in the same direction, is going *down*stairs instead of up. The Right-leaner and the Left-leaner are at right angles to each other.

We have no difficulty in discerning how the Right-leaner is going to reach his garden. But see if you can show that Left-leaner with the sack of coals on his back, and also the Left-leaner with the basket at the lower left of the print, how they can find theirs.

Two out of the three large stairways around the center of the print can be climbed on both sides. We have already seen that the Uprighters are able to use two of these stairways. How about

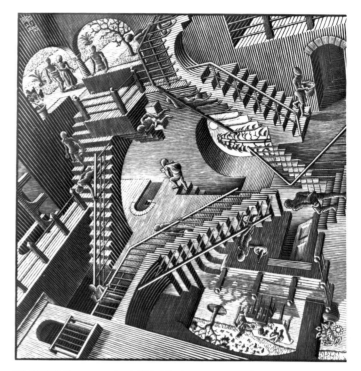

97. *Relativity* as woodcut. This block was never printed.

96. Study for *Relativity* with the three vanishing points, pencil, 1953

48

the Left-leaners and the Right-leaners—are they also able to walk up two or three stairways?

A very extraordinary situation arises on the stairway that runs horizontally across the top of the print. Is this same situation possible on the two other stairways?

Clearly there are three different forces of gravity working at right angles to each other in this print. This means that one of the three existing surfaces serves as a ground for each of the three groups of inhabitants, each of which is subject to the influence of only one of the fields of being.

I daresay an intensive study of this print would come in handy for astronauts; it might help them to get accustomed to the notion that every plane in space is capable of becoming a ground at will, and that one must be prepared to come across one's colleagues in any arbitrary position without getting giddy or confused!

Another version of *Relativity* is to be found, among Escher's nonmultiple reproduction work. That is, he made instead of a lithograph a woodcut of the same print. Apart from a proof, the block was never used for printing (figure 97).

New Rules

If we look at figure 98, then we shall see all the vertical lines converging toward the nadir, which is situated at the center of the lower edge of the drawing. It does not strike us as at all unnatural that these lines should be curved—rather than straight, as they ought to be according to the traditional rules of perspective.

This is one of the most important of all Escher's innovations

98. The upper half of *High and Low*

99. Miniature of Jean Fouquet, 1480

in the realm of perspective; these curved lines correspond to our view of space much more accurately than straight lines do. Escher never used this invention as the main subject of any print; he did, however, immediately start to bring it into play. Therefore, in order to give an idea of the way in which the new principle can be applied in a normal picture, we have reproduced just half of the print *High and Low*.

How is this exchange of straight lines for curved brought about? To find the answer to this we can look at figure 100. Here is a person lying on the grass between two telegraph poles and looking at two parallel wires. The points P and Q are closest to him. If he looks straight ahead, he sees the wires coming together at V_1; if he looks back over, he sees them meeting at V_2. Thus the telegraph wires, continuing endlessly on both sides, would be shown as the lozenge-shaped figure V_1QV_2P (figure 100b). But we simply don't believe it! We have never seen a kink like the one at P and Q, and so for the sake of continuity we end up with curved lines as in figure 100c.

We once confirmed the way in which this method of presentation tallies with what we really see, when we made a panoramic photograph of a river. We stood by the water's edge and took twelve photographs; after each exposure the camera was turned through about 15 degrees. When the twelve photographs were fixed together the picture of the river bank looked very much as in figure 101b.

Painters and draftsmen alike have arrived at this curved-line perspective. In a number of his works the miniaturist Jean Fouquet (*circa* 1480) "has drawn the straight lines curved" (figure 99) and Escher has told how once, when he was drawing a small cloister in a southern Italian village, he drew both the horizontal stretch of the cloister wall and the central church tower with curved lines—simply because that was how he saw them.

As we have said above, it is for the sake of continuity that we arrive at the use of curved lines. But what is the geometrical aspect of this? Is there any explanation of why these lines have

100. The telegraph-wire effect

101a.

101b.

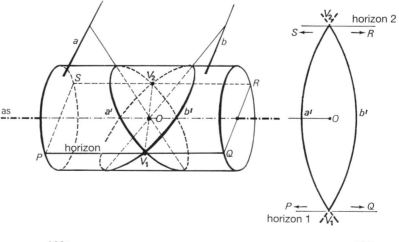

102. **103a.** **103b.**

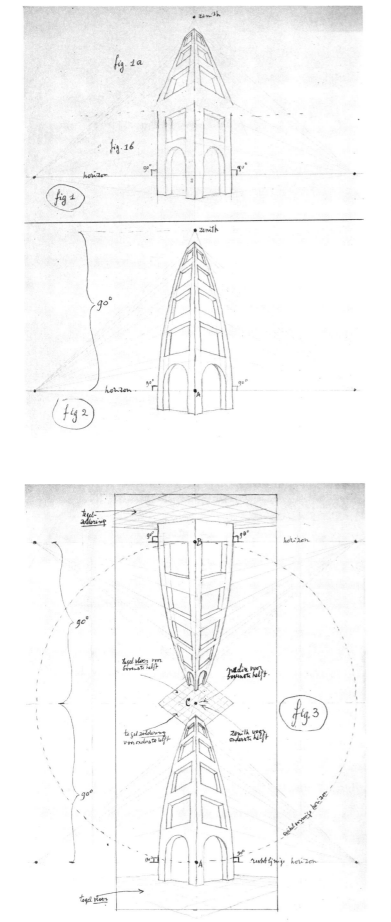

104-106. Escher's explanation of the construction of *High and Low*

got to be rendered as curved? And what sort of curves are they? Are they segments of a circle, parts of a hyperbola, or parts of an ellipse?

To get to the bottom of this matter we can study figure 101a. O is the eye of the man lying beneath the telegraph wires. When he looks straight ahead he can see the wires projected, as it were, onto a picture T_1. If he looks up a little then the picture moves up too (T_2). The picture always stands at right angles to the axis of his eye. The pictures T_1 to T_6 correspond to the series of river photographs. Of course it is artificial to take only six photographs; in reality their number is infinite (figure 101b). The whole picture, then, is cylindrical, and in this figure we see drawn a transverse section of it.

In figure 102 the whole cylinder is illustrated, and a is a line crossing the axis at right angles just as a telegraph wire would. Now how will this appear on the cylinder? To show this we must connect O to every point along a; and all the points where these connecting lines intersect the cylinder outline will be image-points of a.

Of course, we can also construct a surface passing through a and the point O. This plane intersects the cylinder in the form of an ellipse and a is shown as that part of it marked ABC.

In figure 103a, a and b are two telegraph wires, and also the cylindrical image is drawn in, together with the eye of the observer at O.

The pictures of a and b are the semiellipses a' and b'. We observe at the same time that they intersect at the vanishing points V_1 and V_2.

Finally we have to see that our picture comes out flat, because we want to show it on a flat surface. There is, however, no difficulty here. We cut through the cylinder along the lines PQ and RS and fold the upper portion flat (figure 103b); a' and b', though, no longer remain as semiellipses but turn into sinusoids. (Space does not allow of an explanation of this.)

Escher himself arrived at the above result by a process of intuitive construction. For instance he had no idea that his curved lines were sinusoids, yet it has been shown by measuring up his lines of construction that they do in fact correspond fairly accurately with sinusoidal curves. As he himself has explained in a letter on the subject of how he decided on curved lines, he used figures 104 to 106.

High and Low

As we have already remarked, Escher did not use sets of curved lines on their own in any print but proceeded to combine them with the relativity of vanishing points in the lithograph *High and Low* (1947). In the sketch (figure 106) he once sent to me with a view to clarifying the construction of *High and Low*, we can see not only the curves but also the dual function of the center point of the print, *i.e.*, as zenith for the lower tower and as nadir for the upper one.

Now, first of all, let us take a close look at *High and Low*. Together with *Print Gallery*, it is probably the best print in the whole of Escher's work. Not only is its meaning put over with very great skill, but the print itself is a remarkably handsome one.

Anyone coming up the cellar steps to the right of the bottom of the print will be quite incapable of understanding yet what his point of departure is. But he won't be allowed much time to stand around wondering; it is as though he were shot upward along the curved lines of the pillars and the palm trees to the dark tiled floors in the center of the print. But his eye cannot rest there; automatically it leaps further up again along the pillars and seems to be forced to swing away up the left across the archway, with its two-colored blocks of stone.

51

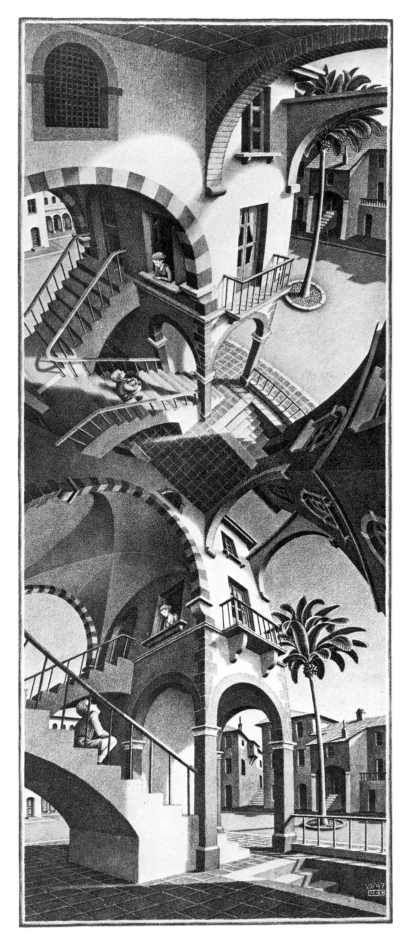

107. *High and Low*, lithograph, 1947

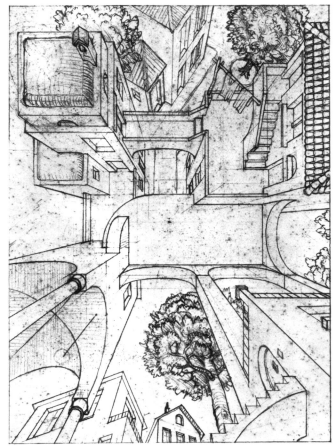

108. First version of *High and Low*, pencil, 1947

109. Second version of *High and Low*, pencil, 1947

110. Version of *High and Low* with curved lines and two different images, pencil, 1947

We experience a similar soaring sensation if we try to follow the print from the top downward. At first, then, all we can do is leap up and down in this strange world where the main lines fan out from the center and plunge back into it again—such as the leaves of the palm tree, which appear twice in the print. To study this print in peace and calm, the best thing to do is to cover the upper half of it with a sheet of paper. There we find ourselves standing between a tower, on the right, and a house. At the top, the house is joined to the tower by two stones, and if we get the opportunity to stop and survey the scene we find we are looking down over a peaceful, sunny square such as might be met with anywhere in southern Italy.

On the left we can reach the first floor of the house up two flights of stairs, and here at the window a girl is looking down and holding a wordless conversation with the boy on the stairs. The house appears to stand at the corner of a street and to be joined to another house on the left, outside the print.

In the middle of the upper part of the uncovered section of the print we can see a tiled ceiling; this is immediately above us and its central point is our zenith. All rising lines curve inward toward this point. If we now slide the masking paper so that only the top half of the print is visible, as in figure 109, then we get a view of precisely the same scene again—the square, the palm tree, the corner house, the boy and the girl, the stairs, and the tower.

Just as forcibly as our gaze was at first dragged upward so it is now equally forcibly dragged downward. It is as though we are looking down on the scene from a great height; the tiled floor—yes indeed, a tiled *floor* now—comes at the bottom edge of the visible part of the sketch. Its central point is directly below us. What was at first ceiling is now floor, for the zenith has become the nadir and serves as vanishing point for all downward-curving lines.

At this point we can clearly see where it was we entered the print; we were entering from the door that leads to the tower.

And now we can take away the piece of paper and have a look at the complete drawing. The tiled floor (alias ceiling) appears three times over—at the bottom as a floor, at the top as a ceiling and in the center as both floor *and* ceiling. We are now in a position to study the tower on the right as a whole; and it is here that the tension between above and below is at its most acute. A little above the middle is a window, turned upside down, and a little below the middle is a window right way up. This means that the corner room at this spot takes on some highly unusual features. There must be a diagonal line running through this room, one that cannot be crossed without a certain amount of danger, because along this diagonal "above" and "below" change places, and so do the floor and the ceiling. Anyone who thinks he is standing fairly and squarely on the floor has only to take one step over the diagonal to find himself suddenly hanging down from the ceiling. Escher has not drawn this situation in the interior but he implies it by means of the two corner windows.

There is still more to observe in the middle of the print. Just go down the stairs toward the tower entrance; if you continue all the way down then you will be walking upside down toward the top of the tower. No doubt, on discovering this you will hurriedly return to walking right way up. Now just take a look out of the topmost window of the tower. Are you looking at the roofs of the houses, or at the underside of the square? Are you high up in the air or crawling about under the ground?

And then on the left, up along the stairway where the boy is sitting, there is a viewpoint from which you can get horribly giddy. Not only can you look down below to the central tiled floor, but you can look beneath-below. Are you hanging or standing? And how about the boy in the top half—suppose he should lean over the banisters and gaze down at himself on the lowest stair? And can the girl at the very top see the boy at the very bottom?

This is very much a print with a mind of its own, for the top

half is by no means the mirror image of the bottom half. Everything stays firmly in its right place. We can see above and below precisely as they are; only we are driven to take up two different standpoints. In the lower half of the print eye level comes just about where the letterboxes of the houses would have been, if drawn, and one's eye is instinctively drawn upward toward the center of the print. In the upper part of the print eye level is where the two highest windows come, and we look out of them almost automatically downward toward the center of the print. No wonder our eye cannot stay still, for it cannot decide between two equally valid standpoints. It keeps on hesitating between the scene above and scene below; and yet in spite of this the print comes over to us as a unity, a mysterious unity of two incompatible aspects of the same scene expressed visually.

Why did Escher draw this on his lithographic stone? What secret lurks behind this fantastic construction?

From the constructional point of view two main elements immediately come to the fore:

1. All vertical lines are curved. On closer inspection we find that some horizontal lines are also curved (for instance, those of the guttering on the tower, to the right of the center of the print).

2. All these "vertical curves" can be seen to radiate from the center of the print. Where the verticals in the top half are concerned, we interpret this central point, for the time being, as basepoint or nadir. Yet the same point also serves as zenith for the lower half.

The two elements mentioned above are independent of each other. Two very elaborate preparatory studies for the print *High and Low* were based on the second of these elements only—that is to say, the twofold function of an identical vanishing point in the drawing. Figure 108 does not use any curved lines. Escher considered this to be too uninteresting and so he turned the linear

111. Cubic space filling with curved lines (study for *House of Stairs*, India ink and pencil, 1951)

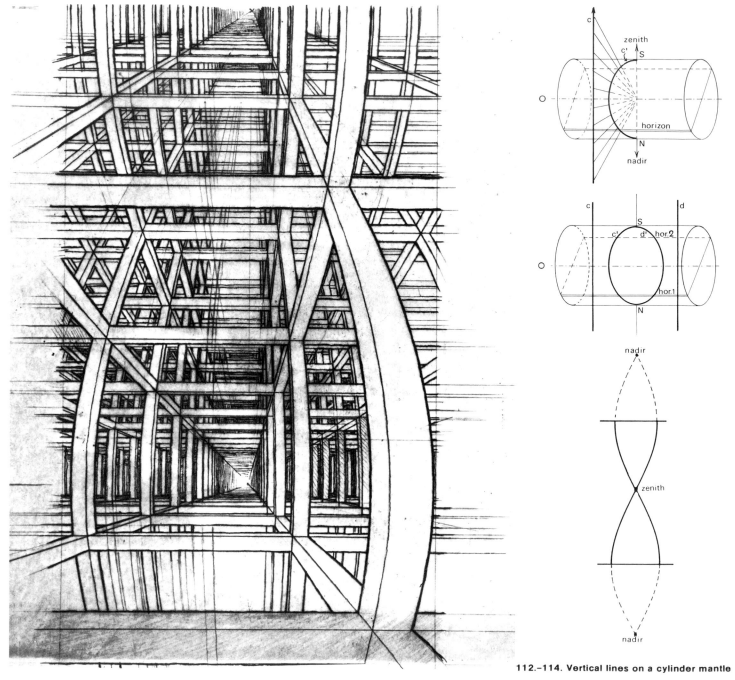

112.–114. Vertical lines on a cylinder mantle

construction through 45 degrees. These drawings are thus in the same category as the *Other World* prints. It is not until one of the later preparatory drawings that we come across curved vertical lines pointing with increasing compulsion toward the zenith-cum-nadir point.

Strange as it may seem, this produces a greater suggestion of reality. The lower part of figure 110 is already very similar to the lower part of the finished print *High and Low*. However, none of the preparatory sketches approached here have yet managed to supply any satisfactory solution to the empty space around the zenith-nadir point. It has to be an area both of sky and of pavement, something which it is scarcely possible to draw. In the finished print, however, a truly remarkable unity has been achieved by the simple device of using only one picture twice. Thus the very difficult problem of the zenith-nadir point is solved with considerable charm; in the center we find some tiling that can serve both as floor covering and as ceiling decoration.

A New Perspective for Cubic Space-Filling

The drawing illustrated as figure 111 may be regarded as a trial run for the lithograph *House of Stairs* (1951). However, it deviates from it to such an extent that it would be preferable to deal with it as an entirely independent print, albeit one not intended for multiple reproduction. The subject is identical with that of *Cubic Space Division* (1952), which we have already considered, except that in this case the newly discovered laws of perspective, involving curved lines, have been applied and our eye is immediately caught by the relativity of vanishing points. Is the vanishing point at the top of the drawing a distance point or a zenith?

115. Grid for *House of Stairs*

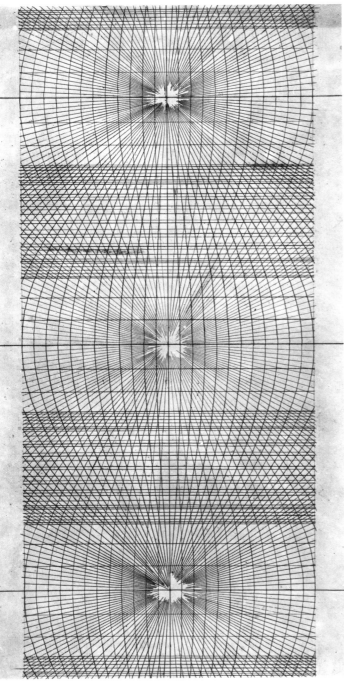

118. *House of Stairs*, lithograph, 1951

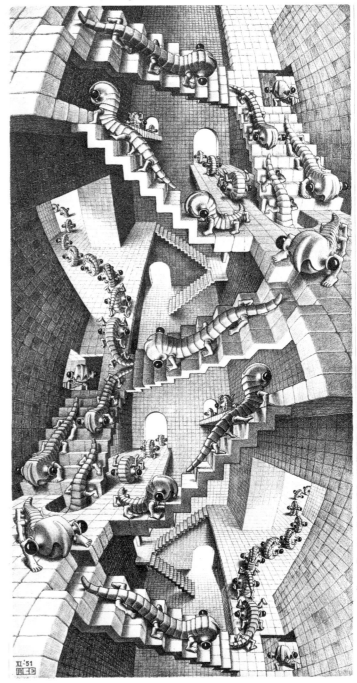

Let us reconstruct step by step the perspective grid that forms the basis of this drawing.

In figure 112, O is once again the position of the viewer's eye, and we can imagine a cylindrical image. How is the line c to be shown on the outline of the cylinder? If we construct a surface passing through c and O this will intersect the cylinder edge in the shape of an ellipse c' (only the front side of which has been drawn). In figure 113 we observe that the parallel vertical lines c and d are shown as the ellipses c' and d'; the upper point of intersection is the zenith and the lower one is the nadir. If the cylinder side is then cut and folded open we arrive at figure 114, in which the sinusoids intersect at the zenith and then again at the nadir, the upper nadir point having coincided with the lower one on the cylinder.

Now we must find out what will appear on the side of the cylinder when both horizontal and vertical lines are drawn. Figure 116 shows the horizontal lines a and b, as already seen in figure 103a, coming out as a' and b', and, at the same time, the vertical lines c and d coming out as c' and d'. Only the front half of these last two has been drawn, in order to keep the diagram easy to follow. Figure 117 gives the cylinder wall. The section between horizon 1 and horizon 2 almost coincides with the grid pattern

that Escher used for *High and Low*. But now comes the abstraction, on which the grid pattern has no bearing. We can imagine our sinusoids running upward and downward without limit. Every line that passes through a point of intersection on the vertical axis can represent a horizon, and any point of intersection can be zenith, nadir, or distance point, at random.

We have used only a few lines here in sketching a diagram of the guide pattern; a more complete version of it made by Escher, and which he used both for the drawing in figure 111 and for *House of Stairs*, can be seen in figure 115. Here only three vanishing points are to be seen; however, the diagram could be endlessly extended upward and downward.

House of Stairs

The basic pattern for this extremely complicated and sterile house of stairs, inhabited purely by mechanically moving beasts (Curl-ups, Escher calls them)—either walking on six legs or else, in their contracted state, rolling along like a wheel—is the grid shown in figure 115.

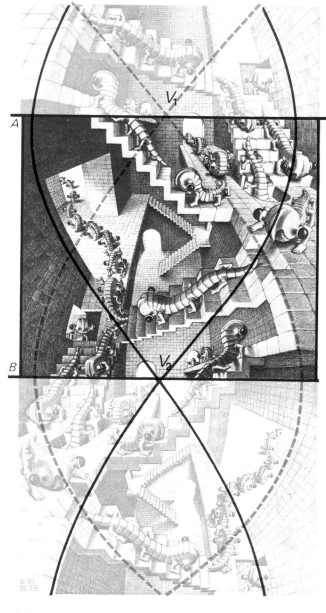

119. The construction of *House of Stairs*

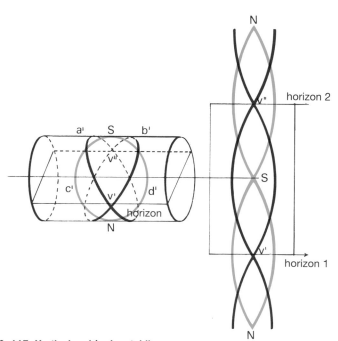

116, 117. Vertical and horizontal lines
on the cylinder mantle

In figure 119 we see a number of lines from this grid drawn across the print. It can be observed from this that the print has two vanishing points, through which horizontal lines are drawn. It can be quite unambiguously established for each Curl-up, whether such or such a vanishing point is zenith, nadir, or, for that matter, distance point. This is the case, for instance, with the large Curl-up, which is to be seen stretched out horizontally in the center of the plate. V_1 being its distance point and V_2 its nadir. A concomitant of all this is that the walls have a different significance for each one of the little creatures, and can serve not only as ground but also as ceiling or as side wall.

It is an infinitely complicated print yet one that is put together with the minimum of constructional material. Even the section between A and B contains all the essential elements. The section about it contains exactly the same elements as this A and B section, by means of glide reflection. This we can verify simply by transferring the A-to-B section, making a rough outline on tracing paper. If we turn this tracing over, with its underside uppermost, and then slide it upward, we shall find that it fits exactly over the higher section. The same thing applies to the section lower down. In this way it would be possible to make a print of infinite length having congruent sections alternating with their mirror images. Figure 121 shows one of the many preparatory sketches for *House of Stairs*.

Perhaps it has already struck you that the cylinder perspective used by Escher, leading to curved lines in place of the straight lines prescribed by traditional perspective, could be developed even further. Why not a spherical picture around the eye of the viewer instead of a cylindrical one? A fish-eye objective produces scenes as they would appear on a spherical picture. Escher certainly did give some thought to this, but he did not put the idea into practice, and therefore we will not pursue this further.

120. Curl-up, the animal that
lived in *House of Stairs*

121. One of the preliminary studies for *House of Stairs*

9 Stamps, Murals, and Bank Notes

At first, Escher undertook almost every possible commission, for he felt duty bound to earn his own living, by his own work in so far as this was possible. He did illustrations for books. The last of these, a book about Delft for which he made the woodcuts in 1939, was never published. In 1956 Escher did both text and illustrations for a bibliophile edition published by the De Roos Foundation. Its subject is periodic surface-division. Escher found working on it a very tiresome experience. He had to try to put into words things he had long known but which he preferred to draw rather than write about. But what a pity it was that this book appeared in such a limited edition (of only 175 copies), for the text is excellent and makes a good introduction to the understanding of the prints in which Escher dealt with periodic surface-division.

In 1932 he even took over the job of official artist for an expedition in the boot of Italy. This expedition was under the leadership of Professor Rellini, and a Dutch participant was Leopold, codirector of the Netherlands Historical Institute in Rome. The drawings remained in Leopold's possession and nobody knows what became of them. Other smaller works commissioned included bookplates, wrapping paper and damask designs, magazine covers, and various solid items. These last were single pieces, except for a candy tin in the shape of an icosahedron decorated with starfish and shells, which was used by a firm of tin manufacturers (Verblifa) as a public-relations handout on the occasion of the seventy-fifth anniversary of the firm in 1963.

So there was, on the average, at least one commission a year to occupy Escher over and above his independent work. However, none of the commissions ever led to important new work. Inspiration did not flow from them; in fact the opposite was the case. He would choose for his commissioned work themes and designs he had already tried out in his independent work. This more or less goes without saying, for those who did the commissioning chose Escher for the job for the simple reason that they knew certain aspects of his work and wanted to have these expressed in the things they had ordered.

His designs for postage stamps can be counted among the most important of his commissions. He designed a stamp for the National Aviation Fund in 1935, one in 1939 for Venezuela, one for the World Postal Union in 1948, one for the United Nations in 1952, and a European stamp in 1956.

His work on the Netherlands bank notes was of longer duration. In July, 1950, he was commissioned to submit designs for the ten-guilder, twenty-five guilder, and hundred-guilder bills. Later there was the design for a fifty-guilder bill. He did some intensive work on it and had regular discussions about his designs with those who had commissioned them. In June, 1952, however, the commission was withdrawn; Escher had not been able to harmonize his designs with the requirements of the checkering machine used to produce the highly complicated curves needed to make forgery an exceedingly difficult operation. All that is now left of this work can be found in the museum of Johan Enschedé, bank-note printers in Haarlem.

He received the first commission for decorative work on a building in 1940, for three inlaid panels for the Leiden city hall; a fourth was added in 1941. Later commissions in this sphere were for work on interior and exterior walls, and on ceilings and pillars. Some of these he carried out himself—for instance, the wall paintings for the Utrecht cemetery; but in most cases he simply supplied the design.

The last great mural was completed in 1967. Engineer Bast, at that time director of posts and telegraphs, used to have the large 1940 *Metamorphosis* hanging in his board room and would gaze at it during boring meetings. So he recommended this self-same *Metamorphosis*, greatly enlarged, as a mural for one of the large post offices in The Hague. The original *Metamorphosis* print was four meters in length, and the plan was to make it four times as big. This did not work in very well with the dimensions of the wall, and so Escher spent half a year on an additional three meters. The final *Metamorphosis*, Escher's swan song, is now seven meters long. This print was enlarged with very great accuracy (to a length of 42 meters) on the post-office wall, to calm the troubled minds of all the people waiting at the counters.

A lesser commission, in 1968, was the very last—the tiling of two pillars in a school in Baarn.

FELICITAS 1956

EUGÈNE & WILLY STRENS

Congratulations card commissioned by
Eugene and Willy Strens

122. Woodcut for a never published book about Delft, 1939

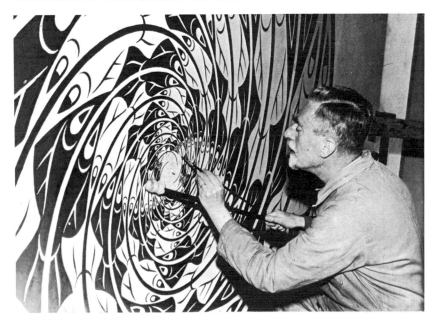

Escher working on mural for cemetery

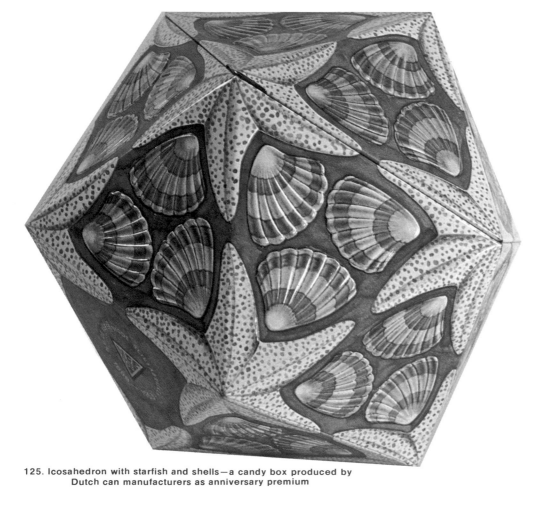

125. Icosahedron with starfish and shells—a candy box produced by
Dutch can manufacturers as anniversary premium

123. The elongated version of *Metamorphosis* in the hall of the
Kerkplein Post Office, The Hague, 1968

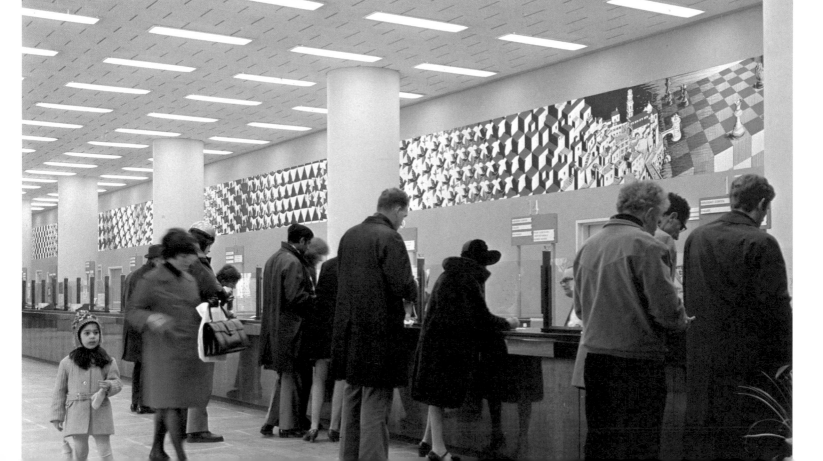

126. Glazed tile column, new girl's
school, The Hague, 1959

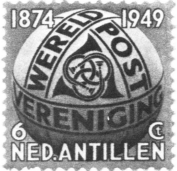

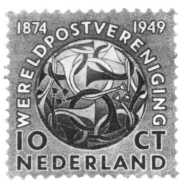

124. Stamps designed by Escher

Detail of tiled column

127. Two intarsia panels in the city hall of Leiden

61

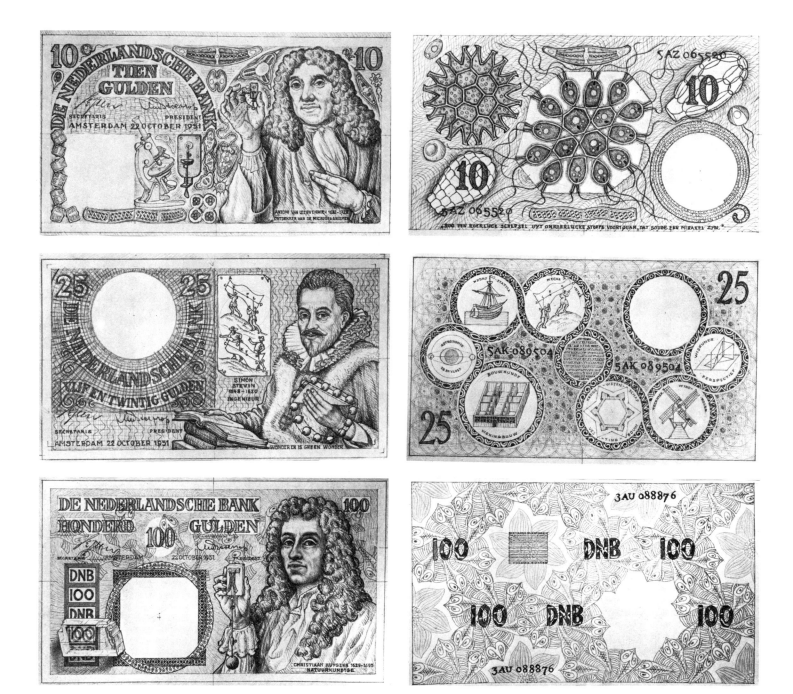

128. Bank note designs that were never used.

Design for a ten guilder bank note, with a portrait of Anthoni van Leeuwenhoek (1632-1723), the Dutch discoverer of microorganisms. Escher has gone to great pains to illustrate as many of van Leeuwenhoek's discoveries and pronouncements as he possibly can using both the obverse and reverse sides. The result is a pleasing if somewhat conventional composition.

Design for a 25 guilder note. The subject is the Dutch engineer Simon Stevin (1548-1620) whose writings contributed to the popularization of the natural sciences. The only typical trace of Escher to be found here is the ribbon-shaped ornamentation which encloses the nine circles on the reverse side.

Design for a 100 guilder note: obverse, reverse and watermark. The subject is the Dutch scientist Christian Huygens (1629-1695). At the bottom left corner of the obverse, we see a birefringent crystal, the properties of which were so profoundly studied by Huygens; and the way in which it is shown is typical of Escher. On the reverse there is a regular surface division with fish, and in the watermark a particularly attractive surface division with birds.

Part Two: Worlds that cannot exist

10 Creating Impossible Worlds

"Tell us, master, what is art?"

"Do you want the philosopher's answer? Or are you seeking the opinion of those wealthy folk who decorate their rooms with my pictures? Or again, do you want to know what the bleating herd think of it, as they praise or denigrate my work in speech or written word?"

"No, master—what is your own answer?"

After a few moments Apollonius declared, "If I see, or hear, or feel anything that another man has done or made, if in this track that he has left I can perceive a person, his understanding, his desires, his longings, his struggles— that, to me, is art."

I. Gall., Theories of Art

An important function of representational art is to capture an all-too-transient reality, to prolong its existence. The general notion is that anyone who has his portrait painted is being "perpetuated." Before photography brought this perpetuation within the grasp of all, it was *par excellence* the work of the artist. Not only in pictorial art, but throughout the whole history of artistic expression, we find the idealization of reality. The picture must be more beautiful than the actual object it represents. The artist must perforce correct any faults and blemishes by which reality is marred.

It was a very long time before people began to value, not the picture nor the idealization, but rather, the personal vision of the artist as it shows up in his work. Of course, the artist had never discarded this vision; it would have been impossible to do so. But he had not displayed the vision for its own sake, nor did those who commissioned the works, or the public themselves, value the artist for his self-revelation. It is expected of the present-day artist that his work should be first and foremost an expression of himself. Thus reality is now regarded more as a veil hiding the work of art than as the means whereby self-expression can be manifested. Thus we find emerging a nonfigurative art in which form and color are made the servants of the artist's self-expression. And at much the same time there has appeared a further negation of reality—that is to say, surrealism. Here shapes and colors are in no wise abstracted from reality. They do remain linked to recognizable things; a tree remains a tree—only its

leaves are not green; they are purple, or they have each taken on the shape of a bird. Or the tree has remained intact, in shape still a true-to-life tree, and yet its normal relationship to its surroundings has gone. Reality has not been idealized; it has been abolished, sometimes ending up in contradiction to itself.

If one should wish to see Escher's work, or at least a part of it, in the light of art history, then probably this can best be done against the background of surrealism—not that his work is surrealistic within the meaning attached to it by art historians. But the background of surrealism does serve as a contrast, and a selection of surrealistic work could be made at random for this purpose. We have chosen a few works by René Magritte, in the first place because Escher himself had a high regard for his work, and secondly because the extremely obvious parallels of subject matter, aim, and effect can be used to bring out the totally different nature of Escher's work.

In Magritte's *The Voice of Blood* (1961) we see a lonely plain. A river flows through it and a few trees stand at its edge: in the distance a dim mountain scene; in the foreground a hill on which there stands a mighty tree (an oak, perhaps), taking up more than half of the picture—strong and sturdy oak with an enormous crown of foliage. But Magritte makes the massive trunk come open, as though it were a tall, narrow, triple-doored cupboard revealing a mansion and a sphere. This is simply impossible. Such a "cupboard-tree" is a pure fake, quite incapable of growing or of producing any rich leafy adornment. What is worse, the dimensions of the mansion, with all its room lights blazing, are much greater than those of the hollow cupboard-tree itself. Or can it be a Lilliputian house? Is the sphere in the middle section also as big as the house? And what might be lurking behind that third door?

All we have to do is to close the doors and there stands a great and healthy tree once more: an impressive chunk of reality. Or is it really that? For, after all, we are now aware of the fact that a house and a sphere live inside the trunk.

What are we to make of such a picture? Or rather: what does such a picture do to us? It is absurd, and yet it is attractive in its absurdity.

It is an impossible world. Such a thing cannot really exist. But then Magritte has in fact achieved it; he has turned a tree into a

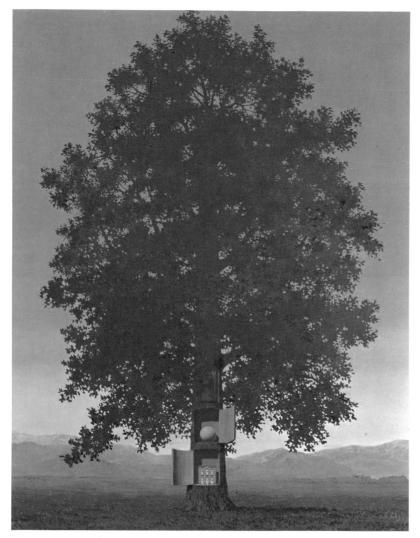

129. René Magritte, *La Voix du Sang* (The Voice of Blood), 1961 (Museum des XX Jahrhunderts, Vienna, © Copyright ADAGP, Paris)

words and according to normal rules of grammar.

Here is a literary version of Magritte's visual absurdities. One can philosophize at great length over Magritte's surrealism but even his contemporaries and friends held radically different opinions about its meaning. I should like to look into the way in which Magritte uses, transforms — yes, does violence to reality, in order to stimulate our predilection for that which astonishes. In *The Voice of Blood* reality is upset in two ways. The massive interior of the tree trunk is made hollow; and different size-scales are used next to each other. Thus the thickness of a tree trunk becomes greater than the width of a fine big building. And so the resultant scene is presented as a bold assertion: "That's the way it is — crazy."

Nevertheless the whole rendering comes so close to reality that it is as though Magritte were telling us, "As a matter of fact, everything to do with our whole existence is crazy and absurd — a great deal more absurd than anything I have shown in this picture of mine." Magritte hides nothing, does nothing in secret. Our very first glance at his picture tells us, "This is impossible." And yet, if we take a closer look at it our intelligence begins to waver and we experience the pleasure which the abolition of reason brings. In our daily lives we are so imprisoned within the strait-jacket of reality that there is a great deal of pleasure to be obtained from giving ourselves over to surrealism, a temporary deliverance from reality. The discursive, reasoning intellect takes a vacation and we stagger around delightfully in an inexplicable world.

Anyone who tries to discover subtlety of meaning in all this, or who would like to know what it is all about in its deepest essence is probably looking for the very thing the painter is trying to release him from.

The impossible worlds Escher has made are something totally different from this. Although he expressed admiration for *The Voice of Blood* as a picture (and this is unusual in view of the low opinion that is all that he could muster for most of his contemporaries), he is not able to approve of the naivete with which Magritte sets forth his statements of visual absurdity. To Escher this is just shouting in the wind. It is all too easy to astound everybody momentarily with a daring statement decked out in attractive forms and colors. You must show that absurdity, *sur*-reality, is based on reality.

Escher has created impossible worlds of an entirely different character in that he has not silenced intellect but has in fact made use of it to build up the world of absurdity. Thus he creates two or three worlds that manage to exist in one and the same place simultaneously.

When Escher begins to experiment with the representation of simultaneous worlds he makes use of methods that display a remarkable similarity to those of Magritte. If we compare Magritte's *Euclidean Walks* (1955) with Escher's *Still Life and Street* (1937), it can be seen that the aims of the two artists do not widely diverge. In Magritte's case, inside and outside are mainly united by the painting on the easel, and in Escher's case by making the structure of the surface of the windowsill coincide with that of the pavement.

We find an even greater similarity when we compare Magritte's *In Praise of Dialectic* (1927) with Escher's *Porthole* (1937). With Magritte, any logic and any connection with reality are fortuitous; with Escher they are consciously pursued. The surrealist creates something enigmatic; and it must perforce remain an enigma to the viewer. Even if there were any solution to it, we should never be able to find it. We have to lose ourselves in the enigma, standing as it does for so much that is puzzling and irrational in our existence. With Escher, too, we find the enigma, yet at the same time — albeit somewhat concealed — the solution. With Escher it is not the puzzle that is of prime importance. He asks us to admire the puzzle but no less to appreciate its solution. To those who

cupboard and has placed a mansion on a shelf inside it. The title, *The Voice of Blood*, serves to heighten the absurdity. It would seem as though Magritte has chosen a title as difficult as possible to relate to the visual content.

In 1926 Rene Magritte wrote an unusual literary contribution to the first issue of a paper of which he himself was one of the editors: *"Avez-vous toujours la même épaule?"*

"Do you always have the same shoulder?" Thus one shoulder becomes a separate entity, and the possibility is introduced that one may or may not have it. The grammatical construction is perfectly normal but opens up something absurd: the possibility of being able to choose one's own shoulder at will. The meaning is surrealistic, but the statement is constructed from ordinary

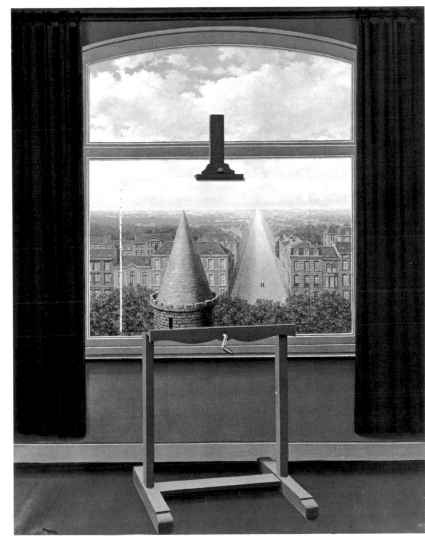

130. René Magritte, *Les Promenades d'Euclide* (Euclidean Walks), 1953 (The Minneapolis Institute of Art, © Copyright ADAGP, Paris)

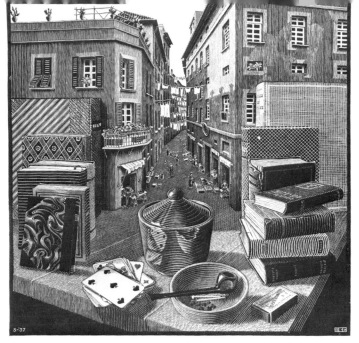

131. *Still Life and Street*, woodcut, 1937

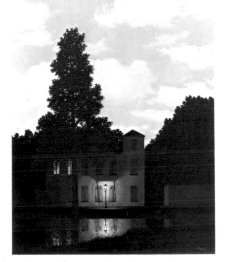

132. René Magritte, *L'Empire des Lumières II* (The Empire of Light II), 1950 (Museum of Modern Art, New York, © Copyright ADAGP, Paris)

cannot see this, or who, though seeing it, are incapable of evincing any appreciation of this highly rational element, the essential meaning of Escher's work remains a closed book.

Escher constantly returns to the theme of the mingling of several worlds. To the problems presented by this theme he finds ever more satisfying solutions. Furthest along this path stand *Rippled Surface* (1950) and *Three Worlds* (1955), prints of great skill and beauty; yet even they will reveal Escher's rational purpose only to such as have steeped themselves in the whole range of his work.

Magritte shows no signs whatever of being influenced in his work by the possibility of merged or interpenetrating worlds. On the contrary, the rational possibility of such merging would

be a hindrance to him, would reduce his power to surprise and be detrimental to the absurdity. How far apart from each other Escher and Magritte are, is perhaps best shown by a comparison between Magritte's *The Empire of Light II* (1950) and Escher's *Day and Night* (1938) or *Sun and Moon* (1948). *The Empire of Light* may be regarded as one of the most important of Magritte's works; for it he was awarded the Guggenheim Prize for Painting in Belgium. Magritte himself wrote of this picture:

What I put into a picture is what the eyes can see; it is the thing, or things, that people must know about already. Thus the things portrayed in the painting *The Empire of Light* are those things

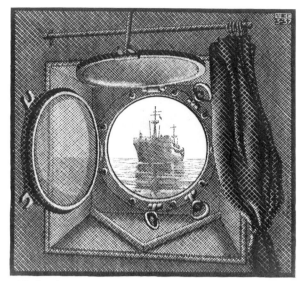

133. *Porthole*, woodcut, 1937

134. René Magritte, *L'Éloge de la Dialectique* (In Praise of Dialectic), 1937 (Private Collection, London, © Copyright ADAGP, Paris)

which I know about, or, to be precise, a nocturnal scene together with a sky such as we can see in broad daylight. *It seems to me that this summoning up of night and day together gives us the power to be both surprised and delighted.* This power I call poetry.

By summoning up day and night together, Magritte seeks to surprise and to delight — to surprise because it is an impossibility. When Escher summons up *Day and Night* or *Sun and Moon* it is also in order to surprise . . . but precisely because it is not an impossibility. It does surprise and delight, simply because it has a look of the impossible about it. But it surprises still more because Escher has discovered a means, a perfect, complete pictorial logic, whereby the impossible can be turned into the possible.

If we seek a literary parallel to this we can find it, so far as Escher is concerned, essentially in the detective novel. The mystery makes no sense until it can be seen in the light of the more-or-less thrilling denouement. And, also in the detective novel, the mystery can take on an absurd, surrealistic form, as is often the case with G. K. Chesterton. In *The Mad Judge,* the judge playing hopscotch in a prison yard is a complete absurdity. In *The Secret Document,* a sailor jumps overboard; no splash is heard, no movement is seen in the water, the man has completely disappeared. Then we have somebody stepping out of the window and leaving no trace. A work of Magritte's such as *The Unexpected Answer* might well have served as an illustration for this. But Chesterton's triumph always turns up a dozen pages later, when he demonstrates that what at first seemed so weird is really strictly logical, normal, part of an overall grand design. The range of Escher's impossible worlds is much greater than the theme from which we

have so far drawn our examples. Escher shows us how a thing can be both concave and convex at one and the same time; that the people he has created can walk, at the same moment and in the same place, both upstairs and down. He makes it clear to us that a thing can be simultaneously inside and outside; or, if he uses differing scales in the one picture, there exists a representational logic capable of rendering this coexistence as the most natural thing in the world.

Escher is no surrealist, conjuring up for us some mirages. He is a constructor of impossible worlds. He builds the impossible according to a strictly legitimate method that everyone can follow; and in his prints he demonstrates not only the end product but also the rules whereby it was arrived at.

Escher's impossible worlds are discoveries; their plausibility stands or falls by the discovery of a plan of construction, and this Escher has usually derived from mathematics. And useful plans of construction were not just there for the picking!

Finally, we should like to point to one uniquely fascinating aspect of Escher's impossible worlds. A century ago it was impossible to travel to other planets or to transmit pictures of them. With the advance of science and technology all sorts of things that are still impossible today will become realities. Nevertheless, some things there are that are totally impossible, such as a squared circle. It is to this latter category that Escher's impossible worlds belong. They remain forever impossible and have their existence purely and simply within the bounds of the print, and by virtue of the imaginative power of the man who made them.

135. René Magritte, *La Reponse Imprevue* **(The Unexpected Answer), 1933**
(Museés Royaux des Beaux Arts de Belgique, Brussels)
(© Copyright ADAGP, Paris)

11 Craftsmanship

Drawing

"I am absolutely incapable of drawing!" This is a most extraordinary remark to come from someone who was busy drawing from earliest childhood to the age of seventy. What Escher really means is that he was incapable of drawing when relying only on his imaginative faculty. It is as though the essential link were between his eyes and his hands. In his case the intermediate emergence of visual concepts is but poorly developed. In his later prints, whenever buildings and landscapes were needed as a setting, he copied these with considerable accuracy from real life. In the calm period that followed the completion of a print he would go through his portfolios of travel sketches, for here was the source material he needed in order that new ideas should take shape.

Whenever he needed human or animal figures he had to draw these from nature. He modeled his Curl-up creatures, in various attitudes, in clay. The ants that are to be seen on *Moebius Strip II* were modeled in plasticine; a praying mantis that landed on his drawing pad during one of his wanderings in southern Italy was swiftly drawn and later pressed into service as a model for his print *Dream*, and when he was working on the last of his prints, *Snakes*, he bought some books of snake photographs. For his print *Encounter* he needed little people in all the required positions; then he posed himself in front of the mirror. "Yes, I am quite incapable of drawing, even the more abstract things such as knots and Moebius rings, so I make paper models of them first and then copy them as accurately as I can. Sculptors have a much easier job. Everyone can model clay—I have no difficulties with that. But drawing is terribly arduous for me. I can't do it well. Drawing, of course, is much more difficult, much more immaterial, but you can suggest much more with it!"

136. Clay models of Curl-ups for *House of Stairs*

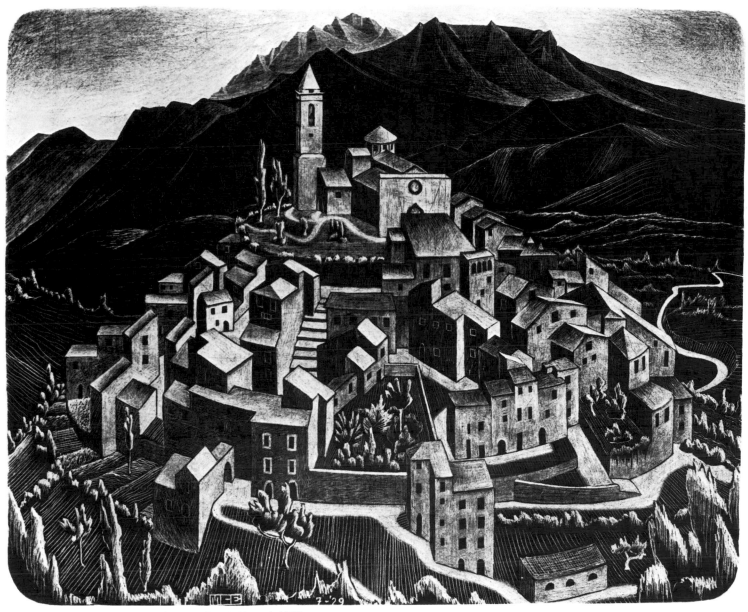

139. Escher's first lithograph: *Goriano Sicoli, Abruzzi*, 1929

137. Ant, plasticine model for *Moebius Strip II*

138. Cardboard model for *Knots*

69

Lithographs and Mezzotints

During his time as a student Escher came to know several graphic techniques. But etching did not suit him at all because, owing to his allegiance to the linocut and woodcut, he had a predilection for working from black to white. To start with, all is black; whatever he cuts away will be white. This was how he made his scraper drawings. A sheet of paper was entirely blacked over with wax crayon, then, taking his knives and pens, he removed those parts that were to become white.

The need to be able to make reproductions of his work also led to the lithograph. At first he went to work on this medium just as though he were trying to execute a scraper drawing on the lithographic stone. The whole surface was blackened and the white was removed. All his early lithographs were produced in this way. In the first lithograph, *Goriano Sicoli* (1929), showing a small town in the Abruzzi, one can see how unaccustomed he still was to the new technique. He used too great an area of the stone, with the result that it is difficult to take good copies of the whole print.

From 1930 onward he was drawing on the stone normally, with lithographer's chalk. It gave him greater freedom of expression than the woodcuts. There was no longer any problem over a smooth transition from black, through gray, to white. He never printed his own lithographs. In Rome, this was done for him by a small commercial printing firm and in the Netherlands also he had a number of skilled people who could do it for him. It is a pity that when he began this work he used borrowed stone. Owing

to the closure of a printing firm from which he had borrowed stones, these latter were lost, and so a large number of prints could no longer be printed.

To anyone who is very fond of the woodcut, with its striking contrast between black and white, a lithographic print is always something of a disappointment. The lithographic chalk drawing on the stone shows up blacks very clearly and well, and there is a good range of contrast. On printing, however, this contrast range recedes and becomes in fact less marked even than what can be achieved with a pencil drawing.

In Brussels Escher made the acquaintance of Lebeer, the keeper of the print room, who was also buying his work privately. Lebeer advised him to turn his attention to the mezzotint, sometimes called the black art. To initiate this process one takes a copper plate and roughens it all over (an endless task, done by hand). This roughened plate holds a great deal of ink and on printing leaves a deep black surface. For the parts that are to be white or a certain shade of gray the roughened plate has to rubbed more or less smooth with steel tools. This is also a technique working from black to white; thus, in contrast to the lithograph, it produces a good range of contrast.

Escher made only seven of these because the technique was particularly time-consuming and because only fifteen or so good prints can be made from each plate. Only if the copper plate is specially hardened or tempered beforehand are more prints possible. All his mezzotints were printed by the bank-note printing firm Enschede, in Haarlem.

Escher was not in any way fettered by the techniques which he

140. *Rome at night (Basilica di Massenzio),* **woodcut, 1934**

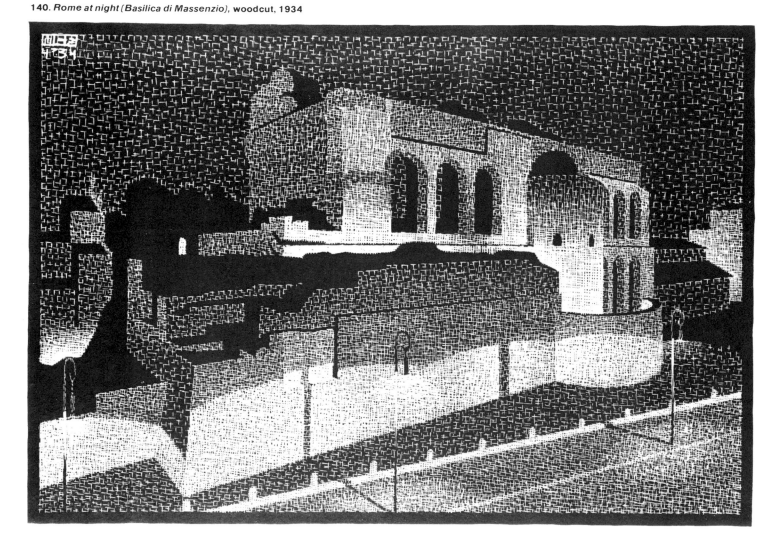

70

used. He regarded them as a means to an end, and only experimented with them so long as they could be considered needful. If one studies the finest details of his woodcuts through a magnifying glass, one can form an idea of how keen was his eye and how firm his hand.

Multiple Reproduction

"I make things to be reproduced in quantity; that's just my way." When Escher was at high school in Arnhem he made linocuts. The fairly brief training that he received from de Mesquita consisted entirely in an extension of this work. He applied himself almost exclusively to woodcuts, using side-grained wood, which meant that the structure of the wood was still visible in the prints. One of the most beautiful examples of this is certainly the large portrait of his wife, *Woman with Flower* (1925). His virtuosity was apparent in a series of prints which he made of nocturnal scenes in Rome, in 1934. For some of these both sketch and woodcut were completed within twenty-four hours! And in each print he had restricted himself to cutting in one or more predetermined directions, so that this series of prints became a kind of sample card of possibilities.

He did make one more linocut, *Rippled Surface*, in 1950 (figure 149) and that was for the simple reason that he had no suitable wood on hand at the time.

As he came to feel the need to depict finer details, he gradually began to change over from side-grain, which de Mesquita had so assiduously recommended, to end-grain wood. Then it was that the first wood engravings appeared: *Vaulted Staircase* (1931), and *Temple of Segeste, Sicily* (1932). The woodcuts and wood engravings were printed, not on a press, but by an old Japanese method using a bone spoon. The printing ink was spread over the wood with a roller and a sheet of paper was laid on it. Then each place of contact between wood and paper was rubbed over with the bone spoon. It is a primitive and complicated method, and yet the wood remains sound and serviceable for a much longer time than is the case with a press; with the latter one has to exert a much greater pressure in order to obtain a good print.

If more than one block of wood was needed, he used an equally primitive method to ensure that the various blocks were printed in the correct positions. Notches on the edge of each block indicate the points where the block is to be held in position with pins. By making notches on the second block correspond with those of the one that was used first, it can be fixed accurately in place.

Modern Art

When an exhibition was held showing the work of twenty-two Dutch artists (at which one of Escher's prints was hung) he sent me the complimentary copy of the catalog he had received. On the cover he had scribbled, "Whatever do you make of such a sick

141. *Rome at Night (Column of Trajanus),* woodcut, 1934

142. *Vaulted Staircase,* wood engraving, 1931

effort as this? Scandalous! Just throw it away when you have looked at it."

His unsympathetic attitude toward most expressions of modern art served as a key to his view of his own work. He could not put up with anything obscure. During an interview with a journalist, the conversation turned on the work of Carel Willink. "If Willink paints a naked woman in a street, I wonder to myself, 'Now, why should he do that?' and if you ask Willink you'll get no reply. Now, with me, you will always get an answer to the question why."

When the conversation turned to the high prices that modern art fetches, Escher became furious. "They are complete fools! It's like the Andersen fairy tale—they buy the Emperor's new clothes. If the art-dealers smell a profit, the work is pushed and sold for big money." But then he took back his words somewhat. "I don't want to condemn it too much. I don't know—it's a closed door to me."

At that time Escher did not foresee that his work would also attract collectors to spend a lot of money on his prints, and that after his death thousands of dollars would be paid for a single copy!

He reproached most modern artists for their lack of professional skill, referring to them as daubers who can do no more than play around. For a Karel Appel he could not muster the slightest feeling of appreciation. But for Dali, on the other hand: "You can tell by looking at his work that he is quite an able man." And yet he was jealous of any artists who had a complete mastery of technique. Among the graphic artists he regarded Pam Ruiter and Dirk van Gelder as being more skilled than himself. However, he was not necessarily attracted by mere mathematical precision. Vasareli's abstract work he regarded as soulless and second-rate. "Maybe other artists can work up an appreciation of my work, but I certainly can't for most of what they turn out. Anyway, I don't want to be labelled as an artist. What I have always aimed at doing is to depict clearly defined things in the best possible way and with the greatest exactitude."

That spontaneity of work which the modern artist holds in such high esteem is altogether lacking in Escher. Every print called for weeks and months of thought and an almost infinite number of preparatory studies. He never allowed himself any "artist's license." Everything was the outcome of a long quest, because it had to be based on an inner principle. This detective work on underlying concepts is the most important feature of his work. The setting, the houses, the trees, and the people are all so many "supers" whose job it is to call attention to things that are taking place according to the rules in the print.

In spite of his infallible sense of composition, refinement of form, and harmony, these things are but by-products of a thoroughly explored inner discipline. When he had almost completed *Print Gallery*, I passed a remark about those ugly curved beams in the top left-hand corner; they were horrible! He looked at the drawing pensively for a while and then he turned to me and said, "You know, that beam has just got to go like that. I constructed it with great exactness; it can't go any other way!" His art consists of discovering principles. The moment he is on the track of something he has got to follow it with sensitivity and, indeed, obedience.

143. *Temple of Segeste, Sicily*, wood engraving, 1932

72

12 Simultaneous Worlds

144. Jan van Eyck, *The Arnolfini Marriage* (detail)
 (The National Gallery, London)

Globe Reflections

Two different worlds existing in one and the same place at the same time create a sense of being under a spell. For this is an impossibility; where one body is, there the other cannot be. We have to think up a new word for this impossibility — "equilocal" — and this we can define as "occupying the same place simultaneously." None but an artist can give us this illusion, thereby procuring for us a sensation of the first order, a sense experience wholly new.

From 1934 onward Escher made prints in which he was consciously seeking this sensation of equilocality. He managed to unite two, and at times three, worlds so naturally in a print that the viewer feels, "Oh yes, that is quite possible; I am quite able to comprehend in thought two worlds at the same time."

Escher discovered an important expedient for these — reflections in convex mirrors. In one of his first great drawings, the *St. Bavo's, Haarlem* (figure 29) we can already see an intuitive adoption of it.

In 1934 *Still Life with Reflecting Sphere* appeared, a lithograph in which not only the book, the newspaper, the enchanted Persian bird, and the bottle can be seen, but also the whole room and the artist himself appear indirectly, as a reflection.

A simple construction taken from optical geometry (figure 148) shows us that this whole mirror-world is contained within a small area within the reflecting globe, and indeed that, in theory, the whole universe, except for that part of it immediately behind the sphere, can be reflected in such a globe.

This reflection in a convex mirror can be found among the works of several artists, as, for instance, in the famous portrait of the Arnolfinis where man and wife, together with the room in which they are standing, are shown again very clearly indeed, reflected in the mirror. But with Escher this is no mere fortuitous element, for he is consciously seeking new possibilities, and so, over a period of almost twenty years, prints keep appearing in which reflections serve to suggest simultaneous worlds.

In *Hand with Reflecting Sphere*, a lithograph made in 1935, this phenomenon is depicted in so concentrated a form that we could well class it as *the* globe reflection; for the hand of the

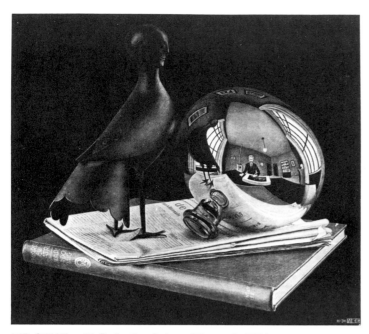

145. *Still Life with Reflecting Sphere*, lithograph, 1934

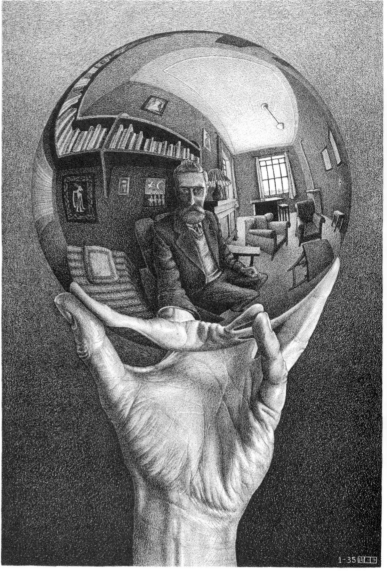

146. *Hand with Reflecting Sphere*, lithograph, 1935

artist is seen to be supporting not only the globe itself but also the whole of the area surrounding him, in this mirror-picture. The real hand is touching the reflected hand, and at their points of contact they each have the same dimensions. The center of this mirror world is, not by chance but in the essential nature of things, the eye of the artist as he stares at the globe.

In the mezzotint *Dewdrop* (1948) we can see three worlds at once, the succulent leaf, the magnified section of that leaf under the drop of water, and the mirror picture of the area facing the drop—all this in a perfectly natural setting; no man-made mirror is needed.

Autumn Beauty

It is also possible to suggest the interweaving of several different worlds by means of flat mirror reflections. We see a first attempt in this direction in 1934, in the lithograph *Still Life with Mirror*, in which a little street (drawn in the Abruzzi) comes right into the world of a bedroom.

In the linocut *Rippled Surface* (1950) all this takes place in a much more natural manner. A leafless tree is reflected in the surface of the water, which would not show up at all were it not for the fact that its smoothness is disturbed by a couple of falling raindrops. Now both mirror and mirror-picture manifest themselves in one and the same place. Escher found this an unusually difficult print to make. He had closely observed the scene in nature

147. *Dewdrop*, mezzotint, 1948 (detail)

74

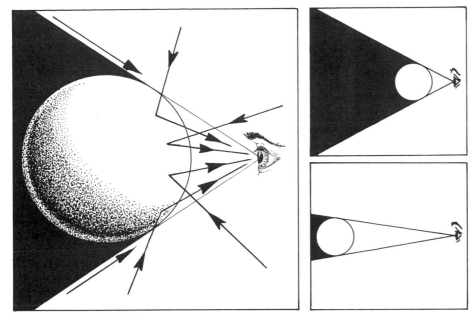

148. In a convex mirror the eye sees the mirror image of the whole universe, with the exception of the part that is covered by the globe. The farther the eye is removed from the convex mirror, the larger the uncovered part becomes.

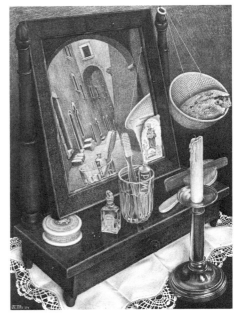

150. *Still Life with Mirror*, lithograph, 1934

149. *Rippled Surface*, linocut, 1950

151. Pencil study for *Rippled Surface*

152. *Three Worlds*, lithograph, 1955

153. *Magic Mirror*, lithograph, 1946

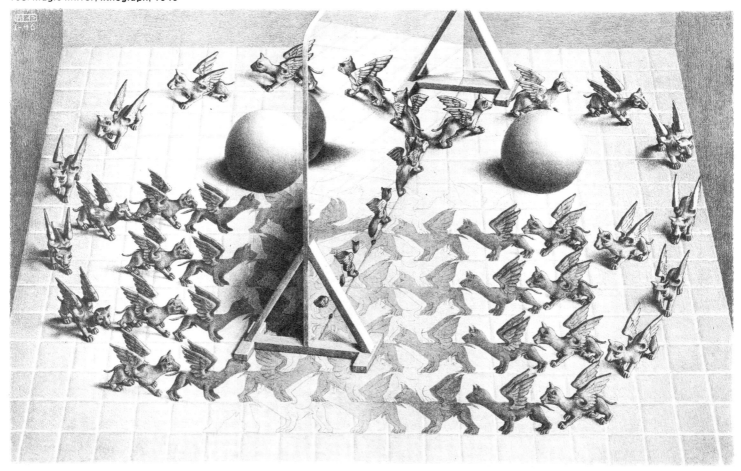

Studies for the fish in *Three Worlds*

154. *Sun and Moon*, woodcut, 1948

and reconstituted it at home without the aid of sketches or photographs. The circular waves had to be shown very precisely as ellipses, in order to suggest the reality of a water surface which was receding into the distance. One of the many working drawings is reproduced here (figure 151).

While *Rippled Surface* with its bare trees and pale solar disk, and its two worlds merged, gives an impression of winter or late autumn, the print *Three Worlds* is typically autumnal. "I was walking over a little bridge in the woods at Baarn, and there it was right before my eyes. I simply had to make a print of it! The title emerged directly from the scene itself. I returned home and started straight away on the drawing."

The direct world is represented here by the floating leaves; they indicate the surface of the water. The fish represents the underwater world and everything above the water is shown as a reflected image. All these worlds are intertwined in a perfectly natural way and presented with such an atmosphere of melancholy autumn mood that the real meaning of the print's title is clear only to those who will give it more than a moment's thought.

Born in a Mirror

In the lithograph *Magic Mirror* (1946), Escher takes things a step further. Not only is there a reflected image but it is even suggested that the reflections come to life and continue their existence in another world. This calls to mind the mirror world from *Alice in Wonderland* and *Through the Looking Glass*, stories that greatly delighted Escher!

On the side of the mirror nearest to the viewer we can see, under the sloping stay, a tiny wing appearing together with its mirror image. As we look further along the mirror there gradually emerges a fully winged dog. Yet this is not all, for its mirror image is growing similarly; and as the real dog moves away from the mirror so does the mirror dog on the other side. On arrival at the edge of the glass this mirror image appears to take on reality. Each line of animals doubles itself twice as it moves forward and so these lines together make a regular space-filling in which white dogs develop into black ones, and vice versa.

Both realities multiply and merge into the background.

Intermingling of Two Worlds

In the woodcut *Sun and Moon* (1948) Escher has used surface-division as a means of creating two simultaneous worlds. Fourteen white and fourteen blue birds fill the entire area. If we turn our attention to the white birds then we are transported into the night; fourteen bright birds show up against the deep blue night sky, in which we can observe the moon and other heavenly bodies.

Now if we concentrate on the blue birds we see these as dark silhouettes against the bright daytime sky, with a radiant sun forming the center. On closer inspection we discover that all the birds are different; so we are dealing here with one of the very few entirely free surface-fillings that Escher has made. (*Mosaic: I*, 1951, and *Mosaic: II*, 1957).

77

155. *Savona*, black and white crayon, 1936

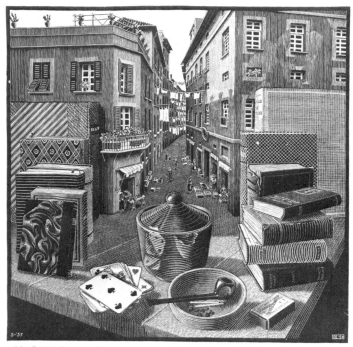

156. *Still Life and Street*, woodcut, 1937

Windowsill Turned Street

A small street in Savona, near Genoa, was the origin of the association of ideas to be found in the woodcut *Still Life and Street* (1937). Here we have two quite distinctly recognizable realities bound together in a natural, and yet at the same time a completely impossible, way. Looked at from the window, the houses make book-rests between which tiny dolls are set up. Looked at from the street, the books stand yards high and a gigantic tobacco jar stands at the crossroads. Actually, the fitting-together device is a very simple one. The borderline between windowsill and street is dispensed with, and the materials of the windowsill merge with those of the street.

In the same year, 1937, Escher made the woodcut *Porthole*, and in this we can see a ship through a porthole and can at the same time take the print to be a painting of a ship in a frame shaped like a porthole. In *Dream* (1935), we see the effigy of a sleeping bishop surrounded by vaulted archways. A praying mantis is sitting on the effigy's chest. But the world of the marble bishop and that of the praying mantis are totally different. The praying mantis is magnified more than twenty times.

Thus we find running through the whole of Escher's work attempts, often with completely different means, to connect different worlds together, to make them pass through one another, to weave them together—in short, to make them coexist. Even in prints that do not have this amalgam of worlds as their main objective, we still find the theme appearing obliquely, as for instance in the mezzotint *Eye* (1946), *Double Planetoid* (1949), *Tetrahedral Planetoid* (1954), *Order and Chaos* (1950) and *Predestination* (1951).

The Print That Escher Never Made

There are many prints for which Escher drew sketches but which never reached completion. But for none of these did Escher

so greatly grieve as for the one I am now going to describe to you. Do you know the fairy tale about the magic gate? In a completely normal landscape—meadows, clumps of trees, low hills—there stands a very ornamental gate. A senseless gate, for it gives access to nothing; all you can do is walk around it. But as soon as the gate opens it leads into a lovely, sun-drenched landscape, with strange kinds of plant growth, golden mountains, and rivers flowing with diamonds. . . .

This fairy tale is known in many countries and has numerous variations. This magic gate would fit perfectly into the series of prints we have been dealing with in this chapter. Did Escher ever consider making it? He had it on his mind first in 1963. What brought it to his attention was a visit from Professor Sparenberg, who told him something about Riemann surfaces and showed him a sketch (figure 158). Two weeks later Escher wrote a letter to the professor referring to the sketch and making a further suggestion. As the content of this letter is very indicative both of Escher's method of working and of his thought processes, we quote the following more important passages:

June 18, 1963

. . . This idea is so fascinating that I only hope . . . I shall be able to obtain the necessary peace and quiet and concentration to be able to work out your plan in a graphic print.

May I, in the first place, have a try at putting into words what I, as a mathematical layman, see in your sketch. . . .

For convenience' sake, I call your "two spaces" *Pr.* (for the Present) and *Pa.* (for the Past). It was only after the closer examination of your drawing that the key to it dawned on me, i.e., that *Pr.* may be regarded not only as a gap in *Pa.* but also as a disk masking a part of *Pa.* Thus *Pr.* is both in front of *Pa.* and also behind it; in other words they each exist as separate spatial projections in exactly the same area of the drawing.

Now there is something in your method of presentation that does not entirely satisfy me—that there is a much greater area devoted to *Pa.* than to *Pr.* Is the past so much more important than the present? As they are shown here as "moments" it would seem to me logical, and more aesthetically satisfying, from the point of view of composition, if they were each to take up an equal amount of space.

In order to achieve such an equivalence I submit the enclosed schematic sketch for your judgment [figure 158]. It may well be

78

157. *Dream*, wood engraving, 1935

158. Sketch made by Prof. Sparenberg and, *below*, Escher's interpretation of his idea.

that I am doing violence to Riemann with it and am adulterating the purity of mathematical thought.

It seems to me that the advantage of my apportionment over yours would be as follows. In the center two bulges lie next to each other; on the left is *Pa.*, ringed around by *Pr.*, and on the right *Pr.* ringed by *Pa.*

When I think of the flow of time I realize that it moves from the past, via the present, to the future. Leaving the future out of our consideration (for it is unknown and so cannot be depicted) there is a stream moving from *Pa.* to *Pr.* Only historians and archaeologists have thoughts that sometimes move in the opposite direction; maybe I too might be able to imagine it that way.

But the logical stream, from *Pa.* to *Pr.*, might be depicted by, say, a perspective series of prehistoric birdlike creatures in flight, diminishing toward the horizon, maintaining their correct shape (in their domain, *Pa.*) until they reach the frontier of *Pr.* The moment they cross this frontier they change, let us say, into jet airplanes belonging to the domain *Pr.*

Now there is a further advantage, in that two streams can be represented, i.e., the one to the left of the horizon emerging from the *Pa.* supply bulge, increasing in size in the direction of the edge where *Pr.* is to be found; and the one to the right of the *Pa.* edge, speeding away, and diminishing, toward the horizon of the *Pr.* swelling.

Suggestive though the telegraph wires in your drawing may be, they don't please me, because in an archaic, prehistoric world, the telegraph hadn't been invented.

You can see how this whole problem takes me! By writing about it I am hopeful that I shall achieve a greater clarity of thought and that I can stir up my inspiration (to use that great clumsy word again).

This whole problem persisted in Escher's mind as the problem of the magic gate he not only wanted to draw, but to which he so much wanted to give a form that would serve as a compelling evidence for the truth, the reality of what he had depicted.

It is a great pity that he was unable to achieve this *tour de force*. The thought of it nagged at him like a headache. And perhaps no other man but Escher could have depicted this for us, using methods he had adopted in his other prints in so masterly a way—that is, reflection, perspective, surface-division, metamorphoses, and the approach to infinity.

79

13 Worlds That Cannot Exist

Concave or Convex?

161.

What do you see when you look at the above print? Is it the outer edge of a convex, shell-shaped ceiling ornament? If so, then you are probably sitting with the main stream of light coming from the right. Contrariwise, if what you see is a shell-shaped basin set in the floor, then the light that aids your vision must be coming from the left, for the image projected on your retina allows of both of these interpretations. You can see it as either concave or convex. One minute your "cerebral calculating center" works it out that you are seeing something convex, and the next minute it tries to persuade you that you are seeing something concave.

Figure 161 is an enlarged detail from the print *Convex and Concave* (1955), which is constructed entirely with elements susceptible to two opposite interpretations. It is only the architectonic filling in, together with the human and animal figures and clearly recognizable objects, that restricts it to one single interpretation. The result of this is that now and again these find themselves in a totally incomprehensible world—that is, the moment we make a wrong interpretation of their environment.

Before we embark on a study of the picture it will be well to become conversant with the more elementary forms of this ambivalence within the one drawing. If we take a brief look at the weather vane (fig. 160) we shall observe that at a given moment it will suddenly change direction. For instance, if you start by seeing its right-hand side pointing more or less toward you, lo and behold, after a few moments the situation changes and the same section is now turned away from you. In the two drawings

below we have tried to emphasize each one of these interpretations equally, but it may be that you will still find the reversal taking place after you have stared at them for a while. Thus we meet the phenomenon here in a very simplified form.

We can take this further (figure 159a). Let us draw a line *AB*. Which do you conclude is nearer to you—*A* or *B*?

Now we draw two parallel lines. By presenting them as very thick bars we can imply that *Q* and *R* are closest to us. And what is more, we no longer see two parallel lines, but two lines crossing each other at right angles. And we can use other methods of imposing one of the possible alternatives on the viewer. This comes out very clearly in the construction with four parallel lines in figure 159b, transformed as they are into two dipole antennae in a totally different position.

We do the same thing with two diamond shapes (figure 159c). These are completely identical, yet a different interpretation is accentuated in each lozenge, with the result that we see the first as a plank at close quarters that we can look up to from below, and next as one we can look down on from above.

In the case of a diamond drawn next to a square, the number of possibilities becomes even greater; and the small illustrations show the four different interpretations (figure 162).

Thus even a single line drawn on a blank sheet of paper allows of two quite distinct interpretations, and obviously this twofold interpretation can also be a feature of the most complicated figures, indeed of every print, every photograph, and every picture. The fact that we usually do not notice this is due to the way in which numerous details of the picture represent things that clearly have only a single meaning in the tangible world of experience. Whenever this does not apply it will be found that one interpretation can be arrived at just as well as another, especially if we change the direction in which the light is shining on the paper. In figure 163 the same photograph of a dewdrop on the leaves of an *Alchemilla mollis* plant has been printed twice over, once in its normal position and once upside down. No doubt you will see the leaves in the one photograph as concave and those in the other as convex. The same thing applies to the lunar landscape which can be seen twice printed in figure 164.

Because the foremost architectural details in the print *Convex and Concave* are the three cubical temples with cross-vaulting, we hae drawn two identical cubes in figure 165 just as they appear in the print. But possible interpretations have been stressed, while their position vis-a-vis the observer is indicated by a number of angular points. *F* stands for in front and *B* stands for behind; *u* is under and *a* is above. These two cubes can easily be recognized in the furthest left and furthest right temples in the print.

The lithograph *Convex and Concave* is a visual shock. Apparently, or in any case at first sight, it is a symmetrical edifice;

159a.

159b.

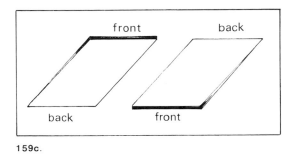

159c.

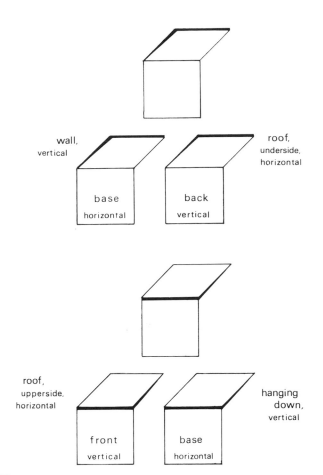

162.

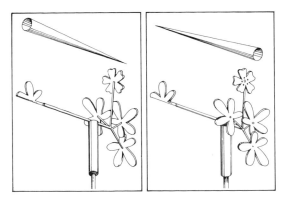

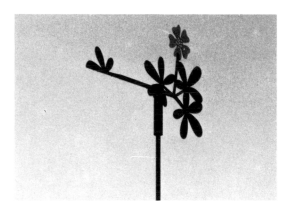

160. The weather vane effect

163. Dewdrops can give a concave or convex effect

164. The same goes for the craters on the moon

81

thus the left-hand side is the mirror image of the right-hand side, the transition in the middle being not abrupt but gradual and entirely natural. However, when the center is crossed something takes place that is worse than falling into a bottomless abyss, for everything is turned literally inside out. Topside becomes underside, front becomes back. The people, the lizards, and the flower pots do resist this inversion, for they are easily identifiable with palpable reality and this, to our way of thinking, cannot have an inside-out form. Yet even they have to pay the price if they dare to cross the frontier: they end up in such an odd relationship with their surroundings that the mere sight of them is enough to make one dizzy. To take a few examples: at the bottom left there is a man climbing up a ladder to a landing. Ahead of him he sees a small temple. He can go and stand beside the sleeping man and wake him up to ask him why the shell-shaped basin in the middle is empty. Then he can have a try at mounting the stairs on the right. By then it is too late, for what looks like a stairway when viewed from the left turns out to be the underside of an arch. He suddenly finds that the landing, once firm ground beneath his feet, has now become a ceiling to which he is strangely fixed, just as if there were no such thing as a force of gravity.

The same thing will also happen to the woman with the basket if she walks down the stairs and then steps over the central line. However, if she stays on the left-hand side nothing untoward will happen to her.

Perhaps we experience our most marked visual shock when we look at the flute players on the opposite side of the vertical middle line. The one to the upper left is looking out of a window and down on the cross-vaulted roof of a small temple. He could, if he wished, climb out and go and stand on that vaulting, then jump down from there onto the landing. Now if we take a look at the flute player slightly lower down to the right, we observe that he can see an overhanging vault above him; he may as well put right out of his head any notion of jumping down onto the "landing," for he is looking down into an abyss. The "landing" is invisible to him because in his half of the print it extends backward. On the banner in the top right corner the

print has been provided with an emblem neatly summarizing the picture's content. If we let our eye travel slowly over from the left half of the print to the right, it is possible to see the right-hand archway as a stairway also—in which case the banner's appearance is totally unreal. We can leave further excursions into this print to the viewer.

Figure 166 gives a diagram of the contents, and here the print is divided into three vertical strips. The left-hand strip has a distinct "convex architecture" and it is as though, at every point, we are looking downward from above. If the print were drawn using normal perspective we should be bound to find a nadir below the bottom limit of the plate. Yet the vertical lines remain parallel, because in this instance what is called oblique or angular perspective is being used, so we must think rather in terms of a pseudo-nadir. In the section to the far right we see everything from below; the architecture is concave and the eye is drawn upward towards a pseudo-zenith. In the central section the interpretation is ambivalent. Only the lizards, the plant pots, and the little people are susceptible to just one single interpretation.

In figure 168 we are shown the plan on which the print has been drawn. It is of course somewhat more complicated than the symbol on the banner, but in any case it presented Escher with many more possibilities.

A fair number of preparatory sketches for the print *Convex and Concave* have been preserved, among which figures 169, 170, 171, and 172 are very intriguing. A year after *Convex and Concave* appeared, Escher wrote to me about it thus:

Just imagine, I spent more than a whole month, without a break, pondering over that print, because none of the attempts I made ever seemed to turn out simple enough. The prerequisite for a good print—and by "good" I mean a print that brings a response from a fairly wide public quite incapable of understanding mathematical inversion unless it is set out extremely simply and explicitly—is that no hocus-pocus must be perpetrated, nor must it lack a proper and effortless connection with reality. You can scarcely imagine how intellectually lazy the "great public" is. I am definitely out to give them a shock; but if I aim too high, it won't work.

165.

apparent zenith ▲

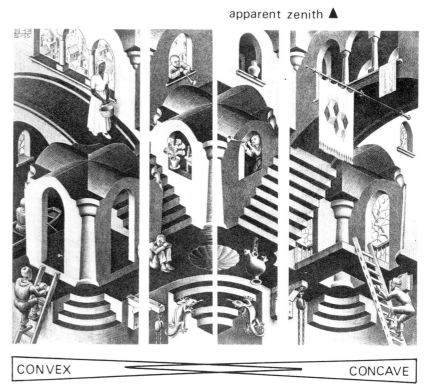

CONVEX CONCAVE

▼ apparent nadir

166. The structure of *Convex and Concave*

82

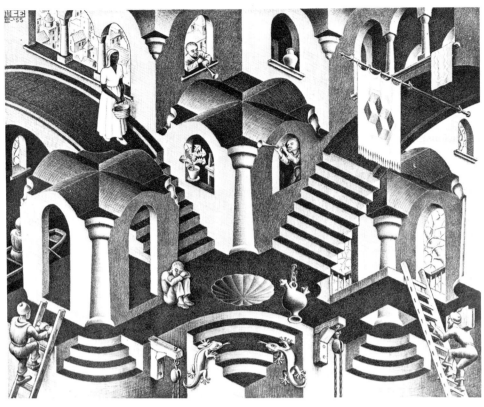

170.

171.

167. *Convex and Concave*, lithograph, 1955

168. Cube scheme for *Convex and Concave*

172.

169.

169-172. Studies for *Convex and Concave*

83

At this same period I introduced Escher to the phenomenon of pseudoscopy, whereby, with the use of two prisms, the retinal images of both eyes can be interchanged. He was most enthusiastic, and for a long while he took the prisms around with him, so as to try out the pseudoscopic effect on all sorts of spatial objects. Here is one of his many descriptions:

Your prisms are basically a simple means of undergoing the same sort of inversion that I have tried to achieve in my print *Convex and Concave*. The tin staircase that the mathematician Professor Schouten gave me, which gave rise to the print *Convex and Concave*, will definitely invert if one looks at it through the prisms. I mounted them between two pieces of cardboard which were held together with elastic bands; this made a handy little viewing box. I took them with me on a walk in the woods and enjoyed myself looking at a pool with fallen leaves, the surface of which suddenly stood on its head; a watery mirror with the water on top and the sky beneath, and never a drop of water falling "down."

And even the interchange of left and right is fascinating too. If you study your own feet, and try moving your right foot, it looks as though it is your left foot that moves.

If you wish to observe a pseudoscopic effect you should obtain two right-angle prisms (of the kind to be found in most binoculars). Mount these between two pieces of cardboard as shown in figure 173. You will have to be able to give a slight turn to at least one of these prisms. As a first object for pseudoscopic observation it is best to select a somewhat exotic flower shape—for instance a double, large-leaved begonia. Hold the pseudoscope in front of your eyes and close your right eye. Make sure that you are looking at the begonia with your left eye. Now close the left eye and, without moving either the pseudoscope or your head, look through the right-hand prism with your right eye. If you cannot see the flower, or if it is not in the same place, turn the right-hand prism until you view the flower from the correct angle. Then open both eyes. As soon as you become accustomed to it, both parts will come together and you will see an inverted image. Indeed everything will seem to have turned back to front. You can see a box or a glass turned out; an orange turns into a paper-thin cavity; the moon advances right up to your window and hangs among the trees in the garden; if you look at a glass of beer while it is filled by somebody, you will have a well-nigh incomprehensible experience. The entire spatial world becomes for you an ever-changing *Convex and Concave* movie!

Cube with Magic Ribbons

The subject embarked upon in the print *Convex and Concave* was too attractive a one not to be pursued further. While *Convex and Concave* was a whole story, the same thing comes to us as a pithy phrase in *Cube with Magic Ribbons*, which came into being a year later. For here too we have the possibility of ever-changing interpretation, in front and behind, concave or convex, while in this case there is also a contrast with an object that has been depicted in such a way as to allow of only one single interpretation. The main theme of the print consists of two ellipses intersecting each other at right angles and broadened out into bands. Each of the four half-ellipses is able to appear turned both toward and away from the viewer, and each point of intersection allows of four different interpretations. The ornaments on the ribbons can be seen as protruding half-spheres with holes in the middle or else as circular depressions with half-spheres in the middle. The reversal effect seen here very closely resembles what we have seen in the moon photograph in figure 164.

Escher's preparatory studies reproduced here show that the idea of a cube did not emerge at first, and that the ornamentation of the ribbons was originally attempted in other ways.

173. The "pseudoscope"

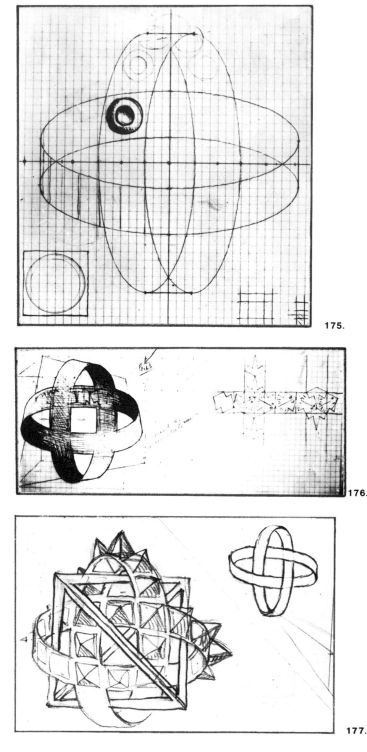

175.

176.

177.

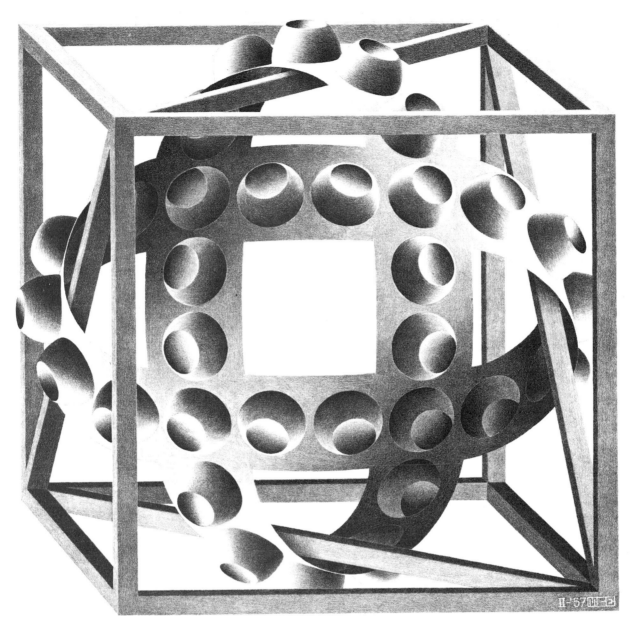

174. *Cube with Magic Ribbons*, lithograph, 1957

178.

179.

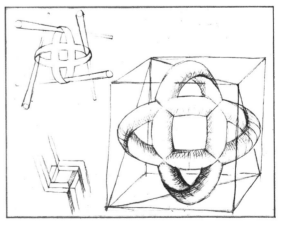

175-180. Studies for *Cube with Magic Ribbons*

Phantom House

In the trial studies for the lithograph *Belvedere* (1958) the edifice was repeatedly called *Phantom House*. But, because the atmosphere of the final print had nothing ghostly about it, the name was changed. Anyhow, ghostly or not, the architecture is quite impossible. Any representation of three-dimensional reality is reckoned to be the projection of that reality on a flat surface. On the other hand, every representation does not have to be a projection of three-dimensional reality. This is made abundantly clear in *Belvedere*, for although it certainly looks as though it is the projection of a building, yet no such building as is illustrated in *Belvedere* could possibly exist. We can see below the basic theme of the print—that is to say, the cubelike shape the pensive young man is holding in his hands (figure 181). In the middle we can see the extremely bizarre outcome of this construction—i.e., a straight ladder standing inside the building and yet at the same time leaning against the outside wall! (Figure 183.)

Belvedere is closely related to *Convex and Concave*, and this we can see by studying figures 182a, b, and c. Figure 182a represents the framework of a cube. We have already seen that the projection of two different realities can be observed within it. We arrive at one of these by assuming points 1 and 4 to be near at

hand and 2 and 3 to be further away from us. For the other reality 2 and 3 are close to us and 1 and 4 further off. This play on both possibilities was the theme of *Convex and Concave*. But it is also possible to regard 2 and 4 as in front and 1 and 3 as behind. Now this goes entirely contrary to our concept of a cube, and so for that reason we do not naturally arrive at this interpretation. However, if we allow some volume to the ribs of the cube, we can force this interpretation on the viewer, making the rib $A2$ pass in front of the rib 1-4, and $C4$ in front of 3-2. At this juncture figure 182b emerges, and this is the basis of *Belvedere*. And even another cuboid shape is possible, as in figure 182c. Now let us study the print itself.

In *Belvedere* one could almost fancy one hears the playing of a spinet.

A Renaissance prince—let us call him Gian Galeazzo Visconti—has had this pavilion built, with its view over a valley in the Abruzzi. However, on closer examination it turns out to be a rather weird-looking place. This is due not so much to the presence of the raging prisoner, of whom nobody seems to take the slightest notice, but to the way the place is built. It would appear that the top floor of the belvedere lies at right angles to the one beneath it. The longitudinal axis of this top floor is in line with the direction in which the woman at the balustrade is gazing, while the axis of the floor below corresponds to the line of vision of the wealthy merchant as he stands looking out over the valley.

181. Detail from *Belvedere*

183. Detail from *Belvedere*—the ladder, starting on the inside and coming out on the outside...

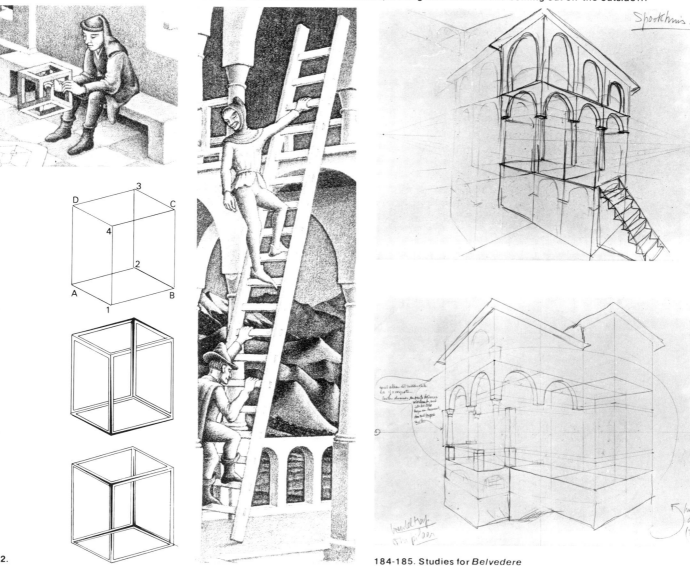

182.

184-185. Studies for *Belvedere*

Then, too, there is something very unusual about the eight pillars that join the two storeys together. Only the extreme right and the extreme left pillars behave normally, just like the ribs *AD* and *BC* in figure 182a. The other six keep on joining front side to rear side, and so must somehow or other pass diagonally through the space in the middle; and this the merchant, who has already laid his right hand against the corner pillar, would quickly discover if he were to place his left hand on the next pillar along.

The sturdily constructed ladder is dead straight, and yet clearly its top end is leaning against the outer edge of the belvedere while its foot stands inside the building. Anyone standing halfway up the ladder is not going to be able to tell whether he is inside or outside the building. When viewed from below he is definitely inside, but from above he is quite as definitely outside.

If we cut the print through the center horizontally, then we shall find that both halves are perfectly normal. It is simply the combination of both parts that constitutes an impossibility. The young man sitting on the bench has worked this out from a much-simplified model which he is holding in his hands. It resembles the framework of a cube, but the top side is joined to the underside in an impossible way. It is in fact, probably quite impossible to hold such a cuboid in one's hands, for the simple reason that such a thing could not exist in space. He might be able to solve this riddle if he were to make a careful study of the drawing which

lies on the ground in front of him.

In the bottom left-hand corner of one of the preparatory studies (figure 185), there is an interesting note: "spiral staircase around pillar." The definitive version certainly includes a ladder, but one would love to know how on earth Escher could have managed to draw a spiral staircase running around one of the pillars joining the front and rear sides of the building.

There has been no lack of attempts to produce a spatial model of the cuboid form used by Escher in *Belvedere*. A very skillful achievement can be seen in figure 187, a photograph by Dr. Cochran of Chicago. But his model consists of two separate pieces that resemble this cuboid only when photographed from a certain angle of vision.

Wrong Connections

In the British *Journal of Psychology* (vol. 49, part 1, February, 1958), R. Penrose published the impossible "tribar" (figure 188). Penrose called it a three-dimensional rectangular structure. But it is certainly not the projection of an intact spatial structure. The "impossible tribar" holds together as a drawing purely and simply by means of incorrect connections between quite normal elements. The three right angles are completely normal, but they

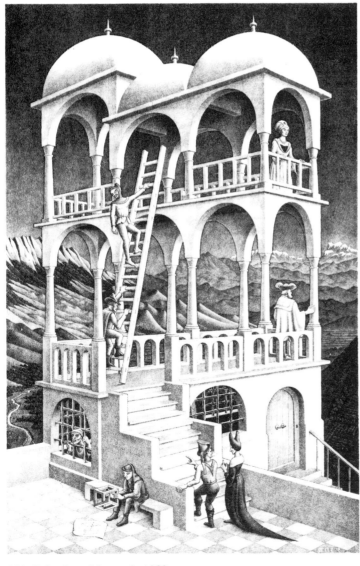

186. *Belvedere*, lithograph, 1958

187. "Crazy Crate," photographed by Dr. Cochran, Chicago

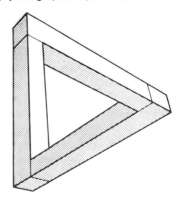

188. Tribar by R. Penrose

have been joined together in a false, spatially impossible way, so as to make a kind of triangle whose angles, incidentally, add up to 270 degrees!

Nowadays innumerable varieties of impossible figures are known, all of them being derived from false junctions. A very simple, although less well-known one, can be seen in the top row in figure 189. Below it sections of it are shown again; and these could very well exist in space, their false connections having been omitted.

It is perfectly feasible to take a photograph of the impossible tribar (figure 191). In this case, just as in the case of the crazy crate in figure 187, this photograph of the unconstructable object can be taken only from a single given point.

Escher came across Penrose's figure just at the time he was engrossed in the construction of impossible worlds, and the tribar gave rise to the lithograph *Waterfall* (1961). In this picture he linked together three such tribars (figure 190). The preparatory sketches show that his original intention was to draw three colossal building complexes. Then the idea suddenly came to him

that falling water could be used to illustrate the absurdity of the tribar in a most intriguing way.

If we start by looking at the upper left part of the print we see the water falling and thereby causing a wheel to turn. It then flows away through a brick outlet-channel. If we follow the course of the water we find that it unquestionably flows continually downward, and at the same time recedes from us. All of a sudden the furthest and lowest point turns out to be identical with the highest and nearest point; therefore the water is able to fall once again and keep the wheel turning; perpetual motion!

The surroundings of this impossible watercourse have the function both of strengthening the bizarre effect (the greatly enlarged mosses in the little garden, and the polyhedrons perched on top of the towers) and at the same time, of lessening it (the adjacent house and the terraced landscape in the background).

The relationship between *Belvedere* and *Waterfall* is obvious, for the cuboid that is basic to *Belvedere* also owes its existence to the intentionally false way in which the corner points of the cube are joined together.

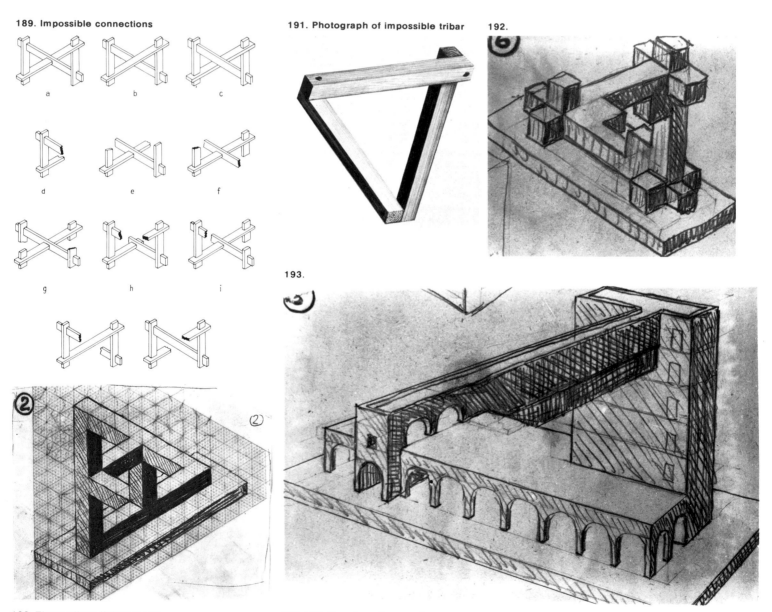

189. Impossible connections

191. Photograph of impossible tribar

192.

193.

190. Three tribars linked together

192-193. Pencil studies for *Waterfall*, seen as a building

194. Another building-like sketch

195-199. Sketches in which the *Waterfall* idea was worked out

196.

195.

197.

198.

199.

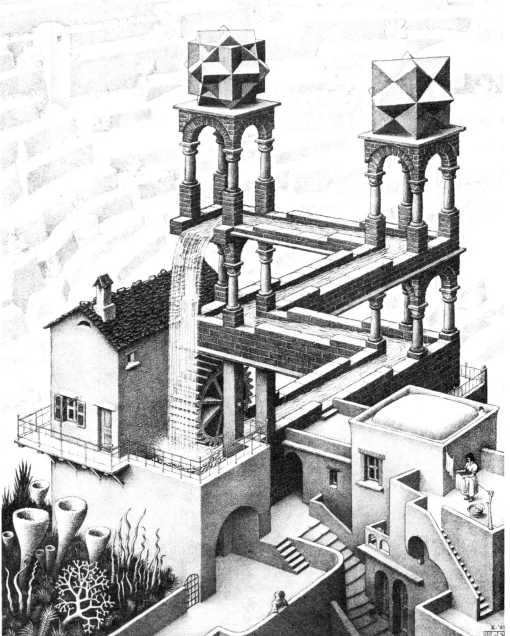

200. *Waterfall*, lithograph, 1961

89

The Quasi-Infinite

Escher has tried to represent the limitless and infinite in many of his prints. The spheres that he carved in ivory and wood, the surfaces he completely covered with one or more human or animal motifs, display both limitlessness and infinity.

In his limit prints, both the square and the circular ones, infinity is depicted by the continuous serial reduction of the figures' dimensions.

In the print *Ascending and Descending*, a lithograph made in 1960, we are confronted with a stairway that can be said to go upward—and downward—without getting any higher. Herein lies the connection between this print and *Waterfall*. If we study the print and follow the monks step by step we shall discover without the slightest doubt that each pace takes a monk a step higher. And yet on completion of one circuit we find ourselves back where we started; therefore in spite of all our ascent we are not a single inch higher. Escher also discovered this concept of quasi-endless ascent (or descent) in an article by L. S. Penrose (figure 203a). The deception is revealed, if we decide to cut the building into slices. Thus we find slice 1 (upper left) repeated at the bottom (right front), at a much lower level (figure 203b). So the sections do not lie in horizontal planes, but they go upward (or downward) spirally. The horizontal is seen to be in reality a spiral movement upward, and it is only the stairway itself that remains in a horizontal plane.

To demonstrate the possibility of drawing a continuous stairway in a horizontal plane, we have set out to construct one ourselves (figure 204a, b, c, and d). *ABCD* represents a quadrilateral lying horizontally. We have then drawn vertical lines from the central point of each side. It is easy to draw steps, which form a stairway rising from *A*, over *B*, to *C* (figure 204a). The trouble arises when we want to continue from *C*, over *D*, and back to *A*.

In figure 204b this is done in such a way that the steps take us downward, and so the whole beauty of the idea is lost. We take two steps up and two steps down, so it comes as no surprise when we find ourselves back at our starting point. However, if we alter the angles (figure 204c) then the stairway does in fact continue to go upward; so this diagram would serve our purpose. However, a building drawn according to this diagram would still have an unsatisfactory shortcoming. The dotted lines indicating the direction of the side walls slope toward each other at the upper right; there is nothing wrong with that, for they fit in (having vanishing point V_1) with the perspective representation of a building of this sort. But the other two dotted lines meet at the point V_2 at the lower right and this plays havoc with the notion of a print drawn with proper perspective.

We can, of course, get V_2 at the upper left if we make the sides *BA* and *DA* longer, as shown in figure 204d. In this way each of the two sides becomes one step longer. Escher's print demonstrates how this solution achieves a semblance of verisimilitude.

We have discovered where it is that this print fools us—i.e., the stairway lies in a completely horizontal plane, whereas the rest of the building, such as the plinths of the columns, the window frames, etc., which really ought to lie in horizontal planes, are in fact moving upward spirally. So the front of the building looks absolutely plausible, but if Escher had drawn the rear view in another print, we should then have discovered that the whole building had collapsed.

Now we can take a further look at the staircase from this point (figure 205). If we draw lines along each large strip we notice that this delineates a prismatic shape whose side surfaces have breadths in the ratio 6:6:3:4. Those parts of the print which appear at a similar height form a spiral (shown in dots). Figure 206 sums up this print once again. But the thin lines indicate horizontal planes (and therefore parallel to the stairway), while the thick-lined spiral shows the quasihorizontal lines of the building.

203a. Original drawing by Penrose **203b. The Penrose drawing sliced**

201. Preparatory sketch for *Ascending and Descending*

203c. Plaster of Paris mold of the impossible Penrose stairs

202. *Ascending and Descending*, lithograph, 1960

a

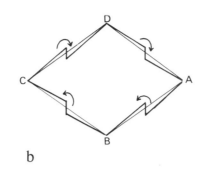

b

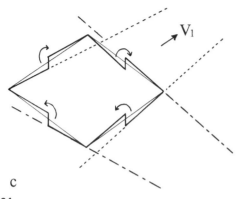

V_1

c

V_2

d

204.

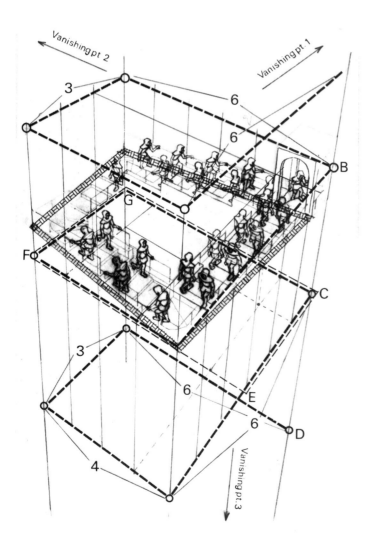

Vanishing pt 2

Vanishing pt. 1

Vanishing pt. 3

205.

206.

92

14 Marvelous Designs of Nature and Mathematics

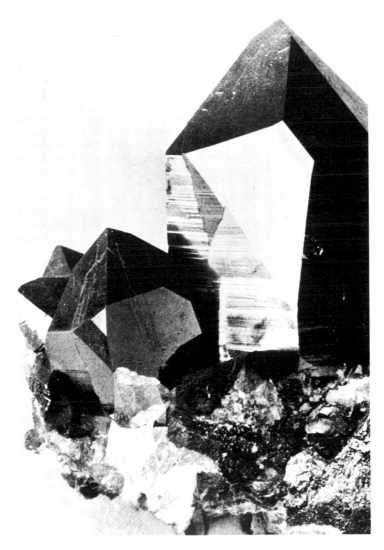

207. "Long before there were men on this globe, all the crystals grew within the earth's crust."

"Long before there were men on this globe, all the crystals grew within the earth's crust. Then came a day when, for the very first time, a human being perceived one of these glittering fragments of regularity; or maybe he struck against it with his stone ax; it broke away and fell at his feet; then he picked it up and gazed at it lying there in his open hand. And he marveled.

"There is something breathtaking about the basic laws of crystals. They are in no sense a discovery of the human mind; they just 'are'— they exist quite independently of us. The most that man can do is to become aware, in a moment of clarity, that they are there, and take cognizance of them."

M. C. Escher, 1959

Escher on the subject of crystals was lyrical. He would take out a minute sample from his collection, lay it in the palm of his hand, and gaze at it as though he had dug it up out of the earth that very minute and had never seen anything like it in his life before. "This marvelous little crystal is many millions of years old. It was there long before living creatures had appeared upon earth."

He was fascinated by the regularity and the inevitability of these shapes, which are to men at once secret and almost wholly unfathomable. And this is what they were to him also, as he modeled them in all sorts of materials and depicted them in many different positions on his paper.

On a flat surface he had to work out ways of producing periodic surface-division. In the spatial world of crystals various configurations had already been realized, and these cried out to be drawn and to be so manipulated that their characteristics could be displayed with greater clarity.

Then too, Escher shared this interest in regular polyhedra (produced in nature as crystal shapes) with his brother, the geologist Professor B. G. Escher. When, in 1924, the latter was appointed to a lectureship in the University of Leiden in general geology, mineralogy, crystallography, and petrography, he found himself held up for lack of a good textbook. So he wrote a standard work of more than five hundred pages on general mineralogy and crystallography, which appeared in 1935.

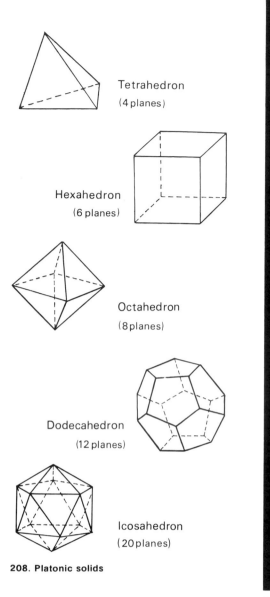

Tetrahedron
(4 planes)

Hexahedron
(6 planes)

Octahedron
(8 planes)

Dodecahedron
(12 planes)

Icosahedron
(20 planes)

208. Platonic solids

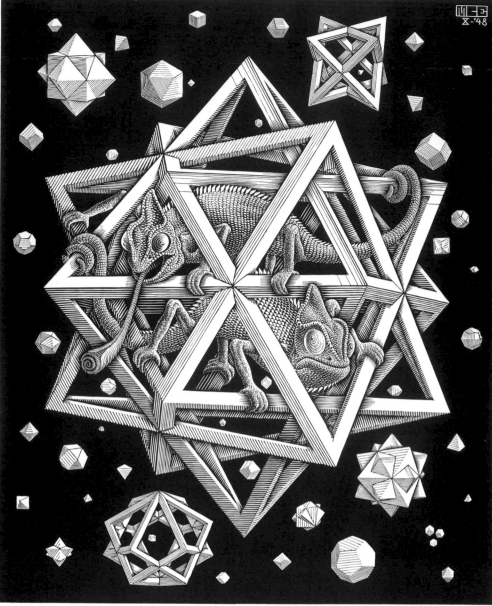

209. Stars, *wood-engraving, 1948*

210. Escher with a model of Platonic solids

cube+octahedron two tetrahedra octahedron

kite-octahedron icosahedron rhombo·dodecahédron

two cubes 2 cubes 3 octahedra

two tetrahedra kite-octahedron dodecahedron

211.

The Greek mathematicians already knew that only five regular solids were possible. They can be bounded by (1) equilateral triangles, as in the cases of the tetrahedron (regular four-faced figure), the octahedron (regular eight-faced), and the icosahedron (regular twenty-faced); (2) by squares, such as the cube, or (3) by regular pentagons, as in the dodecahedron (regular twelve-faced figure) (figure 208).

In the wood engraving *Stars* (1948) (figure 209) we find these Platonic solids, as they are called, illustrated. *Tetrahedral Planetoid* (figure 212) is an inhabited tetrahedron. When, in 1963, the tin-container manufacturing firm Verblifa asked Escher for a design for a biscuit tin he harked back to the simplest polyhedra and gave it the form of an icosahedron, which he decorated with starfish and shells (figure 125).

In order to have before him a permanent reminder of how these five Platonic solids are put together, Escher made a model out of wire and thread (figure 210). When, in 1970, he moved from his own house in Baarn, where he had lived for 15 years, to the Rosa-Spier Home in Laren, he gave away most of his belongings and handed over a number of stereoscopic models, which he himself had made, to The Hague municipal museum; but that great brittle model made entirely from wire and thread he took along with him to hang up in his new studio.

The Platonic solids are all convex. Kepler and Poinsot discovered four more, concave, regular solids. If one accepts different (regular) polyhedra as the boundaries of a regular solid then there are twenty-six further possibilities (the Archimedean solids). Finally, we can take different interpenetrating solids as new regular solids; thereupon we can get an almost infinite series of composite regular solids. In these cases we are going far beyond what nature has contrived in the way of crystal shapes. Of the Platonic solids only the tetrahedron, the octahedron, and the cube appear as natural crystals, and no more than just a small number of the other possible polyhedra. So it looks as though, in this matter, human fantasy is richer than nature.

All these spatial figures fascinated Escher and kept him busy: we come across them in his prints, sometimes as the main subject, as in *Crystal* (1947), *Stars* (1948), *Double Planetoid* (1949), *Order and Chaos* (1950), *Gravity* (1952), and *Tetrahedral Planetoid* (1954), and sometimes as decorative features, as in

Waterfall (1961), in which regular solids crown the two towers. Escher also made a few regular solids in wood and in plexiglass, not as models to be copied but as *objets d'art* in their own right.

One of the finest of these pieces is *Polyhedron with Flowers* (figure 218), which he carved in maple in 1958. It is about thirteen centimeters high and is made up of interpenetrating tetrahedra. Before starting on this elegant freehand version, he had first carved an exact model. He also designed and carved himself the wooden puzzle which, when fitted together, makes an Archimedean solid called a stellated rhombic dodecahedron. A puzzle of this type has long been known, but it had never been so symmetrically constructed as this one of Escher's. Closely related to these spatially constructed regular solids are the various spheres that he covered completely with relief carvings of congruent figures. In *Sphere with Fish* (1940) (figure 217), made out of beechwood and with a diameter of fourteen centimeters, there are twelve identical fish entirely filling up the spherical surface. On other spheres, two or three different figures are used. Take, for instance, *Sphere with Angels and Devils* (1942), which has already been mentioned.

There are some copies of these spheres, carved in ivory by a Japanese at the request of a keen admirer of Escher, the engineer Cornelius Van S. Roosevelt, grandson of President Theodore Roosevelt, who recently donated his collection of about two hundred Escher prints to the National Gallery of Art, Washington, D. C.

Stars (1948)

This little universe is filled with regular solids. Close-up in the center of our field of vision, we see a framework composed of three octahedra. "This handsome cage is inhabited by a chameleon-type creature, and I shouldn't be surprised if it wobbles a bit. My first intention was to draw monkeys on it."

Tetrahedral Planetoid (1954)

This planetoid has the shape of a regular, four-faced solid (that is to say, a tetrahedron). We can see only two faces of it.

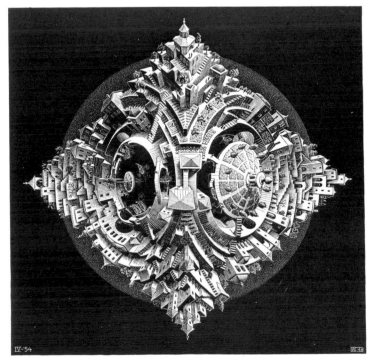

212. *Tetrahedral Planetoid*, woodcut, 1954

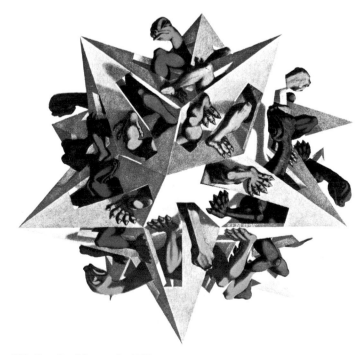

213. *Gravity*, lithograph, 1952

The inhabitants have made the greatest possible use of all the faces and have built terraces on them. This planetoid's atmosphere does not extend to the corner points, so the folk who live up there must have some method or other of taking a bit of atmosphere with them in order to keep alive. Escher constructed these terraces with great accuracy by imagining the planetoid to be carved out of a globe built up in concentric layers like an onion. After he had cut off the globe in order to get his tetrahedron, every ring was carefully carved at right angles.

Gravity, (1952)

This is a stellated dodecahedron, one of the regular solids discovered by Kepler. This interesting solid may be regarded as being constructed in various different ways. Inwardly it consists of a regular twelve-faced body (a dodecahedron), each face of which is a regular pentagon. And upon each of these faces there is superimposed a regular, five-sided pyramid.

A more satisfying way of looking at it is to regard the whole solid as consisting of five-pointed stars, but with each of the rising sides of every pyramid belonging to another five-pointed star.

Escher was very fond of this spatial figure, because it is at once so simple and so complex. He made use of it in a number of prints. Here we see each star-*cum*-pyramid as a little world inhabited by a monster with a long neck and four legs. A tail could not be coped with, because each pyramid has only five openings. For this reason Escher had first thought of having his solid peopled with tortoises (figure 214).

214. The rejected tortoise

215a. Foldout of the tetrahedra and the octahedra

Fold-out of tetrahedron

Fold-out of octahedron

Tetrahedron bounded by 4 equilateral triangles

Octahedron bounded by 3 equilateral triangles

216. *Flatworms,* lithograph, 1959

215b. Combinations

The walls of each monster's tent-shaped house serve as floors on which five of the other monsters are standing. Thus every single surface we can point to is both floor and wall.

Escher called this hand-painted lithograph *Gravity*, because each of these heavily built monsters is so forcibly drawn toward the center of the stellated polyhedron.

There is a definite link between this print and various perspective prints in which the multiple function of surfaces, lines, and points is brought to the fore. Compare, for instance, the concept of this print with that of *Relativity*, which appeared a year later.

New Types of Building Blocks

It is possible to use random-shaped blocks in the building of walls, floors, and ceilings. In large constructions building blocks of similar shape would be preferable, whether they were fired bricks or quarried stone. And the shape of such block is almost without exception barlike—that is to say, a spatial figure bounded by right angles. We are so very accustomed to this shape in build ing blocks that we find it difficult to imagine any other.

And yet it is quite possible to fill up the whole of space (leaving no gaps) with blocks of a totally different shape from this. The queer-looking underwater building to be seen in the lithograph *Flatworms* (1959) is constructed entirely of two different types of blocks, the octahedron and the tetrahedron.

Now it would not be possible to fill the space completely with tetrahedra only, or with octahedra only, for there would always be gaps left between them. But it can be done if one effects a certain alternation of each type of block. And Escher has produced this print to demonstrate the fact. If you wish to make a further study of this strange edifice then there is nothing for it but to cut some octahedra and tetrahedra out of cardboard and stick them together yourself. A fold-out of each of these spatial figures can be seen in figure 215a. The dotted lines indicate where the folds should come. If you set about playing with these spatial figures you will find that you can make with them all the shapes

that are to be seen in the print. To help you over this, figure 215b shows how, in a number of places on the print, the tetrahedra and octahedra lie in relationship to each other. To my way of thinking, it would be an incredibly difficult task to make a spatial copy of the whole print using both types of building block; but if any reader has got the courage and energy to tackle it, they are in for a good deal of enjoyment. Of course, there will not be any horizontal or vertical floors or walls to be found in this, and I believe that nobody is going to feel very much at ease in such a building. Indeed, this is why Escher allocated it to the flatworms for their dwelling.

On reading the foregoing description of his print *Flatworms*, Escher asked me to add the following remarks:

In spite of the lack of horizontal and vertical planes, it is possible to build columns and pillars by piling up tetrahedra and octahedra in such a way that, when viewed as a whole, they do in fact stand vertically. Five of these pillars are shown in the print. The two that stand in the right-hand half of the print are in a sense the reverse of each other. The further to the right of these shows only octahedra, but there must be invisible tetrahedra inside, whereas the pillar to the left of this appears to be built entirely of tetrahedra, yet there must be an internal vertical series of octahedra one on top of the other like beads strung on a necklace.

In addition to folding cardboard and sticking it, it is also possible, and less time-consuming, to make tetrahedra and octahedra by modeling them out of small lumps of plasticine, about the size of a large marble. To fill the space completely you will need twice as many tetrahedra as octahedra. The advantage of this method is that, at room temperature, the plasticine building blocks can easily be fitted together without adhesive and can also be pulled apart again. In this way it is possible to play about and experiment with them. The rules of the game can be made even clearer if different colors of plasticine are used for tetrahedra and for octahedra.

217. Sphere with Fish, stained beech, 1940 (diam. 14 cm.)

218. Polyhedron with Flowers, maple, 1958 (diam. 13 cm.)

Superspiral

Escher was not interested only in spatial figures that have a close relationship with crystal shapes. Any interesting regular spatial figure gave him the urge to depict it. Between 1953 and 1958 he made five prints in which the subject was *spatial spirals*. Let us discuss the first of these: *Spirals* (figure 220), a wood engraving in two colors. The origin of this print is worthy of note.

Now, an artistic effort may well be a response to a challenge. One child says to another, "Hey, you can't draw a horse!" And a horse is promptly drawn. The print *Spirals* itself was the outcome of a challenge. In the print room of the Rijksmuseum in Amsterdam Escher came across an early book of perspective, *La pratica della perspectiva* by Daniel Barbaro (Venice, 1569). The opening of one of the chapters was decorated with a torus, the surface of which consisted of spiral-shaped bands (figure 219). The engraving was not particularly good and the intended geometrical shapes were not very well drawn—two things about it which annoyed Escher and were not unconnected. Escher set himself the even more difficult problem of how to present not simply a

PARTE SECONDA
Nellaquale si tratta della Ichnographia, cioè descrittione delle piante.

PRATICA DI DESCRIVERE LE FIGVRE
di molti anguli in uno circolo. Cap. *I.*

RIMA, che io uegni a descriuere le piante, è necessario pratica
modo di deferiuere le figure dette polygonie, cioè di molti, anguli

220. *Spirals*, wood engraving, 1953

219. Frontispiece of *La pratica della perspectiva*, by Daniel Barbaro, Venice, 1569

XII-'53 MCE

torus, but a body that would become thinner and thinner and would keep spiraling back into itself. "A self-centered sort of thing," as he later referred to it, ironically. The problems caused by this were very troublesome and necessitated months of planning and construction work. We have reproduced only a few of the trial sketches here (figure 221). The final outcome is a remarkably brilliant print in which the artist gets across to us something of his own wonderment at the pure laws of form. Four bands, getting progressively smaller, wind themselves as spatial spirals around an imaginary axis, and this axis itself has the shape of a flattened spiral.

Anyone who could see the many preparatory studies for this engraving would be impressed by the infinite trouble Escher had taken to produce an accurate presentation of the spatial figure he had visualized. Indeed, he would have found it easier to take a photograph of such an object.

However, this spatial object is by no means to be had for the asking. No doubt a worker in precious metals could make one, but it would call for a great deal of time and skillful craftsmanship. This presentation is truly unique; Escher is showing us something we have never seen before.

Moebius Strips

"In 1960 I was exhorted by an English mathematician (whose name I do not call to mind) to make a print of a Moebius strip. At that time I scarcely knew what this was."

In view of the fact that, even as early as 1946 (in his colored woodcut *Horseman*, figure 91), then again in 1956 (the wood engraving *Swans*), Escher had brought into play some figures of considerable topological interest and closely related to the Moebius strip, we do not need to take this statement of his too literally. The mathematician had pointed out to him that a Moebius strip with a half-turn has some remarkable characteristics from a mathematical point of view. For instance, it can be cut down the middle without falling apart as two rings, and it has only one side and one edge. Escher makes the first of these characteristics explicit in *Moebius Strip I* (1961) (figure 222) and the second—which is closely related to it—in *Moebius Strip II* (1963) (figure 226).

These strips are named after Augustus Ferdinand Moebius (1790–1868), who was the first to use them for the purpose of demonstrating certain important topological particularities. It

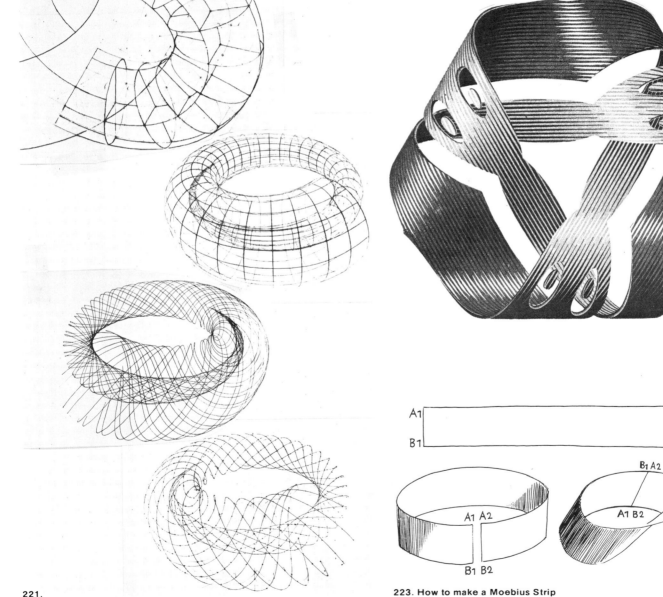

222. *Moebius Strip I*, wood engraving, 1961

221.

223. How to make a Moebius Strip

is a very simple matter to make a model of one (figure 223). First of all we make a band by pasting together a strip of paper. *AB* is the place at which it has been joined. This cylindrical strip has two edges (upper and lower) and both inner and outer surfaces. Next, we imitate Moebius, putting a twist in the strip so that *A* comes next to *B* and *B* next to *A*. And now it comes to light that the strip has only one edge and one side. For if you start to paint the "outside," it turns out that you can keep on doing so until the entire surface of the paper has been colored; and if you run your finger along the "upper" edge toward the right, without taking it off, you will make two circuits and arrive back at your starting point; nor will you have missed touching any single bit of the edge. Thus, the Moebius ring has only one edge and one side. To make this drawing Escher constructed large spatial models, both of the ants and of the strip itself.

Now, if we cut an ordinary cylindrical strip down the center we get two new cylindrical strips that can be taken apart completely. But if we try to do the same thing with a Moebius strip, we shall not end up with two loose parts—it remains intact. Escher demonstrated this in *Moebius Strip I* in which there are snakes biting each other's tails. The whole thing is a Moebius strip cut lengthwise. If we follow the snakes with our eye, they look as though they are fixed together all the way along; but if we pull the strip out a little we shall find we have got one strip with two half-turns in it.

In *Horseman*, a three-colored woodcut made in 1946, we see a Moebius strip with two half-turns. If you make one for yourself you will find that it automatically forms itself into a figure-eight. This strip definitely has two sides and two edges. Escher has colored one side red and the other blue. He conceives of it as a strip of material with a woven-in pattern of horsemen. The warp and woof are of red and blue thread, so that one horseman comes out blue and the other red. The front and the rear of a horseman are mirror images of each other, and there is nothing unusual in this, for it could be said of any figure one cares to choose. But now Escher starts manipulating the strip so that an entirely different topological figure is produced. In the center of the figure-eight he joins the two parts of the band together in such a way that the front and the rear sides become united. We can copy this in our paper model if we use Scotch tape to turn the middle of the figure-eight into a single plane surface. From a purely topological point of view, we ought at this point to drop one of the two colors,

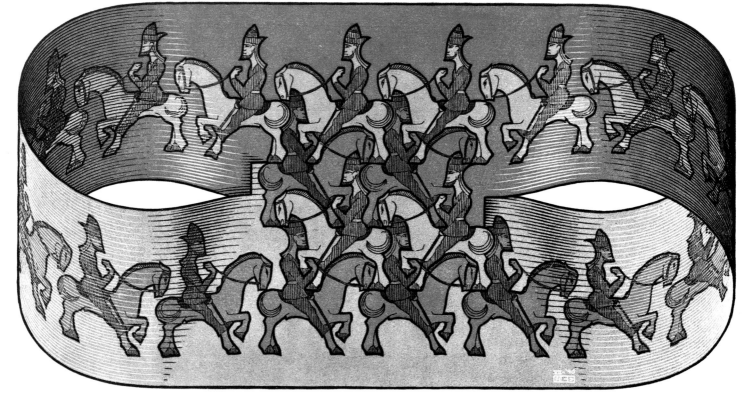

224. Horseman, woodcut, 1946

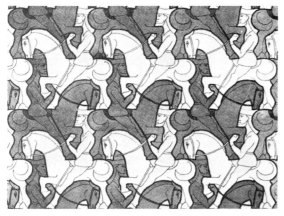

225. Page from Escher's sketchbook

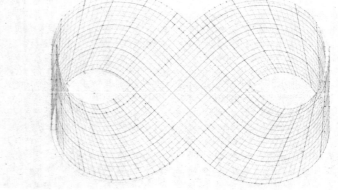

Grid for the print Swans

but this is not really what Escher intended. He wishes to show how the little red horsemen on the underside of the print combine with the blue ones, which are their mirror image, to fill up the surface completely. This is achieved in the center of the print.

Of course, we can also find this in a very fine page from Escher's space-filling sketchbook (figure 225), but in this particular print it is presented in a most dramatic way, for here we can see the filling process actually taking place before our eyes.

Escher also deals with a topological subject in his woodcut *Knots* (1965) (figure 227). He came across the idea for this knot in a de luxe loose-leaf printed book by the graphic artist Albert Flocon. The latter is a keen admirer of Escher and has done a great deal to make Escher's work more widely known in France. In this book, consisting mainly of copperplate engravings, Flocon too was trying to explore the relationship between space and the depicting of it on a flat surface. In this he is, however, much more theoretical than Escher (witness, for example, his reflections on perspective), and on the other hand his engravings are much freer, less exact, less directed toward principles or essential requirements. It was in Flocon's book *Typographies* that Escher found the picture shown on the left in the print *Knots*. At all events

he considered this knot, consisting of two bands set at right angles to each other, so remarkable that he thought he would devote a separate print to it. A drawing made in 1966, when he was on a visit to his son in Canada, indicates that he was still working on it a year later. The large knot is square in section and appears to be made out of four different strips; however, if we follow one of these strips we find that we traverse the entire knot four times, without going over any bounds, finally arriving back at the place where we started. So there is only one strip after all! We can make a model of it ourselves by using a long piece of foam plastic, square in section. Having tied a knot in it we must then turn the ends toward each other and stick them together. There are several possibilities.

The open-work caterpillar-wheel style of the knot was the outcome of repeated attempts to find a form in which both the outside and the inside of the structure would be clearly visible. This is a problem Escher wrestled with many a time, and several prints have had to remain in the planning stage because he was unable to achieve a clear presentation of interior as well as exterior.

226. *Moebius Strip II*, **wood engraving, 1963**

227. *Knots*, **woodcut, 1965**

15 An Artist's Approach to Infinity

In an article published in 1959 Escher expressed in these words what it was that inspired him to depict infinity:

We find it impossible to imagine that somewhere beyond the furthest stars of the night sky there should come an end to space, a frontier beyond which there is nothing more. The notion of "emptiness" does, of course, have some meaning for us, because a space can be empty, at all events conceptually, but our powers of imagination are incapable of encompassing the notion of "nothing" in the sense of "spacelessness." For this reason, as long as there have been men to lie and sit and stand upon this globe, or to crawl and walk upon it, to sail and ride and fly across it (and fly off it), we have held firmly to the notion of a hereafter, purgatory, heaven, hell, rebirth, and nirvana, all of which must continue to be everlasting in time and infinite in space.

It is to be doubted whether there exist today many draftsmen, graphic artists, painters, sculptors, or indeed artists of any kind, to whom the desire has come to penetrate to the depths of infinity by using motionless, visually observable images on a simple piece of paper. For artists nowadays are motivated rather by impulses which they are unable or unwilling to define, or by some compulsion, incomprehensible, unconscious or subconscious, which cannot be expressed in words.

And yet it can happen, so it seems, that someone who has accumulated but little of exact knowledge or of the learning that previous generations achieved through study—that this individual, filling up his days, in the way that artists will, toying with more or less fantastic notions, feels one fine day ripening in him a definite and conscious desire to approach infinity through his art, as accurately and closely as he can.

What kind of shapes is he going to use? Exotic, formless blobs that can awake in us no associative thoughts? Or abstract, geometrical, rectilinear constructions, squares or hexagons which at most will bring to mind a chessboard or a honeycomb? No, we are not blind, deaf, or dumb; we consciously perceive the shapes that are all around us and that, in their rich variety, speak to us in a clear and fascinating language. And so the shapes we use to build up our surface-division are recognizable tokens and clear symbols of the animate or inanimate material all around us. If we are going to construct a universe then let it not be some vague abstraction but rather a concrete image of recognizable objects. Let us build up a two-dimensional universe out of an infinite number of similar-shaped, and at the same time clearly recognizable, building blocks.

228. *Development II*, woodcut, 1939

It can become a universe of stones and stars, of plants and beasts, or people.

What has been achieved in periodic surface-division . . . ? Not infinity, of course, but certainly a fragment of it, a part of the "reptilian universe." If this surface, on which forms fit into one another, were to be of infinite size, then an infinite number of them could be shown upon it. But we are not simply playing a mental game; we are conscious of living in a material, three-dimensional reality, and it is quite beyond the bounds of possibility to fabricate a flat surface stretching endlessly and in all directions.

However, there are other possible ways of presenting the infinite, many without bending our flat surface. Figure 228 shows a first attempt in this direction. The figures that were used to construct this picture are subjected to a constant radial reduction in size,

working from the edges toward the center, the point at which the limit is reached of the infinitely many and the infinitely small. And yet even this treatment remains no more than a fragment, for it could be extended outward just as far as we would like, by the addition of even larger figures.

There is only one possible way of overcoming this fragmentary characteristic and of obtaining an "infinity" entirely enclosed within a logical boundary line, and that is by going to work the other way round. Figure 243 shows an early, albeit clumsy, application of this method. The largest animal shapes are now found in the center and the limit of infinite number and infinite smallness is reached at the circumference.

The virtuosity in periodic surface-division that Escher had reached stood him in good stead with his approaches to infinity. However, an entirely new element is called for: networks to facilitate the representation of the infinite surface on a piece of flat material.

Prints with Similar-shaped Figures

When, after 1937, Escher first started flat surface-division, he used congruent figures only, and it was not until after 1955 that we find him using, to some degree, similar-shaped figures to approach infinity through serial formations. And this possibility was seen and used as early as 1939 in the print *Development*

229. The inner part of *Smaller and Smaller I*, **wood engraving, 1956**

II. But the figures' increase in size outward from the infinitely small at the center is still entirely subservient to the concept of metamorphosis.

The figures are not only small in the center but also unidentifiable; and it is not until they reach the outer rim that they appear as complete lizards. The very title of this print indicates its close connection with metamorphosis, for *Development I* (1937) is a metamorphosis print in which congruent rather than like-shaped figures are used.

We can distinguish three groups among the similar-shaped-figure prints if we take note of the patterns that serve as their underlying frameworks.

1. Square-Division Prints

These are the simplest in construction and yet the first of them did not appear until 1956 *(Smaller and Smaller I)*. A year later Escher worked on a book for the bibliophile club De Roos(M. C. Escher, *Periodic Space-Filling*, Utrecht, 1958), and in it he showed the diagram on which this kind of print is based, also drawing a simple print of a reptile so as to demonstrate the fundamental principle involved. In 1964 he used this diagram once again for a more complicated print, *Square Limit* (figure 230), but this time with the quite clear intention of trying to represent infinity in a print.

The fact that this diagram was so simple was probably the reason why Escher gave up using it.

2. Spiral Prints

The plan of these prints—a circular surface divided up into spirals of like-shaped figures—had already been established with the appearance of *Development II*. The following prints are based on it: *Path of Life I* (1958), *Path of Life II* (1958), *Path of Life III* (1966), and *Butterflies* (1950).

We could probably add *Whirlpools* to this category. The aim of the *Path of Life* prints is not so much to represent infinite smallness as to depict an expansion from infinitely small to infinitely large and back to small again, a process analogous to the one of birth, growth, and decline.

3. The Coxeter Prints

In a book by Professor H. S. M. Coxeter, Escher discovered a diagram that struck him as being very suitable to the representation of an infinite series. This gave rise to *Circle Limit* prints numbers I to IV (1958, 1959, 1959, 1960). *Circle Limit* I, III and IV are reproduced in figures 243, 244 and 77.

Escher's last print, *Snakes* (1969) (figures 245 *et seq.*), also belongs to this group, although the network for this has been adapted to Escher's particular aim in a most ingenious way.

Square Limits

What have we got here (figure 230)? We might say it is an infinite number of flying fish. In figure 231 we see a simple solution to the problem of depicting infinity; the right-angled isosceles triangle *ABC* is the starting point. Two more right-angled isosceles triangles, *DBE* and *DCE*, are drawn on the side *BC*. We repeat this process and so get the triangles 3 and 4, 5 and 6 and so on.

We could continue the process to infinity and still end up very much where we started. If the square *EFCD* is one decimeter in length, then the squares below it must have sides measuring ½ decimeter, those below again ¼ decimeter and so forth (see figure 231, right). A simple calculation tells us that ½ + ¼ + ⅛ + 1/16 + 1/32 + 1/64, = 1. Therefore *CG* = 2 decimeters and nevertheless we find we have an infinite number of squares continually diminishing in size. Figure 231 may be fascinating for the mathematician but not for the average observer. Escher has brought this framework to life by filling each of the triangles with a lizard (figure 232). He made this print as an illustration for a book about periodic surface-division. The same plan is basic to *Smaller and Smaller*, a wood engraving made in 1956 (figure 229).

The woodcut *Square Limit* (1964) has a rather more complicated basic pattern. In figure 233 a quarter of it is shown, plus a

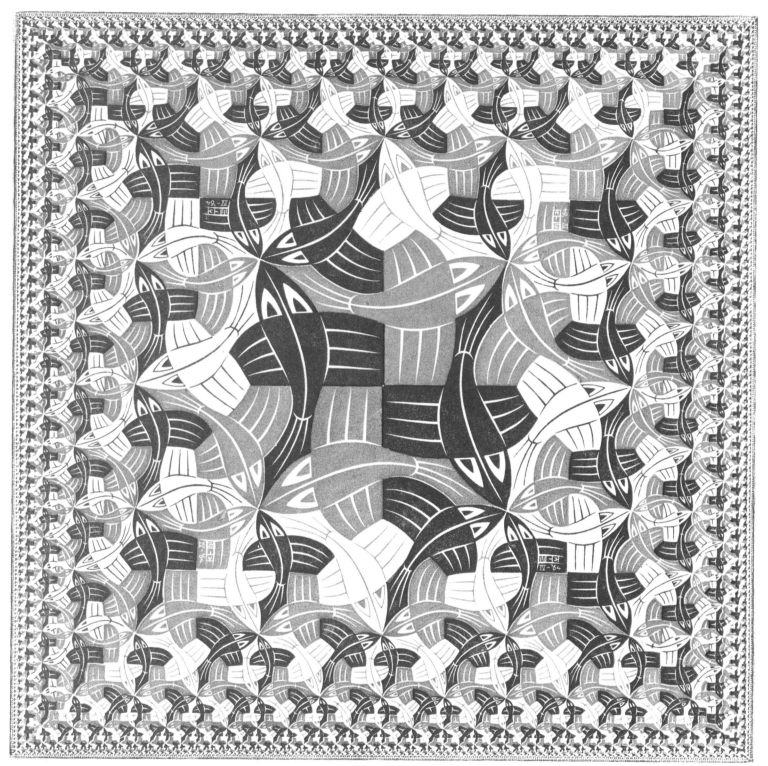

230. *Square Limit,* **woodcut, 1964**

little bit more around the central point of the print at *A*. We come across figure 231 again in several parts, and only along the diagonals of the square is a different solution to be found. Escher made the following marginal note on this print in a letter:

Square Limit (1964) was made *after* the series *Circle Limits I, II,* and *III*. This occurred because Professor Coxeter pointed out to me a method of "reduction from within outwards" which I had been looking for in vain for years. For a reduction from without inwards (as in *Smaller and Smaller*) does not bring with it a philosophical satisfaction because no logical, self-contained, or fully effective composition is to be found within it.

After this empty satisfaction of my longing for an intact and complete symbol of infinity (the best example was achieved in *Circle Limit III*), I tried to substitute a square form for the circular one—because the rectilinear nature of walls of our rooms calls for this. Rather proud of my own invention of *Square Limit*, I sent a copy of it to Coxeter. His comment was, "Very nice, but rather ordinary and Euclidean, and therefore not particularly interesting. The circle limits are much more interesting, being non-Euclidean." This was all Greek to me, being, as I am, a complete and utter layman in things mathematical. However, I will gladly confess that the intellectual purity of a print such as *Circle Limit III* far exceeds that of *Square Limit*.

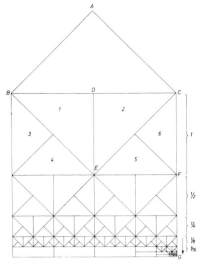

231. Principle of the square division prints

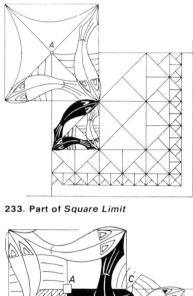

233. Part of *Square Limit*

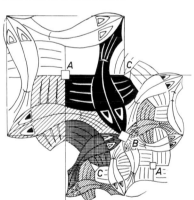

234. The three different meeting-points

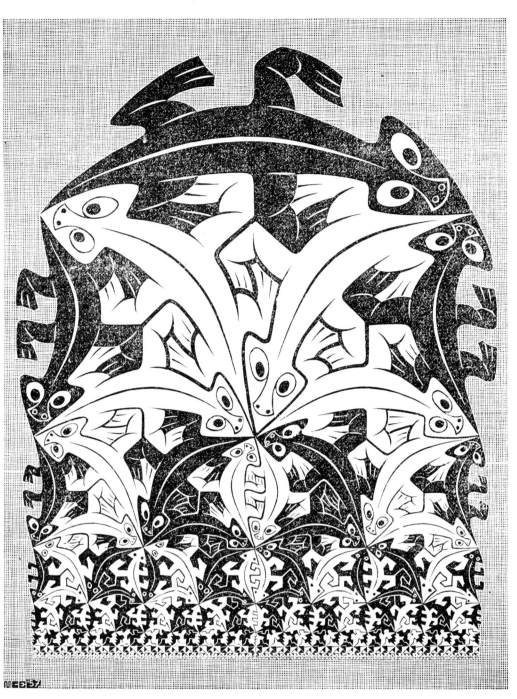

**232. From *Regelmatige Vlakverdeling* (Periodic Space-Filling) by Escher.
Published as a Bibliophile Publication by the De Roos Foundation, 1958.**

If we think we have now completely understood this print, we are deceiving ourselves. The simple question, why does Escher have to use three tints for this print and why can he not make do with two, may well cause us confusion. Let us look at figure 234, in which the same part is illustrated as in figure 233. If we focus our attention on the points where the fish come together, then we shall see that there are three different kinds. At A four fins of four different fish come together, at B four heads and four tails touch, and at C three fins meet. At A only two colors are required, and at B also, if it is merely a question of keeping the creatures apart. But three tints are necessary for this at C.

If we look for several points of the A variety then the first thing we notice is that these points are to be found only on the diagonals of the print. In the center are the fins: gray/black/gray/black; on the diagonal from lower left to upper right we find repeated: white/gray/black/gray and on the diagonal from lower right to upper left we have: white/black/gray/black. No other combinations appear.

When it comes to the B points all we can expect is white/gray/black; but at the C points we start finding some surprising combinations again, if we look closely at the fish heads.

However often one looks at this print it continues to fascinate with its great wealth of variety.

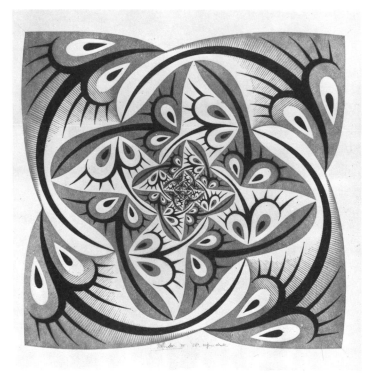

235. *Path of Life II*, woodcut, 1958

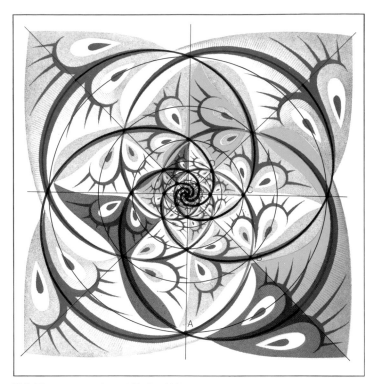

236. The construction of *Path of Life*

Birth, Life, and Death

The network giving the basic pattern of the *spiral prints* is a series of logarithmic spirals. Escher was not acquainted with that mathematical concept but constructed it as follows: First a number of concentric circles are drawn and the distance between them becomes smaller toward the center. Then he drew a number of radii dividing the circles into equal sectors.

Starting at a point on the circumference of the outermost circle, he marked the points of intersection both of consecutive radii and of consecutive circles, moving inward. He then joined up the resultant points with a flowing line. We can also do this moving in the opposite direction. Figure 239 shows such a construction.

The entire structure of circles, radii and spirals forms a grid pattern of similar-shaped figures continuously diminishing in size toward the center. In *Path of Life I* Escher has used double spirals starting at eight points on the circumference. In *Path of Life II*, which to my mind is the finest of them all, there are four starting points, and in *Path of Life III* the twelve spirals set out from six points.

This basic pattern was already drawn up in 1939, when Escher used it for *Development II* (figure 228), but in this instance it serves only to produce steadily diminishing figures. In the *Path of Life* prints this network is used in a more sophisticated way, for here we have two spirals starting out from different points on the circumference, and joined together round the outside. Thus we can reach the center via a spiral from the outer edge and return from thence spiraling to the circumference until we meet up with our first spiral once again. We now shall use *Path of Life II* in order to make a closer study of this.

The large fish at the lower left (figure 235) has a white tail and a gray head. This head is contiguous with the tail of a smaller though similarly shaped fish. And so we proceed via three further and smaller fish in our spiral course toward the center. Close to the center the fish get so small that it is no longer possible to draw them—yet there is an infinite number of them!

In figure 236 the spiral we have just been following is drawn in red; along this path we find only gray fish. From the point of infinite smallness white fish grow out of the gray ones and swim away from the center along the blue spiral. On reaching the edge this merges into the red spiral along which we set out. At this point the fish change color again; white becomes gray and a new cycle begins. Of course, the whole idea of this is that a white fish, coming to life at the center, grows up to its maximum size, only to grow old and to sink back, as a gray fish, whence it came.

I regard this print as a maximum achievement both for the succinct way in which the concept is presented and for its great simplicity and elegance. I rate this print very high indeed and regard it as the best of all Escher's approaches to infinity.

We reproduce only a working drawing of *Butterflies* (1950) (figure 237) and this does not show the basic network very clearly. If one were to attempt an analysis of the final print without realizing that the framework for it was derived from that of the spiral prints, one would be totally misled by the great number of shapes. In this case the strict regularity of them would be almost entirely hidden.

The impressive woodcut *Whirlpools* (1957) (figure 238) came into being prior to the *Path of Life* prints. The same construction is used here as was used for the spirals, while a number of possibilities inherent in this framework were not utilized. Only two spirals are drawn simultaneously in the upper and lower constructions and they both move in the same direction. These spirals are in line with the backbones of two opposing series of fish, and at the center one construction merges with the other.

The gray fish are born in the upper pool and, growing larger, keep swimming further outward. Then they start on their journey (already diminishing in size) toward the lower pool, where after an endless series of reductions, they disappear at the central point. The red fish swim in a contrary direction, from the lower pool to the upper.

The whole picture is printed from two blocks only. The one from which the gray fish of the lower part are printed is used over again to print the red fish of the upper part. This is why we see Escher's signature and the date twice on the same print.

Toward the end of the year in which *Whirlpools* appeared,

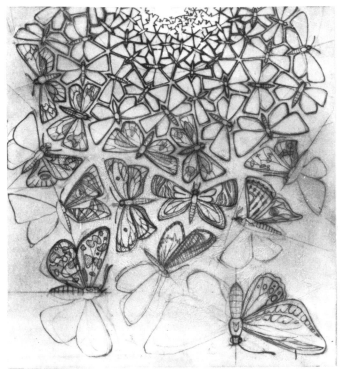

237. Sketch for the wood engraving *Butterflies*

239. Logarithmic spirals as a network for
the spiral prints

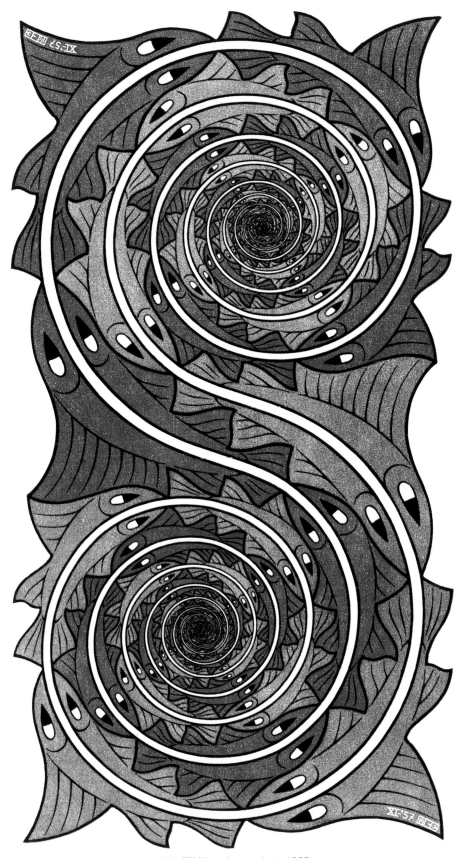

238. *Whirlpools*, woodcut, 1957

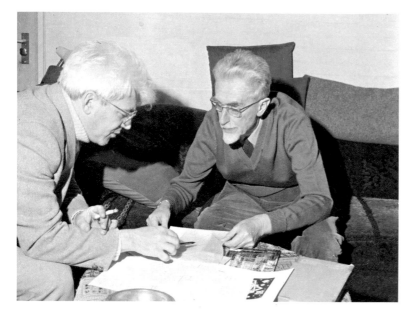

240. The author and M. C. Escher a few weeks before his death.
"I consider my work the most beautiful and also the ugliest."

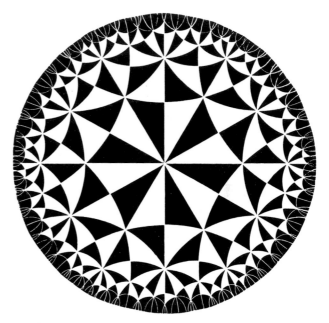

242. The Coxeter illustration

241. Sketch for cemetery mural

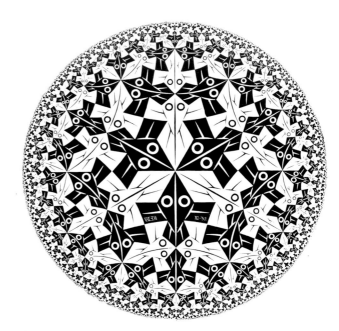

243. *Circle Limit I*, woodcut, 1958

Escher received a commission from the city of Utrecht for a mural in the main hall of the third municipal cemetery. This is done as a circular painting with a diameter of 3.70 meters. Not only did Escher produce the design but he carried out the actual painting himself (page 59). This wall-painting is almost an exact replica of one half of *Whirlpools*.

The Coxeter Prints

In order to demonstrate hyperbolic geometry* the French mathematician Jules Henri Poincaré used a model in which the whole of an infinite flat plane was shown as being within a large finite circle.

From the hyperbolic point of view no points exist on or outside

the circle. All the characteristics of this type of geometry can be deduced from this model. Escher discovered it illustrated in a book by Professor H. S. M. Coxeter (figure 242) and he immediately recognized in it new possibilities for his approaches to infinity. On the basis of this figure he arrived at his own constructional plan.

This was how *Circle Limit I* came into being in 1958; it was described by Escher himself as a not entirely successful effort:

> This woodcut *Circle Limit I*, being a first attempt, displays all sorts of shortcomings. Not only the shape of the fish, still developed from rectilinear abstractions into rudimentary creatures, but also their arrangement and their position vis-à-vis one another

* In contradiction to the long-known principles of Euclidean geometry, through any given point outside a line there pass precisely two lines parallel to that line.

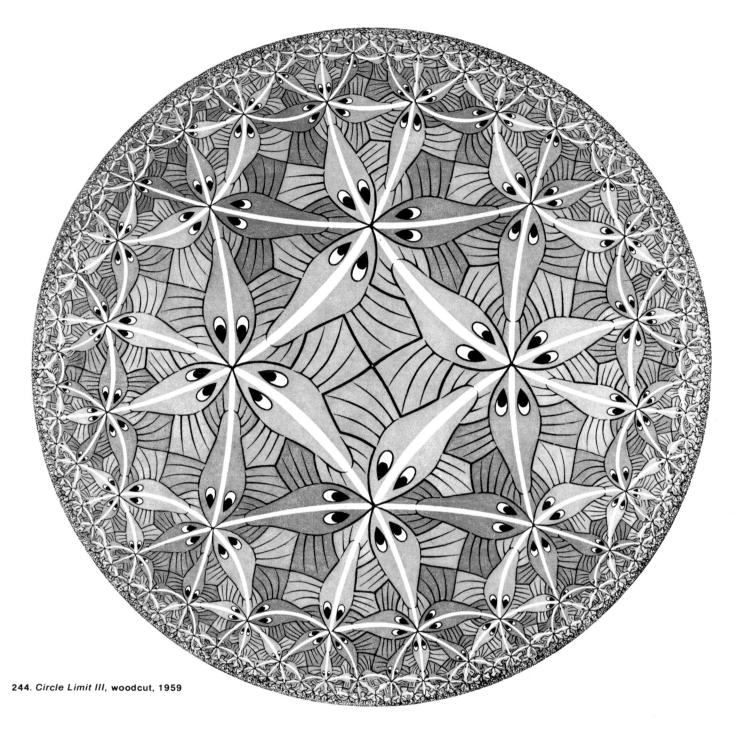

244. *Circle Limit III*, woodcut, 1959

leave much to be desired. It is true that three different series can be discerned, accentuated by the way in which the axes of their bodies run on from one to the other, but these consist of alternating pairs of white fish with their heads together and black ones with their tails touching. Thus there is no continuity, no "traffic flow," nor unity of color in each row.

Circle Limit II is not a very well-known print. It much resembles *Circle Limit I*, but in place of fish it has crosses. Once in a conversation Escher joked about it, saying, "Really, this version ought to be painted on the inside surface of a half-sphere. I offered it to Pope Paul, so that he could decorate the inside of the cupola of St. Peter's with it. Just imagine an infinite number of crosses hanging above your head! But Paul didn't want it."

Circle Limit IV (and here the figures are angels and devils) also closely follows the Coxeter scheme. The best of the four is *Circle Limit III*, dated 1959 (figure 244), a woodcut in five colors. The network for this is a slight variation on the original one. In addi-

tion to arcs placed at right angles to the circumference (as they ought to be), there are also some arcs that are not so placed. Here is how Escher himself describes this print:

In the colored woodcut *Circle Limit III* the shortcomings of *Circle Limit I* are largely eliminated. We now have none but "through traffic" series, and all the fish belonging to one series have the same color and swim after each other head to tail along a circular route from edge to edge. The nearer they get to the center the larger they become. Four colors are needed so that each row can be in complete contrast to its surroundings. As all these strings of fish shoot up like rockets from the infinite distance at right angles from the boundary and fall back again whence they came, not one single component ever reaches the edge. For beyond that there is "absolute nothingness." And yet this round world cannot exist without the emptiness around it, not simply because "within" presupposes "without," but also because it is out there in the "nothingness" that the center points of the arcs that go to build up the framework are fixed with such geometric exactitude.

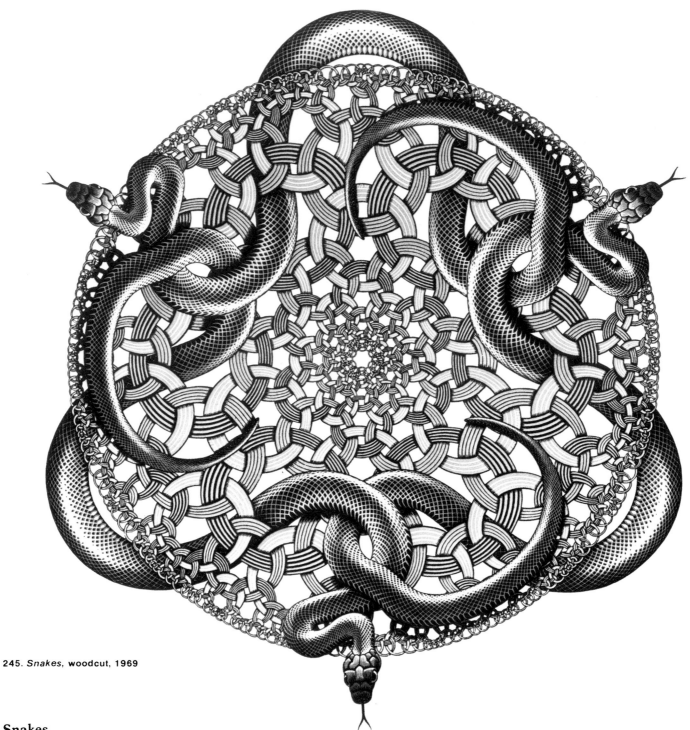

245. *Snakes*, woodcut, 1969

Snakes

In 1969, when Escher was already aware that he would once again have to undergo a serious operation, he used every possible moment in which he felt sufficiently fit to work on his last print: *Snakes*. He gave me a vague description of it at the time — a chain mail, edged with small rings and having large rings at the center. Snakes would be made to twist in and out of the larger gaps. This was a new invention; infinitely small rings would grow out of the center of the circle, reach their maximum size, and then diminish again as they approached the edge. But he wasn't going to divulge any more about it. I was not even allowed to see the preparatory studies. He was staking everything on getting the print finished and he could not put up with any criticism at all, for he was afraid that this might take away his keenness to pursue it.

There is no sign whatsoever, either in the print itself or in the preliminary studies, that Escher was calling upon his last reserves of strength. The drawings are powerful and firm and the final woodcut is particularly brilliant. It does not bear any marks at all of exhaustion or old age.

It is true that the presentation of infinity is considerably less obtrusive. In earlier prints Escher took things to fanatical lengths and, using a magnifying glass, cut out little figures of less than half a millimeter. For the center of the wood engraving *Smaller and Smaller I* he purposely used an extra block of end-grain wood so that he could work in finer detail. In *Snakes* he makes no attempt whatever to keep on with the small rings until they fade away into the thick mist of infinitely small figures. As soon as the

110

idea of constant diminution has been suggested, he takes it no further.

In the sketch of the rings (figure 246), drawn almost entirely freehand, we can see the sophisticated structure of the network. From the center of the biggest ring toward the outer rim of the circle, we come across the Coxeter network once again; but toward the center the arcs curve in opposite directions. By introducing these curved lines Escher achieved a diminution toward the center also. This is a case of Escher's playing the part not merely of a mathematician but of a carpenter using his tools with extraordinary skill, thereby setting the mathematician himself a puzzle as to how this new network can be interpreted.

One can search the biological textbooks in vain for the three snakes that serve to raise the print above mere abstraction. This type of snake is what Escher himself regarded as beautiful and the most "snakish" of all, after studying a large number of snake photographs.

Five of the many preparatory sketches show again how carefully Escher worked and how well considered every detail had to be before he began to cut his wood.

And this meticulous attention to detail was characteristic of the artist. Escher's art is the expression of a lifelong celebration of reality, interpreted in his visualizations, unique to his talent, of the mathematical wonder of a grand design that he intuitively recognized in the patterns and rhythms of natural forms, and in the intrinsic possibilities hidden in the structure of space itself. Over and over again, his work shows the inspired effort to open the eyes of less talented men to the wonders that gave him so much joy. Although he himself has said he spent many nights wretched with his failure to achieve his visions, yet he never gave up the sense of wonder at the infinite ability of life to create beauty.

246. Sketches for *Snakes*

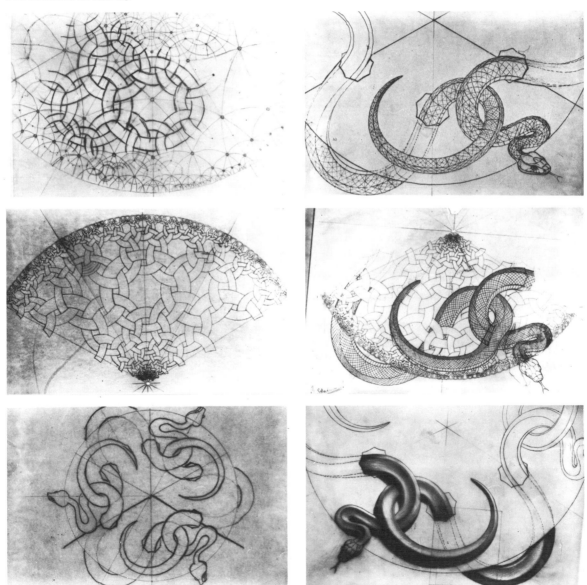

Index to Escher's Work Used for this Book

(Italic numbers denote pages with illustration)

American Academy of Orthopaedic Surgeons

National Safety Council

First Responder

Your First Response in Emergency Care

● ● ●

SECOND EDITION

Principal Authors

David Schottke, RN, REMT-P, MPH
Washington, D.C.

Garry L. Briese, CAE, EMT
Executive Director
International Association of Fire Chiefs
Fairfax, Virginia

Editorial Board

Lynn A. Crosby, MD
Creighton University School of Medicine
Division of Orthopaedic Surgery
Omaha, Nebraska

Karla Holmes, RN, MPA
Training Coordinator
Salt Lake County Fire Department
Salt Lake City, Utah

Jones and Bartlett Publishers
Sudbury, Massachusetts

Boston London Singapore

Library of Congress Cataloging-in-Publication Data
Schottke, David.
 First responder: your first response in emergency care / principal authors, David Schottke,
Garry L. Briese: editorial board, Lynn A. Crosby, Karla Holmes. — 2nd ed.
 p. cm.
 Includes index.
 ISBN 0-86720-541-5
 1. Medical emergencies. 2. Emergency medical technicians. 3. First aid in illness
and injury. I. Briese, Garry L. II. Crosby, Lynn A. III. Holmes, Karla. IV. Title.
 [DNLM: Emergency Medical Technicians—education. 2. Emergencies.
3. First Aid. W 18.2 S375f 1997]
RC86.7.S35 1997
616.02'5-dc21
DNLM/DLC 96-48546
for Library of Congress CIP

Published and Distributed by

Jones and Bartlett Publishers
40 Tall Pine Drive
Sudbury, MA 01776
Internet: http://www.jbpub.com/nsc/, e-mail: nsc@jbpub.com

Jones and Bartlett Publishers International
Barb House, Barb Mews
London W67PA, UK

Chief Executive Officer: Clayton E. Jones
Emergency Care Editor: Tracy Murphy
Production Administrator: Anne S. Noonan
Manufacturing Manager: Dana L. Cerrito
Photo Research: Tanya Barrett, Anne Noonan
Cover Printing: Banta Company
Printing and Binding: Banta Company
Cover Design: Marshall Henrichs

Production Service: Books By Design, Inc.
Typesetting and Pre-Press: Pre-Press Company, Inc.
Text Design: Martucci Studio, Inc.
Illustrations: Rolin Graphics
Cover Photographs: © Craig Jackson,
In the Dark Photography;
© Lt. Luis Fernandez, Metro-Dade
First Rescue Department

Additional credits appear on page 502, which constitutes a continuation of the copyright page.

Printed in the United States of America
00 99 98 97 10 9 8 7 6 5 4 3 2 1

 American Academy of Orthopaedic Surgeons

 National Safety Council

First Responder

BRIEF CONTENTS

CONTENTS

CONTENTS

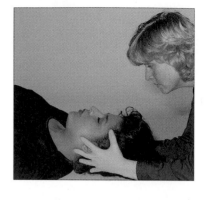

Module 2 AIRWAY 102

Nasopharynx
Mouth
Oropharynx
Trachea (windpipe)
Lung
Diaphragm

Module 3 PATIENT ASSESSMENT 154

CONTENTS

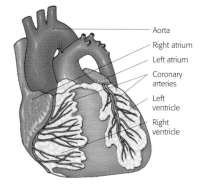

Aorta
Right atrium
Left atrium
Coronary arteries
Left ventricle
Right ventricle

CONTENTS

Module 6 CHILDBIRTH AND CHILDREN 372

FOREWORD

Since the early 1970s, the EMS system has been continuing to evolve into a more structured, more efficient system to provide emergency medical care to the U.S. population. The initial stage of this development was devoted heavily to creating funding sources to develop and improve systems of prehospital emergency care, beginning with well-staffed emergency room departments and full-time ambulance personnel to provide acute care for the victims of trauma, injury, and illness.

The next stage of this development was carried out through the efforts of the U.S. Department of Transportation (DOT), which developed curriculum for training of individuals to carry out this system in a much more efficient manner. The development of basic first aid courses, the *First Responder*, EMT basic, EMT intermediate, and the paramedic were the end results of the effort. Supporting educational materials were developed as the need arose to help disseminate the information in these early curriculums. These textbooks have been revised over the years as the curriculums have changed. Most recently, the DOT has once again found it necessary to change the curriculum of the EMS system. The most notable is from a diagnosis-based to an assessment-based treatment. This textbook has met the challenges of the DOT's new curriculum.

With Jones and Bartlett Publishers, the National Safety Council, and the American Academy of Orthopaedic Surgeons, David Schottke and Garry Briese have worked within the standards of the new curriculum and have once again developed an excellent textbook for the first responder. As in the previous editions, they have combined an easily understood writing style with clean and concise explanations to make the text both easy to read and easy to teach from. Supplemental information has been added in the form of "FYI." New features include Knowledge and Attitude Objectives and Skill Objectives, which correspond to the DOT curriculum. Check point questions within the chapters allow students to gauge their own progress. Voices of Experience essays highlight individuals in the field, as they reflect upon their jobs, their skills, and some of the emergency situations in which they have been involved.

Excellence in education continues to be the primary mission of the American Academy of Orthopaedic Surgeons and, I believe, this new edition of *First Responder*. I recommend this textbook with confidence. It fully meets the need as an educational resource for training first responders as the evolution of the EMS system continues in this country.

Lynn A. Crosby, MD, FACS
Associate Professor of Surgery
Division of Orthopaedic Surgery
Creighton University School of Medicine
Omaha, Nebraska

To the Instructor

The second edition of *First Responder* has been revised to reflect the recent changes in the United States Department of Transportation (DOT) First Responder curriculum that was adopted in 1995. This new curriculum reflects a change from a diagnostic-based approach to an assessment-based approach to patient care. A diagnostic-based approach requires that a responder put a label or diagnosis on the patient's condition in order to decide what treatment is indicated. With the assessment-based approach, a first responder performs an examination of

the patient and determines the patient's history; the responder can then treat the patient using the information obtained. *First Responder* incorporates the National Standard Curriculum guidelines to provide the knowledge and skills needed to work as a first responder. However, some topics are covered in additional depth and are identified as supplemental material by an FYI icon.

In this era of increased awareness of the incidence and transmission of infectious diseases, first responders need to understand how to protect themselves and their patients from infectious diseases. This text stresses the importance of body substance isolation during the discussion of each type of disease or illness. Practical suggestions for the field are highlighted.

Effective first responders need to understand four basic principles. These are:

✔ 1. Know what you should not do.

✔ 2. Know how to use your first responder life support kit.

✔ 3. Know how to improvise.

✔ 4. Know how to assist other emergency medical services providers.

This text has been written with these principles in mind. By continuing to remember the four principles, students will be able to better understand the different roles they will have as first responders.

The Text
This text includes a variety of special features to help you provide your students with the knowledge and techniques they will need to work as a first responder.

● The beginning of each chapter lists the **Knowledge and Attitude Objectives** and **Skill Objectives** addressed in that chapter. These objectives are drawn from the objectives listed in the National Standard Curriculum Instructor's Course Guide.

MEDICAL EMERGENCIES— POISONING

Knowledge and Attitude Objectives As a first responder, you should be able to:

After studying this chapter, you will be expected to:

1. Understand what a poison is.
2. Describe the signs and symptoms of ingested poisons.
3. Describe how to treat a patient who has been poisoned by ingestion.
4. Describe the signs and symptoms of inhaled poisons.
5. Describe how to treat a patient who has been poisoned by inhalation.
6. Describe the signs and symptoms of injected poisons.
7. Describe how to treat a patient who has been poisoned by injection.
8. Describe the signs and symptoms of absorbed poisons.
9. Describe how to treat a patient who has been poisoned by absorption.
10. Describe the signs and symptoms of drug overdose caused by uppers, downers, and hallucinogens.
11. Describe the general treatment for a patient who has suffered a drug overdose.

Skill Objectives As a first responder, you should be able to:

1. Use water to flush a patient who has come in contact with liquid poison.
2. Brush a dry chemical off the patient and then flush with water.

Skill Objectives

● In **Voices of Experience** essays, veteran EMS providers share accounts of memorable incidents and offer advice and encouragement.

VOICES of EXPERIENCE

"One of the most memorable and rewarding events in my EMS experience was a car-motorcycle accident many years ago. On May 6, 1981, I was off duty as a Captain Paramedic when I saw two motorcycles collide with a large Cadillac. A visual size-up of the scene revealed a very critical situation. I asked a passing citizen to call dispatch for assistance, to request a helicopter, and to tell them I was on-scene ordering the resources. I grabbed my trauma kit from the truck and headed for the patients.

A quick triage revealed one patient who was conscious with serious injuries, and I classified him as delayed for any treatment. The priority patient was unconscious with critical injuries. He was on his back with a severely angulated femur fracture and an open tib-fib. The immediate life-threatening injury was multiple fractures of the face causing substantial hemorrhaging into his airway. His entire oral cavity was already filled with blood that was running down the sides of his face. He was not breathing. Using a 50cc syringe and a short section of oxygen tubing as an improvised suction unit, I was able to suction out the blood.

While instructing two citizens, one for C-spine stabilization and the other to continue suctioning, I was able to intubate that patient. A citizen helped ventilate the patient, allowing me to start two IV lines. I was just finishing the second line when the first fire unit arrived. Two members of the crew treated the other patient and two members assisted me in placing a MAST suit on my patient. The helicopter landed just as we finished. The time from dispatch to liftoff was 14 minutes. The patient was flown to a trauma center.

A year later, on May 6, I received a phone call. "Is this Gary Morris?" "Yes, it is," I replied, not recognizing the voice. The person asked: "Do you remember what today's date is? Last year on this date you saved my life." He then went on to describe his injuries and his months of recuperation. Steve went on to become a successful businessman and to raise a family. He still calls me on May 6 each year. He would have died within minutes that day if a first responder was not immediately available to treat his airway hemorrhage."

Gary Morris
EMT-P
Deputy Chief
Phoenix Fire Department
Phoenix, Arizona

"A" Is for Airway 1

CAUTION
Do not use any of the preceding lifts or carries if you suspect that the patient has a spinal injury, unless, of course, it is necessary to remove the patient from a life-threatening situation.

● **Caution** and **Safety Precaution** features are included to reinforce safety concerns for both the responder and the patient.

SAFETY PRECAUTION
Remember BSI techniques when dealing with musculoskeletal injuries that may involve open wounds.

SKILL SCAN: Bleeding Control

1. Direct pressure stops most bleeding. Wearing disposable gloves, place sterile gauze pad or clean cloth over wound. If bleeding does not stop in 10 minutes, press harder over a wider area.
2. A pressure bandage can free you to attend to other injuries or victims.
3. Do not remove a blood-soaked dressing. Add more on top.
4. If disposable gloves are not available, use another barrier or extra gauze pads or cloths.
5. If bleeding persists, use elevation to help reduce blood flow. Combine with direct pressure over the wound.
6. If bleeding still continues, apply pressure at a pressure point to slow blood flow. Locations are: **(a)** brachial or **(b)** femoral. Use with direct pressure over the wound.

Bleeding 113

● Over 20 **Skill Scan pages** present key skills in a format that enhances student comprehension.

 Accurately depicted **illustrations** allow students to better understand proper procedures.

 Real injury photographs prepare students to handle an actual real-life emergency.

● **Special Needs** sections highlight specific concerns or procedures for particular groups such as elderly or pediatric patients.

SPECIAL NEEDS

Infant and Child Respiratory Systems Some differences between the respiratory systems of adults and those of infants and children are as follows:

- Pediatric airways are smaller and more flexible. When you perform CPR on a child, much less force is required than is needed for an adult.
- Because of its smaller size, a child's airway is more easily blocked by a foreign object.
- Very young infants can breathe only through their noses. Therefore, if their nose becomes blocked, they will show signs of respiratory distress.

Focus on Assessment Carefully monitor the child's airway during and after the seizure.

Focus on Treatment First responder treatment of seizures consists of the following steps:

1. Place the patient on the floor or bed to prevent injury.
2. Maintain an adequate airway once the seizure is over.
3. Provide supplemental oxygen after the seizure if it is available and if you are trained to use it.

● **Focus on Assessment** and **Focus on Treatment** sections highlight important techniques.

Check ✓ *Point*

✓ What are the signs of adequate breathing?
✓ What are the signs of inadequate breathing?
✓ What are the causes of respiratory arrest?
✓ What are the major signs of respiratory arrest?
✓ What are three ways to check for the presence of breathing?
✓ What are the steps for performing rescue breathing using each of the following methods:
 • Mouth-to-mask device?
 • Mouth-to-barrier device?
 • Mouth-to-mouth?

● **Check Point questions** within the chapter allow students to gauge their own progress.

● **Self-Test questions** help evaluate student mastery of the subject.

FYI sections include coverage of additional information for further study. This material is beyond the scope of the DOT curriculum and you may choose to incorporate this supplemental material at your discretion.

SELF TEST 6

1. What are the two key factors that determine whether you should deliver the baby or transport the mother?
 a. The mother "needs to go to the bathroom" and her water has broken.
 b. Crowning and this is her first child.
 c. Contractions less than 3 minutes apart and the hospital is close.
 d. Crowning and contractions less than 3 minutes apart.

2. When caring for the newborn, which of the following factors should you consider?
 a. Newborn babies lose lots of body heat.
 b. Healthy newborn babies do not cry.
 c. Newborn babies can breathe only through their nose.
 d. You can check a newborn baby's pulse at the umbilical cord.

3. Describe your care of a woman who is delivering a baby feet first.

4. Describe the steps in caring for a woman who has suffered a miscarriage.

5. Which of the following actions can decrease the mother's bleeding after she has given birth?
 a. Allowing the baby to nurse
 b. Giving the mother fluids
 c. Elevating the mother's legs
 d. Massaging the uterus

6. In opening the airway of a child, you should take which of the following actions?
 a. Use the jaw-thrust technique for medical and trauma patients.
 b. Flex the neck.
 c. Avoid hyperextending the neck.
 d. Extend the neck as far as possible.

7. Describe the difference between clearing a complete airway obstruction in a child and in an infant.

8. Match the following signs with the illnesses listed.
 ___ Croup a. Wheezing sound
 ___ Epiglottitis b. Barking seal-like cough
 ___ Asthma c. Drooling

9. Seizures in children are caused by which of the following conditions?
 a. High fever
 b. Head injury
 c. Poisoning
 d. Hypothermia

10. Describe the signs, symptoms, and treatment of traumatic shock in children.

Answers: 1. d. 2. a, c, d. 3. Arrange for immediate transportation to a medical facility. 4. 1. Save fetus and all tissues that have been passed from the vagina. 2. Control bleeding. 3. Treat for shock. 5. a, d. 6. a, c. 10. Signs and symptoms = cool clammy skin, rapid weak pulse, rapid shallow respirations. Treatment = control external bleeding, elevate the legs, administer oxygen if available, arrange for prompt transportation to a medical facility. 7. Infant—use a combination of 5 back blows and 5 chest thrusts to relieve the obstruction. Child—use abdominal thrusts to relieve the obstruction. 8. Croup—b; Epiglottitis—c; Asthma—a.

Self Test 6 1

● **Key terms** are defined in the text at the point at which they are introduced.

Closed fracture A fracture in which the overlying skin has not been damaged.

In addition to providing the highest quality learning materials for the students, the American Academy of Orthopaedic Surgeons and the National Safety Council have developed exceptional instructor resource materials. The resource materials are designed to support your efforts in the classroom and to ensure your success. They include:

Interactive First Responder: A Scenario-Based Approach

This new CD-ROM covers all the key first responder topics and allows for classroom presentation and/or individual student usage. This interactive CD-ROM includes full motion video, charts, illustrations, photographs, and key content from the text. The CD-ROM has been developed to challenge students' mastery of the first responder material through scenario-based learning.

Instructor's Resource Manual

This new manual includes lesson plans, teaching strategies, proficiency tests, supplemental information, and additional scenarios. This manual helps you utilize all of the outstanding instructor resources below.

First Responder Skills Video

This new full-feature video, designed in a topical format, corresponds with the material in the text. A combination of dramatic, real-life emergencies with a proven format make this video essential for all courses covering first responder skills.

CPR for the Professional Rescuer Video

This outstanding video applies to all CPR training and follows the latest American Heart Association standards as published in the JAMA supplement.

Instructor's Slide Set

An all-new set of 35mm color slides depict key first responder topics and actual injuries. The topical slides outline the most important information in the text while the injury slides prepare your students to handle real-life emergencies.

Instructor's Test Bank

A new 1,000 test question manual corresponds to the chapters in the text and includes scenario-based questions.

Instructor's Computerized Test Bank

A computerized version of the above test bank is available in both IBM and Macintosh formats.

Student Workbook

Designed as an interactive learning aid for students in basic First Responder training programs, the organization and content follow the 1995 U.S. DOT first responder training curriculum. A variety of interesting exercises and scenarios reinforce the objectives and concepts in the text. This workbook will help students achieve a fuller understanding of the role of the first responder in emergency care.

Please call 1-800-832-0034 for more information.

As recently as the mid-1950s there were no commonly used medical techniques that were effective for restarting stopped hearts, and victims often died. Today, simple and advanced techniques can restart a stopped heart. A trained first responder can keep a person alive until advanced techniques can be performed by other medical personnel. Because first responders are often the first medically trained personnel on the scene of an emergency, they can make a critical difference by supplying the first and vital link in a chain of survival. Opening a patient's airway, performing rescue breathing, controlling external bleeding, and treating a patient for the signs and symptoms of shock can make a vital difference. As you study this book, realize that you are about to become a First Responder, an emergency care provider who can make a real difference to patients.

Before studying the knowledge and skills needed to become a medical first responder, it is important to understand more about the following topics: (1) overview of the first responder course, (2) criteria for first responder certification, (3) implications of the Americans with Disabilities Act, and (4) ten standard criteria for EMS systems.

1. The First Responder Course

The first responder course presents an exciting opportunity to develop emergency medical skills and knowledge that will enable you to assist people who have sustained an accidental injury or who are suffering from a sudden illness or medical problem. This course follows a national curriculum that was developed by representatives from many federal and state agencies and from professional medical groups. The material you will learn is divided into seven modules, which follow the national standard curriculum. We have added an eighth module, which covers supplemental skills that may be taught to first responders in some communities. The decision about whether to cover this material will be made by course directors. These modules are:

- **Module 1,** Preparatory
- **Module 2,** Airway
- **Module 3,** Patient Assessment
- **Module 4,** Circulation
- **Module 5,** Illness and Injury
- **Module 6,** Childbirth and Children
- **Module 7,** EMS Operations
- **Module 8,** Supplemental Skills

2. Criteria for Certification

The process of being ready to practice your skills as a first responder begins with your thorough study and mastery of the knowledge and skills presented in this book. To practice these skills you must become certified or registered as a first responder in the state where you will be working. Some states will require you to be certified or registered through a state agency such as a department of health. Other states may require you to become registered through the National Registry of Emergency Medical Technicians. In either case you will be required to successfully complete this course and then pass a written and practical test. Your certification or

registration is good for a limited period of time. To maintain your certification or recertification, you will be required to complete certain course work to refresh your knowledge and skills and probably take some kind of written and practical tests. It is important to remember that your ability to function as a first responder depends on your maintaining your certification or registration. It is your responsibility to do this even though you may receive help from the agency for which you work.

3. The Americans with Disabilities Act

The Americans with Disabilities Act was passed by Congress in 1990 to protect people with physical or mental disabilities against discrimination. This Act, also known as the ADA, has requirements that affect both you and your patients.

> Title I: This section prohibits employment discriminations.
> Title II: This section states that no one can be denied access to services provided by local or state governments based on a person's disability. As a public safety employee, you must provide the same level of care for a disabled patient as you provide to a nondisabled patient.
> Title III: This section prohibits employers from failing to provide full and equal employment to disabled persons.
> Title IV: This section addresses the responsibilities of phone companies to provide special communication features to disabled persons.
> Title V: This section explains the implementation of the Americans with Disabilities Act.

As a provider of emergency medical services, it is important that you understand the general purpose of the ADA. Remember, disabled patients are entitled to the same quality care as other patients.

4. Ten Standard Criteria for EMS Systems

Emergency medical services systems can be categorized in many different ways. Different parts of the system may be provided by different agencies in various locations. The National Highway Traffic Safety Administration (NHTSA) of the United States Department of Transportation evaluates EMS systems based on the following ten criteria:

1. Regulation and policy
2. Resource management
3. Human resources and training
4. Transportation equipment and systems
5. Medical and support facilities
6. Communications facilities
7. Public information and education
8. Medical direction
9. Trauma system and development
10. Evaluation

These criteria are used primarily in the administration of an EMS system. There are many ways to categorize an EMS system. A simple model is presented in Chapter 1 and is based on a functional model of an EMS system.

This overview of four topics related to the first responder is designed to familiarize you with some of the background information that will help to make your first responder training more valuable. By giving you some information about the first responder course content, criteria required for certification and recertification, implications of the Americans with Disabilities Act, and ten criteria for evaluating EMS systems, you will have a background to better understand the material presented throughout this book.

ACKNOWLEDGMENTS

Reviewers

Margarita S. Brown, EMT
El Paso Community College
El Paso, Texas

Raymond W. Burton
Plymouth County Sheriff's Office
Plymouth, Massachusetts

J. Kevin Henson, NREMT-P, I/C
New Mexico EMS Training Coordinator
Vice-Chair, NSCEMSTC
Santa Fe, New Mexico

Wayne Hollis, MA, MITC, EMT-P
Examination and Certification Coordinator
State of Kansas, Board of
Emergency Medical Services
Topeka, Kansas

Robb Rehberg
National Safety Council
Advisory Board Chairman
Ramsey, New Jersey

Donna Siegfried
National Safety Council
Itasca, Illinois

Alton Thygerson
Brigham Young University
Provo, Utah

Trooper James Tzitzon
Criminal Justice Training Council
Bradford, Massachusetts

Holly Weber, EMT-P
SOLO, Wilderness Emergency Medicine
Conway, New Hampshire

Contributors to the Voices of Experience

Michael P. Bell, Chief
Director, Department of Fire
and Rescue Operations
Toledo, Ohio

Joseph Escobedo, EMT-P
Albuquerque, New Mexico

Paul Guns, EMT-P
Orange County Fire Authority
Orange County, California

Judith Guenst, EMT
Consultant/Instructor
H.K. Carr & Associates
New Jersey

Gary P. Morris, Deputy Chief
Phoenix Fire Department
Phoenix, Arizona

Robert Pringle, BS, NEMT-P
Program Manager
Life Air Rescue
Shreveport, Louisiana

Gordon M. Sachs, Deputy Chief
Marion County Fire Rescue
Ocala, Florida

David Spiro, BA, EMT-P
Senior Paramedic
St. Mary's Hospital of Brooklyn
Brooklyn, New York

Peggy Stark
Paramedic Instructor
Springfield, Nebraska

Brian Yeaton, EMT-P
Instructor
SOLO, Wilderness Emergency Medicine
Conway, New Hampshire

A special thanks needs to be extended to the unique team that produced *First Responder*. The editorial board of the Academy of Orthopaedic Surgeons provided valuable input and direction. Medical direction was provided by Dr. Lynn Crosby, the editor of the sixth edition of *Emergency Care and Transport of the Sick and Injured*. Dr. Crosby has the unique insight of a former paramedic who is now a practicing orthopaedic surgeon. Lynne Shindoll from the Academy and Karla Holmes, a veteran EMS educator, were diligent in suggesting many large and small corrections that have made this book much better. I would like to extend a special thanks to Dr. Jim Heckman, who has been instrumental in helping me to look through the eyes of an editor and author as well as an emergency medical care provider.

The staff at Jones and Bartlett Publishers has provided the direction and support for the many changes needed to transform a rough manuscript into a finished product. Tracy Murphy has been never-failing in her ability to meet deadlines and provide direction to the many separate individuals who need to work together like players in an orchestra in order for this project to be completed. Clayton Jones has provided the vision and support to combine the resources of the National Safety Council with those of the American Academy of Orthopaedic Surgeons.

Finally, no thanks would be complete without mentioning the never-ending support and understanding of our families.

M O D U L E

1

PREPARATORY

This module covers information of a general nature that you must learn in order to more easily understand the more specific information presented in the following modules.

Chapter 1 is designed to give you an understanding of your roles and responsibilities as an emergency medical services provider. It will help you to understand what you can do and what you should not do.

Providing emergency medical care as a first responder is stressful physically and emotionally. Chapter 2 covers the material you need to maintain your well-being as a first responder. If you are not in good shape, you will not be able to provide high-quality care to other people.

Providing emergency medical care requires that you have some understanding of selected legal principles and some understanding of what is required of you ethically. These issues are covered in Chapter 3.

Chapter 4 covers the anatomy and function of the human body systems. Understanding the functions of body systems will help you to relate the structures of the body with the functions they perform.

Chapter 5 introduces you to the techniques needed to move or assist others with moving ill or injured patients. Although this material is presented here to keep it in the same place as it is presented in the curriculum, some instructors will find it more advantageous to present this material after covering "Illness and Injury" in Module 5.

CHAPTER

1

INTRODUCTION TO THE EMS SYSTEM

Knowledge and Attitude Objectives *After studying this chapter, you will be expected to:*

1. Understand and describe the four general goals of your first responder training.
2. Define the components of an emergency medical services (EMS) system.
3. Describe how the seriousness of the patient's condition is used to determine the urgency of transportation to an appropriate medical facility.
4. Define the roles and responsibilities of a first responder.
5. Describe the importance of documentation.
6. Describe the relationship between your attitude and conduct and acceptable patient care.
7. Define medical oversight and discuss the first responder's role in the process.

DID YOU KNOW **?**

▶ In ten minutes, as you read this chapter, two people will be killed and 350 people will suffer disabling injuries from some type of accident.

First responder The first medically trained person present at the scene of sudden illness or injury.

First Responder Training

This book has been written to be used as part of a training course for first responders. Although you may gain some knowledge from the book alone, it is strongly suggested that you take an approved first responder course. A first responder course is designed to teach you the basics of good patient care and the skills you need to care appropriately for the victim of an accident or sudden illness until more highly trained emergency personnel arrive.

The skills and knowledge you will learn in this course are important because they are the foundation of the entire emergency medical services (EMS) system. Your actions can prevent a minor situation from becoming serious or may even determine whether a patient lives or dies.

In the first responder course, you will learn how to examine patients and how to use the emergency medical skills needed by a **first responder**. These skills are divided into two main groups: (1) those that are used for patients who have been injured and (2) those that are used for patients suffering from illness or serious medical problems (Figure 1.1).

You will learn the following skills to stabilize and treat persons who have been injured:

- Controlling airway, breathing, and circulation.
- Controlling external bleeding (hemorrhage).
- Treating shock.
- Treating wounds.
- Splinting injuries to stabilize extremities.

In addition to these trauma skills, you will learn to recognize, stabilize, and provide initial treatment for the following medical conditions:

- Altered mental status
- Seizures
- Problems associated with excessive heat or cold
- Behavioral or psychological crisis
- Heart attack
- Stroke
- Diabetes
- Alcohol and drug abuse
- Poisoning
- Bites and stings
- Emergency childbirth

Goals of First Responder Training

One of the primary goals of first responder training is to teach you how to evaluate, stabilize, and treat patients using a minimum of specialized equipment. First responders frequently find themselves in situations where little or no emergency medical equipment is readily available. Therefore, it is important to understand these basic principles of first responder training. You should know:

- What you should not do.
- How to use your first responder life support kit.
- How to improvise.
- How to assist other EMS providers.

Fig. 1.1 A typical emergency scene with injured patients.

Know What You Should Not Do

The first goal of first responder training is to teach you what not to do! For example, it may be better for the first responder to leave a patient in the position found rather than attempt to move the patient without the proper equipment or an adequate number of trained personnel.

- Know what not to do
- Know how to use your first responder life support kit
- Know how to improvise
- Know how to assist other EMS providers

▼ **CAUTION**

Above all, do nothing that would further harm the patient!

The first responder provides initial treatment. The first responder is, by definition, the first medically trained person to arrive on the scene. Your initial care is usually followed by more extensive care given by emergency medical technicians (EMTs), paramedics, nurses, and physicians. The care you give as the first responder is essential because it is given first and it is available sooner than more advanced emergency medical care.

Know How to Use Your First Responder Life Support Kit

- Know what not to do
- Know how to use your first responder life support kit
- Know how to improvise
- Know how to assist other EMS providers

The second goal of first responder training is to teach you to treat patients using limited emergency medical supplies. A first responder life support kit should be small enough to be carried in the trunk of an automobile or to fit easily on almost any fire or rescue vehicle. Although the contents of the kit may appear to be limited, such supplies are all you need to provide immediate care for most patients you will encounter. The suggested contents of a first responder life support kit are shown in Figure 1.2 and described in Table 1.1.

Know How to Improvise

- Know what not to do
- Know how to use your first responder life support kit
- Know how to improvise
- Know how to assist other EMS providers

The third goal of first responder training is to teach you to improvise—to use your knowledge to treat the patient using little or no emergency medical equipment. As a trained first responder, you must often act in situations where little or no equipment is available. Therefore, it is important that you know how to improvise. Your first responder course is meant to teach you, for example, how to use articles of clothing and handkerchiefs to stop bleeding and how to use wooden boards, magazines, or newspapers to immobilize injured parts. Improvisation requires that you be able to think on your feet. Although no course can teach you that, it is the goal of this course to provide examples that you can apply to real-life situations.

Know How to Assist Other EMS Providers

- Know what not to do
- Know how to use your first responder life support kit
- Know how to improvise
- Know how to assist other EMS providers

The fourth goal of first responder training is to train you to assist EMTs and paramedics once they arrive on the scene. Many procedures that EMTs and paramedics use cannot be performed correctly by fewer than three people. First responders often assist under these circumstances. Thus you must be trained to assist with certain specialized procedures.

Fig. 1.2 Suggested contents of a first responder life support kit.

Table 1.1: Suggested Contents of a First Responder Life Support Kit

Patient Examination Equipment	1 flashlight
Personal Safety Equipment	5 pairs of gloves 5 face masks
Resuscitation Equipment	1 mouth-to-mask resuscitation device 1 portable hand-powered suction device
Bandaging and Dressing Equipment	10 gauze-adhesive strips 1" 10 gauze pads 4" x 4" 5 gauze pads 5" x 9" 2 universal trauma dressings 10" x 30" 1 occlusive dressing for sealing chest wounds 4 conforming gauze rolls 3" x 5 yd 4 conforming gauze rolls 4½" x 5 yd 6 triangular bandages 1 adhesive tape 2" 1 burn sheet
Patient Immobilization Equipment	2 (each) cervical collars: small, medium, large 3 rigid conforming splints (SAM splints) OR 1 set air splints for arm and leg OR 2 (each) cardboard splints 18" and 24"
Extrication Equipment	1 spring-loaded center punch 1 pair heavy leather gloves
Miscellaneous Equipment	2 blankets (disposable) 2 cold packs 1 bandage scissors
Other Equipment:	1 set personal protective clothing (helmet, eye protection, turnout coat) 1 reflective vest 1 fire extinguisher (5 lb. ABC dry chemical) 1 Emergency Response Guidebook 6 fusees 1 binoculars

Additional Skills

First responders operate in a variety of settings. Many problems encountered in an urban center differ sharply from those encountered in a rural area. In addition, regional variations in climate create conditions that affect the

Fig. 1.3 The emergency medical services system.

Fig. 1.4 Reporting an emergency.

Emergency services dispatch center A fire, police, or emergency medical services (EMS) agency; a 911 center; or a seven-digit telephone number used by one or all of the emergency agencies.

situations you encounter and require that you use different skills and equipment to treat patients.

Certain skills and equipment mentioned in this book are beyond the essential and minimum level of knowledge you need to successfully complete a first responder course. However, these supplemental skills and equipment may be required in your local EMS system. Supplemental skills are identified by the following icon: **Pri**

The Emergency Medical Services System

The EMS system was developed as a result of evidence that patients who receive appropriate emergency medical care before they reach a hospital have a much greater chance of surviving a major accident or sudden illness than patients who do not receive such care. It is important that you understand the operation and complexity of an EMS system (Figure 1.3).

Problems that occur in the "prehospital" phase of the EMS operation are often ones of control and coordination of resources and personnel. The smooth operation of an EMS system, in both "routine" and multiple-casualty situations, depends on a mutual understanding by all agencies and personnel of their roles in the system. This understanding can only come through close cooperation, careful planning, and continual effort. You can best understand the EMS system by examining the sequence of events involved in an injured or ill patient's progress through the system.

Reporting

The reporting of the emergency incident activates the EMS system (Figure 1.4). The report is usually received by telephone in an **emergency services dispatch center**. The dispatch center may be a fire, police, or EMS agency; a 911 center; or a seven-digit emergency telephone number used by one or all of the emergency agencies. Enhanced 911 centers are even able to determine the location of the caller.

Dispatch

Once notification of the emergency incident has been given to the emergency services dispatch center, appropriate equipment and personnel are dispatched to the scene (Figure 1.5). Communities vary as to how notification occurs (pager, telephone, and so forth) and even in what agencies, personnel, and equipment are involved in the first response.

First Response

Firefighters (paid or volunteer) or law enforcement personnel are likely to be the first responders in most emergencies; they are first on the scene because of their location or their speed in responding (Figure 1.6). Most com-

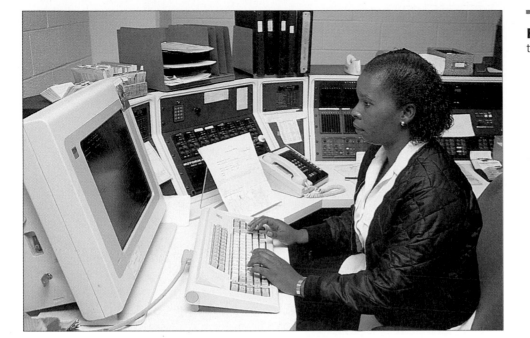

Fig. 1.5 A dispatch center receives the call.

munities have many potential first responders, but few EMTs and even fewer paramedics.

For example, a community with four or five fire stations may have only two or three ambulances. In some situations, first responders' actions can make the difference between life and death. For example, one of the key factors in the survival of persons in cardiac arrest is the time that passes between the stoppage of the heartbeat and the beginning of manual cardiopulmonary resuscitation (CPR).

The patient's first and perhaps most crucial contact with the EMS system occurs with the arrival of the trained first responder. The first responder is a key element in providing emergency care.

EMS Response

The patient's second contact with the EMS system begins with the arrival of an emergency medical vehicle (usually an ambulance) (Figure 1.7) staffed by **Emergency Medical Technicians-Basic (EMT-Bs)** or paramedics. A properly equipped vehicle and the EMTs who staff it make up a **basic life support (BLS)** unit. Each EMT has completed at least a 110-hour training course, though many have completed training courses that are much longer.

Emergency Medical Technician-Basic (EMT-B) A person who is trained and certified to provide basic life support and certain other noninvasive prehospital medical procedures.

Basic life support (BLS) Emergency lifesaving procedures performed without advanced emergency procedures to stabilize patients who have experienced sudden illness or injury.

Fig. 1.6 Firefighters and law enforcement personnel are first responders in many emergencies.

Fig. 1.7 EMS responds.

EMTs continue the care begun by first responders. EMTs stabilize the patient further and prepare the person for transport to the emergency department of the hospital. Careful movement of the patient and proper treatment by well-trained emergency personnel increase the chance that the patient will arrive at the emergency department in the best possible condition.

In addition to BLS services provided by EMTs, patients may receive **advanced life support (ALS)** services provided by paramedics. **Paramedics** have the BLS skills and knowledge of EMTs and have received further training that enables them to provide additional care such as administering intravenous (IV) fluids and certain medications, and monitoring and treating heart conditions that may require **defibrillation**. Defibrillation is the administration of an electric shock to the heart of a patient who is suffering from a highly irregular heartbeat. Paramedics are also trained to place special airway tubes to keep the patient's airway open.

Emergency Medical Technicians-Intermediate (EMT-Is) are able to perform limited ALS skills. These people may work alone to provide these skills or they may work with a paramedic on an ALS unit.

Each level of skill is built upon the one preceding it: the skills of the paramedic originate from those of the EMT-B, and the abilities of the EMT-B are developed from those of the first responder. All skill levels are based on what you will learn in the first responder course: airway maintenance, control of bleeding, and prevention, recognition, and treatment of shock.

The EMS system involves more than emergency medical care. For example, law enforcement personnel are a crucial part of the system because they must provide protection and control at the scene of the accident. Fire units provide fire protection, specialized rescue, and patient extrication.

Hospital Care

Fig. 1.8 Hospital emergency care.

The patient's third contact with the EMS system occurs in the hospital, primarily in the emergency department. After being treated at the accident scene, the patient is transported to the hospital, where definitive treatment can be given (Figure 1.8).

It may be necessary for the patient to be transported to the closest appropriate medical facility first, for stabilization, and then to the hospital that provides specialized treatment. Special facilities include burn centers, pediatric centers, poison control centers, perinatal centers, and trauma centers. You must learn and follow your local patient transportation protocols.

Check Point

✓ Why is it important to understand the sequence of events in the emergency medical services system?

Advanced life support (ALS) The use of specialized equipment such as cardiac monitors, defibrillators, intravenous fluids, drug infusion, and endotracheal intubation to stabilize patients who have experienced sudden illness or injury.

Paramedic An emergency medical technician who has completed an extensive course of 800 or more hours and who can perform advanced life support skills.

Defibrillation Delivery of an electric current through a person's chest wall and heart for the purpose of ending a lethal heart rhythm called ventricular fibrillation.

Ten Standard Components of an EMS System

Emergency medical services systems can be categorized in many different ways. Different parts of the system may be provided by different agencies in various locations. The National Highway Traffic Safety Administration (NHTSA) of the United States Department of Transportation evaluates EMS

VOICES of EXPERIENCE

"Of all the skills that I have learned in the eighteen years of my involvement in EMS, the one skill that has been of the greatest value is not something that I learned in the classroom. I'm not even sure if it is something that can be taught. Rather, it is a skill that is honed through time and experience. It is the art of patience and clear thinking. The highly charged atmosphere of many EMS calls is one that requires you to maintain your own sense of calm even while the environment around you seems to be falling to pieces. This is the mark of a true professional. Others will look to you for guidance, and it will be up to you to provide it. Maintaining control of your own emotions will allow you to make the correct decisions and avoid the trap of "tunnel vision," or not seeing the forest for the trees.

First responders provide a valuable link to the EMS chain. Your observations and actions may contribute directly to a patient's survival. Pre-hospital health care has radically altered the provision of medicine over the past thirty or so years. It was not long ago that many of the skills now so common to first responders, EMTs, and paramedics were considered only for the realm of the physician. How times have changed! Remember that you are not alone and that you should always view yourself as a "team player." Only by working together do we achieve the ultimate goal: the best possible care for our patients."

David C. Spiro
BA, EMT-P
Paramedic
St. Mary's Hospital of Brooklyn
Brooklyn, New York

systems based on the following ten criteria, which are used primarily in the administration of an EMS system.

1. Regulation and policy
2. Resource management
3. Human resources and training
4. Transportation equipment and system
5. Medical and support facilities
6. Communications system
7. Public information and education
8. Medical direction
9. Trauma system and development
10. Evaluation

A Word about Transportation

As a first responder, your primary goal is to provide immediate care for a sick or injured patient. As more highly trained emergency medical service personnel (EMTs or paramedics) arrive on the scene, you will assist them with treatment and with preparing the patient for transportation. Though other EMS personnel almost always provide patient transportation, it is important that you understand when a patient must be transported quickly to a hospital or other medical facility (Figure 1.9).

This book uses three terms to describe proper patient transportation:

- • Transportation to an appropriate medical facility
- • Prompt transportation to an appropriate medical facility
- • Rapid transportation to an appropriate medical facility

■ *Transportation to an appropriate medical facility.* This phrase means that a patient's condition requires care by medical professionals, but speed in getting the patient to a medical facility is not the most important factor. For example, this might describe the transportation needed by a patient who has sustained an isolated injury to an extremity but whose condition is otherwise stable.

Fig. 1.9 Ambulance transport to a hospital or medical facility.

- *Prompt transportation to an appropriate medical facility.* This phrase is used when a patient's condition is serious enough that the patient needs to be taken to an appropriate medical facility in a fairly short period of time. If the patient is not transported fairly quickly, the condition may get worse and the patient may even die.
- *Rapid transportation to an appropriate medical facility.* This phrase is used for the few cases when EMS personnel are unable to give the patient adequate lifesaving care in the field. Such a patient may die unless he or she is transported immediately to an appropriate medical facility. This phrase is rarely used in this book.

Each of these three phrases refers to transportation to an **appropriate medical facility**. An appropriate medical facility may be a hospital, trauma center, or medical clinic. It is essential that you be familiar with the services provided by the medical facilities in your community. EMS personnel must work closely with their medical director to set up transportation protocols to ensure that patients are transported to the closest medical facility capable of providing adequate care.

To provide the best possible care for the patient, all members of the EMS team must remember that they are key parts of the total system. Smooth operation of the team ensures the best care for the patient.

- Transportation to an appropriate medical facility
- Prompt transportation to an appropriate medical facility
- Rapid transportation to an appropriate medical facility

- Transportation to an appropriate medical facility
- Prompt transportation to an appropriate medical facility
- Rapid transportation to an appropriate medical facility

Appropriate medical facility A hospital with adequate medical resources to provide continuing care to sick or injured patients who are transported after field treatment by first responders.

Roles and Responsibilities of the First Responder

As a first responder, you have several roles and responsibilities. Depending on the emergency situation, some or all of the following activities may be necessary:

- Respond promptly to the scene of an accident or sudden illness.
- Protect yourself.
- Protect the incident scene and patients from further harm.
- Summon appropriate assistance (EMTs, fire department, rescue squad).
- Gain access to the patients.
- Perform patient assessment.
- Administer emergency medical care and reassurance.
- Move patients only when necessary.
- Seek and then direct help from bystanders, if necessary.
- Control activities of bystanders.
- Assist EMTs and paramedics, as necessary.
- Document your care.
- Keep your knowledge and skills up to date.

Concern for the patient is primary; you should perform all activities with the patient's well-being in mind.

Prompt response to the scene is essential if you are to provide quality care to the patient. It is important that you know your response area well and that you can quickly determine the most efficient way to get to the emergency scene.

When you reach the emergency scene, park your vehicle so that it does not create an additional hazard. The emergency scene should be protected with the least possible disruption of traffic. Do not block the roadway unnecessarily. As

first responder, you should assess the scene to determine whether any hazards are present, such as downed electrical wires, gasoline spills, or unstable vehicles. This assessment is necessary to ensure that patients suffer no further injuries and that rescuers, other EMS personnel, and bystanders are not hurt.

If coping with the incident is beyond the capabilities of the equipment and personnel already dispatched to the scene, you must summon additional help. Do this right away because it may take some time for additional equipment and personnel to reach the scene, especially in rural areas or communities with systems staffed by volunteers.

Once you have taken the preceding steps, you must gain access to the patient. This may be as simple as opening the door to a car or house, or as difficult as squeezing through the back window of a wrecked automobile.

Next, examine the patient to determine the extent of the injury or illness. This initial assessment of a patient is called the patient assessment sequence. Once the patient assessment is completed, you must stabilize the patient's condition to prevent it from getting worse. The techniques you use to do this are limited by your training and the equipment available. Correct application of these techniques can have a positive effect on the patient's condition.

When EMTs or paramedics arrive to assist, it is important to tell them what you have discovered about the patient's condition and what you have done so far to stabilize or treat it. Your next task is to assist the EMTs or paramedics.

In some communities or situations, you may be asked to accompany the patient in the ambulance. If CPR is being performed, you may be needed to assist or relieve the EMT or paramedic, especially if the hospital is far from the scene. In some EMS systems, you may be asked to drive the ambulance to the hospital so EMS personnel with more advanced training can devote all their efforts to patient care.

The Importance of Documentation

Once your role in treating the patient is finished, it is important that you record your observations about the scene, the patient's condition, and the treatment you provided. Documentation should be done according to the accepted policies of your organization. This documentation is important because you will not be able to remember the treatment you give to all patients. It also serves as a legal record of your treatment and may be required in the event of a lawsuit. Documentation also provides a basis from which to evaluate the quality of care given.

Documentation should always be clear, concise, and accurate. It should include the following information:

- Condition of the patient when found.
- The patient's description of the injury or illness.
- The initial and later vital signs.
- The treatment you gave the patient.
- The agency and personnel who took over treatment of the patient.
- Any other helpful facts.

Attitude and Conduct

As a first responder, you will be judged by your attitude and conduct, as well as by the medical care you administer. It is important to understand that professional behavior has a positive impact on your patients.

Because you often will be the first medically trained person to arrive on the scene of an emergency, it is important for you to act in a calm and caring way. You will gain the confidence of both patient and bystanders more easily by using a courteous and caring tone of voice. Show an interest in your patient. Avoid embarrassing your patient and help protect his or her privacy. Talk with your patient and tell him or her what you are doing.

Remember that medical information about a patient is confidential and you should not discuss it with your family or friends. This information should be shared only with other medical personnel who are involved in the care of that particular patient.

Your appearance should be neat and professional at all times. You should be well groomed and clean. A uniform helps identify you as a first responder. If you are a volunteer who responds from home, always identify yourself as a first responder. Your professional attitude and neat appearance help provide much needed reassurance to the patient (Figure 1.10).

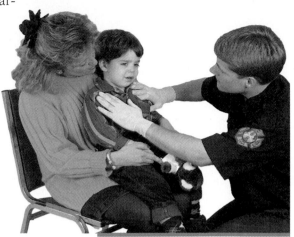

Fig. 1.10 A professional attitude and neat appearance provide reassurance to the patient.

Medical Oversight

The overall leader of the medical care team is the physician. To ensure that the patient receives appropriate medical treatment, it is important that first responders receive direction from a physician. Each first responder agency should have a physician who directs training courses, helps set medical policies, and assures quality management of the EMS system. This type of medical direction is known as indirect, or off-line, medical control.

A second type of medical control is known as direct, or on-line, medical control. On-line medical control is provided by a physician who is in contact with prehospital EMS providers, usually paramedics or EMTs. Usually this medical direction is done by two-way radio or wireless telephone (Figure 1.11). In cases where large numbers of people are injured, physicians may respond to the scene of the incident to provide on-scene medical control.

Fig. 1.11 A physician providing on-scene medical control.

CHAPTER
REVIEW 1

Summary

This chapter provides an introduction to the first responder course and an overview of the operation of an EMS system, the legal principles guiding prehospital emergency care, and the role of the first responder in prehospital emergency care.

 This chapter presents an introduction to first responder training. It outlines the types of skills you will learn as a first responder and presents four goals of first responder training, which are to know what you should not do, how to use your first responder life support kit, how to improvise, and how to assist other EMS providers. It is important that first responders understand their roles in the EMS system. The typical sequence of events of the EMS system are reporting, dispatch, first response, EMS response, hospital care, and medical oversight. Though most first responders do not provide patient transportation, a brief section on patient transportation covers the information you need to determine how rapidly a patient needs to be transported to the hospital. Roles and responsibilities of the first responder are presented, and the importance of documentation and appropriate attitudes and conduct is stressed. Once you have mastered this introductory material, you will be ready to proceed to Chapter 2.

Key Terms

Advanced life support (ALS)—page 12

Appropriate medical facility—page 15

Basic life support (BLS)—page 11

Defibrillation—page 12

Emergency Medical Technician-Basic (EMT-B)—page 11

Emergency services dispatch center—page 10

First responder—page 5

Paramedic—page 12

What Would You Do?

After responding to the scene of a one-car accident, you assessed the scene, examined the patient, and rendered care within the limits of your training. The paramedic ambulance arrives on the scene. What should you do?

You Should Know

1. The four general goals of your first responder training.
2. The components of an emergency medical services (EMS) system.
3. How the seriousness of the patient's condition is used to determine the urgency of transportation to an appropriate medical facility.
4. The roles and responsibilities of a first responder.
5. What information should be included in your documentation of an incident.
6. Why your attitude and conduct are related to your ability to provide acceptable patient care.
7. The meaning of medical oversight and your role in the process of providing emergency care.

The Well-Being of the First Responder

Knowledge and Attitude Objectives *After studying this chapter, you will be expected to:*

1. Define the emotional aspects of emergency care encountered by patients, patients' families, and first responders.
2. Define the five stages in the normal reaction to death and dying.
3. Explain at least six signs and symptoms of stress.
4. Explain the type of actions a first responder can take to reduce or alleviate stress.
5. Describe the following three phases in critical incident stress reduction:
 a. Pre-incident stress education
 b. On-scene peer support
 c. Critical incident stress debriefing (CISD)
6. Discuss the importance of body substance isolation.
7. Describe the universal precautions for preventing infectious diseases from bloodborne and airborne pathogens.
8. Describe three phases of scene safety.
9. Describe ten types of hazards to look for when assessing the scene for unsafe conditions.
10. Describe the safety equipment that first responders should have available for their protection.

Skill Objectives *As a first responder, you should be able to:*

1. Put on medical gloves.
2. Assess the scene of a real or simulated rescue scene for safety hazards.
3. Properly use the safety equipment needed for first responders.

The purpose of this chapter is to help you understand the factors that may affect your physical or emotional well-being as a first responder. These factors include both the stress you experience and the stress patients and their families experience. Methods for preventing and reducing stress are addressed. This chapter also discusses hazards you may encounter from infectious diseases and presents methods you must follow in order to reduce your risk of infection. Finally, this chapter covers scene safety and the methods you can use to prevent injury to yourself and further injury to your patients.

Emotional Aspects of Emergency Medical Care

Providing emergency medical care as a first responder is a stress-producing experience. This stress is felt by you and by patients, their families and friends, and bystanders. Your job as a first responder is to keep yourself in the best condition so you can avoid unnecessary stress. Because stress cannot be completely eliminated, you must learn how to prevent your stress level from getting too high. Some of the same techniques that you will learn can also be used to reduce stress in your patients and in their families and friends.

Though all emergency medical care produces a certain level of stress, some types of calls are more stressful than others. For example, if a patient with severe injuries reminds you of a close family member, you may have a difficult time treating the patient without experiencing a high level of stress. This is especially true if an emergency call involves a very young patient or a very old patient (Figure 2.1). You may find it hard to deal with certain types of calls because of your past experiences. Calls involving death or violence are likely to produce high levels of stress. Pediatric patients and mass casualty situations also produce high levels of stress.

Fig. 2.1 Certain kinds of patients may produce a high level of stress.

CAUTION

Do not underestimate the effect that stress can have on you. A firefighter or law enforcement official in a busy department will see much more suffering in a short period of time than many people will see in their entire lifetime.

It is important to understand that you work in a stressful environment and that you must make an effort to prevent and reduce unnecessary stress. You can do this in several different ways: learn to recognize the signs and symptoms of stress, adjust your lifestyle to include stress-reducing activities, and learn what services and resources are available to help you.

Normal Reactions to Stress

You need to understand how stress can affect you and the people for whom you provide emergency medical services. Because one of the most intense types of stress that we can experience is death and dying, we will use the grief reaction to death and dying as a basis for looking at stress. Remember that not only do the patient and the patient's family go through this grief process when dealing with death and dying, but you as a caregiver must work through the stress of death and dying, too, even though you are not involved with the patient in the same way as the patient's family.

Although not all people move through the grief process in exactly the same way and at the same pace, one well-recognized model for looking at the reaction to death and dying defines five stages: denial, anger, bargaining, depression, and acceptance. Because people work through the process at different rates, they may be experiencing any stage of grief when you first encounter them.

1. *Denial ("Not me!")*. The first stage in the grief process is **denial**. A person experiencing denial cannot believe what is happening. This stage may serve as a protection for the person experiencing the situation, and it may also serve as a protection for you as the caregiver. Realize that this reaction is normal.

 Denial The first stage of a grief reaction, when the person suffering grief rejects the grief-causing event.

2. *Anger ("Why me?")*. The second stage of the grief process is **anger**. Understanding that anger is a normal reaction to stress can also help you deal with anger that is directed toward you by a patient or by a patient's family. Do not get defensive; you need to realize that this anger is a result of the situation. From this understanding comes the ability to tolerate the situation without letting the patient's anger distract you from performing your duties as an emergency medical provider.

 Anger The second stage of the grief reaction, when the person suffering grief becomes upset at the grief-causing event or other situation.

 Your anger may be directed at the patient or the patient's family or it may be directed at your co-worker or your family. Anger is a normal reaction to unpleasant events. Sometimes it is helpful to talk out your anger with co-workers, family members, or a counselor. By talking through your anger, you avoid keeping it bottled up inside where it can cause unhealthy physical symptoms or emotional reactions. Directing the energy from that anger at doing what you can to alleviate the bad situation may help you move forward. For example, at the scene of an auto accident, you may be angry that a child has been injured. Directing your energy to provide the best medical care for the injured child may help you work through your feelings.

Bargaining The third stage of the grief reaction, when the person experiencing grief barters to change the grief-causing event.

Depression The fourth stage of the grief reaction, when the person expresses despair—an absence of cheerfulness and hope—as a result of the grief-causing event.

Acceptance The fifth stage of the grief process, when the person experiencing grief recognizes the finality of the grief-causing event.

3. *Bargaining ("Okay, but . . .").* The third stage of the grief process is **bargaining**. Bargaining is the act of trying to make a deal to postpone death and dying. If you encounter a bargaining patient, try to respond with a truthful and helpful comment such as, "We are doing everything we can and the paramedics will be here in 5 to 7 minutes." Remember that bargaining is a normal part of the grief process.

4. *Depression.* The fourth stage of the grief process is **depression**. Depression is often characterized by sadness or despair. People may be depressed when they are unusually silent, and they seem to retreat into their own world. Depression may be the stage where a person is beginning to accept the situation. It is not surprising that patients and their families get depressed about a situation that involves death and dying. Likewise it is not surprising that you as a rescuer would get depressed, too. Our society tends to consider death a failure of medical care rather than a natural event that will happen to us all. A certain amount of depression is a natural reaction to a major threat or loss. The depression can be mild or severe; it can be of short duration or long lasting. If depression continues, it is important to contact qualified professionals who can help you.

5. *Acceptance.* The fifth stage of the grief process is **acceptance**. Acceptance does not mean that you are satisfied with the situation. It means that you can understand that death and dying cannot be changed. It may require a lot of time to work through the grief process and arrive at the stage of acceptance. As an emergency medical provider, you may see this stage of the grieving process in families who have had a period of time to realize that this illness is a terminal event and that the patient is not going to recover. Not all people experiencing grief are able to work through their grief and accept the loss of their loved one.

By understanding the five stages, you can better understand the grief reaction experienced by patients, their families, and their friends. You can also better understand your reaction to stressful situations. Some helpful techniques for dealing with patients in stressful situations are presented in Chapter 11. These techniques will help you to develop more comfort and skill when dealing with stressful situations.

Stress Management

Stress management has three components: recognition of stress, prevention of stress, and reduction of stress.

Recognition of Stress

An important step in managing your stress or the stress in others is the ability to recognize its signs and symptoms. By learning the following warning signs of stress, you should be able to prevent or reduce stress:

- Irritability (often directed at co-workers, family, and friends)
- Inability to concentrate
- Change in normal disposition
- Difficulty in sleeping or nightmares (hard to recognize because many emergency care workers work a pattern of rotating hours that makes normal sleep patterns hard to maintain)
- Anxiety
- Indecisiveness

- Guilt
- Loss of appetite
- Loss of interest in sexual relations
- Loss of interest in work
- Isolation

These signs of stress should help you recognize stress in co-workers or friends or in yourself.

Prevention of Stress

Three simple-to-remember techniques that can prevent stress are: eat, drink, and be merry (in a healthy stress-reducing manner).

1. *Eat.* A healthy well-balanced diet contributes to the prevention and reduction of stress. A healthy daily diet should include six to eleven servings of bread, cereal, rice, and pasta; three to five servings of vegetables; two to four servings of fruits; two to three servings of milk, yogurt, and cheese; two to three servings of meat, poultry, fish, and eggs; and a limited amount of fats, oils, and sweets. This healthy diet is illustrated by the Food Guide Pyramid (Figure 2.2). Many of us need to cut down on the amount of fat and sweets that we eat. Eating large quantities of sweets raises your blood sugar level and causes blood sugar levels to drop a couple of hours later. This drop in blood sugar levels causes you to crave more sugar. It is much better to eat an adequate amount of breads, cereals, rice, and pasta. These provide energy over a longer period of time and help to reduce the highs and lows brought on by excess sugars.

 It is hard to maintain a regular schedule of eating when you are an emergency medical services provider. By planning your food intake and having healthy food available, you can improve your eating habits.

Fig. 2.2 A healthy diet is illustrated by the USDA food guide pyramid.

KEY ◎ Fat (naturally occurring and added)
▽ Sugar (added)
These symbols show fat and added sugars in foods.

Fats, oils, and sweets
Use sparingly

Milk, yogurt, and cheese group
2–3 servings

Meat, poultry, fish, dry beans, eggs, and nuts group
2–3 servings

Vegetable group
3–5 servings

Fruit group
2–4 servings

Bread, cereal, rice, and pasta group
6–11 servings

Fig. 2.3 Drinking adequate quantities of water and juice is important.

Healthy eating helps to cut down on your stress level and also helps reduce your risk of heart and blood vessel diseases, which are the most common cause of death in public safety workers. Keeping your weight at recommended levels also helps your body deal better with stress.

2. *Drink.* Adequate amounts of liquids are important for active emergency medical services providers (Figure 2.3). Dehydration is a risk for law enforcement officers, firefighters, and EMS providers. Water in adequate quantities is essential for maintaining proper body processes. Natural fruit juices are another good source of fluids.

 Avoid consuming excessive amounts of caffeine and alcohol. Caffeine is a drug that causes adrenaline to be released in your body; adrenaline raises your blood pressure and increases your stress level. By limiting your intake of caffeine-containing beverages such as coffee and cola drinks, you can reduce your tendency toward stress. Drinking alcoholic beverages is to be discouraged. Though alcoholic drinks seem to relax you, they cause depression and reduce your ability to deal with your stress.

3. *Be merry.* A happy person is not suffering from elevated stress. It is important to balance your lifestyle. Assess both your work environment and your home environment. At work, address problems promptly before they produce major stress. Try to schedule your work to allow adequate off-duty time for sleep and personal activities. If you are working in a volunteer agency, avoid having all people on call all the time. Avoid the use of tobacco products; they are stress producers.

 Try to create a stress-reducing environment away from work. Spend time with your friends and family. In your recreational activities, include friends who are not co-workers. Develop hobbies or activities that are not related to your job. Exercise regularly. Exercise is a great stress reliever. Swimming, running, and bicycling are three types of excellent aerobic exercise. For some people, meditation or religious activities reduce stress. People who are able to balance the pressures of work with relaxing activities at home are usually able to enjoy life much more than people who can never leave the stories and stress of work behind. If you are feeling stress away from your job, consider seeking assistance from a mental health care professional.

Reduction of Stress

If pressures at work or home cause continual stress, you may benefit from the help of a mental health professional. This person is trained to listen nonjudgmentally and to help you resolve the issues that are causing your stress. Mental health professionals include psychologists, psychiatrists, social workers, and specially trained clergy. A mental health professional may be connected with your department. Your medical insurance may cover this type of care.

Critical Incident Stress Management is a comprehensive program that is available through many public safety departments. It consists of pre-incident stress education, on-scene peer support, and critical incident stress debriefings (CISDs). You should contact CISD personnel whenever you are exhibiting signs or symptoms of stress.

Pre-incident stress education
Training about stress and stress reactions conducted for public safety providers before they are exposed to stressful situations.

1. **Pre-incident stress education** provides information about the stresses that you will encounter and the reactions you may experience. It helps emergency responders understand the normal stress response to the abnormal emergency situations they encounter.

Fig. 2.4 Critical incident stress debriefings (CISD) are important to relieve stress.

2. **On-scene peer support** and disaster support services provide support for you on the scene of especially stressful situations. Examples of this include major disasters and situations that involve the death of a co-worker or a child.

3. **Critical incident stress debriefings (CISDs)** are used to alleviate the stress reactions caused by high-stress emergency situations. Debriefings consist of a meeting between emergency responders and specially trained leaders. The purpose of debriefings is to allow an open discussion of feelings, fears, and reactions to the high-stress situation.

 A debriefing is not an investigation or an interrogation. Debriefings are usually held within 24 to 72 hours after a major incident. The CISD leaders offer suggestions and information on overcoming the stress (Figure 2.4).

 Find out if your department has a critical incident stress debriefing program. Contact this team if you are involved in a high stress incident such as a call that involves a very young or a very old patient, a mass casualty incident, or a situation that involves unusual violence. If you think you might be experiencing unusual signs or symptoms of stress, contact your supervisor or a stress counselor. More information about critical incident stress is available in Chapter 11.

On-scene peer support Stress counselors at the scene of stressful incidents to deal with stress reduction.

Critical incident stress debriefing (CISD) A system of psychological support designed to reduce stress on emergency personnel after a major stress-producing incident.

Check Point

✔ List six signs and symptoms of stress.

✔ Are you experiencing any of these signs or symptoms of stress?

✔ What actions or changes in your lifestyle might help you reduce your stress?

✔ What calls have you or your department experienced recently that might have caused critical incident stress?

✔ How do you access the CISD system in your department?

Scene Safety

Infectious Diseases and Body Substance Isolation (BSI)

In recent years, partly as a result of the acquired immunodeficiency syndrome (AIDS) epidemic and the growing concern about tuberculosis and hepatitis, there has been an increased awareness of infectious diseases. Some understanding of the most common infectious diseases is important so you can protect yourself from unnecessary exposure to these diseases and so you do not become unduly alarmed about them.

Federal regulations require all health care workers, including first responders, to assume that all patients in all settings are potentially infected with human immunodeficiency virus (HIV), the virus that can lead to AIDS, hepatitis B virus (HBV), or other bloodborne **pathogens**. These regulations require that all health care workers use protective equipment to prevent possible exposure to blood and certain bodily fluids of patients. This concept is known as **body substance isolation (BSI)**.

HIV is transmitted by direct contact with infected blood, semen, or vaginal secretions. There is no scientific documentation that the virus is transmitted by contact with sweat, saliva, tears, sputum, urine, feces, vomitus, or nasal secretions, unless these fluids contain visible signs of blood.

Hepatitis B is also spread by direct contact with infected blood. First responders should follow the universal precautions described in the next section to reduce their chance of contracting hepatitis B. Check with your medical director about receiving injections of hepatitis vaccine to protect you against this infection.

Tuberculosis is also becoming a common problem, and the presence of resistant strains makes this disease very dangerous to first responders. Tuberculosis is spread through the air whenever an infected person coughs or sneezes. Place a face mask or a high-efficiency particulate air (HEPA) respirator (Figure 2.5) on yourself and an oxygen mask on the patient to minimize your exposure. If no oxygen mask is available, place a face mask on the patient. First responders should have a skin test for tuberculosis every year.

Pathogens Microorganisms that are capable of causing disease.

Body substance isolation (BSI) An infection control concept that treats all bodily fluids as potentially infectious.

Fig. 2.5 Two types of respirators that reduce the transmission of airborne diseases.

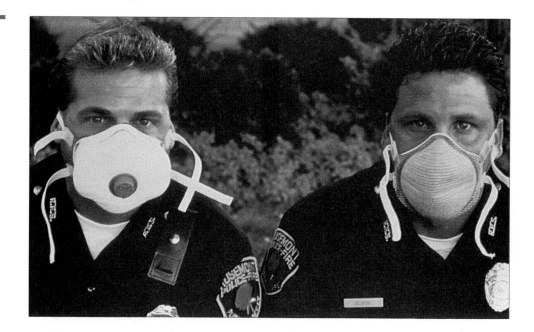

Universal Precautions

You will not always be able to tell whether a patient's bodily fluids contain blood. Therefore, the Centers for Disease Control (CDC) recommends that all health care workers use universal precautions, based on the assumption that all patients are potential carriers of bloodborne pathogens.

The CDC recommends that all health care workers use the following **universal precautions**:

1. Always wear latex gloves when handling patients, and change gloves after contact with each patient (Figure 2.6). Wash your hands immediately after removing gloves. (Note that leather gloves are *not* considered safe—leather is porous and traps fluids.)

2. Always wear protective eye wear or a face shield when you anticipate that blood or other bodily fluids may splatter. Gowns or aprons should be worn if you anticipate splashes of blood or other bodily fluids such as those that occur with childbirth and major trauma.

Universal precautions Procedures for infection control that treat blood and certain bodily fluids as capable of transmitting bloodborne diseases.

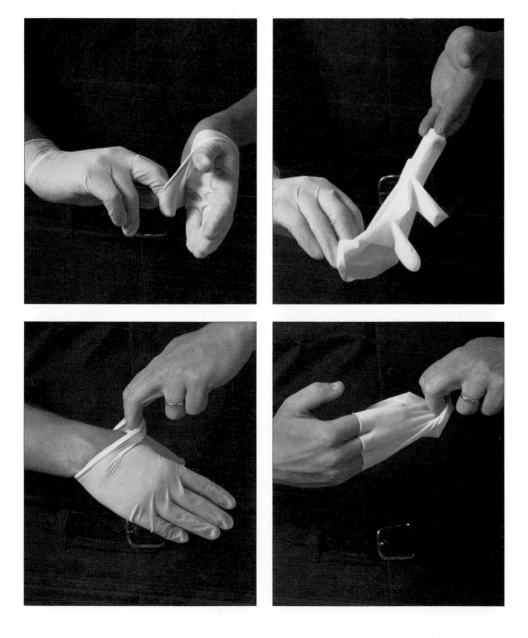

SAFETY PRECAUTION

Simple, portable safety equipment is helpful in preventing injuries and illnesses. Medical gloves, masks, and eye protection prevent the spread of infectious diseases. Brightly colored clothing or vests make you more visible to traffic in the daytime; reflective striping or vests make you more visible in the dark. Heavy gloves can help prevent cuts at a motor vehicle accident scene. A hard hat or helmet is needed when you are at an industrial or motor vehicle accident scene. Some situations require additional safety equipment. Do not hesitate to call for additional equipment as needed.

Fig. 2.6 Proper removal of gloves is important to minimize the spread of pathogens.

Fig. 2.7 Wash your hands thoroughly if you are contaminated with blood or other bodily fluids.

3. Wash your hands and other skin surfaces immediately and thoroughly if contaminated with blood and other bodily fluids (Figure 2.7). Change contaminated clothes and wash exposed skin thoroughly.

4. Do not recap, cut, or bend used needles. Place them directly in a puncture-resistant container designed for "sharps."

5. Even though saliva has not been proven to transmit HIV, use a face shield, pocket mask, or other airway adjunct if the patient needs resuscitation.

Regulations about body substance isolation are constantly changing. It is important for your department to keep up to date on these regulations. Regulations may be passed by federal agencies such as the Occupational Safety and Health Administration (OSHA) or by state agencies such as state public health departments.

Immunizations

Certain immunizations are recommended for emergency medical care providers. These include tetanus prophylaxis and hepatitis B vaccine. Tuberculin testing is also recommended. Your medical director can determine what immunizations and tests are needed for members of your department.

Responding to the Scene

Scene safety is a most important consideration to you as a first responder. Safety considerations need to include your own safety and the safety of all the other people present at the scene of an emergency. Close attention to factors involving safety can prevent unnecessary illness, injuries, and death.

Remember: If you are injured or killed, you lose your ability to help those in need.

Dispatch

Safety begins when you are dispatched to an emergency. Use your dispatch information to anticipate what hazards may be present and to determine how to approach the scene of the emergency.

Response

One of the biggest causes of death and disability of both law enforcement officials and firefighters is vehicle accidents. As you respond to the scene of an emergency, remember the safety information that you have been taught in your driving courses. Fasten your safety belt, plan the best route, and drive quickly but safely to the scene.

Parking Your Vehicle

Upon arrival at the scene, park your vehicle so that it protects the emergency scene from traffic hazards. Check to be sure that the emergency warning lights are operating correctly. Be careful when getting out of your vehicle, especially if you must step into a traffic area. Brightly colored uniforms or vests can help make you more visible in the daytime; reflective material on your uniform or on a safety vest helps make you more visible in the dark (Figure 2.8). If your vehicle is not needed to protect the incident scene, park it out of the way of traffic and in a manner that allows room for other arriving vehicles such as ambulances to be positioned near the patient. Above all else, make sure that you have protected the emergency scene from further accidents.

Fig. 2.8 Reflective clothing helps to make you more visible.

Assessing the Scene

As you approach the emergency, scan the scene carefully to determine what hazards are present. The following hazards may be considered in a different order than that in which they are listed here; the type of emergency dictates the hazards that need to be assessed first. For example, you should assess the scene of a motor vehicle accident for downed electrical wires before you check for broken glass.

Traffic

Is traffic a problem? Sometimes (for example, on a busy highway) your first action should be to control the flow of traffic so that the original accident or incident is not made worse by additional accidents. If you need more help to handle traffic, call for assistance before you get out of your vehicle.

Crime or Violence

If your dispatch information leads you to believe that the incident involves violence or a crime, approach carefully. If you are trained in law enforcement procedures, follow your local protocols. If you are not a law enforcement official, proceed very carefully. If you have any doubts about the safety of the scene, it is better to wait at a safe distance and request help from law enforcement officials. If the scene involves a crime, remember to take a mental picture of the scene and avoid disturbing anything at the scene unless it is absolutely necessary to move objects to provide patient care.

Crowds

Crowds come in all sizes and have different personalities. Friendly neighborhood crowds may interfere very little with your duties. Unfriendly crowds may require a police presence before you are able to treat the patient. Assess the feeling of the crowd before you have gotten yourself in a position from which there is no exit. Request help from law enforcement officials before the crowd is out of control. Safety considerations may require you to wait for the arrival of police before you approach the patient.

Electrical Hazards

Electrical hazards can be present at many different types of emergency scenes. Patients located inside buildings may be in contact with a wide variety of electrical hazards, ranging from a faulty extension cord in a house to a high voltage feeder line in an industrial setting. Patients located outside may be in contact with high voltage electrical power lines that have fallen because of a motor vehicle accident or a storm. Electricity is invisible.

You must assess the emergency scene for any indications of electrical problems. Inside a building, look for cords, electrical wires, or electrical appliances near or in contact with the patient; outside, look for damaged electrical poles and downed electrical wires. Do not approach an emergency scene if there are indications of electrical problems. Keep all other people away from the source of the hazard, too. Make sure that the electrical current has been turned off by a qualified person before you get close to the source of the current.

Fire

Fire is a hazard that can result in injury or death to you and to the patient. If there appears to be a fire, call at once for fire department assistance. If you are trained as a firefighter, follow rescue and fire-fighting procedures for your

department. If you are not a trained firefighter, do not exceed the limits of your training. Entering a burning building without proper turnout gear and self-contained breathing apparatus is an unwise course of action. Any attempt to rescue someone from a burning building is a high risk undertaking. Vehicles that have been involved in accidents also may present a fire hazard from fuel or other spilled fluids. Keep all sources of ignition such as cigarettes and fusees away. Carefully assess the fire hazard before you determine your course of action.

Hazardous Materials

Hazardous materials (sometimes referred to as "haz mats") may be found almost anywhere. Some transportation accidents involve hazardous materials. They may also be found in homes, businesses, and industries. Federal regulations require vehicles that are transporting hazardous materials to be marked with specific placards (Figure 2.9). If you believe that an accident may involve hazardous materials, stop your vehicle far enough away from the accident to determine if the vehicle is marked with a placard. A pair of binoculars in the life support kit is helpful for this. The placard indicates the class of material that is being carried. You should carry a guide book to assist you in determining the hazard involved. The presence of odors or fumes may be the first indication of hazardous materials located in buildings. If you believe that a hazardous material is present, call for assistance from the agency that handles hazardous materials in your community. Remain far enough away from a suspected haz-mat incident that you do not become an additional casualty. (See Chapter 16 for more information on handling hazardous materials incidents.)

Unstable Objects

Unstable objects may include vehicles, trees, poles, buildings, cliffs, and piles of materials. After an accident, a motor vehicle may be located in an unstable position. It is sometimes necessary to stabilize a vehicle before patient extrication can begin. Do not attempt to enter or get under an unstable vehicle. Motor vehicle accidents may result in other unstable objects, including trees or poles that were hit in the accident. Fires and explosions can result in unstable buildings. Assess a building for stability before attempting to enter it. If you are in doubt about the safety of the building, call for trained personnel rather than attempting to enter an unsafe building.

Fig. 2.9 Hazardous materials placards.

Sharp Objects

Sharp objects are present in a wide variety of emergency settings. These range from broken glass at the scene of a motor vehicle accident to hypodermic needles in the pocket of a drug addict. Being aware of sharp objects can reduce the chance of injury to yourself and to your patients. Vinyl or latex medical gloves can help prevent the spread of disease from blood contamination, but they provide no protection against sharp objects. When glass or other sharp objects are present, you should wear heavy leather or fire-fighting gloves to prevent injuries.

Animals

Animals are present in a wide variety of indoor and outdoor settings. If you need to enter a house to take care of a patient, be sure excited pets have been secured in a part of the house away from the patient. Pets can become very upset in the confusion of a medical emergency. Pets may be present at the scene of a motor vehicle accident. Farm animals can be a safety hazard, too. Be careful when entering a field that may contain livestock. Animals may present other hazards such as bites or stings. Careful assessment of the incident scene can prevent unnecessary injuries.

Environmental Conditions

The weather is always with us and we cannot change it. Therefore, you should consider the effect it will have on rescue operations. Dress appropriately for the expected weather. Keep patients at a comfortable temperature and keep them dry. Be prepared for temperature extremes. Avoid getting too hot or too cold. Be prepared for precipitation. Be alert to possible damage from high winds. Darkness makes it hard for you to see all the hazards that may be present. Use any emergency lighting that is present. A flashlight is a valuable tool to have in many rescue situations.

Special Rescue Situations

Special safety considerations are required in special rescue situations, four of which are: water rescue, ice rescue, confined space or below grade rescue, and mass casualty situations. These situations are covered in Chapters 16 and 18. Do not enter an emergency situation that is unsafe unless you have the proper training and equipment.

Airborne and Bloodborne Pathogens

Because airborne and bloodborne pathogens cannot be seen directly, you should always remember the universal precautions described earlier and apply them as appropriate.

CHAPTER
REVIEW 2

Summary

This chapter covers the topics needed to help you understand the role that stress plays in the lives of emergency care providers and patients who have suffered a sudden illness or accident. Stress is a normal part of our lives. The five stages of the grief process that occur as a result of the grief of death or dying are: denial, anger, bargaining, depression, and acceptance. Patients and rescuers move through these stages at different rates. Stress management consists of recognizing, preventing, and reducing critical incident stress.

Scene safety is an important part of your job. You should understand how airborne and bloodborne infectious diseases are spread and how body substance isolation prevents their spread. As you arrive on the scene of an accident or illness, you must assess the scene for a wide variety of hazards, including traffic, crime, crowds, unstable objects, sharp objects, electrical problems, fire, hazardous materials, animals, environmental conditions, special rescue situations, and infectious disease exposure. You should understand the safety equipment that is needed for first responder rescue situations.

Key Terms

Acceptance—page 24

Anger—page 23

Bargaining—page 24

Body substance isolation (BSI)—page 28

Critical incident stress debriefing (CISD)—page 27

Denial—page 23

Depression—page 24

On-scene peer support—page 27

Pathogens—page 28

Pre-incident stress education—page 26

Universal precautions—page 29

What Would You Do?

1. You are dispatched to the scene of a two-vehicle accident. Upon arrival at the scene, you note that one car and one medium-size truck have collided. What hazards should you check for as you assess the scene of this accident?
2. You are called to a residence for a report of a sick person. As you arrive at the door of the house, you are met by a family member who tells you that the patient has an infectious disease. What questions should you ask the family member and what precautions should you take?

You Should Know

1. The emotional aspects of emergency care encountered by patients, patients' families, and first responders.
2. The five stages in the normal reaction to death and dying.
3. The six signs and symptoms of stress.
4. The three major areas involved in the prevention of stress.
5. The three phases in critical incident stress reduction.
 a. Pre-incident stress education
 b. On-scene peer support
 c. Critical incident stress debriefing (CISD)
6. Body substance isolation procedures.
7. The universal precautions for preventing infectious diseases from blood-borne and airborne pathogens.
8. The three phases of scene safety involved with responding to the scene.
9. The ten types of hazards that may be found when assessing the scene for unsafe conditions.
10. The safety equipment that first responders should have available for their protection.

You Should Practice

1. Putting on medical gloves.
2. Assessing the scene of a real or simulated rescue scene for safety hazards.
3. Using the safety equipment needed for first responders' safety.

CHAPTER 3

LEGAL AND ETHICAL ISSUES

Knowledge and Attitude Objectives *After studying this chapter, you will be expected to:*

1. Define "duty to act" as it relates to a first responder.
2. Describe the standard of care and the scope of care for a first responder.
3. Describe and compare the following types of consent:
 a. Expressed consent
 b. Implied consent
 c. Consent for minors
 d. Consent of mentally ill patients
 e. Refusal of care
4. Explain the purpose of living wills and advance directives.
5. Describe the importance of the following legal concepts:
 a. Abandonment
 b. Death on the scene
 c. Negligence
 d. Confidentiality
6. Explain the purpose of Good Samaritan laws.
7. Describe the federal, state, and local regulations that apply to first responders.
8. Describe reportable events in your local area.
9. Describe the steps to be taken at a crime scene.
10. Explain the reasons for documentation.

First responders need to know some basic legal principles related to the way in which they provide care to patients. Knowing these principles can help you provide the best care for patients and prevent situations that could result in legal difficulties for you, your agency, or your department. Because some laws differ from one location to another, you will need to gain an understanding of the laws of your state and your local jurisdiction.

Duty to Act

Duty to act A first responder's legal responsibility to respond promptly to an emergency scene and provide medical care (within the limits of training and available equipment).

The first legal principle to consider is the **duty to act.** As an ordinary citizen arriving on the scene of an automobile accident, you are not required by law to stop and give emergency care to victims. If, however, you are employed by an agency that has designated you as a first responder and if you are dispatched to the scene of an accident or illness, you do have a duty to act. You must proceed promptly to the scene and render emergency medical care within the limits of your training and available equipment (Figure 3.1). Any failure to respond or render necessary emergency medical care leaves you or your agency (or both) open to the threat of legal action.

Standard of Care

What level of care are you expected to give to a patient? As a first responder, you cannot be held accountable for providing the same level of care as a physician could, but you are responsible for providing the level of care that a person with similar training would provide under similar circumstances. As a person trained in a first responder emergency care course, you are expected to use the knowledge and skills you were taught.

Standard of care The manner in which an individual must act or behave when giving care (often defined by national organizations such as the American Heart Association).

The circumstances under which you must provide care may affect the **standard of care**. For example, if you are working in darkness and rain, you may not be able to perform as well as someone working in a well-lighted room. To comply with the standard of care, you must treat the patient to the best of your ability and in a manner in which a reasonable, prudent person with similar training would under similar circumstances. It is important to know exactly what the local standards of care are and what statutes pertain to your community.

Fig. 3.1 First responders being dispatched to an emergency scene.

Scope of Care

The scope of care you give as a first responder may be defined by the National Curriculum for First Responders, developed by the United States Department of Transportation. This curriculum specifies the skills in which you will receive training and the manner in which those skills are to be performed. In some states, your scope of care is prescribed by state laws. These laws may modify in some ways the scope of practice specified in the National Curriculum. The medical director for your department may use medical protocols or standing orders to specify your scope of care. In some cases, on-line medical direction is provided by two-way radio or wireless telephone.

Ethical Responsibilities and Competence

Your community and your department have entrusted you, as a first responder, with certain ethical responsibilities. You have a responsibility to conform to accepted professional standards of conduct. These include maintaining up-to-date first responder skills and knowledge needed to provide good patient care. You are also responsible for reviewing your performance and assessing the techniques you use. You should evaluate your response times and try to follow up patient care outcomes with your medical director or hospital personnel. Always be looking for ways you can improve your performance. Continuing education classes and refresher courses are designed to keep you up to date. Make the most of them. Participate in quality improvement activities within your department.

Ethical behavior requires honesty. Prepare reports to accurately reflect the conditions found. Give complete and accurate reports to other EMS providers. If you make a mistake, document it. Never change a report except to correct an error. Remember that the actions you take in the first few minutes of an emergency may make the difference between life or death for a patient. Your competence and your ethical behavior are valuable to you and to the patient.

Consent for Treatment

Consent simply means approval or permission. Legally, however, there are several types of consent. **Expressed consent** is the permission to treat that the patient gives the first responder. If you approach a patient and the patient can understand who you are and gives expressed consent for treatment, you may begin patient care.

Any patient who does not refuse emergency care can be treated under the principle of **implied consent.** The principles of implied consent are clearest in the situation of the unconscious patient for whom you have been called to provide emergency care. This patient has, under the principles of law, given implied consent for treatment as a result of his or her inability to communicate. Therefore, a first responder need not hesitate to treat an unconscious patient.

Expressed consent Consent actually given by a person authorizing the first responder to provide care or transportation.

Implied consent Consent to receive emergency care that is assumed because the individual is unconscious, underage, or so badly injured or ill that he or she cannot respond.

≡ SPECIAL NEEDS

Consent for Minors A minor is a person who has not yet reached the legal age designated by a particular state. Under the law, minors (who may be as old as 18) are not considered capable of speaking for themselves. In most

cases, emergency treatment of a minor by a physician must wait until permission is received from a parent or legal guardian. If a minor requires emergency medical care in the field (out of the hospital) and the permission of a parent or legal guardian cannot be quickly obtained, do not hesitate to give appropriate emergency medical care. Do not withhold emergency medical treatment from a minor just to obtain permission from a parent or legal guardian (Figure 3.2). Let hospital officials determine what hospital treatment can be delayed until permission is obtained. Remember that good prehospital patient care is your first responsibility. By following the course of action that is best for the patient, you will stand on firm legal ground.

Consent of Mentally Ill If the patient appears to be out of touch with reality, is a danger to self or others, and refuses to be treated, the legal issues can be complicated. A rational adult may legally refuse to be treated. The difficult part, even for highly trained medical personnel, is determining whether the patient has such control. Generally, if the person appears to be a threat to self or to others, arrangements need to be made to place this person under medical care. The legal means by which these arrangements are made vary from state to state. You and other members of the EMS system should know your state's legal mechanism for handling patients who refuse to be treated and who do not appear to be making rational and reasonable decisions. Do not hesitate to involve law enforcement agencies, because this process may require the issuance of a warrant or an order of protective custody.

Fig. 3.2 Do not withhold treatment from a patient who is a minor.

VOICES *of* EXPERIENCE

"I have served as a Lieutenant firefighter/paramedic for the past 21 years and have had the opportunity to acquire and use many skills. The skill that I feel has been the most valuable to my career is not one that you can find in a book or learn in school, but rather it is discovered only through the one-on-one interaction with individuals who depend on you in their time of physical and sometimes emotional emergencies. Compassion is essential in every situation; all patients need to be treated with the same care and respect. I feel that every patient should be treated as you would want your own family to be treated.

The most significant and difficult emergency situations I have experienced involve small children who have been injured by possible child abuse. Another emergency that has been the worst for me is SIDS. The family is found hysterical, and you may have to make the decision to go through the steps of CPR and transport the patient so the family will at least feel that everything possible was done for this infant. In trying to show compassion to grieving families, I have at times found myself shedding a few tears with the family and sharing in their grief.

Responding to emergencies involving individuals who have injured themselves by a drug overdose or alcohol abuse requires a different feeling of compassion. I have dealt with individuals who have hurt themselves with any of a number of different weapons and have little concept of what they are doing to themselves, much less their families. You must be there to show compassion for these people in their time of mental distress.

Patients are often very frightened in traumatic situations, and the compassion of an EMS provider can help to relieve the stress and fear; it can be a tool for treating the patient, loved ones, and fellow EMS providers."

Joseph D. Escobedo
EMT-P
Lt. Firefighter/Paramedic
Albuquerque Fire Department
Albuquerque, New Mexico

Patient Refusal of Care

Competent Able to make rational decisions about personal well-being.

Remember that any person who is mentally "in control," or **competent**, has a legal right to refuse treatment from emergency medical personnel at any time. You can continue to talk with a person refusing treatment and try to help him or her understand the consequences of refusal to accept proper medical care. Sometimes another EMS provider or a law enforcement officer may have more success in convincing a patient of the need to receive treatment.

✓ What are the differences between the following types of consent:

- Actual consent
- Implied consent
- Consent for minors

- Consent of mentally ill patients
- Lack of consent or refusal of care

Living Wills

Living wills Legal documents with specific instructions that the patient does not want to be resuscitated or kept alive by mechanical support systems.

A **living will** is a written document drawn up by a patient, a physician, and a lawyer. Similar documents may also be known as advance directives, advance directives to physicians, durable power of attorney for health care, or do not resuscitate (DNR) orders. Living wills are often written when a patient has a terminal condition. Living wills specify conditions under which patients do not want certain medical procedures to be done for them. For example, terminally ill patients may request that CPR not be performed on them. Because first responders are not in a position to determine if living wills or advance directives are legally valid, or to determine the identity of patients, you should begin appropriate medical care and leave questions about living wills and advance directives to physicians. Some states have systems, such as bracelets, to identify patients with advanced directives. You should become informed about local policies and protocols.

Abandonment

Abandonment Failure of the first responder to continue emergency medical treatment.

Abandonment is a situation in which a trained person begins emergency care and then leaves the patient before another person arrives to take over. Once you have started treatment, you must continue that treatment until a person who has at least as much training as you arrives on the scene and takes over. You should not leave a patient without care after treatment has begun.

In cases of abandonment, the most common scenario is as follows: an EMS provider is called to a patient, examines the patient, assesses the patient's condition, fails to transport the patient to a hospital, and finds out later that the patient died. Treatment was begun, but the patient was abandoned.

Persons Dead at the Scene

If there is any indication that a person is alive when you arrive on the scene, you should begin the care that is needed. Persons who are obviously dead

should be handled according to the laws of your state and the protocols of your service. Generally the only indications that you may use to consider a person to be dead are these four signs:

1. *Decapitation.* Decapitation means that the head is separated from the body. When this occurs, there is obviously no chance of saving the patient.

2. *Rigor mortis.* Rigor mortis is the temporary stiffening of muscles that occurs several hours after death. The presence of this stiffening indicates that the patient is dead and cannot be resuscitated.

Fig. 3.3 Learn the protocol for dealing with patients who are obviously dead at the scene.

3. *Evidence of tissue decomposition.* Tissue decomposition or actual flesh decay occurs only after a person has been dead for more than a day.

4. *Dependent lividity.* Dependent lividity is the red or purple color that occurs on the parts of the patient's body that are closest to the ground. It is caused by blood seeping into the tissues on the dependent or lower part of the person's body. Dependent lividity occurs after a person has been dead for several hours.

If any of these signs is present, you can usually consider the patient to be dead. It is important that you know the protocol your department uses in dealing with patients who are dead on the scene (Figure 3.3). Chapter 8 covers these criteria in relation to the decision on when to start CPR.

Negligence

Negligence occurs when a patient suffers further injury or harm as a result of care administered in a manner that does not meet standards expected from a person with similar training in a similar situation. For negligence to occur, these four conditions must be present:

Negligence Deviation from the accepted standard of care resulting in further injury to the patient.

1. Duty to act
2. Breech of duty
3. Resulting injuries
4. Proximal cause

As a first responder who has been called to a scene to provide patient care, you have a *duty* to help the patient. If you fail to provide care according to the level of your training, this could constitute a *breech of duty*. For negligence to be proved, the patient must sustain *injuries* as a result of your improper care. Injuries related to your failure to act properly constitute *proximal cause,* or cause related to your negligent actions. Examples of negligence include reckless or careless performance or care that does not meet the accepted standard for a first responder.

Confidentiality

Most patient information is confidential. Confidential information includes patient circumstances, patient history, assessment findings, and patient care given. This information should be shared only with other medical personnel who are involved in the care of a patient. You must not discuss this privileged information with your family or friends.

Some information about a patient's care may be classified as public information. Public information may include the type of incident and the patient's name. You should learn what patient information is considered to be public information in your state. Public information can be released to the news media through whatever process your department has approved.

Remember: Patient information is confidential.

Good Samaritan Laws

Good Samaritan laws Laws that encourage individuals to voluntarily help an injured or suddenly ill person by minimizing the liability for any errors or omissions in rendering good faith emergency care.

Good Samaritan laws were passed in an effort to reduce the liability of persons who stop at accidents or emergency situations to give emergency medical care. These laws vary considerably from state to state, and they may or may not apply to first responders in your state. Recently, legal experts have noted that Good Samaritan laws may no longer be needed because they provide no legal protection for a rescuer. Good Samaritan laws, in general, provide little or no legal protection for EMS providers.

Any properly trained first responder who practices the skills and procedures learned in a first responder course should not be overly concerned about lack of protection provided by a Good Samaritan statute.

Regulations

As a first responder, you are subject to a variety of regulations, which may include federal, state, local, and agency regulations. You should become familiar with these regulations so you can follow them. Especially important are the regulations that govern your ability to work as a first responder. You may be required to become registered or certified as a first responder through a state agency or you may be required to become registered through the National Registry of Emergency Medical Technicians. It is your responsibility to keep any required certifications or registrations up to date.

Reportable Events

State and federal agencies have requirements for reporting certain events, including crimes and infectious diseases. Among the crimes that are often reportable are knife wounds, gunshot wounds, auto accidents, suspected child abuse, domestic violence, elder abuse, and rape. You must learn which crimes are reportable in your area. You also need to know the method for reporting these crimes and how that is handled in your agency.

Certain infectious diseases are also reportable. It is important that you learn how this process is handled in your agency and that you learn what you are required to do.

Crime Scene Operations

Many emergency medical situations are also crime scenes. As a first responder, you should keep the following considerations in mind:

1. Protect yourself. Be sure the scene is safe before you try to enter.
2. If you determine that a crime scene is unsafe, wait until law enforcement personnel give the signal that the scene is safe for entry.
3. Your first priority is patient care. Nothing except your personal safety should interfere with that effort.
4. Move the patient only if necessary, such as for rapid transport to the hospital, CPR, or treatment of severe shock. If you must move the patient, take a mental "snapshot" of the scene.
5. Touch only what you need to touch to gain access to the patient. Provide patient care, and then leave the scene.
6. Preserve the crime scene for further investigation. Do not move furniture unless it interferes with your ability to provide care. If you must, move it as little as possible.
7. Be careful where you place equipment. Evidence can be altered or even destroyed by placing equipment on top of it.
8. Keep out nonessential personnel, such as curious neighbors.
9. After you have attended to a patient at a crime scene, write a short report about the incident and make a sketch of the scene that shows how and where you found the patient. This may be useful if you are required to recall the incident two or three years later (Figure 3.4).

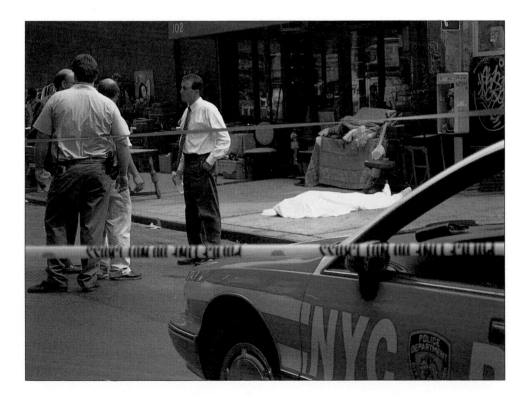

Fig. 3.4 Crime scene operations require you to change the scene as little as possible.

Documentation

Once you are done treating the patient, record your observations about the scene, the patient's condition, and the treatment you provided. Documentation should be done according to the policies of your organization. These policies should follow appropriate local and state laws. Documentation is important because it provides the beginning account of the condition of the patient and the care that the patient received and because you will not be able to remember the treatment you provide to all patients. It also serves as a legal record of your treatment and will be required in the event of a lawsuit. Documentation also provides a basis for evaluating the quality of care provided.

Documentation should be clear, concise, accurate, and readable. It should include the following information:

1. The condition of the patient when found
2. The patient's description of the injury or illness
3. The patient's initial and repeat vital signs
4. The treatment you gave the patient
5. The agency and personnel who took over treatment of the patient
6. Any other helpful facts
7. Any reportable conditions present
8. Any infectious disease exposure
9. Anything unusual regarding the case

CHAPTER REVIEW 3

Summary

This chapter introduces the legal principles you need to know as a first responder. As a first responder, you have a duty to act when you are dispatched on a medical call as a part of your official duties. You are held to a certain standard of care, which is related to your level of training, and you are expected to perform to the level a similarly trained person would perform under similar circumstances.

You should understand the difference in the following concepts of consent: expressed consent, implied consent, consent for minors, consent of mentally ill persons, and the right to refuse care. Living wills and advance directives give a patient the right to have care withheld. Because first responders cannot determine the validity of these documents, it is best to begin treatment for these patients. The concepts of abandonment, negligence, and confidentiality are covered. The purpose of Good Samaritan laws is covered, even though they are not needed for first responders.

You must understand the importance of federal and state regulations that regulate your performance as a first responder. You must also understand the regulations under which your department operates. Certain events that deal with contagious diseases or with illegal acts must be reported to the proper authorities. You should be familiar with the process for dealing with these reportable events. Crime scene operations are a complex environment. Following proper procedures assures that the patient receives good medical care and that the crime scene is not compromised for the law enforcement investigation.

It is said that your job is not complete until the paperwork is done. It is important that first responders document their findings and treatment. This provides good patient care and adequate legal documentation.

By understanding and following these legal concepts, you will have a good foundation for studying the skills you need to be a good first responder.

Key Terms

Abandonment—
page 42

Competent—
page 42

Duty to act—
page 38

Expressed
consent—page 39

Good Samaritan
laws—page 44

Implied consent—
page 39

Living wills—
page 42

Negligence—
page 43

Standard of care—
page 38

What Would You Do?

After responding to the scene of a one-car accident, you assessed the scene, examined the patient, and rendered care within the limits of your training. The paramedic ambulance arrives on the scene. What should you do?

A 12-year-old girl has been injured at school. The school principal cannot locate either of the girl's parents. Does the ambulance have the legal authority to transport the patient to the hospital for needed treatment? What legal principle applies here?

You Should Know

1. How the legal principle of "duty to act" applies to you as a first responder.
2. How the standard of care is determined for a first responder.
3. The difference between the following terms:
 a. Expressed consent
 b. Implied consent
 c. Consent for minors
 d. Consent of mentally ill patients
 e. Refusal of care
4. The purpose of living wills and advance directives.
5. The importance of the following legal concepts:
 a. Abandonment
 b. Death on the scene
 c. Negligence
 d. Confidentiality
6. The purpose of Good Samaritan laws.
7. The federal and state regulations that apply to you as a first responder.
8. The reportable events in your area.
9. The steps to be taken at the scene of a crime.
10. The reasons for documentation.

NOTES

THE HUMAN BODY: ANATOMY AND FUNCTION OF BODY SYSTEMS

Knowledge and Attitude Objectives *After studying this chapter, you will be expected to:*

1. Identify selected topographic (surface) anatomy.
2. Identify the basic structures and describe the basic functions of the following body systems:
 a. Respiratory
 b. Circulatory
 c. Skeletal
 d. Muscular
 e. Nervous
 f. Digestive
 g. Genitourinary
 h. Skin

Skill Objective *As a first responder, you should be able to:*

1. Identify selected topographic anatomy on a real or simulated patient.

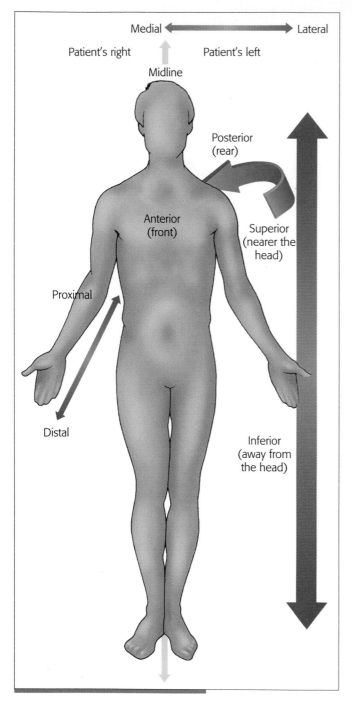

Fig. 4.1 Topographic anatomy terms for describing a location on the body.

Anterior The front surface of the body.

Posterior The back surface of the body.

Midline An imaginary vertical line drawn from the midforehead through the nose and the navel to the floor.

Medial Toward the midline of the body.

This chapter describes human anatomy and the relationships among eight body systems. To be an effective first responder, you must understand the basic structure and functions of the human body. This knowledge will help you understand the problem the patient is experiencing, perform an adequate patient examination, communicate your findings to the other members of the emergency medical team, and provide appropriate emergency treatment for the patient's condition.

Topographic Anatomy

Knowing the basic anatomic terms for human body parts is important because all members of the emergency medical team must be able to speak the same language when treating a patient.

Visualize a person standing in front of you, facing you, with arms at the sides and thumbs pointing outward (palms toward you). This is the standard anatomic position; you should keep it in mind when describing a location on the body. Figure 4.1 identifies topographic anatomy.

The first terms that should be clarified are left and right. These terms always refer to the patient's left and right. **Anterior** and **posterior** simply mean front (anterior) and back (posterior). The **midline** refers to an imaginary vertical line drawn from head to toe that separates the body into a left half and a right half.

Two other useful terms are **medial** and **lateral.** Medial means toward the midline of the body, whereas lateral means away from the midline. In this context, the eyes are lateral to the nose.

The term **proximal** means close, and **distal** means distant. On the body, proximal means close to the point where an arm or leg is attached. Distal means distant from the point of attachment. For example, if the thigh bone (femur) is broken, the break can be either proximal (the end closer to the hip) or distal (the end farther away from the hip).

The term **superior** means closer to the head, and **inferior** means closer to the feet. For example, the legs are inferior to the arms, and the arms are superior to the legs.

These anatomic terms are useful in describing the location of injury or pain. If you cannot remember the proper anatomic term for a certain body location, use lay terms.

Body Systems

Body systems work together to perform common functions. By studying these body systems, you will have a better background to understand illnesses and injuries.

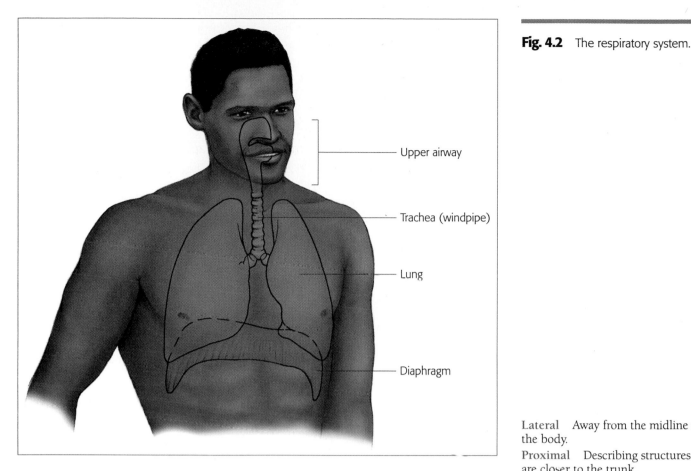

Fig. 4.2 The respiratory system.

Upper airway

Trachea (windpipe)

Lung

Diaphragm

The Respiratory System

Because airway maintenance is one of the most important skills you learn as a first responder, the respiratory system is the first of the body systems we will study.

The **respiratory system** consists of all the structures of the body that contribute to normal breathing. The respiratory system brings oxygen into the body and removes the waste gas, carbon dioxide (Figure 4.2).

The airway consists of the nose (nasopharynx), mouth (oropharynx), throat, **larynx** (voice box), trachea (windpipe), and the passages within the lungs (Figure 4.3). At the upper end of the larynx is a tiny flapper valve, the **epiglottis**. The epiglottis keeps food from entering the larynx. The airway within the lungs branches into narrower and narrower passages that end in tiny air sacs that are surrounded by tiny blood vessels. Oxygen in inhaled air passes through the thin walls that separate the air sacs from the blood vessels and is absorbed by the blood. **Carbon dioxide (CO_2)** passes from the blood across the same thin walls into the air sacs and is exhaled. This exchange of carbon dioxide for oxygen occurs 12 to 16 times per minute, 24 hours a day, without any conscious effort on your part (Figure 4.4).

Air is inhaled when the **diaphragm**, a large muscle that forms the bottom of the chest cavity, moves downward and the chest muscles contract to expand the size of the chest. Air is exhaled when these muscles relax, thus decreasing the size of the chest (Figure 4.5).

The inhaled oxygen is transported in the blood to all parts of the body by means of the circulatory system. The respiratory system is especially important because your body cannot live without oxygen for more than 4 to 6 minutes.

Lateral Away from the midline of the body.

Proximal Describing structures that are closer to the trunk.

Distal Describing structures that are nearer to the free end of an extremity; any location that is farther from the midline than the point of reference named.

Superior Toward the head; lying higher in the body.

Inferior That portion of the body or body part that lies nearer the feet than the head.

Respiratory system All the structures of the body that contribute to normal breathing.

Larynx A structure composed of cartilage in the neck that guards the entrance to the windpipe and functions as the organ of voice. Also called the voice box.

Epiglottis The valve located at the upper end of the voice box that prevents food from entering the larynx.

Carbon dioxide (CO_2) The gas formed in respiration and exhaled in breathing.

Diaphragm A muscular dome that separates the chest from the abdominal cavity. Contraction of the diaphragm and the chest wall muscles brings air into the lungs; relaxation allows air to be expelled from the lungs.

Fig. 4.3 The airway consists of these structures.

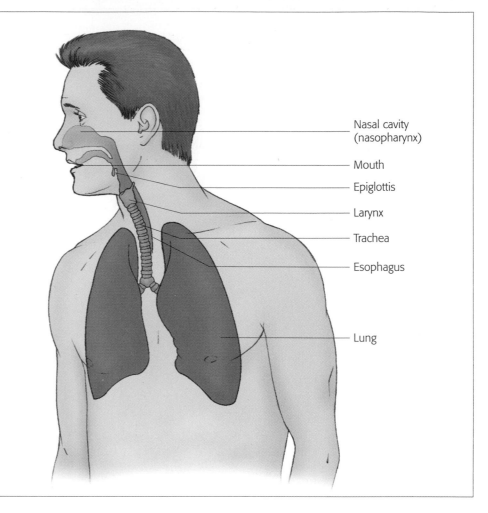

Nasal cavity (nasopharynx)

Mouth

Epiglottis

Larynx

Trachea

Esophagus

Lung

Fig. 4.4 The exchange of carbon dioxide (CO_2) and oxygen (O_2) in the lungs.

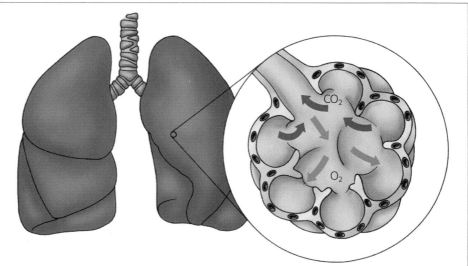

CO_2

O_2

Fig. 4.5 Mechanism of breathing.

Inspiration

Lung

Trachea

Lung

Diaphragm moves downward

Expiration

Lung

Airway branches (bronchial tree)

Diaphragm relaxes

SPECIAL NEEDS

Infant and Child Respiratory Systems Some differences between the respiratory systems of adults and those of infants and children are as follows:

- Pediatric airways are smaller and more flexible. When you perform CPR on a child, much less force is required than is needed for an adult.
- Because of its smaller size, a child's airway is more easily blocked by a foreign object.
- Very young infants can breathe only through their noses. Therefore, if their nose becomes blocked, they will show signs of respiratory distress.

The Circulatory System

The **circulatory system** is similar to a city water system in that it consists of the pump (the heart), a network of pipes (the blood vessels), and fluid (blood). After blood has picked up oxygen in the lungs, it goes to the heart, which pumps the oxygenated blood to the rest of the body. The cells of the body absorb oxygen and nutrients from the blood and produce waste products (including carbon dioxide), which the blood carries back to the lungs. In the lungs, the blood exchanges the carbon dioxide for more oxygen and then returns to the heart to be pumped out again (Figure 4.6).

The human heart consists of four chambers, two in the patient's right side and two on the patient's left side. Each upper chamber is called an atrium. The right atrium receives blood from the veins of the body; the left atrium receives blood from the lungs. The bottom chambers are the right

Circulatory system The heart and blood vessels, which together are responsible for the continuous flow of blood throughout the body.

DID YOU KNOW

► If each air sac in your lungs were a penny, you would have 700 million pennies, or 7 million dollars.

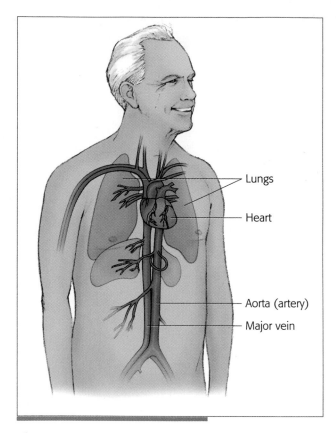

Fig. 4.6 The circulatory system.

and left ventricles. The right ventricle pumps blood to the lungs; the left ventricle pumps blood throughout the body. The most muscular chamber of the heart is the left ventricle. It needs the most power to squeeze blood to all parts of the body. Together the four chambers of the heart work in a well-ordered sequence to pump blood to the lungs and to the rest of the body (Figure 4.7).

One-way check valves in the pump and veins allow the blood to flow in only one direction through the circulatory system. The arteries carry blood away from the pump at high pressure and therefore have thick walls. The arteries closest to the pump are quite large (about 1 inch in diameter) but are smaller farther away from the heart.

Three major arteries are the neck (or carotid) artery, the groin (or femoral) artery, and the wrist (or radial) artery. The locations of these arteries are shown in Figure 4.8. Because these arteries lie between a bony structure and the skin, they are used as locations to measure the patient's **pulse**.

The capillaries are the smallest pipes in the system. Some capillaries are so small that only one blood cell at a time can go through them. At the capillary level, oxygen passes from the blood cells into the cells of body tissues, and carbon dioxide and other waste products pass from the tissue cells to the blood cells, which then return to the lungs.

Veins are the thin-walled pipes of the circulatory system that carry blood back to the heart.

Fig. 4.7 Schematic representation of the functions of the four chambers of the heart.

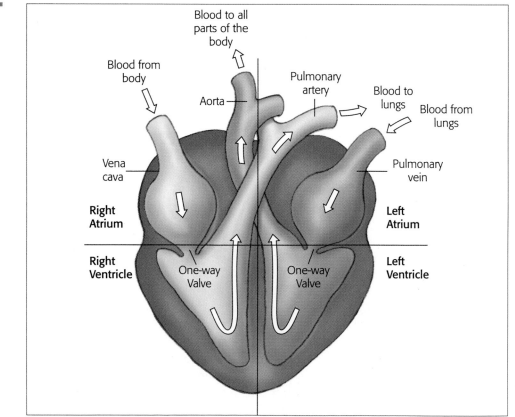

Pulse The wave of pressure that is created by the heart as it contracts and forces blood out of the heart and into the major arteries.

Blood has several components: **plasma** (a clear, straw-colored fluid), red blood cells, white blood cells, and **platelets**. Blood receives its red color from its red blood cells. The red blood cells carry oxygen from the lungs to the body and bring carbon dioxide back to the lungs. The white blood cells are called "infection fighters" because they devour bacteria and other disease-causing organisms. Platelets start the blood-clotting process.

The Skeletal System

The skeletal system consists of bones and is the supporting framework for the body. The three functions of the skeletal system are as follows:

- To support the body
- To protect vital structures
- To manufacture red blood cells

The skeletal system is divided into seven areas beginning with the head (Figure 4.9).

The Skull

The bones of the head include the **skull** and the lower jawbone. The skull consists of many bones fused together to form a hollow sphere that contains and protects the brain. The jawbone is a movable bone that is attached to the skull and completes the structure.

The Spine

The spine is the second area of the skeletal system and consists of a series of separate bones called **vertebrae.** The spinal vertebrae are stacked up on top of each other and are held together by muscles, **tendons,** disks, and **ligaments.** Each spinal vertebra has a hole in its center for the spinal cord, a group of nerves that carry messages to and from the brain, to pass through. The vertebrae provide excellent protection for the spinal cord.

In addition to protecting the spinal cord, the spine is the primary support structure for the entire body (Figure 4.10). The spine has five sections:

- **Cervical spine** (neck)
- **Thoracic spine** (upper back)
- **Lumbar spine** (lower back)
- **Sacrum** (base of spine)
- **Coccyx** (tailbone)

The Shoulder Girdles

The **shoulder girdles** form the third area of the skeletal system. Each shoulder girdle gives support to the arm and consists of the collarbone (clavicle), the shoulder blade (scapula), and the upper arm bone (humerus).

The Upper Extremity

The fourth major area of the skeletal system is the upper extremity, which consists of three major bones. The arm has one bone (the humerus), and the forearm has two bones (the **ulna** and the **radius**). The radius is located on the thumb side of the arm, and the ulna is located on the little-finger side.

The wrist and hand are considered part of the upper extremity and consist of several bones, whose names you do not need to learn. You can consider these bones as one unit for the purposes of emergency treatment.

Fig. 4.8 The location of the carotid, brachial, and femoral pulses.

Plasma The fluid part of the blood that carries blood cells, transports nutrients, and removes cellular waste materials.

Platelets Microscopic disk-shaped elements in the blood that are essential to the process of blood clot formation, the mechanism that stops bleeding.

Skull The bones of the head, collectively; serves as the protective structure for the brain.

Vertebrae The 33 bones of the spinal column: 7 cervical, 12 thoracic, 5 lumbar, 5 sacral, and 4 coccygeal vertebrae.

Tendons Tough, rope-like cords of fibrous tissue that attach muscles to bones.

Ligaments Fibrous bands that connect bones to bones and support and strengthen joints.

Fig. 4.9 The human skeleton.

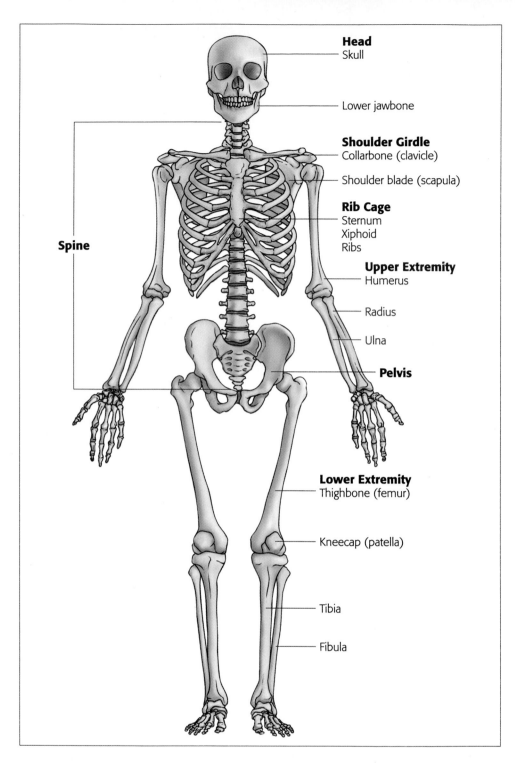

Cervical spine That portion of the spinal column consisting of the 7 vertebrae located in the neck.

Thoracic spine The 12 vertebrae that attach to the 12 ribs; the upper part of the back.

Lumbar spine The lower part of the back formed by the lowest 5 nonfused vertebrae.

Sacrum One of 3 bones (sacrum and 2 pelvic bones) that make up the pelvic ring; forms the base of the spine.

Coccyx The tailbone; the small bone below the sacrum formed by the final 4 vertebrae.

Shoulder girdle The proximal portion of the upper extremity; made up of the clavicle, the scapula, and the humerus.

Ulna The bone on the little-finger side of the forearm.

Radius The bone on the thumb side of the forearm.

Ribs The paired arches of bone, 12 on either side, that extend from the thoracic vertebrae toward the anterior midline of the trunk.

Sternum The breastbone.

Cartilage A tough, elastic form of connective tissue that covers the ends of most bones to form joints. Also found in some specific areas such as the nose and ear.

Floating ribs The eleventh and twelfth ribs, which do not connect to the sternum.

The Rib Cage

The fifth area of the skeletal system is the rib cage (chest). The twelve sets of ribs provide protection for the heart, lungs, liver, and spleen. All of the **ribs** are attached to the spine (Figure 4.11). The upper five ribs connect directly to the **sternum** (breastbone). The ends of the sixth through tenth ribs are connected to each other and to the sternum by a bridge of **cartilage.** The eleventh and twelfth ribs are not attached to the sternum and are called **floating ribs.**

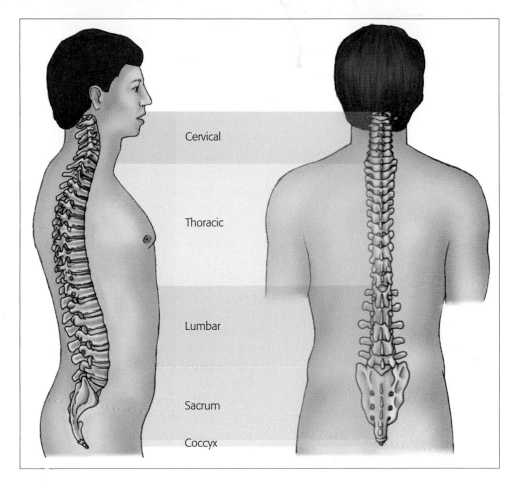

Fig. 4.10 The five sections of the spine.

The sternum is located in the front of the chest. The pointed structure at the bottom of the sternum is called the **xiphoid process.** The xiphoid process is an important location to remember because it is used to determine the proper hand placement during cardiopulmonary resuscitation (CPR).

Xiphoid process The flexible cartilage at the lower tip of the sternum; a key landmark in the administration of CPR and the Heimlich maneuver.

The Pelvis

The sixth area of the skeletal system is the **pelvis.** The pelvis serves as the link between the body and the lower extremities. In addition, the pelvis protects the reproductive organs and the other organs located in the lower abdominal cavity.

Pelvis The closed bony ring, consisting of the sacrum and the pelvic bones, that connects the trunk to the lower extremities.

Note that each of the essential organs of the body is encased in a protective bony structure:

- The skull protects the brain.
- The vertebrae protect the spinal cord.
- The ribs protect the heart and lungs.
- The pelvic bones protect the lower abdominal and reproductive organs.

The Lower Extremities

The lower extremities form the seventh area of the skeletal system. Each lower extremity consists of the thigh and the leg. The thighbone (femur) is the longest and strongest bone in the entire body. The leg has two bones, the tibia and fibula. The kneecap (patella) is a small, relatively flat bone that protects the front of the knee joint. Like the wrist and hand, the ankle and foot contain a

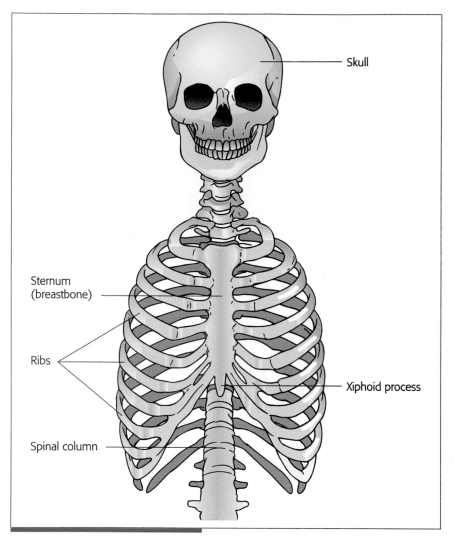

Skull

Sternum
(breastbone)

Ribs

Xiphoid process

Spinal column

Fig. 4.11 The rib cage.

large number of smaller bones that you can consider as one unit.

The Muscular System

Your body contains three different types of muscles: skeletal, smooth, and cardiac.

Skeletal muscles provide both support and movement. They are attached to bones by tendons. These muscles cause movement by alternately contracting (shortening) and relaxing (lengthening). To move bones, skeletal muscles are usually paired in opposition: while one member of the pair is contracting, the other is relaxing. This mechanical opposition enables you to open and close your hand, turn your head, and bend and straighten your elbow. For example, when the biceps relaxes, an opposing muscle on the back of the arm contracts, straightening the elbow. Because skeletal muscles can be contracted or relaxed whenever you want, they are also called voluntary muscles.

Smooth muscles carry out many of the automatic functions of the body, such as propelling food through the digestive system. Smooth muscles are also called involuntary muscles.

Cardiac muscle is a specialized type of muscle that is found only in the heart. Cardiac muscle is adapted to its special function of working all the time. It has a rich blood supply and can live only a few minutes without an adequate supply of oxygen.

Sometimes the skeletal and muscular systems are considered together. In this case, the two systems are referred to as the musculoskeletal system.

The Nervous System

Nervous system The brain, spinal cord, and nerves.

Nerves Fiber tracts or pathways that carry messages from the spinal cord and brain to all body parts and back; sensory, motor, or a combination of both.

The **nervous system** consists of the brain, the spinal cord, and the individual **nerves** that extend throughout the body (Figure 4.12). The brain is the body's "central computer" and controls the functions of thinking, voluntary actions (things you do consciously), and involuntary (automatic) functions such as breathing, heartbeat, and digestion.

The spinal cord is the "trunk line" for a complex network of nerves that make up a two-way communication system between the brain and the rest of the body. Some nerves send signals from the brain to the body, whereas others send signals from the body to the brain.

Nerves branch out from the spinal cord to every part of the body (like telephone lines going into houses and individual rooms). Some nerves send signals to the brain about what is happening to the body, for example, whether it is feeling heat, cold, pain, or pleasure. Other nerves carry signals to

Fig. 4.12 The nervous system.

Brain
Spinal cord
Nerves

muscles that cause the body to move in response to the sensory signals it has received. Without the nervous system, you would not have such sensations, nor would you be able to control the movement of your muscles.

Check Point

✓ What are the functions of the respiratory, circulatory, skeletal, muscular, and nervous systems?

✓ How are the functions of each system interrelated with the other body systems?

The Digestive System

The major organs of the **digestive system** are located in the abdomen. The digestive tract is about 35 feet long. It begins at the mouth and continues through the throat, esophagus (food tube), stomach, small intestine, large

Digestive system The gastrointestinal tract (stomach and intestines), mouth, salivary glands, pharynx, esophagus, liver, gallbladder, pancreas, rectum, and anus, which together are responsible for the absorption of food and the elimination of solid waste from the body.

Fig. 4.13 The digestive system.

Mouth
Pharynx (throat)
Esophagus

Liver
Stomach
Gallbladder
Pancreas
Large intestine
Small intestine
Rectum
Anus

intestine, rectum, and anus. Besides the digestive tract, the digestive system also includes the liver, gallbladder, and pancreas (Figure 4.13).

The digestive system breaks down food into a form that can be carried by the circulatory system to the cells of the body. Food that is not used in the digestive tract is passed from the body during defecation.

The liver performs several digestive functions. One of the most important is the production of bile. Bile is produced by the liver, stored in the gallbladder, and released into the small intestine to help digest fats.

Insulin A hormone produced by the pancreas that enables sugar in the blood to be used by the cells of the body; insulin is used in the treatment and control of diabetes mellitus.

The pancreas also has several digestive functions. Probably its best known function is the production of **insulin.** Insulin is released directly into the bloodstream and aids in the body's use of sugar. Disruption of insulin production causes diabetes.

The Genitourinary System

Genitourinary system The organs of reproduction, together with the organs involved in the production and excretion of urine.

The **genitourinary system** is responsible for the body's reproductive functions and for the removal of waste products from the bloodstream.

The major organs of male reproduction are the testes, which produce sperm, and the penis. The major female reproductive organs are the ovaries, which produce eggs, and the uterus, which holds the fertilized egg as it develops during pregnancy. The ovaries and the uterus are connected by the fallopian tubes. The external opening of the female reproductive system is called the birth canal (vagina).

The removal of waste products by the genitourinary system begins in the kidneys, which filter the blood to form urine. The urine flows down from the kidneys through tubes (ureters) into the bladder. After being collected and stored in the bladder, the urine passes out of the body through the urethra.

Skin

Skin covers all parts of our body, and it has three major functions: protecting against harmful substances, regulating temperature, and receiving information from the outside environment. Figure 4.14 identifies the layers of the skin.

Skin protects our body from the environment. Because skin provides an intact layer of cells that serves as a barrier to most foreign substances, it prevents harmful materials from getting into the body. The skin is an effective barrier to bacteria and viruses as long as it is not damaged.

Skin regulates the internal temperature of the body. If the body gets too hot, the small blood vessels close to the skin open up or dilate to bring more body heat to the surface of the skin, where the heat can be transferred to the air. Another source of cooling occurs because of the evaporation of the sweat that is released by the skin. If the body becomes cold, the blood vessels near the skin surface constrict, allowing more body heat to be transferred to the inside or core part of the body.

Skin receives information from the environment. Your skin can perceive touch, pressure, and pain. It can sense degrees of heat or cold. These sensations are picked up by special sensors in the skin and transmitted through nerves and the spinal cord to the brain. The brain serves as the computer to interpret these sensations.

Fig. 4.14 The skin.

CHAPTER
REVIEW 4

Summary

This chapter covers human anatomy and the function of body systems. To understand the location of specific signs or symptoms, it is necessary to examine topographic anatomy.

A brief explanation of body systems was presented. The respiratory system consists of the lungs and the airway. The function of this system is to take in air through the airway and transport it to the lungs. In the lungs, oxygen is taken into the red blood cells and carbon dioxide is released and removed from the blood.

The circulatory system consists of the heart (the pump), the blood vessels (the pipes), and blood (the fluid). Its role is to transport blood to all parts of the body in order to supply the body with oxygen and to remove waste products, including carbon dioxide.

The skeletal system consists of the bones of your body. These bones function to provide support, to protect vital structures, and to manufacture red blood cells.

The muscular system consists of three kinds of muscles: voluntary (skeletal) muscles, smooth (involuntary) muscles, and cardiac (heart) muscles. Muscles provide both support and movement. The skeletal system works with the muscular system to provide motion. Sometimes these two systems together are called the musculoskeletal system.

The nervous system consists of the brain, the spinal cord, and individual nerves. The brain serves as the central computer and the nerves serve to transmit messages to or from the brain.

The digestive system consists of the mouth, esophagus, stomach, intestines, liver, gallbladder, and pancreas. It breaks down usable food and eliminates solid waste.

The genitourinary system consists of the organs of reproduction together with the organs involved in the production and excretion of urine.

The skin covers all parts of the body. It serves to protect the body from the environment, regulates the internal temperature of the body, and transmits sensations from the skin to the nervous system.

A basic understanding of the body systems provides you with the background you need in order to treat the illnesses and injuries you will encounter as a first responder.

Anterior—page 52
Carbon dioxide
(CO_2)—page 53
Cartilage—page 58
Cervical spine—
page 58
Circulatory
system—page 55
Coccyx—page 58
Diaphragm—page
53
Digestive system—
page 61
Distal—page 53
Epiglottis—page 53
Floating ribs—
page 58
Genitourinary
system—page 62

Inferior—page 53
Insulin—page 62
Larynx—page 53
Lateral—page 53
Ligaments—page 57
Lumbar spine—
page 58
Medial—page 52
Midline—page 52
Nerves—page 60
Nervous system—
page 60
Pelvis—page 59
Plasma—page 57
Platelets—page 57
Posterior—page 52
Proximal—page 53
Pulse—page 56
Radius—page 58

Respiratory
system—page 53
Ribs—page 58
Sacrum—page 58
Shoulder girdle—
page 58
Skull—page 57
Sternum—page 58
Superior—page 53
Tendons—page 57
Thoracic spine—
page 58
Ulna—page 58
Vertebrae—page 57
Xiphoid process—
page 59

You Should Know

1. The important topographic anatomy of the body.
2. The basic structures and be able to describe the basic functions of the following body systems:
 a. Respiratory
 b. Circulatory
 c. Skeletal
 d. Muscular
 e. Nervous
 f. Digestive
 g. Genitourinary
 h. Skin

You Should Practice

1. Identifying the location of the major body components, systems, and organs, using a diagram, chart, or patient.

CHAPTER

5

LIFTING AND MOVING PATIENTS

Knowledge and Attitude Objectives *After studying this chapter, you will be expected to:*

1. Describe the general guidelines for moving patients.
2. Understand the purpose and indications for use of the "recovery position."
3. Describe the components of good body mechanics.
4. Describe the steps needed to perform the following emergency patient drags:
 a. Clothes drag
 b. Blanket drag
 c. Arm-to-arm drag
 d. Firefighter drag
 e. Cardiac arrest patient drag
 f. Emergency drag from a vehicle
5. Describe the steps needed to perform the following carries for nonambulatory patients:
 a. Two-person extremity carry
 b. Two-person seat carry
 c. Cradle-in-arms carry
 d. Two-person chair carry
 e. Pack-strap carry
 f. Direct ground lift
 g. Transfer from a bed to a stretcher
6. Describe the steps needed to perform the following walking assists for ambulatory patients:
 a. One-person assist
 b. Two-person assist
7. Identify and describe the purpose of the following pieces of equipment:
 a. Wheeled ambulance stretcher
 b. Portable stretcher
 c. Stair chair
 d. Long backboard

 e. Short backboard
 f. Scoop stretcher
8. Describe the steps in each of the following procedures for patients with suspected spinal injuries:
 a. Applying a cervical collar
 b. Moving patients using backboards
 c. Assisting with short backboard devices
 d. Logrolling
 e. Straddle lifting
 f. Straddle sliding
 g. Strapping
 h. Immobilizing the patient's head

Skill Objectives *As a first responder, you should be able to:*

1. Place a patient in the "recovery position."
2. Lift and move patients using good body mechanics.
3. Perform the following emergency patient drags:
 a. Clothes drag
 b. Blanket drag
 c. Arm-to-arm drag
 d. Firefighter drag
 e. Cardiac arrest patient drag
 f. Emergency drag from a vehicle
4. Perform the following patient carries:
 a. Two-person extremity carry
 b. Two-person seat carry
 c. Cradle-in-arms carry
 d. Two-person chair carry
 e. Pack-strap carry
 f. Direct ground lift
 g. Transfer from a bed to a stretcher
5. Perform the following walking assists for ambulatory patients:
 a. One-person assist
 b. Two-person assist
6. Assist other EMS providers with the following devices:
 a. Wheeled ambulance stretcher
 b. Portable stretcher
 c. Stair chair
 d. Long backboard
 e. Short backboard
 f. Scoop stretcher
7. Assist other EMS providers with the following procedures for patients with suspected spinal injuries:
 a. Application of cervical collar
 b. Movement of patients using backboards
 c. Applying short backboard device
 d. Logrolling a patient onto a backboard
 e. Straddle lift
 f. Straddle slide
 g. Strapping techniques
 h. Head immobilization

Author's note: Some instructors may prefer to cover the material in this chapter after presenting the skills in Module 5.

As a first responder, you must analyze a situation, quickly evaluate a patient's condition under stressful circumstances and often by yourself, and carry out effective, lifesaving emergency medical procedures. These procedures sometimes include lifting, moving, or positioning patients as well as assisting other EMS providers in moving patients and preparing them for transport.

Usually you do not have to move patients. In most situations, you treat the patient in the position found and later assist other EMS personnel in moving the patient. In some cases, however, your knowledge of emergency movement techniques is essential to the patient's survival. You may have to move patients for their own protection (for example, a patient in a burning building), or you may have to move patients before you can provide needed emergency care (for example, a cardiac arrest patient found in a bathroom must be moved into a larger room before you can administer CPR).

General Principles

Every time you move a patient, keep the following general guidelines in mind:

1. Do no further harm to the patient.
2. Move the patient only when necessary.
3. Move the patient as little as possible.
4. Move the patient's body as a unit.
5. Use proper lifting and moving techniques to assure your own safety.
6. Have one rescuer give commands when moving a patient (usually the rescuer at the patient's head).

You should also consider the following recommendations:

- Delay movement, if possible, until additional EMS personnel arrive.
- Treat the patient before starting the move unless the patient is in an unsafe environment.
- Try not to step over the patient (your shoes may drop sand, dirt, or mud onto the patient).
- Explain to the patient what is going to be done and how. If the patient's condition permits, he or she may be able to assist you.
- Move the patient as few times as possible.

Unless you must move patients for treatment or protection, leave them in the position you found them. There is usually no reason to hurry the moving process. If you suspect the patient has suffered from trauma to the head or spine, keep the patient's head and spine from moving as much as possible.

Recovery Position

Unconscious patients who have not suffered trauma should be placed in a sidelying or **recovery position** to help them keep their airway open. This position is shown in Figure 5.1.

SAFETY PRECAUTION
Whatever technique you use for moving patients, keep these rules of good body mechanics in mind:
1. Know your own physical limitations and capabilities. Do not try to lift too heavy a load.
2. Keep yourself balanced when lifting or moving a patient.
3. Maintain a firm footing.
4. Lift and lower the patient by bending your legs, not your back. Keep your back as straight as possible at all times and use your large leg muscles to do the work.
5. Try to keep your arms close to your body for strength and balance.
6. Move the patient as little as possible.

Recovery position A technique for placing an unconscious patient in a sidelying position to help the patient maintain an open airway.

Fig. 5.1 A patient in the recovery position.

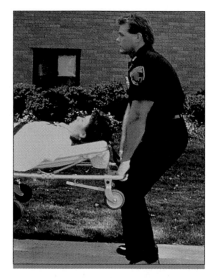

Fig. 5.2 A first responder demonstrates good body mechanics while lifting a patient.

Body Mechanics

Your top priority as a first responder is to ensure your own safety. Improper lifting and moving of patients can result in injury to you or to the patient. By exercising good body mechanics, you reduce the possibility of injuring yourself (Figure 5.2). Good body mechanics consist of using the large muscles in your legs and preventing strains and injuries to weaker muscles, especially in your back. When you need to lift or move a patient, use your legs instead of your back. Get as close to the patient as possible so that your back is in a straight and upright position. Try to keep your back straight. Do not lift when your back is bent over a patient. Lift without twisting your body. Keep your feet in a secure position and be sure you have a firm footing before you start to lift or move a patient.

To lift safely, you must keep certain guidelines in mind. Before attempting to move a patient, assess the weight of the patient. Know your physical limitations and do not attempt to lift or move a patient who is too heavy for you to handle safely. Call for additional personnel if needed for your safety and the safety of the patient. As you are lifting, make sure you communicate with the other members of the lifting team. Failure to give clear commands or failure to lift at the same time can result in serious injuries to rescuers.

Practice makes perfect! Practice lifts and moves until they become smooth for you and for the patient. Because you will at times need to assist other EMS providers, work with them to be sure you are all lifting in a coordinated and helpful manner.

Emergency Movement of Patients

When is emergency movement of a patient necessary? Move a patient immediately in the following situations:

- Danger of fire, explosion, or structural collapse exists.
- Hazardous materials are present.
- The accident scene cannot be protected.

- It is otherwise impossible to gain access to other patients who need life-saving care.
- The patient has suffered cardiac arrest and must be moved for CPR.

Emergency Drags

During emergency situations, make every effort to pull the patient in the direction of the long axis of the body in order to provide as much spinal protection as possible. If the patient is on the floor or ground, drag the person away from the scene by pulling on the clothing in the neck and shoulder area.

There are six types of emergency patient drags:

1. Clothes drag
2. Blanket drag
3. Arm-to-arm drag
4. Firefighter drag
5. Cardiac arrest patient drag
6. Emergency drag from a vehicle

Clothes Drag

The **clothes drag** is used for emergency movement of the patient (Figure 5.3). If the patient is too heavy for you to lift and carry, grasp the clothes just behind the collar, rest the patient's head on your arm for protection, and drag the patient out of danger.

Blanket Drag

If the patient is not dressed or is dressed in clothing that is too flimsy for the clothes drag (for example, a nightgown), move the patient by using a large

Clothes drag An emergency patient move used to remove a patient from a hazardous environment. Performed by grasping the patient's clothes and moving the patient head first from the unsafe area.

Fig. 5.3 Emergency clothes drag.

Fig. 5.4 Blanket drag.

Blanket drag A method by which a
rescuer encloses a patient in a blanket
and drags the patient to safety.

sheet, blanket, or rug. Place the blanket, rug, sheet, or similar item on the
floor and roll the patient onto it. Pull the patient to safety by dragging the
sheet or blanket. The **blanket drag** can be used to move a patient who weighs
more than you do (Figure 5.4).

Arm-to-Arm Drag

If the patient is on the floor, you can place your hands under the patient's
armpits from the back of the patient and grasp the patient's forearms. The
arm-to-arm drag allows you to move the patient by carrying the weight of
the upper part of the patient's body and it allows the patient's lower trunk and
legs to drag on the floor (Figure 5.5). This drag can be used to move a heavy
patient and still provide some protection to the patient's head and neck.

Firefighter Drag

The **firefighter drag** enables you to move a patient who is heavier than you
are because you do not have to lift or carry the patient. Tie the patient's wrists
together with anything that is handy: a cravat (a folded triangular bandage),
gauze, belt, or necktie. Then get down on your hands and knees and straddle
the patient. Pass the patient's tied hands around your neck, straighten your
arms, and drag the patient across the floor by crawling on your hands and
knees (Figure 5.6).

Arm-to-arm drag An emergency
patient move that consists of the res-
cuer grasping the patient's arms from
behind; used to remove a patient
from a hazardous place.

Firefighter drag A method of mov-
ing a patient without lifting or carry-
ing him or her; used when the
patient is heavier than the rescuer.

Cardiac Arrest Patient Drag

In most situations, it is easy to determine whether emergency movement is
necessary. An exception is in cases of cardiac arrest. It is up to you to judge
whether a cardiac arrest patient is in a room or area too small for adequate
provision of either basic life support (BLS) or advanced life support (ALS).
You should move the patient as soon as you have determined that he or she
has suffered cardiac arrest (Figure 5.7).

Fig. 5.5 Arm-to-arm drag.

You will often find a patient in a bathroom or bedroom (or worse yet, in the back bedroom of a mobile home). Use the **cardiac arrest patient drag** to move the patient from a confined space to a location with adequate room to perform two-person CPR and ALS procedures. Drag the patient out of the narrow room and into the bedroom or even the living room. Quickly move furniture out of the way so you have room to work. The time it takes to move

Cardiac arrest patient drag The means by which a rescuer drags a patient who has suffered cardiac arrest to an area large enough for patient care.

Fig. 5.6 Firefighter drag.

A. Tie the patient's wrists together.

B. Drag the patient across the floor by crawling on your hands and knees.

Fig. 5.7 Remove the patient from a confined space to administer CPR.

the patient from a confined situation is more than made up for by the increased efficiency with which BLS or ALS can be administered.

Remember: Take time to provide adequate room before you begin CPR!

Emergency Drag from a Vehicle

One Rescuer Sometimes you have to use emergency movement techniques to remove a patient from a wrecked vehicle (for example, when the vehicle is on fire or CPR must be administered). All the basic movement principles apply, but the techniques need to be slightly modified if the patient is not lying down.

Fig. 5.8 Emergency removal from a vehicle.

A. Grasp the patient under the arms.

B. Pull the patient down into a horizontal position.

Remove the patient from the vehicle by grasping under the arms and cradling the head between your arms (Figure 5.8). Pull the patient down into a horizontal position as you ease him or her from the vehicle. Although there is no effective way to remove a patient from a vehicle by yourself without causing some movement, it is important to prevent excess movement of the patient's neck.

Two or More Rescuers If you must immediately remove a patient from a vehicle and two or more rescuers are present, have one rescuer support the patient's head and neck, while the second rescuer moves the patient by lifting under the arms. The patient can then be removed in line with the long axis of the body, while the head and neck are stabilized in a neutral position. If time permits and if you have one available, use a long backboard for patient removal.

Carries for Nonambulatory Patients

Many patients are not able or should not be allowed to move without your assistance. Patients who are unable to move because of injury or illness must be carried to safety. This section describes several useful carrying and dragging techniques for nonambulatory patients. Whatever technique you use, keep in mind the rules of good body mechanics.

Two-Person Extremity Carry

A carry that can be done by two rescuers with no equipment in tight or narrow spaces, such as mobile home corridors, small hallways, and narrow spaces between buildings, is the **two-person extremity carry** (Figure 5.9). The focus of this carry is on the patient's **extremities**. The rescuers help the

Two-person extremity carry A method of carrying a patient out of tight quarters using two rescuers and no equipment.

Extremities The arms and legs.

Fig. 5.9 Two-person extremity carry.

Fig. 5.10 Two-person seat carry.

A. Link arms.

B. Raise the patient to a sitting position.

Two-person seat carry A method of carrying a patient, using no equipment, by having two rescuers link arms behind the patient's back and under the patient's knees.

Cradle-in-arms carry A one-rescuer patient movement technique used primarily for children. The patient is cradled in the hollow formed by the rescuer's arms and chest.

Two-person chair carry Two rescuers use a chair to support the weight of the patient.

patient sit up. Rescuer One kneels behind the patient and reaches under the patient's arms and grasps the patient's wrists. Rescuer Two then backs in between the patient's legs, reaches around, and grasps the patient behind the knees. At a command from Rescuer One, the two rescuers stand up and carry the patient away, walking straight ahead.

Remember: Keep your back as straight as possible and use the large muscles in your legs to do the lifting!

Two-Person Seat Carry

The **two-person seat carry** is accomplished by having two rescuers kneel beside the patient near the patient's hips. The rescuers then raise the patient to a sitting position and link arms behind the patient's back. The remaining free arm of each rescuer is then placed under the patient's knees and the rescuers again link arms. If possible, the patient puts his or her arms around the necks of the rescuers for additional support. Although the two-person seat carry needs two rescuers, no equipment is required (Figure 5.10).

Cradle-in-Arms Carry

The **cradle-in-arms carry** can be used by one rescuer to carry a child. Kneel beside the patient and place one arm around the child's back and the other arm under the thighs. Lift slightly and roll the child into the hollow formed by your arms and chest. Be sure to use your leg muscles to stand (Figure 5.11).

Two-Person Chair Carry

In the **two-person chair carry**, two rescuers use a chair to support the weight of the patient. A folding chair cannot be used. The chair carry is especially useful for taking patients up or down stairways or through a narrow hallway. An additional benefit is that because the patient is able to hold on to the chair (and should be encouraged to do so), he or she feels much more secure than with the two-person seat carry.

Rescuer One stands behind the seated patient, places his or her arms over the person's shoulders, reaches down, and grasps the back of the chair, as

Fig. 5.11 Cradle-in-arms carry.

shown in Figure 5.12. Rescuer One then tilts the chair slightly backward on its rear legs so that Rescuer Two can back in between the legs of the chair and grasp the tips of the chair's front legs. The patient's legs should be between the legs of the chair. When both rescuers are correctly positioned, Rescuer One gives the command to lift and walk away.

Note: Because the chair carry may force the patient's head forward, Rescuer One should watch the patient for airway problems.

Pack-Strap Carry

The **pack-strap carry** is a one-person carry that allows you to carry a patient while keeping one hand free. Have the patient stand (or have other rescue personnel support the patient) and back into the patient so your shoulders fit into the patient's armpits. Grasp the patient's wrists and cross the arms over your chest (Figure 5.13).

Optimal weight distribution occurs when the patient's armpits are over your shoulders. Squat deeply to avoid potential injury to your back and pull the patient onto your back. Once the patient is positioned correctly, bend forward, stand up, and walk away.

Direct Ground Lift

The direct ground lift is used to move a patient who is on the ground or the floor to an ambulance cot. It should be used only for those patients who have not suffered a traumatic injury. The direct ground lift requires you to bend over the patient and lift with your back in a bent position. Because the use of the direct ground lift results in poor body mechanics, its use is to be discouraged. The use of a backboard or portable cot when possible will be much better for your back and may be more comfortable for the patient. The steps for performing the direct ground lift (Figure 5.14) are as follows:

1. Assess the patient. Do not use this lift if there is any chance of head, spine, or leg injuries.
2. Rescuer One kneels at the patient's right or left side.

Fig. 5.12 Two-person chair carry.

Pack-strap carry A one-person carry that allows the rescuer to carry a patient while keeping one hand free.

Fig. 5.13 Pack-strap carry.

A. Grasp the patient's wrists.

B. Cross the patient's arms over your chest.

Fig. 5.14 Direct ground lift.

A. Kneel at patient's side.

B. Place arms under patient.

C. Lift the patient.

D. Move the patient to ambulance cot or bed.

SAFETY PRECAUTION
The direct ground lift requires poor body mechanics so its use is to be discouraged whenever possible.

3. Rescuer Two kneels at the side of the patient's hips on the same side as Rescuer One.

4. Place the patient's arms on the patient's chest.

5. Rescuer One places one arm under the patient's neck and shoulder and cradles the patient's head and then places the other arm under the patient's lower back.

6. Rescuer Two places one arm under the patient's knees and one arm above the buttocks.

7. On the command "Ready? Roll!" the rescuers roll their forearms up so that the patient is as close to them as possible.

8. On the command "Ready? Lift!" the rescuers lift the patient to their knees and roll the patient as close to their bodies as possible.

9. On the command "Ready? Stand!" the rescuers stand and move the patient to the ambulance cot or bed.

10. To lower the patient to the cot or bed, the rescuers reverse the steps listed above.

▼ **CAUTION**

This lift should never be considered for any patient who may have suffered any injury to the head, spine, or legs.

Transfer of Patient from Bed to Stretcher

Many times patients who are ill will be found in their beds. If the EMS personnel need to transport these patients to the hospital, they may request your assis-

A. Place your hands under the patient.

B. Roll the patient to the rescuers.

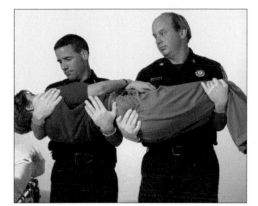

C. Lift the patient.

D. Place the patient on the stretcher.

Fig. 5.15 Transferring a patient from a bed to a stretcher.

tance in moving a patient from the bed to the ambulance cot (Figure 5.15). You can assist the EMS providers by learning and practicing the following steps:

1. Position the ambulance cot at right angles to the patient's bed with the head end of the cot at the foot end of the bed.
2. Prepare the cot by unfastening the belt buckles and folding back the sheets.
3. Rescuer One stands beside the patient's chest and head.
4. Rescuer Two stands beside the patient's hips.
5. Rescuer One slides one arm under the patient's neck and cups the patient's shoulder, and slides the other arm under the patient's back.
6. Rescuer Two slides one hand under the patient's hip and lifts slightly, then places the second arm underneath the patient's calves.
7. Both rescuers slide the patient to the edge of the bed.
8. On the command "Ready? Roll!" the rescuers contract their forearms to roll the patient toward them.
9. On the command "Ready? Lift!" the patient is lifted.
10. The rescuers rotate the patient to in front of the ambulance cot.
11. On the command "Ready? Lower!" the patient is lowered to the ambulance cot.

An alternate method for moving a patient is to loosen the bottom sheet of the patient's bed, place the cot alongside the bed, and reach across the cot to pull the sheet and the patient onto the cot. This method must be used with caution because it requires the rescuers to reach across the cot to get to

the patient. This results in poor body mechanics and therefore is to be discouraged.

Walking Assists for Ambulatory Patients

Frequently many patients simply need assistance to walk to safety. Either one or two rescuers can do this. Choose a technique after you have assessed the patient's condition and the incident scene. The technique you might use to help a patient to a chair is probably not appropriate to help a patient up a highway embankment.

One-Person Walking Assist

One-person walking assist A method used if the patient is able to bear his or her own weight.

Two-person walking assist Used when a patient cannot bear his or her own weight; two rescuers completely support the patient.

The **one-person walking assist** can be used if the patient is able to bear weight. Help the patient stand. Have the patient place his or her arm around your neck, and hold on to the patient's wrist (which should be draped over your shoulder). Put your free arm around the patient's waist and help the patient to walk (Figure 5.16).

Two-Person Walking Assist

The **two-person walking assist** is the same as the one-person walking assist, except that two rescuers are needed. This technique is useful if the patient cannot bear weight. The two rescuers completely support the patient (Figure 5.17).

CAUTION

Do not use any of the preceding lifts or carries if you suspect that the patient has a spinal injury, unless, of course, it is necessary to remove the patient from a life-threatening situation.

Fig. 5.16 One-person walking assist.

Check Point

✓ How can you move a patient by yourself if the patient may have suffered a neck injury?

✓ How can you move a patient by yourself if the patient has not suffered a neck injury?

✓ When should you remove a patient from a wrecked vehicle if you are by yourself? How would you move this patient?

✓ Why is it sometimes best to move a patient who has suffered cardiac arrest before you begin CPR?

Equipment

Most of the lifts and moves described in the previous section are done without any specialized equipment. There are, however, certain devices that EMS services commonly use. To be able to assist other EMS providers, you should be familiar with some of these devices: wheeled ambulance stretcher, portable stretcher, stair chair, long backboard, short backboard, and scoop stretcher.

Fig. 5.17 Two-person walking assist.

VOICES of EXPERIENCE

"The man inside has a stick in his head!" That's what a bystander told the first arriving units when they reached the scene of a pre-dawn accident on a frigid morning.

A car had crashed through a board fence lined with barbed wire, and overturned in a field. The sole occupant of the car, a 21-year-old male, was conscious but pinned in the automobile.

Upon entering the auto, I found the patient with an 18" long, 2" × 2" piece of wood impaled in his right eye socket. In addition, a 1" × 4" fence board had lacerated his scalp and was, in effect, supporting his head and upper body. The patient's only complaint was that he was cold (the outside temperature was about 15° F).

I assessed the patient while other firefighters began stabilizing the scene. Access to the automobile was made and the auto was stabilized using ropes, shoring, and chocks.

A paramedic firefighter joined me and began ALS care while another firefighter and I worked on stabilizing the patient and the 1" × 4" board that was supporting him. Other firefighters used helmets and blankets to "shore up" the patient so that the board entrapping the patient could be removed. Firefighters were finally able to safely remove a rear window and slide the board out, freeing the victim.

As this was going on, we carefully stabilized the impaled wood. Firefighters slid a spine board under the victim as the three of us inside the car lifted him. The patient was loaded into the ALS ambulance. He was further stabilized and transported to a waiting helicopter for airlift to a trauma center. Evaluation at the trauma center showed no other injuries, and the patient was taken into surgery. The impaled board was removed, and the wound examined. There was no damage beyond the eye socket, and the surgical team was able to replant the eye.

Within a few days, the patient had regained sight in his right eye. The ophthalmologic surgeon felt a full recovery was likely. The surgeon credited the rapid and conscientious actions of the firefighters—who had the patient evaluated, stabilized, extricated, treated, transported, and into surgery in less than two hours—with saving the young man's sight. Of particular importance, he said, was the stabilization of the impaled object: one of the "basics" taught in EMS training.

Gordon M. Sachs
EMT
Deputy Chief
Marion County Fire Department
Ocalo, Florida

Fig. 5.18 A wheeled ambulance stretcher.

Wheeled Ambulance Stretchers

Wheeled ambulance stretchers are carried by ambulances and are one of the most commonly used EMS devices (Figure 5.18). These stretchers are also called cots. Most of them can be raised or lowered to several different heights. The head end of the cot can be raised to elevate the patient's head. These stretchers have belts to secure the patient. There are many different levers and controls for raising and lowering stretchers. If you are going to be assisting a given EMS unit, it will be helpful to work with the EMS provider to learn how you may assist them with their type of stretcher.

Stretchers can be rolled or can be carried with two or four persons. If the surface is smooth, a wheeled stretcher can be rolled using one person to guide the head end and one person to pull the foot end. If the loaded stretcher must be carried, it is best to use four people. One person should carry each corner. This gives stability and requires less strength than carrying with fewer people. If the stretcher must be carried through a narrow area, it will be necessary to carry with only two people. The two rescuers should face each other from opposite ends of the stretcher. Carrying with two people requires more strength, and it is harder to balance than carrying with four people.

You may also be asked to assist with loading a patient into the ambulance. You need to practice this procedure with your local EMS provider because if you are not lifting in a uniform way, you can injure yourself or the other rescuers. Learn the method of loading ambulance stretchers that your EMS provider uses if you will be assisting them.

Portable Stretchers

Fig. 5.19 (right) A portable stretcher.

Portable stretchers are used when the wheeled cot cannot be moved into a small space. They are smaller and lighter to carry than a wheeled stretcher. Portable cots can be carried in the same ways in which a wheeled cot is carried. An example of one type of portable stretcher is shown in Figure 5.19.

Stair Chair

Portable stretcher A lightweight nonwheeled device for transporting a patient. Used in small spaces where the wheeled ambulance stretcher cannot be used.

Stair chairs are portable moving devices that are used to carry patients in a sitting position. They are good for patients who are short of breath or who are more comfortable in a sitting position. They are small and light and easier to carry in narrow spaces. The stair chair is not intended for use with

Stair chair A small portable device used for transporting patients in a sitting position.

patients who are suffering any type of trauma. When carrying a stair chair, the rescuers must face each other and lift on a set command. If you are going to be assisting your local EMS provider with this device, you should learn how to open it up from the folded position and how to assist with carrying it. One type of stair chair is shown in Figure 5.20.

Fig. 5.20 A stair chair.

Backboards

Long Backboards

Long backboards are used for moving patients who have suffered trauma, especially if they may have suffered neck or back injuries. They are also a useful device for lifting and moving patients who are in small places or who need to be moved off the ground or floor. Many times, long backboards are used because they make lifting a patient much easier for the rescuer. Long backboards are made of varnished plywood or of various types of plastic. Patients placed on long backboards must be secured with straps, and if they may have suffered back or neck injuries, their heads should be immobilized. Procedures for assisting EMS providers with these devices are covered later in this chapter. One type of long backboard is pictured in Figure 5.21.

Scoop stretcher A firm patient-carrying device that can be split into halves and applied to the patient from both sides.

Fig. 5.21 A wooden backboard.

Short Backboard Devices

Short backboard devices are used to immobilize the head and spine of patients who have suffered possible head or spine injuries. These devices are used when a patient is found in a sitting position. Short backboard devices are made of wood or plastic. Some of these devices are in the form of a vest-like garment that wraps around the patient. Procedures to help you assist other EMS providers in applying these devices are covered later in this chapter. A short backboard device is pictured in Figure 5.22.

Fig. 5.22 A short backboard device.

Scoop Stretchers

Scoop stretchers or orthopaedic stretchers are rigid devices that separate into a right half and a left half. These devices are applied by placing one half on each side of the patient and then attaching the two halves together. These devices are helpful in moving patients out of small spaces. They should not be used if the patient has suffered head or spine injuries. You should practice using these devices if you will be assisting your local EMS provider with them. One type of scoop stretcher is shown in Figure 5.23.

Fig. 5.23 A scoop stretcher.

Treatment of Patients with Suspected Head or Spine Injury

Any time a patient has suffered a traumatic injury, you should suspect that the patient may have injured his or her head, neck, or spine. In this case, the patient's head should be kept in a neutral position and immobilized. You learn how to do this later in this chapter. It is important that you be able to assist other EMS personnel in caring for patients who may have suffered head or spine injuries because improper initial treatment can lead to permanent damage or paralysis. The following sections show you how to immobilize a patient's head and neck, and how to assist other EMS providers in placing a patient on a backboard. More information on spinal cord injuries is presented in Chapter 13.

Application of Cervical Collars

Cervical collar A neck brace that partially stabilizes the neck following injury.

Cervical collars are used to prevent excess movement of the head and neck (Figure 5.24). These collars do not prevent head and neck movement; rather they minimize the movement. When cervical collars are used, it is still necessary to immobilize the head and neck with your hands, a blanket roll, or foam blocks.

Soft cervical collars do not provide sufficient support for trauma patients. Many different types of rigid cervical collars for trauma patients are available. Figure 5.25 illustrates the application of one common style of rigid cervical

Fig. 5.24 Types of cervical collars.

A. Stabilize head and neck.

B. Insert back part of collar.

C. Apply front part of collar.

D. Secure collar together.

Fig. 5.25 Applying a cervical collar.

collar. A cervical collar should be applied before the patient is placed on a backboard.

Movement of Patients Using Backboards

Placing a patient on a backboard is not your primary responsibility, but you are often required to assist other EMS personnel. Therefore, you must be familiar with the proper handling of patients who must be moved on backboards. Any patient who has suffered spinal trauma in an auto accident or fall or any victim of gunshot wounds to the trunk should be transported on a backboard (Figure 5.26). Although the specific technique used depends on the circumstances, the general principles described in the remainder of this chapter are relevant in nearly all cases.

Fig. 5.26 Long backboard.

The following principles are especially important if spinal injury is suspected:

1. Move the patient as a unit.
2. Transport the patient face up (supine), the only position that gives adequate spinal stabilization. However, because patients secured to backboards often vomit, be prepared to turn the patient and backboard quickly as a unit to permit the vomitus to drain from the patient's mouth.
3. Keep the patient's head and neck in the neutral position.
4. Be sure that all rescuers understand what is to be done before any movement is attempted.
5. Be sure that one rescuer is responsible for giving commands.

Assisting with Short Backboard Devices

Short backboard devices are used to immobilize patients who have suffered trauma to the head, neck, or spine and who are found in a sitting position. Short backboard devices allow rescuers to immobilize the patient before moving. After the short backboard device is applied, the patient is carefully placed on a long backboard. As a first responder, you will not be applying a short backboard device by yourself. However, you may need to assist with the application of this device. Figure 5.27 illustrates the application of one common short backboard device.

Logrolling

Logrolling is the primary technique used to move a patient onto a long backboard. It is usually easy to accomplish, but it requires a team of five rescuers for safety and effectiveness—four to move the patient and one (not shown here) to maneuver the backboard. Logrolling is the movement technique of choice in all cases of suspected spinal injury. Because the logrolling maneuver requires sufficient space for five rescuers, it is not always possible to perform it correctly. That is why the principles of movement rather than specific rules are stressed here. The five-person logroll is shown in Figure 5.28.

In any patient movement technique, but especially if spinal injury is suspected, everyone must understand who is directing the maneuver. The rescuer holding the patient's head (Rescuer One) should always give the commands so that all rescuers are better able to coordinate their actions. The specific wording of the command is not important, as long as every team

Logrolling A technique used to move a patient onto a long backboard.

A. Stabilize the head.

B. Apply a cervical collar.

C. Insert the device head first.

Fig. 5.27 Applying a short back-board device.

D. Apply the middle strap.

E. Apply the other straps.

F. Place wings around head.

G. Secure the head strap.

member understands what the command is. Each member of the team must understand his or her specific position and function.

All patient movement commands have two parts, a question and the order for movement. Rescuer One says, "The command will be 'Ready? Roll!'" When everyone is ready to roll the patient, Rescuer One says, "Ready? (short pause, to allow for response from the team) Roll!"

Fig. 5.28 Five-person logroll.

A. In position to roll the patient.

B. Roll the patient onto side.

C. Slide the backboard toward the patient.

Fig. 5.28 Five-person logroll. (cont.)

D. Roll patient onto back.

E. Center patient on backboard.

In any logrolling technique, you must move the patient as a unit. The head must be kept in a neutral position at all times. Do not allow the head to rotate, move backward (extend), or move forward (flex). Sometimes this is simply stated as, "Keep the nose in line with the bellybutton at all times."

Straddle Lift

Straddle lift A method used to place a patient on a backboard if there is not enough space to perform a logroll.

The **straddle lift** can be used to place a patient on a backboard if you do not have enough space to perform a logroll. Modified versions of the straddle lift are commonly used to remove patients from automobiles. Like logrolling, the straddle lift requires five rescuers: one at the head and neck, one to straddle the shoulders and chest, one to straddle the hips and thighs, one to straddle the legs, and one to insert the backboard under the patient after the other four have lifted the patient ¾ to 1 inch off the ground (Figure 5.29). *Note:* Lift the patient just enough to slide in the backboard.

The hardest part of the straddle lift technique is to coordinate the lifting and to lift the patient just far enough to slide the backboard under the

patient. Because such team coordination can be difficult, it is important to practice frequently.

Straddle Slide

The **straddle slide** is a modification of the straddle lift technique in which the patient, rather than the backboard, is moved (Figure 5.30). The rescuers'

Fig. 5.29 Straddle lift.

Straddle slide A method of placing a patient on a long backboard by straddling both the board and patient and sliding the patient onto the board

Fig. 5.30 Straddle slide.

A. Slide the patient about 10 inches at a time onto the backboard.

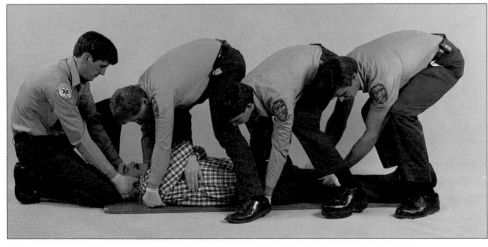

B. Center the patient on the backboard.

✚ SAFETY PRECAUTION
Make the up-and-forward movement in a single, smooth action. Lifting the patient up and then forward can strain your muscles.

positions are the same as for the straddle lift. Each rescuer should have a firm grip on the patient (or the patient's clothing). The patient is lifted as a unit just enough to be slid (break the resistance with the ground) forward onto the waiting backboard. Slide the patient forward about 10 inches each time. Distances greater than 10 to 12 inches cause team coordination problems.

Do not lift the patient off the ground. Rather, slide the patient along the ground and onto the backboard. Each rescuer should lean forward slightly and use a swinging motion to bring the patient onto the board. Rescuer One (who is at the patient's head) faces the other rescuers and moves backward during each movement. Rescuer One must not allow the patient's head to be driven into his or her knees!

Fig. 5.31 Seat-belt-type straps.

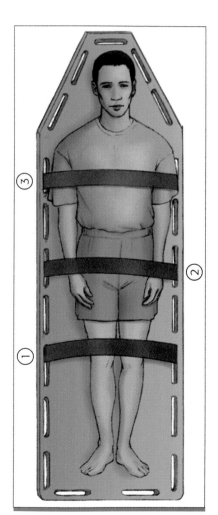

Fig. 5.32 Strap placement for effective immobilization on a backboard.
1. Just above knees
2. Wrists and hips
3. Upper arms

Straps and Strapping Techniques

Every patient who is on a backboard should be strapped down to avoid sliding or slipping off the backboard. There are many ways to strap a patient to a backboard. The method described here is simple to learn and effective in securing the patient.

In strapping a patient to a backboard, the straps should be long enough to go around the entire board and a large patient. Six-foot or 9-foot straps with seat belt–type buckles work well (Figure 5.31). Around-the-board strapping works best and is easiest to understand and apply. The straps are not looped through the handholes on the sides of the backboard but are passed around both the backboard and the patient. Use three straps and place them around the upper arm area, the wrist and hip area, and just above the knees. This placement affords maximum stabilization of the heaviest parts of the patient's body. Strap placement is shown in Figure 5.32.

Head Immobilization

Once a patient has been placed on a backboard, the head and neck must be immobilized using commercially prepared devices (such as foam blocks) or improvised devices (such as a blanket roll). The use of a blanket roll is explained here because it works well and because one is almost always available. The blanket roll should be assembled ahead of time. A blanket is folded and then rolled (with towels as bulk filler) as shown in Figure 5.33.

To place the blanket roll under a patient's head, unroll it enough to fit around the head. This should be done while head stabilization is maintained by one rescuer. The hands of the rescuer holding the patient's head (Rescuer One) are slid carefully from under the blanket, and stabilization is maintained by the blanket roll (Figure 5.34). Head stabilization must be maintained throughout the entire procedure (first by manually stabilizing the patient's head, then by using the blanket roll).

The blanket roll must be fitted securely against the patient's shoulders in order to widen the base of support for the patient's head. Secure the blanket roll to the head with two cravats, and tie them around the blanket roll, over the patient's forehead, and under the chin. Use two more cravats to bind the head and the blanket roll to the backboard. The patient's head and neck are now adequately stabilized against the backboard. This head immobilization technique, coupled with proper placement of straps around the backboard, adequately immobilizes the spine of an injured patient and packages the patient for movement as a unit.

A. Fold blanket.

B. Insert rolled towel and roll from each end.

C. Roll the ends together.

D. Place extra cravats inside.

E. Tie with two cravats.

F. The finished blanket roll.

Fig. 5.33 Preparing a blanket roll.

A. Stabilize the head.

B. Apply a cervical collar.

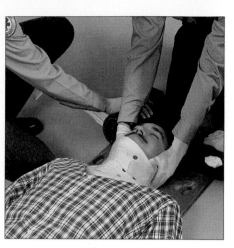

C. Insert the blanket roll.

D. Roll blanket snugly against the neck and shoulders.

E. Tie two cravats around the blanket roll and patient's head.

F. Continue to stabilize the patient's head.

G. Tie two cravats around blackboard.

H. Place straps around backboard and patient.

I. A secured patient.

Fig. 5.34 Applying the blanket roll to stabilize the patient's head and neck.

Foam blocks are quick to apply and provide good stabilization of the patient's head and neck. The use of one type of foam blocks is shown in Figure 5.35.

Remember: Carefully monitor all immobilized patients for airway problems.

A. Apply the head blocks.

B. Secure the device.

C. Apply the immobilization straps.

D. The head is immobilized.

Fig. 5.35 Application of a commercial device to stabilize a patient's head and neck.

In an extreme emergency where a patient must be moved from a dangerous environment and a commercially prepared backboard is not available, you should improvise. Some devices that you can use as backboards include wide, sturdy planks, doors, ironing boards, sturdy folding tables, and full-length lawn chair recliners. These devices should be used only when a patient must be moved to prevent further injury or death and when a commercially prepared backboard is not available.

CHAPTER
REVIEW 5

Summary

As a first responder, you may sometimes have to move patients by yourself. This is necessary if the patient is in a dangerous environment or must be moved in order to receive CPR. Six emergency patient drags are presented in this chapter. These drags enable you to move a patient out of an unsafe environment quickly and without equipment. They are useful even when the patient is heavier than the rescuer. Seven carries for nonambulatory patients are presented. These carries enable two people to carry a patient with little equipment. Two walking assists are presented that allow you to help a patient who cannot walk without some help.

You should be familiar with certain equipment that your local ambulances carry. You may be asked to assist your EMS provider in lifting or moving patients. By learning how to assist with these devices, you can become a more valuable part of the EMS team. You should practice these skills with your local EMS provider. You must also know how to help move patients with spinal injuries. Stabilization and immobilization of trauma patients prevent further injury. Placing the patient on a backboard also makes moving easier. Because you will be called upon to help move patients onto backboards, it is important that you practice these skills involved with treating these patients.

Key Terms

Arm-to-arm drag—page 72

Blanket drag—page 72

Cardiac arrest patient drag—page 73

Cervical collar—page 84

Clothes drag—page 71

Cradle-in-arms carry—page 76

Extremities—page 75

Firefighter drag—page 72

Logrolling—page 86

One-person walking assist—page 80

Pack-strap carry—page 77

Portable stretcher—page 82

Recovery position—page 69

Scoop stretcher—page 83

Stair chair—page 82

Straddle lift—page 88

Straddle slide—page 89

Two-person chair carry—page 76

Two-person extremity carry—page 75

Two-person seat carry—page 76

Two-person walking assist—page 80

What Would You Do?

You are driving home when you come upon a burning car. As you get closer, you see that the driver is still in the car. You notice a handicapped license on the car. What would you do?

At the scene of a two-vehicle accident you are asked by a paramedic if you can help her with stabilizing and immobilizing one patient on a long backboard. What would you do?

You Should Know

1. General principles of moving patients.
2. The purpose of the "recovery position."
3. The importance of good body mechanics.
4. How to determine if a patient should be moved.
5. How best to move a patient if needed.
6. The steps needed to perform the following emergency patient drags:
 a. Clothing drag
 b. Blanket drag
 c. Arm-to-arm drag
 d. Firefighter drag
 e. Cardiac arrest patient drag
 f. Emergency removal from a vehicle
7. The steps needed to perform the following carries for nonambulatory patients:
 a. Two-person extremity carry
 b. Two-person seat carry
 c. Cradle-in-arms carry
 d. Two-person chair carry
 e. Pack-strap carry
 f. Direct ground lift
 g. Transfer from a bed to a stretcher
8. The steps needed to perform the following walking assists:
 a. One-person assist
 b. Two-person assist
9. Identify and describe the purpose of the following pieces of equipment:
 a. Wheeled ambulance stretcher
 b. Portable stretcher
 c. Stair chair
 d. Long backboard
 e. Short backboard devices
 f. Scoop stretcher
10. Describe the steps in each of the following procedures for patients with suspected spinal injuries:
 a. Applying a cervical collar
 b. Moving patients using backboards

c. Assisting with short backboard devices
d. Logrolling
e. Straddle lifting
f. Straddle sliding
g. Strapping
h. Immobilizing the patient's head

You Should Practice

1. Placing a patient in the "recovery position."
2. Lifting and moving patients using good body mechanics.
3. Performing the following emergency patient drags:
 a. Clothes drag
 b. Blanket drag
 c. Arm-to-arm drag
 d. Firefighter drag
 e. Cardiac arrest patient drag
 f. Emergency drag from a vehicle
4. Performing the following patient carries:
 a. Two-person extremity carry
 b. Two-person seat carry
 c. Cradle-in-arms carry
 d. Two-person chair carry
 e. Pack-strap carry
 f. Direct ground lift
 g. Transfer from a bed to a stretcher
5. Performing the following walking assists for ambulatory patients:
 a. One-person assist
 b. Two-person assist
6. Assisting other EMS providers with the following devices:
 a. Wheeled ambulance stretcher
 b. Portable stretcher
 c. Stair chair
 d. Long backboard
 e. Short backboard
 f. Scoop stretcher
7. Assisting other EMS providers with the following procedures for patients with suspected spinal injuries:
 a. Applying a cervical collar
 b. Moving patients using backboards
 c. Applying short backboard devices
 d. Logrolling onto a backboard
 e. Straddle lifting onto a backboard
 f. Straddle sliding onto a backboard
 g. Strapping a patient onto a backboard
 h. Immobilizing a patient's head to a backboard

SKILL SCAN: The Most Common Patient Moves

1.

2.

3.

1. Clothing drag
2. Two-person extremity carry
3–7. Five-person log roll

4.

6.

5.

7.

SELF TEST 1

1. As a first responder, you should move patients
 a. To get them out of a wet environment
 b. To save work for other EMS personnel
 c. Only when necessary to avoid further harm to the patient
 d. At the patient's request

2. Place "EMT" beside each skill that can be done by a basic emergency medical technician and "PM" beside each skill that should be done by a paramedic.
 a. Monitor heart rhythms
 b. Immobilize patients' necks
 c. Administer oxygen
 d. Control external bleeding
 e. Bandage wounds
 f. Administer intravenous fluids

3. Each first responder system should have a medical director.
 a. True
 b. False

4. Place "yes" beside each role that is a responsibility of a first responder.
 a. Perform patient assessment
 b. Provide reassurance
 c. Administer medications
 d. Document patient care
 e. Administer emergency medical care
 f. Rescue patients from certain hazardous environments

5. List six signs of stress.

6. Eat, drink, and be merry are ways of preventing stress. Explain what this statement means.

7. Explain what is meant by the statement "Body substance isolation procedures offer protection in two ways."

8. Place the following reactions to death and dying in order of occurrence.
 Acceptance
 Anger
 Bargaining
 Denial
 Depression

9. Which of the following signs of stress have you experienced recently?
 Irritability
 Inability to concentrate
 Difficulty sleeping
 Anxiety
 Indecisiveness
 Guilt
 Loss of appetite
 Loss of interest in work

10. How do you prevent or reduce the following hazards at the scene of an emergency?
 a. Traffic
 b. Crime or violence
 c. Electrical hazard
 d. Fire
 e. Hazardous materials
 f. Unstable objects

Answers: 1. c. **2.** a. pm; b. emt; c. emt; d. emt, pm; e. emt, pm; f. pm. **3.** a. **4.** a. yes; b. yes; c. no; d. yes; e. yes; f. yes. **5.** Any six of the following are correct: Irritability; Inability to concentrate; Change in normal disposition; Difficulty in sleeping or nightmares; Anxiety; Indecisiveness; Guilt; Loss of appetite; Loss of interest in sexual relations; Loss of interest in work; Isolation. **6.** By eating a balanced, healthful diet, drinking adequate water and fruit juices, avoiding caffeine and alcohol, and engaging in healthy stress-relieving activities, you can prevent and reduce stress. **7.** Body substance isolation protects you from contracting a disease from a patient and it protects a patient from getting a disease from you. **8.** Denial ("not me"); Anger ("why me"); Bargaining ("Okay but"); Depression; Acceptance. **9.** Answer this question by evaluating your reactions to recent stresses in your life. **10.** a. Control scene traffic to prevent further vehicle crashes; park your vehicle to protect the emergency scene. b. Do not enter a scene that is unsafe; call for law enforcement backup, preserve the evidence in a crime scene for law enforcement investigation. c. Be alert for wires down or other signs of electrical hazards; assume all wires are dangerous until turned off; do not approach an emergency scene if there are signs of electrical problems. d. Call for fire department assistance; do not enter a burning building without proper training and equipment; avoid sources of ignition at vehicle crash scenes. e. Look for signs of the presence of hazardous materials as you approach the emergency scene; stay away from potential hazardous material scenes; do not become a casualty. f. Assess emergency scenes for unstable objects; avoid placing yourself in a situation where you may be injured; stabilize vehicles before entering them.

Self Test 1 99

11. What are the differences between the following types of consent?

 a. Expressed consent
 b. Implied consent
 c. Consent of minors
 d. Consent of mentally ill patients
 e. Lack of consent or refusal of care

12. Compare the consent for treatment of adults with the consent for treatment of children.

13. Which of the following conditions can you use to determine that a patient at an emergency scene is dead?

 a. Tissue decomposition
 b. Cold skin
 c. Rigor mortis
 d. Decapitation
 e. No pulse
 f. Dependent lividity

14. Name six factors you should address when documenting your handling of a patient care incident.

15. Match each body system with the appropriate definition.

 a. Respiratory
 b. Circulatory
 c. Skeletal
 d. Muscular
 e. Nervous
 f. Digestive
 g. Genitourinary
 h. Skin

 1. Provides protection and cooling to the body
 2. Protects vital organs and allows motion
 3. Gets rid of metabolic waste products
 4. Absorbs nutrients
 5. All the structures that contribute to breathing
 6. Controls voluntary and involuntary activities
 7. Provides motion
 8. Transports oxygen, nutrients, and waste products

16. Match the pairs of words from the following list:
Anterior
Distal
Inferior
Lateral
Medial
Posterior
Proximal
Superior

17. The xiphoid process is

 1. The flexible cartilage at the lower tip of the sternum
 2. Important in maintaining an open airway
 3. Used in determining the correct position for doing CPR
 4. Should not be used on trauma patients
 5. A key landmark in administering the Heimlich maneuver

 a. 2, 4, and 5
 b. 3, 4, and 5
 c. 1, 2, and 4
 d. 1, 3, and 5
 e. 2 and 4

11. a. Permission given by a competent adult, usually given verbally at an emergency scene. b. Permission to treat is assumed in any patient who does not refuse emergency care; unconscious patient is assumed to have given his consent because of inability to respond. c. Consent for treatment of minors must be given by their parent or guardian; if a patient or guardian is not present at the emergency scene, you should treat the patient and let the hospital get permission for further treatment. d. Patients who are out of touch with reality may require you to contact law enforcement officials if they refuse treatment. e. Any patient who is mentally "in control" or competent can refuse treatment at any time. **12.** Treatment of conscious adults is based on their given expressed permission; in unconscious children, the consent is assumed in the absence of their parent or guardian; if a parent or guardian is present they must give expressed consent for treatment of the child. **13.** a, c, d, f. **14.** 1. The condition of the patient when found; 2. The patient's description of the injury or illness; 3. The patient's initial and repeat vital signs; 4. The treatment you gave the patient; 5. The agency and personnel who took over the treatment of the patient; 6. Any other helpful facts; 7. Any reportable conditions present; 8. Any infectious diseases present; 9. Anything unusual regarding the case. **15.** a, 5; b, 8; c, 2; d, 7; e, 6; f, 4; g, 3; h, 1. **16.** anterior-posterior distal-proximal inferior-superior lateral-medial. **17.** d.

18. The purpose of the recovery position is
 1. To help the patient recover faster
 2. To help keep the airway open
 3. To aid in the removal of secretions
 4. To keep the spine stabilized
 a. 1 and 2
 b. 3 and 4
 c. 1 and 4
 d. 2 and 3

19. When should you move a patient?

20. Which of the following moves and carries are appropriate to use for a patient with a possible neck or spine injury?
 a. Clothes drag
 b. Arm-to-arm drag
 c. Firefighter drag
 d. Emergency removal from a vehicle
 e. Two-person extremity carry
 f. Two-person chair carry

21. List, in order, the steps involved in logrolling a patient.

18. d. **19.** 1. When danger of fire or explosion or structural collapse exists. 2. When hazardous materials are present. 3. When the accident scene cannot be protected. 4. When it is otherwise impossible to gain access to other patients who need lifesaving care. 5. When the patient has suffered cardiac arrest and must be moved for CPR. **20.** None of these moves and carries are designed for moving patients who have suffered a possible neck or back injury. However, in extreme emergency situations where patients must be moved to save their lives, a, b, c, or d could be used. **21.** Move the patient as a unit. Keep the head in a neutral position at all times. Be sure that all rescuers understand what is to be done before any movement is attempted. Be sure that the rescuer at the head is responsible for giving commands. Roll the patient on his or her side. Slide the backboard toward the patient. Roll the patient onto his or her back. Center the patient on the backboard. Secure the patient to the backboard.

M O D U L E

2

AIRWAY

The purpose of this module is to teach you the skills you need to open a patient's airway and perform rescue breathing. You will learn the skills required to determine if a patient is experiencing respiratory difficulty. You will learn two different ways to open a patient's airway, the head-tilt/chin-lift and the jaw-thrust techniques. The module describes how to check for foreign substances in the patient's airway and how to remove these substances with finger sweeps and suction machines. The indications for using oral and nasal airways are covered, and the steps for inserting these devices are listed.

Signs of adequate and inadequate breathing are presented. You will learn how to perform rescue breathing using mouth-to-mask devices, mouth-to-barrier devices, and mouth-to-mouth techniques. The use of abdominal thrusts to clear a patient's airway is an easily learned technique that can save many lives. This chapter presents the steps needed to relieve choking in adults, infants, and children.

The final section of this module covers patients with special considerations. These include patients who have stomas, patients with dental appliances, and patients who are in vehicles.

The airway and breathing skills you learn in this chapter will be the basis for learning the circulation skills in Chapter 8. By putting together airway, breathing, and circulation skills, you will be able to perform cardiopulmonary resuscitation, or CPR.

AIRWAY CARE AND RESCUE BREATHING

Knowledge and Attitude Objectives *After studying this chapter, you will be expected to:*

1. Identify the anatomical structures of the respiratory system and state the function for each structure.
2. State the differences in the respiratory systems of infants, adults, and children.
3. Describe the process used to check a patient's responsiveness.
4. Describe the steps in the head-tilt/chin-lift technique.
5. Describe the steps in the jaw-thrust technique.
6. Describe how to check for fluids, solids, and dentures in a patient's mouth.
7. State the steps needed to clear a patient's airway using finger sweeps and suction.
8. Describe the steps required to maintain a patient's airway using the recovery position, oral airways, and nasal airways.
9. Describe the signs of adequate breathing, the signs of inadequate breathing, the causes of respiratory arrest, and major signs of respiratory arrest.
10. Describe how to check a patient for the presence of breathing.
11. Describe how to perform rescue breathing using a mouth-to-mask device, a mouth-to-barrier device, and mouth-to-mouth techniques.
12. Describe, in order, the steps for recognizing respiratory arrest and performing rescue breathing in adults, children, and infants.
13. Describe the differences between the signs and symptoms of partial airway obstruction and complete airway obstruction.
14. List the steps in managing a foreign body airway obstruction in conscious and unconscious adults, in conscious and unconscious children, and in conscious and unconscious infants.
15. List the special considerations needed to perform rescue breathing in patients with stomas.
16. Describe the special considerations of airway care and rescue breathing in children and infants.
17. Describe the hazards dental appliances present when performing airway skills.
18. Describe the steps in providing airway care to a patient in a vehicle.

Skill Objectives *As a first responder, you should be able to:*

1. Demonstrate the head-tilt/chin-lift and jaw-thrust techniques for opening blocked airways.
2. Check for fluids, solids, and dentures in a patient's airway.
3. Correct a blocked airway using finger sweeps and suction.
4. Place a patient in the recovery position.
5. Insert oral and nasal airways.
6. Check for the presence of breathing.
7. Perform rescue breathing using a mouth-to-mask device, a mouth-to-barrier device, and mouth-to-mouth techniques.
8. Demonstrate the steps in recognizing respiratory arrest and performing rescue breathing on an adult patient, a child, and an infant.
9. Perform the steps needed to remove a foreign body airway obstruction in an adult patient, a child, and an infant.
10. Demonstrate rescue breathing on a patient with a stoma.
11. Perform airway management on a patient in a vehicle.

This chapter introduces the two most important lifesaving skills, airway care and rescue breathing. Patients must have an open airway passage and must maintain adequate breathing to live. By learning and practicing the simple skills in this chapter, you can often make the difference between life and death for a patient.

To practice airway and rescue breathing skills, it is necessary to review the major structures of the respiratory system. By learning the functions of these structures, you will be a long way down the road to becoming proficient in performing these skills.

The skills of airway care and rescue breathing are as easy as A and B—the "A" stands for airway, and the "B" stands for breathing. Because the assessment and correction of the airway is done before you turn your attention to the patient's breathing status, it is helpful to remember the AB sequence. In Chapter 8, we will add "C" for the assessment and correction of the patient's circulation. As you learn the skills presented in this chapter and in Chapter 8, remember the ABC sequence. A second mnemonic that will be used throughout this chapter and Chapter 8 is "check and correct." By remembering this two-step sequence for each of the ABCs, you will be able to remember the steps needed to check and correct problems involving the patient's airway, breathing, and circulation.

The A section presents airway skills, including checking the level of consciousness and manually correcting a blocked airway by means of the head-tilt/chin-lift and jaw-thrust techniques. You must check the patient's airway for foreign objects. If you find foreign objects, you must correct the problem by removing the objects using a manual technique or a suction device. You will learn when and how to use oral and nasal airways to keep the patient's airway open.

The B section describes how to check patients to determine whether or not they are breathing adequately. You will learn how to correct breathing

problems by using three rescue breathing techniques: mouth-to-mask, mouth-to-barrier device, and mouth-to-mouth.

Finally, you will learn how to check patients to determine if they have an airway obstruction that can cause death in a few minutes. You will learn how to correct this condition using manual techniques that require no special equipment.

As you study this chapter, remember the check and correct process for the airway and breathing skills. And do not forget that the A and B skills presented in this chapter are followed by C (for "circulation") skills in Chapter 8. Once you have learned the Airway, Breathing, and Circulation skills (the ABCs), you will be able to perform **cardiopulmonary resuscitation (CPR)**. CPR is used to save the lives of people suffering cardiac arrest.*

Anatomy and Function of the Respiratory System

To maintain life, all organisms must receive a constant supply of certain substances. In human beings, these basic life-sustaining substances are food, water, and **oxygen**. A person can live several weeks without food because the body uses nutrients stored in the body. Although the body does not store as much water, it is possible to live several days without fluid intake. But lack of oxygen, even for a few minutes, can result in irreversible damage and death.

The most sensitive cells in the human body are in the brain. If brain cells are deprived of oxygen and nutrients for 4 to 6 minutes, they begin to die. Brain death is followed by the death of the entire body. Once brain cells have been destroyed, they cannot be replaced. For this reason, an understanding of the anatomy and function of the respiratory system is important.

The main purpose of the respiratory system is to provide oxygen and to remove carbon dioxide from the red blood cells as they pass through the lungs. This knowledge is the basis for your study of the lifesaving skill of CPR.

The parts of the body used in breathing are shown in Figure 6.1 and include the mouth (**oropharynx**), the nose (**nasopharynx**), the throat, the **trachea** (windpipe), the lungs, the diaphragm (the dome-shaped muscle between the chest and the abdomen), and numerous chest muscles. Air enters the body through the nose and mouth. In an unconscious patient lying on his or her back, the passage of air through both nose and mouth may be blocked by

Cardiopulmonary resuscitation (CPR) The artificial circulation of the blood and movement of air into and out of the lungs in a pulseless, nonbreathing patient.

Oxygen (O$_2$) A colorless, odorless gas that is essential for life.

Oropharynx The posterior part of the mouth.

Nasopharynx The posterior part of the nose.

Trachea The windpipe.

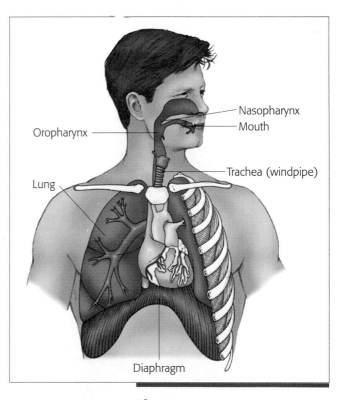

Fig. 6.1 The respiratory system.

*The material presented in this book concerning CPR is intended to follow the CPR standards set by the American Heart Association (AHA). Although the information presented here follows AHA standards at the time of publication, be aware that these standards are subject to periodic revision and updating. You should follow the AHA's most current CPR standards.

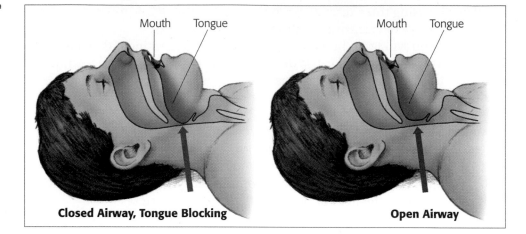

Fig. 6.2 In an unconscious patient, the airway may be blocked by the tongue (left). Open airway (right).

Mouth Tongue Mouth Tongue

Closed Airway, Tongue Blocking **Open Airway**

Mandible The lower jaw.

Esophagus The tube through which food passes. It starts at the throat and ends at the stomach.

Airway The passages from the openings of the mouth and nose to the air sacs in the lungs through which air enters and leaves the lungs.

Bronchi The two main branches of the windpipe that lead into the right and left lungs. Within the lungs, they branch into smaller airways.

Lungs The organs that supply the body with oxygen and eliminate carbon dioxide from the blood.

Alveoli The air sacs of the lungs where the exchange of oxygen and carbon dioxide takes place.

Capillaries The smallest blood vessels that connect small arteries and small veins. Capillary walls serve as the membrane to exchange oxygen and carbon dioxide.

the tongue (Figure 6.2). The tongue is attached to the lower jaw (**mandible**). During unconsciousness, the jaw relaxes and the tongue falls backward into the rear of the mouth, effectively blocking the passage of air from both nose and mouth to the lungs. A partially blocked airway often produces a snoring sound.

At the bottom of the throat are two passages, the **esophagus** (the food tube) and the trachea. The epiglottis is a thin flapper valve that allows air to enter the trachea but prevents food or water from getting into the trachea. Air passes from the throat to the larynx (voice box). The larynx is seen externally as the Adam's apple in the neck. Below the trachea, the **airway** divides into the **bronchi** (two large tubes). The bronchi branch into smaller and smaller airways in the **lungs**. The lungs are located on either side of the heart and are protected by the sternum at the front and by the rib cage at the sides and back (Figure 6.3).

The airways branch into smaller and smaller passages, which end as tiny air sacs called **alveoli**. The alveoli are surrounded by very small blood vessels, the **capillaries** (Figure 6.4). The actual exchange of gases takes place across a thin membrane that separates the capillaries of the circulatory system from the alveoli of the lungs. The incoming oxygen passes from the alveoli into the blood, and outgoing carbon dioxide passes from the blood into the alveoli.

The lungs consist of soft, spongy tissue with no muscles. Therefore, movement of air into the lungs depends on movement of the rib cage and the diaphragm. As the rib cage expands, air is drawn into the lungs through the trachea. The diaphragm is a muscle that separates the abdominal cavity from the chest. When relaxed, it is dome shaped; when contracted, it flattens and moves downward. This action increases the size of the chest cavity and draws air into the lungs through the trachea. In normal breathing, the action of the diaphragm and rib cage together automatically produces adequate inhalation and exhalation (Figure 6.5).

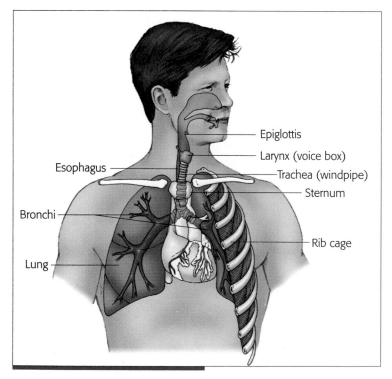

Epiglottis
Larynx (voice box)
Trachea (windpipe)
Sternum
Esophagus
Rib cage
Bronchi
Lung

Fig. 6.3 Anatomy of the respiratory system.

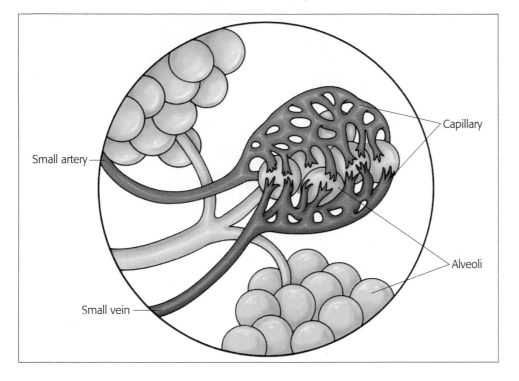

Fig. 6.4 The exchange of gases occurs in the alveoli of the lungs.

Capillary

Small artery

Alveoli

Small vein

≡ SPECIAL NEEDS

Special Considerations for Infants and Children

- The structures of the respiratory systems of children and infants are smaller than they are in adults. Thus the air passages of children and infants may be more easily blocked by secretions or by foreign objects.
- In children and infants, the tongue is proportionally larger than it is in adults. Thus the tongue of these smaller patients is more likely to block their airway than it would in an adult patient.
- Because the trachea of an infant or child is more flexible than that of an adult, it is more likely to become narrowed or blocked than that of an adult.
- The head of a child or an infant is proportionally larger than the head of an adult. You will have to learn slightly different techniques for opening the airway of children.

Fig. 6.5 Normal mechanical act of breathing.

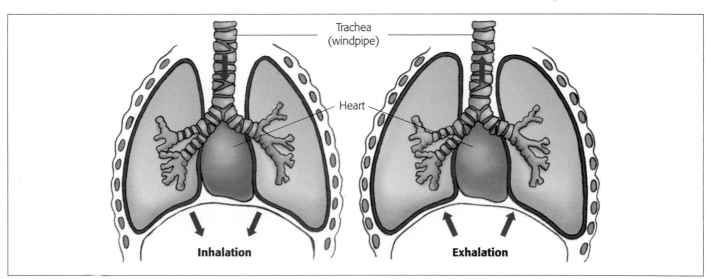

Trachea (windpipe)

Heart

Inhalation

Exhalation

Rescue breathing Artificial means of breathing for a patient.

Fig. 6.6 Establish the level of consciousness.

- Children and infants have smaller lungs than adults. You need to give them smaller breaths when you perform **rescue breathing**.
- Most children and infants have healthy hearts. When a child or infant suffers cardiac arrest (stoppage of the heart), it is usually because the patient has a blocked airway or has stopped breathing, not because of problems with their hearts.

Check Point

✔ What are the major structures of the respiratory system?

✔ What is the function of each structure?

✔ How are these functions interrelated?

"A" Is for Airway

The patient's airway is the pipeline that transports life-giving oxygen from the air to the lungs and transports the waste product, carbon dioxide, from the lungs to the air. When we are healthy, we keep our airways open without thinking about it. If we are injured or seriously ill, we may not be able to protect our airway and it may become blocked. If a patient cannot protect his or her airway, you must take certain steps to check the condition of the patient's airway and correct the problem to keep the patient alive.

A

- Check
- Correct
- Check
- Correct
- Maintain

Check for Responsiveness

The first step in assessing a patient's airway is to check the patient's level of responsiveness. When you first approach a patient, immediately find out whether the patient is conscious or unconscious by asking, "Are you okay? Can you hear me?" (See Figure 6.6.) If you get a response, assume that the patient is conscious and has an open airway. If there is no response, grasp the patient's shoulder and gently shake the patient. Then repeat your question. If the patient still does not respond, you can assume the patient is unconscious and that you will need more help. Before doing anything for the patient, call 9-1-1 if the EMS system has not already been activated, especially if you are the only rescuer. Position the patient by supporting the patient's head and neck and place the patient on his or her back.

A

- Check
- Correct
- Check
- Correct
- Maintain

Correct the Blocked Airway

An unconscious patient's airway is often blocked (occluded) because the tongue has dropped back and is obstructing it. In this case, the act of opening the airway may enable the patient to breathe spontaneously.

Head-Tilt/Chin-Lift Technique

Head-tilt/chin-lift technique Opening the airway by tilting the patient's head backward and lifting the chin forward, bringing the entire lower jaw with it.

To open the airway, place one hand on the forehead and place the fingers of the other hand under the point of the chin. Push down on the forehead and lift up and forward on the chin. Be certain you are not merely pushing the mouth closed when you use this technique. This means of opening the airway is called the **head-tilt/chin-lift technique** (Figure 6.7).

Follow these steps to perform the head-tilt/chin-lift technique:

1. Place the patient on his or her back and kneel beside the patient.
2. Place one hand on the patient's forehead and apply firm pressure backward with your palm. Move the patient's head back as far as possible.
3. Place the tips of the fingers of your other hand under the bony part of the chin.
4. Lift the chin forward to help tilt the head back.

Jaw-Thrust Technique

The **jaw-thrust technique,** or maneuver, is another way to open a patient's airway. If a patient has suffered an injury such as a fall, diving mishap, or automobile accident, do not tilt the head to open the airway. To do so may cause permanent paralysis in a patient with a neck injury. If you suspect neck injury, use the jaw-thrust technique. Open the airway by placing your fingers under the angles of the jaw and pushing upward. At the same time, use your thumbs to open the mouth slightly. The jaw-thrust technique should open the airway without extending the neck (Figure 6.8).

Follow these steps to perform the jaw-thrust technique:

1. Place the patient on his or her back and kneel at the top of the patient's head. Place your fingers behind the angles of the patient's lower jaw and move the jaw forward with firm pressure.
2. Tilt the head backward to a neutral or slight sniffing position. Do not extend the cervical spine in a patient who has suffered an injury to the head or neck.
3. Use your thumbs to pull the patient's lower jaw down, opening the mouth enough to allow breathing through the mouth and nose.

Check for Fluids, Foreign Bodies, or Dentures

After you have opened the patient's airway by using the head-tilt/chin-lift or jaw-thrust technique, look in the patient's mouth to see if anything is blocking the patient's airway. Look for secretions such as vomitus, mucus, or blood. Look for foreign objects such as candy, food, or dirt. Look for dentures or false teeth that may have become dislodged and may be blocking the patient's airway (Figure 6.9). If you find anything in the patient's mouth, remove it by using one of the following techniques. If you do not find any objects in the patient's mouth, consider using one of the devices described in the section on airway devices.

Focus on Treatment

Jaw-thrust technique Opening the airway by bringing the patient's jaw forward without extending the head.

Focus on Treatment

- Check
- Correct
- Check
- Correct
- Maintain

A

Fig. 6.7 (below left) Open the patient's airway using the head-tilt/chin-lift technique.

Fig. 6.8 (below right) The jaw-thrust technique should open the patient's airway without extending the neck.

Fig. 6.9 Check for fluids, foreign bodies, and dentures.

SAFETY PRECAUTION
Use body substance isolation (BSI) techniques whenever you may be in contact with body secretions that might contain blood.

A
- Check
- Correct
- Check
- Correct
- Maintain

Correct the Airway Using Finger Sweeps or Suction

Vomitus, mucus, blood, and foreign objects must be cleared from the patient's airway. This can be done by using finger sweeps, suctioning, or the recovery position.

Finger Sweeps

Finger sweeps can be done quickly and require no special equipment except a set of latex gloves. They are performed by turning the patient's head to one side and using the gloved index and middle fingers to scoop out as much of the material as possible (Figure 6.10). A gauze pad wrapped around your gloved fingers may help remove the obstructing materials. Repeat the finger sweeps if needed to remove all the foreign material in the patient's mouth. Finger sweeps should be your first attempt at clearing the airway even if suction equipment is available.

Fig. 6.10 Clear the airway using finger sweeps.

A. Turn the patient onto his or her side.

B. Insert your finger into the patient's mouth.

C. Curve your finger into a C-shape and sweep it from one side of the back of the mouth to the other.

Suctioning

Sometimes just sweeping out the mouth is not enough to clear the materials completely from the mouth and upper airway. Suction machines can be helpful in removing secretions such as vomitus, blood, and mucus from the patient's mouth. Two types of suction devices are available, manual and mechanical suction devices.

Manual Suction Devices

Several **manual suction devices** are available to first responders (Figure 6.11). These devices are relatively inexpensive and are compact enough to fit into first responder life support kits. With most manual suction devices, you insert the end of the suction tip into the patient's mouth and squeeze or pump the hand-powered pump. Be sure that you do not insert the tip of the suction farther than you can see. Except for the means by which manual suction devices are powered, they are operated according to the same steps as the mechanical suction devices described in the following section. Be sure to follow local medical protocols regarding first responders' authorization to use suction devices in the field.

Remember: Do not forget to ventilate all patients who are not breathing.

Manual suction device A hand-powered device used for clearing the upper airway of mucus, blood, or vomitus.

Mechanical Suction Devices

A **mechanical suction device** uses either a battery-powered pump or an oxygen-powered **aspirator** to create a vacuum that will draw the obstructing materials from the patient's airway (Figure 6.12). To use this type of suction machine, you must learn how to operate the device and control the force of the suction.

Two different types of suction tips are commonly used with mechanical suction devices: the rigid tip and the flexible whistle tip catheter.

When using mechanical suction, first clear the mouth of large pieces of material with your gloved fingers. After the mouth is clear, turn the suction device on and begin suctioning with the rigid tip to remove most of the remaining material. Suction for less than 15 seconds at a time because the suction will draw not only the obstructing material but also air from the patient's airway.

Mechanical suction device An electrically powered device used for clearing the upper airway of mucus, blood, or vomitus.

Aspirator A suction device.

Fig. 6.11 (left) Manual suction device.

Fig. 6.12 (right) Battery-powered suction device.

Fig. 6.13 (left) Rigid suction tip.

Fig. 6.14 (right) Flexible suction catheter.

≡ SPECIAL NEEDS

Pediatric Considerations

- When suctioning a child's airway, suction for no more than 10 seconds at a time.
- When suctioning an infant's airway, suction for no more than 5 seconds at a time.

SAFETY PRECAUTION
Use body substance isolation (BSI) techniques when clearing the patient's airway.

If the rigid tip has a suction control port (a small hole located close to the tip's handle), you must place a finger over the hole to create the suction (Figure 6.13). Do not keep your finger over this control port for longer than 15 seconds at one time because you may rob the patient of oxygen.

Once you have cleared most of the obstructing material out of the patient's mouth and upper airway with the rigid tip, change to the flexible tip to clear out material from the deeper parts of the patient's throat (Figure 6.14).

The flexible whistle tip catheters have suction control ports, which are located close to the end of the catheter that attaches to the suction machine. Again, place a finger over the control port to achieve suction.

Remember: Do not suction any deeper than you can see.

Suctioning the airway (either manually or mechanically) is a lifesaving technique. Although a gauze pad and your gloved fingers can do most of the work, the use of supplementary suction devices enables you to remove much more obstructing material from the patient's airway.

A
- Check
- Correct
- Check
- Correct
- Maintain

Maintain the Airway

In patients who are unable to keep their airway open, you must open their airway manually. You have learned how to do this by using the head-tilt/chin-lift or jaw-thrust technique to open the airway. Unconscious patients will not be able to keep their airway open. You can continue to keep their airway open by using the head-tilt/chin-lift or jaw-thrust technique. To do this, you must continue to keep holding the patient's head to maintain the head-tilt or the jaw-thrust position.

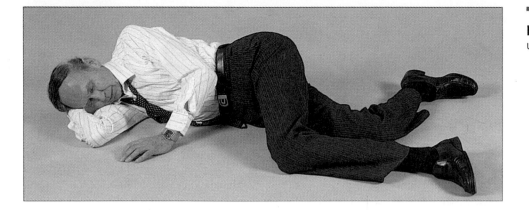

Fig. 6.15 Recovery position for an unconscious patient.

If the patient is breathing adequately, you can keep the airway open by placing the patient in the recovery position. You can also insert an oral or nasal airway to keep the patient's airway open. These two mechanical airway devices will maintain the patient's airway once you have opened it manually.

Recovery Position

If an unconscious patient is breathing and the patient has not suffered trauma, one way to keep the airway open is to place the patient in the recovery position. The recovery position helps keep the patient's airway open by allowing secretions to drain out of the mouth instead of draining into the trachea. It also uses gravity to help keep the patient's tongue and lower jaw from blocking the airway.

To place a patient in the recovery position, carefully roll the patient onto one side while carefully supporting the patient's head. Roll the patient as a unit without twisting the body. After the patient has been placed on one side, support the person's head with the arm that is now on the lower side of the person's body. Place the patient's face so any secretions can drain out of the mouth and place the head in a position similar to the tilted back position of the head-tilt/chin-lift technique. You can use the patient's hand to help hold his or her head in a good position. See Figure 6.15 for a demonstration of the recovery position.

Oral Airway

An **oral airway** has two primary purposes. It is used to maintain the patient's airway once you have opened the airway manually. It also functions as a pathway through which you can suction the patient. An oral airway can be used in any unconscious patient who does not have a **gag reflex**. It cannot be used in conscious patients because they have a gag reflex. Oral airways can be used for unconscious patients who are breathing or who are in **respiratory arrest**. These airways can be used with mechanical breathing devices such as the **pocket mask**.

There are two styles of oral airways. One has an opening down the center, and the other has a slot along each side. The opening or slot permits the free flow of air and allows you to suction through the airway (Figure 6.16). Before you insert the oral airway, you need to select the proper size. Choose the proper size by measuring from the earlobe to the corner of the patient's mouth (Figure 6.17). When properly inserted, the airway will rest inside the

Oral airway An airway adjunct that is inserted into the mouth to keep the tongue from blocking the upper airway. It is also called an oropharyngeal or nasopharyngeal airway.

Gag reflex A strong involuntary effort to vomit caused by something being placed or caught in the throat.

Respiratory arrest Sudden stoppage of breathing.

Pocket mask A mechanical breathing device used to administer mouth-to-mask rescue breathing.

Fig. 6.16 Oral airways.

Fig. 6.17 Proper sizing of an oral airway.

Fig. 6.18 Inserting an oral airway.

A. Inserting the airway.

B. Proper position of flange after insertion.

mouth. The curve of the airway should follow the contour of the tongue. The flange should rest against the lips. The other end should be resting in the back of the throat.

 Focus on Treatment

Follow these steps to insert an oral airway:

1. Select the proper sized airway by measuring from the patient's earlobe to the corner of the mouth (Figure 6.17).
2. Open the patient's mouth with one hand after manually opening the patient's airway with a head-tilt/chin-lift or jaw-thrust technique.
3. Hold the airway upside down with your other hand. Insert the airway into the patient's mouth and guide the tip of the airway along the roof of the patient's mouth, advancing it until you feel resistance (Figure 6.18A).
4. Rotate the airway 180 degrees until the flange comes to rest on the patient's teeth or lips (Figure 6.18B).

Be especially careful to avoid rough handling when you insert the airway. The roof of the patient's mouth can be injured by the rough insertion of an oral airway. Remember that an oral airway does not open the patient's airway. It maintains the open airway after you have opened it with a manual technique.

SPECIAL NEEDS

Pediatric Considerations When inserting an oral airway in a child, be careful to avoid injuring the roof of the child's mouth because it is much more fragile than that of an adult. The technique for inserting an oral airway is almost the same as for an adult patient. The exception is that the tongue is depressed with two or three stacked tongue blades. This presses the tongue forward and away from the roof of the mouth and makes it easier to insert the airway.

Nasal airway An airway adjunct that is inserted into the nostril of a patient who is not able to maintain a natural airway. It is also called a nasopharyngeal airway.

Nasal Airway

A second type of device you can use to keep the patient's airway open is a **nasal airway** (Figure 6.19). This device is inserted into the patient's nose. Nasal airways can be used in unconscious patients and in conscious patients who are not able to maintain an open airway. Usually a patient will tolerate a nasal airway better than an oral airway. It is not as likely to cause vomiting. One disadvantage of a nasal airway is that you cannot suction through it because the inside diameter of the airway is too small for the standard suction tip, a whistle tip catheter.

Fig. 6.19 A nasal airway.

VOICES of EXPERIENCE

"One of the most memorable and rewarding events in my EMS experience was a car-motorcycle accident many years ago. On May 6, 1981, I was off duty as a Captain Paramedic when I saw two motorcycles collide with a large Cadillac. A visual size-up of the scene revealed a very critical situation. I asked a passing citizen to call dispatch for assistance, to request a helicopter, and to tell them I was on-scene ordering the resources. I grabbed my trauma kit from the truck and headed for the patients.

A quick triage revealed one patient who was conscious with serious injuries, and I classified him as delayed for any treatment. The priority patient was unconscious with critical injuries. He was on his back with a severely angulated femur fracture and an open tib-fib. The immediate life-threatening injury was multiple fractures of the face causing substantial hemorrhaging into his airway. His entire oral cavity was already filled with blood that was running down the sides of his face. He was not breathing. Using a 50cc syringe and a short section of oxygen tubing as an improvised suction unit, I was able to suction out the blood. While instructing two citizens, one for C-spine stabilization and the other to continue suctioning, I was able to intubate that patient. A citizen helped ventilate the patient, allowing me to start two IV lines. I was just finishing the second line when the first fire unit arrived. Two members of the crew treated the other patient and two members assisted me in placing a MAST suit on my patient. The helicopter landed just as we finished. The time from dispatch to liftoff was 14 minutes. The patient was flown to a trauma center.

A year later, on May 6, I received a phone call. "Is this Gary Morris?" "Yes, it is," I replied, not recognizing the voice. The person asked, "Do you remember what today's date is? Last year on this date you saved my life." He then went on to describe his injuries and his months of recuperation. Steve went on to become a successful businessman and to raise a family. He still calls me on May 6 each year. He would have died within minutes that day if a first responder was not immediately available to treat his airway hemorrhage."

Gary Morris
EMT-P
Deputy Chief
Phoenix Fire Department
Phoenix, Arizona

Fig. 6.20 Proper sizing of a nasal airway.

Fig. 6.21 Inserting a nasal airway.

It is necessary to select the proper size nasal airway for the patient. Measure from the tip of the patient's nose to the bottom of the ear, as shown in Figure 6.20. Coat the airway with a water-soluble lubricant before inserting it. This makes it easier for you to insert the airway and reduces the chance of trauma to the patient's airway.

Select whichever nostril is larger to make the airway insertion easier. As you insert the airway, follow the curvature of the floor of the nose (Figure 6.21). You are done inserting the airway when the flange or trumpet rests against the patient's nostril. At this point, the other end of the airway will be in the back of the patient's throat maintaining an open airway for the patient.

A. Inserting a nasal airway.

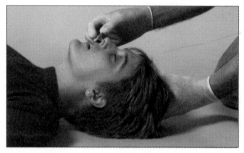
B. Proper position of flange after insertion.

Focus on Treatment

Follow these steps to insert a nasal airway:

1. Select the proper size airway by measuring from the tip of the patient's nose to the earlobe.
2. Coat the airway with a water-soluble lubricant.
3. Select the larger nostril.
4. Gently stretch the nostril open by using your thumb.
5. Gently insert the airway until the flange rests against the nose. Do not force the airway. If you feel any resistance, remove the airway and try to insert it in the other nostril.

Practice the proper sizing and insertion until you can do it quickly and smoothly.

Remember:

- To *open* the patient's airway,
 1. Perform the head-tilt/chin-lift technique, *or*
 2. Perform the jaw-thrust technique.

- To *maintain* the patient's airway,
 1. Continue to apply the head-tilt/chin-lift technique, *or*
 2. Continue to apply the jaw-thrust technique, *or*
 3. Insert an oral airway, *or*
 4. Insert a nasal airway, *or*
 5. Place the patient in the recovery position.

- Having opened and maintained the patient's airway, you need to continue to monitor the status of the patient's breathing.

Check Point

Fill in the following blanks:

✓ First, check the patient for _responsiveness_

✓ Correct the blocked airway by 1. _head tilt_ or 2. _jaw thrust_.

✓ Check for 1. _secretions_, 2. _vomitus_, or 3. _solid objects_

✓ Correct the airway using 1. _finger sweep_ or 2. _suctioning_

or

✓ Maintain the airway by 1. _manually holding open_ 2. _oral airway_, or 3. _nasal airway_

"B" Is for Breathing

After you have checked and corrected the patient's airway, you should move on to checking and correcting the patient's breathing. To be able to check the patient's breathing status, you must understand the signs of adequate breathing, the signs of inadequate breathing, and the signs and causes of respiratory arrest.

Signs of Adequate Breathing

To check for adequate breathing, you must look, listen, and feel at the same time. If a patient is breathing adequately, you can look for the rise and fall of the patient's chest, you can listen for the sounds of air passing into or out of the patient's nose and mouth, and you can feel for the movement of air on the side of your face. Place the side of your face close to the patient's nose and mouth and watch the patient's chest. You are *looking* for movement of the chest, *listening* for sounds of air movement, and *feeling* for the movement of air in and out of the patient's nose and mouth. A normal adult has a resting breathing rate of approximately 12 to 20 breaths per minute. Remember that inhalation and exhalation are counted as one breath.

Signs of Inadequate Breathing

If a patient is breathing inadequately, you will detect signs of abnormal respirations—noisy respirations, wheezing, or gurgling—all of which indicate partial blockage or constriction somewhere along the respiratory tract. Rapid or gasping respirations may indicate that the patient is not receiving an adequate amount of oxygen due to illness or injury. The patient's skin may be pale or even blue, especially around the lips or fingernail beds.

The most critical sign of inadequate breathing is respiratory arrest (total lack of respirations). This critical state is characterized by no movement of the

chest, no breath sounds, and no sensation of air movement on the side of your face. In patients with severe hypothermia, respirations can be slowed (and/or shallow) to the point that the patient appears clinically dead.

There are many causes of respiratory arrest. By far the most common cause is heart attack, which claims more than 500,000 lives each year. The primary causes of respiratory arrest are as follows:

- Mechanical blockage or obstruction caused by the tongue
 - Vomitus, particularly in a patient weakened by illness, such as a stroke
 - Foreign objects: teeth, dentures, balloons, marbles, pieces of food, or hard candy (especially in small children)
- Illness or disease such as heart attack or severe stroke
- Overdose of drugs
- Poisoning
- Severe loss of blood
- Electrocution by electrical current or lightning

The major signs of respiratory arrest are

- No chest movement
- No breath sounds
- No air movement
- Blue skin (cyanosis), especially around the lips

Check for the Presence of Breathing

After establishing the loss of consciousness and opening the airway of the unconscious patient, check for breathing by looking, listening, and feeling (Figure 6.22):

- *Look* for the rising and falling of the patient's chest.
- *Listen* for the sound of air moving in and out of the patient's nose and mouth.
- *Feel* for the movement of air on the side of your face and ear.

Focus on Assessment

B • Check
• Correct

Fig. 6.22 Check for breathing by looking, listening, and feeling.

Fig. 6.23 To perform rescue breathing, pinch the patient's nose with your thumb and forefinger.

Continue to look, listen, and feel for at least 3 to 5 seconds; if you do not, you risk checking the patient between breaths and missing any signs of breathing that are present. If there are no signs of breathing, proceed to the next step, correcting the lack of breathing by beginning rescue breathing. If the patient is breathing adequately (about 12 to 20 times a minute), you can continue to maintain the airway and monitor the rate and depth of respirations to make sure the patient is breathing adequately.

Correct the Breathing

You must breathe for any patient who is not breathing. Throughout rescue breathing, keep the airway open by using the head-tilt/chin-lift method (or the jaw-thrust method for patients with head or neck injuries). Rescue breathing is done by blowing your air into the patient's mouth. You should pinch the patient's nose with your thumb and forefinger, take a deep breath, and blow slowly for 1½ to 2 seconds (Figures 6.23 and 6.24).

Use just enough force to make the patient's chest rise. Use slow, gentle, sustained breathing that just makes the chest rise. This minimizes the amount of air that is blown into the stomach. Remove your mouth and allow the lungs to deflate. Breathe for the patient a second time. After these first two breaths, breathe once into the patient's mouth every 3 to 4 seconds. The rate of breaths should be 10 to 12 per minute for an adult.

Rescue breathing can be done by using a mouth-to-mask device, a barrier device, or just your mouth. The mouth-to-mask device and the barrier device provide you with a barrier to prevent you from putting your mouth directly on the patient's mouth. These devices should be available to you as a first responder. If a rescue breathing device is not available, you must weigh the potential good to the patient against the limited chance that you will contract an infectious disease from mouth-to-mouth breathing.

Mouth-to-Mask Rescue Breathing

Your first responder life support kit should contain some type of artificial ventilation equipment that enables you to perform rescue breathing without

Fig. 6.24 Perform rescue breathing on a patient.

Mouth-to-mask ventilation device
A piece of equipment that consists of a mask, a one-way valve, and a mouthpiece. Rescue breathing is performed by breathing into the mouthpiece after placing the mask over the patient's mouth and nose.

 Focus on Treatment

Fig. 6.25 Types of mouth-to-mask ventilation devices.

mouth-to-mouth contact with the patient. This simple piece of equipment is called a **mouth-to-mask ventilation device**. A mouth-to-mask ventilation device consists of a mask that fits over the patient's face, a one-way valve, and a mouthpiece through which the rescuer breathes.

Some of these ventilation devices also have an inlet port for supplemental oxygen and a tube between the mouthpiece and the mask. These devices are shown in Figure 6.25. They prevent direct contact between the rescuer and the patient, decreasing the risk of transmitting infectious diseases.

To use a mouth-to-mask ventilation device for rescue breathing, proceed as follows (Figures 6.26 and 6.27):

1. Position yourself at the patient's head.
2. Use the head-tilt/chin-lift or jaw-thrust technique to open the patient's airway.
3. Place the mask over the patient's mouth and nose (making sure that the mask's nose notch is on the nose and not the chin).
4. Grasp the mask and the patient's jaw, using both hands. Use the thumb and forefinger of each hand to hold the mask tightly against the face. Hook the other three fingers of each hand under the patient's jaw and lift up to hold the mask tightly against the patient's face.
5. Maintain an airtight seal while pulling up on the jaw to maintain the proper head position.
6. Take a deep breath, then seal your mouth over the mouthpiece.
7. Breathe slowly into the patient's mouth for 1½ to 2 seconds. Breathe until the patient's chest rises.
8. Monitor the patient for proper head position, air exchange, and vomiting.

This technique must be practiced frequently on a manikin until you can do it well.

Mouth-to-Barrier Rescue Breathing

Mouth-to barrier devices are designed to provide a barrier between the rescuer and the patient (Figure 6.28). Some of these devices are small enough to carry in your pocket. Although a wide variety of devices is available, most of them consist of a port or hole for you to breathe in and a mask or plastic film

Fig. 6.26 Performing pocket mask rescue breathing.

A. Open the airway using the head-tilt/chin-lift technique.

B. Seal the mask against the patient's face.

C. Breathe through the mouthpiece.

A. Open the airway.

B. Seal the mask against the patient's face.

C. Seal your mouth over the mouthpiece and begin rescue breathing.

Fig. 6.27 Mouth-to-mask rescue breathing.

to cover the patient's face. These devices provide a variable degree of infection control. Some devices contain a one-way valve that prevents backflow of secretions and gases.

To perform mouth-to-mouth rescue breathing with a barrier device, follow these steps (Figure 6.29):

1. Open the airway with the head-tilt/chin-lift technique.
2. Press on the forehead to maintain the backward tilt of the head.
3. Pinch the patient's nostrils together with your thumb and forefinger.
4. Keep the patient's mouth open with the thumb of whichever hand you are using to lift the patient's chin.
5. Place the barrier device over the patient's mouth.
6. Take a deep breath, then make a tight seal by placing your mouth around the patient's mouth.
7. Breathe slowly into the patient's mouth for 1½ to 2 seconds. Breathe until the patient's chest rises.
8. Remove your mouth and allow the patient to exhale passively. Check to see that the patient's chest falls after each exhalation.
9. Repeat this rescue breathing sequence 12 to 20 times per minute.

Focus on Treatment

Fig. 6.28 A barrier device.

Mouth-to-Mouth Rescue Breathing

Mouth-to-mouth rescue breathing is an effective way to provide artificial ventilation for nonbreathing patients. It requires no equipment except you. There is a somewhat higher risk of getting a disease when using this method. Therefore, you should use a mouth-to-mask or mouth-to-barrier device if available. If a rescue breathing device is not available, you must weigh the potential good to the patient against the limited chance that you will contract an infectious disease from mouth-to-mouth breathing.

To perform mouth-to-mouth rescue breathing, follow these steps:

1. Open the airway with the head-tilt/chin-lift technique.
2. Press on the forehead to maintain the backward tilt of the head.
3. Pinch the patient's nostrils together with your thumb and forefinger.
4. Keep the patient's mouth open with the thumb of whichever hand you are using to lift the patient's chin.

Focus on Treatment

Fig. 6.29 Performing mouth-to-mouth rescue breathing with a barrier device.

A. Place one hand on the patient's forehead.

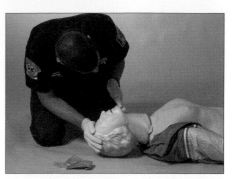

B. Place the other hand under patient's chin.

C. Place barrier device over patient's mouth.

D. Pinch the patient's nostrils together.

E. Perform rescue breathing.

5. Take a deep breath, then make a tight seal by placing your mouth over the patient's mouth.
6. Breathe slowly into the patient's mouth for 1½ to 2 seconds. Breathe until the patient's chest rises.
7. Remove your mouth and allow the patient to exhale passively. Check to see that the patient's chest falls after each exhalation.
8. Repeat this rescue breathing sequence 12 times per minute for adult patients and 20 times per minute for children and infants.

Remember: The three methods for performing rescue breathing are all potentially lifesaving. You should use a mouth-to-mask or mouth-to-barrier breathing device whenever possible. If a rescue breathing device is not available, you must weigh the potential good to the patient against the limited chance that you will contract an infectious disease from mouth-to-mouth breathing.

Performing Rescue Breathing

The A steps required to check and correct the patient's airway and the B steps needed to check and correct the patient's breathing are similar for adults, children, and infants. However, there are some differences that you must know. It is important that you learn and practice the airway and breathing sequences for the different patients.

Remember: Assume that all patients may be in respiratory arrest until you can assess them and determine that they are breathing adequately.

Adults

The steps for recognizing respiratory arrest and performing rescue breathing in adults are as follows:

Airway

1. *Check* for responsiveness by shouting "Are you okay?" and gently shaking the patient's shoulder. If the patient is unresponsive and the EMS system has not been notified, activate the EMS system. Place the patient on his or her back.
2. *Correct* the airway if closed by using the head-tilt/chin-lift technique or, if the patient has suffered any injury to the head or neck, the jaw-thrust technique.
3. *Check* the mouth for secretions, vomitus, or solid objects.
4. *Correct* the airway, if needed, by using finger sweeps or suction to remove foreign substances.
5. *Maintain* the airway by manually holding it open or by using an oral or nasal airway.

Breathing

1. *Check* for the presence of breathing:
 - *Look* for the rising and falling of the patient's chest.
 - *Listen* for the sound of air moving in and out of the patient's nose and mouth.
 - *Feel* for the movement of air on the side of your face and ear.

 Continue to look, listen, and feel for 3 to 5 seconds. If there is adequate breathing, place the patient in the recovery position. If there is no breathing, go to step 2.
2. *Correct* the lack of breathing by performing rescue breathing using a mouth-to-mask or mouth-to-barrier device, if available. Blow slowly into the patient's mouth for 1½ to 2 seconds, using enough force to make the chest rise. Use slow, gentle, sustained breaths that make the chest rise. Remove your mouth and allow the lungs to deflate. Breathe for the patient a second time. After these first two breaths, breathe once into the patient's mouth about every 5 seconds.

Generally, when mouth-to-mouth rescue breathing is necessary, **external cardiac compressions** are also required. External cardiac compression, the "C" part of the ABCs, is explained in Chapter 8. The 1993 American Heart Association skill performance sheet entitled "Adult One-Rescuer CPR" is shown in Figure 6.30 for your review and practice.

External cardiac compressions A means of applying artificial circulation by applying rhythmic pressure and relaxation on the lower half of the sternum.

SPECIAL NEEDS

Rescue Breathing for Children For purposes of performing rescue breathing, a child is a person between one and eight years of age. The steps for determining responsiveness, checking and correcting airways, and checking and correcting a child's breathing are essentially the same as for an adult patient, but you should keep the following differences in mind:

1. Children are smaller, and you will not have to use as much force to open their airways and tilt their heads.
2. You should perform rescue breathing for 1 minute before activating the EMS system if you are on the scene by yourself and EMS has not been notified.
3. Each rescue breath for a child should be for 1 to 1½ seconds instead of for 1½ to 2 seconds for an adult patient.

4. Rescue breathing is done slightly faster, one breath every 3 seconds with about 20 breaths per minute, instead of the adult rate of one breath every 5 seconds with about 12 breaths per minute.

The 1993 American Heart Association skill performance sheet entitled "Child One-Rescuer CPR" is shown in Figure 6.31 for your review and practice.

Fig. 6.30 Adult one-rescuer CPR Skill Performance Sheet.

WE'RE FIGHTING FOR YOUR LIFE
American Heart Association

SKILL AND PERFORMANCE SHEET

ADULT ONE-RESCUER CPR

Student Name _____ Date _____

Performance Guidelines	Performed
1. Establish unresponsiveness. Activate the EMS system.	
2. Open airway (head tilt-chin lift or jaw thrust) check breathing (look, listen, and feel).*	
3. Give two slow breaths (1½ to 2 seconds per breath), if airway is obstructed, reposition head and try to ventilate again. Watch chest rise, allow for exhalation between breaths.	
4. Check carotid pulse. If breathing is absent but pulse is present, provide rescue breathing (1 breath every 5 seconds, about 12 breaths per minute).	
5. If no pulse, give cycles of 15 chest compressions (rate, 80 to 100 compressions per minute) followed by 2 slow breaths.	
6. After 4 cycles of 15:2 (about 1 minute), check pulse.* If no pulse, continue 15:2 cycle beginning with chest compressions.	

* If victim is breathing or resumes effective breathing, place in recovery position.

Comments _____

Instructor_____

Circle one: Complete Needs more practice

Fig. 6.31 Child one-rescuer CPR Skill Performance Sheet.

WE'RE FIGHTING FOR YOUR LIFE
American Heart Association

SKILL AND PERFORMANCE SHEET

CHILD ONE-RESCUER CPR

Student Name _____ Date _____

Performance Guidelines	Performed
1. Establish unresponsiveness. If second rescuer is available, have him or her activate the EMS system.	
2. Open airway (head tilt-chin lift or jaw thrust). Check breathing (look, listen, and feel).*	
3. Give two slow breaths (1 to 1½ seconds per breath), if airway is obstructed, reposition head and try to ventilate again. Watch chest rise, allow for exhalation between breaths.	
4. Check carotid pulse. If breathing is absent but pulse is present, provide rescue breathing (1 breath every 3 seconds, about 20 breaths per minute).	
5. If no pulse, give 5 chest compressions (rate 100 compressions per minute), open airway with chin lift, and provide 1 slow breath. Repeat this cycle.	
6. After about 1 minute of rescue support, check pulse.* If rescuer is alone, activate the EMS system. If no pulse, continue 5:1 cycles.	

* If victim is breathing or resumes effective breathing, place in recovery position.

Comments _____

Instructor_____

Circle one: Complete Needs more practice

▬▬▬ SPECIAL NEEDS

Rescue Breathing for Infants If the patient is an infant (a child under the age of one year), you must vary rescue breathing techniques slightly. Keep in mind that the infant is tiny and must be treated very gently. The steps in rescue breathing for an infant are as follows:

Fig. 6.32 Establish the patient's level of responsiveness.

A
- Check
- Correct
- Check
- Correct
- Maintain

B
- Check
- Correct

Airway

1. *Check* for responsiveness by gently shaking the infant's shoulder or tapping the bottom of the foot (Figure 6.32). If the infant is unresponsive, place the infant on his or her back and proceed to step 2.
2. *Correct* the airway, if closed, by using the head-tilt/chin-lift technique (Figure 6.33). Do not tip the infant's head back too far because this may block the infant's airway. Tilt it only enough to open the airway.
3. *Check* for any visible secretions or foreign objects.
4. *Correct* any airway problems. Use finger sweeps only if there is a foreign object visible. If suction is needed, use it gently.
5. *Maintain* the airway by continuing to use the head-tilt/chin-lift technique.

Breathing

1. *Check* for the presence of breathing:
 - *Look* for the rising and falling of the infant's chest.
 - *Listen* for the sound of air moving in and out of the patient's mouth and nose.
 - *Feel* for the movement of air on the side of your face and ear (see Figure 6.33).

 Continue to look, listen, and feel for 3 to 5 seconds. If there is adequate breathing, place the patient in the recovery position. If there is no breathing, go to step 2.
2. *Correct* the lack of breathing by performing rescue breathing (Figure 6.34). Cover the infant's mouth and nose with your mouth. Blow gently into the infant's mouth and nose for 1 to 1½ seconds. Watch the chest rise with each breath. Remove your mouth and allow the lungs to deflate. Breathe for the infant a second time. After these first two breaths, breathe into the infant's mouth and nose every 3 seconds (20 rescue breaths per minute).

Often when mouth-to-mouth rescue breathing is necessary, external cardiac compressions are also required. External cardiac compressions, the "C" part of the ABCs, is explained in Chapter 8. The 1993 American Heart Association skill performance sheet entitled "Infant One-Rescuer CPR" is shown in Figure 6.35 for your review and practice.

Fig. 6.33 (left) Open the infant's airway using the head-tilt/chin-lift technique and check for breathing by looking, listening, and feeling.

Fig. 6.34 (right) Perform infant rescue breathing.

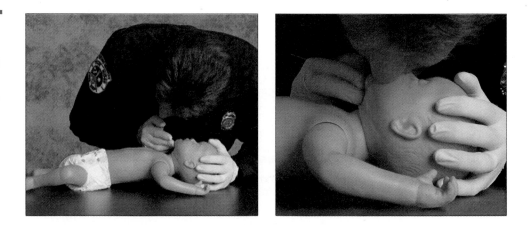

Fig. 6.35 Infant one-rescuer CPR Skill Performance Sheet.

WE'RE FIGHTING FOR YOUR LIFE
American Heart Association

SKILL AND PERFORMANCE SHEET

INFANT ONE-RESCUER CPR

Student Name _____ Date _____

Performance Guidelines	Performed
1. Establish unresponsiveness. If second rescuer is available, have him or her activate the EMS system.	
2. Open airway (head tilt-chin lift or jaw thrust). Check breathing (look, listen, and feel).*	
3. Give two slow breaths (1 to 1½ seconds per breath), if airway is obstructed, reposition head and try to ventilate again. Watch chest rise, allow for exhalation between breaths.	
4. Check brachial pulse. If breathing is absent but pulse is present, provide rescue breathing (1 breath every 3 seconds, about 20 breaths per minute).	
5. If no pulse, give 5 chest compressions (rate at least 100 compressions per minute), followed by one slow breath.	
6. After about 1 minute of rescue support, check pulse.* If rescuer is alone, activate the EMS system. If no pulse, continue 5:1 cycles.	

* If victim is breathing or resumes effective breathing, place in recovery position.

Comments _____

Instructor _____

Circle one: Complete Needs more practice

✔ What are the signs of adequate breathing?

✔ What are the signs of inadequate breathing?

✔ What are the causes of respiratory arrest?

✔ What are the major signs of respiratory arrest?

✔ What are three ways to check for the presence of breathing?

✔ What are the steps for performing rescue breathing using each of the following methods:
- Mouth-to-mask device?
- Mouth-to-barrier device?
- Mouth-to-mouth?

Foreign Body Airway Obstruction

Causes of Airway Obstruction

Airway obstruction Partial or complete obstruction of the respiratory passages resulting from blockage by food, small objects, or vomitus.

Your attempt to perform rescue breathing may not be effective because of an **airway obstruction**. The most common cause of obstruction is the tongue. If the obstruction is caused by the tongue blocking the airway, the head-tilt/chin-lift technique or the jaw-thrust technique should open the airway. However, if the obstruction is caused by a foreign body lodged in the air passages, you must use other techniques.

Food is the most common foreign object that causes an airway obstruction. An adult may choke on a large piece of meat; a child may inhale candy, a peanut, or a piece of a hot dog. Children who put small objects in their mouths also may inhale such things as toys or balloons. Vomitus may obstruct the airway of a child or an adult (Figure 6.36).

Types of Airway Obstruction

Airway obstruction may be partial or complete. The first step in dealing with a conscious person who may have an obstructed airway is to ask, "Are you choking?" If the patient can reply to your question, the airway is not completely obstructed. If the patient is unable to speak or cough, the airway is completely obstructed.

Partial Airway Obstruction

- Transportation to an appropriate medical facility
- Prompt transportation to an appropriate medical facility
- Rapid transportation to an appropriate medical facility

In partial airway obstruction, the patient coughs and gags, indicating that some air is passing around the obstruction. The patient may even be able to speak, although with difficulty.

Treatment for a partially obstructed airway is to encourage the patient to cough. Coughing is the most effective way of expelling a foreign object. If the patient is unable to expel the object by coughing (if, for example, a bone is stuck in the throat), you should arrange for the patient's prompt transport to an appropriate medical facility. Such a patient must be monitored carefully

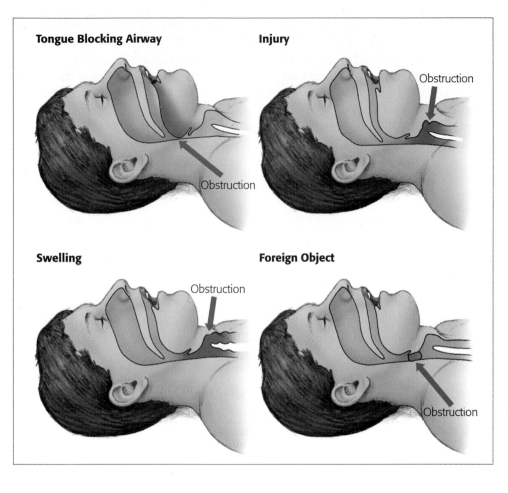

Fig. 6.36 Common causes of airway obstruction.

while awaiting transport and during transport because a partial obstruction can become a complete obstruction at any moment.

Complete Airway Obstruction

In complete airway obstruction, the patient has different signs and symptoms. In a short time, the body uses all the oxygen breathed in with the last breath. The patient is unable to breathe in or out and, because he or she cannot exhale air, speech is impossible. When the airway is completely obstructed, the patient loses consciousness in 3 to 4 minutes.

The currently accepted treatment for a completely obstructed airway in an adult or child involves abdominal thrusts. This technique is also called the **Heimlich maneuver**. Abdominal thrusts compress the air that remains in the lungs, pushing it upward through the airway and exerting pressure against the foreign object. The pressure pops the object out. This can be likened to a cork popping out of a bottle after the bottle has been shaken to increase the pressure. Many rescuers report that abdominal thrusts may cause an obstructing piece of food to fly across the room. A person who has had an obstruction removed from their airway by the Heimlich maneuver should be transported to a hospital for examination by a physician.

Heimlich maneuver A series of manual thrusts to the abdomen to relieve upper airway obstruction.

- Transportation to an appropriate medical facility
- Prompt transportation to an appropriate medical facility
- Rapid transportation to an appropriate medical facility

Management of Foreign Body Airway Obstructions

Airway Obstruction in a Conscious Adult

The steps to treat complete airway obstruction vary, depending on whether the patient is conscious or unconscious. If the patient is conscious, stand

behind the patient and perform the abdominal thrusts while the patient is standing or seated in a chair.

Locate the xiphoid process (the bottom of the sternum) and the navel. Place one fist above the navel and well below the xiphoid process, thumb side against the patient's abdomen. Grasp your fist with your other hand. Then apply abdominal thrusts sharply and firmly, bringing your fist in and slightly upward. Do not give the patient a bear hug; rather, apply pressure at the point where your fist contacts the patient's abdomen. Each thrust should be distinct and forceful. Repeat these abdominal thrusts until the foreign object is expelled or until the patient becomes unconscious (Figure 6.37).

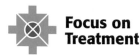 **Focus on Treatment**

Review the following sequence until you can carry it out automatically. To assist a conscious patient with a complete airway obstruction, you must proceed as follows:

1. Ask, "Are you choking? Can you speak?" If there is no response, assume that the airway obstruction is complete.

2. Stand behind the patient and deliver an abdominal thrust (position the thumb side of your fist above the patient's navel and well below the xiphoid process). Press into the patient's abdomen with a quick upward thrust.

3. Repeat the abdominal thrusts until either the foreign body is expelled or the patient becomes unconscious.

4. If the patient is obese or in the late stages of pregnancy, use chest thrusts instead of abdominal thrusts. Chest thrusts are done by standing behind the patient and placing your arms under the patient's armpits to encircle the patient's chest. Press with quick backward thrusts.

A 1993 American Heart Association skill performance sheet entitled "Adult Foreign Body Airway Obstruction" is shown in Figure 6.38 for your review and practice.

Fig. 6.37 Airway obstruction in a conscious patient.

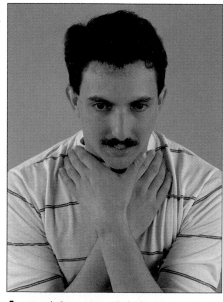

A. Look for a sign of choking.

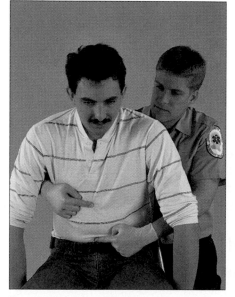

B. Locate the xiphoid process and the navel.

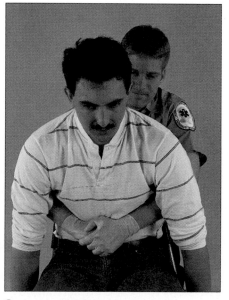

C. Apply abdominal thrusts.

**American Heart
Association**

SKILL AND PERFORMANCE SHEET

ADULT FOREIGN BODY AIRWAY OBSTRUCTION

Student Name _____ Date _____

Performance Guidelines	Performed
1. Ask "Are you choking?"	
2. Give abdominal thrusts (chest thrusts for pregnant or obese victim).	
3. Repeat thrusts until effective or victim becomes unconscious.	
Adult Foreign Body Airway Obstruction— Victim Becomes Unconscious.	
4. Activate the EMS system.	
5. Perform a tongue-jaw lift followed by a finger sweep to remove the object.	
6. Open airway and try to ventilate; if obstructed, reposition head and try to ventilate again.	
7. Give up to five abdominal thrusts.	
8. Repeat steps 5 through 7 until effective.*	

* If victim is breathing or resumes effective breathing, place in recovery position.

Comments _____

Instructor_____

Circle one: Complete Needs more practice

Airway Obstruction in an Unconscious Adult

You can perform abdominal thrusts on patients who are unconscious or so large that you cannot encircle them with your arms by placing the patient flat on his or her back. Straddle the patient. Locate the xiphoid process and the navel (Figure 6.39). Place the heel of one hand slightly above the navel and well below the xiphoid process. Place your other hand directly on top of the first hand. Lean your shoulders forward and quickly press in and slightly upward (Figure 6.40). The force of the thrust should come from your shoulders and be delivered in the midline of the abdomen, not to either side.

Fig. 6.39 Locating the xiphoid process and the navel in an unconscious patient.

Fig. 6.40 Performing an abdominal thrust on an unconscious adult.

A. Place your other hand on top of your first hand.

B. Thrust inward and slightly upward.

 Focus on Treatment

Review the following sequence until you can carry it out automatically. To assist an unconscious patient who has a complete airway obstruction, you must proceed as follows:

1. Verify unconsciousness. Ask the patient, "Are you okay?" Tap or gently shake the patient's shoulder. If the patient is unresponsive, call 9-1-1 immediately to activate the EMS system if it has not already been activated.

2. Place the patient on his or her back while supporting the head and neck.

3. Open the airway by using the head-tilt/chin-lift technique. If trauma to the head or neck is suspected, use the jaw-thrust technique.

4. Check for breathing for 3 to 5 seconds. If breathing is absent, proceed with step 5.

5. Attempt rescue breathing. If there is an obstruction, air does not move into or out of the patient. Proceed with step 6.

6. Reposition the head to improve the likelihood of opening the airway by repeating the head-tilt/chin-lift or jaw-thrust technique to open the airway.

7. Attempt rescue breathing again. If there is still no air movement, assume the presence of complete obstruction and proceed with steps 8 through 11.

8. Deliver an abdominal thrust. Straddle the patient and place the heel of your hand slightly above the navel and well below the xiphoid process. Place your other hand on top of the first hand and press into the abdomen with a quick thrust inward and slightly upward. If the foreign body is not expelled, repeat the abdominal thrust four times. If this does not work, proceed to step 9.

9. Use the tongue-jaw lift to open the patient's mouth to check for obstructions. The tongue-jaw lift is done by grasping the lower jaw, placing your thumb on the tongue, and wrapping your gloved fingers around the chin. Lift the jaw to open the mouth. Holding the patient's tongue down against the lower jaw with your thumb may offer better access to sweep an object from the throat.

10. Use your finger to sweep the mouth clear. Curve your finger into a C-shape and sweep it from one side of the back of the mouth to the other.

11. Attempt rescue breathing again. If there is still an obstruction, proceed with step 12.

12. Repeat abdominal thrusts, finger sweeps, and breathing attempts until the airway is cleared.

A 1993 American Heart Association skill performance sheet entitled "Adult Foreign Body Airway Obstruction—Unconscious" is shown in Figure 6.41 for your review and practice.

≡ SPECIAL NEEDS

Airway Obstruction in a Conscious Child The steps for relieving an airway obstruction in a conscious child (one to eight years old) are the same as for an adult patient except that you should not perform blind finger sweeps. Instead, perform the tongue-jaw lift, look down into the airway, and use your fingers to sweep the airway only if you can actually see the obstruction.

A 1993 American Heart Association skill performance sheet entitled "Child Foreign Body Airway Obstruction—Conscious" is shown in Figure 6.42 for your review and practice.

≡ SPECIAL NEEDS

Airway Obstruction in an Unconscious Child The steps for relieving a complete airway obstruction in an unconscious child (one to eight years old) are almost the same as those for an unconscious adult. The only difference is that with a child you should perform a finger sweep only if you can see the object that is obstructing the airway. Because the child's airway is so much smaller than an adult's, it is important that you do not push the foreign object farther down into the child's airway. If you are alone, you should attempt to remove the foreign body obstruction for 1 minute before you stop to activate the EMS system.

The 1993 American Heart Association skill performance sheet entitled "Child Foreign Body Airway Obstruction—Unconscious" is shown in Figure 6.43 for your review and practice.

Fig. 6.41 Adult foreign body airway obstruction (unconscious) Skill Performance Sheet.

SPECIAL NEEDS

Airway Obstruction in a Conscious Infant The steps for relieving an airway obstruction in a conscious infant (less than one year old) must take into consideration that an infant is very fragile. An infant's airway structures are very small, and they are more easily injured than those of an adult. If you suspect an airway obstruction, assess the infant to determine if there is any air exchange. If the infant is crying, the airway is not completely obstructed. Ask the person who was with the infant what was happening when the infant stopped breathing. This person may have seen the infant put a foreign body into his or her mouth. If there is no movement of air from the infant's mouth and nose, suspect that the airway is obstructed. To relieve an airway obstruction in an infant, use a combination of back blows and chest thrusts. You must have a good grasp of the infant in order to alternate the back blows and the chest thrusts.

SKILL AND PERFORMANCE SHEET

CHILD FOREIGN BODY AIRWAY OBSTRUCTION (CONSCIOUS)

Fig. 6.42 Child foreign body airway obstruction (conscious) Skill Performance Sheet.

Student Name _____ Date _____

Performance Guidelines	Performed
1. Ask "Are you choking?"	
2. Give abdominal thrusts.	
3. Repeat thrusts until effective or victim becomes unconscious.	
Child Foreign Body Airway Obstruction— Victim Becomes Unconscious	
4. If second rescuer is available, have him or her activate the EMS System.	
5. Perform a tongue-jaw lift, and if you see the object, perform a finger sweep to remove it.	
6. Open airway and try to ventilate; if obstructed, reposition head and try to ventilate again.	
7. Give up to five abdominal thrusts.	
8. Repeat steps 5 through 7 until effective.*	
9. If airway obstruction is not relieved after about 1 minute, activate the EMS system.	

* If victim is breathing or resumes effective breathing, place in recovery position.

Comments _____

Instructor_____

Circle one: Complete Needs more practice

Review the following sequence until you can carry it out automatically. To assist a conscious infant who has a complete airway obstruction, you must proceed as follows:

Focus on Treatment

1. Assess the infant's airway and breathing status. Determine that there is no airway exchange.
2. Place the infant in a face-down position over one arm and deliver five back blows. This is done by supporting the infant's head and neck with one hand, placing the infant face down with the head lower than the

Fig. 6.43 Child foreign body airway obstruction (unconscious) Skill Sheet.

WE'RE FIGHTING FOR
YOUR LIFE
**American Heart
Association**

SKILL AND PERFORMANCE SHEET

CHILD FOREIGN BODY AIRWAY OBSTRUCTION (UNCONSCIOUS)

Student Name _____ Date _____

Performance Guidelines	Performed
1. Establish unresponsiveness. If second rescuer is available, have him or her activate the EMS system.	
2. Open airway, check breathing (look, listen, and feel), try to ventilate; if obstructed, reposition head and try to ventilate again.	
3. Give up to five abdominal thrusts.	
4. Perform a tongue-jaw lift and if you see the object, perform a finger sweep to remove it.	
5. Try to ventilate; if still obstructed reposition the head and try to ventilate again.	
6. Repeat steps 3 through 5 until effective.*	
7. If airway is obstruction is not relieved after about 1 minute, activate the EMS system.	

* If victim is breathing or resumes effective breathing, place in recovery position.

Comments _____

Instructor_____

Circle one: Complete Needs more practice

Reproduced with permission. ©Basic Life Support Heartsaver Guide, 1993. Copyright American Heart Association.

trunk. Support the infant over your forearm and support your forearm on your thigh. Use the heel of your hand to deliver up to five back blows forcefully between the infant's shoulder blades.

3. Turn the infant face up by supporting the head, sandwiching the infant between your hands and arms and turning the infant on his or her back with the head lower than the trunk.

4. Deliver up to five chest thrusts in the middle of the sternum. Use two fingers to deliver the chest thrusts in a firm manner.

5. Repeat the series of back blows and chest thrusts until the foreign object is expelled or until the infant becomes unconscious.

A 1993 American Heart Association skill performance sheet entitled "Infant Foreign Body Airway Obstruction—Conscious" is shown in Figure 6.44 for your review and practice.

138 Ch 6 ▸ Airway Care and Rescue Breathing

SKILL AND PERFORMANCE SHEET

INFANT FOREIGN BODY AIRWAY OBSTRUCTION (CONSCIOUS)

Student Name _____ Date _____

Performance Guidelines	Performed
1. Confirm complete airway obstruction. Check for serious breathing difficulty, ineffective cough, no strong cry.	
2. Give up to 5 back blows and chest thrusts.	
3. Repeat step 2 until effective or victim becomes unconscious.	
Infant Foreign Body Airway Obstruction— **Victim Becomes Unconscious**	
4. If second rescuer is available, have him or her activate the EMS system.	
5. Perform a tongue-jaw lift, and if you see the object, perform a finger sweep to remove it.	
6. Open airway and try to ventilate; if obstructed, reposition head and try to ventilate again.	
7. Give up to 5 back blows and chest thrusts.	
8. Repeat steps 5 through 7 until effective.*	
9. If airway obstruction is not relieved after about 1 minute, activate the EMS system.	

* If victim is breathing or resumes effective breathing, place in recovery position.

Comments _____

Instructor_____

Circle one: Complete Needs more practice

Fig. 6.44 Infant foreign body obstruction (conscious) Skill Performance Sheet.

═══ SPECIAL NEEDS

Airway Obstruction in an Unconscious Infant The steps for relieving an airway obstruction in an unconscious infant (less than one year old) are the same as the sequence of back blows and chest thrusts that you use for a conscious infant. However, the steps that are taken to determine unconsciousness and to determine that an airway obstruction is present are somewhat different.

Review the following sequence until you can carry it out automatically. To assist an unconscious infant who has a complete airway obstruction, you must proceed as follows:

1. Determine unresponsiveness by gently shaking the shoulder or by gently tapping the bottom of the foot.
2. Position the infant on a firm, hard surface and support the head and neck.
3. Open the airway using the head-tilt/chin-lift technique. Be careful not to tilt the infant's head back too far.
4. Determine breathlessness by placing your ear close to the infant's mouth and nose. Listen and feel for the infant's breathing.
5. Attempt rescue breathing. If unsuccessful, proceed to step 6.
6. Reposition the airway and reattempt rescue breathing.

Note: Steps 1 through 6 are similar to the steps that you use for infant rescue breathing.

7. Deliver up to five back blows using the same technique that you use for a conscious infant.
8. Deliver up to five chest thrusts using the same technique that you use for a conscious infant.
9. Perform tongue-jaw lift and remove any foreign object that you can see.
10. Repeat the sequence of back blows and chest thrusts until the foreign body has been expelled.

A 1993 American Heart Association skill performance sheet entitled "Infant Foreign Body Airway Obstruction—Unconscious" is shown in Figure 6.45 for your review and practice.

Remember: Though the sequences listed for relieving airway obstructions may seem complicated, keep in mind that they all contain the following steps:

1. Determine responsiveness or unresponsiveness.
2. Open the airway.
3. Determine if there is any air exchange.
4. If a complete obstruction is present, perform abdominal thrusts on adults and children or back blows and chest thrusts on infants.
5. Perform finger sweeps on adult patients, but do not perform finger sweeps on children and infants unless you can see the foreign object.

Check ✔ *Point*

✓ What are the signs and symptoms of a partial airway obstruction?

✓ How do you treat a partial airway obstruction?

✓ What are the signs and symptoms of a complete airway obstruction?

✓ What are the steps for treating a complete airway obstruction in a conscious adult? In an unconscious adult?

✓ How does the treatment of a complete airway obstruction differ for a child and an infant?

**WE'RE FIGHTING FOR
YOUR LIFE
American Heart
Association**

SKILL AND PERFORMANCE SHEET

INFANT FOREIGN BODY AIRWAY OBSTRUCTION (UNCONSCIOUS)

Student Name _____ Date _____

Performance Guidelines	Performed
1. Establish unresponsiveness. If second rescuer is available, have him or her activate the EMS system.	
2. Open airway, check breathing (look, listen, and feel), try to ventilate; if obstructed, reposition head and try to ventilate again.	
3. Give up to five back blows and five chest thrusts.	
4. Perform a tongue-jaw lift and if you see the object, perform a finger sweep to remove it.	
5. Try to ventilate; if still obstructed, reposition the head and try to ventilate again.	
6. Repeat steps 3 through 5 until effective.*	
7. If airway is obstruction is not relieved after about 1 minute, activate the EMS system.	

* If victim is breathing or resumes effective breathing, place in recovery position.

Comments _____

Instructor_____

Circle one: Complete Needs more practice

Special Considerations

Rescue Breathing for Patients with Stomas

If the patient has undergone surgery to remove part or all of the larynx (voice box), the upper airway has been rerouted to open through a **stoma** in the

Stoma An opening in the neck that connects the windpipe (trachea) to the skin.

neck. These patients are called **neck breathers**. Rescue breathing must therefore be given through the stoma (hole) in the patient's neck. The technique is called **mouth-to-stoma breathing**.

To perform mouth-to-stoma breathing, proceed as follows:

1. Check every patient for the presence of a stoma.
2. If you locate a stoma, keep the patient's neck straight; do not hyperextend the patient's head and neck.
3. Examine the stoma and clean away any mucus in it.
4. If a breathing tube is in the opening, remove it to be sure it is clear. Clean it rapidly and replace it into the stoma. Moistening the tube with water or the patient's own saliva helps it to slide in.
5. Place your mouth directly over the stoma and use the same procedures as in mouth-to-mouth breathing. It is not necessary to seal the mouth and nose of most neck breathers.
6. If the patient's chest does not rise, he or she may be a partial neck breather, and you must seal the mouth and nose with one hand and then breathe through the stoma (Figure 6.46).

Infant and Child Patients

When you are caring for infants and children, you need to keep some differences in mind in order to provide the best care for the patient. When opening the airway of a child or infant, be careful that you do not tilt the head back too far. If the head is tilted back too far, the airway of the child or infant can become obstructed. Therefore, it is best to tilt the head back just past the neutral position. Avoid hyperextending the neck.

Gastric Distention

Gastric distention occurs when air is forced into the stomach. Gastric distention may make it harder to get an adequate amount of air into the patient's lungs, and it increases the chance that the patient will vomit. When treating children or infants, be sure that you are not forcing too much air into their lungs, which may cause gastric distention. Blow into the patient's mouth just enough to make the chest rise. Preventing gastric distention is much better than trying to cure the results of it.

Dental Appliances

Dental appliances may cause problems when you are trying to perform rescue breathing. Dental appliances that are firmly attached should be left in place. They may help to keep the mouth fuller and thereby help you to make a better seal between the patient's mouth and your mouth or a breathing device. Do not remove dental appliances if they are firmly in place. Partial dentures may be dislodged during trauma or while you are performing airway care and rescue breathing. If you discover loose dental appliances when examining the patient's airway, remove the dentures to prevent them from occluding the airway. Try to put them in a safe place so they will not get damaged or lost.

Focus on Treatment

Neck breathers Patients who have a stoma and breathe through the opening in their neck.

Mouth-to-stoma breathing Rescue breathing for patients who, because of surgical removal of the larynx, have a stoma.

Fig. 6.46 Perform mouth-to-stoma rescue breathing by sealing the mouth and nose with one hand and breathing through the stoma.

A. To open the airway, place one hand under the chin and the other hand on the back of the patient's head.

B. Raise the head to neutral position to open airway.

Fig. 6.47 Airway management in a vehicle.

Airway Management in a Vehicle

If you arrive on the scene of an automobile accident and find that the patient has airway problems, how can you best assist the patient and maintain an open airway? If the patient is lying on the seat or floor of the car, you can apply the standard jaw-thrust technique. Use the jaw-thrust technique if there is any possibility that the accident could have caused a head or spinal injury.

When the patient is in a sitting or semireclining position, approach him or her from the side (leaning in through the window or across the front seat) and grasp the patient's head with both hands (one hand under the patient's chin and the other hand on the back of the patient's head just above the neck), as shown in Figure 6.47. Maintain slight upward pressure to support the head and cervical spine and to ensure that the airway remains open. By using this technique, it is often possible to maintain an open airway without moving the patient. This technique has several advantages:

1. You do not have to enter the automobile.
2. You can easily monitor the patient's carotid pulse and breathing patterns by using your fingers.
3. It stabilizes the patient's cervical spine.
4. It opens the patient's airway.

Check ✔ *Point*

✔ How do you perform rescue breathing on a neck breather?

✔ What are the steps in maintaining the airway of a patient in a vehicle?

CHAPTER REVIEW 6

Summary

In this chapter, you have learned the anatomy and physiology of the respiratory system and the procedure for performing rescue breathing. When a patient experiences possible respiratory arrest, you should *check* for responsiveness, *correct* the blocked airway using the head-tilt/chin-lift or jaw-thrust technique, *check* for fluids, solids, or dentures in the mouth, and *correct* the airway, if needed, using finger sweeps or suction. Maintaining the airway is done by continuing to manually hold the airway open, by placing the patient in the recovery position, or by inserting an oral or a nasal airway. Breathing is *checked* by looking, listening, and feeling for air movement, and it is *corrected* by using a mouth-to-mask or a mouth-to-barrier device or by performing mouth-to-mouth rescue breathing. It is important to learn the sequences for adults, children, and infants.

If the patient's airway is obstructed, you must perform abdominal or chest thrusts. Back blows and chest thrusts are used for infants with airway obstructions. You should know how to perform rescue breathing on a patient with a stoma. Airway management of a patient who is in a vehicle can be done easily with a simple technique.

You should learn these lifesaving skills thoroughly. Practice them until they become almost automatic for you. In Chapter 8, these skills will be combined with circulation skills to allow you to learn and perform CPR. To keep these skills current, you should maintain current certification through an agency that uses the American Heart Association standards.

Airway—page 108

Airway obstruction—page 130

Alveoli—page 108

Aspirator—page 113

Bronchi—page 108

Capillaries—page 108

Cardiopulmonary resuscitation (CPR)—page 107

Esophagus—page 108

External cardiac compressions—page 125

Gag reflex—page 115

Head-tilt/chin-lift technique—page 110

Heimlich maneuver—page 131

Jaw-thrust technique—page 111

Lungs—page 108

Mandible—page 108

Manual suction device—page 113

Mechanical suction device—page 113

Mouth-to-mask ventilation device—page 122

Mouth-to-stoma breathing—page 142

Nasal airway—page 116

Nasopharynx—page 107

Neck breathers—page 142

Oral airway—page 115

Oropharynx—page 107

Oxygen—page 107

Pocket mask—page 115

Rescue breathing—page 108

Respiratory arrest—page 115

Stoma—page 141

Trachea—page 107

What Would You Do?

1. You are sitting in a restaurant when you see an elderly man who is holding his hands to his neck. You rush over to him and ask him if he is okay. He shakes his head no. What would you do?
2. You are beginning to assess the airway and breathing of a ten-year-old child. Suddenly the child vomits. She does not appear to be breathing. What would you do?
3. You are dispatched to a report of a sick baby. As you arrive at the residential address, the baby's mother hands you a six-month-old boy and cries that her child has just stopped breathing. What would you do?

You Should Know

1. How to identify the anatomy structures of the respiratory system and state the function for each structure.
2. The differences in the respiratory systems of infants, children, and adults.
3. The process used to check for the responsiveness of a patient.

4. The steps in the head-tilt/chin-lift technique.
5. The steps in the jaw-thrust technique.
6. How to check for fluids, solids, and dentures in a patient's mouth.
7. The steps needed to clear a patient's airway using finger sweeps and suction.
8. The steps required to maintain a patient's airway using the recovery position, oral airways, and nasal airways.
9. The signs of adequate breathing, the signs of inadequate breathing, the causes of respiratory arrest, and the major signs of respiratory arrest.
10. How to check a patient for the presence of breathing.
11. How to perform rescue breathing using a mouth-to-mask device, using a mouth-to-barrier device, and doing mouth-to-mouth rescue breathing.
12. The steps for recognizing respiratory arrest and performing rescue breathing in adults, children, and infants.
13. The differences between the signs and symptoms of partial airway obstruction and those of complete airway obstruction.
14. The steps in managing a foreign body airway obstruction in conscious and unconscious adults, in conscious and unconscious children, and in conscious and unconscious infants.
15. The special considerations needed to perform rescue breathing in patients with stomas.
16. The special considerations of airway care and rescue breathing in children and infants.
17. The hazards of dental appliances when performing airway skills.
18. The steps in providing airway care to a patient in a vehicle.

You Should Practice

1. Performing the head-tilt/chin-lift and jaw-thrust techniques for opening blocked airways.
2. Checking for fluids, solids, and dentures in a patient's airway.
3. Correcting a blocked airway using finger sweeps and suction.
4. Placing a patient in the recovery position.
5. Inserting oral and nasal airways.
6. Checking for the presence of breathing.
7. Performing rescue breathing using a mouth-to-mask device, a mouth-to-barrier device, and mouth-to-mouth techniques.
8. Demonstrating the steps in recognizing respiratory arrest and performing rescue breathing on an adult patient, a child, and an infant.
9. Performing the steps needed to remove a foreign body airway obstruction in an adult patient, a child, and an infant.
10. Demonstrating rescue breathing on a patient with a stoma.
11. Performing airway management on a patient in a vehicle.

SKILL SCAN: Inserting an Oral Airway

1. Proper sizing of an oral airway.
2. Inserting an oral airway.
3. Proper position of the flange after insertion.

2.

3.

1.

2.

3.

1. Check for breathing by looking, listening, and feeling.
2. To perform rescue breathing, pinch the patient's nose with your thumb and forefinger.
3. Perform rescue breathing on a patient.

1.

2.

3.

1. Open the airway using the head-tilt/chin-lift method.
2. Seal the mask against the patient's face.
3. Breathe through the mouthpiece.

1. Establish the patient's level of responsiveness.
2. Open the infant's airway using the head-tilt/chin-lift method and check for breathing by looking, listening, and feeling.
3. Perform infant rescue breathing.

1.

2.

3.

1.

2.

3.

1. Look for a sign of choking.
2. Locate the xiphoid process and the navel.
3. Apply abdominal thrusts.

SELF TEST 2

1. If brain cells are deprived of oxygen for more than _____ to _____ minutes, they will begin to die.

2. What are the major structures of the respiratory system?

3. What are the functions of these structures?

4. The part of the lungs where oxygen and carbon dioxide are exchanged is the

 a. Trachea
 b. Alveoli
 c. Bronchi
 d. Capillaries

5. What is the first step in checking a patient's airway?

6. Under what circumstances do you use the head-tilt/chin-lift and jaw-thrust techniques for opening a patient's airway?

7. Describe the steps for performing each of these techniques.

8. After you have opened the patient's airway, you should check for what three things?

9. How do you perform finger sweeps?

10. How long can you suction an adult patient?

11. Describe the techniques for using whistle tip and rigid tip catheters.

12. What are two advantages of using an oral airway?

13. What are two advantages of using a nasal airway?

14. Describe the steps for inserting an oral airway and the steps for inserting a nasal airway.

15. What are five ways you can maintain a patient's airway?

16. To check for the presence or absence of breathing, you should_____, _____, and _____.

17. What are five signs of inadequate breathing?

18. What are four signs of respiratory arrest?

19. What are six causes of respiratory arrest?

20. How many rescue breaths per minute do you give for:

 a. An adult?
 b. An infant?
 c. A child?

21. What is the treatment for a partial airway obstruction?

22. How do you apply abdominal thrusts to a choking patient?

Answers: 1. 4 to 6. **2.** mouth, nose, throat, trachea, bronchi, lungs, diaphragm. **3.** The mouth, nose, throat, trachea, and bronchi are part of the airway. The lungs are the location of the gas exchange. The diaphragm is a muscular structure that contracts and causes the lungs to expand. **4.** b. **5.** Check the patient's level of responsiveness. **6.** Head-tilt/chin-lift is used for patients who have not suffered trauma. Jaw thrust is used for patients who have suffered trauma. **7.** Head-tilt/chin-lift: 1. Place the patient on his or her back and kneel beside the patient. 2. Place one hand on the patient's forehead and apply firm pressure backward with your palm. Move the patient's head back as far as possible. 3. Place the tips of the fingers of your other hand under the bony part of the chin. 4. Lift the chin forward to help tilt the head back. Jaw thrust: 1. Place the patient on his or her back and kneel at the top of the patient's head. 2. Tilt the head backward to a neutral or slight sniffing position. Do not extend the cervical spine in a patient who has suffered an injury to the head or neck. 3. Use your thumb to pull the patient's lower jaw down, opening the mouth enough to allow breathing through the mouth and nose. **8.** Fluids, foreign bodies, dentures. **9.** Turn the patient's head to one side and use your gloved middle and index fingers to scoop out as much of the material as possible. **10.** No more than 15 seconds. **11.** First clear the mouth of large pieces of material with your gloved fingers, turn on the suction device and begin suctioning with the rigid tip to remove most of the remaining material. Suction for no more than 15 seconds at one time. Use the suction port to control the flow of air. Use the flexible tip in the same manner (it can be used to suction the deeper parts of the throat). **12.** Maintain the patient's airway. Suction through the airway. **13.** Can be used to maintain the patient's airway. Tolerated by the patient better than an oral airway. **14.** Oral airway: 1. Select the proper-sized airway. 2. Open the patient's mouth after opening the patient's airway. 3. Hold the airway upside down and insert the tip of the airway along the roof of the patient's mouth until you feel resistance. 4. Rotate the airway 180 degrees until the flange comes to rest on the patient's teeth or lips. Nasal airway: 1. Select the proper sized airway. 2. Coat the airway with lubricant. 3. Select the larger-sized nostril. 4. Gently stretch the nostril open by using your thumb. 5. Gently insert the airway until the flange rests against the nose. Do not force the airway. **15.** 1. Continue to apply the head-tilt/chin-lift technique. 2. Continue to apply the jaw-thrust technique. 3. Insert an oral airway. 4. Insert a nasal airway. 5. Place the patient in the recovery position. **16.** Look, listen, feel. **17.** Noisy respirations, wheezing, gurgling, rapid or gasping respirations, pale or blue skin color. **18.** Lack of chest movement, no breath sounds, no sensation of air movement on the side of your face, blue skin especially around the lips. **19.** Electrocution, severe blood loss, poisoning, overdose of drugs, illness or injury such as heart attack or stroke, mechanical blockage or airway obstruction. **20.** a. adult—5 seconds, 20 breaths per minute b. infant—3 seconds, 12 breaths per minute c. child—5 seconds, 12 breaths per minute **21.** Encourage the patient to cough and breathe. **22.** 1. Ask the patient if he or she can speak. 2. Stand behind the patient and deliver an abdominal thrust by placing the thumb side of your fist above the patient's navel and well below the xiphoid process. 3. Press into the patient's abdomen with a quick upward thrust.

23. What are the steps for administering rescue breathing to a patient with a stoma?

24. What can you do to prevent gastric distention?

25. What are the steps for managing the airway of a patient who is sitting in a vehicle?

23. 1. Check for the presence of stoma. 2. Keep the neck in a neutral position. 3. Place a mask or barrier over the stoma. 4. Perform rescue breathing through the stoma. **24.** Make sure the airway is open by checking the position of the head. Do not overinflate the patient's lungs. **25.** Open the airway by stabilizing the patient's head by placing one hand under the patient's chin and one hand behind the patient's head.

MODULE

3

PATIENT ASSESSMENT

This module presents a series of five steps that will enable you to systematically approach the scene of an accident or illness, assess the scene for safety, and determine the type and extent of the patient's problem. By completing these steps, you will be able to assess the severity of the patient's condition and determine the type of care the patient requires.

This module stresses the safety precautions that are needed to protect the first responder and the patient from further harm. It presents the skills needed to perform a simple physical examination, including the initial head-to-toe assessment; determination of the patient's mental status; assessment of the patient's airway, breathing, and circulatory status; and physical exam. It describes the information needed to assess the medical history of the patient, including identification of the patient's chief complaint and completion of a SAMPLE history. Signs and symptoms are defined and explained. The importance of reporting these findings to other medical providers and performing an on-going assessment is also described.

7

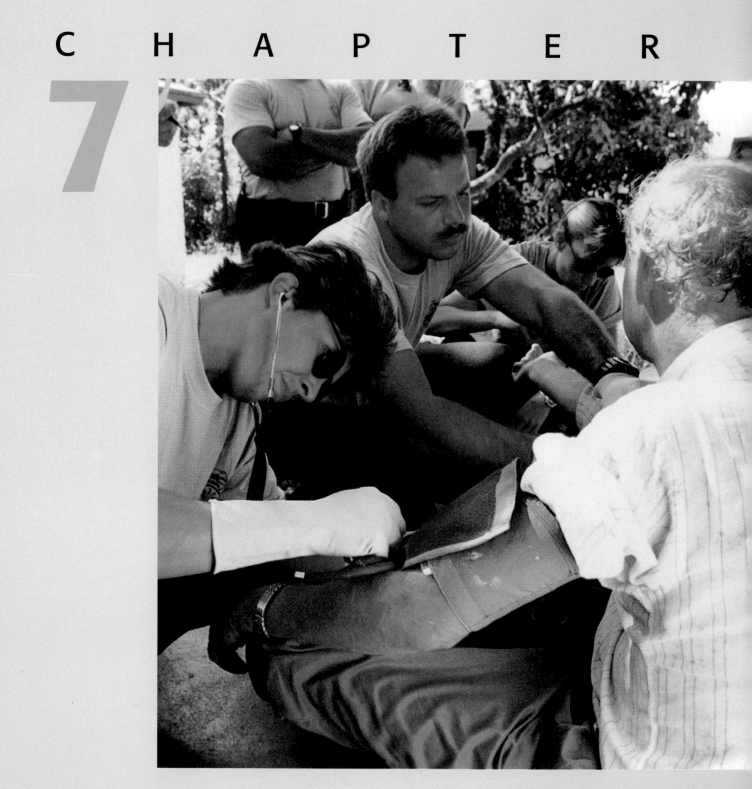

PATIENT ASSESSMENT

Knowledge and Attitude Objectives *After studying this chapter, you will be expected to:*

1. Discuss the importance of each of the following steps in the patient assessment sequence:
 a. Scene size-up
 b. Initial patient assessment
 c. Examination of the patient from head to toe
 d. Obtaining the patient's medical history
 e. Performing an on-going assessment

2. Discuss the components of a scene size-up.

3. Describe why it is important to get an idea of the number of patients at an emergency scene as soon as possible.

4. List and describe the importance of the following steps of the initial patient assessment:
 a. Forming a general impression of the patient
 b. Assessing the patient's responsiveness and stabilizing the spine if necessary
 c. Assessing the patient's airway
 d. Assessing the patient's breathing
 e. Assessing the patient's circulation
 f. Updating responding EMS units

5. Describe the differences in checking the patient's airway, breathing, and circulation in an adult, a child, and an infant.

6. Explain the significance of the following signs: respiration, circulation, skin condition, pupil size and reactivity, level of consciousness.

7. Describe the sequence used to perform a head-to-toe physical examination.

8. State the areas of the body that you are looking for when performing a physical examination.

9. Describe the importance of obtaining the patient's medical history.

10. State the information that you should obtain when taking a patient's medical history.

11. List the information that should be addressed in your hand-off report about the patient's condition.

12. List the differences between performing a patient assessment on a trauma patient and on a medical patient.

13. Describe the components of the on-going assessment.

Skill Objectives *As a first responder, you should be able to:*

1. Perform the following five steps of the patient assessment sequence given a real or simulated incident:
 a. Scene size-up
 b. Initial patient assessment, including:
 (1) Forming a general impression of the patient
 (2) Assessing the patient's responsiveness and stabilizing the patient's spine if necessary
 (3) Assessing the patient's airway
 (4) Assessing the patient's breathing
 (5) Assessing the patient's circulation (including severe bleeding) and stabilizing those functions if necessary
 (6) Updating responding EMS units
 c. Examination of the patient from head to toe
 d. Obtaining the patient's medical history using the SAMPLE format
 e. Performing an on-going assessment
2. Identify and measure the following signs on adult, child, and infant patients: respiration, pulse, capillary refill, skin color, skin temperature, skin moisture, pupil size and reactivity, level of consciousness.

As a first responder, you will be the first trained EMS person on many emergency scenes. Your initial actions will affect not only you, but also the patient and other responders. Your scene size-up will determine whether the scene is safe to enter. You will determine what type of incident is present and whether additional resources will be needed to handle the situation. Your initial actions in assessing patients will affect the level of care requested for the patient.

It is important that you are able to systematically assess a patient to determine what injuries or illness the patient has suffered. To do this, you must perform a patient assessment. The patient assessment is a sequence that consists of the following steps:

1. Perform a scene size-up.
2. Perform an initial patient assessment to identify immediate threats to life.
3. Examine the patient from head to toe.
4. Obtain the patient's medical history.
5. Perform an on-going assessment.

By learning to perform these steps, you can systematically gather the information you need to assess the patient. After you have learned these five steps, you will discover that you can modify them to gather needed information about a patient who is suffering from a medical problem instead of a patient who is suffering from trauma.

As you study this chapter, be aware that the skills and knowledge you are learning follow an **assessment-based care** model. With assessment-based care, the treatment rendered is based on the patient's symptoms.

Assessment-based care requires careful and thorough evaluation of the patient in order to provide appropriate care. You should realize that you will sometimes know the patient's diagnosis if a given condition has already been diagnosed by a physician and is known to the patient. For that reason, we present signs and symptoms of certain medical conditions in later chapters.

Careful and thorough study of the skills and knowledge related to patient assessment will go a long way in helping you perform as a valuable member of the EMS team in your community.

As you study this chapter, you will see that a five-part list appears in the margin next to each step of the patient assessment sequence. Each part of this symbol represents one of the five steps of patient assessment. The portion of the list that is highlighted shows you which step of the sequence is being discussed. By following this symbol, you can keep track of how each part of the sequence fits into the total assessment.

Assessment-based care A system of patient evaluation in which the chief complaint of the patient and other signs and symptoms are gathered and the care given is based on this information rather than on a formal diagnosis.

Patient Assessment
- Scene size-up
- Initial assessment
- Physical examination
- Medical history
- On-going assessment

Patient Assessment Sequence

The patient assessment you will perform as a first responder consists of a series of five steps designed to give you a framework in which to safely approach an emergency scene, determine the need for additional help, examine the patient to determine if injuries or illnesses are present, obtain the patient's medical history, and report the results of your assessment to other EMS personnel. A complete patient assessment consists of the following five steps:

1. Perform a scene size-up.
2. Perform an initial patient assessment to determine and correct life-threatening conditions.
3. Examine the patient from head to toe.
4. Obtain the patient's medical history using the SAMPLE format.
5. Perform an on-going assessment.

Perform a Scene Size-up
Review Dispatch Information
Your scene size-up begins before you arrive at the actual scene of the emergency. You can begin to anticipate possible conditions by reviewing and understanding dispatch information. Your dispatcher should have obtained the following information: the location of the incident, the main problem or type of incident, the number of people involved, and the safety level of the scene. As you receive the dispatcher's information, you should begin to assess it (Figure 7.1).

Besides the information you obtain from the dispatcher, consider such factors as time of day, weather condition, day of the week, and how any of these factors could affect actions you might take. For example, a call from a school during school hours may require a different response than a call during the weekend. Finally, consider the resources that may be needed and mentally prepare for other situations you may find when you arrive on the scene.

Patient Assessment
- Scene size-up
- Initial assessment
- Physical examination
- Medical history
- On-going assessment

Fig. 7.1 Review dispatch information.

SAFETY PRECAUTION

Remember that performing a patient assessment may bring you in contact with the patient's blood, body fluids, waste products, and mucous membranes. You need to wear approved gloves and take other precautions to ensure that you maintain body substance isolation (BSI) to prevent any exposure to infected body fluids. Follow the latest standards from the CDC and OSHA.

Fig. 7.2 Perform a scene size-up.

If you happen on a medical emergency, notify the emergency medical dispatch center by using your two-way radio. If you do not have a two-way radio, send someone to call for help. Relay the following information: the location of the incident, the main problem or type of incident, the number of people involved, and the safety of the scene.

Body Substance Isolation

Part of your preparation before arriving at the scene should be to anticipate the types of body substance isolation (BSI) that may be required. Gloves should be readily available. Consider whether the use of additional protection, such as eye protection, gowns, or masks, may be necessary. In other words, try to anticipate your needs for equipment to ensure good BSI.

Scene Safety

On arriving at the scene, remember to park your vehicle so as to secure the scene and minimize traffic blockage. As you approach, scan the scene to determine the extent of the incident, the possible number of people injured, and the presence of possible hazards (Figure 7.2). It is important to scan the scene to ensure that you are not putting yourself in danger.

Hazards can be visible or invisible. Visible hazards include such things as the scene of a crash, fallen electrical wires, traffic, spilled gasoline, unstable buildings, a crime scene, and crowds. Be especially alert for indications of invisible hazards such as electricity, hazardous materials, and poisonous fumes. Unstable surfaces such as slopes, ice, and water pose potential hazards. Downed electrical wires or broken poles may indicate an electrical hazard. Never assume a downed electrical wire is safe. Confined spaces such as farm silos, industrial tanks, and below-ground pits often contain poisonous gases or lack enough oxygen to support life. Hazardous materials placards may indicate the presence of a chemical hazard.

As you spot these hazards, consider your ability to manage them and decide whether to call for assistance. This assistance may include the fire department, additional EMS units, law enforcement officers, heavy rescue equipment, hazardous materials teams, electric or gas company personnel, or

other special resources. If a hazardous condition exists, make every effort to ensure that bystanders, rescuers, and patients are not exposed to it unnecessarily. If possible, see to it that any hazardous conditions are corrected or minimized as soon as possible. Noting such conditions early keeps them from becoming part of the problem later.

Some emergency scenes will not be safe for you to enter. These scenes will require personnel with special training and equipment. If a scene is unsafe, keep people away until specially trained teams arrive. It is also important to identify potential exit routes from the scene in case a hazard becomes life threatening to you or your patients.

SAFETY PRECAUTION
Never enter an enclosed space without self-contained breathing apparatus (SCBA).

Mechanism of Injury or Nature of Illness

As you approach the scene, look for telltale clues about how the accident happened (Figure 7.3). This is called the mechanism of injury. If you can determine the mechanism of injury or the nature of the illness, you can sometimes predict the patient's injuries. For example, a ladder lying on the ground with a spilled paint bucket probably indicates that the patient fell from the ladder. If the incident is an automobile accident, knowing what type of accident occurred makes it possible to anticipate the types of injuries that may be present. For example, a rollover accident results in different injuries than a car-tree collision. It is also possible to anticipate injuries by examining the extent of damage to an automobile. If the windshield is broken, look for head and spine injuries; if the steering wheel is bent, check for a chest injury. Ask the patient (if conscious) or family members or bystanders for additional information about the mechanism of injury. The same type of overview that gives you information at the scene of an accident can help you to gain information about a patient's condition. Again, ask the patient, family, or bystanders why you were called.

You should not, however, rule out any injury without conducting a head-to-toe physical examination of the patient. The mechanism of the accident

Fig. 7.3 Determine the mechanism of injury.

may provide clues, but it cannot be used to determine what injuries are present in a particular patient.

Determine Need for Additional Resources

If there is more than one patient, count the total number of patients. Call for additional assistance if you think it will be required. It may be necessary to sort patients into groups according to the severity of their injuries to determine which patients need to be treated first and to determine the priority for transportation. The topic of "triage," or patient sorting, is covered more thoroughly in Chapter 16.

Perform an Initial Assessment

The second step in the patient assessment sequence is to perform an **initial patient assessment**. The initial patient assessment is performed to determine and correct any life-threatening conditions. It consists of the following actions:

1. Form a general impression of the patient.
2. Assess the patient's responsiveness and stabilize the spine if necessary.
3. Assess the patient's airway and correct any life-threatening conditions.
4. Assess the patient's breathing and correct any life-threatening conditions.
5. Assess the patient's circulation, including severe bleeding and correct any life-threatening conditions.
6. Update responding EMS units.

These steps are all done in a short time as you make contact with the patient.

Form a General Impression of the Patient

As you approach the patient, form a general impression. Note the sex and the approximate age of the patient. The environment of the emergency may help you determine whether the patient has experienced trauma or illness. (If you cannot determine whether the patient is suffering from an illness or an injury, treat the patient as a trauma patient.) You may suspect what is bothering the patient by the patient's position or by the sounds the patient is making. You may also get some impression of the patient's level of consciousness. While your first impression may be valuable in guiding you in the correct direction, do not let your first impression block out later information that may lead you in another direction.

Assess Responsiveness

The first part of determining the patient's responsiveness is to introduce yourself to the patient. Many patients will be conscious and able to interact with you. As you approach the patient, introduce yourself (Figure 7.4). Tell the patient your name and function. For example, "I'm Jill Smith from the Sheriff's Department, and I'm here to help you." The patient's response to your introduction helps you determine the level of consciousness and also establish

- Your reason for being at the accident
- The fact that you will be helping the patient
- The level of consciousness of the patient

The introduction is your first contact with the patient. It should put the patient at ease by conveying the fact that you are a trained person ready to help.

Patient Assessment
- Scene size-up
- Initial assessment
- Physical examination
- Medical history
- On-going assessment

Initial patient assessment The first actions taken to form an impression of the patient's condition; to determine the patient's responsiveness and introduce yourself to the patient; to check the patient's airway, breathing, and circulation; and to acknowledge the patient's chief complaint.

Fig. 7.4 As you approach the patient, introduce yourself. If an adult patient appears unconscious, gently touch or shake the patient's shoulder to get a response.

Next, ask the patient's name, and then use it when talking with the patient, family, or friends. The patient's response helps you determine the patient's level of consciousness. Avoid telling the patient that everything will be all right.

Even if the patient appears to be unconscious, introduce yourself and talk with the patient as you conduct the rest of the patient assessment. Many patients who appear to be unconscious can hear your voice and need the reassurance it carries. Do not say anything you do not want the patient to hear!

If an adult patient appears to be unconscious, call to the patient in a tone of voice that is loud enough for the patient to hear. If the patient does not respond to the sound of your voice, gently touch the patient or shake the patient's shoulder.

The patient's level of consciousness can range from fully conscious to unconscious. Describe the patient's level of consciousness using the four-level **AVPU scale**:

- *"A" is for Alert.* An alert patient is able to answer the following questions accurately and appropriately: What is your name? Where are you? What is today's date? A patient who can answer these questions is said to be "alert and oriented."
- *"V" is for Verbal.* A patient who is responsive to verbal stimulus will react to loud sounds. The patient is said to be "responsive to verbal stimuli."
- *"P" is for Pain.* A patient in this category who is responsive to pain will not respond to a verbal stimulus but will move or cry out in response to pain. Response to pain is tested by pinching the patient's earlobe or pinching the patient's skin over the collarbone. An appropriate response is withdrawal from the painful stimulus. The patient is said to be "responsive to painful stimuli."
- *"U" is for Unresponsive.* An unresponsive patient will not respond to a verbal or painful stimulus. This patient's condition is described as "unresponsive."

If the patient has suffered from any type of major trauma, you should stabilize the patient's neck as soon as possible by providing manual stabilization of the neck. This will prevent any further injury to the neck and spinal column.

SPECIAL NEEDS

When you are dealing with infants or children, realize that they will not respond to the same methods used to assess responsiveness in adults. Therefore, you should assess the interaction of children and infants with their environment and with their parents.

Check the Patient's Airway

The third part of the initial assessment is to check the patient's airway. If the patient is alert and is able to answer questions without difficulty, then the airway is open. If the patient is not responsive to verbal stimuli, then you must assume that the airway may be closed. In the case of an unconscious patient, open the airway by using the head-tilt/chin-lift technique if the patient has a medical problem. In the case of an unconscious patient who has suffered trauma, open the airway using the jaw-thrust technique without tilting the patient's head. Once the airway is open, inspect it for foreign bodies or secretions. Clear the airway as needed. You may need to insert an airway

Focus on Treatment

AVPU scale A scale to measure a patient's level of consciousness. The letters stand for Alert, Verbal, Pain, and Unresponsive.

adjunct to keep the airway open. (See Chapter 6 for information about airway adjuncts.)

Check the Patient's Breathing

If the patient is conscious, assess the rate and quality of the patient's breathing. Does the chest rise and fall with each breath? Or does the patient appear to be short of breath? If the patient is unconscious, check for breathing by placing the side of your face next to the patient's nose and mouth. If the patient is breathing, you should be able to hear the sounds of breathing, see the chest rise and fall, and even feel the movement of air on your cheek (Figure 7.5). If breathing is difficult, or if you hear unusual sounds, it may be necessary to remove an object from the patient's mouth, such as food, vomitus, dentures, gum, chewing tobacco, or broken teeth. If there is no movement of the chest and no sounds of air are coming from the nose and mouth, breathing is absent, and you must take immediate steps to open the patient's airway and perform rescue breathing. To protect the cervical spine, keep the patient's head in a neutral position and use the jaw-thrust technique to open the airway. Maintain cervical stabilization until the head and neck are immobilized (these procedures are covered in Chapter 6).

Fig. 7.5 Check the patient's breathing.

Check the Patient's Circulation

Next, check the patient's circulation (heartbeat). If the patient is unconscious, take the carotid pulse (Figure 7.6). Place your index and middle fingers together and touch the larynx (Adam's apple) in the patient's neck. Then slide your two fingers off the larynx toward the patient's ear until you feel a slight notch. Practice this maneuver until you are able to find a carotid pulse within 5 seconds of touching the patient's larynx. If you cannot feel a pulse with your fingers in 5 to 10 seconds, it is necessary to begin cardiopulmonary resuscitation (CPR). See Chapter 8.

If the patient is conscious, assess the radial pulse rather than the carotid pulse. This is done by placing your index and middle fingers on the patient's wrist at the thumb side. You should practice taking the radial pulse often to develop this skill (Figure 7.7).

SPECIAL NEEDS

When assessing the circulation in an infant, you should check the brachial pulse. The brachial pulse is on the inside of the arm. You can feel it by placing your index and middle fingers on the inside of the infant's arm halfway between the shoulder and the elbow (Figure 7.8). Check for 5 to 10 seconds.

SAFETY PRECAUTION
Remember to wear gloves to avoid contact with body fluids that may contain blood.

Fig. 7.6 (left) Check an unconscious patient's circulation by taking the carotid pulse.

Fig. 7.7 (right) Take the radial pulse if the patient is conscious.

Next, quickly check the patient for severe bleeding. If you discover severe bleeding, you must take immediate action to control it using direct pressure over the wound. These procedures are covered in Chapter 12. Quickly assess the patient's skin color and temperature. This assessment will give you an idea of whether the patient may be suffering from internal bleeding and shock. It is important to check the color of the patient's skin when you arrive on the scene so that you can tell if the color changes as time goes on. Skin color is described as:

- Pale (whitish, indicating decreased circulation to that part of the body or all of the body)
- Flushed (reddish, indicating excess circulation to that part of the body)
- Blue (also called **cyanosis**, indicating lack of oxygen and possible airway problems)
- Yellow (indicating liver problems)
- Normal

In patients with deeply pigmented skin, color changes may be apparent in the fingernail beds, in the whites of the eyes, or inside the mouth.

Acknowledge the Patient's Chief Complaint

While performing the initial patient assessment, you will often form an impression of the patient's **chief complaint**. It is important to acknowledge the patient's chief complaint and provide reassurance. A conscious patient will often complain of an injury that causes great pain or results in obvious bleeding. The injury most readily apparent to the patient may or may not be the most serious injury (Figure 7.9). Do not allow a conscious patient's comments to distract you from completing the patient assessment sequence. You can acknowledge the patient's chief complaint by saying something like, "Yes, I can see that your arm appears to be broken, but let me check you completely so that we can find any other injuries. I will then treat your injured arm." In an unconscious patient, the primary "complaint" is unconsciousness.

Update Responding EMS Units

In some EMS systems you will be expected to update responding EMS units about the condition of your patient. This report should include age and sex of the patient, the chief complaint, level of responsiveness, status of airway, breathing, and circulation. This update helps them know what to expect when they arrive on the scene.

First Responder Physical Examination

The **physical examination** of the patient from head to toe is done to assess non-life-threatening conditions after you have completed the initial assessment and stabilized life-threatening conditions. The first responder physical exam is designed to locate and begin initial management of the signs and symptoms of illness or injury. Once you have completed the physical examination, review any positive signs and symptoms of injury or illness. This review will help you to get a better picture of the patient's overall condition.

Signs and Symptoms

Remember: As you perform the patient examination, look and feel for the following signs of injury: deformities, open injuries, tenderness, and swelling. Use the acronym DOTS to remember these signs.

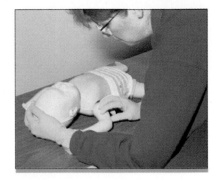

Fig. 7.8 Take the brachial pulse if the patient is an infant.

Fig. 7.9 Acknowledge the patient's chief complaint.

Cyanosis Bluish coloration of the skin resulting from poor oxygenation of the circulating blood.

Chief complaint The patient's response to a question such as "What happened?" or "What's wrong?"

Patient Assessment
- Scene size-up
- Initial assessment
- Physical examination
- Medical history
- On-going assessment

Physical examination The step in the patient assessment sequence in which the first responder carefully examines the patient from head to toe, looking for additional injuries and other problems.

Fig. 7.10 Taking the radial pulse.

Fig. 7.11 Taking the carotid pulse.

Fig. 7.12 Taking the brachial pulse.

Fig. 7.13 Taking the ankle pulse.

Sign A condition that you observe in a patient, such as bleeding or the temperature of a patient's skin.
Symptom A condition the patient tells you, such as "I feel dizzy."

To carefully and systematically assess a patient, you need to understand the difference between a sign and a symptom. You need to be able to assess selected signs and report them systematically. You also need to be able to understand and report the symptoms that the patient reports.

Simply put, a **sign** is something about the patient you can see or feel for yourself. A **symptom** is something the patient tells you about his or her condition, such as "My back hurts" or "I think I am going to vomit." It is important that you be able to identify and measure the important signs: respiration, pulse, capillary refill, skin color, skin temperature, skin moisture, pupil reaction, and level of consciousness.

Respiration The **respiratory rate** is the speed at which the patient is breathing. It is measured as breaths per minute. In a normal adult, the resting respiratory rate is between 12 and 20 breaths per minute. One cycle of inhaling (breathing in) and exhaling (breathing out) is counted as one breath. Count the patient's respirations for one minute to determine the respiratory rate.

Respirations may be rapid and shallow (as when the patient is in shock) or slow (as when the patient has suffered a stroke or drug overdose). Respirations are further characterized as deep, wheezing, gasping, panting, snoring, noisy, or labored. If the patient is not breathing, respiration is described as "absent," a condition that you would have addressed during your initial assessment.

When you are checking the rate or noting the quality of respirations, make sure that your face or hand is close enough to the patient's face to feel the exhaled air on your skin. Also watch for the rise and fall of the chest. When counting respirations in a conscious patient, try not to let the patient know you are counting his or her respirations. If the patient knows you are counting respirations, you may not get an accurate count.

Pulse Pulse indicates the speed and force with which the heart is beating. The pulse can be felt anywhere on the body where an artery passes over a hard structure such as a bone. Although there are many such places on the body, this discussion concentrates on only four: radial (wrist) pulse, carotid (neck) pulse, brachial (arm) pulse, and posterior tibial (ankle) pulse.

The most commonly taken pulse is the **radial pulse**, which is located at the wrist where the radial artery passes over one of the forearm bones, the radius (Figure 7.10). The **carotid pulse** is taken over a **carotid artery,** which is located on either side of the patient's neck just under the jawbone (Figure 7.11). The **brachial pulse** is taken on the inside of the arm, halfway between the shoulder and the elbow (Figure 7.12). The **posterior tibial pulse** is located on the inner aspect of the ankle just behind the ankle bone (Figure 7.13).

In general, you should take the radial pulse of a conscious patient and the carotid pulse of an unconscious patient. When examining an infant, use the brachial pulse. The posterior tibial pulse is used to assess the circulatory status of a leg.

To check a patient's pulse, you need to determine three things: rate, rhythm, and quality.

To determine the pulse rate (heartbeats per minute), find the patient's pulse with your fingers, count the beats for 30 seconds, and multiply by 2. In a normal adult, the resting pulse rate is about 60 to 80 beats per minute, although in a physically fit person (such as a jogger) the resting rate may be lower (about 40 to 60 beats per minute). In children, the pulse rate is normally faster. A child's resting pulse rate is about 80 to 100 beats per minute. (See Chapter 15.)

A very slow pulse (less than 40 beats per minute) can be the result of a se-

rious illness, whereas a very fast pulse (more than 120 beats per minute) can indicate that the patient is in shock. Remember, however, that a person who is in excellent physical condition may have a pulse rate of less than 50 beats per minute, and a person who is simply anxious or worried could have a fast pulse rate (more than 110 beats per minute).

You should be able to determine the rhythm of the pulse. Note whether the pulse is regular or irregular.

You should also be able to describe the quality of the pulse. A strong pulse is often referred to as a **bounding pulse**. This is similar to the heart rate that follows physical exertion such as running or lifting heavy objects. The beats are very strong and well defined. A weak pulse is often called a **thready pulse**. The pulse is present, but the beats are not easily detected. A thready pulse is a more dangerous sign than a bounding pulse. A bounding pulse can be dangerous if the patient has high blood pressure and is at risk for a stroke.

Capillary Refill

Capillary refill is the ability of the circulatory system to return blood to the capillary vessels after blood has been squeezed out. The capillary refill test is done on the patient's fingernails or toenails. To perform this test, squeeze the patient's nail bed firmly between your thumb and forefinger (Figure 7.14). The patient's nail bed will look pale. Release the pressure. Count 2 seconds by saying "capillary refill." The patient's nail bed should become pink. This indicates a normal capillary refill time.

If the patient has lost a lot of blood and is in shock, or if there has been damage to the blood vessels supplying that limb, the capillary refill will be delayed or entirely absent. Capillary refill will be delayed in a cold environment and should not be used as the sole means for assessing the circulatory status of an extremity. Check with your medical director to determine if you should use the capillary refill test.

Skin Condition

The patient's skin should be checked for color, temperature, and moisture. For information on checking skin color, see page 165.

Normal body temperature is about 98.6°F, or 37°C. Precise body temperature is taken with a thermometer, but you can estimate a patient's body temperature by placing the back of your hand on the patient's forehead. The patient's skin temperature is judged, in relation to your skin temperature, as hot or cold.

Some illnesses can cause the skin to become excessively moist or excessively dry. Therefore, together with its relative temperature, the patient's skin might be described as hot and dry, hot and moist, cold and dry, or cold and moist.

Respiratory rate The speed at which a person is breathing (measured in breaths per minute).

Pulse The wave of pressure that is created by the heart as it contracts and forces blood out of the heart and into the major arteries.

Radial pulse Wrist pulse.

Carotid pulse A pulse that can be felt on each side of the neck where the carotid artery is close to the skin.

Carotid arteries The principle arteries of the neck. They supply blood to the face, head, and brain.

Brachial pulse Pulse located in the arm between the elbow and shoulder; used for checking pulse in infants.

Posterior tibial pulse Ankle pulse.

Bounding pulse A strong pulse (similar to the pulse that follows physical exertion like running or lifting heavy objects).

Thready pulse A weak pulse.

Capillary refill The ability of the circulatory system to restore blood to the capillary blood vessels after it has been squeezed out by the examiner.

A. Squeeze the nail bed between your thumb and forefinger.

B. Release the pressure.

Fig. 7.14 Checking capillary refill time.

Pupil The circular opening in the middle of the eye.

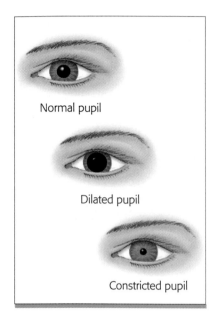

Fig. 7.15 Normal, dilated, and constricted pupils.

Fig. 7.16 Unequal pupils may indicate a stroke or injury to the brain.

Pupil Size and Reactivity It is important to examine each eye to detect signs of head injury, stroke, or drug overdose. Look to see whether the **pupils** are of equal size and whether they both react (contract) when light is shone into them (Figure 7.15). The following findings are abnormal:

- *Pupils of unequal size.* Unequal pupils can indicate a stroke or injury to the brain (Figure 7.16). A small percentage of people normally have unequal pupils, but unequal pupils are usually a valuable diagnostic sign in an injured or ill patient.
- *Pupils that remain constricted.* Constricted pupils are often present in a person who is taking narcotics. They are also a sign of certain central nervous system diseases.
- *Pupils that remain dilated* (enlarged). Dilated pupils indicate a relaxed or unconscious state. Dilation of pupils usually occurs within 30 to 60 seconds of cardiac arrest. Head injuries and the use of certain drugs such as barbiturates can also cause dilated pupils.

Level of Consciousness While the patient's level of consciousness is usually done as part of the initial assessment, it is important to observe and note any change in the patient's level of consciousness between the time of your arrival and the time you turn over the patient's care to personnel at the next level of the EMS system. Any changes from one level of consciousness to another are very important and should be reported. Describe the patient's response according to the AVPU scale (see page 163).

Signs Signs are those things that a first responder observes in a patient. They help you to determine what is wrong with the patient and the severity of the patient's condition. You should be able to evaluate the patient's respiratory status, circulatory status, skin condition, pupil reaction, and level of consciousness.

Assessment of a patient's respiratory status consists of determining the rate of the patient's respirations and whether they are rapid or slow, shallow or deep, noisy or quiet. Assessment of a patient's circulatory status consists of determining the rate, rhythm, and quality of the victim's pulse and determining if the patient's capillary refill is normal, slow, or absent. Assessment of a patient's skin condition consists of determining whether the skin is pale, flushed, blue, or yellow. Assessment of the patient's pupils consists of determining if the pupils are equal or unequal and whether they remain constricted or dilated. Assessment of the patient's level of consciousness consists of determining whether the patient is alert, responsive to verbal stimuli, responsive to pain, or unresponsive (AVPU).

Check Point

Describe the importance of the following signs:

✔ Respirations ✔ Pupil size and reactivity

✔ Pulse ✔ Level of consciousness

✔ Skin color, temperature, and moisture

Examine the Patient

Conduct a thorough, hands-on, head-to-toe examination in a logical, systematic manner. It is important to conduct the examination the same way each time to be sure you search all areas of the body for injuries and to communicate your findings to other medical personnel in a clear, concise format.

The first step of the physical examination is to determine the patient's **vital signs.** These consist of respiration, pulse, and temperature. (Blood pressure, a fourth vital sign, is not routinely taken by first responders; however, your service may choose to teach it as an optional skill. It is covered in Chapter 19.)

The head-to-toe examination can be done on a conscious or an unconscious patient. If the patient is conscious, you should watch the reactions to your examination. You may want to ask what the patient is feeling as you proceed with your examination. Remember that your examination is the main focus of this part of the assessment. Do not ask the patient so many questions that you are not doing a thorough physical examination.

If the patient is unconscious, it is vitally important to have assessed the airway, breathing, and circulation first during the initial assessment. Once breathing and pulse have been established, begin a head-to-toe examination of the unconscious patient. Examination of an unconscious patient is difficult because the patient cannot cooperate or tell you where something hurts. Your examination often will elicit grimaces or moans from an unconscious patient.

An injured patient who is unconscious must be treated as if a spine injury were present. Stabilize the head and spine to minimize movement during the patient examination. A patient who is unconscious because of illness should also be treated cautiously.

Treat all unconscious patients who may have suffered trauma as though a spine injury is present. It is essential to fully immobilize all injured, unconscious patients on a **backboard** before transporting them. (See Chapter 5.)

Examine the Head Use both hands to examine thoroughly all areas of the scalp (Figure 7.17). Do not move the patient's head! This is especially important if the patient is unconscious or has suffered a spine injury. Injuries to the head bleed a lot. Be sure to find the actual wound; do not be fooled by globs of matted, bloody hair.

If necessary, remove the patient's eyeglasses and put them in a safe place. Many patients who need glasses become upset if their glasses are taken away. Use your judgment in each case. Be considerate of the patient.

If the patient is wearing a wig, it may be necessary to remove the hairpiece to complete the head examination. Be sure to check the entire head for bumps, areas of tenderness, and bleeding.

Examine the Eyes Cover the eye for 5 seconds. Then quickly open the eyelid and watch the pupil, the dark part at the center of the eye. The normal reaction of the pupil is to contract (get smaller). This should happen in about 1 second. If you are examining a patient's eyes at night or in the dark, use a flashlight and aim the light at the closed eye (Figure 7.18).

A pupil that fails to react to light or pupils that are unequal in size may be important diagnostic signs and should be reported to personnel at the next level of medical care.

Examine the Nose Examine the nose for tenderness or deformity, which indicates a broken nose, and to see if there is any blood or fluid coming from it.

Vital signs Signs of life, specifically pulse, respiration, blood pressure, and temperature.

Backboard A straight board used for splinting, extricating, and transporting patients with suspected spine injuries.

Fig. 7.17 Use both hands to examine the head.

 Focus on Treatment

Fig. 7.18 Examine the patient's eyes.

Examine the Mouth Your first examination of the mouth should have taken place when you checked to see whether the patient was breathing. Now recheck the mouth for foreign objects such as food, vomitus, dentures, gum, chewing tobacco, and loose teeth. Be sure to clear away carefully any material that obstructs the patient's breathing. In addition, you should be ready to deal with vomiting. It is important to prevent **aspiration** (inhalation) of vomitus into the lungs.

Use your sense of smell to determine whether any unusual odors are present. Do not allow the presence of alcohol on the patient's breath to change the way you treat the patient. In fact, the detection of alcohol should alert you to the necessity of conducting an especially careful physical examination, particularly if the patient appears to be severely injured. A patient who is sick with diabetes may have a fruity breath odor.

Remember to place any unconscious patient who has not suffered trauma in the recovery position. This helps keep the patient's airway open and prevents aspiration of vomitus into the airway or lungs.

Examine the Neck Examine the neck carefully using both hands, one on each side of the patient's neck. Be sure to touch the vertebrae (the bony part of the back of the neck) to see whether gentle pressure produces pain (Figure 7.19).

CAUTION
Be careful not to move the neck or head!

Check the neck veins. If they are swollen (distended), this may indicate heart problems or major trauma to the chest.

As your hands move down the patient's scalp and onto the neck, check for the presence of an emergency medical identification neck chain. Any chain around a patient's neck should be examined for medical information. The internationally recognized symbol shown in Figure 7.20 is found on necklaces, arm bracelets, ankle bracelets, wallet cards and is carried by people who have a medical condition that warrants special attention if they become ill or injured. If you find such a warning on a patient, it is your responsibility to give the information it contains to the next person in the EMS system.

Examine the neck for a **stoma** (opening), which indicates that the patient is a "neck breather." A neck breather is a person who has undergone major surgery in which the airway above the stoma has been removed. The stoma may be the patient's only means of breathing, and the patient may not be able to speak normally. The stoma is usually concealed behind an article of clothing or a bib.

Examine the Face While you are performing the hands-on examination of the head and neck, be sure to note the color of the facial skin, its temperature, and whether it is moist or dry (Table 7.1).

After you have completed the head examination, be sure to note any bumps, bruises, cuts, or other abnormalities.

Examine the Chest If the patient is conscious, ask him or her to take a deep breath and tell you whether there is any pain on **inhalation** or **exhalation.** Note whether the patient breathes with difficulty. Look and listen

Aspiration Breathing in foreign matter such as food, drink, or vomitus into the airway or lungs.

⊗ **Focus on Treatment**

Fig. 7.19 Use both hands to examine the patient's neck.

Stoma An opening.

Fig. 7.20 The Medic-Alert symbol is found on wrist and ankle bracelets, necklaces, and wallet cards.

Table 7.1: Skin Color

Color	Term	Problem
Red	Flushed	Fever or sunburn
White	Pale	Shock
Blue	Cyanotic	Airway obstruction
Yellow	Jaundiced	Liver disease

Fig. 7.21 Examine the patient's chest.

for signs of difficult breathing such as coughing, wheezing, or foaming at the mouth.

It is important to look at both sides of the chest completely, noting any injuries, bleeding, or sections of the chest that move abnormally, unequally, or painfully. Unequal motion of one side or section may be a sign of a serious condition, called a **flail chest,** that can result from multiple rib fractures. Be sure to run your hands over all parts of the chest and examine the patient's back. Like the head and neck examinations, this must be accomplished with minimal patient movement (Figure 7.21).

Apply firm but gentle pressure to the collarbone (**clavicle**) to check for **fractures.** Check the chest for fractured ribs by placing your hands on the chest and pushing down gently but firmly. Then put your hands on each side of the chest and push inward, squeezing the chest.

Examine the Abdomen Continue downward to the **abdomen** (stomach and groin). Look for any signs of external bleeding, penetrating injuries, or protruding parts, such as intestines (Figure 7.22).

Ask the patient to relax the stomach muscles and observe whether the stomach is rigid without the patient's voluntary tightening of the stomach muscles. Rigidity is often a sign of abdominal injury. Swelling is also a sign of abdominal injury.

Note whether the clothing has been soiled with urine or feces. This may be an important diagnostic sign for certain illnesses or injuries, such as stroke. Make sure you check the genital area for external injuries. Although both the patient and you may be socially uncomfortable during this examination, it must be done if there is any suspicion of injury.

Remember: Continue talking to the patient throughout the entire patient assessment. Tell the patient what you are doing and why.

Fig. 7.22 Examine the patient's abdomen.

Next check for fractures of the pelvis. First check for signs of obvious bruising, bleeding, or swelling. If no pain is reported by the patient, then gently press on the pelvic bones. If the patient reports pain or tenderness or any movement is noted, a severe injury may be present in this region (Figure 7.23).

Examine the Back Check one side of the back at a time, using one hand to gently lift the patient's shoulder and the other to slide downward in the examination (Figure 7.24). In cases where a patient has been injured, stabilize the head and neck to prevent movement while you are examining the patient.

As you check each side of the back, be sure that your hands go all the way to the midline of the patient's body so you can feel the spinal column. Check half the back from one side; then switch and check the other side in the same manner. This ensures that no part of the back is missed during the

FYi

Inhalation Breathing in.
Exhalation Breathing out.

Fig. 7.23 Examine the patient's pelvis by gently pressing on the pelvic bones.

A. Place your hands on both sides of the pelvis.

B. Push downward and push inward.

Fig. 7.24 Examine the patient's back.

examination. If the patient is lying on his or her side or stomach, it will be much easier to examine the patient's back.

Examine the Extremities A systematic examination of each extremity is done to determine if there are any injuries. This examination consists of the following five steps:

1. Observe the extremity to determine if there is any visible injury. Look for bleeding and deformity.
2. Examine for tenderness in each extremity by encircling it with both hands and gently, but firmly, squeezing each part of the limb. Watch the patient's face and listen to see if the patient shows any signs of pain.
3. Ask the patient to move the extremity. Check for normal movement. Determine if there is any pain when he or she moves the extremity.

⚠ CAUTION

Do not ask the patient to move an extremity if step 1 or 2 has shown any deformity or tenderness.

4. Check for sensation by touching the bare skin of each extremity. See if the patient can feel your touch.
5. Assess the circulatory status of each extremity by checking for the presence of a pulse in that extremity and by checking for capillary refill.

Each upper extremity consists of the **arm,** the forearm, the wrist, and the hand. The arm extends from the shoulder to the elbow; the forearm extends from the elbow to the wrist.

Examine one upper extremity at a time (Figure 7.25):

1. *Observe the extremity.* Start by looking at its position. Is it in a normal or an abnormal position? Does it look broken (deformed) to you?
2. *Examine for tenderness.* Encircle the upper extremity with your hands. Work from the shoulder downward to the hand. Firmly squeeze the limb to locate any possible fractures.
3. *Check for movement.* Take the patient's hand in yours and ask the patient to squeeze your hand. Squeezing is usually painful for the patient

Flail chest A condition that occurs when three or more ribs are broken each in two places, and the chest wall lying between the fractures becomes a free-floating segment.

Clavicle The collarbone.

Fracture Any break in a bone.

Abdomen The body cavity, lying between the thorax and the pelvis that contains the major organs of digestion and excretion.

Arm Part of the upper extremity that extends from the shoulder to the elbow.

if there is a fracture or other injury. If a conscious patient cannot squeeze your hand, you should assume that the extremity is seriously injured or paralyzed.

4. *Check for sensation.* Ask the patient if he or she feels any tingling or numbness in the extremity. Such tingling or numbness may be a sign of a spine injury. Check for sensation by touching the palm of the patient's hand. See if the patient can feel your touch.

5. *Assess the circulatory status.* Check the patient's radial pulse. Absence of a radial pulse indicates blood vessel damage. Check the fingers for capillary refill. Check the color, temperature, and moisture of the hand.

Repeat this examination for the other upper extremity.

Each lower extremity consists of the thigh, the **leg**, the ankle, and the foot. The thigh extends from the hip to the knee. The leg extends from knee to the ankle.

Examine one lower extremity at a time (Figure 7.26):

1. *Observe the extremity.* The first step in examining the lower extremity is to observe it. Is it deformed? Is the foot rotated inward or outward?

2. *Examine for tenderness.* Encircle the lower extremity with your hands, as you did with the upper extremities. Move from the groin to the foot. Be sure to make contact with all surfaces of the limb. Use firm but gentle pressure to identify tender (injured) areas. You are not handling eggs but are attempting to locate injuries.

3. *Check for movement.* Ask the patient to move the limb only if you have found no signs of injury in the first two steps. Movement is usually painful if there is a significant injury. If a conscious patient cannot move the foot or toes, the limb is seriously injured or paralyzed.

4. *Check for sensation.* Ask the patient whether he or she can feel your touch as you examine the extremity. Tingling or numbness in a limb is a sign of spine injury.

5. *Assess the circulatory status.* Check the posterior tibial (ankle) pulse, located just behind the ankle bone on the medial side of the ankle. Absence of this pulse indicates blood vessel damage, which is sometimes caused by fractures. Check the toes for capillary refill. Check the skin color, temperature, and moisture of the extremity.

Repeat this examination for the other lower extremity.

Check ✔ *Point*

✔ Describe the steps involved in performing a physical examination of a patient.

Fig. 7.25 Examine the upper extremities one at a time.

Leg The lower extremity; specifically, the lower portion, from the knee to the ankle.

Fig. 7.26 Examine the lower extremities one at a time.

Patient Assessment
• Scene size-up
• Initial assessment
• Physical examination
• Medical history
• On-going assessment

The Patient's Medical History

Knowing the patient's health status prior to the incident can help medical personnel give proper treatment and avoid measures that might endanger the

Fig. 7.27 Obtain the patient's medical history (SAMPLE).

patient further. Therefore, you should attempt to gather important facts about the patient's general medical history (Figure 7.27). Important questions you should ask include:

- How old are you?
- Do you have any existing medical problems (such as a heart condition or diabetes)?
- Are you under the care of a physician at the present time?
- Do you have any allergies?

If the patient is unconscious, a family member, friend, or co-worker may be able to answer these questions. Important information can often be found on a medical identification necklace, bracelet, or card.

There are many different formats for taking medical histories. One of the most commonly used formats is the **SAMPLE history.** An explanation of the SAMPLE history is given in Table 7.2.

Patient Assessment
- Scene size-up
- Initial assessment
- Physical examination
- Medical history
- On-going assessment

Ongoing Assessment

The patient assessment sequence helps you determine each patient's initial condition. Patients who appear stable can become unstable quickly. Therefore, it is essential that you watch all patients carefully for changes in status. As a general rule, you should monitor the patient's vital signs every 15 minutes. Continue to maintain an open airway, monitor breathing and pulse for rate and quality, and monitor the skin color and temperature. If the patient is unstable, take the patient's vital signs every 5 minutes.

▼ CAUTION
Serious changes can occur rapidly!

Providing a "Hand-off" Report It is important that you be able to describe your findings concisely and accurately to the emergency medical personnel who take over the care of your patients in a "hand-off" report (Figure 7.28). The easiest way to report your patient assessment results is

SAMPLE history A patient's medical history. S=signs/symptoms, A=allergies, M=medications, P=pertinent past history, L=last oral intake, E=events associated with the illness or injury.

Table 7.2: SAMPLE Medical History
S = **S**igns/**S**ymptoms
A = **A**llergies
M = **M**edications
P = **P**ertinent past history
L = **L**ast oral intake
E = **E**vents associated with this illness or injury

VOICES *of* EXPERIENCE

"My first encounter with pre-hospital care was 22 years ago, and the memory is still vivid. The sound of the sirens had interrupted supper, and I raced up the hill to the fire station. Entering the building, I answered the "red phone" to hear an excited voice notifying us of a car accident. As fellow volunteer responders arrived, we jumped into the squad car and hurried to the scene. As we filed out, we found a vehicle off the road lying against a tree. Five young men were scattered everywhere. One was still in the vehicle, bent over in knee-chest position and complaining of severe pain in his left hip area; he was not about to let us straighten him from that position either. As we placed the backboard under his knees, I looked out of the car window to see at least a 10-foot drop. After placing the patient on the backboard, which seemed like an eternity, we moved him from the vehicle, still in knee-chest position, to the squad car and quickly transported him to the local hospital.

As I continued to work in pre-hospital emergency care, I felt the need to learn more. I started attending weekend workshops throughout the state and found that there was more that I could offer my patients. Excited about improving my skills, I communicated the information I had attained to my fellow volunteers. Our department arranged for a local physician who was interested in EMS to assist in training our members. We offered more "hands on" monthly drills, such as simulated car accidents, falls, and gunshot wounds. Care improved as we focused on the sequence of actions to take upon arriving at the scene. We no longer rushed up to an incident without first securing the area. We learned to better assess the patient's condition, initiating airway management and immobilizing patients prior to moving them. Patient outcome improved from the knowledge we had gained.

As time passed, my desire to work in EMS expanded. I am now a paramedic and faculty member in pre-hospital education, teaching all levels of EMS personnel. I continue to be active in a volunteer fire and rescue department."

Peggy Stark
LPN, NRPM
Paramedic Instructor
Creighton University
Omaha, Nebraska

Fig. 7.28 Report your findings in a hand-off report.

to use the same systematic approach you followed during the patient assessment, as follows:

1. Provide the age and sex of the patient.
2. Describe the history of the incident.
3. Describe the patient's chief complaint.
4. Describe the patient's level of responsiveness.
5. Report on the status of the vital signs: airway, breathing, and circulation (including severe bleeding).
6. Describe the results of your physical examination.
7. Report any pertinent medical conditions, using the SAMPLE format.
8. Report the interventions you provided.

Working in a systematic manner will help ensure that you do not overlook a significant symptom, sign, or injury and will help to make the hand-off report complete and accurate.

A hand-off report on a 23-year-old man injured in an automobile accident might be as follows:

1. I have a 23-year-old man.
2. He was involved in a two-car, head-on collision.
3. He is complaining of pain in his stomach and has a 2-inch cut on his forehead.
4. He is conscious and alert.
5. His pulse is 78 and strong. His respirations are 16 and are regular and deep.
6. Our patient examination reveals a 2-inch cut on his forehead. There are marks on his stomach. There is moderate pain midway between his right knee and ankle.
7. He has no known medical conditions.
8. The patient is on his back, covered with a blanket to preserve his body heat. We have bandaged his laceration and immobilized his leg with an inflatable splint.

Remember that the purpose of the patient assessment sequence is to:

- Assist you in finding the patient's injuries so that you can treat them.
- Obtain information about the patient's condition, which you hand off to the EMS personnel at the next level of medical care.

With practice, you can complete the patient assessment sequence in about 2 minutes. This is not a complete medical examination but, as the name implies, is a patient assessment by first responders.

Examine every patient involved in an incident before you begin major treatment of any single patient. The exceptions to this rule are airway, breathing, and circulatory problems (severe bleeding or shock), which must be treated as they are encountered during patient assessment. Except for these

life-threatening conditions, begin no treatment until you have examined all patients to determine the extent and severity of their injuries and to make sure that you treat injuries in their order of severity.

A Word about Trauma and Medical Patients

Patients can generally be divided into two main categories: those who suffer from **trauma** and those who have a sudden **illness**. Trauma is the term used for an injury to a patient. The injury may be major or minor. Incidents that cause trauma include falls, motor vehicle accidents, and sports-related accidents. Sudden illnesses include heart attacks, strokes, asthma, and gallbladder problems.

Trauma A wound or injury.

Illness Sickness.

Now that you have learned the patient assessment sequence, you need to consider how it is used to examine patients who have suffered from trauma, illnesses, or both. You can use the same basic sequence for both types of patients. When examining trauma patients, follow the sequence as you learned it:

1. Size up the scene.
2. Perform an initial patient assessment:
 a. Form a general impression of the patient.
 b. Assess the patient's responsiveness and stabilize the patient's spine if necessary.
 c. Assess the patient's airway.
 d. Assess the patient's breathing.
 e. Assess the patient's circulation (including severe bleeding) and stabilize it if necessary.
 f. Update the responding EMS units.
3. Examine the patient from head to toe.
4. Obtain the patient's medical history using the SAMPLE format.
5. Provide on-going assessment.

This sequence gives you the information about the trauma patient in a logical order. It allows you to assess the most critical factors first. Although you may have to vary the order of the steps somewhat for certain patients, you should try to generally follow this order of steps.

When dealing with a patient who has suffered from a sudden illness, you can modify the preceding sequence slightly. When dealing with an illness, perform the first two steps of the patient assessment sequence in the same order. Change the sequence to obtain the patient's medical history before you perform the head-to-toe examination. In a conscious patient, the most important thing is to make sure you gather all the information that you need to perform a complete patient assessment.

As discussed previously, although it is often helpful to consider whether the patient's problem is caused by trauma or sudden illness, you should avoid jumping to conclusions. Some patients will need to be treated for *both* trauma and sudden illness. (For example, a person who has a heart attack while driving a car needs to be treated for the heart attack and for any trauma suffered in a subsequent auto accident.) The most important factor to remember is to follow a system of patient assessment that will gather all the information you need.

CHAPTER
REVIEW 7

Summary

This chapter has covered the five steps of the patient assessment sequence you will need to perform in the first minutes you are on the scene of an emergency. The first assessment you make as you arrive on the scene of an emergency is to determine whether it is safe. As a first responder, you are responsible for determining if additional equipment and personnel are required. You need to perform an initial assessment of the patients to determine if they are conscious; to check their airway, breathing, and circulation; and to acknowledge their chief complaints. A more thorough head-to-toe physical examination will give you additional information about any other injuries the patients may have experienced. A medical history such as the SAMPLE history gives you needed information about patients' medical problems. Reporting the results of your assessment will give vital patient information to other emergency medical personnel.

These patient assessment steps have been presented to help you perform patient assessments in a logical order. To perform the steps of the patient assessment, you learned the difference between signs and symptoms. The significance of respiration, circulation, skin condition, pupil size and reactivity, and level of consciousness was stressed.

You need to be somewhat flexible in assessing patients. When dealing with trauma patients, you generally perform the head-to-toe physical examination before you obtain the patient's medical history. When caring for a patient with a medical condition, you generally obtain the patient's medical history before you perform the needed physical examination.

As you study the upcoming chapters, you will learn about specific types of illnesses and injuries. Remember that the information you learned in this chapter on patient assessment will be used to assess patients who are experiencing illnesses or trauma. It will be necessary to combine your knowledge of patient assessment with your knowledge of specific illnesses and injuries. Good patient assessment skills will get you halfway down the road to being a good first responder.

Abdomen—page 171

Arm—page 172

Aspiration—page 170

Assessment-based care—page 159

AVPU scale—page 163

Backboard—page 169

Bounding pulse—page 167

Brachial pulse—page 166

Capillary refill—page 167

Carotid arteries—page 166

Carotid pulse—page 166

Chief complaint—page 165

Clavicle—page 171

Cyanosis—page 165

Exhalation—page 170

Flail chest—page 171

Fracture—page 171

Illness—page 177

Inhalation—page 170

Initial patient assessment—page 162

Leg—page 173

Physical examination—page 165

Posterior tibial pulse—page 166

Pulse—page 166

Pupil—page 168

Radial pulse—page 166

Respiratory rate—page 166

SAMPLE history—page 174

Sign—page 166

Stoma—page 170

Symptom—page 166

Thready pulse—page 167

Trauma—page 177

Vital signs—page 169

What Would You Do?

1. You are called to the scene of an accident where a painter has fallen 15 feet from a ladder. Describe the five steps you need to take to assess this person's injuries.
2. You have been called to a house where a 78-year-old female is complaining of sharp pains in her chest. Describe your patient assessment sequence.

You Should Know

1. The differences between signs and patient symptoms.
2. The significance of the following signs: respiration, circulation, skin condition, pupil size and reactivity, level of consciousness.
3. The importance of each of the following steps in the patient assessment:
 a. Performing a scene size-up
 b. Performing an initial patient assessment to determine and correct life-threatening conditions
 c. Examining the patient from head to toe

d. Obtaining the patient's medical history using the SAMPLE format

e. Performing an on-going assessment

4. The information you can use from dispatch information.

5. The components of scene size-up.

6. Why it is important to get an idea of the number of patients at an emergency scene as soon as possible.

7. The importance of the following steps of the initial patient assessment:

 a. Forming a general impression of the patient

 b. Assessing the patient's responsiveness and stabilizing the patient's spine if necessary

 c. Assessing the patient's airway

 d. Assessing the patient's breathing

 e. Assessing the patient's circulation

 f. Updating report to the responding EMS units

8. The differences involved in checking the airway, breathing, and circulation in adult, child, and infant patients.

9. The sequence used to perform a head-to-toe physical examination.

10. The body areas you are checking when performing a physical examination.

11. The importance of obtaining the patient's medical history.

12. The information that should be obtained when taking a patient's medical history.

13. The differences between performing a patient assessment on a trauma patient and on a medical patient.

14. The information that should be addressed in your hand-off report about the patient's condition.

You Should Practice

1. Identifying and measuring the following diagnostic signs on adult, child, and infant patients: respiration, pulse, capillary refill, skin color, skin temperature, skin moisture, pupil size and reaction, and level of consciousness.

2. Performing the following five steps of the patient assessment sequence given a real or simulated incident:

 a. Scene size-up

 b. Initial patient assessment

 c. Examining the patient from head to toe

 d. Obtaining the patient's medical history

 e. Performing on-going assessment

SKILL SCAN: Checking Circulation

1.

1. Taking the radial pulse.
2. Taking the carotid pulse.
3. Taking the brachial pulse for an infant.
4. Checking capillary refill.
 a. Squeeze the nailbed.
 b. Release the pressure.

2.

3.

4a.

4b.

SKILL SCAN: Patient Assessment Sequence

1. Perform scene size-up.
2. Perform an initial assessment.

1.

2

3. Examine the patient from head to toe.

4. Obtain the patient's medical history (SAMPLE).

5. Perform an on-going assessment.

3.

4.

5.

1. Describe the difference between a sign and a symptom.

2. List the normal values for the following signs for an adult patient:
 a. Respiration
 b. Circulation
 c. Skin condition
 d. Pupil size and reactivity

3. You should check the patient's breathing for
 a. 60 seconds
 b. 30 seconds
 c. 15 seconds
 d. 5–10 seconds

4. To check for the presence of a pulse, you should check for at least
 a. 60 seconds
 b. 30 seconds
 c. 15 seconds
 d. 5–10 seconds

5. Match the type of patient with the appropriate method of checking a pulse.

 ____ Conscious adult a. Brachial pulse
 ____ Unconscious adult b. Carotid pulse
 ____ Conscious child c. Posterior tibial pulse
 ____ Unconscious child d. Radial pulse
 ____ Conscious infant
 ____ Unconscious infant

6. Match the skin color with the associated problem.

 ____ White a. Airway obstruction
 ____ Yellow b. Shock
 ____ Blue c. Fever or sunburn
 ____ Red d. Liver disease

7. Define the following levels of consciousness:
 a. A
 b. V
 c. P
 d. U

8. Describe three types of information you might get from a dispatcher.

9. List five types of hazards you should assess while performing a scene size-up.

10. List and describe the five steps of the patient assessment.

11. Number the following body parts in the order in which you would examine them during a physical examination:

 ____ Back ____ Mouth
 ____ Face ____ Extremities
 ____ Eyes ____ Chest
 ____ Head ____ Abdomen
 ____ Neck ____ Nose

12. A stoma is
 a. Used to assess circulation
 b. Used to assess breathing in children
 c. A birth defect
 d. A surgical opening in the neck

Answers: 1. A sign is something the first responder observes in a patient, such as bleeding or the temperature of a patient's skin. A symptom is something that a patient feels, such as, "I feel dizzy." **2.** a. Respiration = 12–20 breaths per minute; b. Circulation = 60–80 beats per minute; c. Skin condition: usually dry and warm; d. Pupil size and reactivity: equal and reactive to light. **3.** a. **4.** d. **5.** Conscious adult = d; Unconscious adult = b; Conscious child = d; Unconscious child = b; Conscious infant = a; Unconscious infant = a. **6.** White = Shock; Yellow = Liver disease; Blue = Airway obstruction; Red = Fever or sunburn. **7.** A = Alert: able to talk and answer questions appropriately; V = Verbal: responsive to verbal stimuli; P = Pain: responsive to painful stimuli; U = Unresponsive. **8.** Location, type of incident, number of people involved. **9.** Electrical hazards, hazardous materials, unstable structures, unruly crowds, confined spaces. **10.** a. Scene size-up; b. Initial patient assessment; c. Examining the patient from head to toe; d. Obtaining the patient's medical history; e. Perform an on-going assessment. **11.** Back = 9; Face = 6; Eyes = 2; Head = 1; Neck = 5; Mouth = 4; Extremities = 7; Chest = 10; Abdomen = 8; Nose = 3. **12.** d.

13. Name four abnormalities you should check for when examining the abdomen.

14. Why is it important to check the circulatory status of each extremity?

15. Which of the following steps is not part of an examination of a lower extremity?
 a. Examining for tenderness
 b. Checking for sensation
 c. Checking for muscle tone
 d. Observing the extremity

16. What does SAMPLE stand for as it applies to a patient's medical history?

 S _____
 A _____
 M _____
 P _____
 L _____
 E _____

17. Compose a hand-off report you might deliver as a result of an auto-pedestrian accident involving an 8-year-old girl who has suffered head and leg injuries and is unconscious.

13. D = Deformity; O = Open injury; T = Tenderness; S = Swelling. **14.** To determine if an injury has damaged the circulation in that extremity. **15.** c. **16.** S = Signs and symptoms of present illness; A = Allergies; M = Current medications; P = Pertinent medical history; L = Last oral intake; E = Events leading up to this illness or injury. **17.** Your hand-off report should include the following information: Age and sex of patient; Chief complaint; Responsiveness; Airway and breathing status; Circulation status; Physical findings; SAMPLE history; Interventions provided.

NOTES

M O D U L E

4

CIRCULATION

Each year in the United States, more than 600,000 people die because of heart and blood vessel diseases. Many of these are heart attacks and strokes. Over one-half of these deaths occur outside the hospital. In many cases, the first sign of cardiac disease is sudden stoppage of the patient's heart. In cases of out-of-hospital cardiac arrest, a first responder or bystander trained in cardiopulmonary resuscitation (CPR) can make the difference between life and death for this patient.

This module covers the skills you will need to perform CPR on infants, children, and adults. These skills are easily learned and can be carried with you at all times. You will learn the structure and function of the circulatory system, the reasons the heart stops beating, and the components of CPR. You will learn why first responders are such an important link in the "chain of survival" for cardiac patients. By learning the signs of effective CPR and the complications of CPR, you will be able to perform effective CPR.

CPR AND CIRCULATION

1. Describe the anatomy and function of the circulatory system.
2. List the reasons for a heart to stop beating.
3. Describe the components of CPR.
4. Explain the links in the cardiac chain of survival.
5. Describe the conditions under which you should start and stop CPR.
6. Describe the techniques of external chest compressions on an adult, a child, and an infant.
7. Explain the steps of one-rescuer adult CPR.
8. Explain the steps of two-rescuer adult CPR.
9. Explain how to switch rescuers.
10. Explain the steps of infant and child CPR.
11. Describe the signs of effective CPR.
12. State the complications of performing CPR.
13. Describe the importance of creating sufficient space for CPR.
14. Describe the importance of CPR training.
15. Explain the legal implications related to CPR.

Skill Objectives *As a first responder, you should be able to:*

1. Perform one-rescuer adult CPR.
2. Perform two-rescuer adult CPR.
3. Perform infant CPR.
4. Perform child CPR.

The purpose of this chapter is to teach you the remaining skills needed to perform the sequence of skills that make up cardiopulmonary resuscitation, or CPR. CPR consists of three major skills: the "A" (airway) skills, the "B" (breathing) skills, and the "C" (circulation) skills. In Chapter 6, you learned the airway and breathing skills. These airway and breathing steps may be life-saving procedures for a patient who has just stopped breathing and whose heart is still beating. In most cases, however, by the time you arrive on the scene, the patient has not only stopped breathing, but the heart has stopped beating as well. If the patient is not breathing and has no heartbeat, rescue breathing alone will not save the patient's life. Forcing air into the lungs does no good unless the circulatory system can carry the oxygen in the lungs to all parts of the body.

In this chapter, you will learn the C (circulation) skills. If the patient's heart has stopped, you can maintain or restore circulation manually through the use of chest compressions (closed-chest cardiac massage). To maintain both breathing and heartbeat, rescue breathing and chest compressions must be done together. By combining the airway, breathing, and circulation skills, you will be able to perform CPR.

Anatomy and Function of the Circulatory System

Circulatory system The heart and blood vessels, which together are responsible for the continuous flow of blood throughout the body.

The **circulatory system** is similar to a city water system in that it consists of the pump (the heart), a network of pipes (the blood vessels), and fluid (blood). After blood has picked up oxygen in the lungs, it goes to the heart, which pumps the oxygenated blood to the rest of the body.

In Chapter 4 you learned how the heart functions as a pump. The heart, which is about the size of your fist, is located in the chest between the lungs. The cells of the body absorb oxygen and nutrients from the blood and produce waste products (including carbon dioxide), which the blood carries back to the lungs. In the lungs, the blood exchanges the carbon dioxide for more oxygen and then returns to the heart to be pumped out again.

The human heart consists of four chambers, two on the patient's right side and two on the patient's left side. Each upper chamber is called an atrium. The right atrium receives blood from the veins of the body; the left atrium receives blood from the lungs. The bottom chambers are the right and left ventricles. The right ventricle pumps blood to the lungs; the left ventricle pumps blood throughout the body. The most muscular chamber of the heart is the left ventricle. It needs the most power to squeeze blood to all parts of the body. Together the four chambers of the heart work in a well-ordered sequence to pump blood to the lungs and to the rest of the body (Figure 8.1).

One-way check valves in the pump and veins allow the blood to flow in only one direction through the circulatory system. The arteries carry blood away from the pump at high pressure and are therefore thick walled. The arteries closest to the pump are quite large (about 1 inch in diameter) but are smaller farther away from the heart.

The four major arteries are the neck, or carotid artery; the wrist, or radial artery; the arm, or brachial artery; and the groin, or femoral artery. The locations of these arteries are shown in Figure 8.2. Because these arteries lie between a bony structure and the skin, they are used as locations to measure the

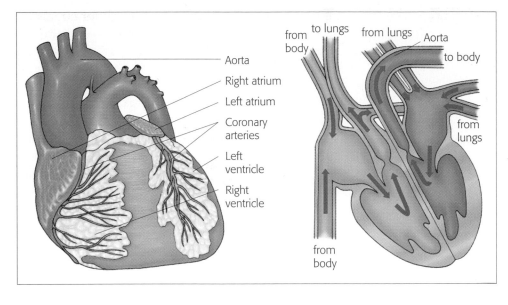

Fig. 8.1 The heart functions as the human circulatory system's pump.

Aorta
Right atrium
Left atrium
Coronary arteries
Left ventricle
Right ventricle

from body
to lungs
from lungs
Aorta
to body
from lungs
from body

patient's **pulse.** A pulse is generated when the heart contracts and sends a wave through the artery.

The capillaries are the smallest pipes in the system. Some capillaries are so small that only one blood cell at a time can go through them. At the capillary level, oxygen passes from the blood cells into the cells of body tissues, and carbon dioxide and other waste products pass from the tissue cells to the blood cells, which then return to the lungs. Veins are the thin-walled pipes of the circulatory system that carry blood back to the heart.

Blood has several components: **plasma** (a clear, straw-colored fluid), red blood cells, white blood cells, and **platelets.** Blood receives its red color from its red blood cells. The red blood cells carry oxygen from the lungs to the body and bring carbon dioxide back to the lungs. The white blood cells are called "infection fighters" because they devour bacteria and other disease-causing organisms (Figure 8.3). Platelets start the blood-clotting process.

Pulse The wave of pressure that is created by the heart as it contracts and forces blood out of the heart and into the major arteries.

Plasma The fluid part of the blood that carries blood cells, transports nutrients, and removes cellular waste materials.

Platelets Microscopic disc-shaped elements in the blood that are essential to the process of blood clot formation, the mechanism that stops bleeding.

A. Neck or carotid pulse.

B. Wrist or radial pulse.

C. Arm or brachial pulse.

D. Groin or femoral pulse.

Fig. 8.2 Locations for assessing the patient's pulse.

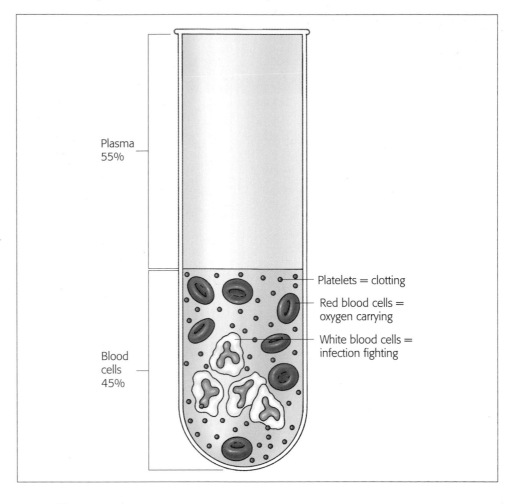

Fig. 8.3 The components of blood.

Plasma
55%

Platelets = clotting

Red blood cells =
oxygen carrying

White blood cells =
infection fighting

Blood
cells
45%

Cardiac Arrest

Cardiac arrest A sudden ceasing of heart function.

If the heart stops contracting, no blood is pumped through the blood vessels. This is called **cardiac arrest.** Without a supply of blood, the cells of the body will die because they cannot get any oxygen and nutrients and they cannot eliminate waste products. Organ damage begins once the heart stops beating. Some organs are more sensitive than others. Brain damage begins within 4 to 6 minutes after the patient has suffered cardiac arrest. Within 8 to 10 minutes, the damage to the brain may become irreversible.

Focus on Assessment

Cardiac arrest may have many different causes:

1. Heart and blood vessel diseases such as heart attack and stroke
2. Respiratory arrest, if untreated
3. Medical emergencies such as epilepsy, diabetes, allergic reactions, electrical shock, and poisoning
4. Drowning
5. Suffocation
6. Trauma and shock caused by massive blood loss

A patient who has suffered cardiac arrest is unconscious and is not breathing. You cannot feel a pulse, and the patient looks dead. Even though cardiac arrest has many different causes, the initial treatment for a patient suffering from cardiac arrest is CPR.

Components of CPR

The skill of cardiopulmonary resuscitation consists of three parts: the A (airway) skills, the B (breathing) skills, and the C (circulation) skills. In Chapter 6, you learned the airway and breathing skills. You learned how to check patients to determine if the airway is open and to correct a blocked airway by using the head-tilt/chin-lift or jaw-thrust technique. You learned how to check patients to determine if they are breathing by using the look, listen, and feel technique. You learned to correct the absence of breathing by performing rescue breathing.

To perform CPR, you must combine the airway and breathing skills with the circulation skills. You do this by checking the patient for a pulse. If there is no pulse, you must correct the patient's circulation by performing external chest compressions. The airway and breathing components push oxygen into the patient's lungs. The external chest compressions move the oxygenated blood throughout the body. External chest compressions are done by depressing the patient's sternum (breastbone). This causes a change in the pressure in the patient's chest and causes enough blood to flow to sustain life for a short period of time.

CPR by itself cannot sustain life indefinitely. It should be started as soon as possible to give the patient the best chance for survival. It is only by performing all three parts of the CPR sequence that you can keep the patient alive until more advanced medical care can be administered. In many cases, the patient will need defibrillation and medication in order to recover from cardiac arrest.

The Cardiac Chain of Survival

In most cases of cardiac arrest, CPR by itself will not be enough to save lives. It is the first link in the American Heart Association's "chain of survival," which includes the following links:

1. Early access to the emergency medical services (EMS) system
2. Early CPR
3. Early defibrillation
4. Early advanced care by paramedics and hospital personnel

As a first responder, you have the ability to help the patient by providing early CPR and by making sure that the EMS system has been activated. Some first responders may also be trained in the use of automated defibrillators. By keeping these links of the chain strong, you will help to keep the patient alive until early advanced care can be administered by paramedics and hospital personnel.

Just as an actual chain is only as strong as its weakest link, so too this CPR chain of survival is only as good as its weakest link. Your actions in performing early CPR are vital to giving cardiac arrest patients their best chance for survival. (See Figure 8.4.)

When to Start and Stop CPR

When to Start CPR CPR should be started on all nonbreathing, pulseless patients, unless they are obviously dead. Few reliable criteria exist

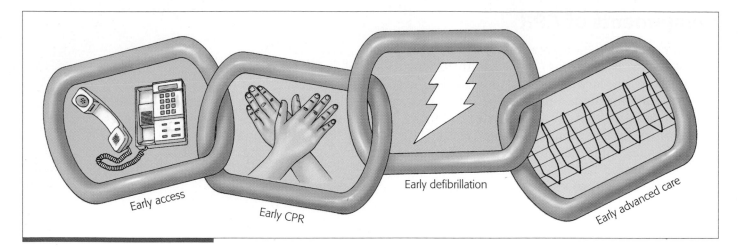

Fig. 8.4 The CPR chain of survival.

Early access

Early CPR

Early defibrillation

Early advanced care

by which death can be determined immediately. The following criteria are reliable and indicate that CPR should *not* be started.

1. *Decapitation.* Decapitation occurs when the head is separated from the rest of the body. When this occurs, there is obviously no chance of saving the patient.

2. *Rigor mortis.* This is the temporary stiffening of muscles that occurs several hours after death. The presence of this stiffening indicates the patient is dead and cannot be resuscitated.

3. *Evidence of tissue decomposition.* Tissue decomposition or actual flesh decay occurs only after a person has been dead for more than a day.

4. *Dependent lividity.* Dependent lividity is the red or purple color that occurs on the parts of the patient's body that are closest to the ground. It is caused by blood seeping into the tissues on the dependent, or lower, part of the person's body. Dependent lividity occurs after a person has been dead for several hours.

If any of the preceding signs is present in a pulseless, nonbreathing person, you should not begin CPR. If none of these signs is present, you should begin CPR. It is far better to start CPR on a person who is later declared dead by a physician than to withhold CPR from a patient whose life might have been saved.

Remember: Unless you are sure that a person is obviously dead, activate the EMS system and then begin CPR.

When to Stop CPR

You should discontinue CPR only when:

1. Effective spontaneous circulation and ventilation have been restored.
2. Resuscitation efforts have been transferred to another trained person who continues CPR.
3. A physician assumes responsibility for the patient.
4. The patient is transferred to properly trained EMS personnel.
5. Reliable criteria for death (as previously listed) are recognized.
6. You are too exhausted to continue resuscitation, environmental hazards endanger your safety, or continued resuscitation would place the lives of others at risk.

The Technique of External Cardiac Compression in an Adult

A patient who has suffered cardiac arrest is unconscious and is not breathing. You cannot feel a pulse, and the patient looks dead. If you suspect that the patient has suffered cardiac arrest, first check and correct the airway, next check and correct the breathing, and then check for circulation. This last step is done by checking the carotid pulse. To check the carotid pulse, place your index and middle fingers on the larynx (Adam's apple) and slide your two fingers into the groove between the larynx and the muscles at the side of the neck (Figure 8.5). Keep your fingers there for 5 to 10 seconds to be sure the pulse is absent and not just slow.

If there is no carotid pulse in an unresponsive patient, you must begin **chest compressions.** For chest compressions to be effective, the patient must be lying on a firm, horizontal surface. If the patient is on a soft surface, such as a bed, it is impossible to compress the chest. Immediately place all patients needing CPR on a firm, level surface.

To perform chest compressions effectively, you must kneel beside the patient's chest facing the patient. Place the fingers of one hand on the notch at the upper end of the patient's sternum and run your other hand firmly down the sternum until you feel the **xiphoid process.** Place the heel of the first hand on the bottom third of the sternum two finger widths above the xiphoid process (Figure 8.6). Place the heel of the other hand on top of the hand on the chest.

It is important to locate and maintain the proper hand position while applying chest compressions. If your hands are higher than two fingers above the xiphoid process, the force you apply cannot produce adequate chest compressions. If your hands are too low on the sternum, you may damage the

Fig. 8.5 Check the patient's carotid pulse.

Chest compression Manual chest-pressing method that mimics the squeezing and relaxation cycles a normal heart goes through; administered to a person in cardiac arrest. (It is also called "external chest compression" and "closed-chest cardiac massage.")

Xiphoid process The flexible cartilage at the lower end of the sternum (breastbone), a key landmark in the administration of CPR and the Heimlich maneuver.

Fig. 8.6 Perform chest compressions.

A. Locate the top and bottom of the sternum.

B. Place the heel of your hand two finger widths above the bottom on the sternum.

C. Place your other hand on top of your first hand.

liver. If your hands slip sideways off the sternum and onto the ribs, the compressions will not be effective, and you may damage the ribs and lungs.

> ## ▼ CAUTION
>
> **Do not let your fingers touch the chest wall; your fingers could dig into the patient, causing injury. Interlocking your fingers will help avoid this.**

After you have both hands in the proper position, compress the chest of an adult 1½ to 2 inches straight down. To apply effective compressions, you must kneel close to the patient's side and lean forward so that your arms are directly over the patient. Keep your back straight and elbows stiff so the force of each compression is transmitted from your whole body, not just your arm muscles. Between compressions, the pressure from the heel of the hand must be completely released. The heel of your hand should remain in contact with the patient's chest, however.

Compressions must be rhythmic and continuous. One-half of each compression cycle should consist of the downward push and the other half should consist of resting, which allows the heart to refill with blood. Compressions should be at the rate of 80 to 100 compressions per minute in an adult patient. You will give two rescue breaths after every 15 chest compressions. Practice on a manikin until you can compress the chest smoothly and rhythmically.

External Chest Compressions on an Infant

Infants who have suffered cardiac arrest will be unconscious and not breathing. They will have no pulse. To check for cardiac arrest, you first need to check and correct the airway. Do not tilt the head back too far as this may occlude the infant's airway. Next check for breathing by using the look, listen, and feel technique. Correct the absence of breathing by giving mouth–to–mouth-and-nose rescue breathing.

To check for the presence of circulation, feel for the brachial pulse on the inside of the upper arm (Figure 8.7). Use two fingers on one hand, while maintaining the head tilt with the other hand. If there is no pulse, you must begin chest compressions. Draw an imaginary horizontal line between the two nipples, and place your index finger below the imaginary line in the middle of the chest. Place your middle and ring fingers next to your index finger. Use your middle and ring fingers to compress the sternum. Make sure you do not compress above the xiphoid process. Compress the sternum about ½ to 1 inch (approximately one-third to one-half the depth of the chest). Compress the sternum at least 100 times per minute. You will give one rescue breath after every five chest compressions.

When doing chest compressions on an infant, you can place the infant on a solid surface such as a table or you can cradle the infant in your arm, as shown in Figure 8.8. You will not need to use much force to achieve adequate compressions on infants because they are so small and their chests are so pliable.

External Chest Compressions on a Child

The signs of cardiac arrest in a child are the same as those for an adult and for an infant. If you suspect that the child has suffered cardiac arrest, first check

Fig. 8.7 Check the brachial pulse on the inside of the infant's arm.

Fig. 8.8 Positioning the infant patient for proper CPR

and correct the child's airway, check and correct the child's breathing, and then check for circulation. Check the carotid pulse by placing two or three fingers on the larynx. Slide your fingers into the groove between the Adam's apple and the muscle. Feel for the carotid pulse with one hand while maintaining the head-tilt position with the other hand. Locate the child's sternum by placing the fingers of one hand on the upper end of the sternum and use the fingers of the other hand to locate the bottom of the sternum, the xiphoid process. Place the heel of one hand on the lower third of the sternum. Use the heel of one hand instead of two hands as you do for an adult patient. Compress the sternum approximately one-third to one-half the depth of the chest. This will be approximately 1 to 1½ inches. Compress the chest 100 times per minute. Give one rescue breath for every five compressions.

Steps in One-Rescuer Adult CPR

CPR consists of three steps: checking and correcting the airway, checking and correcting the breathing, and checking and correcting the circulation. In Chapter 6, you learned to perform the airway and breathing skills. Now that you have learned how to check for circulation and perform chest compressions, you are ready to put them together to perform CPR. If you are the only trained person at the scene, you must perform **one-person CPR** (Figure 8.9). The steps for one-person CPR are as follows:

One-person CPR Cardiopulmonary resuscitation performed by one rescuer.

1. Establish the patient's level of consciousness. Ask the patient, "Are you okay?" Shake the patient's shoulder. If there is no response, call for additional help—activate the EMS system. (If you are alone, call for help first and then begin CPR.)

2. Turn the patient on his or her back while supporting the head and neck.

3. Open the airway. Use the head-tilt/chin-lift technique or, if the patient is injured, use the jaw-thrust technique. Maintain the open airway.

4. Check for breathing. Place the side of your face and your ear close to the nose and mouth of the patient. Look, listen, and feel for the movement of

Fig. 8.9 The sequence of steps for one-person CPR.

A. Establish responsiveness.

B. Open the airway.

C. Check for breathing.

D. Perform rescue breathing.

E. Check for circulation.

F. Perform chest compressions.

air: Look for movement of the chest, listen for sounds of air exchange, and feel for air movement on the side of your face. Check for breathing for 3 to 5 seconds. If signs of breathing are absent, place your mouth over the patient's mouth, seal the patient's nose with your thumb and index finger, and begin mouth-to-mouth rescue breathing. A mouth-to-mask ventilation device may be used.

5. Give two breaths. Blow slowly for 1½ to 2 seconds using just enough force to make the chest rise. Allow the lungs to deflate between breaths.

6. Check for circulation. Locate the patient's larynx with your index and middle fingers. Slide your fingers into the groove between the larynx and the muscles at the side of the neck to feel for the carotid pulse. Check for 5 to 10 seconds. If the pulse is absent, proceed to step 7. (If the pulse is present, continue rescue breathing.)

7. Begin chest compressions. Place the heel of one hand on the lower third of the sternum, two finger widths above the xiphoid process. Place the other hand on top and apply 15 compressions over a 10-second period. Each compression should be about 1½ to 2 inches and at the rate of 80 to 100 compressions per minute. Count the compressions out loud: "One and two and three and. . . ."

8. After 15 chest compressions, ventilate the patient's lungs. Deliver two full-size breaths.

9. Continue compressions and **ventilations.** Continue a sequence of 15 compressions followed by 2 ventilations.

10. Check for a pulse. After 1 minute and every few minutes thereafter, check for a carotid pulse.

Ventilation The exchange of air between the lungs and the air of the environment; breathing.

When performing one-person CPR, you must deliver chest compressions and mouth-to-mouth ventilations at a ratio of 15 compressions to 2 breaths. Immediately give two lung inflations after each set of 15 chest compressions. Because you must interrupt chest compressions to ventilate, you should perform each series of 15 chest compressions in 10 seconds (a rate of 80 to 100 compressions per minute). At this rate, the patient will actually receive about 70 compressions per minute.

Check ✓ *Point*

✓ List the steps for performing one-person CPR.

A 1993 American Heart Association skill performance sheet entitled "Adult One-Rescuer CPR" is shown in Figure 8.10 for your review and practice.

Although one-person CPR can keep the patient alive, two-person CPR is preferable for an adult patient because it is less exhausting for the rescuers. Whenever possible, CPR for an adult should be performed by two rescuers.

Remember: If you do not have help, do not wait for another rescuer to arrive; begin one-person CPR immediately!

Two-Rescuer Adult CPR

In many cases, a second trained person will be on the scene to help you perform CPR. Two-person CPR is more effective than one-person CPR. One rescuer can deliver chest compressions while the other performs rescue breathing. Chest compressions and ventilations can be given more regularly and without interruption. Two-person CPR is also less tiring for the rescuers.

Fig. 8.10 Adult one-rescuer CPR Skill Performance Sheet.

SKILL AND PERFORMANCE SHEET

ADULT ONE-RESCUER CPR

Student Name _____ Date _____

Performance Guidelines	Performed
1. Establish unresponsiveness. Activate the EMS system.	
2. Open airway (head tilt-chin lift or jaw thrust) check breathing (look, listen, and feel).*	
3. Give two slow breaths (1½ to 2 seconds per breath), if airway is obstructed, reposition head and try to ventilate again. Watch chest rise, allow for exhalation between breaths.	
4. Check carotid pulse. If breathing is absent but pulse is present, provide rescue breathing (1 breath every 5 seconds, about 12 breaths per minute).	
5. If no pulse, give cycles of 15 chest compressions (rate, 80 to 100 compressions per minute) followed by 2 slow breaths.	
6. After 4 cycles of 15:2 (about 1 minute), check pulse.* If no pulse, continue 15:2 cycle beginning with chest compressions.	

* If victim is breathing or resumes effective breathing, place in recovery position.

Comments _____

Instructor_____

Circle one: Complete Needs more practice

You and a partner can continue to perform effective CPR for a longer period of time than you could alone.

In **two-person CPR**, one rescuer delivers ventilations (mouth-to-mouth or mouth-to-mask breathing) and the other gives chest compressions. Position yourselves on either side of the patient (Figure 8.11). The sequence of steps is the same as for one-person CPR, but the tasks are divided as follows:

Two-person CPR Cardiopulmonary resuscitation performed by two rescuers.

A. Establish responsiveness.

B. Open the airway using the head-tilt/chin-lift or jaw-thrust technique.

Fig. 8.11 Rescuer positions for two-person CPR.

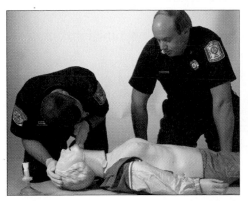

C. Check for breathing—look, listen, and feel.

D. Perform rescue breathing; give two breaths.

E. Check for circulation using the carotid pulse and begin chest compressions.

F. Continue rescue breathing and chest compressions.

1. Rescuer One determines the patient's state of consciousness by asking, "Are you okay?" If there is no response, the rescuer shakes the person's shoulder.
2. Call 9-1-1 to activate the EMS system if the patient is unconscious. If other people are present, ask them to call for EMS. If only two rescuers are present, one will have to leave to call.
3. Turn the patient on his or her back. Turn the patient as a unit, supporting the head and neck to protect the spine.
4. Rescuer One opens the airway using the head-tilt/chin-lift or jaw-thrust technique.
5. Rescuer One checks for breathing by placing the side of his or her face close to the mouth and nose of the patient to look, listen, and feel for movement of air. Watch for chest movement; check for 3 to 5 seconds. If there are no signs of breathing, proceed to step 6.
6. Rescuer One gives two 1½- to-2-second breaths. Allow time for complete deflation between breaths.
7. Rescuer One checks for the presence of a carotid pulse. If there is no carotid pulse, proceed to step 8.
8. Rescuer Two begins chest compressions at a rate of 80 to 100 compressions per minute (Figure 8.12). Count "one and two and three and" and so forth to maintain the proper rate between compressions and to let Rescuer One know when to ventilate.

Fig. 8.12 Perform chest compressions.

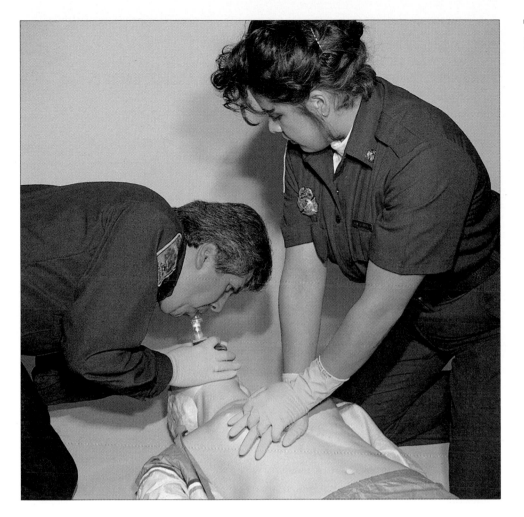

Fig. 8.13 Perform rescue breathing.

9. After Rescuer Two has completed each fifth compression, Rescuer One gives one ventilation (Figure 8.13). Rescuer Two should pause just long enough for Rescuer One to ventilate once.

10. Rescuer One places his or her fingers on the carotid pulse of the patient periodically, while Rescuer Two continues to do compressions. If the compressions are done correctly, Rescuer One should feel a beat for each compression. This confirms that adequate CPR is being accomplished.

11. Every few minutes, Rescuer One should feel for the carotid pulse and then ask Rescuer Two to stop compressions. If the patient's heart is beating on its own, Rescuer One can feel a pulse. In this case, compressions can be stopped. Rescue breathing should be continued until spontaneous breathing resumes. If there is no pulse, CPR should be resumed.

Check Point

✓ Why is two-rescuer CPR better for the patient?

Compressions and ventilations should remain rhythmic and uninterrupted. By counting out loud, Rescuer Two can maintain delivery of

Fig. 8.14 Adult two-rescuer CPR Skill Performance Sheet.

SKILL AND PERFORMANCE SHEET

ADULT TWO-RESCUER CPR

Student Name _____ Date _____

Performance Guidelines	Performed
1. Establish unresponsiveness. EMS system has been activated.	
RESCUER 1	
2. Open airway (head tilt-chin lift or jaw thrust). Check breathing (look, listen, and feel), try to ventilate; if obstructed, reposition head and try to ventilate again.	
3. Give two slow breaths (1½ to 2 seconds per breath), watch chest rise, allow for exhalation between breaths.	
4. Check carotid pulse.	
RESCUER 2	
5. If no pulse, give cycles of 5 chest compressions (rate, 80 to 100 compressions per minute) followed by 1 slow breath by rescuer 1.	
6. After 1 minute of rescuer support, check pulse*. If no pulse, continue 5:1 cycles.	

* If victim is breathing or resumes effective breathing, place in recovery position.

Comments _____

Instructor _____

Circle one: Complete Needs more practice

compressions at the rate of 80 to 100 per minute and also let Rescuer One know when to ventilate the patient's lungs. Once you and your partner establish a smooth pattern of CPR, do not stop, except for 5 seconds to check for a return of the patient's pulse or to move the patient.

Note: Two-person CPR is not performed on infants because they are too small to be worked on by two people.

A 1993 American Heart Association skill performance sheet entitled "Adult Two-Rescuer CPR" is shown in Figure 8.14 for your review and practice.

Switching Rescuers

If two-person CPR must be continued for a long period of time, you or your partner may become exhausted. If this occurs, it helps to switch positions. A switch allows the person giving compressions (Rescuer Two) to rest his or her arms. Switch only when necessary, and do it as smoothly as possible so the break in rate and regularity of compressions and ventilations is minimal. There are many orderly ways to switch positions. You should learn the method practiced in your EMS system. One method is as follows:

1. As Rescuer Two becomes tired, he or she says the following out loud (instead of counting): "We—will—switch—next—time." One word is spoken as each compression is done. These words replace the counting sequence for these five compressions.
2. After this sentence is spoken, Rescuer One completes one ventilation after the fifth compression and then moves to the chest to do the compressions.
3. Rescuer Two completes the fifth compression and moves to the head of the patient to maintain the airway and ventilation.
4. Rescuer Two then checks the carotid pulse for 5 seconds. If the carotid pulse is absent, Rescuer Two says "No pulse" and ventilates the patient once.
5. Rescuer One then begins compressions.

You should practice switching until you can do it smoothly and quickly. Switching is much easier if the rescuers work on opposite sides of the patient.

Steps in One-Person CPR for Infants

An **infant** is defined as anyone under one year of age. The principles of CPR are the same for adults and infants. In actual practice, however, you must use slightly different techniques for an infant. The steps for one-person CPR for infants are as follows:

Infant Anyone under one year of age.

1. Position the infant on a firm surface.
2. Establish the infant's level of responsiveness. An unresponsive infant is limp. Gently shake or tap the infant to determine whether he or she is unconscious. Call for additional help if the patient is unconscious. Activate the EMS system.
3. Open the airway. This is best done by the head-tilt/chin-lift method. It is possible to obstruct the airway of an infant by tilting the head back too far. Therefore, to open the airway of an infant, tilt the head back to a sniffing position, but do not tilt it back as far as it will go. Continue holding the head with one hand.
4. Check for breathing. Place the side of your face close to the mouth and nose of the infant as you would for an adult. Look, listen, and feel for 3 to 5 seconds.
5. Give two slow, 1- to-1½-second breaths. To breathe for an infant, place your mouth over the infant's mouth and nose. Because the lungs of an infant are very small, it is important to give very small puffs of air. Use enough air to make the chest rise. Do not use large or forceful breaths (Figure 8.15).

Fig. 8.15 Rescue breathing for an infant patient.

Fig. 8.16 Check the brachial pulse.

Fig. 8.17 Perform chest compressions with two or three fingers.

Brachial pulse The pulse on the inside of the upper arm.
Child Anyone between one and eight years of age.

6. Check for circulation. Check the **brachial pulse** rather than the carotid pulse. The brachial pulse is on the inside of the arm (Figure 8.16). You can feel it by placing your index and middle fingers on the inside of the infant's arm halfway between the shoulder and the elbow. Check for 5 to 10 seconds.

7. Begin chest compressions. An infant's heart is located relatively higher in the chest than an adult's heart. Therefore, you must deliver chest compressions by pressing on the middle (rather than lower) portion of the sternum. Imagine a horizontal line drawn between the nipples. Place your index finger below that line in the middle of the chest. Place your middle and ring fingers next to your index finger. Use the middle and ring fingers to compress the sternum. Because the chest of an infant is smaller and more pliable than the chest of an adult, use only two fingers to compress the chest. Compress the sternum ½ to 1 inch. To achieve good results, the infant must be lying on a firm surface. Since the heart rate of an infant is faster than an adult's, you must deliver compressions at the rate of at least 100 per minute (Figure 8.17). The ratio of cardiac compressions to ventilations is 5 compressions to 1 ventilation instead of the 15 to 2 ratio in the adult. The size of the infant makes two-person CPR impractical.

8. Continue compressions and ventilations. Give one slow ventilation after each set of 5 compressions during a 1- to 1½-second pause.

9. Reassess the patient after 20 repetitions (about 1 minute) and every few minutes thereafter.

Check *Point*

✓ How is infant CPR different from adult one-rescuer CPR?

Remember: The small size of an infant makes two-person CPR impractical.

A 1993 American Heart Association skill performance sheet entitled "Infant One-Rescuer CPR" is shown in Figure 8.18 for your review and practice.

The Steps of Child CPR

A **child** is defined as a person between the ages of one and eight years. The steps for child CPR are almost the same as for an adult; however, there are variations in the way some steps are performed. These variations are:

- Use less force to compress the child's chest.
- Use only one hand to depress the sternum 1 to 1½ inches.

Fig. 8.18 Infant one-rescuer CPR Skill Performance Sheet.

WE'RE FIGHTING FOR YOUR LIFE
American Heart Association

SKILL AND PERFORMANCE SHEET

INFANT ONE-RESCUER CPR

Student Name _____ Date _____

Performance Guidelines	Performed
1. Establish unresponsiveness. If second rescuer is available, have him or her activate the EMS system.	
2. Open airway (head tilt-chin lift or jaw thrust). Check breathing (look, listen, and feel).*	
3. Give two slow breaths (1 to 1½ seconds per breath), if airway is obstructed, reposition head and try to ventilate again. Watch chest rise, allow for exhalation between breaths.	
4. Check brachial pulse. If breathing is absent but pulse is present, provide rescue breathing (1 breath every 3 seconds, about 20 breaths per minute).	
5. If no pulse, give 5 chest compressions (rate at least 100 compressions per minute), followed by one slow breath.	
6. After about 1 minute of rescue support, check pulse.* If rescuer is alone, activate the EMS system. If no pulse, continue 5:1 cycles.	

* If victim is breathing or resumes effective breathing, place in recovery position.

Comments _____

Instructor _____

Circle one: Complete Needs more practice

- Use less force to ventilate the child. Ventilate only until the child's chest rises.
- The rate of compressions is 100 per minute, instead of 80 to 100 compressions per minute for an adult.
- Breaths should be given at a rate of one breath every 3 seconds, instead of one breath every 5 seconds for an adult.

Fig. 8.19 Performing chest compressions on a child.

A. Locate the top and bottom of the sternum.

B. Place one hand two fingers width above the bottom of the sternum.

The steps for child CPR are as follows:

1. Establish the child's level of responsiveness. Tap and gently shake the shoulder and shout, "Are you okay?" If a second rescuer is available, have him or her activate the EMS system.

2. Turn the child on his or her back, while supporting the head and neck.

3. Open the airway. Use the head-tilt/chin-lift technique or, if the child is injured, use the jaw-thrust technique. Maintain the open airway.

4. Check for breathing. Place the side of your face and your ear close to the nose and mouth of the child. Look, listen, and feel for the movement of air: Look for movement of the chest, listen for sounds of air exchange, and feel for air movement on the side of your face. Check for breathing for 3 to 5 seconds. If signs of breathing are absent, place your mouth over the child's mouth, seal the child's nose with your thumb and index finger, and begin mouth-to-mouth rescue breathing. A mouth-to-mask ventilation device may be used.

5. Give two breaths. Blow slowly for 1 to 1½ seconds using just enough force to make the chest rise. Allow the lungs to deflate between breaths.

6. Check for circulation. Locate the child's larynx with your index and middle fingers. Slide your fingers into the groove between the larynx and the muscles at the side of the neck to feel for the carotid pulse. Check for 5 to 10 seconds. If the pulse is absent, proceed to step 7. (If the pulse is present, continue rescue breathing.)

7. Begin chest compressions. Place the heel of one hand on the lower third of the sternum, two finger widths above the xiphoid process (Figure 8.19). Place the other hand on top and apply 5 compressions. Each compression should be about 1 to 1½ inches and at the rate of 100 compressions per minute. Count the compressions out loud: "One and two and three and. . . ."

8. After 5 chest compressions, ventilate the patient's lungs. Deliver 1 full-size breath.

9. Continue compressions and ventilations. Continue a sequence of 5 compressions followed by 1 ventilation.

10. Check for a pulse. After 1 minute and every few minutes thereafter, check for a carotid pulse.

SAFETY PRECAUTION
Practice good body substance isolation (BSI) when doing CPR.

A 1993 American Heart Association skill performance sheet entitled "Child One-Rescuer CPR" is shown in Figure 8.20 for your review and practice.

Signs of Effective CPR

It is important to know the signs of effective CPR so you can assess your efforts to resuscitate the patient. The signs of effective CPR are:

1. A second rescuer feels a carotid pulse while you are compressing the chest.
2. The patient's pupils constrict when they are exposed to light.
3. The patient's skin color improves (from blue to pink).
4. Independent breathing begins or the patient gasps.
5. An independent heartbeat, which is the goal of CPR, begins. This does not occur often without advanced life support procedures.

If some of these signs are not present, evaluate your technique to see if it can be improved.

Complications of CPR

A discussion of CPR would not be complete without mention of its complications. They can be minimized by using proper technique.

Broken Bones

If your hands slip to the side of the sternum during chest compressions, or if your fingers rest on the ribs, you may break ribs while delivering a compression. To prevent this, use proper hand position and do not let your fingers come in contact with the ribs. If you hear a cracking sound while performing CPR, check and correct your hand position but continue CPR. Sometimes you may break bones or cartilage even with proper CPR technique.

Gastric Distention

Bloating of the stomach is called **gastric distention** and is caused by too much air blown too fast and too forcefully into the stomach. It may also be caused by a partially obstructed airway, which allows some of the air you breathe into the patient's airway to go into the stomach rather than into the lungs.

Gastric distention causes the abdomen to increase in size. A distended abdomen pushes up on the diaphragm, preventing adequate lung inflation. Gastric distention also often causes vomiting. If vomiting occurs, quickly turn the

Gastric distention Inflation of the stomach caused when excessive pressures are used during artificial ventilation and air is directed into the stomach rather than the lungs.

Fig. 8.20 Child one-rescuer CPR Skill Performance Sheet.

WE'RE FIGHTING FOR
YOUR LIFE
**American Heart
Association**

SKILL AND PERFORMANCE SHEET

CHILD ONE-RESCUER CPR

Student Name _____ Date _____

Performance Guidelines	Performed
1. Establish unresponsiveness. If second rescuer is available, have him or her activate the EMS system.	
2. Open airway (head tilt-chin lift or jaw thrust). Check breathing (look, listen, and feel).*	
3. Give two slow breaths (1 to 1½ seconds per breath), if airway is obstructed, reposition head and try to ventilate again. Watch chest rise, allow for exhalation between breaths.	
4. Check carotid pulse. If breathing is absent but pulse is present, provide rescue breathing (1 breath every 3 seconds, about 20 breaths per minute).	
5. If no pulse, give 5 chest compressions (rate 100 compressions per minute), open airway with chin lift, and provide 1 slow breath. Repeat this cycle.	
6. After about 1 minute rescue support, check pulse.* If rescuer is alone, activate the EMS system. If no pulse, continue 5:1 cycles.	

* If victim is breathing or resumes effective breathing, place in recovery position.

Comments _____

Instructor_____

Circle one: Complete Needs more practice

patient to the side, wipe out the mouth with your gloved fingers, and then return the patient to a supine position.

Gastric distention is mentioned here so you will work hard to prevent it. Make sure you have completely opened the airway and you are not blowing excessive amounts of air into the patient. Be especially careful if you are a large person with a large lung capacity and the patient is smaller than you are.

When ventilation becomes very difficult because of gastric distention, you can relieve the gastric distention by turning the patient's entire body to one side and pressing on the upper abdomen. Although this technique usually relieves the distention, it is also likely to make the patient vomit.

Vomiting

Vomiting is common during CPR, so you must be prepared to deal with it. There is not much you can do to prevent vomiting, except to keep air out of the patient's stomach. Vomiting is likely to occur if the patient has suffered cardiac arrest. The patient may have just consumed a large meal. When cardiac arrest occurs, the muscle that keeps food in the stomach relaxes, causing the patient to vomit.

If the patient vomits while you are administering CPR, immediately turn the patient onto his or her side to allow the vomitus to spill out of the mouth. Then clear the patient's mouth of remaining vomitus, first with your fingers and then with a clean cloth (if one is handy).

The patient may experience several rounds of vomiting, so you must be prepared to take these actions repeatedly. EMS units carry a suction machine with which to clear the patient's mouth. You cannot wait for one's arrival, however, because you must not wait to begin or resume CPR.

You must be sure that the patient's airway is clear for three primary reasons:

1. The patient may breathe in (aspirate) the vomitus.
2. You may force vomited material into the lungs with the next artificial ventilation.
3. It takes a strong stomach and the realization that you are saving the patient's life to continue with resuscitation. But you must continue. Remove the vomitus with a towel, the patient's shirt, your fingers, or any other available object. As soon as you have cleared away the vomitus, take a deep breath and continue rescue breathing.

Creating Sufficient Space for CPR

As a first responder, you will frequently find yourself alone with a patient experiencing cardiac arrest. One of the first things you must do is to create or find a space in which to perform CPR. Ask yourself, "Is there enough room in this location to perform CPR?" To perform CPR effectively, you need 3 to 4 feet of space on all sides of the patient. This allows for the change of rescuers, the institution of advanced life support (ALS) procedures, and the entry of the ambulance stretcher.

If there is not enough space around the patient, you have two options:

1. Quickly rearrange the furniture in the room to make space.
2. Quickly drag the patient into an area that has more room, for instance, out of the bathroom and into the living room—not the hallway (Figure 8.21).

Space is essential to a smooth rescue operation following cardiac arrest. It only takes 15 to 30 seconds either to clear a space around the patient or to move the patient into a larger area.

Fig. 8.21 Create sufficient space for CPR.

CPR Training

As a first responder, you should successfully complete a CPR course through a recognized agency such the American Heart Association (AHA), the National Safety Council (NSC), or the American Red Cross (ARC). You should regularly update your skills by successfully completing a recognized recertification course.

Proficiency in CPR cannot be achieved without adequate practice on adult and infant manikins. Your department should schedule periodic reviews of CPR theory and practice for all people who are trained as first responders.

Legal Implications of CPR

Living wills and advance directives are legal documents in which patients request that specified medical procedures not be started on them. These are explained in Chapter 3. First responders sometimes wonder if they should start CPR on a person who has a living will or an advance directive. Because you are not in a position to determine if the living will or advance directive is valid, CPR should be started on all patients unless they are obviously dead. If a patient has a living will or advance directive, the physician at the hospital will determine whether or not to stop CPR. You should check your local policies and protocols on this matter.

Do not hesitate to begin CPR on a pulseless, nonbreathing patient. Without your help, the patient will certainly die. You may have legal problems if you begin CPR on a patient who does not need it if this action harms the patient. However, the chances of this happening are minimal if you assess the patient carefully before beginning CPR.

Another potential legal pitfall is abandonment—the discontinuing of CPR without the order of a licensed physician or without turning the patient over to someone who is at least as qualified as you are.

If you avoid these pitfalls, you need not be overly concerned about the legal implications of performing CPR. Your most important protection against possible legal suit is to become thoroughly proficient in the theory and practice of CPR.

CHAPTER REVIEW 8

Summary

CPR is one of the most important lifesaving skills that you will learn as a first responder. By combining the airway skills and the breathing skills from Chapter 6 with the circulation skills presented in this chapter, you should be able to perform effective CPR. The anatomy and function of the circulatory system was presented to give you a better understanding of the way in which the circulatory system works. The problems that may cause the heart to stop beating were covered.

It is important to understand how a first responder fits into the cardiac chain of survival. The techniques for performing external chest compressions in adults, infants, and children are presented. The steps for one-rescuer and two-rescuer adult CPR are outlined. The steps for infant CPR and child CPR are also described. It is important that you understand the signs of effective CPR so you can evaluate your performance. It is also important that you understand the complications of performing CPR so you can work to prevent these from occurring. This chapter describes why you should be certified in CPR. Finally legal implications of CPR are discussed.

Once you have mastered CPR skills by practicing on a manikin under the watchful eye of a good instructor, you can keep those skills by practicing and refreshing your knowledge periodically. Practice as though a life depended on it, because one day it will!

Key Terms

Brachial pulse—page 208

Cardiac arrest—page 194

Chest compression—page 197

Child—page 208

Circulatory system—page 192

Gastric distention—page 211

Infant—page 207

One-person CPR—page 199

Plasma—page 193

Platelets—page 193

Pulse—page 193

Two-person CPR—page 202

Ventilation—page 201

Xiphoid process—page 197

What Would You Do?

1. You are called to a house. When you arrive, an excited babysitter hands you a three-month-old baby. The babysitter is crying and tells you that she thinks the baby has stopped breathing. What would you do?
2. You are called to a church on Sunday morning. When you arrive, an usher leads you to a bathroom where you find an elderly man who has collapsed on the floor. He looks blue and does not respond to your shout. What would you do?

You Should Know

1. The anatomy and function of the circulatory system.
2. The reasons for a heart to stop beating.
3. The components of CPR.
4. The links in the cardiac chain of survival.
5. The conditions under which you should start and stop CPR.
6. The techniques of external chest compressions on an adult, a child, and an infant.
7. The steps of one-rescuer adult CPR.
8. The steps of two-rescuer adult CPR.
9. How to switch rescuers.
10. The steps of infant and child CPR.
11. The signs of effective CPR.
12. The complications of performing CPR.
13. The importance of creating sufficient space for CPR.
14. The importance of CPR training.
15. The legal implications related to CPR.

You Should Practice

1. Performing one-rescuer adult CPR.
2. Performing two-rescuer adult CPR.
3. Performing infant CPR.
4. Performing child CPR.

1.

2.

3.

4.

1. Neck or carotid pulse
2. Femoral pulse
3. Radial pulse
4. Brachial pulse

SKILL SCAN: The Sequence of Steps for One-Rescuer Adult CPR

1.

1. Establish responsiveness.
2. Open the airway.
3. Check for breathing.
4. Perform rescue breathing.
5. Check the carotid pulse.
6. Perform chest compressions.

2.

3.

4.

5.

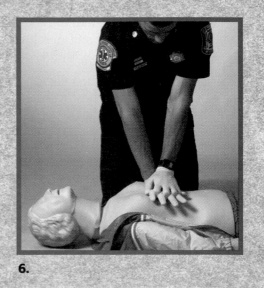

6.

1. Before attempting to resuscitate a patient by performing CPR, you should make sure the following condition exists:
 a. Shallow breathing
 b. Dilated pupils
 c. Absence of breathing and circulation
 d. Shortness of breath

2. Which of the following factors is not a link in the cardiac chain of survival?
 a. Early defibrillation
 b. Rapid transportation
 c. Early CPR
 d. Early advanced care

3. What criteria indicate that CPR should not be started?
 a. Evidence of tissue decomposition
 b. Rigor mortis
 c. Decapitation
 d. Dilated pupils

4. What criteria indicate that CPR should be stopped?
 a. A physician assumes responsibility for the patient.
 b. The patient vomits.
 c. The patient begins breathing and has a pulse.
 d. You are too exhausted to continue.

5. When performing external chest compressions, each compression should be
 a. Followed by a ventilation.
 b. Done quickly.
 c. One-half of each compression downward and one-half upward.
 d. Done with relaxed arms.

6. Match the following items.
 a. Depth of compression on an adult
 b. Depth of compression on an infant
 c. Depth of compression on a child

 1. 1 to 1½ inches
 2. 1½ to 2 inches
 3. ½ to 1 inch

7. Match the following items.
 a. Rate of chest compressions for infant CPR
 b. Rate of chest compressions for one-rescuer adult CPR
 c. Rate of chest compressions for child CPR
 d. Rate of chest compressions for two-rescuer adult CPR

 1. 80–100
 2. 100
 3. at least 100

8. The ratio of compressions to ventilations in one-rescuer adult CPR is
 a. 5:1
 b. 2:15
 c. 1:5
 d. 15:2

9. The ratio of compressions to ventilations in two-rescuer adult CPR is
 a. 5:1
 b. 2:15
 c. 1:5
 d. 15:2

10. In performing infant CPR, each breath should be given over a period of
 a. ½ to 1 second
 b. 1 to 1½ seconds
 c. 1½ to 2 seconds
 d. Until the chest rises

11. Describe how you determine the correct position for doing chest compressions in an infant.

12. You should initially assess the infant's pulse after performing CPR for how long?
 a. 45 seconds
 b. 2 minutes
 c. 1 minute
 d. 90 seconds

Answers: 1. c. **2.** b. **3.** a, b, c. **4.** a, c. **5.** a. **6.** a=2, b=3, c=1. **7.** a=3, b=1, c=2, d=1. **8.** d. **9.** a. **10.** b. **11.** Draw an imaginary line between the infant's nipples. Place your index finger below the imaginary line in the middle of the sternum. Place your middle and ring fingers next to your index finger. Use your middle and ring fingers to compress the sternum ½ to 1 inch. **12.** c.

13. In one-rescuer child CPR, the ratio of chest compressions to ventilations is
 a. 15:2
 b. 2:15
 c. 5:1
 d. 1:5

14. List five signs of effective CPR.
15. Describe three complications of proper CPR.

13. c. **14.** 1. A second rescuer feels a pulse while you are compressing the chest. 2. The patient's pupils constrict when exposed to light. 3. The patient's skin color improves. 4. Independent breathing begins. 5. An independent heartbeat begins. **15.** 1. Gastric distention; 2. Broken bones; 3. Vomiting.

5

ILLNESS AND INJURY

Patients who require emergency medical services can be divided into two types: those who suffer from medical conditions and those who suffer from trauma. Medical conditions refer to various types of illness. Some illnesses occur suddenly; other conditions are present for a long time, suddenly get worse, and require emergency medical care. The five chapters in this module contain information that you will use on many of your emergency calls as a first responder. Chapter 9 covers the assessment and treatment of medical conditions. Chapter 10 covers medical conditions related to poisoning. Chapter 11 covers behavioral emergencies and crisis intervention. Almost every emergency call you handle as a first responder results in stress and crisis for the patient and the patient's family and friends. Having some special knowledge about how to handle calls that involve crises and behavioral emergencies will be beneficial to you.

Trauma, the second type of emergency, is caused by an injury. Injuries can range from minor to life threatening. Chapters 12 and 13 cover conditions caused by trauma.

C H A P T E R
9

MEDICAL EMERGENCIES

Knowledge and Attitude Objectives *After studying this chapter, you will be expected to:*

1. Describe the general approach to a medical patient.
2. Explain the causes, symptoms, and treatment of a patient with altered mental status.
3. Explain the causes, symptoms, and treatment of a patient with seizures.
4. Describe the treatment of a patient showing signs and symptoms of exposure to heat.
5. Describe the treatment of a patient showing signs and symptoms of exposure to cold.

Note: These objectives contain supplemental material.

6. Explain the causes of angina pectoris.
7. Describe the signs, symptoms, and initial treatment of a patient with angina pectoris.
8. Explain the major cause of a heart attack.
9. Describe the signs, symptoms, and initial treatment of a patient with a heart attack.
10. Explain the cause of congestive heart failure.
11. Describe the signs, symptoms, and initial treatment of a patient with congestive heart failure.
12. Describe the causes of dyspnea.
13. Explain the signs, symptoms, and initial treatment of a patient with dyspnea.
14. Describe the major cause of a stroke.
15. Explain the signs, symptoms, and initial treatment of a patient with a stroke.
16. Describe the signs and symptoms of insulin shock.
17. Describe the initial treatment of a patient in insulin shock.
18. Describe the signs and symptoms of a patient in a diabetic coma.
19. Describe the initial treatment of a patient in a diabetic coma.

Skill Objectives *As a first responder, you should be able to:*

1. Perform a patient assessment on a medical patient.
2. Place an unconscious patient in the recovery position.
3. Prevent a patient who is seizing from further harm.
4. Cool a patient who has suffered exposure to heat.
5. Treat a patient who has suffered exposure to cold.
6. Position a patient who has congestive heart failure.
7. Administer fluids or oral glucose to a patient who is in insulin shock.

This chapter on medical conditions has two parts. The first part covers the general medical complaints you will see, including altered mental status and seizures. General medical complaints may be the result of a wide variety of medical conditions. By studying the first part of the chapter, you will learn the signs, symptoms, and common treatment steps for patients with these general medical complaints.

The second part of this chapter addresses some of the specific medical conditions you will encounter, including generalized heat emergencies, generalized cold emergencies, angina pectoris, heart attack, congestive heart failure, dyspnea, stroke, insulin shock, and diabetic coma. By studying the second part of the chapter, you will learn the signs, symptoms, and treatment of patients with these specific medical conditions. Treating patients with medical conditions can be some of the most challenging work you perform as a first responder. By carefully studying these conditions, you will be prepared to provide reassuring and sometimes lifesaving care to patients suffering from medical emergencies.

General Medical Conditions

Even though they have many different causes, general medical conditions result in similar signs and symptoms. By learning to recognize the signs and symptoms of these conditions and learning to apply the general treatment for them, you will be able to provide immediate care for patients even if you are not able to determine the exact cause of their problems. By providing this initial treatment, you can stabilize the patients and allow other EMS and hospital personnel to diagnose and further treat the patients.

General Approaches to a Medical Patient

Your approach to a patient who has a general medical complaint should follow the systematic approach that you learned in the patient assessment sequence in Chapter 7. Review your dispatch information to give you an idea of the possible problems you may encounter. Carefully overview the scene to assess your safety and that of the patient. As you perform your initial patient assessment, first try to get an impression of the patient's problem. Then proceed with the initial patient assessment by determining the patient's responsiveness, introducing yourself, checking the patient's ABCs, and acknowledging the patient's chief complaint.

Table 9.1: SAMPLE History

S = Signs/symptoms
A = Allergies
M = Medications
P = Pertinent past history
L = Last oral intake
E = Events associated with the illness or injury

With most patients experiencing a medical problem, it is best to collect a medical history before performing a physical examination. The medical history should be complete and include all factors that may relate to the patient's current illness. The SAMPLE history format shown in Table 9.1 will help you secure the information you need.

The physical examination should focus on the areas related to the patient's current illness. Realize that the patient may not always be aware of all facets of his or her problem. Therefore, it is better to perform a complete physical examination and find all the problems than to perform a partial examination and miss the patient's problem. Determine the patient's vital signs and do not forget to perform ongoing assessment if additional EMS personnel are delayed.

As you are performing your patient assessment, remember to reassure the patient. Any call for emergency medical care is a frightening experience for the patient. Many medical conditions are made worse by stress. If you can reduce the patient's stress, you will go a long way toward making the patient more comfortable.

Altered Mental Status

Altered mental status is a sudden or gradual decrease in the patient's level of responsiveness. This change may range from a decrease in the level of understanding to unresponsiveness. Any patient who is unresponsive is suffering a severe change in mental status. In assessing altered mental status, remember the AVPU scale (Table 9.2).

Table 9.2: AVPU Scale

A is for *alert.* An alert patient will answer simple questions accurately and appropriately.

V is for *verbal.* A patient who is responsive to a verbal stimulus will react to loud voices.

P is for *pain.* A patient who is responsive to a painful stimulus will react to the pain by moving or crying out.

U is for *unresponsive.* An unresponsive patient will not respond to a verbal or painful stimulus.

When assessing the patient's mental status, you should consider two factors: the patient's initial level of consciousness and any change in the patient's level of consciousness. A patient who is initially alert and who then becomes responsive only to verbal stimuli has suffered a decrease in level of consciousness.

Many different conditions may cause an altered level of consciousness, including:

- Head injury
- Shock
- Decreased level of oxygen to the brain
- High fever
- Infection
- Poisoning, including drugs and alcohol
- Low blood sugar (diabetic emergencies)
- Insulin reaction
- Psychiatric condition

Sometimes you will not be able to determine what is causing the patient's altered level of consciousness. You will be able to help the patient, however, by treating the symptoms of the problem.

You should complete the patient assessment sequence (Table 9.3) to provide scene safety and assess the patient. Your treatment consists of maintaining the patient's ABCs, maintaining the patient's normal body temperature, and keeping the patient from additional harm. If the patient is unconscious and has not suffered trauma, place the patient in the recovery position or use an airway adjunct to help maintain an open airway. Be prepared to suction if there is a chance that the patient may vomit or not be able to handle secretions. Some of the specific conditions that cause altered mental status are explained in the second part of this chapter.

Table 9.3: Patient Assessment Sequence

1. Scene size-up.
2. Perform an initial assessment.
 a. Form a general impression of the patient.
 b. Assess responsiveness—stabilize the spine if trauma.
 c. Assess the patient's airway.
 d. Assess the patient's breathing.
 e. Assess the patient's circulation.
 f. Update responding EMS units.
3. Examine the patient from head to toe.
4. Obtain the patient's medical history (SAMPLE).
5. Perform an on-going assessment.

Seizures

Seizures are characterized by random shaking movements, which may involve the entire body. Most seizures usually last less than five minutes. Prolonged seizures may continue for over five minutes. While seizures are rarely life-threatening, they are a serious medical emergency and may be the sign of a life-threatening condition. When seizures occur, the patient may need help in maintaining an open airway. Patients are usually unconscious during seizures and do not remember them afterward. They may lose bowel and/or bladder control, soiling their clothing. There are many different types of seizures, and they can be caused by many factors, including:

- Epilepsy
- Trauma
- Head injury
- Stroke
- Shock
- Decreased level of oxygen to the brain
- High fever
- Infection
- Poisoning, including drugs and alcohol
- Brain tumor
- Diabetic emergencies
- Complication of pregnancy
- Unknown causes

- Transportation to an appropriate medical facility
- Prompt transportation to an appropriate medical facility
- Rapid transportation to an appropriate medical facility

Many times you will not be able to determine the cause of the patient's seizure. After a seizure, the patient may be sleepy, confused, upset, hostile, or out of touch with reality for up to an hour. You must monitor the patient's ABCs and arrange for transport to an appropriate medical facility.

Seizures often end before you arrive at the scene. If they have not ended, your treatment during a seizure consists of protecting the patient from injury. **Do not** restrain the patient's movements. If you attempt to, you may cause further injury. If a patient suffers a seizure while on a hard surface, control the patient's arms and head to keep the patient from further harm. The patient should be moved only if he or she is in a dangerous location, such as in a busy street or close to something hard, hot, or sharp.

..

⊽ CAUTION
Do not attempt to put anything in the mouth of a patient who is actively seizing.

..

During a seizure, the patient generally does not breathe and turns blue. You cannot do anything about the patient's airway during the seizure, but once the seizure has stopped, it is essential that you ensure an open airway. This is usually best accomplished with the head-tilt/chin-lift technique.

Observe the seizure activity so you can report your observations and assessment finding to other EMS providers. This may be important in determining the cause of the seizure.

After you have opened the airway, place the patient in the recovery position to help keep the airway open and to allow any secretions (saliva or blood from a bitten tongue) to drain out (Figure 9.1). Patient's who have suffered a seizure may have excess oral secretions.

Most patients start to breathe soon after the seizure has ended. If the patient does not resume breathing after a seizure or if the seizure is prolonged, begin mouth-to-mask or mouth-to-mouth breathing (see Chapter 6).

Most patients are confused after a seizure and may become anxious, hostile, and belligerent. At this point, the patient needs privacy. Because the person is probably embarrassed about what happened and where it happened (perhaps in a public place such as a restaurant or shopping mall), move the patient to a more comfortable, private place if other EMS personnel are delayed. The state of confusion after a seizure may last for 30 to 45 minutes. Do not leave the patient. Every patient who suffers a seizure should be encouraged to go to a medical facility for examination and treatment.

Your treatment for a seizure is to protect the patient from self-injury and, after the seizure is over, to ensure that the airway is open, that the patient is breathing adequately, and that secretions and blood in the mouth have been cleared. (See Table 9.4.)

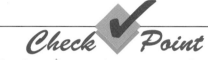

Check ✔ Point

✔ Describe the medical conditions that can cause both altered mental status and seizures.

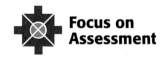

Focus on Assessment

Although there is a strong tendency to quickly categorize patients as "medical patients" or as "trauma patients," it is important to realize that many of the patients you encounter may have a medical condition *and* have suffered trauma, too. For example, a diabetic who is suffering from insulin shock will have an altered level of consciousness, which may have contributed to a motor vehicle accident. As you study this chapter, try to visualize how you can

Fig. 9.1 Position for an unconscious patient.

Table 9.4: Treatment for Seizures

- Stay calm. You cannot stop a seizure once it has started.
- Do not restrain the patient.
- Clear the area of hard, sharp, or hot objects to protect the patient from injury.
- Do not force anything between the patient's teeth.
- Do not be concerned if the patient stops breathing temporarily during the seizure.
- After the seizure, turn the patient on his or her side and make sure breathing is not obstructed.
- If the patient does not begin breathing after a seizure, start rescue breathing.

use this knowledge to treat patients with a single problem or to treat patients with a variety of problems. Remember to carefully assess the patient and treat the problems that you identify.

Specific Medical Conditions

In the first part of this chapter, you learned how to assess general medical complaints and treat patients based on their signs and symptoms. This should be the beginning basis for your assessment and treatment of patients who present with medical conditions. It is, however, helpful to learn more about some of the more specific medical conditions you are likely to encounter as a first responder. This second part of the chapter covers some of those conditions.

Sometimes the patient or the patient's family will tell you that the patient has a certain medical condition; other times your careful assessment of the patient will reveal information that leads you to suspect a particular condition, and by this determination, you may be able to take more specific steps to help the patient. The added knowledge you gain from the second part of this chapter will help you assess, treat, and communicate more effectively with patients who have medical conditions.

Exposure to Heat and Cold

As a first responder, you will encounter patients who have been exposed to heat and to cold. When assessing these patients, you should follow the steps of the patient assessment sequence. The signs and symptoms the patient exhibits will guide you in your treatment. To help you recognize and treat these patients, the signs, symptoms, and treatment for **heat exhaustion, heatstroke, frostbite,** and **hypothermia** are presented.

Heat Exhaustion

Heat exhaustion may be seen in exposures to temperatures above 80°F (26°C), usually in combination with high humidity. A person suffering from heat exhaustion sweats profusely and becomes lightheaded, dizzy, and nauseated.

Predisposing factors may make people more susceptible to heat-related illnesses. High ambient temperatures reduce the ability of the body to lose

Heat exhaustion A form of shock that occurs when the body loses too much water and too many electrolytes through very heavy sweating after exposure to heat.

Heatstroke A condition of rapidly rising internal body temperature that occurs when the body's mechanisms for the release of heat are overwhelmed. Untreated heatstroke can result in death.

Frostbite Partial or complete freezing of the skin and deeper tissues caused by exposure to the cold.

Hypothermia A condition in which the internal body temperature falls below 95°F after prolonged exposure to cool or freezing temperatures.

heat by radiation. High humidity reduces the ability of the body to lose heat through evaporation. Exercise results in greater loss of sweat. Very young and old people are more prone to suffer from heat-related conditions. Pre-existing medical conditions and certain medications may make people more likely to suffer from heat-related illness.

The patient's blood pressure drops (causing a weak pulse), and the patient frequently complains of feeling weak. Body temperature is usually normal. The signs and symptoms of heat exhaustion (Figure 9.2) are similar to the early signs of shock, and its treatment is similar as well.

To treat heat exhaustion, move the patient to a cooler place (for example, from a baseball diamond to a shady spot under a tree). If the patient is conscious, give fluids by mouth to replace the fluids lost through sweating. Drinking cool water is excellent treatment for cases of heat exhaustion. Monitor the ABCs and arrange for transport to a medical facility. As with other patients, complete a scene size-up and then an initial patient assessment.

Patients experiencing heat exhaustion sweat heavily and are in mild shock from fluid loss. Treat for shock. Encourage the patient to drink fluids unless the patient is nauseated or vomiting.

Heatstroke

Heatstroke results when a person has been in a hot environment for a long period of time, overwhelming the body's sweating mechanism. The patient's body temperature rises until it reaches a level at which brain damage occurs. If not treated, a patient with heatstroke will die.

The patient usually has hot, flushed dry skin. The skin feels hot to the touch. A person who is suffering from heatstroke may be semiconscious, and unconsciousness may develop rapidly (Figure 9.3). Such patients may have temperatures as high as 106°F (41.1°C).

Remember: Heatstroke is an emergency that requires immediate action!

Maintain the patient's ABCs. Remove the patient from the heat and into a cool place as soon as possible.

Remember: Body temperature must be lowered quickly!

Soak the patient with water (Figure 9.4). Remember that most fire trucks have water available in booster tanks. The patient should be undressed down to his or her underwear. If the patient is conscious, administer a drink of cold

- Transportation to an appropriate medical facility
- Prompt transportation to an appropriate medical facility
- Rapid transportation to an appropriate medical facility

Focus on Assessment

SIGNS and SYMPTOMS

1. *Light-headedness*
2. *Dizziness*
3. *Weak pulse*
4. *Profuse sweating*
5. *Nausea*

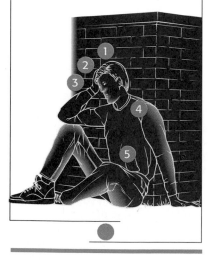

Fig. 9.2 Signs and symptoms of heat exhaustion.

Table 9.5: Comparing Heat Exhaustion and Heatstroke

Heat Exhaustion	Heatstroke
Normal body temperature	High body temperature
Sweating	Dry skin (usually)
Cool and clammy skin	Hot and red skin
Dizziness and nausea	Semiconscious (or unconscious)

water quickly. Arrange for rapid transport to an appropriate medical facility for further treatment. The signs and symptoms of heat exhaustion and heatstroke are compared in Table 9.5.

Frostbite

Frostbite can result when exposed parts of the body are in a cold environment. It can occur outdoors in the winter or even in a walk-in food freezer or cold-storage warehouse in the middle of the summer. Exposed body parts actually freeze. The body parts most susceptible to frostbite are the face, ears, fingers, and toes. Depending on the temperature and wind velocity, frostbite can occur in even a short period of time.

Increases in wind speed have the same effect as decreases in temperature. Think about holding your hand outside an automobile traveling at 55 mph on a cold winter day! The combination of wind and low temperature produces a wind chill factor (Figure 9.5). Note in Figure 9.5 that even when the temperature is relatively mild (35°F, or 2°C), an accompanying wind blowing at only 20 mph will produce a wind chill that has the same effect on the body as an actual temperature of 12°F (–11°C). If there is a combination of low temperature and high wind, you must protect yourself and your patient from the dangers of wind chill.

People weakened by old age, exhaustion, or hunger are the most susceptible to frostbite. In superficial frostbite, the part first becomes numb and then acquires a bright red color. Eventually the area loses its color and changes to pale white. There may be a loss of feeling and sensation in the injured area. If the area is re-warmed, the patient may experience a tingling feeling. The frostbitten part must be quickly rewarmed. This can often be easily accomplished by placing the fingers, toes, or ears next to a warm body part. For example, place frostbitten fingers in the armpits. Treat the frostbitten patient for shock. *Do not* rub a frostbitten area in an attempt to rewarm it and never rub snow or ice onto a suspected frostbitten area. Doing so will only make the problem worse.

A frostbitten patient who has been outside for an extended period of time may suffer deep frostbite. In this case, the skin will be white and waxy. The skin may be firm or frozen. Swelling and blisters may be present. If the skin is thawed, the skin may appear flushed with areas of purple and blanching or may be mottled and cyanotic. These patients should be transported to a medical facility for rewarming under carefully controlled conditions. Follow the usual sequence of scene size-up, initial patient assessment, and physical exam. Remove any jewelry the patient is wearing, cover the extremity with dry clothing or dry dressings. Do not break blisters, rub the injured area, apply heat to rewarm, or allow the patient to walk on an affected lower extremity.

- Transportation to an appropriate medical facility
- Prompt transportation to an appropriate medical facility
- Rapid transportation to an appropriate medical facility

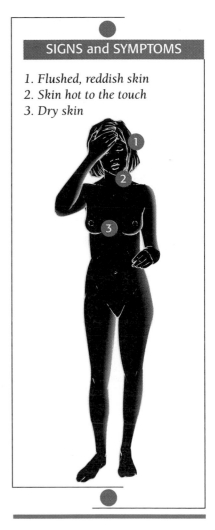

SIGNS and SYMPTOMS

1. *Flushed, reddish skin*
2. *Skin hot to the touch*
3. *Dry skin*

Fig. 9.3 (above) Signs and symptoms of heatstroke.

Fig. 9.4 (left) Cool the patient with water.

SAFETY PRECAUTION
Prevention is the only effective means of combating frostbite. If you are going outside in freezing weather, dress warmly and make sure the vulnerable parts of the body are well covered or protected.

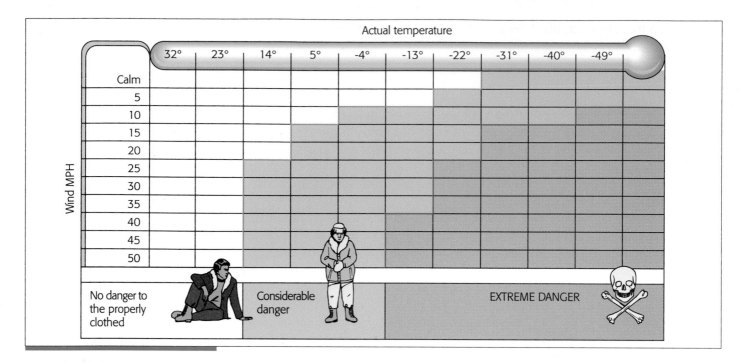

Fig. 9.5 Wind-chill table.

Hypothermia

When the body temperature falls into the subnormal area (below about 95°F), the condition is called hypothermia ("low temperature"). Hypothermia occurs when a person's body is not able to produce enough energy to keep the internal (core) body temperature at a satisfactory level.

Hypothermia is not only a winter problem; it can occur in temperatures as high as 50°F (10°C). People who become cold because of inadequate or wet clothing are susceptible to hypothermia, especially if they are weakened by illness.

The signs of hypothermia include feelings of being cold, shivering, decreasing level of consciousness, and sleepiness. Shivering is the body's way of trying to produce more heat. As hypothermia progresses, shivering stops. A patient who cannot even shiver cools down even faster than before.

Signs of increasing hypothermia include a lack of coordination, mental confusion, and slowed reactions. If the patient is not treated and rewarmed, unconsciousness will result. Unconsciousness occurs when the patient's body temperature goes below about 90°F (32°C). If not reversed by rewarming, the downward spiral continues until death occurs.

If you suspect that a patient is suffering from hypothermia, move the patient to a warm (or warmer) location. Remove wet clothing and place warm blankets over and under the patient. Doing this helps to retain body heat and begins the rewarming process. If the patient is conscious, give warm fluids to drink.

If you are outdoors and cannot easily take the patient inside a building, move the patient into a heated vehicle as soon as possible. If you cannot move the patient to a warmer environment, keep the patient dry and place as many blankets and insulating materials as possible around the patient. Sometimes you can use your own body heat to rewarm the patient. Wrap blankets around yourself and the patient or get into a sleeping bag with the patient to use your body heat to start the rewarming process even during transport.

If the patient's temperature falls even lower (to about 83°F), the heart may stop and you will need to start CPR. Any patient suffering from hypothermia must be examined by a physician.

Cardiac Arrest and Hypothermia

In some cases, hypothermia may protect patients from death. Therefore, always start CPR on hypothermic patients even if you believe they may have been "dead" for several hours. Hypothermic patients should never be considered dead until they have been rewarmed in an appropriate medical facility.

Heart Conditions

The heart must receive a constant supply of oxygen or it will die. Oxygen is delivered to the heart muscle by a complex system of arteries. As long as the coronary arteries (arteries of the heart) continue to supply the heart with an adequate amount of oxygen, the heart can continue to function properly.

As the body ages, however, the coronary arteries may become narrower as a result of a disease process called **atherosclerosis**. Atherosclerosis causes layers of fat to coat the inner walls of the arteries. Progressive atherosclerosis can cause angina pectoris, heart attack, and even **cardiac arrest** (Figure 9.6).

Angina Pectoris

As atherosclerosis progresses, the blood (oxygen) supply to the heart is reduced enough to cause pain or pressure in the chest. The heart simply needs more oxygen than the narrowed coronary arteries can deliver. This pain is known as **angina pectoris,** or simply "angina."

When a patient has chest pain, your first action is to ask the person to describe the pain. Angina is often described as pressure or heavy discomfort.

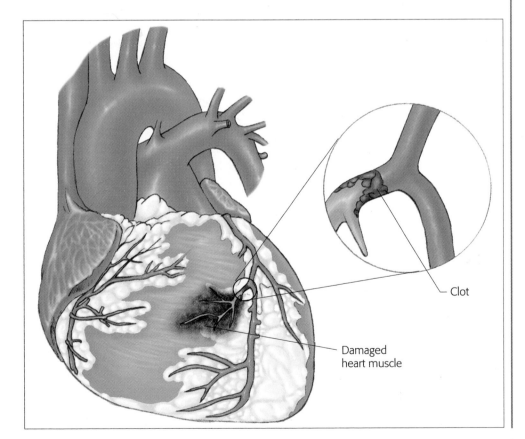

Clot

Damaged heart muscle

Fig. 9.6 Blocked cardiac artery results in heart attack.

Atherosclerosis A disease characterized by a thickening and destruction of the arterial walls and caused by fatty deposits within them; the arteries lose the ability to dilate and carry blood.

Cardiac arrest Sudden cessation of heart function.

Angina pectoris Chest pain with squeezing or tightness in the chest caused by an inadequate flow of blood to the heart muscle.

Fig. 9.7 Nitroglycerin pills and spray used for relief of chest pain.

Nitroglycerin A medicine used to treat angina pectoris; it increases blood flow and oxygen supply to the heart muscle and reduces or eliminates the pain of angina pectoris.

The patient may say something like, "It feels like an elephant is sitting on my chest." Angina attacks are usually brought on by exertion, emotion, or eating. Crushing pain may be felt in the chest and may radiate to either or both arms, the neck, jaw, or any combination of these sites. The patient is often short of breath and sweating, is extremely frightened, and has a sense of doom.

Ask whether the patient is already being treated for a diagnosed heart condition. If the patient's answer is "yes," ask the patient if there is a pill or spray he or she can take for angina pain. A patient who has suffered previous bouts of angina usually has medication that can be taken (placed or sprayed under the tongue) to relieve the pain. The most common medication of this type is **nitroglycerin.** Often the patient has already taken a nitroglycerin pill by the time you arrive on the scene (Figure 9.7).

If the patient has nitroglycerin but has not taken it during the past 5 minutes, help place one of the tiny pills under his or her tongue or help the patient to administer the aerosol form of the medication.

Nitroglycerin usually relieves angina pain within 5 minutes. If the pain has not diminished after 5 minutes, help the patient take a second pill. If the pain has not lessened 5 minutes after the patient has taken the second pill, assume that the patient is having a heart attack. You should follow your local protocols regarding the administration of nitroglycerin.

Heart Attack

A heart attack (myocardial infarction) is caused by complete blockage of a coronary artery. Blockage may be caused by severe atherosclerosis or by a blood clot that has broken free somewhere else in the circulatory system and has become lodged in the artery. If one of the coronary arteries becomes blocked, the part of the heart muscle served by that artery is deprived of oxygen and dies.

Blockage of a coronary artery causes the patient to suffer immediate and severe pain. The pain of angina pectoris and heart attack may be similar at first. The pain of a heart attack is not relieved by nitroglycerin pills (Figure 9.8). Most heart attack patients describe the pain as crushing. The pain may radiate from the chest to the left arm or to the jaw. The patient is usually short of breath, weak, sweating, and nauseated, and may vomit. The pain of a heart attack persists, but angina rarely lasts more than 5 minutes.

If the area of heart muscle supplied by the blocked artery is either critical or large, the heart may stop completely. Complete cessation of heartbeat is called cardiac arrest. CPR is your first emergency treatment for cardiac arrest. (See Chapters 6 and 8.)

Remember: The signs of cardiac arrest are:

- Unconsciousness
- Absence of respirations
- Absence of carotid pulse

Most heart attack patients do not experience immediate cardiac arrest. To support the patient and reduce the probability of cardiac arrest, you can take the following actions:

- Summon additional help.
- Talk to the patient to relieve his or her anxiety.
- Touch the patient to establish a bond. Hold the person's hand.

- Reassure the patient that you are there to help. The person is afraid that death is close, and fear can create tension and make the pain worse.

- Move the patient as little as possible and do not allow the person to move! If the patient must be moved, you and other bystanders must move the patient.

- Place the patient in the position he or she finds most comfortable. This is usually a semireclining or sitting position.

- If oxygen is available and you are trained to use it, administer it to the patient. Supplemental oxygen increases the amount of oxygen the blood can carry. The increase in oxygen reduces pain and anxiety. It also eases the minds of the patient's family and friends to see that something is being done to relieve the patient's physical distress.

Since you do not have extensive equipment available to help the heart attack patient, your primary role is to provide psychological support and arrange for prompt transportation to an appropriate medical facility. Because the patient's emotional state can affect his or her physical condition, psychological support is valuable. It can prevent cardiac arrest.

DID YOU KNOW ?

▶ In the last few years, great advances have been made in the treatment of patients who have suffered heart attacks caused by blocked coronary arteries. Thirty years ago, most patients who suffered heart attacks were treated only with medicines that kept their hearts from going into an irregular rhythm. Their damaged heart muscle was left to heal as well as it could without further help. About fifteen years ago, it became more common for a heart attack patient to undergo a cardiac bypass, in which surgeons replaced blocked coronary arteries with blood vessels taken from the patient's leg. This operation helped to reduce the damage to patients' hearts and allowed many patients to resume a more active lifestyle.

 Within the last ten years, a further advance in treating patient with heart attacks has been the use of "clot busting" drugs. To be effective, these drugs must be administered by a specially trained physician within a few hours of the heart attack. Clot buster drugs can often open the blocked coronary vessels and prevent the need for costly and painful operations. Because clot busters must be administered within a few hours of the beginning of a heart attack, your prompt response and thoughtful care of a heart attack patient may be the first step in returning that patient to a comfortable, healthy, and productive life.

Congestive Heart Failure

Congestive heart failure (CHF) is not directly caused by narrowing or blockage of the coronary arteries, but by failure of the heart to pump adequately.

 As explained in Chapters 4 and 8, the heart has two sides. The right side receives "used" blood from the body and sends it to the lungs; the left side receives oxygenated blood from the lungs and pumps it to the body. If one side of the heart becomes weak and cannot pump as well as the other side, the circulatory system becomes unbalanced, resulting in circulatory congestion. In CHF, the failure is in the heart muscle, but the congestion is in the blood vessels.

 Figure 9.9 shows what happens if CHF occurs on the left side of the heart, which sends blood to the body. More blood is sent to the lungs than to the body. This results in congestion (overload) in the blood vessels of the lungs.

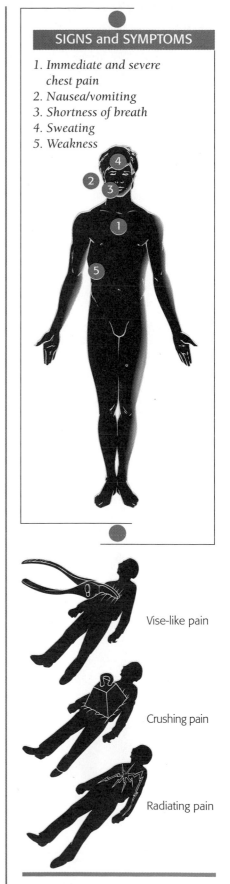

SIGNS and SYMPTOMS

1. *Immediate and severe chest pain*
2. *Nausea/vomiting*
3. *Shortness of breath*
4. *Sweating*
5. *Weakness*

Vise-like pain

Crushing pain

Radiating pain

Fig. 9.8 Signs and symptoms of heart attack (top). Descriptions of pain caused by heart attack (bottom).

Fig. 9.9 Normal exchange of oxygen and carbon dioxide between a capillary and an alveolus(left). Pulmonary edema (right). Congestive heart failure causes fluid to leak from the capillary and build up in the alveolus, impeding oxygen and carbon dioxide exchange.

SIGNS and SYMPTOMS

1. *Shortness of breath*
2. *Rapid, shallow breathing*
3. *Moist or gurgling respirations*
4. *Profuse sweating*
5. *Enlarged neck veins*
6. *Swollen ankles*
7. *Anxiety*

Fig. 9.10 Signs and symptoms of congestive heart failure.

The major symptom of CHF is breathing difficulty, not chest pain. If you are called to assist a patient who has respiratory problems but no signs of injury or airway obstruction are present, look for the signs and symptoms of CHF (Figure 9.10), which include:

- Shortness of breath
- Rapid, shallow breathing
- Moist or gurgling respirations
- Profuse sweating
- Enlarged neck veins
- Swollen ankles
- Anxiety

As blood pressure builds in the vessels of the lungs, fluid is forced into lung tissue, causing it to swell. The patient may make a gurgling sound when breathing and start spitting up a white or pink froth or foamy fluid. At this point, the patient is actually "drowning" in his or her own body fluids. The patient is very anxious but is usually in little or no pain (unless he or she is suffering a heart attack coupled with CHF).

As soon as you determine that the patient is suffering from CHF, take these simple, lifesaving actions:

1. Place the patient in a sitting position, preferably on a bed or chair. Having the legs hang down over the edge of the bed or chair helps drain some

of the fluid back into the lower parts of the body and may improve breathing.

2. Administer oxygen, if it is available and you are trained to give it, in large quantities and at a high flow rate.
3. Summon additional help.
4. Arrange for prompt transportation to an appropriate medical facility.

The most important action is to place the patient in a sitting position with the legs down. This position helps relieve CHF symptoms until more highly trained EMS personnel arrive.

The major symptom of heart attack is chest pain; the major symptom of CHF is difficulty breathing.

Dyspnea (Shortness of Breath)

Dyspnea means shortness of breath or difficulty breathing. Although shortness of breath can occur in healthy people during intense physical exertion or at high altitudes, it is usually associated with serious disease of the heart or lungs. Heart-related causes of dyspnea include angina pectoris, heart attack, and CHF. These conditions have already been discussed. Pulmonary (lung) diseases such as **chronic obstructive lung disease (COLD)**, emphysema, chronic **bronchitis,** and pneumonia can also cause dyspnea. Chronic obstructive lung disease and emphysema are caused by damage to the small air sacs (alveoli) in the lungs. This damage results in a decrease in the amount of working lung capacity, causing the patient to be short of breath. Chronic bronchitis is caused by an inflammation of the airways in the lungs. Pneumonia is caused by an infection in the lungs.

As a first responder, you will not always be able to determine what is causing a patient to be short of breath. Do not spend too much time trying to determine the specific cause. Treat the symptoms of dyspnea. Your treatment for these patients will be based on the fact that they display dyspnea. General treatment for these patients consists of the following steps:

1. Check the patient's airway to be sure it is not obstructed.
2. Check the rate and depth of the patient's breathing. If the rate is below 8 breaths per minute or above 40 breaths per minute, be prepared to assist with mouth-to-mask or mouth-to-barrier-device rescue breathing.
3. Place the patient in a comfortable position. A conscious patient is usually most comfortable when sitting.
4. Provide reassurance.
5. Loosen any tight clothing.
6. Administer oxygen, if it is available and you are trained to do so.

- Transportation to an appropriate medical facility
- Prompt transportation to an appropriate medical facility
- Rapid transportation to an appropriate medical facility

Focus on Assessment

Dyspnea Difficulty or pain with breathing.

Chronic obstructive lung disease (COLD) A slow process of destruction of the airways, alveoli, and pulmonary blood vessels caused by chronic bronchial obstruction (emphysema). This condition is also known as chronic obstructive pulmonary disease (COPD).

Bronchitis Inflammation of the airways in the lungs.

⚠ CAUTION

Some patients with chronic obstructive lung (pulmonary) disease or emphysema actually stop breathing when given oxygen. Great care must be taken when giving oxygen to these patients. Special knowledge, training, and equipment are required.

Cerebrovascular accident (CVA)
A stroke; a sudden lessening or loss of consciousness, sensation, and voluntary movement caused by rupture or obstruction of an artery in the brain.

Diabetes A disease in which the body is unable to use sugar normally because of a deficiency or total lack of insulin; often called "sugar diabetes."

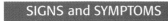

SIGNS and SYMPTOMS

1. *Headache*
2. *Numbness or paralysis on one side of the body*
3. *Dizziness*
4. *Confusion*
5. *Drooling*
6. *Inability to speak*
7. *Difficulty seeing*
8. *Unequal pupil size*
9. *Convulsions*
10. *Respiratory arrest*

Fig. 9.11 Signs and symptoms of stroke.

Stroke

Stroke (**cerebrovascular accident,** or **CVA**) can be caused either by a blood clot that lodges in a vessel, stopping blood supply to a portion of the brain, or by the rupture of a blood vessel in the brain.

The blood vessel rupture may be a result of weakness in the vessel or high blood pressure "blowing out" the vessel. Whether caused by blockage or rupture of a blood vessel, stroke deprives a portion of the brain of an adequate supply of blood and oxygen.

Although they vary depending on which portion of the brain is affected, the signs and symptoms of stroke (Figure 9.11) include:

- Headache
- Numbness or paralysis on one side of the body
- Dizziness
- Confusion
- Drooling
- Inability to speak
- Difficulty seeing
- Unequal pupil size
- Unconsciousness
- Convulsions
- Respiratory arrest
- Incontinence

A stroke patient may be conscious or unconscious and may or may not be able to speak. The patient may have a headache or suffer seizures. Your treatment of the stroke patient depends on the symptoms you encounter.

Your first priority is to maintain an open airway. Administer oxygen (if available and you are trained to use it) at moderate flow rates. If the patient is having convulsions, try to prevent further injury from occurring but do not completely restrain the patient during the seizure.

If you must move a patient who is suffering from paralysis or numbness, do so very carefully. A person who has numbness or paralysis may have another injury that he or she cannot feel. Examine the patient carefully during your patient assessment to locate any suspected fractures or other injuries that may have resulted from the stroke.

Remember: A stroke patient may be able to hear what you are saying even if he or she cannot speak or appears to be unconscious. Do not say anything that would increase the patient's anxiety.

Other than airway maintenance and administration of oxygen (if available), your treatment should consist of giving psychological support by talking to and touching the patient, and preventing further injury from occurring.

If a patient's throat muscles are paralyzed, the patient may not be able to swallow. Place an unconscious person in the recovery position to help keep the airway open and to allow any secretions to drain from the mouth (Figure 9.12).

In cases of severe stroke, the patient may stop breathing. If this occurs, begin rescue breathing or full CPR, if necessary. Any patient you think has suffered a stroke should be transported by ambulance to a medical facility for treatment.

Fig. 9.12 Recovery position for the unconscious patient.

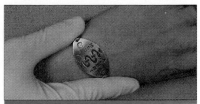

Fig. 9.13 Medic-Alert tag.

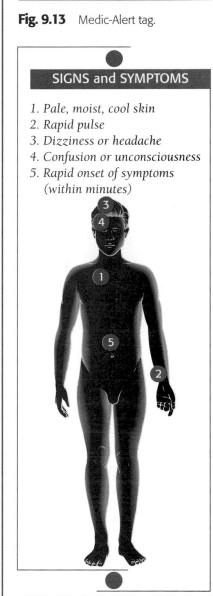

SIGNS and SYMPTOMS

1. *Pale, moist, cool skin*
2. *Rapid pulse*
3. *Dizziness or headache*
4. *Confusion or unconsciousness*
5. *Rapid onset of symptoms (within minutes)*

Fig. 9.14 Signs and symptoms of insulin shock.

Insulin shock Condition that occurs in a diabetic who has taken too much insulin or has not eaten enough food. (Also referred to as a low blood sugar reaction or just "a reaction.")

Diabetic coma A state of unconsciousness that occurs when the body has too much sugar and not enough insulin.

Diabetes

Diabetes is caused by the body's inability to process and use the type of sugar that is carried by the bloodstream to the body's cells.

Sugar is an essential nutrient. The cells of the body need both oxygen and sugar to survive. The body produces a hormone (chemical) called insulin, which enables sugar carried by the blood to move into individual cells, where it is used as fuel.

If the body does not produce enough insulin, body cells become "starved" for sugar. This condition is called diabetes. Many diabetics (people with diabetes) must take supplemental insulin, by injection, to bring insulin levels up to normal. Mild diabetes can sometimes be treated by oral medicine rather than insulin.

Diabetes is a serious medical condition. Therefore, all diabetic patients who are sick must be evaluated and treated in an appropriate medical facility. Two specific things can go wrong in the management of diabetes: **insulin shock** and **diabetic coma.** Both are medical emergencies that you must deal with as a first responder.

Insulin Shock

Insulin shock occurs if the body has enough insulin but not enough blood sugar. A diabetic may take insulin in the morning and then alter his or her usual routine by not eating or by exercising vigorously. In either case, the level of blood sugar drops and the patient suffers insulin shock.

The signs and symptoms of insulin shock are similar to those of other types of shock. Suspect insulin shock if a patient has a history of diabetes or is carrying medical emergency information, such as a Medic-Alert tag (Figure 9.13). Symptoms of insulin shock (Figure 9.14) include:

- Pale, moist, cool skin
- Rapid pulse
- Dizziness or headache
- Confusion or unconsciousness
- Rapid onset of symptoms (within minutes)

1. *History of diabetes—talk or listen*
2. *Warm, dry skin*
3. *Rapid, weak pulse, (radial) arm*
4. *Deep rapid breathing*
5. *Fruity odor on breath*
6. *Slow onset of symptoms*

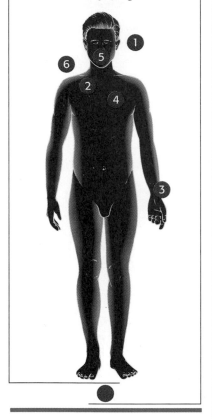

Fig. 9.15 Signs and symptoms of diabetic coma.

Fig. 9.16 Instant glucose provides high concentrations of sugar.

SPECIAL NEEDS

Look for a Medic-Alert tag that identifies the patient as a diabetic!

During your initial examination of every patient, look for an emergency medical alerting device to find out whether the patient has a preexisting medical condition.

A person experiencing insulin shock may appear to be drunk. You must keep this fact in mind. Mistakes have been and will continue to be made by first responders and others misinterpreting insulin shock as intoxication.

Insulin shock is a serious medical emergency. If insulin shock is not diagnosed and corrected by the administration of sugar in some form, the patient may die. Insulin shock can occur quickly, within a few minutes.

If you suspect that a patient is suffering from insulin shock, try to get answers to the following questions:

- Are you a diabetic?
- Did you take your insulin today?
- Have you eaten today?

If the patient is diabetic, has taken insulin that day, but has not eaten, you should suspect that the patient is going into insulin shock.

If the patient is partly conscious, attempt to get some sugar into the patient's mouth. This is best done by helping the patient to drink something that contains a high concentration of sugar such as a cola drink, orange juice, or honey. Some first responders carry a tube of oral glucose which can be placed inside the cheek. This can be administered to unconscious patients and may be effective in providing the patient with the needed glucose. (Figure 9.15.)

Remember: Be sure that a drink you provide a person suffering from insulin shock is not "sugar free."

The amount of sugar absorbed by the body as a result of your efforts is often small, but it may be enough to prolong consciousness until the patient receives further medical treatment.

If the patient is unconscious, do not try to administer fluids by mouth because the patient may choke and aspirate the fluid into the lungs. Summon help immediately. Open the patient's airway and assist breathing and circulation, if necessary. The patient must have sugar administered intravenously as soon as possible. This can be done by a paramedic or a physician.

Diabetic Coma

Diabetic coma occurs when the body has too much blood sugar and not enough insulin. A person with diabetes may fail to take insulin for several days. Blood sugar builds to higher and higher levels, but there is no insulin to process it for use by body cells. The signs and symptoms of diabetic coma include (Figure 9.16):

- History of diabetes
- Warm, dry skin
- Rapid, weak pulse
- Deep, rapid breathing

Table 9.6: Comparing Insulin Shock and Diabetic Coma

Insulin Shock	Diabetic Coma
Pale, moist, cool skin	Warm, dry skin
Rapid, weak pulse	Rapid pulse
Normal breathing	Deep, rapid breathing
Dizziness or headache	–
Confusion or unconsciousness	Unresponsiveness or unconsciousness
Rapid onset of symptoms (minutes)	Slow onset of symptoms (days)

- Fruity odor on the patient's breath
- Slow onset of symptoms (days)

The patient may be unresponsive or unconscious. A patient suffering from diabetic coma may appear to have the flu (influenza) or a severe cold. As with insulin shock, misdiagnosis is common. It is not always easy to tell the difference between insulin shock and diabetic coma (Table 9.6).

If the patient is conscious or partly conscious, if you cannot get definite answers to your questions, or if you are not sure whether the patient is suffering from insulin shock or diabetic coma, you can do no harm by administering a liquid sugar substance. Sugar may improve the condition of a patient suffering from insulin shock. If instead the patient is going into diabetic coma, the amount of sugar ingested will not raise blood sugar levels enough to do further harm.

Remember: Progression into insulin shock is rapid and may be fatal; progression into diabetic coma usually takes several days.

Give conscious diabetic patients sugar by mouth and arrange for prompt transport to an appropriate medical facility. Your treatment for unconscious diabetic patients consists of arranging for prompt transport to an appropriate medical facility and administration of oral glucose only if approved by your medical director. Every sick diabetic patient must be transported by ambulance to an appropriate medical facility for further treatment and examination.

- Transportation to an appropriate medical facility
- Prompt transportation to an appropriate medical facility
- Rapid transportation to an appropriate medical facility

Check ✔ *Point*

✔ Compare the treatment for insulin shock and diabetic coma.

CHAPTER
REVIEW 9

Summary

This chapter discusses some of the more common medical problems that you will encounter as a first responder. The first part of this chapter covers general medical conditions. These conditions, altered mental status and seizures, can be caused by a variety of problems. When you encounter general medical conditions, it is not necessary to determine their cause. Your treatment is based on the symptoms the patient displays.

The second part of this chapter covers more specific medical conditions. By learning something about the causes and knowing the signs and symptoms of these conditions, you can sometimes provide more specific care for the patient. Although these conditions must be diagnosed and treated by a physician, you can greatly improve the patient's chances of survival by taking the simple actions described here until more highly trained EMS personnel arrive on the scene to assist you.

Key Terms

Angina pectoris—page 235

Atherosclerosis—page 235

Bronchitis—page 239

Cardiac arrest—page 235

Cerebrovascular accident (CVA)—page 240

Chronic obstructive lung disease (COLD)—page 239

Diabetes—page 240

Diabetic coma—page 241

Dyspnea—page 239

Frostbite—page 231

Heat exhaustion—page 231

Heatstroke—page 231

Hypothermia—page 231

Insulin shock—page 241

Nitroglycerin—page 236

? What Would You Do?

1. You are dispatched to a residence where a man tells you he has not been able to wake his 39-year-old wife. What would you do?
2. You are dispatched to the local supermarket, where you find a 25-year-old man seizing in front of the store. What would you do?
3. You are dispatched to the local bowling center for a report of a 68-year-old man who is complaining of severe pain in his chest and arm. He states that it feels like his chest is in a vise. What would you do?

You Should Know

1. The general approach to a medical patient.
2. The causes, symptoms, and treatment of a patient with altered mental status.
3. The causes, symptoms, and treatment of a patient with seizures.
4. The treatment of a patient showing signs and symptoms of exposure to heat, including heat exhaustion and heatstroke.
5. The treatment of a patient showing signs and symptoms of exposure to cold, including frostbite and hypothermia.
6. The causes of angina pectoris.
7. The signs, symptoms, and initial treatment of a patient with angina pectoris.
8. The major cause of a heart attack.
9. The signs, symptoms, and initial treatment of a patient with a heart attack.
10. The cause of congestive heart failure.
11. The signs, symptoms, and initial treatment of a patient with congestive heart failure.
12. The causes of dyspnea.
13. The signs, symptoms, and initial treatment of a patient with dyspnea.
14. The major cause of a stroke.
15. The signs, symptoms, and initial treatment of a patient with a stroke.
16. The signs and symptoms of insulin shock.
17. The initial treatment of a patient in insulin shock.
18. The signs and symptoms of a patient in a diabetic coma.
19. The initial treatment of a patient in a diabetic coma.

You Should Practice

1. Performing a patient assessment sequence on a medical patient.
2. Placing an unconscious patient in the recovery position.
3. Preventing a patient who is seizing from further harm.
4. Treating a patient who has suffered exposure to heat.
5. Treating a patient who has suffered exposure to cold.
6. Positioning a patient who has congestive heart failure.
7. Administering fluids or oral glucose to a patient who is in insulin shock.

SIGNS and SYMPTOMS

1. Light-headedness
2. Dizziness
3. Weak pulse
4. Profuse sweating
5. Nausea

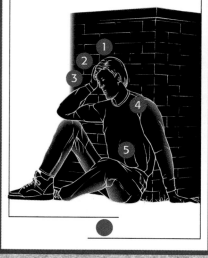

1.

1. Heat exhaustion
2. Heatstroke

SIGNS and SYMPTOMS

1. Flushed, reddish skin
2. Skin hot to the touch
3. Dry skin

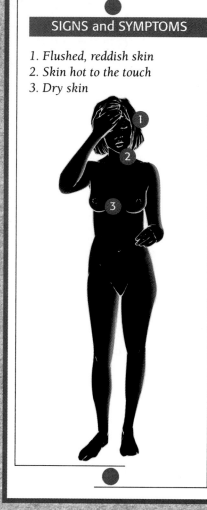

2.

SKILL SCAN: Recognizing the Signs and Symptoms of Heart Conditions and Stroke

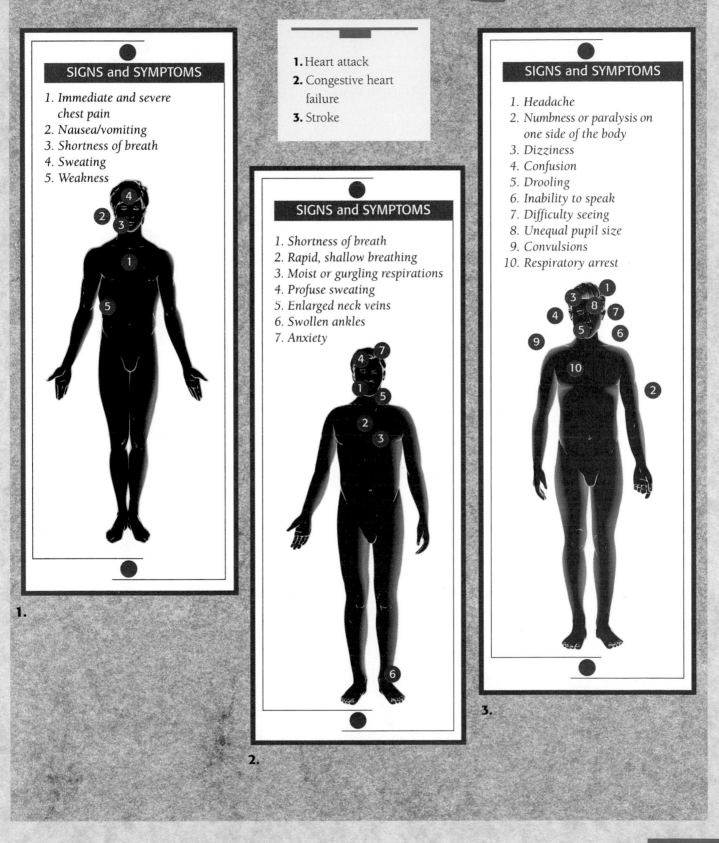

1. Heart attack
2. Congestive heart failure
3. Stroke

SIGNS and SYMPTOMS

1. Immediate and severe chest pain
2. Nausea/vomiting
3. Shortness of breath
4. Sweating
5. Weakness

1.

SIGNS and SYMPTOMS

1. Shortness of breath
2. Rapid, shallow breathing
3. Moist or gurgling respirations
4. Profuse sweating
5. Enlarged neck veins
6. Swollen ankles
7. Anxiety

2.

SIGNS and SYMPTOMS

1. Headache
2. Numbness or paralysis on one side of the body
3. Dizziness
4. Confusion
5. Drooling
6. Inability to speak
7. Difficulty seeing
8. Unequal pupil size
9. Convulsions
10. Respiratory arrest

3.

SIGNS and SYMPTOMS

1. *Pale, moist, cool skin*
2. *Rapid pulse*
3. *Dizziness or headache*
4. *Confusion or unconsciousness*
5. *Rapid onset of symptoms (within minutes)*

1. Insulin shock
2. Diabetic coma

SIGNS and SYMPTOMS

1. *History of diabetes— talk or listen*
2. *Warm, dry skin*
3. *Rapid, weak pulse, (radial) arm*
4. *Deep rapid breathing*
5. *Fruity odor on breath*
6. *Slow onset of symptoms*

1.

2.

NOTES

CHAPTER
10

MEDICAL EMERGENCIES— POISONING

Knowledge and Attitude Objectives *After studying this chapter, you will be expected to:*

1. Understand what a poison is.
2. Describe the signs and symptoms of ingested poisons.
3. Describe how to treat a patient who has been poisoned by ingestion.
4. Describe the signs and symptoms of inhaled poisons.
5. Describe how to treat a patient who has been poisoned by inhalation.
6. Describe the signs and symptoms of injected poisons.
7. Describe how to treat a patient who has been poisoned by injection.
8. Describe the signs and symptoms of absorbed poisons.
9. Describe how to treat a patient who has been poisoned by absorption.
10. Describe the signs and symptoms of drug overdose caused by uppers, downers, and hallucinogens.
11. Describe the general treatment for a patient who has suffered a drug overdose.

Skill Objectives *As a first responder, you should be able to:*

1. Use water to flush a patient who has come in contact with liquid poison.
2. Brush a dry chemical off the patient and then flush with water.

| All material in this chapter is supplemental to the DOT curriculum.

A poison is a substance that causes illness or death when eaten, drunk, injected, or absorbed in relatively small quantities. This chapter covers signs, symptoms, emergency care, and treatment of patients suffering from accidental or intentional poisoning, bites, stings, or alcohol or substance abuse.

Poisoning can be classified according to the means by which the poison enters the body. Poisons can be ingested (taken by mouth), injected (by bees, wasps, other poisonous insects, snakes, and hypodermic needles), inhaled (breathed in), and absorbed through the skin. Typical sources of poison are shown in Figure 10.1. Your early recognition and prompt treatment of a serious poisoning can save a patient's life.

General Considerations

As a first responder, you need to be a good detective when dealing with patients who have come in contact with **poisons**. Poisons can enter the body by four primary routes:

- *Ingestion* occurs when a poison enters the body through the mouth and is absorbed by the digestive system.
- *Inhalation* occurs when a poison enters the body through the mouth or nose and is absorbed by the mucous membranes lining the respiratory system.
- *Injection* occurs when a poison enters the body through a small opening in the skin. This poison may be spread by the circulatory system. Injection can occur as a result of an insect sting or a snake bite, or it can occur as a result of a person intentionally using a hypodermic needle to inject a poisonous substance into the body.
- *Absorption* occurs when a poison enters the body through intact skin. This poison may also be spread by the circulatory system.

Fig. 10.1 Sources of poisons.

Poison Any substance that may cause injury or death if relatively small amounts are ingested, inhaled, or absorbed, or applied to, injected into, or developed within the body.

SAFETY PRECAUTION
Be especially careful when performing an overview of the scene to determine if it is safe to enter. Be alert for odors. Look for containers close to the patient. If you believe the scene is unsafe, stay a safe distance away and call for specialized assistance.

Even though the routes by which a poison is introduced into the body differ, some of the effects of the poison on the body may be very similar.

The general guidelines for assessing and treating patients who have suffered poisoning consist of thorough assessment following the steps of the patient assessment sequence. If you suspect the patient may have been poisoned, obtain a thorough history from the patient or from bystanders. A good history of the incident will help to guide you in your patient assessment.

Be alert for any visual clues that may indicate the patient has been in contact with a poison. These include traces of the substance on the patient's face and mouth if the person has ingested the substance, traces of the substance on the skin if the patient has absorbed the substance, and respiratory distress if the substance has been inhaled.

Much of the emergency care you give will be based on the symptoms the patient exhibits. A patient with a poisonous substance on the skin needs to have the substance removed. A patient who is showing signs of respiratory distress needs to receive respiratory support. A patient who is exhibiting signs of digestive distress needs to receive support for that problem. Sometimes the

Table 10.1: General Signs and Symptoms of Poisoning

History	History of ingesting, inhaling, injecting, or absorbing a poison
Respiratory	Difficulty breathing or decreased respirations
Digestive	Nausea and vomiting
	Abdominal pain
	Diarrhea
Central Nervous System	Unconsciousness or altered mental status
	Dilation or constriction of the pupils
	Convulsions
Other	Excess salivation
	Sweating
	Cyanosis
	Empty containers

patient's signs and symptoms may be less specific, and you will have to treat the patient according to the general signs and symptoms. The general signs and symptoms of poisoning are listed in Table 10.1.

Ingested Poisons

An ingested poison is taken by mouth. More than 80 percent of all poisoning cases are caused by ingestion. You can identify such poisoning by chemical burns, odors, or stains around the mouth. The person may also be suffering from nausea, vomiting, abdominal pain, or diarrhea. Later symptoms may include abnormal or decreased respirations, unconsciousness, or seizures. See Table 10.2 for signs and symptoms of ingested poisons.

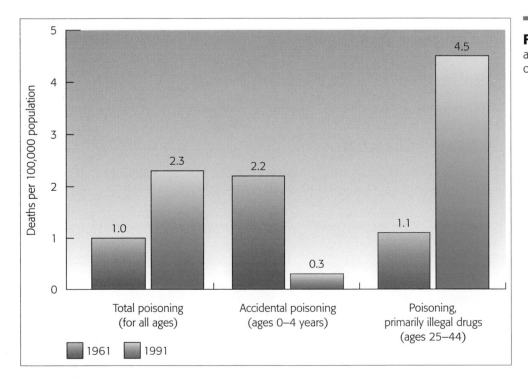

Fig. 10.2 Deaths from poisoning are highest in people 25 to 44 years of age.

Table 10.2: Signs and Symptoms of Ingested Poisons

Unusual breath odors

Discoloration or burning around the mouth

Nausea and vomiting

Abdominal pain

Diarrhea

Any other general signs and symptoms of poisoning listed in Table 10.1

Focus on Treatment

- Transportation to an appropriate medical facility
- **Prompt transportation to an appropriate medical facility**
- Rapid transportation to an appropriate medical facility

Focus on Treatment

To treat a person who has ingested a poison:

- Identify the poison.
- Call the poison control center for instructions and follow their instructions. If you are unable to contact the poison control center, dilute the poison by giving water.
- Arrange for prompt transport to a hospital.

Before treating a person who has ingested a poison, attempt to identify the substance that has been ingested. Question the patient's family or bystanders and look for empty containers such as empty pill bottles that may indicate what the patient has eaten or drunk.

Place an unconscious patient in the recovery position to help keep the airway open and to facilitate the drainage of mucus and vomitus from the mouth and nose (Figure 10.3).

If the transport of the patient will be delayed, contact the poison control center in your community. The poison control center can tell you if any treatment should be started before the patient is transported to the hospital. Post the number of your poison control center in your first responder life support kit (Figure 10.4).

Cases of poisoning by ingestion can be treated by three general means: dilution, activated charcoal, and vomiting.

Dilution

Most poisons can be diluted by giving the patient large quantities of water.

Activated Charcoal

The second means of treating poisonings is the oral administration of activated charcoal (See Figure 10.5). Activated charcoal is a finely ground powder

Fig. 10.3 Position for an unconscious patient.

that is mixed with water to make it easier to take. It works by binding to some poisons, thereby preventing the poison from being absorbed in the patient's digestive tract. It can be administered by having the patient use a straw. This is helpful because the mixture looks like mud.

Some first responder systems may carry activated charcoal to treat poisonings if they are a long distance from the nearest medical facility. You should give activated charcoal only if you are trained in its use and have approval from your medical director or your poison control center. Do not give it if the patient has ingested an **acid** or an alkali, or is unconscious. The usual dose for an adult patient is 25 to 50 grams. The usual dose for a pediatric patient is 12.5 to 25 grams.

Vomiting

The third means of treating poisonings is to induce vomiting. Vomiting may be induced if the person is far from a medical facility, if the poisoning has occurred less than one hour before your arrival, and if the person is totally alert. You should induce vomiting in a patient only if you have been instructed to do so by your medical director or by your local poison control center.

Vomiting should not be induced if the person has ingested a strong acid, a strong alkaline substance (such as liquid drain cleaner), or an oil-based product (such as gasoline or kerosene). To induce vomiting in these cases may cause additional chemical burns as the poison is vomited, or it may result in inhalation of vapors, which can damage the lungs.

────────────────────────────

⚠ CAUTION
Do not induce vomiting if the patient has a history of heart disease.

────────────────────────────

To induce vomiting, administer syrup of ipecac. This drug can be obtained from a pharmacy without a prescription. Two tablespoons of syrup of ipecac are given to an adult, and one tablespoon to a child. This is followed by as many glasses of warm water as the patient can drink.

────────────────────────────

⚠ CAUTION
You should not induce vomiting unless you have received instruction in the use of ipecac and you have permission from your medical director or your local poison control center.

────────────────────────────

Ipecac will produce vomiting in approximately 95 percent of patients within 30 minutes. Watch the patient carefully to be sure that he or she remains conscious and that the induced vomiting does not cause any respiratory problems.

Inhaled Poisons

Poisoning by inhalation occurs if a **toxic** substance is breathed in and absorbed through the lungs. Some of these substances such as **carbon monoxide (CO)** are very poisonous but are not irritating. Carbon monoxide is an odorless, colorless, tasteless gas that cannot be detected by your normal

Fig. 10.4 Post the number of your poison control center in your first responder life support kit.

Fig. 10.5 Activated charcoal.

Acid A chemical substance with a pH of less than 7.0 that can cause severe burns.

Toxic Poisonous.

Carbon monoxide (CO) A colorless, odorless, poisonous gas formed by incomplete combustion, such as in a fire.

1. *Headache*
2. *Nausea*
3. *Disorientation*
4. *Unconsciousness*

Fig. 10.6 Signs and symptoms of carbon monoxide poisoning.

Fig. 10.7 Fertilizer trucks on farms often contain ammonia.

Table 10.3: Signs and Symptoms of Inhaled Poisons	
Respiratory distress	Dizziness
Cough	Headache
Hoarseness	Confusion
Chest pain	
Any other general signs and symptoms of poisoning listed in Table 10.1	

senses. Other gases such as chlorine gas and ammonia are very irritating and will cause the patient to cough and have severe respiratory distress. These gases can be classified as irritants. General signs and symptoms of inhaled poisons are shown in Table 10.3.

Carbon Monoxide

One of the most common causes of carbon monoxide poisoning is an improperly vented heating appliance. Carbon monoxide is present in smoke. People caught in building fires often suffer carbon monoxide poisoning.

The inhalation of relatively small quantities of carbon monoxide gas can result in severe poisoning because carbon monoxide gas combines with red blood cells about 200 times more readily than oxygen. Therefore, a small quantity of carbon monoxide can "monopolize" the red blood cells and prevent oxygen from being transported to all parts of the body.

The signs and symptoms of carbon monoxide poisoning are headache, nausea, disorientation, and unconsciousness (Figure 10.6). Low levels of carbon monoxide poisoning have signs and symptoms that are just like the flu. If you find several patients together who all have these symptoms (especially in winter), suspect carbon monoxide poisoning and remove everyone from the structure or vehicle.

Irritants

Many gases irritate the respiratory tract. Two of the more frequently encountered gases are:

1. *Ammonia.* Inhalation of ammonia is likely to occur in agricultural settings, where it is used as a fertilizer (Figure 10.7). It has a strong, irritating odor that is highly toxic. Inhaling large amounts of ammonia gas deadens the sense of smell and severely irritates the lungs and upper respiratory tract, causing violent coughing. Ammonia can also severely burn the skin. Anyone who enters an environment containing ammonia must wear a proper encapsulating suit with a **self-contained breathing apparatus (SCBA)** (Figure 10.8).

2. *Chlorine.* Chlorine gas is commonly found in large quantities around swimming pools and water treatment plants. The odor of chlorine is familiar to anyone who has used chlorine bleach or been in a swimming pool or hot tub. Chlorine can severely irritate the lungs and the upper respiratory tract, causing violent coughing (Figure 10.9). Chlorine gas can also cause skin burns. Anyone who enters an environment containing chlorine must wear a proper encapsulating suit with an SCBA.

The first step in treating a patient who is suffering from inhalation of any poison gas is to remove him or her from the source of the gas.

If the patient is not breathing, begin mouth-to-mask breathing. If the patient is breathing, administer large quantities of oxygen (if available). Any patient who has suffered from inhalation poisoning should be transported promptly to a medical facility for further examination because a delayed reaction to the poison gas could occur.

In some situations, your first response is to evacuate people. If you are called to the scene of a large poison gas leak (or leakage of other hazardous material), you may have to evacuate large numbers of people to prevent further injuries. Once this has been done, begin to treat the evacuees as necessary.

Check Point

✓ How would you treat a patient who has inhaled carbon monoxide?

Injected Poisons

Poisoning by injection is caused by animal bites and stings or by toxic injection. Toxic injection is discussed under the topic of substance abuse. The signs and symptoms of poisonous stings and bites are tenderness and swelling at the site of the injury, red streaks radiating from the injection site, weakness, dizziness, and pain. (See Table 10.4.)

If a person has received a large amount of poison (for example, multiple bee stings) or if a person is especially sensitive to this poison (that is,

Fig. 10.8 Self-contained breathing apparatus (SCBA).

Fig. 10.9 Placard used to identify the presence of chlorine.

⊗ **Focus on Treatment**

- Transportation to an appropriate medical facility
- Prompt transportation to an appropriate medical facility
- Rapid transportation to an appropriate medical facility

Self-contained breathing apparatus (SCBA) A complete unit for delivery of air to a rescuer who enters a contaminated area; contains a mask, regulator, and air supply.

✚ **SAFETY PRECAUTION**
Do not venture into areas where poison gases are present. Call an agency (such as the fire department) that is equipped with a self-contained breathing apparatus (SCBA) . You should be especially aware of the hidden dangers found in farm silos, sewers, and other below-ground structures. Every year, rescuers lose their lives by venturing into a silo, sewer, or pit to save a person who may already be dead.

1. *Itching all over the body*
2. *Hives, swelling*
3. *Generalized weakness*
4. *Unconsciousness*
5. *Rapid, weak pulse*
6. *Rapid, shallow breathing*

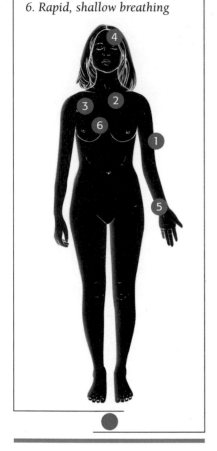

Fig. 10.10 Signs and symptoms of anaphylactic shock.

- Transportation to an appropriate medical facility
- Prompt transportation to an appropriate medical facility
- Rapid transportation to an appropriate medical facility

Anaphylactic shock Severe shock caused by an allergic reaction to food, medicine, or insect stings.

Hives An allergic skin disorder marked by patches of swelling, redness, and intense itching.

Table 10.4: Signs and Symptoms of Injected Poisons	
Signs and symptoms of an insect bite or sting	Localized redness
Signs and symptoms of an animal bite	Localized pain
Hypodermic needle marks	Itching
Localized swelling	
Any other general signs and symptoms of poisoning listed in Table 10.1	

has an anaphylactic reaction), he or she may collapse and become unconscious.

Insect Stings and Bites

Begin treatment for insect stings and bites by keeping the patient quiet. A light constricting band may be used if there is severe swelling. Apply the light constricting band between the sting or bite and the patient's heart. Apply the band snugly but not so snug that it cuts off circulation. (Check for a distal pulse after application.) Ice packs may help reduce local swelling and pain.

Some people suffer an extreme allergic reaction to stings and bites and may go into **anaphylactic shock.** (See Chapter 12.) The signs and symptoms of anaphylactic shock are itching all over the body, **hives,** generalized weakness, and even unconsciousness (Figure 10.10). The patient's blood pressure drops, and the patient may even suffer cardiac arrest.

Elevating the patient's legs (shock treatment) may help in some cases. If the patient's condition progresses to the point of respiratory or cardiac arrest, begin mouth-to-mask breathing or CPR.

As soon as a patient appears to be going into anaphylactic shock, arrange for his or her rapid transport to a medical facility for treatment with specific medications. Medication may also be started by a paramedic who is working under the direction of a physician.

Snakebite

In the United States, there are only four kinds of poisonous snakes: rattlesnake, cottonmouth, copperhead, and coral snake. The snake injects its poison into the skin and muscles with its fangs. This poison can cause local injury to the skin and muscle and may even involve the entire extremity. Signs and symptoms may affect the entire body. A bite from a poisonous snake is rarely fatal; there are only about 20 deaths per year in the United States. However, permanent injury can sometimes still result.

The signs and symptoms of poisonous snakebite (Figure 10.11) include:

- Immediate pain at the bite site
- Swelling and tenderness around the bite site
- Fainting (from the emotional shock of the bite)
- Sweating
- Nausea and vomiting
- Shock

"I entered the emergency services arena, both as a volunteer and a first responder, with certifications in firefighting, as a hazmat technician, and as an EMT. I was fortunate to be assigned to work with a seasoned paramedic in Pennsylvania who believed that it was important to treat a patient medically, but it was equally important to learn to listen. I have learned through 13 years of response to use all of my senses during all responses. In addition to visually assessing a scene, the patient's injuries, and potential problems, it is important to listen carefully to information given prior to and during response. On the way to a scene, it is helpful to discuss the dispatch information and be open to what all crew members have to say—you may be missing or misinterpreting something. Learn to work together as a team and look out for one another.

Listening plays a major role with patients who have become distraught. When involved in a situation in which there is no life-threatening injury, it may take a period of time to gain the patient's confidence in order to diffuse the situation and accomplish your task. Our actions directly reflect the response we receive from others. You can sometimes diffuse a potentially explosive incident just by the way you respond. Listening without passing judgment can play an essential role. Sometimes we need to use a firm voice to get results; sometimes a soothing tone works better. If you meet resistance and just cannot get control of a situation, try to change places with your partner or another response person.

Everyone in the medical field has had good and bad or uneasy feelings about a response or type of response. Communicate these feelings to your supervisor so that your strong areas can be utilized to their best advantage. We need to learn about fellow responders' likes and dislikes to function as a well-rounded team. Some people can handle specific problems better than others. If we don't learn to work things out, we become prime candidates for critical incident stress and problems on the job with fellow employees, patients, and families."

Judith Guenst
EMT, Technician, Firefighter
H.K. Carr & Associates

▶ Although nearly 7000 are bitten by snakes each year in the United States, fewer than 20 people die from snakebites.

• Transportation to an appropriate medical facility
• Prompt transportation to an appropriate medical facility
• Rapid transportation to an appropriate medical facility

SIGNS and SYMPTOMS

1. *Immediate pain at the bite site*
2. *Swelling and tenderness around the bite site*
3. *Fainting*
4. *Sweating*
5. *Nausea and vomiting*
6. *Shock*

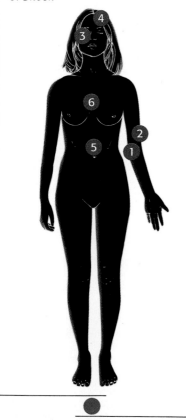

Fig. 10.11 Signs and symptoms of snakebite.

The coral snake's bite carries a slightly different poison than the other three snakes, and its bite may cause these additional problems:

- Respiratory difficulties
- Slurred speech
- Paralysis
- Coma
- Seizures

Any poisonous snakebite should receive prompt treatment at a medical facility. The only effective treatment for poisonous snakebites is the administration of antivenin in the hospital. The field treatment of snakebite is basically the same as the treatment for shock (see Chapter 12). Keep the patient quiet. Have the patient lie down and try to relax.

You should wash the poison off the patient's skin with soap and water and apply a light constricting band to the extremity above the bite site if less than one-half hour has passed since the bite occurred. The band should be snug but not tight enough to stop the flow of blood. You should be able to slip your finger under the band. Use a light rubber constricting band from your first responder life support kit, or improvise one with a shoelace or rubber glove. Do not use a rubber band! It will probably be too tight. Check with your local protocols or medical control regarding the use of constricting bands. Treat the patient carefully and arrange for prompt transport to the hospital.

Absorbed Poisons

Poisoning by absorption occurs when a poisonous substance enters the body through the skin. Two common examples are absorption of insecticides and toxic industrial chemicals. A person suffering from absorption poisoning may have localized symptoms, such as skin irritation, or systematic signs and symptoms of the poisoning, such as nausea, vomiting, dizziness, and shock. (See Table 10.5.)

Begin treatment of a patient who has absorbed a poisonous substance by ensuring that the patient is no longer in contact with the toxic substance. You

Table 10.5: Signs and Symptoms of Absorbed Poisons
Traces of powder or liquid on the skin
Inflammation or redness of the skin
Chemical burn
Skin rash
Burning
Itching
Nausea and vomiting
Dizziness
Shock
Any other general signs and symptoms of poisoning listed in Table 10.1

may have to ask the patient to remove all clothing. Then brush—*do not wash*—any dry chemical off the patient. Contact with water may activate the dry chemical and result in a burning or caustic reaction.

After all the dry chemical has been brushed off, the patient should be completely washed for at least 20 minutes. Use any water source that is available: an industrial shower, a home shower, a garden hose, or even a fire engine's booster hose. Do not forget to wash out the patient's eyes if they have been in contact with the poison. If additional EMS personnel are delayed, contact the poison control center or your medical director for additional treatment information.

When in doubt in absorbed-poison situations, have the patient remove all clothing so that he or she is no longer in contact with the toxic substance.

If the patient is suffering from shock, have the patient lie down and elevate the legs. If the patient is having difficulty breathing, administer oxygen if it is available and you are trained to use it.

Focus on Treatment

Substance Abuse

Alcohol

Alcohol is the most commonly abused drug in our society. Deaths as a result of alcohol abuse are two and one-half times as numerous as deaths from motor vehicle accidents. Alcohol intoxication may be seen in people of any age, including children and teenagers. Alcohol abuse is present in more than one-half of all traffic fatalities, more than one-half of all murders, and more than one-third of all suicides. The symptoms of alcohol intoxication are often present in patients who have an underlying medical illness or a severe injury. Do not assume that an apparently intoxicated person is "just another drunk."

A person who appears intoxicated may be suffering instead from any one of a number of serious illnesses or injuries. Insulin shock, diabetic **coma**, head injury, traumatic shock, and drug reactions may all display the same symptoms as alcohol intoxication.

In addition, people who have been drinking can be injured or suddenly develop a serious illness. You cannot assume that the symptoms (including the smell of alcohol on someone's breath) are caused by drunkenness. If you are in any doubt about whether a patient who appears to be intoxicated has a serious injury or illness, be extra careful with your examination. You should arrange for prompt transport to an appropriate medical facility, where a physician can make a complete assessment.

Alcohol is an addictive drug, meaning that people who drink alcohol regularly and then are suddenly deprived of it will develop withdrawal symptoms. Alcohol withdrawal symptoms are called **delirium tremens (DTs).** The signs and symptoms of DTs include shaking, restlessness, confusion, hallucinations, gastrointestinal distress, chest pain, and fever. These signs and symptoms usually appear three to four days after the person stops drinking. A person suffering from DTs must be transported to an appropriate medical facility. DTs are a serious medical emergency and can be fatal.

Alcohol A liquid obtained by fermentation of carbohydrates with yeast.

Focus on Assessment

Coma A state of unconsciousness from which the patient cannot be aroused.

Delirium tremens (DTs) A severe, often fatal, complication of alcohol withdrawal that can occur from one to seven days after withdrawal. It is characterized by restlessness, fever, sweating, confusion, disorientation, agitation, hallucinations, and convulsions.

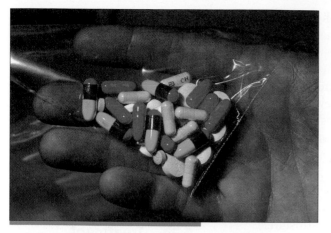

Fig. 10.12 Types of drugs that are commonly abused.

Uppers Drugs that stimulate the central nervous system. These include amphetamines and cocaine.

Central nervous system (CNS) The brain and spinal cord.

Amphetamines Stimulants produce a general mood elevation, improve task performance, suppress appetite, or prevent sleepiness.

Cocaine A powerful stimulant that induces an extreme state of euphoria. Legitimately, it is a potent local anesthetic. On the street, it is commonly known as "coke." Synthetic cocaine is known as "crack."

Downers Depressants; barbiturates.

Barbiturates Drugs that depress the nervous system; they can alter the state of consciousness so that the individual may appear drowsy or peaceful.

Hallucinogens Chemicals that cause a person to see visions or hear sounds that are not real.

 Focus on Treatment

- Transportation to an appropriate medical facility
- Prompt transportation to an appropriate medical facility
- Rapid transportation to an appropriate medical facility

Drugs

Within our society today, people of all ages abuse many different prescription and street drugs. The type of drug used tends to vary from one location to another. People in specific regions, cities, or neighborhoods sometimes use one (or more) particular drug and not others (Figure 10.12).

Uppers

Uppers are drugs that stimulate the **central nervous system (CNS).** They include **amphetamines** (speed, ice, or crystal) and **cocaine** (coke). People using these substances show signs of restlessness, irritability, and talkativeness. Users of uppers may need to be kept from harming themselves. They need to be taken to a facility where someone can monitor them until the effect of the drug has worn off.

Downers

Like alcohol, **downers** are depressants. Downers include **barbiturates**, tranquilizers, opiates, and marijuana. An overdose of one of these drugs usually results in respiratory depression or even respiratory arrest.

A person suffering from a severe overdose of one of these drugs may be breathing shallowly or not at all. If the person is not breathing, begin mouth-to-mask resuscitation. If cardiac arrest occurs, begin CPR immediately.

Hallucinogens

Hallucinogens include PCP, LSD, peyote, mescaline, and some types of mushrooms. Hallucinogens cause people to see things that are not there. A patient who is hallucinating may become frightened and may not be able to distinguish between reality and fantasy.

The physical effects of PCP include the blockage of pain receptors. Patients on PCP may feel no pain and may seriously injure themselves and others. Large PCP doses can produce convulsions, coma, heart and lung failure, or stroke.

Drug Overdose

Your treatment for drug overdose is to provide basic life support (clear the airway and perform mouth-to-mask breathing or CPR) and arrange for prompt transport to an appropriate medical facility.

Once you have determined that a patient is suffering from a drug overdose, your job is to:

- Provide basic life support (clear the airway and perform mouth-to-mask breathing or CPR, as necessary)
- Keep the patient from hurting himself or herself and others
- Provide reassurance and psychological support
- Arrange for prompt transport to a medical facility for treatment

The effects of some drugs can only be counteracted by other drugs, which can be administered by a paramedic or a physician. While you are waiting for assistance or transport, try to keep patients from harming themselves (or others) and speak in a calm, reassuring tone of voice.

If a person reports seeing things that are not there, say, "I believe you are seeing those things; however, I do not see them myself." This statement lets

the patient know that you are aware of what he or she is going through, but that the perceived object is not really there.

Patients who are suffering adverse reactions from drug overdose require specialized treatment. You and other EMS personnel should be aware of the facilities in your community equipped to deal with such cases. Keep in mind that a person suffering from a drug overdose may also have other injuries or medical conditions that require medical treatment. Try to avoid classifying the patient as "just another overdose."

Toxic Injection from Drugs

Toxic injection results from an overdose of a drug. The reaction that the patient has will depend on the quantity and type of drug injected. Sometimes the patient will not know what has been injected because street drugs may be diluted, or "cut," with sugar or other substances that should not be injected into a vein. After a toxic injection, the patient may complain of weakness, dizziness, fever, or chills. This type of emergency requires you to support the patient, treat the symptoms, and provide transport to an appropriate medical facility.

You should also check the injection site for redness, swelling, and increased skin temperature. If any of these signs is present, it may indicate an infection that will require medical care.

Intentional Poisoning

Intentional self-poisoning is attempted suicide. People try to kill themselves by ingesting poisons (or drugs) or by inhaling poisons (such as carbon monoxide). Medical treatment is the same as for accidental poisoning.

A patient who has just attempted suicide needs your medical and psychological support just as much or more than a patient with a broken leg. The patient may not want your help and may be difficult to treat. Nevertheless you and all EMS personnel must make every effort to preserve life and offer reassurance.

SAFETY PRECAUTION
You should be aware that people who use intravenous drugs have a high incidence of bloodborne diseases such as hepatitis B and AIDS. Maintain body substance isolation (BSI) to decrease your chance of coming in contact with bloodborne pathogens.

- Transportation to an appropriate medical facility
- Prompt transportation to an appropriate medical facility
- Rapid transportation to an appropriate medical facility

Summary

This chapter discusses common poisoning problems that you will encounter as a first responder. These poisonings may occur by ingestion, inhalation, injection, or absorption. Alcohol abuse, drug overdose, and attempted suicide are also discussed. It is important to remember that you will not always be able to identify the poisonous substance, but you can treat the patient's symptoms. As you approach the scene of a poisoning, follow the patient assessment steps you learned in Chapter 7. Pay special attention to scene safety and do not enter a hazardous environment without the proper training and equipment.

Key Terms

Acid—page 255
Alcohol—page 261
Amphetamines—page 262
Anaphylactic shock—page 258
Barbiturates—page 262
Carbon monoxide (CO)—page 255

Central nervous system (CNS)—page 262
Cocaine—page 262
Coma—page 261
Delirium tremens (DTs)—page 261
Downers—page 262

Hallucinogens—page 262
Hives—page 258
Poison—page 253
Self-contained breathing apparatus (SCBA)—page 257
Toxic—page 255
Uppers—page 262

 # What Would You Do?

1. You are called to a house. When you arrive, an excited babysitter tells you that he thinks the 2-year-old baby drank some cleaning fluid. What would you do?
2. You are called to a hardware store where you find a 47-year-old employee who says he is dizzy. He states that he broke a bottle of pesticide about 15 minutes ago and it spilled all over his pants. What would you do?
3. You are called to a residence for a report of an unconscious person. As you perform an assessment of the patient, you find a 27-year-old female who is unconscious and breathing shallowly at a rate of 8 times per minute. You note a used syringe nearby and a tourniquet near her right arm. What would you do?

You Should Know

1. What a poison is.
2. The signs and symptoms of ingested poisons.
3. How to treat a patient who has been poisoned by ingestion.
4. The signs and symptoms of inhaled poisons.
5. How to treat a patient who has been poisoned by inhalation.
6. The signs and symptoms of injected poisons.
7. How to treat a patient who has been poisoned by injection.
8. The signs and symptoms of absorbed poisons.
9. How to treat a patient who has been poisoned by absorption.
10. The signs and symptoms of drug overdose caused by uppers, downers, and hallucinogens.
11. The general treatment of a patient who has suffered a drug overdose.

You Should Practice

1. Using water to flush a patient who has come in contact with liquid poison.
2. Brushing a dry chemical off a patient and then flushing with water.

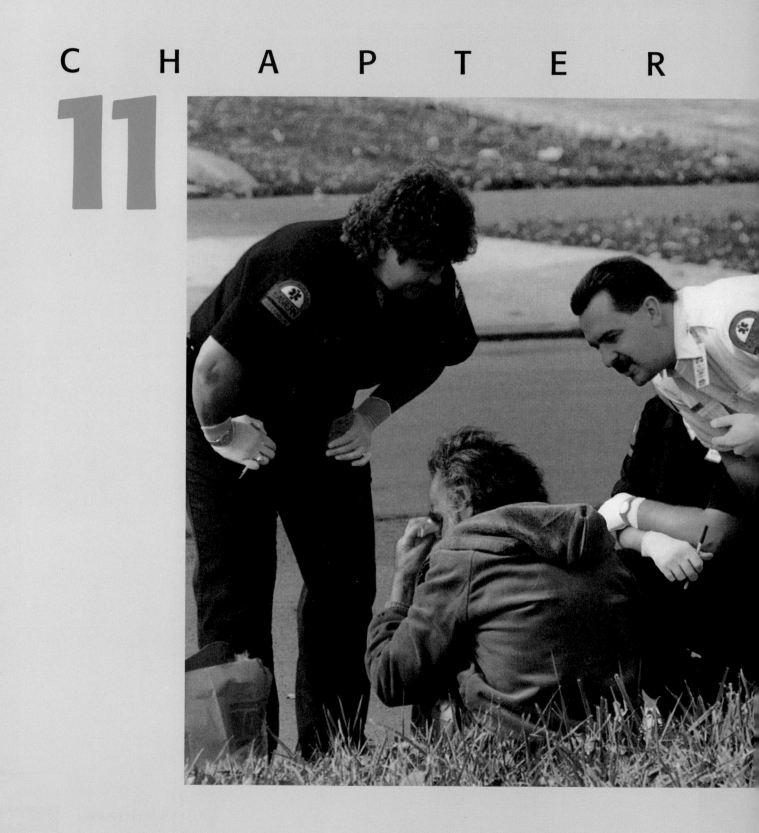

BEHAVIORAL EMERGENCIES— CRISIS INTERVENTION

Knowledge and Attitude Objectives *After studying this chapter, you will be expected to:*

1. Identify patients experiencing signs of a behavioral crisis.
2. List the five factors that may cause behavioral emergencies.
3. Describe phases of a situational crisis.
4. Explain the role of a first responder in dealing with a patient experiencing a behavioral emergency.
5. Describe the principles for assessing behavioral emergency patients.
6. Explain the following communication skills:
 a. Restatement
 b. Redirection
 c. Empathy
7. Describe the method for assessing potentially violent patients.
8. Describe the safety precautions that should be taken when dealing with a potentially violent patient.
9. Describe the first responder's role in dealing with an armed patient.
10. Explain the medical/legal considerations related to dealing with behavioral emergencies.
11. Describe the approaches to be used when dealing with:
 a. Suicide crisis
 b. Sexual assault
 c. Death and dying
12. Explain the purpose of critical incident stress debriefing.

Skill Objectives *As a first responder, you should be able to:*

1. Master the following communication techniques:
 a. Restatement
 b. Redirection
 c. Empathy
2. Calm a patient experiencing a behavioral crisis.

Your role in behavioral emergencies is to give psychological support as well as needed emergency medical care. Every emergency situation you face as a first responder has emotional and psychological effects on you, the patient, the patient's family and friends, and even bystanders. This is true whether the emergency is an illness or an injury. This chapter explains the five major factors that cause behavioral crises.

The role of a first responder consists of assessment and providing care, which may be physical or emotional. Many patients experience high anxiety, denial, anger, remorse, and grief during a situational crisis. Restatement, redirection, and empathy are three skills that are useful in communicating with patients in crisis. This chapter also provides information on how to deal with crowd control, violent patients, armed patients, suicide crisis, sexual assault, and death and dying. Medical/legal considerations and the role of critical incident stress debriefings are also covered.

By focusing on the simple intervention techniques addressed in this chapter, you will be much better prepared to deal with patients and their families during the stressful experience of a medical emergency. You will also be better able to identify and understand the reactions to the grief that you observe.

Behavioral Crises

As a first responder, you will encounter situations where patients exhibit behavior that is abnormal. Sometimes this abnormal behavior is the primary cause of your being called, and sometimes it is the secondary reaction to another situation such as an accident or illness. **Behavioral emergencies** are defined as situations in which a person exhibits abnormal behavior that is unacceptable or cannot be tolerated by the patients themselves or by family, friends, or the community. Behavioral emergencies sometimes involve your patient and other times involve the patient's family or friends.

Five main factors may cause behavioral changes:

1. *Medical conditions* include uncontrolled diabetes that causes low blood sugar, respiratory conditions that prevent the patient's brain from receiving enough oxygen, high fevers, and excess cold.
2. *Physical trauma* conditions include head injuries and injuries that result in shock, which causes a loss of adequate blood supply to the brain.
3. *Psychiatric illnesses* can cause depression, panic, or **psychotic behavior.**
4. *Mind-altering substances* include alcohol and a wide variety of chemical substances.
5. *Situational stresses* can be caused by a wide variety of emotional trauma such as death or serious injury to a loved one.

To better understand a behavioral crisis, you need to look at the stages a person passes through when experiencing a situational crisis.

What Is a Situational Crisis?

Simply put, a **situational crisis** is a state of emotional upset or turmoil. It is caused by a sudden and disruptive event such as a physical illness or injury, or it can be caused by the death of a loved one. Every emergency creates some form of situational crisis for the patient and those persons close to the patient.

Behavioral emergencies Situations where a person exhibits abnormal behavior that is unacceptable or cannot be tolerated by the patients themselves or by family, friends, or the community.

Psychotic behavior Mental disturbance characterized by defective or lost contact with reality.

Situational crisis A state of emotional upset or turmoil caused by a sudden and disruptive event.

You will often encounter this type of crisis as a first responder. Some of the concepts covered here are similar to the concepts covered in Chapter 2.

Most situational crises are sudden and unexpected (such as an automobile accident), cannot be handled by the person's usual coping mechanisms, last only a short time, and can cause socially unacceptable, self-destructive, or dangerous behavior.

Remember: Virtually every emergency call requires some degree of psychological intervention.

Phases of a Situational Crisis

A person experiencing a situational crisis goes through all or some of the following emotional phases:

- High anxiety or emotional shock
- Denial
- Anger
- Remorse and grief

If you understand what these phases are and why they occur, you can better understand how to help people who are experiencing an emotional crisis.

High Anxiety or Emotional Shock

In the first phase of a situational crisis, a person exhibits high anxiety or **emotional shock.** High anxiety is characterized by rather obvious signs and symptoms: flushed (red) face, rapid breathing, rapid speech, increased activity, loud or screaming voice, and general agitation. Emotional shock is often the result of sudden illness, accident, or sudden death of a loved one. It is characterized, like most other types of shock, by cool, clammy skin; a rapid, weak pulse; vomiting and nausea; and general inactivity and weakness.

Emotional shock A state of shock caused by sudden illness, accident, or death of a loved one.

Denial

The next phase of a situational crisis may be denial—refusal to accept the fact that an event has occurred. For example, a child who has just lost a parent may refuse to accept the death by telling everyone that the parent is sleeping or has gone away.

Allow the patient to express denial. Do not argue with the patient, but try to understand the emotional and psychological trauma that he or she is experiencing.

Focus on Treatment

Anger

Anger may follow denial or, in some cases, may occur instead of denial. For example, the spouse of a patient may, for no apparent reason, begin screaming at you, calling you incompetent, or using foul language or racial slurs. Although it may be difficult, you should remember that anger is a normal human response to emotional overload or frustration.

Anger may be expressed by aggressive physical behavior. This behavior occurs because, in crisis situations, it is often easier to vent angry feelings on

an unknown person (the first responder) or an authority figure (a law enforcement officer) than on a friend or family member. Anger is perhaps the most difficult emotion to deal with objectively because the angry person may seem to be directing it at you. Do not take the person's anger personally, but acknowledge that it is a reaction to stress.

Frustration can result in anger. If anger is not released, it can develop into violent behavior. For example, in a serious accident involving a school bus, you may have to demonstrate to bystanders that you and other rescue personnel are indeed removing children. If little activity is apparent to the bystanders, they may become angry, hostile, and even violent. In such situations, show confidence. Demonstrate that you are making progress. Be professional and do not react to anger by becoming angry yourself. If necessary, a member of the EMS team may have to explain the situation—what is being done and why it appears to be taking so long. Acknowledge anger by saying something like, "What's the matter? Can you tell me what I can do to help?" Then allow the person to express his or her anger.

Remorse or Grief

Remorse or grief may follow anger. People may experience remorse about their behavior or actions during an incident. They may also express grief about the incident itself.

✓ *Check* *Point*

✓ List and explain the types of behavior you would expect to encounter from a patient experiencing each phase of a situational crisis.

Crisis Management

As a first responder, you should consider how you can deal with the patient's emotional concerns or crises. It is important to deal with the patient using the same general framework for patient assessment that you use for other types of patients. This section provides you with some additional skills that you can use for patients who are exhibiting behavioral crises or emotional stress.

Role of the First Responder

As a first responder, your approach to a patient who may be exhibiting abnormal behavior is to follow the steps of your patient assessment sequence:

1. Perform a scene size-up.
2. Perform an initial patient assessment.
3. Examine the patient from head to toe—first responder physical examination.
4. Obtain the patient's medical history (SAMPLE).
5. Perform on-going assessment.

Fig. 11.1 Crouch or seat yourself at the same level as the patient.

After you have completed this initial assessment, you may need to perform a physical examination or obtain the patient's medical history, depending on the needs of that individual patient. As you perform these steps, it is important that you provide a calm and reassuring environment for the patient. Your most important assessment skill may be your ability to communicate with the patient. This skill enables you to obtain needed information from the patient and also helps to calm and reassure the patient.

Communicating with the Patient

The first and most important step in crisis management is to talk with the person. Talking lets the person know that someone cares. When communicating with the patient, be honest, warm, caring, and empathetic.

When you begin talking with the person, crouch or seat yourself at the same level. If the person is lying down, kneel beside him or her (Figure 11.1). If the person is sitting, move down to his or her level. Do not stand above the person with your hands on your hips. This is a threatening position and communicates to the patient by body language that you believe the patient's problem is not important (Figure 11.2).

Remember: Body language is very important.

Establish eye contact. This assures the person that you are, indeed, interested in helping. Use a calm, steady voice when you talk to the person and provide honest reassurance. Avoid making false statements or giving false assurances. The patient does not want to be told that everything is all right when it obviously is not.

Fig. 11.2 This body language communicates an uncaring attitude.

Focus on Treatment

Use the following crisis intervention techniques:

- Remain calm.
- Reassure the patient.
- Take your time.
- Use eye contact.
- Touch the patient.
- Talk in a calm, steady voice.
- Demonstrate confidence.
- Do not take the patient's comments personally.
- Keep your sense of humor.

Try not to let negative personal feelings about the person or about the person's behavior interfere with your attempt to assist. Your function is to help the person deal with the events that caused the crisis. You should remain neutral and avoid taking sides in any situation or argument.

Sometimes a simple act, such as offering a tissue or a warm blanket, defuses the person's immediate crisis reaction. Simple acts of kindness can comfort and reassure the person that you are there to help.

Restatement

Restatement Rephrasing a patient's own statement to show that he or she is being heard and understood by the rescuer.

To show the person that you understand what he or she is saying, you can use a technique known as **restatement.** This means rephrasing a person's own words and thoughts to show that you understand. An example of restatement is as follows:

Patient with fractured arm: "I can't take any more of this pain!"

First responder: "The pain seems unbearable to you now, but it will ease up when we finish applying this splint."

It is not usually helpful simply to say, "I know what you mean," or "I know how you feel." You do not know exactly how the patient is feeling, even though you may have been through a similar experience. Be honest and give the patient hope, but do not give false hope.

Redirection

Redirection A means of focusing the patient's attention on the immediate situation or crisis.

Redirection helps focus a patient's attention on the immediate situation or crisis. This is an attempt to alleviate the patient's expressed concerns and draw his or her attention back to the immediate situation. An example of redirection is as follows:

Patient involved in automobile accident: "Oh my God! Where are my children? What's wrong with my children?"

First responder: "Your children are being taken care of by my partner; they are in good hands. Now, we must take care of you."

If the patient is in a public place such as on a sidewalk or in the lobby of a building, move the patient to a location that is quieter and more private, if the injury or illness permits.

Empathy

The ability to empathize involves participating in another person's feelings or ideas. Try to understand the emotional or psychological trauma the patient is experiencing. Ask yourself, "How would I feel if I were lying on the side-

walk with my clothes torn and bloody and strangers looking down at me?" **Empathy** is one of the most helpful concepts you can use in dealing with patients in crisis situations.

By using these communication skills, you will be able to more effectively deal with the patient's problems. Practice these skills with another person until you are able to use these techniques comfortably. Some principles you can use when assessing patients with a behavioral problem are listed in Table 11.1.

Check ✓ Point

✓ Explain how the use of restatement, redirection, and empathy can improve your communication with a patient.

Crowd Control

Simple crowd control may help reduce the patient's anxiety when there are too many people around. Encourage bystanders to leave. Sometimes too many emergency personnel have been dispatched to the scene. The presence of many uniformed personnel in a small apartment, for instance, is overwhelming or threatening to some people. Any emergency personnel who are not needed right away should leave the room or immediate vicinity until the patient has calmed down.

As you make your initial overview of the emergency scene, you also need to be able to identify crowds that may become hostile. It is better to ask for help in dealing with an unhappy crowd than it is to wait until the situation is unsafe for you and your patient.

The Violent Patient

If you must treat an unarmed patient who is or may become violent, immediately attempt to establish verbal and eye contact with the patient. Try to check

Table 11.1: Communications Skills

1. Identify yourself and let the patient know you are there to help.

2. Inform the patient of what you are doing.

3. Ask questions in a calm, reassuring voice.

4. Allow the patient to tell what happened. Do not be judgmental.

5. Show you are listening by using restatement and redirection.

6. Acknowledge the patient's feelings.

7. Assess the patient's mental status:
 a. Appearance
 b. Activity
 c. Speech
 d. Orientation to person, place, and time

with family members or friends to determine if the patient has a history of violence. Listen to the patient for yelling or verbal threatening. Assess the patient's posture to determine if he or she shows threatening behavior. Do not force the patient into a corner, and do not allow yourself to be cut off from a route of retreat.

It is usually best in situations like this to have only one person talk with the patient. Having more than one rescuer attempt conversation is often very threatening. The communicator should be the rescuer with whom the patient seems to have the best initial rapport.

Remember: Most violent patients calm down as time passes. The longer you can keep the patient talking, the better your chances are of resolving the situation without violence. Time is on your side.

If all other means of approach and intervention fail, it may be necessary to have law enforcement personnel control a violent patient.

The Armed Patient

You may encounter a person who is armed with a gun, knife, or other weapon. It is not your role to handle this situation unless you are a law enforcement officer.

Be alert for potentially threatening situations, and summon assistance if you think the person is armed. Do not proceed into an area where there may be an armed person without assistance from law enforcement personnel. If you must wait for the arrival of law enforcement personnel, stay with your vehicle in a safe location.

If, despite caution, you are confronted by an armed person, immediately attempt to withdraw.

Remember: Your best defense is to avoid confronting a person who is armed!

Medical/Legal Considerations

To protect the rights of the patient and yourself from any possible legal action, you must understand the laws of your state and community as they relate to dealing with emotionally disturbed patients. If an emotionally disturbed patient agrees to be treated, there should be few legal issues. However, if a patient who appears to be disturbed refuses to accept treatment, it may be necessary to provide care against the patient's will. To do this, you must have a reasonable belief that the patient would harm himself, herself, or others.

Usually, if patients are a threat to themselves or to others, it is possible to treat and transport them without their consent. As a first responder, you will usually not be responsible for transporting the patient, but you should know what the laws permit you to do as a first responder. This direction should come from your medical director and from legal counsel.

There may be times when it is necessary for you to apply reasonable force to keep patients from injuring themselves or others. If you are required to restrain a patient, you should consider the following factors: the patient's size and strength, the sex of the patient, the type of abnormal behavior, the mental state of the patient, and the method of restraint. Avoid acts of physical force that may injure the patient, whenever possible. You may, however, use reasonable force to defend yourself against an attack by an emotionally disturbed patient.

SAFETY PRECAUTION

If you cannot withdraw from the scene:

- Stay calm.
- Do not turn your back on the patient.
- Do not make threatening moves.
- Try to talk with the person and explain that you are there to give emergency medical assistance.

To prevent problems, you should seek assistance from law enforcement officials or from your medical director if you must restrain a patient. It is also important to document the conditions present in cases where you must restrain or subdue a patient. To prevent accusations of sexual misconduct by emotionally disturbed patients, try to have a caregiver of the same sex take primary responsibility for the care of the patient, whenever possible.

Your communications skills are especially needed in three other types of emotional crisis: suicide crisis, sexual assault, and death and dying. Each of these is difficult for the patient and for the first responder.

Suicide Crisis

Each year, thousands of people attempt **suicide.** They range in age from teenagers to elderly persons. People attempt suicide by ingesting poisons, jumping from heights and in front of cars or trains, cutting their wrists or neck, and shooting or hanging themselves. Not all suicide attempts result in death, and many patients who attempt suicide once will attempt it again.

Most people who attempt suicide have a serious psychiatric illness. Many suffer from alcohol or substance abuse or from depression. Many people attempt suicide while under the influence of alcohol or drugs. For many people, the underlying psychiatric disease is treatable, and with proper treatment the patient will no longer be suicidal. However, until that treatment is carried out, the patient must at all times be considered suicidal. All suicide attempts should be taken seriously.

Management of a suicide crisis consists of the following steps:

1. Get a complete history of the incident.
2. Support the patient's ABCs, as needed.
3. Dress open wounds.
4. Treat the patient for spinal injuries, if indicated.
5. Do not judge the patient. Treat him or her for the injuries or conditions you discover.
6. Provide emotional support for the patient and family.

Talk with the patient during treatment. Remember that many suicide attempts are cries for help. In addition to treating the patient, you should provide emotional support for the patient's family. Help the family understand that a suicide attempt usually indicates an underlying psychiatric illness, and that it is not the fault of the family or friends. It is not your role as a first responder to pass judgment on a patient; it is your role to provide a caring attitude and good medical care.

Sexual Assault

Special consideration should be given to any victim of sexual assault. Such victims may be male or female, old or young. Because sexual assault creates an emotional crisis, the psychological aspects of treatment are important.

The patient may have a hard time dealing with a rescuer of the same sex as the person who has just committed the assault. You may have to delay all but the most essential treatment until a rescuer of the same sex as the victim arrives. You must, of course, remember that your first priority is the medical well-being of the patient. Treat any injuries the person may have (knife wounds, gunshot wounds, and so forth). However, because sexual assault is a

Suicide Self-inflicted death.

crime, you should not remove clothing except to give medical care, not allow the victim to bathe, keep the scene and any evidence as undisturbed and intact as possible, and avoid aggressively questioning the patient as to what happened.

Remember: Your primary role as a first responder is to give emergency medical care.

In addition to giving medical care, treat the patient with empathy. Maintain the patient's privacy by covering the patient with a sheet or blanket and do not leave the patient alone. Contact your local law enforcement agency and rape crisis center, if one is available in your community.

Death and Dying

As a first responder, you will encounter death and dying from natural, accidental, and intentional causes. How well you can help the dying patient and the person's family or relatives largely depends on your own feelings about death. The material presented here is an expansion of the material about death and dying that was presented in Chapter 2.

In some situations, you cannot do anything, and the patient dies. In other situations, despite everyone's best effort, the patient still dies. In yet other situations, the patient's death is completely unexpected. In every case, you must do whatever you can to meet the patient's medical needs. Your attempts to save or give comfort to the patient help everyone (the patient, the family, and you) to deal emotionally with the patient's death.

Most human beings are afraid of dying. Witnessing the death of another human being brings that fear to the forefront, if only for a brief time. You must work through your personal feelings about death so you can confront it in the field. Although you may be somewhat uncomfortable about bringing up the subject, it helps to discuss it with others in the emergency care field. If you are uncomfortable talking with your peers, talk to a member of your hospital's emergency department staff.

Once you have done everything you can to treat a patient medically, consider the patient's psychological needs and those of the patient's family. Just being there as an empathetic caregiver is helpful. Do not be afraid to touch. Putting an arm around a shoulder or holding the hand of the patient or a member of the family helps everyone, including you.

Do not make false statements about the situation, but just as important, do not destroy hope. Even if, in your judgment, the situation is hopeless, try to give comfort by making such positive statements as, "We're here to help you, and we are doing everything we can. The ambulance is on its way, and you will be at the hospital as soon as possible."

Dealing with the deaths of others is a routine aspect of your job as a first responder. You must, therefore, constantly be on guard to prevent any callousness from entering into your interactions with patients and their families.

One specific type of death, **sudden infant death syndrome (SIDS)**, is discussed in Chapter 15.

Sudden infant death syndrome (SIDS) Death from unknown cause occurring during sleep in an otherwise healthy infant; also called crib death.

Critical Incident Stress Debriefing

Providing emergency care is stressful for you as well as for the patient. As a first responder, you will deal with patients experiencing high levels of stress

and anxiety. In emergency situations, you may not always be able to help patients. Some types of situations, such as rescue missions involving children or mass-casualty incidents, tend to produce more stress than others. First responders may need counseling to deal with such stress.

Stress may continue to build up until it begins to have negative effects on you and your performance. Signs and symptoms of extreme stress include depression, inability to sleep, weight change, increased alcohol consumption, inability to get along with family and co-workers, and lack of interest in food or sex.

To help prevent this stress and to relieve stress caused by critical incidents, psychologists have developed a process called **critical incident stress debriefing (CISD).** CISD brings rescuers and a trained person together to talk about the rescuers' feelings. CISD helps rescuers understand the signs and symptoms of stress and to receive reassurance from the group leader. It also allows people to obtain more help from trained professionals, if needed. Many public safety agencies have set up CISD teams to handle stressful events. These teams have been helpful to rescuers who have been through an overwhelming or stressful event. Additional information about critical incident stress debriefing was presented in Chapter 2. Check with your agency to see what resources are available (Figure 11.3).

Critical incident stress debriefing (CISD) A system of psychological support designed to reduce stress on emergency personnel.

Fig. 11.3 A critical incident stress debriefing session.

CHAPTER REVIEW 11

Summary

Only a small percentage of the patients you treat are severely mentally disturbed, but almost every patient you deal with is experiencing some degree of mental and emotional crisis. Even "normal" people react to stress in unexpected ways. No matter what the incident or crisis, your response must be to help the patient. This chapter has presented you with some tools to help you deal with patients who are experiencing a stressful medical emergency or a behavioral emergency.

This chapter covered five major factors that cause behavioral crises: medical conditions, physical trauma, psychiatric illnesses, mind-altering substances, and emotional trauma. Your role as a first responder consists of assessing the patient and providing physical and emotional care. Because many patients experience high anxiety, denial, anger, remorse, and grief during an emotional crisis, it is important to understand how to use restatement, redirection, and empathy. These concepts will help you be a more effective and caring first responder.

Understanding how to deal with crowds, violent patients, armed patients, suicide crisis, sexual assault, and death and dying is an important part of being an effective first responder. This chapter has presented medical/legal considerations and the role of critical incident stress debriefing. Even with these tools for managing behavioral crises, it is important to remember that sometimes the best approach is to ask yourself, "How would I like to be treated if I were in this situation?"

Key Terms

Behavioral emergencies—page 268

Critical incident stress debriefing (CISD)—page 277

Emotional shock—page 269

Empathy—page 273

Psychotic behavior—page 268

Redirection—page 272

Restatement—page 272

Situational crisis—page 268

Sudden infant death syndrome (SIDS)—page 276

Suicide—page 275

What Would You Do?

1. You are called to a residence at 7:04 AM. You are met at the door by a 75-year-old man. He tells you that he was unable to wake up his wife this morning. As you examine the woman, you note a nonbreathing, pulseless woman who has dependent lividity on her arms and legs. Her skin temperature is the same as the temperature of the room. What would you do?

2. You arrive at a house for the report of an injury. A neighbor tells you that she thought she heard the sound of several gunshots a few minutes before you arrived on the scene. What would you do?

You Should Know

1. How to identify patients experiencing signs of a behavioral crisis.
2. Five factors that may cause behavioral emergencies.
3. The phases of a situational crisis.
4. The role of a first responder in dealing with a patient experiencing a behavioral emergency.
5. The principles for assessing behavioral emergency patients.
6. The following communication skills:
 a. Restatement
 b. Redirection
 c. Empathy
7. The method for assessing potentially violent patients.
8. The safety precautions that should be taken when dealing with a potentially violent patient.
9. The first responder's role in dealing with an armed patient.
10. The medical/legal considerations related to dealing with behavioral emergencies.
11. The approaches to be used when dealing with:
 a. Suicide crisis
 b. Sexual assault
 c. Death and dying
12. The purpose of critical incident stress debriefing.

You Should Practice

1. The following communication techniques:
 a. Restatement
 b. Redirection
 c. Empathy
2. Calming a patient experiencing a behavioral crisis.

12

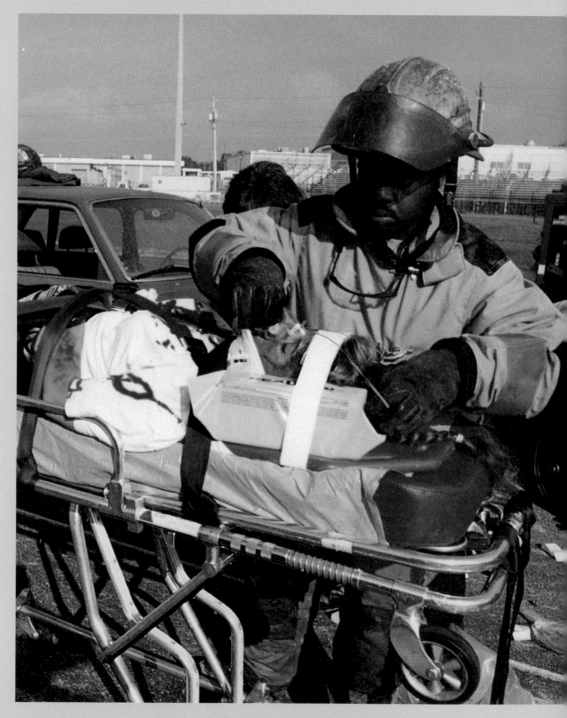

SHOCK, BLEEDING, AND SOFT TISSUE INJURIES

Knowledge and Attitude Objectives *After studying this chapter, you will be expected to:*

1. Establish the relationship between body substance isolation and bleeding.
2. Describe the function and relationship between the following parts of the circulatory system:
 a. Pump (heart)
 b. Pipes (blood vessels)
 c. Fluid (blood)
3. Explain how shock is caused by pump failure, pipe failure, and fluid loss.
4. List three types of shock caused by pipe failure.
5. List signs and symptoms of internal bleeding or shock.
6. List the general treatment for internal bleeding or shock.
7. Differentiate among arterial, venous, and capillary bleeding.
8. Explain the emergency care for external bleeding.
9. Describe the use of the femoral and brachial pressure points.
10. Explain the relationship between body substance isolation and soft tissue injuries.
11. List and explain four types of soft tissue injuries.
12. Describe the principles of treatment for soft tissue injuries.
13. Explain the functions of dressings and bandages.
14. Discuss the emergency medical care for patients with the following injuries:
 a. Face wounds
 b. Nosebleeds
 c. Eye injuries
 d. Neck wounds
 e. Chest and back wounds
 f. Impaled objects
 g. Closed abdominal wounds
 h. Open abdominal wounds
 i. Genital wounds
 j. Extremity wounds
 k. Gunshot wounds
 l. Bites
15. Describe the reasons why the use of a tourniquet is to be discouraged.
16. Describe how the seriousness of a burn is related to the depth of the burn.
17. Describe how the seriousness of a burn is related to the extent of the burn.

18. Describe the signs and symptoms and the possible complications associated with each of the following types of burns:
 a. Thermal
 b. Respiratory
 c. Chemical
 d. Electrical

19. Explain the emergency treatment for each of the following types of burns:
 a. Thermal
 b. Respiratory
 c. Chemical
 d. Electrical

Skill Objectives *As a first responder, you should be able to:*

1. Perform body substance isolation procedures for patients with wounds.

2. Treat patients with signs and symptoms of internal bleeding or shock.

3. Control bleeding using the following techniques:
 a. Direct pressure
 b. Elevation
 c. Femoral pressure point
 d. Brachial pressure point

4. Dress and bandage the following types of wounds:
 a. Face wounds
 b. Nosebleeds
 c. Eye injuries
 d. Neck wounds
 e. Chest and back wounds
 f. Impaled objects
 g. Closed abdominal wounds
 h. Open abdominal wounds
 i. Genital wounds
 j. Extremity wounds
 k. Gunshot wounds
 l. Bites

5. Perform emergency medical care for patients suffering the following types of burns:
 a. Thermal
 b. Respiratory
 c. Chemical
 d. Electrical

This chapter presents the skills you need to recognize and care for patients who have suffered from shock, bleeding, or soft tissue injuries. Because most soft tissue injuries result in bleeding, maintaining good body substance isolation (BSI) is important when you are caring for these injuries. The chapter describes four types of wounds: abrasions, lacerations, puncture wounds, and avulsions. Techniques for controlling external bleeding are stressed. It is important that you learn the techniques for dressing and bandaging wounds that are presented here.

Damage to internal soft tissues and organs can cause life-threatening problems for the patient. Internal bleeding causes the patient to lose blood in the circulatory system and results in shock. Shock is the greatest cause of death in trauma patients. Your ability to recognize the signs and symptoms of shock and to take simple measures to aid shock patients will give them the best chance for survival. This chapter presents shock from a simplified view using the analogy of a pump, pipes, and fluid. You will learn how a failure of any part of the system can cause shock. Signs and symptoms of shock and the general treatment for shock are presented.

Burns are another type of soft tissue injury. Burns may be caused by heat, chemicals, or electricity. They may damage any part of the body and are especially damaging if they occur inside the respiratory tract. This chapter considers burns by looking at the extent, depth, and cause of burns. Throughout all parts of the chapter, you need to keep in mind the importance of maintaining good BSI techniques to prevent the spread of disease-carrying organisms.

Body Substance Isolation and Soft Tissue Injuries

Most soft tissue injuries involve some degree of bleeding. Any time you approach a patient who may have suffered a soft tissue injury, you need to consider your BSI strategy. Remember that BSI is a concept that considers all body fluids to be potentially dangerous. Therefore, you must take appropriate measures to prevent contact with the patient's body fluids. When dealing with patients who have soft tissue injuries, you must wear gloves to prevent contact with the patient's blood. At times, you may also need to use a surgical mask and eye protection if you may be exposed to the splatter of blood from a massive wound or if the patient is coughing or vomiting bloody material.

SAFETY PRECAUTION
Body substance isolation techniques must be followed when you treat soft tissue injuries.

Review of the Parts and Function of the Circulatory System

As was discussed in Chapter 4, the circulatory system consists of three primary parts:

1. Pump (heart)
2. Pipes (arteries, capillaries, and veins)
3. Fluid (blood cells and other blood components)

A schematic illustration of the circulatory system is shown in Figure 12.1.

The Pump

The heart functions as the human circulatory system's pump. The heart consists of four separate chambers, two on top and two on the bottom. The lower chambers are the left and right **ventricles,** and the upper chambers are the left and right atria (a single chamber is called an **atrium**). The ventricles are the larger of the two and do most of the actual pumping. The atria are somewhat less muscular and serve more as a reservoir for blood flowing into and out of the heart (Figure 12.2).

Ventricle Either of the two lower chambers of the heart.

Atrium Either of the two upper chambers of the heart.

Fig. 12.1 A schematic representation of the parts of the circulatory system.

The Pipes

The human body has three main types of blood vessels: arteries, capillaries, and veins. The *arteries* (big-flow, heavy-duty, high-pressure pipes) carry oxygenated blood away from the heart to the body. The *capillaries* (distribution pipes), the smallest of the blood vessels, form a network that distributes blood to all parts of the body. At its point of smallest diameter, a capillary is so narrow that blood cells have to flow "single file." The *veins* return the blood from the capillaries to the heart, where it is pumped to the lungs. There, the blood gives off carbon dioxide and takes on oxygen.

The Fluid

Fluid consists of blood cells and other blood components, each with a specific function. The liquid part of the blood is known as plasma. Plasma serves as the transporting medium for the "solid" parts of the blood, which are the red blood cells, white blood cells, and platelets. Red blood cells are the blood's chief oxygen and carbon dioxide carriers (Figure 12.3). White blood cells have a "search and destroy" function. They consume bacteria and viruses to combat body infections. Platelets interact with each other and with other substances in the blood to form blood clots that help stop bleeding.

Pulse

A pulse is the pressure wave generated by the pumping action of the heart. The beat you feel is caused by blood surging from the left ventricle as it contracts, pushing blood out into the main arteries of the body. In counting the number of pulsations

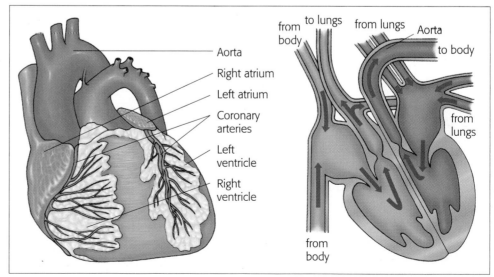

Fig. 12.2 The heart functions as the pump of the human circulatory system.

Aorta

Right atrium

Left atrium

Coronary arteries

Left ventricle

Right ventricle

to lungs

from body

from lungs

Aorta

to body

from lungs

from body

per minute, you also count heartbeats per minute. In other words, the pulse rate reflects the heart rate.

Usually you can feel a patient's radial and carotid pulses. The radial pulse (in the wrist) is easily found in a conscious patient at the base of the thumb. If the patient is unconscious or suffering from **shock**, or both, it may be impossible for you to feel a radial pulse. Therefore, it is vital that you know how to locate the carotid (neck) pulse. If the patient appears to be in shock or is unconscious, attempt to locate the carotid pulse first. You locate the carotid pulse by placing two fingers lightly on the larynx and sliding the fingers off to one side until you feel a slight notch. You should be able to feel the carotid pulse at this spot (Figure 12.4).

═══ SPECIAL NEEDS

In an infant, you should check the brachial pulse instead of the carotid pulse.

Practice locating the carotid pulse of another person in a dark room. You should be able to locate the pulse within 3 seconds of touching the person's larynx.

Shock

Shock is defined as failure of the circulatory system. Circulatory failure has many possible causes, but the three primary causes are:

1. Pump failure
2. Pipe failure
3. Fluid loss

Pump Failure

Cardiogenic shock occurs if the heart is incapable of pumping enough blood to supply the needs of the body. Pump failure can result if the heart has been weakened by a heart attack. Inadequate pumping of the heart can cause blood to back up in the vessels of the lungs, resulting in a condition known as **congestive heart failure (CHF).**

Pipe Failure

Pipe failure is caused by the expansion (dilation) of the capillaries to as much as three or four times their normal size. This causes blood to pool in the capillaries, instead of circulating throughout the system. When blood pools in the capillaries, there is less circulating blood for the rest of the body. The heart and other vital organs are deprived of blood. **Blood pressure** falls, and shock results.

In shock caused by sudden expansion of the capillaries, blood pressure may drop so rapidly that you are unable to feel either a radial or a carotid pulse. Three types of shock caused by capillary expansion are:

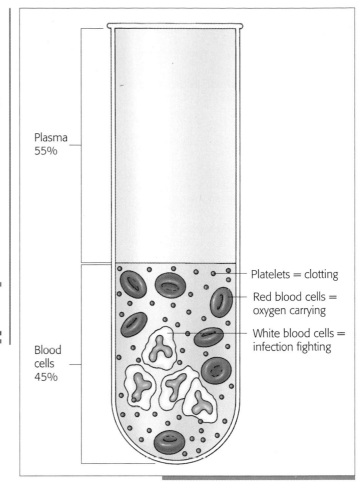

Plasma 55%

Blood cells 45%

Platelets = clotting

Red blood cells = oxygen carrying

White blood cells = infection fighting

Fig. 12.3 The components of blood.

Fig. 12.4 Taking the carotid pulse.

Shock A state of collapse of the cardiovascular system; the state of inadequate delivery of blood to the organs of the body.

Cardiogenic shock Shock resulting from inadequate functioning of the heart.

Congestive heart failure (CHF) Heart disease characterized by breathlessness, fluid retention in the lungs, and generalized swelling of the body.

Blood pressure The pressure of the circulating blood against the walls of the arteries.

Psychogenic shock Commonly known as fainting; caused by a temporary reduction in blood supply to the brain.

Anaphylactic shock Severe shock caused by an allergic reaction to food, medicine, or insect stings.

Hemorrhage Bleeding.

1. Shock induced by fainting
2. Anaphylactic shock
3. Spinal shock

The least serious type of "shock" caused by pipe failure is fainting. Fainting (**psychogenic shock**) often results from a psychological reaction to a major stress. The capillaries suddenly expand to three or four times their normal size. Fainting is a short-term condition that corrects itself once the patient is placed in a horizontal position.

Anaphylactic shock is caused by an allergic reaction to a foreign substance, such as venom from bee stings (see Chapter 10), drugs like penicillin, or certain foods . Shock develops very quickly following exposure. The patient may suddenly start to itch, a rash or hives may appear, the face and tongue may swell very quickly, and a blue color may appear around the mouth. The patient appears flushed (reddish), and breathing may quickly become difficult, with wheezing sounds coming from the chest.

Blood pressure drops very quickly as the blood pools into the expanded capillaries. The pulse may be so weak that you cannot feel it. Pipe failure has occurred, and death will result if quick action is not taken.

Spinal shock may occur in patients who have suffered a spinal cord injury. These patients may show signs and symptoms of shock because the injury to the spinal cord allows the capillaries to expand, causing the blood to pool in the lower extremities.

Fluid Loss

The third general type of shock is caused by fluid loss. Fluid loss caused by excessive bleeding (**hemorrhage**) is the most common cause of shock. Blood escapes from the normally closed circulatory system through an internal or external wound, lowering the system's total fluid level (blood volume) until the pump cannot operate efficiently. To compensate for fluid loss, the pump begins to work faster to maintain pressure in the pipes. But as the fluid continues to drain out, the pump eventually "loses its prime" and stops pumping altogether.

External bleeding is not difficult to detect because you can see blood escaping from the circulatory system to the outside. With internal bleeding, blood escapes from the system, but you cannot see it. Even though the escaped blood remains inside the body, it cannot reenter the circulatory system and is not available to be pumped by the heart. Whether external or internal, unchecked bleeding causes shock, eventual pump failure, and death.

The volume of blood in an average adult is about 12 pints. The loss of 1 pint of blood does not produce shock in a healthy adult. In fact, 1 pint per donor is the amount that blood banks collect. The loss of 2 or more pints of blood can produce shock. This amount of blood can be lost as a result of injuries such as a fractured femur. Figure 12.5 shows the amount of blood that can be lost as a result of injuries in various parts of the body.

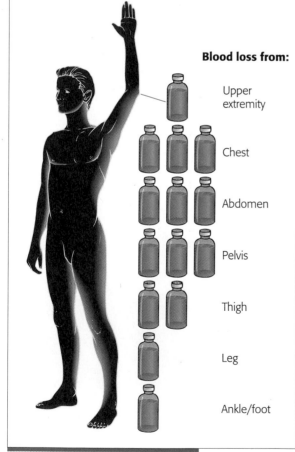

Blood loss from:

Upper extremity

Chest

Abdomen

Pelvis

Thigh

Leg

Ankle/foot

Fig. 12.5 Potential blood loss from injuries in various parts of the body (each bottle equals 1 pint).

Signs and Symptoms of Shock

Shock deprives the body of sufficient blood to function normally. As shock progresses, the body alters some of its functions in an attempt to maintain sufficient blood supply to its vital parts. A patient who is suffering from shock may exhibit some or all of the following signs and symptoms (Figure 12.6):

1. Confusion, restlessness, or anxiety. These changes in mental status may be the first signs of shock. In severe cases, the patient loses consciousness.
2. Cold, clammy, sweaty, and pale skin.
3. Rapid, weak pulse.
4. Increased capillary refill time.
5. Rapid breathing. Initially, the patient's breathing may be rapid and deep, but as shock progresses in severity, breathing becomes rapid and shallow.
6. Nausea and vomiting.
7. Weakness or fainting.
8. Thirst.

Monitoring the overall mental status of a patient can help you detect shock. Any change in mental status may be significant. If a trauma patient who has been quiet suddenly becomes agitated, restless, and vocal, you should suspect shock. If a trauma patient who has been loud, vocal, and belligerent becomes quiet, you should also suspect shock and begin treatment.

> ⚠️ **CAUTION**
> **A quiet patient is often a patient in shock. Watch carefully!**

If the patient has dark skin, you will not be able to use skin color changes to help you detect shock. Because you cannot see skin color changes in these patients, you must be especially alert for other signs of shock. Test for capillary refill to help determine if shock is present. Cool, clammy skin will help you recognize shock in patients who have dark skin.

General Treatment for Shock

As a first responder, you can combat shock from any cause and keep it from getting worse by taking several important and simple steps:

1. Position the patient correctly.
2. Maintain the patient's ABCs.
3. Treat the cause of shock, if possible.
4. Maintain the patient's body temperature by placing blankets under and over the patient.
5. Make sure the patient does not eat or drink anything.
6. Assist with other treatments (such as administering oxygen, if available).
7. Arrange for immediate and prompt ambulance transport to an appropriate medical facility.

Position the Patient Correctly

If there is no head injury, extreme discomfort, or difficulty breathing, lay the patient flat on the back on a horizontal surface. Place the patient on a blanket,

SIGNS and SYMPTOMS

1. *Cold, clammy, sweaty pale skin*
2. *Rapid breathing*
3. *Rapid, weak pulse*
4. *Increased capillary refill time*
5. *Confusion, restlessness, anxiety*
6. *Nausea and vomiting*
7. *Weakness or fainting*
8. *Thirst*

Fig. 12.6 Signs and symptoms of shock.

Focus on Treatment

- Transportation to an appropriate medical facility
- Prompt transportation to an appropriate medical facility
- Rapid transportation to an appropriate medical facility

if available. Elevate the patient's legs 12 to 18 inches off the floor or ground (Figure 12.7). This enables some blood to drain from the legs back into the circulatory system. If the patient has a head injury, do not elevate the legs.

If the patient is having chest pain or difficulty breathing (which is likely to occur in cases of heart attack and emphysema), place the patient in a sitting or semireclining position.

CAUTION
Do not allow the patient to stand!

Maintain the Patient's ABCs
Check the patient's airway, breathing, and circulation at least every 5 minutes. If necessary, open the airway, perform rescue breathing, or begin CPR.

Treat the Cause of Shock If Necessary
Most causes of shock must be treated in the hospital. Often this treatment consists of surgery by specially trained physicians. The most common cause of shock you will be able to treat is external bleeding. By controlling external bleeding with direct pressure, elevation, or pressure points, you will be able to temporarily treat this cause of shock and help to get the patient to an appropriate medical facility for more advanced treatment.

Maintain the Patient's Body Temperature
Attempt to keep the patient comfortably warm. A patient with cold, clammy skin should be covered. It is as important to place blankets *under* the patient to keep body heat from escaping into the ground as it is to cover the patient with blankets.

Remember: In the summer or in hot rooms, it is not necessary to cover every shock patient with blankets. You are trying to maintain body heat, not produce more.

Make Sure the Patient Does Not Eat or Drink Anything
Even though a patient in shock is very thirsty, do not give liquids by mouth. There are two reasons for this.

Fig. 12.7 Position for treatment of shock if there is no head injury. If the patient is experiencing difficulty breathing, place the patient in a sitting or semireclining position.

1. A patient in shock may be nauseated, and eating or drinking may cause vomiting.
2. A patient in shock may need emergency surgery. Patients should not have anything in their stomachs before surgery.

If you are working in an area where ambulance response time is more than 20 minutes, you may allow patients to relieve their thirst by sucking on a clean cloth or gauze pad that has been soaked in water. This relieves dryness of the mouth but does not quench thirst. No matter how thirsty patients are, do not permit them to drink anything.

Assist with Other Treatments

When a basic life support (BLS) or advanced life support (ALS) unit arrives on the scene, be ready to assist unit personnel with further treatments. Patients may be given oxygen or **intravenous (IV) fluids; pneumatic antishock garments (PASGs)** may be used.

If you are trained in the administration of oxygen and have it available, give it to shock patients. Oxygen benefits such patients by saturating the reduced number of red blood cells, enabling each cell to carry more oxygen than normal.

EMTs or paramedics administer IV solutions. Adding fluid to the body combats the loss of blood volume.

Some EMS personnel use PASGs in the field to treat pelvic fractures or to treat shock. PASGs are placed around the patient's legs and abdomen and inflated with air. Inflation of these devices exerts pressure around the legs and abdomen. Although you, as a first responder, are not involved in the application of these devices, you should know their purpose and function. It is also important to understand that they are not removed in the field. Removal must be done in a hospital and under the direct supervision of a physician.

Arrange for Immediate and Prompt Ambulance Transport to an Appropriate Medical Facility

As soon as you realize that you have a patient who is suffering from shock, you should make sure that an ambulance has been dispatched. As soon as the ambulance has arrived, it is important to give the EMS personnel a concise hand-off report that emphasizes the signs and symptoms of shock that you have noted. The EMTs or paramedics should make sure that the patient is quickly prepared for immediate and prompt transport to a medical facility that can handle a trauma patient with these severe problems. The cure for this type of shock is usually surgical repair, and the sooner the patient gets to the hospital, the better the chance of survival will be.

Treatment for Shock Caused by Pump Failure

Patients suffering from pump failure may be confused, restless, anxious, or unconscious. Their pulse is usually rapid and weak. Their skin is cold and clammy, sweaty, and pale. Their respirations are often rapid and shallow.

Treatment for pump failure includes the following steps:

1. Keep the patient lying down unless breathing is better in a sitting position.
2. Maintain the patient's ABCs. Be prepared to do CPR, if necessary.
3. Conserve the patient's normal body temperature.

- Transportation to an appropriate medical facility
- Prompt transportation to an appropriate medical facility
- Rapid transportation to an appropriate medical facility

Focus on Treatment

4. Make sure the patient does not eat or drink anything.

5. Keep the patient quiet and do any necessary moving for him or her.

6. Provide reassurance.

7. Arrange for prompt ambulance transport to an appropriate medical facility.

8. Provide high-flow oxygen as soon as it is available.

Pump failure is a serious condition. A large percentage of patients with pump failure die. Your proper treatment and prompt ambulance transport will give such patients the best chance for survival.

Treatment for Shock Caused by Pipe Failure

Patients who have fainted, who are suffering from anaphylactic shock, or who have suffered a severe spinal cord injury will have pipe failure. The size of their capillaries may increase three or four times, causing signs and symptoms of shock.

Focus on Treatment

Treatment for Fainting

Treatment for fainting consists of the following steps:

1. Examine the patient to make sure there is no injury.

2. Keep the patient lying down with legs elevated 12 to 18 inches off the floor or ground. This enables the blood to drain from the legs back into the central circulatory system.

3. Maintain the ABCs.

4. Maintain the patient's normal body temperature.

5. Provide reassurance.

Treatment for Anaphylactic Shock

The initial treatment for anaphylactic shock (shock caused by an allergic reaction) is similar to the treatment for any other type of shock. Anaphylactic shock is an extreme emergency and the patient must be transported as soon as possible. Paramedics, nurses, and doctors can give medications that may reverse the allergic reaction.

Focus on Treatment

The following steps describe the treatment for patients with anaphylactic shock:

1. Keep the patient lying down. Elevate the legs 12 to 18 inches off the floor or ground.

2. Maintain the patient's ABCs. Anaphylactic shock may cause airway swelling. In severe reactions, the patient may require mouth-to-mask breathing or full CPR.

3. Maintain the patient's normal body temperature.

4. Provide reassurance.

5. Arrange for prompt ambulance transportation to an appropriate medical facility.

Treatment for Spinal Shock

The following steps describe the treatment for patients with spinal shock:

1. Place the patient on his or her back. Because the spine may be injured, keep the patient's head and neck stabilized to protect the spinal cord

Focus on Treatment

(Chapter 13). In this case, do not elevate the patient's feet because this will make it harder for him or her to breathe.

2. Maintain the patient's ABCs and stabilize the neck.
3. Maintain the patient's body temperature.
4. Make sure the patient does not eat or drink anything.
5. Assist with other treatments. Help other medical providers to place the patient on a backboard.

Treatment for Shock Caused by Fluid Loss

Shock may be caused by internal blood loss (blood that escapes from damaged blood vessels and stays inside the body) or by external blood loss (blood that escapes from the body). Excessive bleeding is the most common cause of shock.

Shock Caused by Internal Blood Loss

Patients die quickly and quietly from internal bleeding following abdominal injuries that can cause rupture of the spleen, liver, or large blood vessels. You must be alert to catch its earliest signs and symptoms and to begin treatment for shock. If you are treating several injured patients, those with internal bleeding should be transported to the medical facility first, as immediate surgery may be needed. (Chapter 16 discusses how to decide which patients should receive care first.)

Internal bleeding resulting in shock can be caused by bleeding from stomach ulcers, ruptured blood vessels, or tumors. This bleeding can be spontaneous, massive, and rapid, often leading to the loss of large quantities of blood by vomiting or bloody diarrhea.

It is important that you recognize the signs and symptoms of internal blood loss and take prompt corrective action. In addition to the classic signs of shock (confusion, rapid pulse, cold and clammy skin, and rapid breathing), patients with internal bleeding may show some of the signs and symptoms depicted in Figure 12.8. The important signs and symptoms include:

- Coughing or vomiting of blood
- Abdominal tenderness, rigidity, or distention
- Rectal bleeding
- Vaginal bleeding in women

Remember: You cannot stop internal bleeding. You can only treat its symptoms and arrange for immediate ambulance transport to an appropriate medical facility.

The treatment of shock resulting from internal blood loss consists of many of the same steps as for other types of shock:

1. Keep the patient lying down. Elevate the legs 12 to 18 inches off the floor or ground.
2. Maintain the patient's ABCs.
3. Maintain the patient's normal body temperature.
4. Make sure the patient does not eat or drink anything.
5. Provide reassurance.
6. Keep the patient quiet and do any necessary moving for him or her.
7. Provide a high flow of oxygen as soon as it is available.

SIGNS and SYMPTOMS

1. *Coughing or vomiting blood*
2. *Abdominal tenderness, rigidity, or distension*
3. *Rectal bleeding*
4. *Vaginal bleeding in women*
5. *Confusion**
6. *Rapid pulse**
7. *Cold and clammy skin**
8. *Rapid breathing**
* *These are also signs and symptoms of shock.*

Fig. 12.8 Signs and symptoms of internal blood loss.

 Focus on Treatment

 Focus on Treatment

Pressure points Points where a blood vessel lies near a bone; pressure can be applied to these points to help control bleeding.

Capillary bleeding Bleeding from the capillaries in which blood oozes from the open wound.

Venous bleeding External bleeding from a vein, characterized by steady flow; the bleeding may be profuse and life threatening.

Arterial bleeding Serious bleeding from an artery in which blood frequently pulses or spurts from an open wound.

Fig. 12.9 External bleeding.

8. Monitor the patient's vital signs at least every 5 minutes.

9. Arrange for prompt ambulance transportation to an appropriate medical facility.

Shock Caused by External Blood Loss

The treatment of shock resulting from external blood loss consists of the following steps:

1. Control bleeding by applying direct pressure on the wound, elevating the injured part, and using **pressure points** (compressing a major artery against the bone). This is the most important step.

2. Make sure the patient is lying down. Elevate the legs 12 to 18 inches off the floor or ground.

3. Maintain the patient's ABCs.

4. Maintain the patient's body temperature.

5. Make sure the patient does not eat or drink anything.

6. Provide reassurance.

7. Provide a high flow of oxygen as soon as it is available.

8. Arrange for prompt ambulance transportation to an appropriate medical facility.

Bleeding

Controlling External Blood Loss

There are three types of external blood loss: capillary, venous, and arterial (Figure 12.9).

The most common type of external blood loss is **capillary bleeding.** In capillary bleeding, the blood oozes out (such as from a cut finger). You can control capillary bleeding simply by applying direct pressure to the site.

The next most common type of bleeding is **venous bleeding.** This bleeding has a steady flow. Bleeding from a large vein may be profuse and life threatening. To control venous bleeding, apply direct pressure.

The most serious type of bleeding is **arterial bleeding.** Arterial blood spurts or surges from the laceration or wound with each heartbeat. Blood

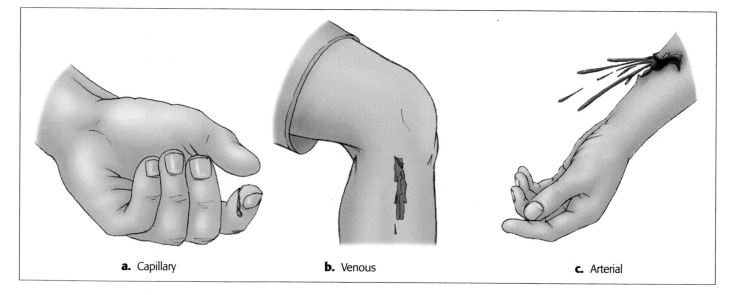

a. Capillary **b.** Venous **c.** Arterial

pressure in arteries is higher than in capillaries or veins, and unchecked arterial bleeding can result in death from loss of blood in a short time. To control arterial bleeding, exert direct pressure and, if necessary, apply pressure to a pressure point. This is done by compressing a major artery against the underlying bone.

Because many patients who die from injuries die from shock caused by blood loss, it is vitally important that you control external bleeding quickly. Three methods of controlling external bleeding are:

1. Application of direct pressure
2. Elevation of the body part
3. Application of pressure at a pressure point

Direct Pressure

Most external bleeding can be controlled by applying direct pressure to the wound. Place a dry, sterile **dressing** directly on the wound and press on it with your gloved hand (Figure 12.10). Wear the gloves from your first responder life support kit. If you do not have a sterile dressing or gauze bandage, use the cleanest cloth available.

To maintain direct pressure on the wound, wrap the dressing and wound snugly with a roller gauze bandage. Do not remove a dressing after it has been placed, even if it becomes blood soaked. Place another dressing on top of the first and keep them both in place.

In rare cases when no gloves or other barrier are available, you may have to place your bare hand directly on the wound to control the bleeding. According to the American Medical Association, it is extremely unlikely that you—as a first responder providing emergency care—will contract AIDS from a patient who is bleeding. For more information, call the Centers for Disease Control National AIDS Hotline at 1-800-342-AIDS. Direct exposure to blood must be reported to the emergency physician.

Elevation

If direct pressure does not stop external bleeding from an extremity, elevate the injured arm or leg while maintaining direct pressure. Elevation, in conjunction with direct pressure, will usually stop severe bleeding (Figure 12.11).

Pressure Points

If the combination of direct pressure and elevation does not control bleeding from an arm or leg wound, you must try to control it indirectly by preventing blood from flowing into the limb. This is accomplished by compressing a major artery against the bone at a pressure point.

Compressing the artery at its pressure point stops blood flow in much the same way that stepping on a garden hose stops the flow of water. Although there are several pressure points in the body, the **brachial artery pressure point** (in the upper arm) and the **femoral artery pressure point** (in the groin) are the most important (Figure 12.12).

Dressing A bandage.

Brachial artery pressure point Pressure point located in the arm between the elbow and the shoulder; also used in taking blood pressure and for checking the pulse in infants.

Femoral artery pressure point Pressure point located in the groin, where the femoral artery is close to the skin.

Fig. 12.10 Applying direct pressure to a wound.

Fig. 12.11 Applying direct pressure to a wound.

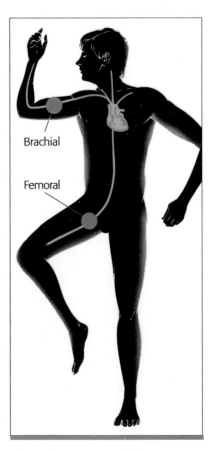

Brachial

Femoral

Fig. 12.12 The location of the brachial and femoral pressure points.

Fig. 12.13 Applying pressure to the brachial artery.

SAFETY PRECAUTION
Before you touch blood, put on gloves and other precautionary devices, as necessary.

In applying pressure to the brachial artery, you should remember the words "slap, slide, and squeeze." Proceed as follows:

1. Position the patient's arm so the elbow is bent at 90 degrees and the upper arm is held away from the patient's body.
2. Gently "slap" the inside of the biceps with your fingers halfway between the shoulder and the elbow to push the biceps out of the way.
3. "Slide" your fingers up to push the biceps away.
4. "Squeeze" (press) your hand down on the humerus (upper arm bone). You should be able to feel the pulse as you press down.

If the patient is in a sitting position, "squeeze" by placing your fingers in the manner just described and your thumb on the opposite side of the patient's arm. If done properly, this technique (in combination with direct wound pressure and elevation) will quickly stop any bleeding below the point of application (Figure 12.13).

The femoral artery pressure point is more difficult to locate and squeeze. Proceed as follows:

1. Position the patient on his or her back and kneel next to the patient's hips, facing the patient's head. You should be on the side of the patient opposite the extremity in which you want to stop the bleeding.
2. Find the pelvis and place the little finger of the hand closest to the injured leg along the anterior crest on the injured side (Figure 12.14A).
3. Rotate your hand down firmly into the groin area between the genitals and the pelvic bone. This compresses the femoral artery and usually stops the bleeding when combined with elevation and direct pressure over the bleeding site (Figure 12.14B). If you are using correct technique, pressure is exerted by your body weight.
 Note: Do not hesitate to lean into the pressure point.
4. If the bleeding does not slow immediately, reposition your hand and try again.

Remember: In applying femoral pressure, you must face the patient, kneel on the side opposite the injury, and use the hand closest to the injury to stop the bleeding.

Fig. 12.14 Locating and applying pressure to the femoral artery.

A. Locate the femoral pressure point

B. Apply pressure to the femoral artery.

CAUTION

A word about tourniquets: *No!*

Tourniquets are mentioned only to discourage their use. A tourniquet is made of a band of material that is placed around an arm or leg above a wound and is used to stop severe bleeding. Tourniquets are difficult to make from improvised materials. They are also difficult to apply properly. If a tourniquet is applied improperly, it can actually increase bleeding. Tourniquets are almost never needed to control external hemorrhage. You should concentrate on the combined use of direct pressure, elevation of arms or legs, and pressure points to control bleeding.

Check Point

✓ Describe three major causes of shock and outline the treatment for each.

Body Substance Isolation and Bleeding Control

Certain communicable diseases such as hepatitis or AIDS can be spread by contact with blood from an infected person. This risk is greatly increased when the infected blood contacts a cut or an open sore on your skin. Although the risk of contracting hepatitis or AIDS through intact skin is small, you should minimize this risk as much as possible by wearing vinyl or latex gloves whenever you might come in contact with a patient's blood or bodily fluids (Figure 12.15). These gloves should be carried on top of your first responder life support kit or in a pouch on your belt for quick access (Figure 12.16). If you do get blood on your hands, wash it off as soon as possible with soap and water. If you are in the field and cannot wash your hands, you can use a waterless hand-cleaning solution that contains an effective germ-killing agent.

Fig. 12.15 Putting on gloves.

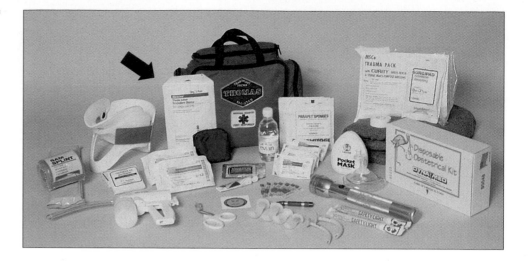

Fig. 12.16 Keep your gloves on top in your first responder life support kit.

Wounds

A wound is an injury caused by any physical means that leads to damage of a body part. Wounds are classified as closed or open. In the instance of a **closed wound**, the skin remains intact; in an **open wound**, the skin has been disrupted.

Closed Wounds

The only closed wound is the **bruise** (contusion). A bruise is an injury of the soft tissue beneath the skin. Because small blood vessels are broken, the injured area becomes discolored and swells. The severity of these closed soft tissue injuries varies greatly. A simple bruise heals quickly. In contrast, bruising and swelling following an injury may also be a sign of an underlying fracture that could take months to heal. Whenever you encounter a significant amount of swelling or bruising, suspect the possibility of an underlying fracture.

Open Wounds

There are four major types of open wounds (Figures 12.17–12.20):

1. Abrasion
2. Puncture
3. Laceration
4. Avulsion

Abrasion

Abrasions are commonly called scrapes, **road rashes,** or rug burns. They occur when the skin is rubbed across a rough surface.

Puncture

Puncture wounds are caused by a sharp object that penetrates the skin. Such wounds may cause significant deep injury that is not immediately recognized. These types of wounds do not bleed freely. If an object causing a puncture wound remains sticking out of the skin, it is called an **impaled object.**

Closed wound Injury in which soft tissue damage occurs beneath the skin but there is no break in the surface of the skin.

Open wound Injury that breaks the skin or mucous membrane.

Bruise Injury caused by a blunt object striking the body and crushing the tissue beneath the skin. Also called a contusion.

Abrasion Loss of skin as a result of a body part being rubbed or scraped across a rough or hard surface.

Road rash An abrasion caused by sliding along a highway. Usually seen after motorcycle or bicycle accidents.

Puncture A wound resulting from a bullet, knife, ice pick, splinter, or any other pointed object.

Impaled object An object such as a knife, splinter of wood, or glass that penetrates the skin and remains in the body.

Fig. 12.17 Abrasions involve variable depths of the skin; they are often called scrapes or road rashes.

A **gunshot wound** is a special type of puncture wound. The amount of damage done by a gunshot depends on the type of gun used and the distance between the gun and the victim. Some gunshot wounds are smaller than a dime, and some are large enough to destroy significant amounts of tissue. Gunshot wounds usually consist of both an **entrance wound** and an **exit wound.** The entrance wound is usually smaller than the exit wound. Most deaths from gunshot wounds result from internal blood loss caused by damage to internal organs and major blood vessels. A gunshot wound may appear as an insignificant hole but may do massive damage to internal organs. There

Gunshot wound A puncture wound caused by a bullet or shotgun pellet.

Entrance wound Point where an injurious object such as a bullet enters the body.

Fig. 12.18 Puncture wounds may penetrate the skin to any depth.

Fig. 12.19 Lacerations are cuts produced by sharp objects.

Exit wound Point where an injurious object such as a bullet passes out of the body.

Laceration An irregular cut or tear through the skin.

Fig. 12.20 Avulsions raise flaps of tissue, usually along normal tissue planes.

is often more than one gunshot wound. A thorough patient examination is important to be sure that you have discovered all of the entrance and exit wounds.

Laceration

The most common type of open wound is a **laceration.** Lacerations are commonly called cuts. Minor lacerations may require little care, but large lacerations can cause extensive bleeding and even be life threatening.

Avulsion

An **avulsion** is a tearing away of body tissue. The avulsed part may be totally severed from the body or it may be attached by a flap of skin. Avul-

sions may include small or large amounts of tissue. If an entire body part is torn away, the wound is called a traumatic amputation (Figure 12.21). Any amputated body part should be located, placed in a clean plastic bag, kept cool, and taken with the patient to the hospital for possible reattachment (reimplantation).

Principles of Wound Treatment

Very minor bruises need no treatment. Other closed wounds should be treated by the application of ice, gentle compression, and elevation of the injured part. Because extensive bruising may indicate an underlying fracture, all contusions should be **splinted.** (See Chapter 13.)

The major principles of open-wound treatment are to:

- Control bleeding.
- Prevent further contamination of the wound.
- **Immobilize** the injured part.
- Stabilize any impaled object.

It is important that bleeding be stopped as quickly as possible using the cleanest dressing that is available. Control of bleeding can usually be accomplished by covering an open wound with a dry, clean, or sterile dressing and applying pressure with your hand to the dressing. If the first dressing does not control the bleeding, it should be reinforced with a second layer. Further steps in bleeding control include elevation of an extremity and the use of pressure points.

A dressing should cover the entire wound to prevent further contamination. Do not attempt to clean the contaminated wound in the field, as cleaning will only cause more bleeding. A thorough cleaning will be done at the hospital. All dressings should be secured in place by a compression bandage.

Learning to dress and bandage wounds requires practice. As a trained first responder, you should be able to bandage all parts of the body quickly and competently (Figure 12.22).

Dressing and Bandaging Wounds

Dressing and bandaging are done to:

- Control bleeding.
- Prevent further contamination.
- Immobilize the injured area.
- Prevent movement of impaled objects.

Dressings

A dressing is an object placed directly on a wound to control bleeding and prevent further contamination. Once a dressing is in place, apply firm direct manual pressure on it to stop the bleeding. It is important that severe bleeding be stopped as quickly as possible using the cleanest dressing available. If no equipment is available, you may have to apply direct pressure with your hand to a wound that is bleeding extensively, even though gloves should normally be used.

Sterile dressings come packaged in many different sizes. Three of the most common sizes are 4-inch by 4-inch gauze squares (commonly known as

Fig. 12.21 An amputated finger.

Focus on Assessment

Avulsion An injury in which a piece of skin is either torn completely loose from all of its attachments or is left hanging as a flap.
Splinting Immobilizing an injured part by using a rigid or soft support splint.
Immobilize To reduce or prevent movement of a limb, usually by splinting.

SAFETY PRECAUTION
Direct exposure to blood must be reported to the emergency physician.

Fig. 12.22 Head bandage.

Fig. 12.23 Common sizes of wound dressings are 4"×4", 5"×9", and 10"×30".

Fig. 12.24 Open package containing a sterile dressing carefully.

Fig. 12.25 Improvised dressings may include a towel or clean handkerchief.

Cravat A triangular swathe of cloth that is used to hold a body part splinted against the body.

Fig. 12.26 (left) Roller gauze bandage.

Fig. 12.27 (right) Triangular bandage.

4×4s). Heavier pads measure 5 inches by 9 inches (5×9s). A trauma dressing is a thick sterile dressing that measures 10 inches by 30 inches. Use a trauma dressing to cover a large wound on the abdomen, neck, thigh, or scalp—or as padding for splints (Figure 12.23).

When you open a package containing a sterile dressing, touch only one corner of the dressing (Figure 12.24). Place it on the wound without touching the side of the dressing that will touch the wound. If bleeding continues after you have placed a compression dressing on the wound, put additional gauze pads over the original dressing. Do not remove the original dressing because the blood-clotting process has already started and should not be disrupted. If commercially prepared dressings are not available, use the cleanest cloth object available. You could also use a clean handkerchief, wash cloth, disposable diaper, or article of clothing (Figure 12.25). When you are satisfied that the wound is sufficiently dressed, proceed to bandage.

Bandaging

A bandage is used to hold the dressing in place. Two types of bandages are commonly used in the field: roller gauze and triangular bandages. The first type, conforming roller gauze, stretches slightly and is easy to wrap around the body part (Figure 12.26). Triangular bandages are usually 36 inches across (Figure 12.27). A triangular bandage can be folded and used as a wide **cravat**, or it can be used without folding (Figure 12.28). Roller gauze is easier to apply and stays in place better than a triangular bandage, but a triangular bandage is very useful for bandaging scalp lacerations and lacerations of the chest, back, or thigh.

Fig. 12.28 Folding a triangular bandage to make a cravat.

You must follow certain principles if the bandage is to hold the dressing in place, control bleeding, and prevent further contamination. Before you apply a bandage, check to ensure that the dressing completely covers the wound and extends beyond all sides of the wound (Figure 12.29). Wrap a bandage just tightly enough to control bleeding. Do not apply it too tightly because it may cut off all circulation. It is important to check circulation distal (away from the heart) to the point of injury at regular intervals because swelling may occur, making the bandage too tight. If this happens while the patient is under your care, remove the roller gauze or triangular bandage and reapply it, making sure that you do not disturb the dressing beneath.

Once bandaging is complete, secure the bandage so it cannot slip. Also make sure that any loose ends have been secured by taping, tying, or tucking. Figures 12.31 through 12.39 show how to dress and bandage wounds of various parts of the body. Practice these bandaging techniques for several types of wounds using both roller gauze and triangular bandages. Although bandaging is easy, it does require a certain amount of practice, especially on the more difficult body parts.

Fig. 12.29 Check to make sure the dressing completely covers the wound.

Fig. 12.30 Always wear gloves when in contact with body fluids.

Body Substance Isolation Techniques for the First Responder

Providing for your own safety and that of patients is always a high priority when you are examining and treating open wounds. Some infectious disease organisms, including the hepatitis and AIDS viruses, can be transmitted if blood from an infected person enters the bloodstream of a healthy person through a small cut or opening in the skin. Because you may have such a cut, it is important that you wear gloves to avoid contact with patients' blood (Figure 12.30). The use of gloves also protects wounds from being contaminated by dirt or infectious organisms you may have on your hands. Vinyl or latex medical gloves can be stored on the top of your first responder life support kit or in a pouch on your belt, where they will be readily available. (See Chapters 2 and 9 for more information on infectious diseases.)

Specific Wound Treatment

Face and Scalp Wounds

The face and scalp have many blood vessels. Because of this generous blood supply, a relatively small laceration can result in a large amount of bleeding. Although face and scalp lacerations may not be life threatening, they are always bloody and cause much anxiety for the patient and the first responder.

You can control almost all bleeding from the scalp and face by applying direct manual pressure. Direct pressure is effective because the skull is located under the skin. By applying direct pressure over the wound, you can compress blood vessels against the skull, stopping the bleeding. If bleeding continues, do not remove the dressing. Instead, reinforce it with a second layer and continue to apply manual pressure. Once the bleeding has stopped, wrap the head with a bandage (Figure 12.31).

For cheek wounds, hold a gauze pad inside the cheek (in the mouth). If necessary, also hold a pad outside the cheek. Always keep the airway open.

Severe scalp lacerations may be associated with skull fractures or even brain injury. If any brain tissue or bone fragment is visible, do not apply pressure to the wound. Instead, cover the wound loosely, being careful not to exert direct pressure on the brain or the bone fragments.

If the patient has a head injury, the neck and spine may also be injured. Move the head as little as possible and stabilize the neck. (Treatment of spinal injuries is discussed in Chapter 13.)

Fig. 12.31 Bandaging a head wound.

In cases of head injury, always evaluate the patient's level of consciousness. Carefully monitor the patient's airway and breathing and protect the spine.

Nosebleeds

Nosebleeds can result from injury or high blood pressure. In some cases, there is no apparent cause. A nosebleed with no apparent cause is called a **spontaneous nosebleed.** In a patient with high blood pressure, increased pressure in the small blood vessels of the nose may cause one to rupture, resulting in bleeding. A patient with high blood pressure should be seen and treated by a physician.

Most nosebleeds can be controlled easily. Unless the patient is suffering from shock, seat the person and tilt the head slightly forward. This position keeps the blood from dripping down the throat. Swallowing blood may cause coughing or vomiting, making the nosebleed worse.

Once the patient is seated correctly, pinch both nostrils together for at least 5 minutes. The patient may wish to do this without assistance. This treatment usually controls nosebleeds (Figure 12.32). If a nosebleed persists or is very severe, arrange to have the patient transported to an appropriate medical facility. Instruct the patient to avoid blowing his or her nose because this will often cause additional bleeding.

Remember: Any patient you think may have high blood pressure must be evaluated in the hospital.

Eye Injuries

All eye injuries are potentially serious and require medical evaluation. When an eye laceration is suspected, cover the entire eye with a dry gauze pad. Have the patient lie on his or her back and arrange for transport to an appropriate medical facility.

Occasionally an object will be impaled in the eye. Immediately place the patient on his or her back and cover the injured eye with a dressing and a paper cup so the impaled object cannot move. Bandage both eyes. This is important because both eyes move together, and if the patient attempts to look at something with the uninjured eye, the injured eye will move also, aggravating the injury (Figure 12.33). Arrange for transport of the patient to the hospital.

Note: Whenever you must bandage both eyes, explain to the patient why you are doing so. Having both eyes covered can be very distressing. Stay with the patient to help reassure him or her.

Spontaneous nosebleed A nosebleed with no apparent cause.

Fig. 12.32 Controlling a nosebleed.

- Transportation to an appropriate medical facility
- Prompt transportation to an appropriate medical facility
- Rapid transportation to an appropriate medical facility

Fig. 12.33 Bandaging an eye wound.

Fig. 12.34 Bandaging a neck wound.

Neck Wounds

The neck contains many important structures: the trachea, the esophagus, large arteries, veins, muscles, vertebrae, and the spinal cord. Because an injury to any of these structures may be life threatening, all neck injuries are serious.

Use direct pressure to control bleeding neck wounds. Once bleeding is controlled, bandage the neck (Figure 12.34). In rare cases, you may have to exert finger pressure above and below the injury site to prevent further neck bleeding.

Always keep in mind that major trauma to the neck may be associated with airway problems and with neck fracture or spinal cord injury. Therefore, maintain the patient's airway and stabilize the head and neck.

Chest Wounds and Back Wounds

The major organs affected by chest wounds and back wounds are the lungs, large vessels, and heart. Any wound involving these organs is a life-threatening injury. If a lung is punctured, air can escape from the lung, causing it to collapse. The patient may cough up bright red blood. To help maintain air pressure in the lung, your first act should be to cover any open chest wound with an airtight material, sealing it. This covering is called an **occlusive dressing.** Use a clear plastic cover from your medical supplies, aluminum foil, plastic wrap, or a special dressing that has been impregnated with petroleum jelly (Vaseline). Any material that will occlude (seal off) the wound is sufficient (Figure 12.35). Place the patient with a chest injury in a comfortable position (usually sitting). (See Chapter 13.)

Administration of oxygen is important early treatment for an injured lung. It should be given by EMS personnel when they arrive or by first responders who are trained and have the equipment available.

Chest wounds may also damage the heart. Seal the wound in the manner described. Monitor the patient's airway, breathing, and circulation. Treat the patient for shock and perform CPR, if necessary.

Impaled Objects

If an object is impaled in the patient, apply a stabilizing dressing and arrange for the patient's immediate transport to an appropriate medical facility. Sometimes an impaled object is too long to permit the patient to be removed from the accident scene and transported to an appropriate medical facility. In these cases, it may be necessary to stabilize the impaled object and carefully cut it close to the patient's body. If you encounter a situation like this, stabilize the impaled object as well as you can and immediately request a specialized rescue team that has the tools and training to handle such a situation.

Occlusive dressing An airtight dressing or bandage for a wound.

Fig. 12.35 For occlusive dressings, use plastic, petroleum jelly, or gloves.

If you find the patient with a knife or other object protruding from the abdomen, do not attempt to remove it. Rather, support the impaled object so it cannot move. Place a large roll of gauze on either side of it and secure the rolls with additional gauze wrapped around the body. It is important to stabilize the object so it will not move while the patient is being transported to the hospital (Figure 12.36). Any movement of the object may cause further internal damage.

Closed Abdominal Wounds

Closed abdominal wounds occur commonly as the result of a direct blow from a blunt object. You should check for a closed abdominal wound whenever force has been applied to the abdomen. Look for bruises or other marks on the abdomen that indicate blunt injury.

Any time an injured patient suffers from shock, you should remember that there may be internal abdominal injuries accompanied by bleeding. When there is internal bleeding, the abdomen may become swollen, rigid, or even boardlike.

Treat patients with closed abdominal injuries and signs of shock by placing them on their backs with legs elevated at least 6 inches (unless they are having difficulty breathing). Conserve their body heat.

If the patient is vomiting blood (ranging in color from bright red to dark brown), it may be an indication of bleeding from the esophagus or stomach. Monitor the patient's vital functions carefully because shock may result. Give the patient nothing by mouth. Arrange for prompt transport to an appropriate medical facility.

Open Abdominal Wounds

Open abdominal wounds usually result from slashing with a knife or other sharp object and are always serious injuries.

Treatment for an open abdominal wound consists of the following steps:

1. Apply a dry, sterile dressing to the wound.
2. Maintain the patient's body temperature.
3. Place the patient on his or her back with the legs elevated.
4. Place the patient who is having difficulty breathing in a semireclining position.
5. Administer oxygen if it is available.

SAFETY PRECAUTION
Never remove an impaled object!

- Transportation to an appropriate medical facility
- Prompt transportation to an appropriate medical facility
- Rapid transportation to an appropriate medical facility

 Focus on Treatment

Fig. 12.36 Bandaging an impaled object.

Fig. 12.37 Bandaging an open abdominal wound.

If the intestines are protruding from the abdomen, place the patient on his or her back with the knees bent, to relax the abdominal muscles. Cover the injured area with a sterile dressing (Figure 12.37). Do not attempt to replace the intestines inside the abdomen.

A bandage for intestines protruding from the abdomen is made from a large trauma pad (10 × 30 inches) and several cravats. Position the trauma pad to cover the whole area of the wound. Place two or three wide cravats loosely over the trauma pad just tightly enough to keep it firmly in place, but not tightly enough to push the intestines back into the abdomen.

Saline Salt water.

EMTs and paramedics carry sterile **saline** (salt water), which can be poured on the dressing to keep the protruding organs moist so they do not dry out. Only sterile saline should be used.

Genital Wounds

Both male and female genitals have a rich blood supply. Injury to the genitals can often result in severe bleeding. Apply direct pressure to any genital wound with a dry, sterile dressing. Direct pressure usually stops the bleeding. Although it may be socially awkward to examine the patient's genital area to determine the severity of the injury, you must do so if you suspect such injuries. The patient can suffer a critical loss of blood if you do not find the injury and control the bleeding.

Extremity Wounds

To treat all open extremity wounds, you should apply a dry, sterile compression dressing and bandage it securely in place (Figures 12.38 and 12.39). Elevation of the injured part decreases bleeding and swelling. You should splint all injured extremities prior to transport because of the possibility of an underlying fracture.

Fig. 12.38 Bandaging a hand wound.

Fig. 12.39 Bandaging extremity wounds.

Gunshot Wounds

Some gunshot wounds are easy to miss unless you perform a thorough patient examination. Most deaths from gunshot wounds result from internal blood loss caused by damage to internal organs and major blood vessels. Because gunshot wounds are so serious, it is important that prompt and effective treatment be performed. Gunshot wounds of the trunk and neck are a major cause of spinal cord injuries. Because you cannot tell where the bullets have gone, you should treat these patients for spinal cord injuries.

Treatment for gunshot wounds consists of the following steps:

1. Open the airway and establish adequate ventilation and circulation.
2. Control any external bleeding by covering wounds with sterile dressings and apply pressure with your hand or with a bandage.
3. Examine the patient thoroughly to be sure you have discovered all entrance and exit wounds.
4. Treat for symptoms of shock by:
 a. Maintaining the patient's body temperature.
 b. Placing the patient on his or her back with the legs elevated 6 inches.
 c. Placing a patient who is having difficulty breathing in a semireclining position.
 d. Administering oxygen, if available.
5. Arrange for prompt transportation of the patient to an appropriate medical facility.
6. Perform CPR if the patient's heart stops as a result of loss of blood.

Bites

Bites from animals or humans may range from minor to severe. All bites have a high chance of causing infection. Bites from an unvaccinated animal may cause **rabies.** Minor bites can be washed with soap and water, if it is available. Major bite wounds should be treated by controlling the bleeding and applying a suitable dressing and bandage.

 Focus on Treatment

- Transportation to an appropriate medical facility
- Prompt transportation to an appropriate medical facility
- Rapid transportation to an appropriate medical facility

Rabies An acute viral infection of the central nervous system transmitted by the bite of an infected animal.

All patients who have been bitten by an animal or another person must be treated by a physician. In most states, EMS personnel are required to report animal bites to the local health department or a law enforcement agency. You should check the laws in your local area to determine requirements.

Check Point

✓ List and describe the four principles of wound treatment.

Burns

The skin serves as a barrier that prevents foreign substances, such as bacteria, from entering the body. It also prevents the loss of body fluids. When the skin is damaged, such as by a burn, it can no longer perform these essential functions.

Burns are classified according to the following characteristics:

- Depth
- Extent (amount of the body injured by the burn)
- Cause or type

Depth of Burns

A burn is classified by depth as superficial or first-degree burns, partial-thickness or second-degree burns, and full-thickness or third-degree burns. Although it is not always possible to determine the exact degree of a burn injury, it is important that the first responder understand this concept.

In cases of **superficial** or first-degree **burns**, the skin is reddened and painful. The injury is confined to the outermost layers of skin, and the patient experiences minor to moderate pain. An example of a superficial burn is a sunburn, which usually heals in about one week, with or without treatment (Figure 12.40).

Partial-thickness or second-degree **burns** are somewhat deeper but do not damage the deepest layers of the skin (Figure 12.41). Blistering is present, although in some cases blisters may not form for several hours. Fluid loss may occur and pain is moderate to severe because the nerve endings are damaged. Partial-thickness burns require medical treatment. They usually heal within two to three weeks.

Superficial burns Burns in which only the superficial part of the skin has been injured; an example is a sunburn.

Partial-thickness burns Burns in which the outer layers of skin are burned; these burns are characterized by blister formation.

Fig. 12.40 Superficial, or first-degree, burn.

Fig. 12.41 Partial-thickness, or second-degree, burn.

Fig. 12.42 Full-thickness, or third degree, burn.

Full-thickness or third-degree **burns** damage all layers of the skin, and in some cases the damage is deep enough to injure and destroy underlying muscles and other tissues (Figure 12.42). Pain is often absent because the nerve endings have been destroyed. Because the skin has been destroyed, patients who have suffered extensive full-thickness burns lose large quantities of body fluids and are susceptible to shock and infection.

Full-thickness burns Burns that extend through the skin and into or beyond the underlying tissues; the most serious class of burn.

Extent of Burns

The **Rule of Nines** is a method for determining what percentage of the body has been burned. Although this rule is most useful for EMTs and paramedics who report information to the hospital from the field, first responders should be able to roughly estimate the extent of a burn.

Figure 12.43 shows the various divisions that have been made for the Rule of Nines. In an adult, the head and arms each equal 9 percent of the total body surface. The front and back of the trunk and each leg are equal to 18 percent of the total body surface.

For example, if one-half of the back and all of the right arm of a patient are burned, the burn involves about 18 percent of the total body area. The Rule of Nines is slightly modified for young children, but the adult figures serve as an adequate guide.

Rule of Nines A way to calculate the amount of body surface burned; the body is divided into sections, each of which constitutes approximately 9 or 18 percent of the total body surface area.

Cause or Type of Burns

Burns are injuries to the skin and the underlying tissues and are caused by exposure to the following elements:

- Heat (thermal burns)
- Chemicals
- Electricity

Fig. 12.43 Use the Rule of Nines to determine the extent of burns.

Fig. 12.44 Sterile burn sheet.

Thermal Burns

Thermal burns are caused by heat. The first step when treating thermal burns is to put out the fire. Superficial burns can be quite painful, but if there is clean, cold water available, placing the burning area in cold water helps to reduce pain. Clean towels wet with cold water can also be placed on superficial burns. Once the burned area has been cooled, cover it with a dry, sterile dressing or the large sterile cloth (found in your first responder life support kit) called a burn sheet (Figure 12.44).

> ## ▼ CAUTION
> **Do not apply burn ointments, butter, grease, or cream to any burn!**

Partial-thickness burns should be cooled if the burn area is still warm. Cooling does several things: it helps reduce pain and it actually stops the heat from cooking the skin. Cooling also helps stop the swelling caused by partial-thickness burns.

If blisters are present, handle the skin very carefully to prevent breaking the blisters. Intact skin, even if blistered, provides an excellent barrier against infection. If the blisters are broken, the danger of infection increases. Cover partial-thickness burns with a dry, sterile dressing or burn sheet.

Full-thickness burns, if still warm, should also be cooled with water to keep the heat from damaging more skin and tissue. Remove clothing by cutting it away from the burned area. However, leave any clothing that is stuck to the burn. Cover full-thickness burns with a dry, sterile dressing or burn sheet (Figure 12.45).

Patients who have suffered large superficial burns and all patients with any amount of partial-thickness or full-thickness burns must be treated for shock and transported to a hospital.

Respiratory Burns

A burn to any part of the airway is a **respiratory burn** (Figure 12.46). If a patient has been burned around the head and face or while in a confined space (such as in a burning house), you should look for the following signs and symptoms of respiratory burns:

- Singed nose hairs
- Blackened nasal mucus
- Difficulty breathing
- Pain while breathing
- Burns around the face
- Unconsciousness as a result of fire

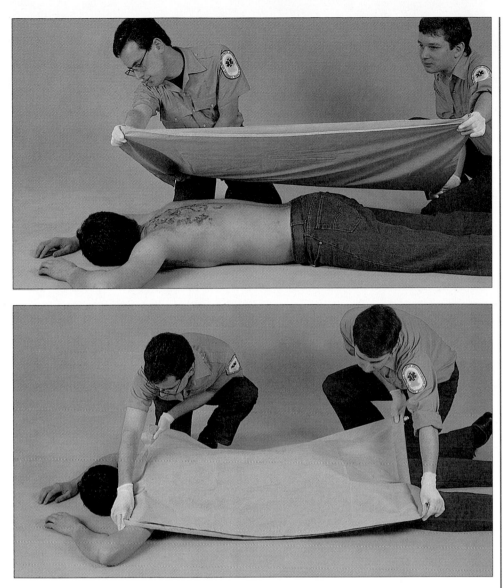

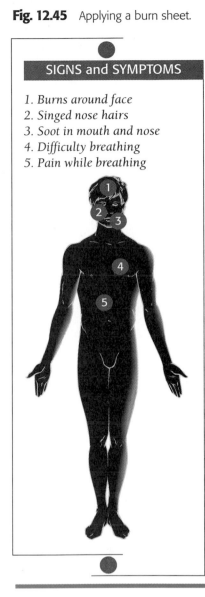

Fig. 12.45 Applying a burn sheet.

SIGNS and SYMPTOMS

1. *Burns around face*
2. *Singed nose hairs*
3. *Soot in mouth and nose*
4. *Difficulty breathing*
5. *Pain while breathing*

Watch the patient carefully. Breathing problems that result from this type of burn can develop rapidly or slowly over several hours. Administer oxygen as soon as it is available and be prepared to perform CPR. If you suspect that a patient has suffered respiratory burns, arrange for prompt transport to a medical facility.

If the patient has injuries in addition to the burn injuries, treat them before the patient is transported. For example, if a patient has suffered a partial-thickness burn of the arm and has also fallen off a ladder and fractured both legs, splint the fractures and place the patient on a backboard, in addition to treating the burn injury.

Chemical Burns

Many strong substances can cause **chemical burns** to the skin. Such chemicals include strong acids (such as battery acid) or strong alkalis (such as drain cleaners). The longer the chemical remains in contact with the skin, the more damage occurs to the skin and underlying tissues. Chemicals are extremely dangerous to the eyes and can cause superficial, partial-thickness, or full-thickness burns to the skin.

Fig. 12.46 Signs and symptoms of respiratory burns.

- Transportation to an appropriate medical facility
- Prompt transportation to an appropriate medical facility
- Rapid transportation to an appropriate medical facility

Thermal burns Burns caused by heat; the most common type of burn.
Respiratory burns Burns to the respiratory system resulting from inhaling superheated air.
Chemical burns Burns that occur when any toxic substance comes in contact with the skin. Most chemical burns are caused by strong acids or alkalis.

VOICES of EXPERIENCE

Paul Guns
EMT-P
Firefighter/Paramedic
Orange County Fire Authority
Orange County, California

"On Tuesday, March 22, 1994, while standing in line to order his dinner at a local fast-food restaurant, a 24-year-old male was approached by three men. As their conversation became increasingly heated, witnesses stated that it escalated into an argument and one of the men appeared to "take a punch" at the victim. Following this, the three men quickly ran out of the restaurant and fled in an awaiting car.

Meanwhile the victim was now staggering and holding the right side of his neck with his hands. Bright red blood was pouring profusely through his fingers, despite his attempts to stop his own bleeding. As he staggered outside, now appearing deathly pale and apparently ready to pass out, a businessman just arriving, jumped out of his car and yelled to the victim to lie down on the ground before he passed out. As the victim lay down, the businessman ran to the trunk of his car and retrieved a large towel, which he then used to apply direct pressure to the victim's neck while awaiting EMS.

Upon our arrival, we found the victim lapsing in and out of consciousness, having lost a significant amount of blood prior to the arrival of the first responder. If not for the first responder's immediate assistance, the victim would undoubtedly have bled to death.

We rapidly loaded the victim in the ambulance and en route to the trauma center began three large IVs, high-flow oxygen, and had a PASG put in place. With all the fluid we were giving the victim, we were able to stabilize his blood pressure upon arrival at the trauma center, buying precious minutes for our final team member, the trauma surgeon.

We later found out that the victim's right jugular vein had been 100 percent transected. This call is a classic example of how a medical emergency can be successfully managed when the pre-hospital care members utilize an effective team approach.

The first responder played an instrumental role as a member of our team. His unselfish, immediate actions literally saved this young man's life."

The initial treatment for chemical burns includes removing the patient from exposure to the chemical. You may have to ask the patient to remove all clothing. Then brush—*do not wash*—any dry chemical off the patient. Contact with water may activate the dry chemical and result in burning or a caustic reaction.

After all the dry chemical has been brushed off, flush the contaminated skin with abundant quantities of water. Flushing can be done with water from a garden hose, a shower in the home or factory, or even the booster hose of a fire engine. It is essential that the chemical be washed off the skin quickly to avoid further injury. After you have flushed the affected area of the body for at least 10 minutes, cover the burned area with a dry, sterile dressing or a burn sheet and arrange for prompt transport to an appropriate medical facility.

Chemical burns to the eyes cause extreme pain and severe injury. Gently flush the affected eye or eyes with water for at least 20 minutes (Figure 12.47). You must hold the eye open to allow water to flow over its entire surface. You should direct the water from the inner corner of the eye to the outward edge of the eye. You may have to put the patient's face under a shower, garden hose, or faucet so that the water flows across the patient's entire face. Flushing the eyes can continue while the patient is being transported.

After flushing the eyes for 20 minutes, loosely cover the injured eye or eyes with gauze bandages and arrange for prompt transport to an appropriate medical facility. All chemical burns should be examined by a physician. Some chemicals cause damage even if they are on the skin or in the eyes for only a short period of time.

Electrical Burns

Electrical burns can cause severe injuries or even death, but they leave little evidence of injury on the outside of the body. These burns are caused by electrical current that enters the body at one point (for example, the hand that touches the live electrical wire), travels through the body tissues and organs, and exits from the body at the point of ground contact (Figure 12.48).

The major damage caused by electricity is internal, rather than external. There is often major damage to muscles, nerves, blood vessels, and internal organs because a strong electrical current can actually cook the vital organs. Patients who have been subjected to a strong electrical current can also suffer irregularities of cardiac rhythm or even full cardiac arrest and death.

Children often suffer electrical burns to the mouth by chewing on an electrical cord (Figure 12.49). Although the burn may not look serious at first, it is often quite severe because of underlying tissue injury.

Persons who have been hit or nearly hit by lightning frequently suffer electrical burns. Treat such patients as you would electrical burn patients. Evaluate them carefully because they may also suffer cardiac arrest. Arrange for prompt transport to an appropriate medical facility.

Before you touch or treat a person who has suffered an electrical burn, be certain that the patient is not still in contact with the electrical power source

SAFETY PRECAUTION
Avoid direct or indirect contact with live electrical wires. Direct contact occurs when you touch a live electrical wire. Indirect contact occurs when you touch a vehicle, a patient, a fence, a tree, or other object that is in contact with a live electrical wire.

Fig. 12.47 Flushing the eyes with water.

- Transportation to an appropriate medical facility
- Prompt transportation to an appropriate medical facility
- Rapid transportation to an appropriate medical facility

Electrical burns Burns caused by electric current.

Fig. 12.48 Electrical burn.

Fig. 12.49 Electrical burns to the mouth may be severe.

that caused the burn. If the patient is still in contact with the power source, anyone who touches him or her may be electrocuted.

If the patient is touching a live power source, your first act must be to unplug, disconnect, or turn off the power (Figure 12.50). If this is not possible,

Fig. 12.50 Do not touch the patient without unplugging, disconnecting, or turning off the power first.

call for assistance from the power company or from a qualified rescue squad or fire department.

If a motor vehicle accident has caused a power line to come down on top of the vehicle, the people inside the vehicle must be told to stay there until qualified personnel can remove the hazard or turn the power off.

After ensuring that the power has been disconnected, examine each electrical burn patient carefully, assess the ABCs, and treat the patient for visible, external burns. Cover these external burns with a dry, sterile dressing and arrange for prompt transport to an appropriate medical facility.

Monitor the airway, breathing, and circulation of electrical burn patients closely and arrange to have such patients transported promptly to an emergency department for further treatment.

- Transportation to an appropriate medical facility
- Prompt transportation to an appropriate medical facility
- Rapid transportation to an appropriate medical facility

Focus on Assessment

Check ✔ *Point*

✔ Describe the importance of body substance isolation as it relates to the treatment of soft tissue injuries.

Summary

This chapter has covered the knowledge and skills you need to treat patients suffering shock, bleeding, and soft tissue injuries. Shock is the silent killer of trauma patients. You have reviewed the functions of the pump (heart), the pipes (blood vessels), and the fluid (the blood). If you understand the role of each component of the circulatory system, you can understand how shock is caused by pump failure, pipe failure, and fluid loss. It is important to learn the signs and symptoms of shock. You also need to understand the general treatment for it.

Four types of open wounds are defined and explained. You need to understand how to control external bleeding, the principles of wound treatment, and how to dress and bandage the types of wounds you may encounter as a first responder. Body substance isolation techniques are stressed and need to be used any time you are at risk for contact with a patient's bodily fluids.

Burns are a special type of soft tissue injury. You should understand how burns can be caused by heat, chemicals, or electricity and the complications that may go along with specific types of burns. As a first responder, you need to be able to recognize respiratory burns and provide initial care for them. The severity of burns is related to the depth and extent of the burn. It is important that you be able to estimate the severity of burns.

By learning to recognize and provide initial emergency treatment for patients suffering shock, soft tissue injuries, and bleeding, you will be able to provide physical and emotional assistance to these patients in their time of need. And, at times, your prompt recognition and treatment will make a real difference.

Abrasion—page 296

Anaphylactic shock—page 286

Arterial bleeding—page 292

Atrium—page 283

Avulsion—page 299

Blood pressure—page 286

Brachial artery pressure point—page 293

Bruise—page 296

Capillary bleeding—page 292

Cardiogenic shock—page 286

Chemical burns—page 311

Closed wound—page 296

Congestive heart failure (CHF)—page 286

Cravat—page 300

Dressing—page 293

Electrical burns—page 313

Entrance wound—page 298

Exit wound—page 299

Femoral artery pressure point—page 293

Full-thickness burns—page 309

Gunshot wound—page 298

Hemorrhage—page 286

Immobilize—page 299

Impaled object—page 297

Intravenous (IV) fluid—page 289

Laceration—page 299

Occlusive dressing—page 304

Open wound—page 296

Partial-thickness burns—page 308

Pneumatic antishock garment (PASG)—page 289

Pressure points—page 292

Psychogenic shock—page 286

Puncture—page 296

Rabies—page 307

Respiratory burns—page 311

Road rash—page 296

Rule of Nines—page 309

Saline—page 306

Shock—page 285

Splinting—page 299

Spontaneous nose-bleed—page 303

Superficial burns—page 308

Thermal burns—page 311

Venous bleeding—page 292

Ventricle—page 283

What Would You Do?

1. You are dispatched to an industrial accident. Upon arrival, you find a 23-year-old woman who has sustained a 6-inch-long laceration to her forearm. Blood is spurting from the wound. What would you do?

2. You are dispatched on a call for a man down. Upon arrival, you find a 31-year-old man lying on the sidewalk. He appears pale, sweaty, short of breath. He states he was shot by a person attempting to steal his wallet. What would you do?

3. You are dispatched to the scene of a house fire. Upon arrival, you find that the fire is under control. A 47-year-old woman has been removed from the house. She is coughing, short of breath, and has soot around her face. Her voice is hoarse. What do you suspect is wrong with the woman? What would you do?

1. The relationship between body substance isolation and bleeding.
2. The function and relationship between the following parts of the circulatory system:
 a. Pump (heart)
 b. Pipes (blood vessels)
 c. Fluid (blood)
3. How shock is caused by pump failure, pipe failure, and fluid loss.
4. The three types of shock caused by pipe failure.
5. The signs and symptoms of internal bleeding or shock.
6. The general treatment for internal bleeding or shock.
7. How to differentiate between arterial, venous, and capillary bleeding.
8. The emergency care for external bleeding.
9. How to use the femoral and brachial pressure points.
10. The relationship between body substance isolation and soft tissue injuries.
11. The four types of soft tissue injuries.
12. The principles of treatment for soft tissue injuries.
13. The functions of dressings and bandages.
14. The emergency medical care for patients with the following injuries:
 a. Face wounds
 b. Nosebleeds
 c. Eye injuries
 d. Neck wounds
 e. Chest and back wounds
 f. Impaled objects
 g. Closed abdominal wounds
 h. Open abdominal wounds
 i. Genital wounds
 j. Extremity wounds
 k. Gunshot wounds
 l. Bites
15. Why the use of a tourniquet is to be discouraged.
16. How the seriousness of a burn is related to the depth of the burn.
17. How the seriousness of a burn is related to the extent of the burn.
18. The signs and symptoms, and the possible complications associated with each of the following types of burns:
 a. Thermal burns
 b. Respiratory burns
 c. Chemical burns
 d. Electrical burns
19. The emergency treatment for each of the following types of burns:
 a. Thermal burns
 b. Respiratory burns
 c. Chemical burns
 d. Electrical burns

You Should Practice

1. Performing body substance isolation procedures for patients with wounds.
2. Treating patients with signs and symptoms of internal bleeding or shock.
3. Controlling bleeding using the following techniques:
 a. Direct pressure
 b. Elevation
 c. Femoral pressure point
 d. Brachial pressure point
4. Dressing and bandaging the following types of wounds:
 a. Face wounds
 b. Nosebleeds
 c. Eye injuries
 d. Neck wounds
 e. Chest and back wounds
 f. Impaled objects
 g. Closed abdominal wounds
 h. Open abdominal wounds
 i. Genital wounds
 j. Extremity wounds
 k. Gunshot wounds
 l. Bites
5. Performing emergency medical care for patients suffering the following types of burns:
 a. Thermal burns
 b. Respiratory burns
 c. Chemical burns
 d. Electrical burns

SKILL SCAN: Recognizing Types of External Bleeding

1.

2.

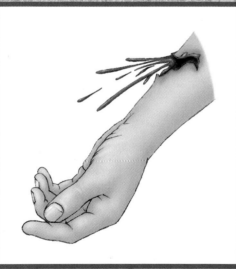

3.

1. Capillary
2. Venous
3. Arterial

1.

1. Direct pressure
2. Elevation
3. Brachial pressure point
4. Locate femoral pressure point
5. Apply pressure to femoral artery

2.

3.

4.

5.

1.

2.

3.

4.

5.

1. Abrasion
2. Puncture wounds
3. Laceration
4. Avulsions
5. Amputation

1.

2.

3.

1. Superficial, or first degree
2. Partial-thickness, or second degree
3. Full-thickness, or third degree

INJURIES TO MUSCLES AND BONES

Knowledge and Attitude Objectives *After studying this chapter, you will be expected to:*

1. Describe the anatomy and functions of the parts of the musculoskeletal system.
2. Describe the mechanism of injury for musculoskeletal injuries.
3. Define fracture, dislocation, and sprains.
4. Describe the need for body substance isolation techniques when examining and treating patients with musculoskeletal injuries.
5. Describe the importance of the following three steps when examining patients with musculoskeletal injuries:
 a. General assessment of the patient
 b. Examination of the injured part
 c. Evaluation of circulation and sensation
6. Describe the general principles of splinting.
7. Explain how to splint the following sites:
 a. Shoulder girdles
 b. Dislocation of the shoulder
 c. Elbow injuries
 d. Injuries of the forearm
 e. Injuries of the hand, wrist, and fingers
 f. Pelvic fractures
 g. Hip injuries
 h. Injuries of the thigh
 i. Knee injuries
 j. Leg injuries
 k. Injuries of the ankle and foot
8. Describe the mechanism for head and spine injuries.
9. Explain the two types of head injuries.
10. Describe the signs and symptoms of head injuries.
11. Describe the treatment of head-injured patients.
12. Describe the treatment of facial injuries.
13. Explain the mechanism of spine injuries.
14. Describe the signs and symptoms of spinal cord injuries.

15. Describe the treatment of spine injuries.
16. Describe the signs and symptoms, and treatment of the following injuries:
 a. Fractured ribs
 b. Flail chest
 c. Penetrating chest wounds

Skill Objectives *As a first responder, you should be able to:*

1. Perform body substance isolation techniques on a patient with musculoskeletal injuries.
2. Examine a patient with musculoskeletal injuries.
3. Evaluate the circulation and sensation of a patient with an extremity injury.
4. Splint the following musculoskeletal injuries:
 a. Shoulder girdle injuries
 b. Dislocation of the shoulder
 c. Elbow injuries
 d. Injuries of the forearm
 e. Injuries of the hand, wrist, and fingers
 f. Pelvic fractures
 g. Hip injuries
 h. Injuries of the thigh
 i. Knee injuries
 j. Leg injuries
 k. Injuries of the ankle and foot
5. Treat injuries of the face.
6. Stabilize spine injuries.
7. Treat the following injuries of the chest:
 a. Fractured ribs
 b. Flail chest
 c. Penetrating chest injuries

As a first responder, you will treat many patients who have suffered various types of musculoskeletal injuries. These include fractures, dislocations, sprains, head injuries, spinal cord injuries, and chest injuries. It is important that you understand the anatomy and functions of the parts of the musculoskeletal system. By studying the causes, or mechanisms of injury, you will gain a better understanding of the results of various injuries.

Before you can treat these injuries, you must be able to recognize the signs and symptoms of these musculoskeletal injuries and differentiate between open and closed injuries. Proper care given at the scene can prevent additional injury or disability. This chapter describes how to manage upper and lower extremity injuries, head injuries, spinal cord injuries, and chest injuries. Body substance isolation techniques and their relation to musculoskeletal injuries are also stressed.

The Anatomy and Function of the Musculoskeletal System

The musculoskeletal system consists of the skeletal system, which provides support and form for the body, and the muscular system, which provides both support and movement.

The Skeletal System

The skeletal system consists of 206 bones and is the supporting framework for the body. The four functions of the skeletal system are:

- To support the body
- To protect vital structures
- To assist in body movement
- To manufacture red blood cells

The skeletal system (Figure 13.1) is divided into seven areas:

1. Head, skull, and face
2. Spinal column
3. Shoulder girdle
4. Upper extremity
5. Rib cage, thorax
6. Pelvis
7. Lower extremity

The bones of the *head* include the skull and the lower jawbone. The skull consists of many bones fused together to form a hollow sphere that contains and protects the brain. The jawbone is a movable bone that is attached to the skull and completes the structure.

The *spine* is the second area of the skeletal system and consists of a series of separate bones called vertebrae. The spinal vertebrae are stacked on top of each other and are held together by muscles, tendons, disks, and ligaments. Each spinal vertebra has a hole in its center for the spinal cord, a group of nerves that carry messages to and from the brain, to pass through. The vertebrae provide excellent protection for the spinal cord.

In addition to protecting the spinal cord, the spine is the primary support structure for the entire body. The spine has five sections (Figure 13.2):

- Cervical spine (neck)
- Thoracic spine (upper back)
- Lumbar spine (lower back)
- Sacrum
- Coccyx (tailbone)

The *shoulder girdles* form the third area of the skeletal system. Each shoulder girdle gives support to the arm and consists of the collarbone (clavicle) and the shoulder blade (scapula).

The fourth major area of the skeletal system is the *upper extremity*, which consists of three major bones. The arm has one bone (the humerus), and the forearm has two bones (the radius and the ulna). The radius is located on the thumb side of the arm, whereas the ulna is located on the little-finger side.

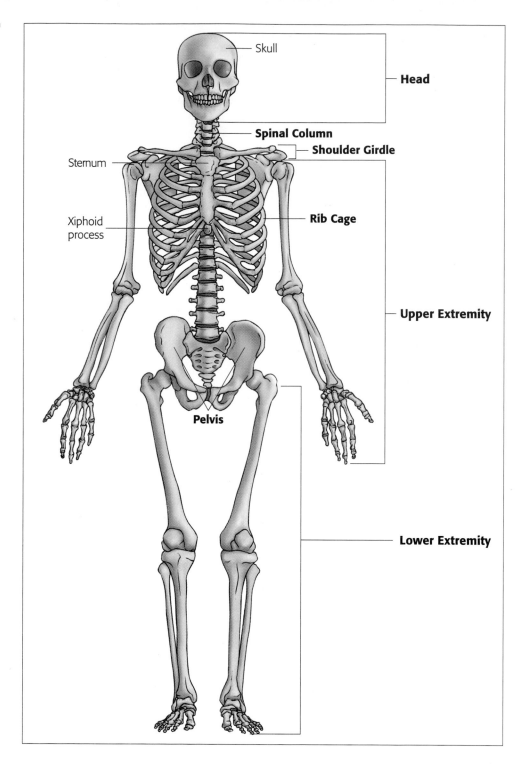

Fig. 13.1 The seven major areas of the human skeleton.

Skull

Head

Spinal Column

Shoulder Girdle

Sternum

Xiphoid process

Rib Cage

Upper Extremity

Pelvis

Lower Extremity

The wrist and hand are considered part of the upper extremity and consist of several bones, whose names you do not need to learn. You can consider these as one unit for the purposes of emergency treatment.

The fifth area of the skeletal system is the *rib cage* (chest). The 12 sets of ribs provide protection for the heart, lungs, liver, and spleen. All the ribs are attached to the spine (Figure 13.3). The upper five ribs connect directly to the sternum (breastbone). The ends of the sixth through tenth ribs are connected to each other and to the sternum by a bridge of cartilage. The eleventh and twelfth ribs are not attached to the sternum and are called floating ribs. The sternum is located in the front of the chest. The pointed structure at the bot-

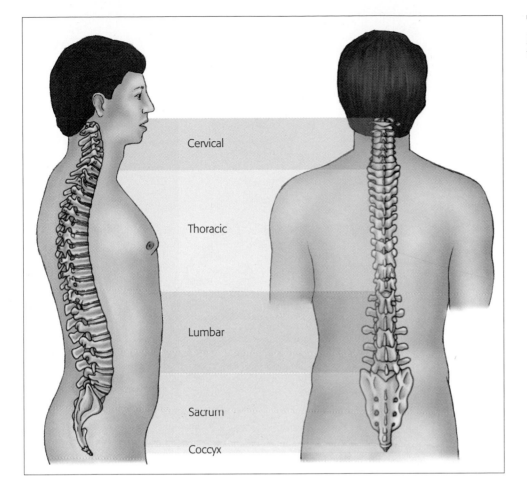

Fig. 13.2 The five sections of the spine.

Cervical

Thoracic

Lumbar

Sacrum

Coccyx

tom of the sternum is called the xiphoid process. The xiphoid process is an important location to remember because it is used for proper hand placement during cardiopulmonary resuscitation (CPR).

The sixth area of the skeletal system is the *pelvis*. The pelvis serves as the link between the body and the lower extremities. In addition, the pelvis protects the reproductive organs and the other organs located in the lower abdominal cavity.

Note: Each of the essential organs of the body is encased in a protective bony structure. The skull protects the brain. The vertebrae protect the spinal cord. The ribs protect the heart and lungs. The pelvic bones protect the lower abdominal and reproductive organs.

The *lower extremities* form the seventh area of the skeletal system. Each lower extremity consists of the thigh and the leg. The thigh bone (femur) is the longest and strongest bone in the entire body. The leg has two bones, the tibia and fibula. The kneecap (patella) is a small, relatively flat bone that protects the front of the knee **joint**. Like the wrist and hand, the ankle and foot contain a large number of smaller bones that you can consider as one unit.

A vital but often overlooked function of the skeletal system is the production of red blood cells. Red blood cells are manufactured primarily within the spaces inside the bone called the marrow.

Joint The place where two bones come in contact.

The Muscular System

The muscles of the body provide both support and movement. Muscles are attached to bones by tendons and cause movement by alternately contracting

Fig. 13.3 The rib cage.

Skull

Sternum (breastbone)

Ribs

Xiphoid process

Spinal column

(shortening) and relaxing (lengthening). To move bones, muscles are usually paired in opposition: while one member of the pair is contracting, the other is relaxing. This mechanical opposition enables you to open and close your hand, turn your head, and bend and straighten your elbow. When the biceps relaxes, an opposing muscle on the back of the arm contracts, straightening the elbow.

Because muscles and bones work together to produce movement, they are often called the musculoskeletal system. This movement occurs at joints, the contact points between bones that are next to one another. The joints are held together by ligaments, thick bands that arise from one bone, span the joint, and insert into the adjacent bone.

The body has three types of muscles: voluntary muscles, involuntary muscles, and cardiac muscle. Voluntary muscles are also called skeletal muscles because they are attached to bones. Voluntary muscles can be contracted and relaxed by a person at will. They are responsible for the movement of the body. Involuntary muscles are found on the inside of the digestive tract and other internal organs of the body. They are also called smooth muscle. They cannot be voluntarily controlled by the person. The third type of muscle is cardiac muscle. Cardiac muscle is found only in the heart (Figure 13.4). When treating a patient with musculoskeletal injuries you will be concerned with skeletal, or voluntary, muscles.

Fig. 13.4 Three types of muscle in the human body.

Skeletal muscle

Cardiac muscle

Smooth muscle

Mechanism of Injury

As a first responder, you must understand how injuries occur. This is called the **mechanism of injury.** Musculoskeletal injuries are caused by three types of mechanisms of injury: direct force, indirect force, and twisting force. (See Figure 13.5.) Examples of injuries caused by each of these types of mechanisms are as follows:

Mechanism of injury The means by which a traumatic injury occurs.

- *Direct force:* A pedestrian is struck on the leg by the bumper of a car and sustains a broken leg.
- *Indirect force:* A woman falls on her shoulder and suffers a broken clavicle. The force of the fall transmits the energy to the middle of the clavicle, which breaks because of the excess force transmitted to it.
- *Twisting force:* A football player is tackled as he is turning and twists his leg, causing a severe injury to his knee.

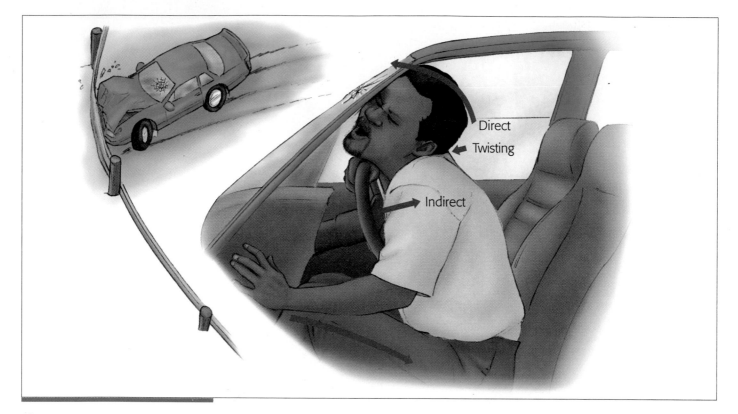

Fig. 13.5 Three types of mechanisms of injury cause musculoskeletal injuries: direct force, indirect force, and twisting force.

Remember: Injuries can be caused by direct force at the site of impact or can be caused by indirect force at a site removed from the site of impact.

As a first responder, you will see many different types of traumatic injuries. Some of these will be the result of motor vehicle crashes or auto/pedestrian accidents; others will be the result of athletic activities, work-related accidents, or violence. You will see injuries in people of all ages from very young children to elderly people. You should be prepared to use the information you gather from dispatch information and from your overview of the scene to form an impression of the possible mechanisms of injury. You will gain additional information from your patient examination and from questioning the patient. By understanding the mechanism of injury or how injuries occur, you will be able to best assess patients and give them the needed treatment.

A Word about Terminology

There are different ways of describing a patient's injuries. You must rely on your senses of sight and touch to determine what type of injury the patient has experienced. You must also listen to the information that the patient can give you. However, keep in mind that, as a first responder, you do not have the training or tools to diagnose an injury as a physician can.

The following section defines fractures, dislocations, and sprains. Although you are not expected to diagnose these injuries, your patient's signs and symptoms will lead you to *suspect* that a certain injury is most probable. Some instructors and medical directors may choose to identify musculoskeletal injuries strictly in terms of the signs and symptoms present, such as a painful, swollen, deformed extremity. Others may choose to use terms such as

suspected fracture, dislocation, or sprain. To meet the needs of the instructors and medical directors who want to use the term "painful, swollen, deformed extremity," we use "PSDE" after each relevant term. Above all we should remember that the most important part of our job is to provide the best assessment and treatment for the patient.

Types of Injuries

There are three major types of musculoskeletal injuries:

- Fractures
- Dislocations
- Sprains

It is often difficult to distinguish one type of extremity injury from another. All three types are serious, and all extremity injuries must be identified so they can receive appropriate medical treatment.

Fractures

A fracture is a broken bone. Fractures can be caused by a variety of mechanisms, but a significant force is almost always required. Fractures are generally classified as either closed or open (Figure 13.6). **Closed fractures** are more common. In the case of a closed fracture, the bone is broken but does not cause a break in the skin.

Closed fracture A fracture in which the overlying skin has not been damaged.

Fig. 13.6 Closed and open fractures.

A. Closed fracture.

B. Two types of open fractures: gunshot and exposed bone.

Open fracture Any fracture in which the overlying skin has been damaged.

In an **open fracture**, the bone is broken and the overlying skin is lacerated. The open wound can be caused by a penetrating object, such as a bullet, or by the fractured bone end protruding through the skin. The open fracture is contaminated by dirt and bacteria; this contamination may lead to infection. Every fracture, whether open or closed, injures adjacent soft tissues, resulting in bleeding at the fracture site. In addition, fractures can injure adjacent nerves and blood vessels, causing severe nerve injury and excessive bleeding. Open fractures result in more bleeding than do closed fractures.

Dislocations

Dislocation Disruption of a joint so that the bone ends are no longer in alignment.

A **dislocation** is a disruption that tears the supporting ligaments of the joint. The bone ends that make up the joint separate completely from each other and lock in one position. Any attempted motion of a dislocated joint is very painful. Because many nerves and blood vessels lie near joints, a dislocation can damage these structures, also.

Sprains

Sprain A joint injury in which the joint is partially, temporarily dislocated, and some of the supporting ligaments are either stretched or torn.

A **sprain** is a joint injury caused by excessive stretching of the supporting ligaments. It can be thought of as a partial dislocation.

Body Substance Isolation and Musculoskeletal Injuries

As you examine and treat patients who have suffered musculoskeletal injuries, you need to practice body substance isolation (BSI). Be aware that these patients may have open wounds related to the musculoskeletal injury or to a separate, open soft tissue injury. Assume that trauma patients may have open wounds. These wounds pose a threat of infection. You should wear approved gloves. If the patient has active bleeding that may splatter, you should have protection for your eyes, nose, and mouth. When responding to motor vehicle accidents or other situations that may present a hazard from broken glass or other sharp objects, it is wise to wear heavy rescue gloves that are made to protect you from sharp objects. Some responders wear latex gloves under the heavy rescue gloves for added BSI protection.

SAFETY PRECAUTION
Remember BSI techniques when dealing with musculoskeletal injuries that may involve open wounds.

Remember: BSI is for your protection.

Signs and Symptoms of Extremity Injuries

Figure 13.7 illustrates the following primary signs and symptoms of extremity injuries:

- Pain at the injury site
- An open wound
- Swelling and discoloration (bruising)
- The patient's inability or unwillingness to move the part
- Deformity or angulation
- Tenderness at the injury site

Examination of Musculoskeletal Injuries

Examining persons with limb injuries involves three essential steps:

1. General assessment of the patient following the patient assessment sequence
2. Examination of the injured part
3. Evaluation of the circulation and sensation in the injured limb

Focus on Assessment

General Patient Assessment

A general, primary assessment of the injured patient must be carried out before attention is focused on any injured limb. All the steps in the patient assessment must be followed. Once you have checked and stabilized the patient's airway, breathing, and circulation (ABCs), you can then direct your attention to the injured limb identified during the physical examination.

Limb injuries are not life threatening unless there is excessive bleeding from an open wound. Therefore, it is essential for you to stabilize the ABCs first—before focusing on a limb injury, regardless of the pain or deformity that may be present at that injury site.

Examination of the Injured Limb

Initially the first responder should inspect the injured limb and compare it to the opposite, uninjured limb. To do this, the clothing should be gently and carefully cut away, if necessary. (Do not ever hesitate to cut clothing in order to uncover a suspected injury.) When examining the limb, you may find any one of the following:

- An open wound
- Deformity
- Swelling
- Bruising

After you have uncovered and looked at the injured limb, you should gently feel it for any points of tenderness. Tenderness is the best indicator of an underlying fracture, dislocation, or sprain (PSDE).

To detect limb injury, start at the top of each limb and, using both hands, squeeze the entire limb in a systematic, firm (yet gentle) manner, moving toward the distal aspect. Make sure you have examined the entire extremity.

While you carry out your hands-on examination, it is important to ask the patient where it hurts most; the location of greatest pain is probably the injury site. Also ask if the patient feels tingling or numbness in the extremity because this may indicate nerve damage or lack of circulation.

Remember: Listen to the patient. He or she is usually right about the location and type of injury.

Careful inspection and a gentle hands-on examination will identify most musculoskeletal injuries (Figure 13.8). If, after a careful visual and hands-on examination, the patient shows no sign of injury, ask the patient to move the limb carefully. If there is an injury, the patient will complain of pain and refuse to move the limb.

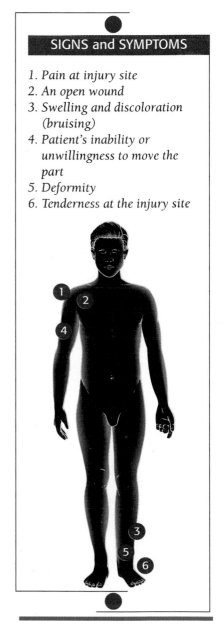

SIGNS and SYMPTOMS

1. *Pain at injury site*
2. *An open wound*
3. *Swelling and discoloration (bruising)*
4. *Patient's inability or unwillingness to move the part*
5. *Deformity*
6. *Tenderness at the injury site*

Fig. 13.7 Signs and symptoms of extremity injuries.

Fig. 13.8 Examine the extremities.

Any of the signs or symptoms described earlier (deformity, swelling, bruising, tenderness, or pain with motion) indicate the presence of a limb injury (PSDE). Only one sign is necessary to indicate an "injury to the limb." All limb injuries, regardless of type or severity, are managed in the same way.

Evaluation of Circulation and Sensation in the Injured Limb

Once you suspect limb injury, you must evaluate the circulation and sensation in that limb. Many important blood vessels and nerves lie close to the bone, especially around major joints. Therefore, any injury may have associated blood vessel or nerve damage.

It is also essential to check circulation and sensation after any movement of the limb (such as for splinting). Movement during splinting might have caused a bone fragment to press against or even cut a blood vessel or nerve. Carry out an examination of each of these factors for each injured limb:

- Pulse
- Capillary refill
- Sensation
- Movement

Pulse

Feel the pulse distal to the point of injury. If the patient has an upper extremity injury, check the radial pulse (Figure 13.9A). If the patient has a lower extremity injury, check the posterior ankle pulse (tibial pulse), as in Figure 13.9B.

Capillary Refill

Test the capillary refill in a finger or toe of any injured limb. Firm pressure on the tip of the nail causes the nail bed to turn white (Figure 13.10A). Upon release of the pressure, the normal pink color should return by the time it takes to say "capillary refill" (Figure 13.10B). If the pink color does not return in this two-second interval, it is considered to be delayed or absent and indicates a circulation problem in the limb. Capillary refill is delayed if the patient is in a cold environment. In this situation, do not use capillary refill to assess an injured limb.

Fig. 13.9 Check radial and ankle pulses.

A. Radial pulse

B. Ankle pulse

Fig. 13.10 Checking capillary refill.

Fig. 13.11 Check for sensation at fingertips and toes.

The absence of a pulse or capillary refill indicates that a limb is in immediate danger. Impaired circulation demands prompt transportation and prompt medical treatment at an appropriate medical facility.

 Focus on Assessment

Sensation

The patient's ability to feel your light touch on the fingers or toes is a good indication that the nerve supply is intact. In the hand, check sensation by touching lightly the tips of the index and little fingers. In the foot, the tip of the big toe and the top of the foot should be checked for sensation (Figure 13.11).

Movement

If the hand or foot is injured, do not have the patient do this part of the test. When the injury is proximal to the hand or foot, have the patient open and close the fist or wiggle the toes of the injured limb (Figure 13.12). These simple movements indicate that the nerves to these muscles are working. Sometimes any attempt at motion will produce pain. In this case, do not ask the patient to move the limb any further.

Any open wound, deformity, swelling, or bruising of a limb should be considered evidence of a possible limb injury and treated as such.

Focus on Assessment

Check ✔ *Point*

✔ Describe the three major steps of examining a patient for musculoskeletal injuries.

✔ Describe the components in each part of the examination.

Fig. 13.12 Check for movement of the extremities.

Treatment of Musculoskeletal Injuries

Regardless of the extent or severity of limb injury, all are treated in the same way in the field. All open extremity wounds are managed by first covering the entire wound with a dry, sterile dressing and applying firm but gentle pressure to control bleeding, if necessary. The sterile compression dressing protects the wound and underlying tissues from further contamination. The injured limb should then be splinted.

General Principles of Splinting

All limb injuries (PSDE) should be splinted before a patient is moved, unless the environment prevents effective splinting or threatens the patient's life (or that of the rescuer). Splinting prevents the movement of broken bone ends, a dislocated joint, or damaged soft tissues and thereby reduces pain. The decreased pain relaxes the patient and makes the trip to the medical facility easier.

Splinting also helps to control bleeding and decreases the risk of damage to the nearby nerves and vessels by sharp bone fragments. Splinting prevents closed fractures (PSDE) from becoming open fractures (PSDE) during movement or transportation.

Focus on Treatment

All first responders should know the following general principles of splinting:

1. In most situations, remove clothing from the injured limb (PSDE) to inspect the limb for open wounds, deformity, swelling, bruising, and capillary refill.
2. Note and record the pulse, capillary refill, sensation, and movement distal to the point of injury.

3. Cover all open wounds with a dry, sterile dressing before applying the splint.
4. Do not move the patient before splinting, unless there is an immediate danger to the patient or the first responder.
5. Immobilize the joint above and the joint below the injury site.
6. Pad all rigid splints.
7. When applying the splint, use your hands to support the injury site and minimize movement of the limb until splinting is completed.
8. Splint the limb in the position in which it is found.
9. When in doubt, splint.

Materials Used for Splinting

Many different materials can be used as splints, if necessary. Even when standard splints are not available, the arm can be bound to the chest and an injured leg can be secured to the other, uninjured lower extremity for temporary stability. There are three basic types of splints:

- Rigid
- Soft
- Traction

Rigid Splints

Rigid splints are made from firm material and are applied to the sides, front, or back of an injured extremity. Common types of rigid splints include padded board splints, molded plastic or aluminum splints, padded wire ladder splints, SAM® splints, and folded cardboard splints (Figure 13.13). Padded wire ladder or SAM splints can be molded to the shape of the limb to splint it in the position found.

Soft Splints

The most commonly used **soft splint** is the inflatable, clear plastic air splint. This splint is available in a variety of sizes and shapes with or without a zipper that runs the length of the splint (Figure 13.14). After application, the splint is inflated by mouth—never by using a pump or air cylinder. The air splint is comfortable for the patient and provides uniform pressure to a bleeding wound.

Rigid splints Splints made from firm materials such as wood, aluminum, or plastic.

Soft splint A splint made from soft material that provides gentle support.

Fig. 13.13 Different kinds of splints.

A. Rigid cardboard splints.

B. SAM® splint.

Fig. 13.14 Soft splints.

Fig. 13.15 Improvised splints (magazines, newspapers, belt, towel).

The air splint has some disadvantages, particularly when it is applied in cold, dirty areas. The zipper can stick, clog with dirt, or freeze. The inflated splint can also be punctured by sharp fragments of glass or other objects. With temperature and altitude changes, the pressure in the air splint can increase or decrease, requiring careful monitoring by emergency care personnel. Improvised splints can be made from rolled newspapers, magazines, towels, or belts (Figure 13.15).

Traction Splints

Traction splint A splint used to immobilize a fractured thighbone that produces a longitudinal pull on the extremity.

A **traction splint** holds a lower extremity fracture (PSDE) in alignment through a constant, steady pull on the extremity. Proper application of a traction splint requires two well-trained EMTs working together. First responders do not learn the skills necessary to apply this type of splint. It is impossible for one person to apply most traction splints. Therefore, you may be asked to assist trained medical personnel in the placement of a traction splint, and you should be familiar with the general techniques, as shown later in Figure 13.30.

Splinting Specific Injury Sites

The treatment techniques described here can be carried out by a person with your level of training and with materials readily available to you. Most splinting techniques are two-person operations. One person stabilizes and supports the injured limb, while the other person applies the splint.

Shoulder Girdle Injuries

Sling A triangular bandage or material tied around the neck to support the weight of an injured upper extremity.

The easiest way to splint most shoulder injuries is to apply a **sling** made of a triangular bandage and to secure the sling (and arm) to the body with

Fig. 13.16 (far left) Sling.

Fig. 13.17 (left) Sling and swathe.

Fig. 13.18 (above) Improvised sling using a belt.

swathes around the arm and chest (Figure 13.16). Apply the sling by tying a knot in the point of the triangular bandage, placing the elbow into the cup formed by the knot, and passing the two ends of the bandage up and around the patient's neck. Tie the sling so the wrist is slightly higher than the elbow.

To keep the arm immobilized, fold another triangular bandage to make a 3-inch to 4-inch-wide swathe (Figure 13.17). Tie one or two swathes around the upper arm and chest of the patient. This easily applied splint adequately immobilizes fractures of the clavicle, most shoulder injuries, and fractures of the upper humerus.

When triangular bandages are not available, loop a length of gauze (or even a belt) around the patient's wrist and suspend the limb from the neck (Figure 13.18). Secure the arm gently, but firmly, to the chest wall with another length of gauze or belt. Temporary splinting can be achieved by pinning the coat sleeve to the front of the coat (Figure 13.19). This technique is less secure than a sling and swathe, but it may be of use in cold weather areas.

Dislocation of the Shoulder

The dislocated shoulder is the only shoulder girdle injury that is difficult to immobilize with a sling and swathe. Dislocation of the shoulder often creates a space between the upper arm and the chest wall. Fill this space with a pillow or rolled blanket and then apply a sling and swathe as for other shoulder injuries (see Figure 13.17).

Elbow Injuries

Do not move an injured elbow from the position in which you find it. The elbow must be splinted as it lies because any movement can cause nerve or blood vessel damage. If the elbow is straight, splint it straight. If the elbow is bent at an unusual angle, splint it in that position.

After splinting the injured elbow of a patient who does not have a significant shoulder injury (and only if it does not cause pain), gently move the splinted injury to the patient's side, for comfort and ease of transport.

An effective splint for an injured elbow is a pillow splint. Wrap the elbow in a pillow, add additional padding to keep the elbow in the position found, and secure the pillow as shown in Figure 13.20. The patient is usually transported in a sitting position with the splinted elbow resting on his or her lap. A padded wire ladder or SAM splint is also effective for splinting elbows that are found in severely deformed positions.

Fig. 13.19 Improvised sling using safety pins.

Fig. 13.20 Pillow splint.

Injuries of the Forearm

Several splints can be used for **forearm** stabilization: the air splint, the cardboard splint, the SAM splint (Figure 13.21), even rolled newspapers and magazines. Be sure to pad all rigid splints adequately.

An air splint can be applied quickly, and it immobilizes the forearm quite well. Several types of air splints are available. The type that is easiest to work with has a full-length zipper (Figure 13.22).

Unzip the air splint completely, making sure the air intake valve is on the outside of the splint. Carefully slip the unzipped air splint under the injured

Fig. 13.21 Applying a SAM splint.

forearm, taking care to support the forearm during placement. After the air splint is positioned to correctly support the injured site, connect the zipper, zip the air splint, and inflate it by mouth until the plastic can be depressed slightly when you exert firm pressure with your fingers.

⚠️ CAUTION
Never use anything but the air from your mouth to inflate air splints!

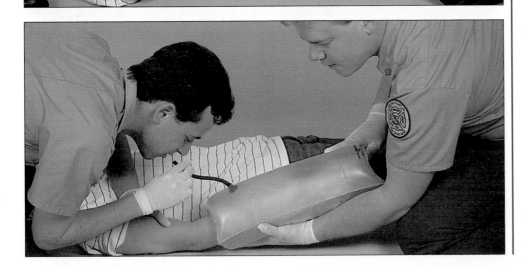

Fig. 13.22 Applying an air splint.

Air splints without zippers are applied using a different technique. Place the air splint over your hand and lower arm and grasp the patient's hand. Have a second person support the patient's elbow and upper arm to prevent movement. Slip the air splint off your arm and onto the patient's injured forearm. The air splint should extend over the patient's hand and wrist, to prevent swelling. Inflate the splint, as described earlier. Figure 13.23 shows how to apply a splint made of magazines and newspapers.

Injuries of the Hand, Wrist, and Fingers

The first responder will see a variety of hand injuries, all of which can be potentially serious. The functions of the fingers and hand are so complex that

Fig. 13.23 Improvised splint using magazines.

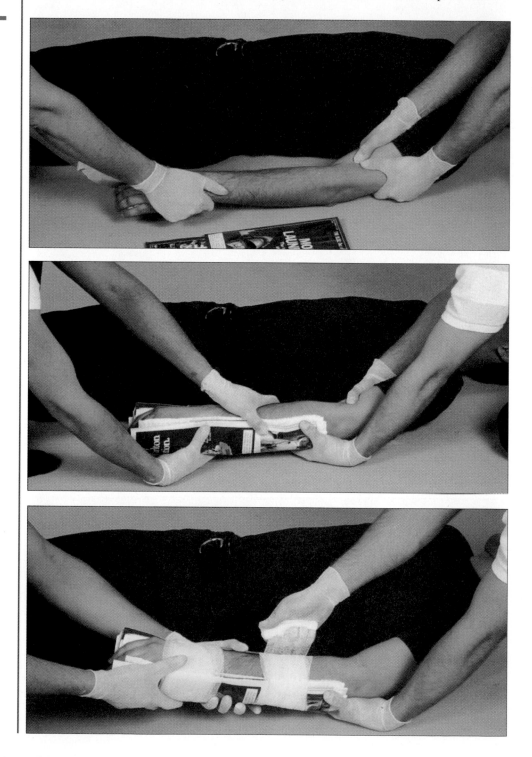

any injury, if poorly or inadequately treated, may result in permanent deformity and disability. Treat even seemingly simple lacerations carefully. Any amputated parts should be sent to the hospital with the patient. All injuries of the wrist, hand, and fingers can be immobilized with a bulky hand dressing and a short splint.

First, cover all wounds with a dry, sterile dressing. Then place the injured hand and wrist into what is called the "position of function" (Figure 13.24). Place one or two soft roller dressings into the palm of the patient's hand. Apply a splint to hold the wrist, hand, and fingers in the position of function and secure the splint with a soft roller bandage.

Pelvic Fractures

Fractures of the pelvis are often accompanied by severe blood loss because the large blood vessels that run directly beside the pelvis are easily lacerated at the time of the fracture. A great amount of blood can pour from these large vessels into the pelvic area. Pelvic fractures commonly cause shock. Therefore, the first responder must always treat the patient for shock. However, do not raise the patient's legs until he or she is secured on a backboard.

The surest sign of pelvic fracture is tenderness when both the examiner's hands firmly compress the patient's pelvis (Figure 13.25). Immobilize fractures of the pelvis with a long backboard. See Figure 13.28 for an example of long-backboard immobilization of hip and pelvic fractures. EMTs may apply a pneumatic antishock garment (PASG) to stabilize the fracture and treat shock. (See Chapter 5 for information on how to assist with the application of backboards and the PASG.)

Hip Injuries

Two types of hip injuries are commonly seen: dislocations and fractures. Both injuries may result from high-energy **trauma**. When an unbelted automobile passenger is thrown forward in an accident and crashes against the dashboard, the impact of the knee against the dashboard is transmitted up the shaft of the femur, injuring the hip and often producing either a dislocation or a fracture (Figure 13.26).

Fig. 13.24 Position of function for hand and wrist.

Trauma A wound or injury, either physical or psychological.

Fig. 13.25 Examining the patient for pelvic fracture.

A. Push down.

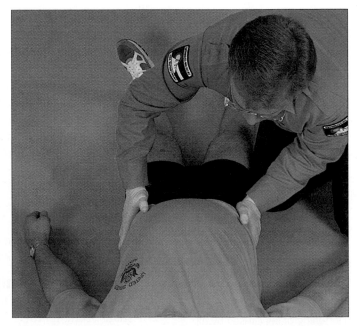

B. Push in.

Fig. 13.26 Posterior dislocation of hip.

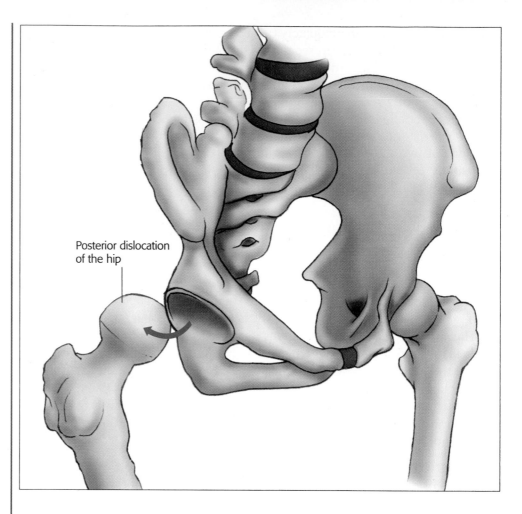

Posterior dislocation
of the hip

Osteoporosis Abnormal brittleness of the bones in older people caused by loss of calcium; affected bones fracture easily.

Hip fractures actually occur at the upper end of the femur, rather than in the hip joint itself. Hip fractures do not occur only as a result of high-energy trauma; they can occur in elderly people, especially women, after only minimal trauma (such as falling down). These fractures occur in the elderly because bone weakens as we age, a condition called **osteoporosis.**

A dislocated hip is extremely painful, especially when any movement is attempted. The joint is usually locked with the thigh flexed and rotated inward across the midline of the body. The knee joint is often flexed as well. Fractures of the hip region usually cause the injured limb to become shortened and externally (outwardly) rotated (Figure 13.27).

Treat all hip injuries by immobilizing the hip in the position found. Splinting is best accomplished with the use of several pillows and/or rolled blankets, especially under the flexed knee. The patient should be placed on a long backboard for transportation. The patient and the limb should be stabilized well enough under the backboard to eliminate all motion in the hip region (Figure 13.28).

Because fractures of the upper end of the femur are so common in elderly patients, any elderly person who has fallen and complains of pain in the hip, thigh, or knee—even if there is no deformity—should be splinted and transported to the hospital for x-ray evaluation.

Injuries of the Thigh

Trauma to the thigh results in bruising of the muscles or a fracture of the shaft of the femur. A fractured femur is very unstable and usually produces significant thigh deformity. There is much bleeding and swelling.

Fig. 13.27 External rotation and shortening of leg caused by hip fracture.

Fig. 13.28 Immobilization of hip injuries on backboard.

The treatment of femur fractures (PSDE) requires skill and proper equipment. Often, the only thing you can do by yourself is place the patient in as comfortable a position as possible, treat for shock, and call for additional personnel and equipment. In this situation, the most important treatment a first responder can give is for shock and prevention of further injury.

Do not elevate the injured leg when treating for shock.

After a motor vehicle accident, you may have to move the patient quickly before proper equipment and additional personnel arrive. You should learn and practice emergency temporary splinting for lower extremity injuries. This technique consists of securing both legs together with several swathes, cravats, or bandages to immobilize the two lower extremities as one unit. Securing the lower extremities together allows you to remove the patient from a dangerous environment quickly.

The most effective way to splint a fractured femur is to use a traction splint. Traction splints are designed specifically to stabilize a fractured femur. Although a traction splint is not likely to be a part of your first responder life support kit, you should know how it is used so you can assist other EMS personnel, as needed.

Many different types of traction splints are available. Most are applied basically using the same method:

1. Trained EMTs align deformed fractures (PSDE) by applying manual longitudinal traction. Once manual traction is applied, it must be maintained until the traction splint is fully in place (Figure 13.29).

2. An ankle hitch is placed around the ankle.

3. The traction splint is adjusted to the correct length by laying the splint beside the uninjured leg and extending it about 8 to 10 inches beyond the bottom of the patient's foot.

4. The splint is placed under the patient's injured leg and hip. The easiest way to do this is to gently logroll the patient onto his or her uninjured side only high enough to allow you to place the splint under the injured limb, up to the level of the hip.

5. The splint is attached at the hip, using the strap provided for this purpose.

Focus on Treatment

Fig. 13.29 Straightening an injured leg for splinting.

Focus on Assessment

6. The ankle hitch is attached to the foot end of the splint and the mechanical traction device tightened until it exerts traction equal to the force that has been exerted manually. The correct amount of traction has been applied when the patient's pain begins to diminish.

7. Wide supporting straps are added to secure the limb to the splint. These supports are placed about every 8 inches along the limb. A support should not be placed directly on the injury site; rather, one should be positioned above and another below the site (Figure 13.30).

To apply proper traction using this type of splint, it is essential that the foot end of the traction splint be elevated 6 to 8 inches off the ground. If the heel of the injured leg is allowed to touch the ground, traction is lost and must be reapplied. Most traction splints include a foot stand that elevates the limb.

Check and recheck pulse, capillary refill, and nerve function before and after a splint is applied (Figure 13.31).

Knee Injuries
Always immobilize an injured knee in the position in which you found it. If it is straight, use long, padded board splints or a long-leg air splint. If there is a significant deformity, place pillows, blankets, or clothing beneath the knee, secure the splint materials to the leg with bandages, swathes, or cravats, and secure the injured leg to the uninjured leg (Figure 13.32). Then place the patient on a backboard.

Leg Injuries
Like fractures of the forearm, fractures of the leg can be splinted with air splints, cardboard splints, and even magazines and newspapers. Figure 13.33 shows how to apply an air splint to the leg.

Fig. 13.30 Applying a traction splint.

It takes two trained people to splint an injured leg. One person supports the leg with both hands (above and below the injury site), while the other person applies the splint.

Remember: Pad all rigid splints to provide the best stabilization and pain relief. Do not apply any splint too tightly (Figure 13.34). Recheck pulse, capillary refill, and sensation after the splint is applied, to make sure that no damage has been done.

Injuries of the Ankle and Foot

Fractures of the ankle and foot can be splinted with either a pillow or air splints. Place the pillow splint around the injured ankle and foot, and tie or pin it in place (Figure 13.35).

Fig. 13.31 Checking the ankle pulse.

Fig. 13.32 Immobilizing an injured knee.

Fig. 13.33 Applying an air splint to the leg.

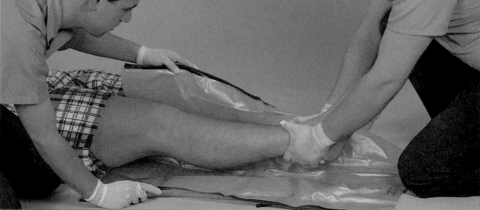

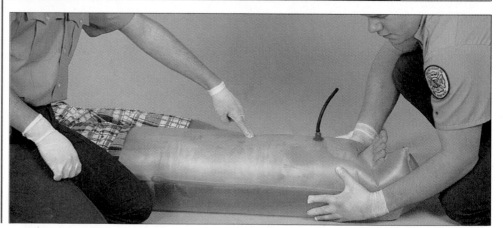

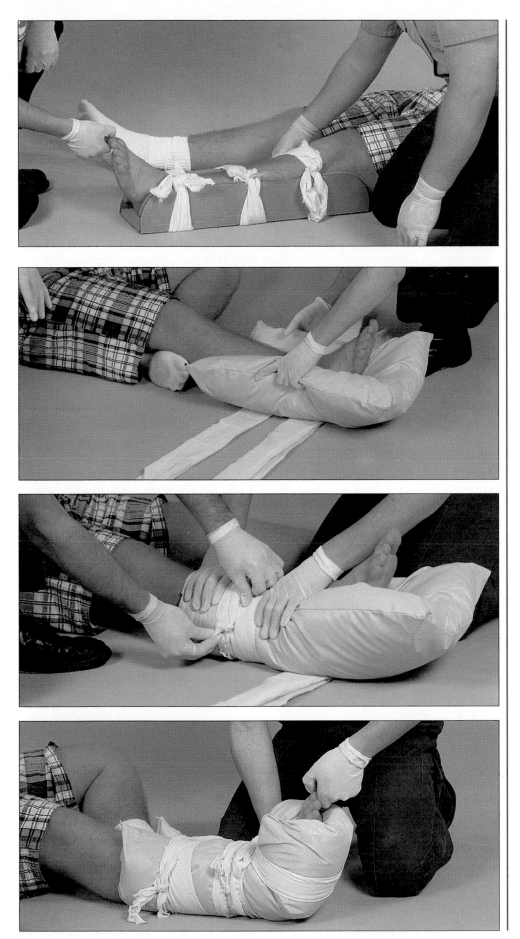

Fig. 13.34 Checking capillary refill on splinted injured leg.

Fig. 13.34 Checking capillary refill on splinted injured leg.

Fig. 13.35 Applying a pillow splint for ankle or foot injury.

Additional Considerations

Remember that extremity injuries are not, in themselves, life threatening unless excessive bleeding is present.

You may not always have the equipment or help you need to manage all types of extremity injuries. You may not even have time to splint an injury before additional EMS personnel arrive. There are times, however, when you are the only trained person at the scene of an accident. To prepare for such situations, practice splinting until you are sure you can apply the principles in any situation. The patient may be found in a variety of positions and locations. Practice splinting a volunteer, while he or she is both sitting and lying down.

It takes two people to adequately splint most limb injuries: one to stabilize and support the extremity and one to apply the splint. Therefore, you must be prepared to work with any member of the EMS team who arrives to assist you. It is important to learn how the team functions as a unit during stressful situations. Most of the principles and techniques of splinting that you have learned require that you work with another member of the EMS team.

Injuries of the Head (Skull and Brain)

Severe head and spinal cord injuries can result from many different kinds of trauma. Head and spinal cord injuries are common causes of death. These injuries can also cause irreversible paralysis and permanent brain damage. Improper handling of a patient after an accident can cause further injury or death. Spinal injuries can be caused, for example, by well-intended citizens pulling a patient from a wrecked car, or by poor treatment from inadequately trained emergency personnel. As a first responder, you must know what to do to provide prompt treatment and avoid errors that may make the injury worse.

As shown in Figure 13.36, the human skull has two primary parts: the cranium, a tough four-bone shell that protects the brain, and the facial bones, which give form to the face and furnish frontal protection for the brain.

Mechanisms of Injury

Head injuries occur commonly with certain types of trauma. Of patients involved in automobile accidents, 70 percent suffer some degree of head injury

Imagine the cranium as a rigid bowl. It contains the delicate brain (Figure 13.37). Between the skull and brain, there is a fluid called **cerebrospinal fluid (CSF)** that cushions the brain from direct blows. Injury to the skull and the brain inside can be produced by direct forces such as a hammer blow or by indirect forces such as the rapid deceleration of the head when it strikes the windshield in an automobile accident (see Figure 13.5). In this latter situation, the brain violently strikes the inside of the skull, producing the brain injury.

Spinal injury is often associated with head injury. The force of direct blows to the head is often transmitted to the spine, producing a fracture or dislocation. The injuries may damage the spinal cord or at least put it at risk for injury. Therefore, all patients with head injuries must have the cervical spine splinted to protect the spinal cord.

Cerebrospinal fluid (CSF) A clear, watery fluid that fills the space between the brain and spinal cord and their protective coverings.

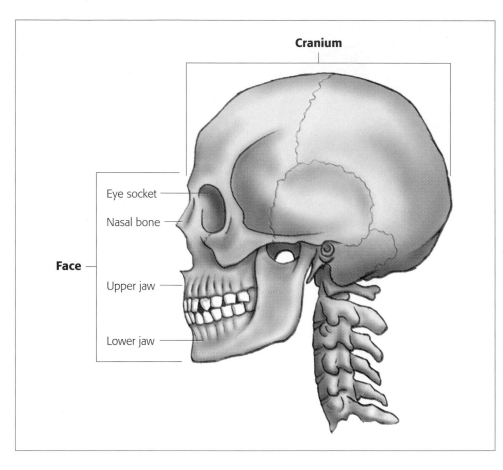

Fig. 13.36 Cranium and face of the human skull.

Cranium

Eye socket

Nasal bone

Face

Upper jaw

Lower jaw

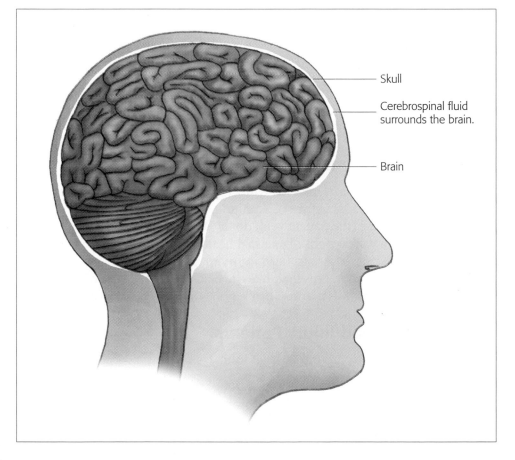

Fig. 13.37 The brain.

Skull

Cerebrospinal fluid surrounds the brain.

Brain

Injuries of the Head (Skull and Brain)

a. A head injury may cause a cervical spine injury.

b. A closed head injury.

c. An open head injury.

Fig. 13.38 Open and closed head injuries.

Types of Head Injuries

Closed head injury Injury where there is bleeding and/or swelling within the skull.

Injuries of the head are classified as open or closed. In the case of a **closed head injury**, bleeding and swelling within the skull may cause increased pressure. This increased pressure produces irreversible brain damage and death if it is not relieved. An open injury of the head usually bleeds profusely (Figure 13.38).

Examine the nose, eyes, and the wound itself for seepage of blood or cerebrospinal fluid (CSF), which is clear, watery, and straw-colored. In severe cases of open head injury, brain tissue or bone may be visible.

Focus on Assessment

Severe open head injuries are serious but not always fatal. Any time you suspect or identify an injury to the head or skull, you should also suspect injury to the neck and spinal cord.

Signs and Symptoms of Head Injuries

Paralysis Inability of a conscious person to move voluntarily.

Seizures Sudden episodes of uncontrolled electrical activity in the brain.

Signs and symptoms of head injury (Figure 13.39) include confusion, unusual behavior, unconsciousness, nausea or vomiting, blood from an ear, and decreasing consciousness (the patient gets "dopey"). Unequal pupils, **paralysis**, and/or **seizures** are visible signs of external head trauma, as well as bleeding, bumps, and contusions. A serious head injury may also produce "raccoon eyes" and "Battle's sign." Raccoon eyes look like the black eyes that develop after a fist fight. Battle's sign appears as a bruise behind one or both ears (Figure 13.40).

Treatment of Head Injury Patients

Focus on Treatment

When any one sign or symptom of head injury is present, proceed as follows:

1. Immobilize the head in a neutral position. Stabilize the patient's neck and prevent movement of the head.
2. Maintain an open airway. Use the jaw-thrust technique to open the airway (see Chapter 6). Avoid movement of the head and neck.

3. Support the patient's breathing. Be sure that the patient is breathing adequately on his or her own. If not, institute mouth-to-mask or mouth-to-barrier ventilation. As soon as oxygen becomes available, it should be administered to the patient. Oxygen helps minimize swelling of the brain.

4. Monitor circulation. Be prepared to support circulation by performing full CPR if the patient's heart stops.

5. Check to see if CFS or blood is seeping from a wound or from the nose or ears (Figure 13.41). CFS is clear, watery, and straw-colored. Do not try to stop leakage of CFS from a wound or any other opening because leakage from inside the skull relieves internal pressure.

6. Control bleeding from all head wounds with dry, sterile dressings using enough direct pressure to control the bleeding without disturbing the underlying tissue.

7. Examine and treat other serious injuries.

8. Arrange for prompt ambulance transport to an appropriate medical facility.

 CAUTION

If a patient has a head injury, assume that an associated neck or spinal cord injury is also present. Do nothing that would cause undue movement of the head and spine. Always splint the entire spine before moving the patient.

SIGNS and SYMPTOMS

1. *Confusion*
2. *Unusual behavior*
3. *Unconsciousness*
4. *Decreasing consciousness*
5. *Unequal pupils*
6. *Paralysis*
7. *Seizures*
8. *External head trauma: bleeding, bumps, contusions*

Fig. 13.39 (above) Signs and symptoms of head injuries.

Fig. 13.40 (left) Signs of head injury.

A. Raccoon eyes.

B. Battle's sign.

Check ✔ Point

✔ List the steps for treating a patient with possible head injury.

Fig. 13.41 Blood or CSF from the ear indicates head injury.

Injuries of the Face

Facial injuries are most commonly the result of:

- Motor vehicle accidents in which the patient's face hits the steering wheel or windshield
- Assaults
- Falls

The primary danger in severe facial injuries is obstruction of the airway. When severe damage to the face and facial bones occurs, bleeding, coupled with the collapse of the facial bones, can cause airway problems. If the patient has facial injuries, you should also suspect a spinal injury. Although facial injuries may bleed considerably, they are rarely life threatening unless the airway is obstructed.

Treatment of Facial Injuries

Focus on Treatment

When facial injuries are present, proceed as follows:

1. Immobilize the head in a neutral position. Stabilize it to prevent further movement of the neck.
2. Maintain an open airway. Use the jaw-thrust technique to open the airway. Clear any blood or vomitus from the patient's mouth with your gloved fingers.
3. Support breathing. Be prepared to ventilate the patient, if necessary.
4. Monitor circulation.
5. Control bleeding by covering any wound with a dry, sterile dressing and applying direct pressure. Be sure to check for wounds inside the mouth. Try to prevent the patient from swallowing blood because it can cause vomiting.
6. Look for and stabilize other serious injuries.
7. Arrange for prompt ambulance transport to an appropriate medical facility.

- Transportation to an appropriate medical facility
- Prompt transportation to an appropriate medical facility
- Rapid transportation to an appropriate medical facility

If these measures do not keep the airway clear, or if you are unable to control severe facial bleeding, logroll the patient onto his or her side, keeping the head and spine stable and rolling the whole body as a unit. Turn the head and body at the same time. The neck must not be allowed to twist (Figure 13.42).

Fig. 13.42 Keep the head and spine in alignment by using logroll technique.

Bandage facial injuries as described in Chapter 12. If possible, leave the patient's eyes clear of bandages so he or she can see what is happening. Being able to see reduces the patient's tendency to panic.

Injuries of the Spine

The spine consists of 33 vertebrae stacked one upon the other and held together by ligaments. Each vertebra has a hollow center through which passes the great mass of nerves known as the spinal cord. The spinal cord is connected to the brain above. It can be compared to a large telephone trunk line that carries two-way communication to and from the brain.

Mechanisms of Injury

If one or more vertebrae are injured, the spinal cord may also be injured. A displaced vertebra, swelling, or bleeding (Figure 13.43) may put pressure on the spinal cord and damage it. In severe cases, the cord may be severed. If all or part of the spinal cord is cut, nerve impulses (which are like telephone calls) cannot travel to and from the brain. Then the patient is paralyzed below the point of injury. Injury to the spinal cord high in the neck paralyzes the diaphragm and results in death. Gunshot wounds to the chest or abdomen may produce spinal cord injury at that level.

Remember: All head injuries indicate the possibility of spinal injuries.

Signs and Symptoms of Spinal Cord Injury

To determine if a patient has sustained an injury to the spinal cord, carefully examine and talk to the patient and attempt to determine the mechanism of

Fig. 13.43 Types of spinal injuries.

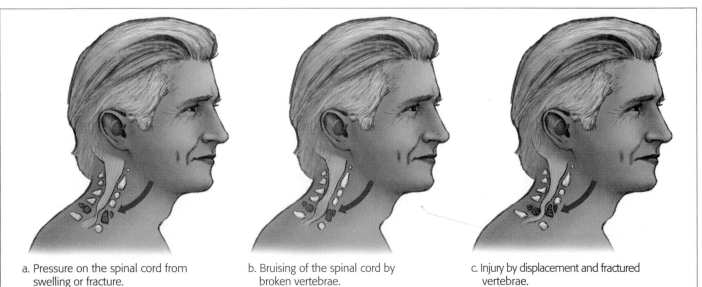

a. Pressure on the spinal cord from swelling or fracture.

b. Bruising of the spinal cord by broken vertebrae.

c. Injury by displacement and fractured vertebrae.

injury. Gently conduct a hands-on examination, as described in Chapter 7, to detect paralysis or weakness. Ask the patient to describe any points of tenderness or pain. Do not move the patient during the examination. Further, do not allow the patient to move. The key signs and symptoms of a spinal injury are (Figure 13.44):

- Laceration, bruise, or other sign of injury to the head, neck, or spine
- Tenderness over any point on the spine or neck
- Extremity weakness, paralysis, or loss of movement
- Loss of sensation or tingling in any part of the body below the neck

During your examination, be extremely careful. Take your time. Do not move patients unless they are in a hazardous area.

Treatment of Spinal Injuries

If any one sign or symptom of spinal injury is present, proceed as follows:

1. Immobilize the head and neck in a neutral position (Figure 13.45). Avoid unnecessary movement of the head. Stabilize the head and prevent movement of the neck (Figure 13.46).
2. Maintain an open airway. Use the jaw-thrust technique to open the airway to avoid movement of the head and neck (Figure 13.47). Clear any blood or vomitus from the mouth with your gloved fingers.
3. Support the patient's breathing. With spinal cord injury, some or all of the muscles of respiration may be paralyzed. Breathing patterns may be abnormal. In some cases, only the diaphragm is working. Breathing using the diaphragm only is called **abdominal breathing.** The abdomen swells and collapses with each breath. Help the patient breathe by administering oxygen (if available) and by keeping the airway open.
4. Monitor circulation.
5. Assess pulse, movement, and sensation in all extremities.
6. Examine and treat other serious injuries.
7. Do not move the patient unless it is necessary to perform CPR or to remove him or her from a dangerous environment.
8. Assist in immobilizing the patient using a long or short backboard.
9. Arrange for prompt ambulance transport to an appropriate medical facility.

Remember: Once you suspect the presence of a spinal injury, it is absolutely essential that the injury be splinted and protected until hospital tests rule out a spinal cord injury.

Stabilizing the Cervical Spine

Stabilization of the cervical spine is initially accomplished manually, as shown in Figure 13.46. In this position, the rescuer can maintain an open airway with the jaw-thrust technique (Figure 13.47).

Stabilize the head and neck in a neutral position. (The neutral position was shown in Figure 13.45.) Do not manipulate or twist the head and neck.

Abdominal breathing Breathing using only the diaphragm.

Focus on Assessment

SIGNS and SYMPTOMS

1. *Laceration or bruise*
2. *Tenderness over any point of spine, neck*
3. *Extremity weakness, paralysis, loss of movement*
4. *Loss of sensation or tingling in any part of the body below the neck*

Fig. 13.44 Signs and symptoms of spinal injuries.

Fig. 13.45 Neutral position of head and neck.

Fig. 13.46 Manual stabilization of head and neck.

Fig. 13.47 Use jaw-thrust technique for airway management in suspected spinal injury.

Once the head and neck are stabilized manually, you must maintain support until the entire spine is fully splinted. Splinting of the cervical spine is accomplished with a rigid collar and a long or short backboard.

..

▼ CAUTION

Do not move patients unless it is necessary to perform CPR or remove them from a dangerous environment.

..

Motorcycle and Football Helmets

Many patients with neck injuries are motorcyclists or football players who are wearing protective helmets. In almost all instances, helmets do not need to be removed. Indeed, they are frequently fitted so snugly to the head that they can be secured directly to the spinal immobilization device.

You should remove part of, or all of, a helmet only under two circumstances:

1. When the face mask or visor interferes with adequate ventilation, or with your ability to restore an adequate airway.
2. When the helmet is so loose that securing it to the spinal immobilization device will not provide adequate immobilization of the head.

When part of a motorcycle helmet interferes with ventilation, the visor should be lifted away from the face. In the case of a football helmet, the face guard should be removed. Most football face guards are fastened to the helmet by four rubber clips. These clips can be cut easily with a sharp knife or scissors to remove the face guard (Figure 13.48). Some newer football helmets have a tough plastic strap fixing the face guard to the mask. Trainers and coaches should have a tool readily available that can remove the face guard. The chin strap should also be loosened to facilitate the jaw-thrust technique. In most instances, exposing the face and jaw allows you access to the airway to secure adequate ventilation.

Remember: Only if you cannot gain adequate access to the airway should the entire helmet be removed.

The second indication for helmet removal is a loose helmet that will not ensure adequate immobilization of the head when secured to the spinal immobilization device. Such a loose helmet can be removed easily while the

Fig. 13.48 Cutting football helmet clips.

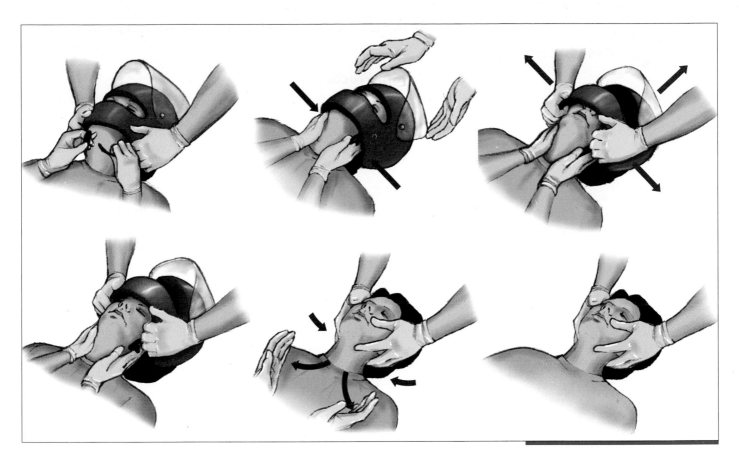

Fig. 13.49 Procedure for helmet removal.

head and neck are being stabilized manually. The procedure for helmet removal in this circumstance is shown in Figure 13.49. Note that this procedure requires two experienced people.

Injuries of the Chest

The chest cavity contains the lungs, the heart, and several major blood vessels. The cavity is surrounded and protected by the chest wall, which is made up of the ribs, cartilage, and associated chest muscles. The most common chest injuries are fractures of the ribs, flail chest, and penetrating wounds.

Fractures of the Ribs

Injury may produce fracture of one or more ribs. Even a simple fracture of one rib produces pain at the site of the fracture and difficulty with breathing (Figure 13.50). Multiple rib fractures result in significant breathing difficulty. The pain may be so intense that the patient cannot breathe deeply enough to take in adequate amounts of oxygen. Rib fractures may be associated with injury to the underlying organs.

To tell if a rib is bruised or broken, apply some pressure to another part of the rib. If the pressure produces pain in the injured area, you can presume that the rib is cracked or fractured.

If the injury is to the side of the chest, place one hand on the front of the chest and the other on the rear of the chest and gently squeeze your hands together. To check an injury to the front or back of the rib cage, put your hands on either side of the chest and gently squeeze. If there is no pain, the rib is probably not broken.

Fig. 13.50 Broken or fractured ribs.

Fig. 13.51 A flail chest occurs when three or more ribs are broken in at least two places.

- Transportation to an appropriate medical facility
- Prompt transportation to an appropriate medical facility
- Rapid transportation to an appropriate medical facility

In cases of rib fractures, be alert for signs and symptoms of internal injury, particularly shock.

Treatment of Rib Fractures

You can make a patient with rib fractures more comfortable and reassured by placing a pillow against the injured ribs to splint them. Prevent excessive movement of the patient as you prepare for transportation to an appropriate medical facility. Administer oxygen if it is available and you are trained to use it.

Flail Chest

If three or more ribs are broken in at least two places, the injured portion of the chest wall does not move at the same time as the rest of the chest. The injured part bulges outward when the patient exhales and moves inward when the patient inhales. This reversed movement is called a flail chest (Figure 13.51). A flail chest results in a decreased amount of oxygen and carbon dioxide exchange in the lungs. It causes breathing problems that become progressively worse.

You can identify a flail chest by examining the chest wall and observing chest movements during breathing. If the injured portion of the chest moves inward as the rest of the chest moves outward (and vice versa), the patient has a flail chest (Figure 13.52).

Treatment of Flail Chest

If the patient is having difficulty breathing, firmly place a pillow (or even your hand) on the flail section of the chest to stabilize it. In severe cases of flail chest, it may be necessary to support the patient's breathing. This can be done by EMTs or paramedics with mouth-to-mask or bag-valve-mask resuscitation devices and by using supplemental oxygen. Monitor and support the patient's ABCs and arrange for prompt transport to an appropriate medical facility.

Penetrating Chest Wounds

Penetration of the chest wall by an object (usually a knife or bullet) often introduces air and blood between the lung and chest wall (Figure 13.53). The air and blood cause the lung to collapse. Lung collapse greatly reduces the amount of oxygen and carbon dioxide that is exchanged and can result in

Fig. 13.52 As the patient breathes, the flail portion of the chest moves in the opposite direction.

Lungs

Ribs

Heart

Heart

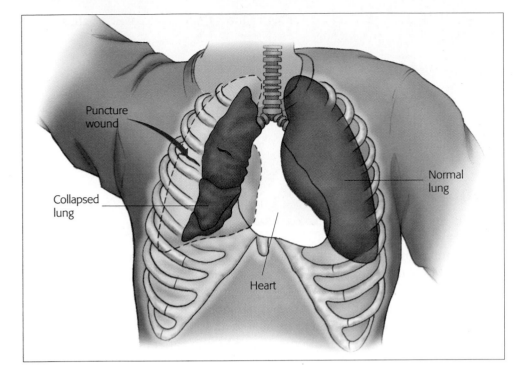

Puncture wound

Normal lung

Collapsed lung

Heart

shock and death. Blood loss into the chest cavity can produce hemorrhagic shock.

Treatment of Penetrating Chest Wounds

Quickly seal an open chest wound with something that will prevent more air from entering the chest cavity. (Occlusive dressings were discussed in Chapter 12, and are shown in Figure 13.54.) You can use petroleum jelly gauze, aluminum foil, plastic wrap, or even cellophane.

In rare cases, sealing the wound may cause the patient to have increased difficulty breathing. If a patient has more difficulty breathing after you seal the wound, uncover one corner of the occlusive dressing to see if the breathing improves. Administer oxygen if it is available and you are trained to use it. If a knife or other object is impaled in the chest, do not remove it. Seal the wound around the object with a dressing to prevent air from entering the chest. Stabilize the impaled object with bulky dressings.

Any chest injury that results in air leakage and bleeding requires prompt attention. For these reasons, patients with severe chest injuries should be transported rapidly to an appropriate medical facility.

A conscious patient with chest trauma may demand to be placed in a sitting position to ease breathing. Unless you must immobilize the spine or treat the patient for shock, help the patient assume whatever position eases breathing. If oxygen is available, administer it. If the patient's respirations are excessively slow or absent, perform mouth-to-mask breathing. A bag-valve-mask device may also be used by trained personnel. If the heart stops, begin chest compressions, regardless of whether there are chest injuries.

Fig. 13.54 Occlusive dressings.

- Transportation to an appropriate medical facility
- Prompt transportation to an appropriate medical facility
- Rapid transportation to an appropriate medical facility

Check Point

✓ How would you examine and treat a patient with a penetrating chest wound caused by a gunshot?

Summary

This chapter has covered the skills you need to handle musculoskeletal injuries of the extremities, head injuries, spine injuries, and injuries of the chest. Sometimes you will not have time to splint an extremity injury before additional EMS personnel arrive. There will be times, however, when you are the only trained person at the scene of an accident. To prepare for these situations and to be able to assist other EMS personnel with splinting procedures, you should practice splinting patients with extremity injuries. Many of these techniques can be accomplished with simple improvised materials.

This chapter has also outlined the major bones of the head, spine, and chest. Major injuries of the head, spine, and chest can result in permanent disability, paralysis, or death. Understanding the mechanism of these injuries and performing a thorough patient examination help you discover head, spine, and chest injuries. Proper treatment of these injuries consists of supporting the patient's ABCs, monitoring the patient's level of consciousness, bandaging open wounds, keeping the patient from moving the injured part, and arranging emergency medical transport to an appropriate medical facility. Remember that sometimes the best treatment you can give patients is the assurance that no further harm is done to them. Move patients with head or spine trauma only if you need to remove them from a harmful environment or to perform CPR.

Key Terms

Abdominal breathing—page 358

Cerebrospinal fluid (CSF)—page 352

Closed fracture—page 333

Closed head injury—page 354

Dislocation—page 334

Forearm—page 342

Joint—page 329

Mechanism of injury—page 331

Open fracture—page 334

Osteoporosis—page 346

Paralysis—page 354

Rigid splints—page 339

Seizure—page 354

Sling—page 340

Soft splint—page 339

Sprain—page 334

Traction splint—page 340

Trauma—page 345

What Would You Do?

1. You are walking to the grocery store when you see a 13-year-old boy on a bicycle hit the curb. He flies over the handlebars and lands on the concrete sidewalk. As you examine him, he keeps asking you what happened to him. He also cries, "My arm is killing me." What would you do?

2. You are called to a residence where a 71-year-old man tells you that his wife has fallen in the kitchen. As you examine her, she complains of severe pain in her lower right side. You note that her right leg seems to be shorter than the left and that her toes are pointed outward. What would you do?

3. You are called to the scene of an auto/pedestrian accident. The patient is lying close to the curb. As you approach the scene, you find a woman about 30 who is unresponsive. What would you do?

You Should Know

1. The anatomy and functions of the parts of the musculoskeletal system.
2. The mechanism of injury for musculoskeletal injuries.
3. How to define fracture, dislocation, and sprains.
4. The need for body substance isolation techniques when examining and treating patients with musculoskeletal injuries.
5. The importance of the following three steps when examining patients with musculoskeletal injuries:
 a. General assessment of the patient
 b. Examination of the injured part
 c. Evaluation of circulation and sensation
6. The general principles of splinting.
7. How to splint the following sites:
 a. Shoulder girdles
 b. Dislocation of the shoulder
 c. Elbow injuries
 d. Injuries of the forearm
 e. Injuries of the hand, wrist, and fingers
 f. Pelvic fractures
 g. Hip injuries
 h. Injuries of the thigh
 i. Knee injuries
 j. Leg injuries
 k. Injuries of the ankle and foot
8. The mechanism for head and spine injuries.
9. The two types of head injuries.
10. The signs and symptoms of head injuries.
11. How to treat head-injured patients.

12. How to treat facial injuries.
13. The mechanism of spinal injuries.
14. The signs and symptoms of spinal cord injuries.
15. The treatment of spine injuries.
16. The signs, symptoms, and treatment for the following injuries:
 a. Fractured ribs
 b. Flail chest
 c. Penetrating chest wound

You Should Practice

1. Performing body substance isolation techniques on a patient with musculoskeletal injuries.
2. Examining a patient with musculoskeletal injuries.
3. Evaluating the circulation and sensation of a patient with an extremity injury.
4. Splinting the following musculoskeletal injuries:
 a. Shoulder girdles
 b. Dislocation of the shoulder
 c. Elbow injuries
 d. Injuries of the forearm
 e. Injuries of the hand, wrist, and fingers
 f. Pelvic fractures
 g. Hip injuries
 h. Injuries of the thigh
 i. Knee injuries
 j. Leg injuries
 k. Injuries of the ankle and foot
5. Treating injuries of the face.
6. Stabilizing spine injuries.
7. Treating the following injuries of the chest:
 a. Fractured ribs
 b. Flail chest
 c. Penetrating chest wound

SKILL SCAN: Checking Circulation, Sensation, and Movement in an Injured Extremity

1.

2.

1. Radial pulse
2. Ankle pulse
3, 4. Capillary refill
5, 6. Check for sensation at fingertips and toes
7–10. Check for movements of extremities

3.

4.

5.

6.

7.

8.

9.

10.

1. Which type of patient assessment should you perform on a medical patient?
 a. A patient assessment, but delete the steps involving the actual patient examination
 b. A medical patient assessment
 c. A patient assessment the same way you do for a trauma patient
 d. A patient assessment, but perform the medical history before the physical exam

2. When considering a patient with altered mental status, which of the following factors are important?
 1. The patient's initial level of consciousness
 2. Whether the patient can respond to verbal stimuli
 3. The change in the patient's level of consciousness
 4. Whether the patient is responsive or not
 a. 1 and 3
 b. 2 and 4
 c. 1, 2, and 4
 d. All of the above

3. In caring for a patient who is seizing, which of the following actions should you take?
 1. Find out what is causing the seizure.
 2. Protect the patient from injury.
 3. Restrain the patient to stop the seizure.
 4. Move the patient to a protected place.
 a. 1 and 4
 b. 2 and 4
 c. 1 and 2
 d. 3 and 4

4. Match each of the following words with the appropriate condition:
 ___ Heat exhaustion
 ___ Heatstroke
 ___ Frostbite
 ___ Hypothermia
 a. Decrease in the patient's body temperature
 b. Localized to limited parts of the body
 c. Rapid increase in the patient's body temperature
 d. A form of shock

5. A heart attack is often related to which of the following conditions?
 a. Atherosclerosis
 b. Lack of oxygen to the coronary blood vessels
 c. Severe pressurelike pain in the chest
 d. Pain radiating to the arms

6. The signs and symptoms of congestive heart failure include which of the following conditions? (Choose one from each pair.)
 a. Normal breathing or shortness of breath
 b. Dry skin or profuse sweating
 c. Collapsed neck veins or enlarged neck veins
 d. Dry cough or gurgling respirations
 e. Cold feet or swollen ankles

7. Carbon monoxide is an odorless, colorless, tasteless, and nonirritating gas.
 a. True
 b. False

8. Eighty percent of all poisonings are caused by which of the following means?
 a. Ingestion
 b. Inhalation
 c. Absorption
 d. Injection

Answers: 1. d. **2.** d. **3.** b. **4.** d = heat exhaustion; c = heatstroke; b = frostbite; a = hypothermia. **5.** a, b, c, d. **6.** a = shortness of breath; b = profuse sweating; c = enlargement of neck veins; d = gurgling respirations; e = swollen ankles. **7.** a. **8.** a.

Self Test 5 369

9. The primary cause of death from poisoning today is due to illegal drugs.
 a. True
 b. False

10. Place the following phases of a situational crisis in order of their usual occurrence.
 ___ a. Remorse and grief
 ___ b. Anger
 ___ c. Denial
 ___ d. High anxiety or emotional shock

11. Give an example of how you might use each of the following communication techniques.
 a. Restatement
 b. Redirection
 c. Empathy

12. Describe how you would deal with an armed patient.

13. What are the three major types of problems that cause shock?

14. Circle the correct treatments for a patient who is suffering shock.
 a. Maintain the ABCs.
 b. Maintain the patient's body temperature.
 c. Give the patient fluids for thirst.
 d. Sit the patient up.
 e. Treat the cause of shock if possible.

15. Define the following types of wounds.
 a. Avulsion
 b. Laceration
 c. Puncture
 d. Abrasion

16. Describe the BSI techniques for wound care.

17. Which of the following conditions are signs and symptoms of respiratory burns?
 a. Difficulty breathing
 b. Blackened nose hairs
 c. The smell of smoke on the patient
 d. Pain while breathing
 e. Unconsciousness as a result of a fire
 f. Burns around the face

18. Describe the differences between the following conditions.
 a. Fracture
 b. Sprain
 c. Dislocation

19. List six items that can be used for emergency splinting.

20. Describe the care for a dislocated elbow.

21. Which of the following are signs and symptoms of a head injury?
 a. Battle's sign
 b. Raccoon eyes
 c. Unequal pupils
 d. Fear
 e. Consciousness
 f. Paralysis
 g. Vomiting

22. Unconscious patients with head injuries should be placed in the recovery position.
 a. True
 b. False

9. a. **10.** 4 = a; 3 = b; 2 = c; 1 = d. **11.** a. Restatement-rephrasing a person's own words or thoughts to show that you understand. b. Redirection-helping to focus a patient's attention on the immediate situation or crisis. c. Empathy-trying to understand how you would feel if you were in the patient's situation. **12.** Do not proceed into any area where there may be an armed person; call for assistance from law enforcement personnel. **13.** Pump failure, pipe problems, and fluid problems. **14.** a, b, e. **15.** a: An injury in which a piece of skin is with torn completely loose from all of its attachments or is left hanging as a flap; b: An irregular cut or tear through the skin; c: A wound result-ing from a bullet, knife, ice pick, or any other pointed object; d: Loss of skin as a result of a body part being rubbed or scraped across a rough or hard surface. **16.** Wear gloves to prevent contact with the patient's blood; wear mask and eye protection if you may be exposed to the splatter of blood from a massive wound or if the patient is coughing or vomiting blood. **17.** All are signs and symptoms of respira-tory burns. **18.** Fracture = any break in a bone; Sprain = a joint injury in which the joint is partially temporarily dislocated and some of the supporting ligaments are either stretched or torn; Dislocation = disruption of a joint so that the bone ends are no longer in alignment. **19.** Newspaper, magazine, towels, belts, the patient's body, padded boards. **20.** Do not move the injured elbow from the position in which you find it; consider the use of a pillow or SAM splint; move the limb to the patient's side if this does not cause pain. **21.** a, b, c, f, g. **22.** b.

23. Patients with possible spinal injuries should be moved under which of the following circumstances?
 a. To remove them from a dangerous environment
 b. To make them more comfortable
 c. If necessary to perform CPR
 d. Only when adequate equipment and personnel are available

24. When should you remove a football or motorcycle helmet?

25. Gunshot wounds are a significant cause of spinal cord injuries.
 a. True
 b. False

23. a, c, d. 24. Only if it is needed to maintain the patient's airway or breathing. 25. a.

6

CHILDBIRTH AND CHILDREN

As a first responder, you will be called upon to assist people of all ages. Newborn infants and children represent special kinds of patients. In Chapter 14 you will learn the simple steps that will give you the knowledge and skills you need to assist a woman with the delivery of an infant. Few situations are as scary to the untrained and as rewarding to trained emergency medical services personnel as delivering a baby.

Children are people too, and as such the steps in providing emergency medical care are generally the same as for adults. However, children have special needs, and some of the care you give them needs to be modified because of the differences in pediatric anatomy and function. For this reason, Chapter 15 covers the special conditions and treatments that you need to know in order to administer care to sick and injured children.

CHAPTER
14

CHILDBIRTH

Knowledge and Attitude Objectives

After studying this chapter, you will be expected to:

1. Identify the following structures:
 a. Birth canal
 b. Placenta
 c. Umbilical cord
 d. Amniotic sac
2. Define the following terms:
 a. Crowning
 b. Bloody show
 c. Labor
 d. Miscarriage (spontaneous abortion)
3. Explain the three stages of the labor and delivery process.
4. State the signs and symptoms that indicate that delivery is imminent.
5. State the steps you need to take to prepare a mother for delivery.
6. Explain the importance of body substance isolation in childbirth situations.
7. Describe the equipment you should have for an emergency childbirth situation.
8. Describe the steps you should take to assist a mother in childbirth.
9. Describe the steps you should take to care for a newborn infant.
10. Discuss the steps in the delivery of the placenta.
11. List the steps you should take in caring for a mother after delivery.
12. Describe the steps in resuscitating a newborn infant.
13. Describe the steps you should take in caring for the following complications of childbirth:
 a. Unbroken bag of waters
 b. Breech birth
 c. Prolapse of the umbilical cord
 d. Excessive bleeding after delivery
 e. Miscarriage
 f. Stillborn
 g. Premature birth
 h. Multiple births

1. Assist in the normal delivery of an infant.
2. Assist in the delivery of the placenta.
3. Provide care for a newborn infant.
4. Resuscitate a newborn infant.
5. Provide after-delivery care to a new mother.

As a first responder, you must sometimes assist in the birth of a child. Childbirth is an exciting, dramatic, and stressful event, even when it occurs as planned. If you are called upon to assist with childbirth, it is probably not occurring as planned. However, if you remember some easy steps, you can effectively assist in the birth process and offer comfort and support to both mother and child.

Childbirth is a normal and natural part of life. If you are concerned about your ability to handle such a situation, just remember that thousands of deliveries occur each day and that in many countries medical assistance at childbirth is the exception, not the rule.

You may not have the time or necessary assistance to transport the expectant mother to the hospital. Therefore, you must be prepared to help the mother deliver the child. In most cases, the mother is the one who delivers the child and you will only assist her, as needed. During the birth process, the baby is literally pushed out of the mother. You will assist by "catching" the baby and helping it begin to breathe adequately.

Generally, pregnancy and the birth process are not a surprise for the mother, and she may be quite knowledgeable and well prepared. However, you may have been called to assist because the timing of the childbirth has caught everyone by surprise. In reviewing this chapter, you will find that the birth process has several stages, but you need to be primarily concerned about two key indicators: the frequency of contractions and the crowning of the baby's head.

The Anatomy and Function of the Female Reproductive System

The major female reproductive organs are the ovaries, which produce eggs, and the **uterus,** which holds the fertilized egg as it develops during pregnancy. The ovaries and the uterus are connected by the fallopian tubes. The external opening of the female reproductive system is called the **birth canal,** or the **vagina.** The developing **fetus** receives oxygen and nutrients through the **umbilical cord,** which transports nutrients and oxygen from the **placenta** to the baby. The placenta draws nutrients from the wall of the mother's uterus. The developing baby is encased in an amniotic sac for support and floats in amniotic fluid. Figure 14.1 shows the anatomy of a pregnant female.

Assessing the Birth Situation

Should you help deliver a baby away from the hospital or transport the mother to the hospital? To make this decision, you need to understand that normal **labor** consists of three distinct stages.

Uterus (womb) Muscular organ that holds and nourishes the developing baby.

Birth canal The vagina and the lower part of the uterus.

Vagina The opening through which the baby emerges.

Fetus A developing baby in the uterus or womb.

Umbilical cord Rope-like attachment between the mother and baby; nourishment and waste products pass to and from the baby and the mother through this cord.

Placenta Life-support system of the baby during its time inside the mother (commonly called the "afterbirth").

Labor The process of delivering a baby.

Stages of Labor

1. *Stage One* is when the mother's body prepares for birth and the following conditions are present: initial **contractions** occur; the "water" breaks; the **bloody show** occurs, but no **crowning** of the baby's head occurs during the contractions. If, after carefully checking the mother, you determine that the baby is not crowning, report this to the responding ambulance crew because they may then choose to transport the mother to the hospital during this stage of labor.

2. *Stage Two* involves the actual birth of the baby. (See Figure 14.2.) You will see the baby's head crowning during contractions, at which time you must prepare to assist the mother in the delivery of the baby. No transport now!

3. *Stage Three,* the final stage, involves delivery of the placenta (afterbirth). You must assist in the stabilization of the mother and baby and the delivery of the placenta.

Fig. 14.1 Anatomy of a pregnant woman.

The Key Factors

Make your decisions based on answers to the following questions:

- When is the baby due?
- Is there any chance that this will be a multiple birth?
- Does the mother feel as if she is having a bowel movement with increasing pressure in the vaginal area?
- Is this the mother's first pregnancy? (The first baby usually takes a long time to deliver; subsequent babies are delivered much faster.)
- What is the time of the contraction cycle?
- Is there a bloody show (expelling of the mucus plug from the opening of the vagina)?
- Has the **bag of waters** broken? How long ago?
- Is the baby crowning?
- Is transportation available?
- Is there enough time to transport the mother before the birth occurs? (Find out not only if the ambulance is ready, but also how far it is to the hospital.)
- Is travel restricted (for example, during a snowstorm or rush-hour traffic)?

While you prepare to assist in the delivery of a baby, keep these two things in mind:

1. Calm the mother. Delivery is a natural process.
2. Calm yourself. You are there to help.

Focus on Assessment

Contractions Muscular movements of the uterus that push the baby out of the mother.

Bloody show The bloody mucus plug that is discharged from the vagina when labor begins.

Crowning Appearance of the baby's head during a contraction as it is pushed outward through the vagina.

Bag of waters The amniotic fluid that surrounds the baby before birth.

--

▼ **CAUTION**

 If the mother reports that she needs to move her bowels, do not allow her to go to the bathroom! This feeling is caused by the downward movement of the baby.

--

Body Substance Isolation and Childbirth

You should use sterile gloves during any delivery whenever possible. Sterile gloves protect the mother and infant from infection and they protect you from contamination in the event that the mother has a disease that is spread through contact with body fluids. Try not to get any more blood or fluids on you than is absolutely necessary. Because there is some chance that you may be splattered on the face during the delivery process, it is recommended that you have face and eye protection to keep possible splatter out of your eyes, nose, and mouth. The use of surgical gowns is also recommended to keep fluids off your body.

As a first responder, you must do what you can to prevent unnecessary exposure to body fluids. You will not have all the equipment that is available in a hospital, however. Report all direct exposures of blood or fluids to the emergency physician or to your medical director.

Equipment

You should have a prepackaged delivery kit in your emergency care equipment (Figure 14.5). That kit contains everything you need, including the following items :

- Sterile gloves
- Sterile drapes and towels
- 4 × 4 gauze pads
- Bulb syringe
- Umbilical cord clamp
- Sanitary pads
- A towel or blanket for the baby

In addition, you will need:

- Sheets or towels for the mother
- Oxygen (if available)
- Suction (if available)
- Infant mask

If you do not have a delivery kit, look for appropriate substitute materials. Many of these materials are available in your first responder life support kit or in most homes. Even if you do not have any equipment, remember that you can still do everything using common sense and no equipment other than your gloved hands (Figure 14.6).

Assisting with Delivery

Remember that your primary purpose is to deliver the baby. The mother is going to feel pressure in the vaginal area, as if she has to move her bowels. This is a normal feeling during the delivery process. Do not let her go to the bathroom, and do not hold her legs together.

Fig. 14.5 Commercial obstetrical (OB) kit.

Fig.

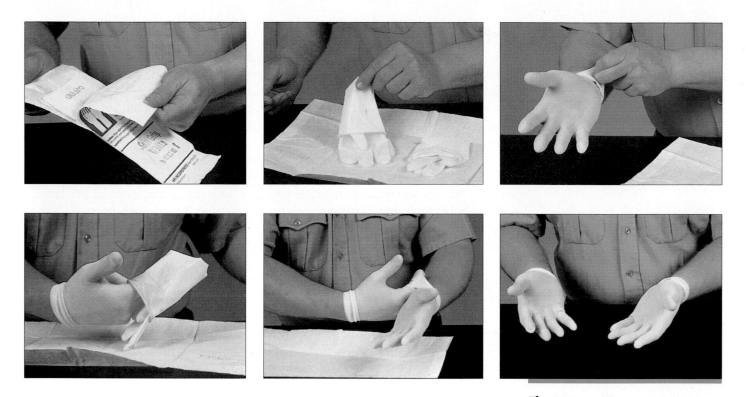

Fig. 14.6 Putting on sterile gloves requires that specific steps be followed to maintain sterility.

Be as clean as possible during the entire delivery process. Follow the BSI techniques described above. Do not touch the vaginal area except during a delivery. If you have a partner, have him or her stay with you during the delivery.

Have the mother lie on her back. If pillows or blankets are available, cover them with clean towels or sheets and place them under the mother's buttocks to elevate her hips. Have the mother draw up her knees and spread her legs apart.

The baby's head should emerge slowly to prevent tearing of the vagina and undue stress on the baby. As the head is being delivered, the mother must stop pushing. To help her stop pushing, tell her to breathe rapidly. Some EMS systems advise their personnel to use the palm of the hand to provide slight counter-pressure over the baby's head to slow down the birth process. Be sure to check with your local medical authority regarding how your EMS system wants to handle this subject.

Do not attempt to pull the baby during delivery. As the head is delivered, the baby will turn by itself to its side, and the delivery of the rest of the body will follow spontaneously. Be ready to catch the baby in a clean towel as soon as the head appears. Support the baby's head. Remember, the baby will be wet and slippery. As the torso and the legs are delivered, support the infant with both hands. Do not pull the infant. As the feet are delivered, grasp the baby's feet. Keep the infant's head at about the level of the mother's vagina.

If the amniotic sac has not broken as the baby's head starts to deliver, tear it with your fingers and push it away from the infant's head and mouth. As the infant's head is being delivered, check to see if the umbilical cord is wrapped around the infant's neck. If the cord is wrapped around the infant's neck, attempt to slip the cord over the baby's shoulder. If you cannot do this, attempt to reduce the pressure on the cord. Never pull on the umbilical cord; it is extremely fragile.

Caring for the Newborn

As soon as you are holding the newborn baby in a clean towel, lay him or her down between the mother's legs and immediately clear the baby's mouth and nose. Suction the mouth and the nostrils two to three times. Use a **bulb syringe** from the OB kit if available. Use caution to avoid contact with the back of the baby's mouth. If a bulb syringe is not available, wipe the baby's mouth and nose with a gauze pad.

You can place the infant on the mother's abdomen. This will help to keep the baby from losing too much warmth. Wipe blood and mucus from the baby's mouth and nose with sterile gauze or with the cleanest object available. If the baby is not breathing, suction the baby's mouth and nose again. Rub the baby's back or flick the soles of the baby's feet to stimulate breathing. Dry the infant as soon as possible and then wrap the infant in a blanket. This will help prevent loss of warmth. Place the infant on his or her side with the head slightly lower than the trunk. This will help to aid the drainage of secretions from the airway.

When the umbilical cord stops pulsating, it can be tied with gauze between the mother and the newborn. In a normal delivery there is no need for you to cut the umbilical cord. Keep the infant warm and wait for more highly trained EMS personnel to arrive on the scene. They will have the proper equipment to clamp and cut the umbilical cord in an approved manner.

Note the time of the delivery so it can be properly reported on the baby's birth certificate. In the rare event that there may be multiple births, prepare for the second delivery.

Delivery of the Placenta

The placenta will deliver on its own, usually within 30 minutes of the baby's delivery. Never pull on the cord to help deliver the placenta!

The safest and best method for both mother and child is to leave the umbilical cord uncut and attached to both the placenta and the baby—at least until the transporting EMS unit arrives. After the placenta is delivered, it should be wrapped in a towel or newspaper with three-quarters of the umbilical cord and placed in a plastic bag and transported to the hospital with the mother and child so it can be examined by a physician. Try to keep the placenta at the same level as the baby to minimize any backflow of blood from the infant. This is especially important if you arc unable to tie the umbilical cord (Figure 14.7). The mother can be transported to the hospital before the placenta is delivered, if necessary.

Bleeding usually stops after the placenta is delivered. The first responder can massage the uterus to assist in stopping this bleeding. To massage the uterus, place one hand with fingers fully extended just above the mother's pubic bone and use your other hand to press down into the abdomen and gently massage the uterus until it becomes firm. This should take from 3 to 5 minutes. As the uterus firms up, it should feel about the size of a softball or large grapefruit.

Remember: Keep the baby warm. Be sure to cover the baby's head and body to prevent loss of body heat.

Bulb syringe A rubber or plastic device used for gentle suction in newborns and small infants.

DID YOU KNOW ?

► Children breathe with their mouths wide open, but newborn babies breathe through their noses! Clean the newborn's nose carefully and completely.

Fig. 14.7 When sterile supplies are not available and you cannot cut the umbilical cord, keep the placenta, still attached to the cord, at the same level as the baby during transport to the hospital.

Aftercare of the Mother and Newborn

Continue to carefully observe both the mother and child. Be sure to keep them both warm. About every 3 to 5 minutes, recheck the uterus for firmness. Also recheck the vagina to see if there is any excessive bleeding. In a normal delivery, there is a blood loss of about 300 to 500 mL (1 to 2 cups) of blood. Continue to massage the uterus if it is not firm or if bleeding continues.

Clean the mother with clean, moist towels or cloths. Cover the vaginal opening with a clean sanitary pad or large dressing. Replace the sheets with clean ones, if possible. If the mother is thirsty, she can be given small amounts of water.

The newborn infant should:

- Breathe at a rate greater than 40 breaths per minute.
- Be crying right after birth.
- Have a pulse of greater than 100 beats per minute. (Check the pulse at the brachial pulse or at the umbilical cord.)

 Focus on Assessment

Resuscitating the Newborn

If the infant does not breathe on its own within the first minute after birth, proceed with the following steps:

1. Tilt the infant's head down and to the side (Figure 14.8) to encourage drainage of mucus.
2. Suction the nose and mouth with a bulb syringe (if available) after delivery of the shoulders. Drying and **suctioning** usually produce enough stimulation to induce respirations. Other methods include gently snapping the fingers on the soles of the feet (Figure 14.9) and/or rubbing the infant's back. Rough handling is not needed. An infant responds best to simple, gentle techniques. If the infant still does not breathe, proceed to step 3.

 Focus on Treatment

Suctioning Aspirating (sucking out) fluid by mechanical means.

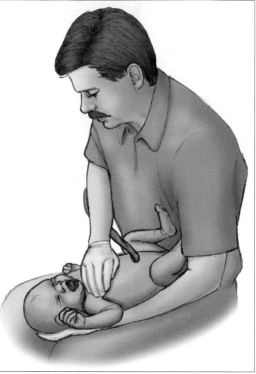

Fig. 14.8 Tilt the infant so the head is down and to the side to clear the airway.

SAFETY PRECAUTION
Report to the emergency physician if you did rescue breathing without a barrier device and may have been exposed to blood or fluids.

- Transportation to an appropriate medical facility
- Prompt transportation to an appropriate medical facility
- Rapid transportation to an appropriate medical facility

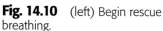

Fig. 14.9 Gently snap your fingers against the soles of the feet to stimulate the baby.

3. Begin mouth-to-mouth-and-nose or mouth-to-mask breathing by gently puffing twice into the infant's mouth and nose (Figure 14.10). If the infant then starts to breathe, support and assist respirations and recheck the airway to be sure it remains clear. (See Chapter 8.)

4. If the infant still does not start breathing on his or her own, continue mouth-to-mouth-and-nose or mouth-to-mask breathing and check for a brachial pulse.

5. If you cannot feel a brachial pulse, or if the heart rate is less than 80 beats per minute, begin closed-chest cardiac compressions (Figure 14.11). Use only your first two fingers to depress the chest of an infant. (See Chapter 8.)

6. Continue CPR until the infant breathes or until it is pronounced dead by a physician. Provide rapid transport to the hospital as quickly as possible. Do not give up!

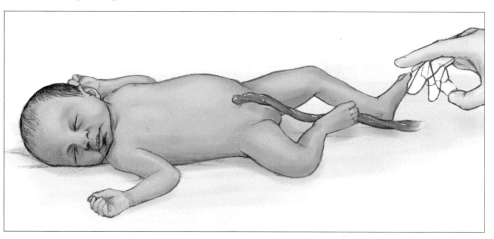

Fig. 14.10 (left) Begin rescue breathing.

Fig. 14.11 (right) Begin chest compressions with two fingers.

Automobile Accidents and the Pregnant Woman

Any pregnant woman involved in an automobile accident should be examined by a physician. The forces involved in even minor accidents may be great enough to cause injury to the mother or unborn child, even though the child is usually well protected in the uterus.

In rare circumstances, an accident is severe enough to kill the mother, yet the unborn child can still be saved. Provide CPR to the mother while transporting her to the closest medical facility.

Complications of Childbirth

Although the vast majority of births are normal, you should be aware of the complications.

✓ Describe the actions you can take as a first responder to assist a mother with a normal delivery.

Unbroken Bag of Waters

In rare instances, the bag of fluid that surrounds the baby does not break. If the baby is born surrounded by the bag of waters, carefully break the bag and push it away from the baby's nose and mouth so the child can breathe. Be careful not to injure the baby in the process. Then suction the baby's nose and mouth to help him or her begin to breathe.

Breech Birth

A breech birth is an abnormal delivery in which part of the baby other than the top of its head comes down the birth canal first. In a breech birth, the first thing you see may be the baby's leg, arm, shoulder, or buttocks. This type of delivery can result in injury to both the baby and the mother.

If, instead of the normal crowning, you see a **breech presentation,** make every attempt to arrange for immediate transport to a medical facility. Labor will be slowed by a breech birth, giving more time for transport to the emergency department. If you are stranded and not able to transport, you will have to assist with the breech birth.

Support the baby's legs and body as they are delivered; the head usually follows on its own. If the head does not deliver within 3 minutes, arrange for prompt transport to a hospital. Use your fingers to keep the baby's airway open.

Breech presentation A delivery in which the baby's buttocks, arm, shoulder, or leg appears first rather than the head.

⚠ CAUTION
Do not attempt to pull a breech baby out of the vagina!

- Transportation to an appropriate medical facility
- Prompt transportation to an appropriate medical facility
- Rapid transportation to an appropriate medical facility

Prolapse of the umbilical cord A delivery in which the umbilical cord appears before the baby does; the baby's head may compress the cord and cut off all circulation to the baby.

- Transportation to an appropriate medical facility
- Prompt transportation to an appropriate medical facility
- Rapid transportation to an appropriate medical facility

- Transportation to an appropriate medical facility
- Prompt transportation to an appropriate medical facility
- Rapid transportation to an appropriate medical facility

Anus The distal or terminal ending of the gastrointestinal tract.

Miscarriage Delivery of the fetus before it is mature enough to survive outside the womb (about 20 weeks), either from natural causes (spontaneous abortion) or induced.

- Transportation to an appropriate medical facility
- Prompt transportation to an appropriate medical facility
- Rapid transportation to an appropriate medical facility

In very rare cases, the arm is the first part of the baby to appear in the birth canal. This circumstance is an extreme emergency that cannot be handled in the field. You must arrange for the mother's rapid and immediate transport to the hospital by ambulance.

Prolapse of the Umbilical Cord

On rare occasions, the umbilical cord comes out of the vagina before the baby is born. This is called **prolapse of the umbilical cord.** The umbilical cord may be compressed between the baby and the mother's pelvis during contractions, cutting off the baby's blood supply. This is a serious emergency and transport to a hospital must be immediate.

Get the mother's hips up! Place the mother on her back and prop her hips and legs higher than the rest of her body with pillows, blankets, or articles of clothing. Keep the cord covered and moist and do not try to push it back into the vagina. Administer oxygen to the mother if it is available. Arrange for rapid transport to the hospital.

Some EMS systems will advise you to place the mother in a kneeling position (knee-chest position) to take the pressure off the cord. Check with your medical director regarding local procedures.

Excessive Bleeding after Delivery

In addition to the early bloody show that precedes birth, about one or two cups of blood are lost during normal childbirth. If the mother is bleeding severely, place one or more clean sanitary pads at the opening of the vagina, elevate the mother's legs and hips, treat her for shock, and arrange for rapid ambulance transport to the hospital.

Encourage the baby to nurse at the mother's breast because nursing contracts the uterus and often stops the bleeding. Massage the uterus with your hand, as described earlier in this chapter.

If the area between the mother's vagina and **anus** is torn and bleeding, treat it as you would an open wound. Apply direct pressure, using sanitary pads or gauze dressings.

Miscarriage

A **miscarriage** (spontaneous abortion) is the delivery of an incomplete or underdeveloped fetus (baby). If a miscarriage occurs, you should save the fetus and all the tissues that have been passed from the vagina. The mother's bleeding should be controlled by placing a sanitary pad or other large dressing at the vaginal opening. Also treat her for shock. Arrange for prompt transport to a hospital for a physician to examine her and control continued bleeding.

A mother who has experienced a miscarriage is upset about losing the baby and needs your psychological support as well as your emergency medical care. Be sensitive to the needs and concerns of the mother and other members of the family.

Stillborn Delivery

Resuscitation should be started and continued on all newborns who are not breathing. However, sometimes a baby has died long before delivery. Those babies generally have unpleasant odors and are without any signs of life.

Such a lifeless fetus is referred to as a "stillborn." In a case like this, you should turn your attention to the mother in order to provide physical care and psychological support.

Premature Birth

Any baby weighing less than 5½ lb or delivered before eight months of pregnancy is called premature. Premature infants are smaller, thinner, and usually redder than full-term babies.

Remember that premature babies especially must be kept warm because they lose body heat rapidly. Wrap all infants in a clean towel or sheet and cover their heads. Wrapping the **premature baby** in an additional length of aluminum foil can help maintain its temperature. Arrange for prompt transport to a medical facility.

Multiple Births

In the event of multiple births (such as twins), another set of labor contractions will begin shortly after the delivery of the first baby. A mother generally knows of a multiple birth in advance. However, occasionally everyone is surprised. Do not worry—just get ready to repeat the procedures you have completed for the first baby!

Check Point

✓ After helping a mother deliver a normal healthy baby, you notice excessive bleeding. What steps should you take?

Premature baby A baby who delivers before 8 months gestation or who weighs less than 5½ pounds at birth.

- Transportation to an appropriate medical facility
- Prompt transportation to an appropriate medical facility
- Rapid transportation to an appropriate medical facility

CHAPTER
REVIEW 14

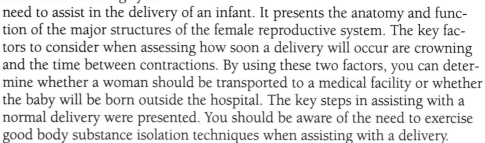

Summary

This chapter presents the skills and knowledge you need to assist in the delivery of an infant. It presents the anatomy and function of the major structures of the female reproductive system. The key factors to consider when assessing how soon a delivery will occur are crowning and the time between contractions. By using these two factors, you can determine whether a woman should be transported to a medical facility or whether the baby will be born outside the hospital. The key steps in assisting with a normal delivery were presented. You should be aware of the need to exercise good body substance isolation techniques when assisting with a delivery.

Care of the mother and infant after the delivery are important. You should have the skills needed to resuscitate a newborn. Careful delivery of the placenta is important. You should understand the complications that can occur during labor and delivery and know the appropriate care for these complications. Finally keep in mind that childbirth is normally a happy event. You are there to assist in the delivery, which in most cases has a happy, healthy outcome.

Key Terms

Anus—page 386

Bag of waters—page 377

Birth canal—page 376

Bloody show—page 377

Breech presentation—page 385

Bulb syringe—page 382

Contractions—page 377

Crowning—page 377

Fetus—page 376

Labor—page 376

Miscarriage—page 386

Placenta—page 376

Premature baby—page 387

Prolapse of the umbilical cord—page 386

Suctioning—page 383

Umbilical cord—page 376

Uterus (womb)—page 376

Vagina—page 376

What Would You Do?

1. You are called to the home of a woman who is 7 months pregnant and is complaining of severe abdominal pain. She states that the pains started 20 minutes ago. You notice her skirt is bloodstained. What would you do?
2. As you are directing traffic at a major auto accident on the freeway, a man comes running up to you and tells you that his wife is in labor and is having contractions every 4 minutes. The freeway is gridlocked with traffic. What would you do?

You Should Know

1. The following structures:
 a. Birth canal
 b. Placenta
 c. Umbilical cord
 d. Amniotic sac
2. The following terms:
 a. Crowning
 b. Bloody show
 c. Labor
 d. Miscarriage (spontaneous abortion)
3. The three stages of the labor and delivery process.
4. The signs and symptoms that indicate that delivery is imminent.
5. The steps you need to take to prepare a mother for delivery.
6. The importance of body substance isolation in childbirth situations.
7. The equipment you should have for an emergency childbirth situation.
8. The steps you should take to assist a mother in childbirth.
9. The steps you should take to care for a newborn infant.
10. The steps in the delivery of the placenta.
11. The steps you should take in caring for a mother after delivery.
12. The steps in resuscitating a newborn infant.
13. The steps you should take in caring for the following complications of childbirth:
 a. Unbroken bag of waters
 b. Breech birth
 c. Prolapse of the umbilical cord
 d. Excessive bleeding after delivery
 e. Miscarriage
 f. Stillborn
 g. Premature birth
 h. Multiple births

You Should Practice

1. Assisting in the normal delivery of an infant or a manikin.
2. Assisting in the delivery of a real or simulated placenta.
3. Providing care for a newborn infant.
4. Resuscitating a newborn infant.
5. Providing after-delivery care to a new mother.

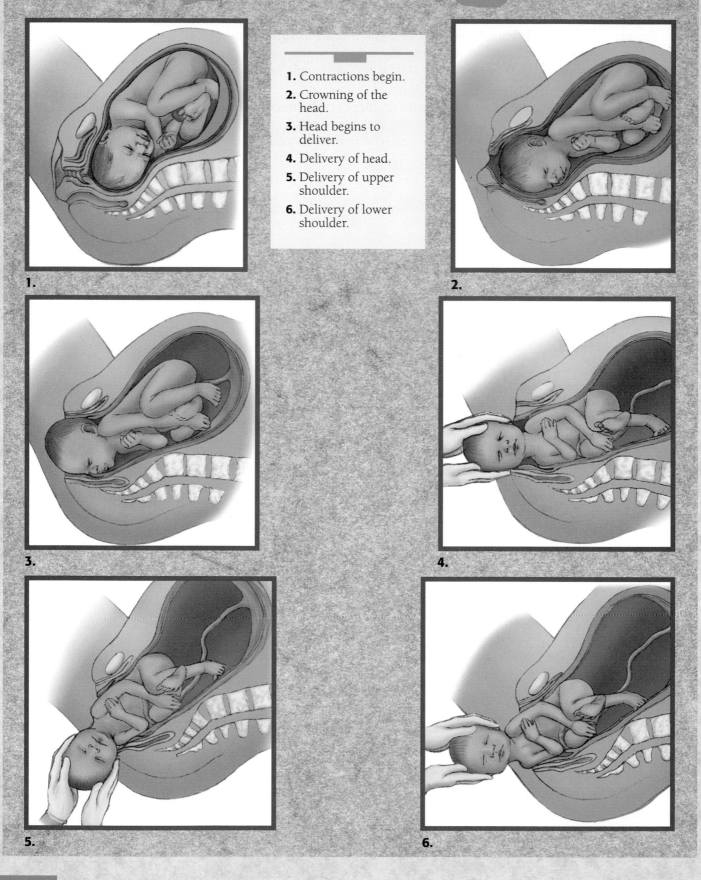

SKILL SCAN: Recognizing Phases of Labor

1. Contractions begin.
2. Crowning of the head.
3. Head begins to deliver.
4. Delivery of head.
5. Delivery of upper shoulder.
6. Delivery of lower shoulder.

1.

2.

3.

4.

5.

6.

NOTES

INFANTS AND CHILDREN—PEDIATRIC EMERGENCIES

Knowledge and Attitude Objectives *After studying this chapter, you will be expected to:*

1. Describe the differences in a child's anatomy compared to that of an adult.
2. Describe the normal rates of respiration and pulse for a child.
3. Explain the differences in performing the following skills on a child:
 a. Opening the airway
 b. Basic life support
 c. Suctioning
 d. Inserting an oral airway
4. Describe how to treat a child and an infant with:
 a. A partial airway obstruction
 b. A complete airway obstruction
 c. Respiratory distress
 d. Respiratory failure
 e. A swallowed object
 f. Circulatory failure
5. Describe how to treat the following illnesses and medical emergencies:
 a. Altered mental status
 b. Asthma
 c. Croup
 d. Epiglottitis
 e. Heat illnesses
 f. High fever
 g. Seizures
 h. Abdominal pain
 i. Poisoning
 j. Sudden infant death syndrome
6. Describe the patterns of pediatric injury.
7. Describe the signs and symptoms of shock in pediatric patients.
8. Explain the steps you should take in caring for a child who has signs of child abuse or sexual assault.
9. Describe the need for first responder critical incident stress debriefing.

Skill Objectives
As a first responder, you should be able to:

1. Determine the respiratory rate, pulse rate, and body temperature in a child.
2. Perform the following respiratory skills:
 a. Opening the airways
 b. Basic life support
 c. Suctioning
 d. Inserting an oral airway
3. Treat the following conditions:
 a. Partial airway obstruction in children and infants
 b. Complete airway obstruction in children and infants
4. Cool a child with a high fever.

This chapter covers the special knowledge and skills you need to assess and treat children and infants who are suffering from sudden illness or trauma. The differences between the anatomy of an adult and that of a child are covered. The special considerations for examining pediatric patients are highlighted. Respiratory care for children is very important. The following respiratory skills are covered: opening the airway, basic life support, suctioning, and relieving airway obstructions. The signs of respiratory distress, respiratory failure, and circulatory failure in children and infants are explained.

Sudden illnesses and medical emergencies are common in children and infants. It is important that you learn some basic information and treatment for the following conditions: altered mental status, asthma, croup, epiglottitis, heat illnesses, high fever, seizures, abdominal pain, poisoning, and sudden infant death syndrome. Because trauma is the leading cause of death in children, this chapter covers patterns of injury and the signs of traumatic shock in children. Finally you should be able to recognize some of the signs and symptoms of child abuse and sexual abuse in children so you can take the proper steps to get help for these children.

General Considerations

The management of a pediatric emergency can be one of the most stressful situations you face as a first responder. The child is frightened, anxious, and usually unable to communicate his or her problems to you clearly. The parents are anxious and frightened and so are you, particularly if you are not prepared.

EMS personnel often have feelings of inadequacy when treating a child. In some cases, the child reminds them of a child they know. Even the most experienced personnel respond emotionally to a seriously ill or injured child. In this atmosphere, where everyone else is tense, you must behave in a calm, controlled, and professional manner.

The Parents

The child's parents can be your greatest allies or greatest problem. You must respond to them as much as to the child, although in a different way. Talk to

both parents and to the child as much as possible. Parents are understandably concerned about their child's condition, especially if they don't clearly understand the situation or if they think the situation is more serious than it is. For instance, imagine a mother's reaction to a bleeding laceration of her child's forehead. Your training has taught you that scalp wounds can bleed profusely, but that such bleeding can be easily controlled by using direct pressure. However, most parents don't know that and may become emotional.

Children get many of their behavioral cues from their parents. Calm the parents, talk with them, and ask their assistance in calming the child. It is a good idea to allow a parent to hold the child if the illness or injury permits. Let the parent hold the child's hand or at least keep the parents where the child can see them.

Quickly try to develop rapport with the child. Tell the child your first name, find out what the child's name is, and use the child's name when explaining what you are doing. Do not stand over the child. Squat, kneel, or sit down and establish eye contact. Ask the child simple questions concerning pain, and ask the child to help you by pointing to (or touching) the painful area.

Be honest with the child. For instance, if you must move an arm or leg for splinting, tell the child what you are going to do and explain that the movement may hurt. Ask the child to help by calming down, lying still, or holding a bandage. The level of understanding and cooperation you receive from an ill or injured child is often remarkable and may surprise you. Some emergency service agencies have gone one step further to provide the child with a trauma teddy bear to hold while being examined (Figure 15.1).

Fig. 15.1 The trauma teddy bear helps keep a child calm while being examined.

Pediatric Anatomy and Function

Children have the same body systems as adults and these systems perform the same functions as adults, but there are certain differences in the anatomy and function that you should know. Several of these differences relate to the airway. Children's airways are smaller in relation to the rest of their body.

Therefore, a child's airway is more easily blocked by secretions or by swelling. This swelling can be caused by illnesses or by trauma. Because a child's tongue is relatively larger than the tongue of an adult, a child's tongue can more easily block the airway if the child becomes unresponsive.

Because the anatomy of a child's upper airway is more flexible than the airway of an adult, you must remember to avoid hyperextending the neck of an infant or child when attempting to open the airway. Position the head in a neutral or slight sniffing position, but do not hyperextend the neck. Hyperextending a child's neck can occlude the airway. For at least the first six months of their lives, infants can breathe only through their nose. If an infant's nose becomes blocked by mucus secretions, the infant cannot breathe through the mouth. Therefore, it is important to clear the nose of an infant to enable breathing.

Children are able to compensate quickly for changes in the demands on their respiratory system. They can increase their rate of breathing and increase their effort of breathing for a short period of time. However, they will "run out of steam" in a relatively short period of time. When this happens, the child may quickly show signs of severe respiratory distress and in a short period of time progress into respiratory failure. Therefore, it is important to perform a complete and thorough assessment and to monitor their vital signs. Repeat the vital signs at least every 5 minutes when caring for seriously ill or injured pediatric patients.

Because infants and children have limited abilities to compensate for respiratory changes, they also have limited abilities to compensate for changes in temperature. Children have a greater surface area relative to the mass of their body. This means that they lose relatively more heat than adults do. Therefore, you need to keep the body temperature of children as close to normal as possible and to rewarm them if they become chilled.

Examining a Child

Observe the child carefully when you first meet. Does the child appear to be ill or injured? Children often "look sick," or you may note an obvious injury (Figure 15.2).

The child who is unresponsive, lackluster, and appears ill should be evaluated carefully because lack of activity and interest can signal serious illness or injury. Infants and young children normally cry in response to fear or pain; a child who is not crying may have a decreased level of consciousness. If the child is crying, does the cry sound like a normal healthy cry or is it a subdued whimper?

Carry out the routine patient examination described in Chapter 7, paying special attention to mental awareness, activity level, respirations, pulse rate, body temperature, and color of the skin.

Respirations

From birth to about six months of age, children are "nose breathers." They have not yet learned to breathe through their mouths.

Respiratory rate can best be calculated by counting respirations for 30 seconds and multiplying by 2. Counting for less than 30 seconds can cause inaccurate results because children often have irregular breathing patterns.

As you examine children, look for the following signs of respiratory distress: restlessness, noisy breathing, flaring of the nose, and retractions of

Fig. 15.2 Observe the child carefully.

the neck and chest. Respiratory distress is discussed under respiratory emergencies.

Pulse Rate

The normal pulse rate of a child—80 to 100 beats per minute—is faster than an adult's normal rate. The best place to take a pulse in a child one year of age or younger is either over the brachial artery, which is halfway between the shoulder and the elbow on the inside of the upper arm, or directly over the heart (see Figure 15.3).

Table 15.1 describes the usual, normal vital signs for children at various ages.

High Body Temperature

High temperatures in children are accompanied by several signs, including flushed, red skin; sweating; and restlessness. You can often feel a high temperature just by touching the child's chest and head. The heart rate of children becomes faster with each degree of temperature increase.

Fig. 15.3 The best place to take the pulse in an infant is over the brachial artery or directly over the heart.

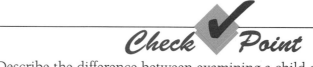

Table 15.1 Normal Vital Signs in Children at Rest		
Age	Heart Rate	Respirations
Newborn	140	40–60
1 year	130	22–30
3 years	80	20–26
10 years	75	18–22

Check ✔ *Point*

✔ Describe the difference between examining a child and an adult.

Respiratory Care

Like adults, children are not able to tolerate a lack of oxygen for more than a few minutes before permanent brain damage occurs. Therefore, the rules for applying basic life support (BLS) are no different for children than for adults.

Cardiopulmonary arrest in an adult is usually caused by a heart attack. In contrast, infants and children usually first suffer respiratory arrest. Then they may undergo cardiac arrest, as a result of the lack of oxygen produced by the respiratory arrest. It is, therefore, important for the first responder to open and maintain the airway and to ventilate adequately any child with respiratory problems.

Some of the specific causes of cardiopulmonary arrest in children include suffocation caused by the aspiration of a foreign body, infections of the airway such as croup and acute epiglottitis, sudden infant death syndrome (SIDS), accidental poisonings, and injuries around the head and neck. Each problem is discussed in detail later in this chapter.

Essential Skills

The skills you need to treat respiratory emergencies include opening the airway, basic life support, suctioning, and the use of airway adjuncts.

Opening the Airway

The general techniques you use to open the airway of a child or an infant are generally the same as for an adult patient. The head-tilt/chin-lift technique can be used for children who have not suffered an injury to the neck or head (Figure 15.4). When using the head-tilt/chin-lift technique on a child, be sure that you do not hyperextend the neck when you tilt the head back. Hyperextending a child's neck can cause the airway to become occluded. Use a neutral or slight sniffing position. You can place a folded towel under the child's shoulders to help maintain this position. If there is any chance of injury to the head or neck, you should not use the head-tilt/chin-lift technique. Instead use the jaw-thrust technique while keeping the head and neck stabilized.

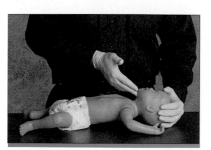

Fig. 15.4 Open the infant's airway using the head-tilt/chin-lift technique.

Fig. 15.5 Place one hand two fingers above the bottom of the sternum.

Basic Life Support

Because children are smaller than adults, specific techniques must be used when performing CPR on children. These include special procedures for hand placement, compression pressure, and airway positioning.

When performing CPR on children (1 to 8 years old), there are four differences from adult CPR:

1. If a single rescuer has no help and EMS has not been called, you should perform 1 minute of CPR before activating the EMS system.
2. Use the heel of one hand in performing chest compressions rather than both hands (Figure 15.5).
3. Depress the sternum about 1 to 1½ inches.
4. Provide 100 compressions per minute, giving one rescue breath after every five chest compressions.

When performing CPR on infants (less than 1 year old), there are six differences from adult CPR:

1. Check for responsiveness by tapping the foot or gently shaking the shoulder.
2. Give rescue breaths by using mouth-to-mouth-and-nose ventilations and give gentle breaths.
3. Check the pulse by using the brachial pulse (Figure 15.6).
4. Use your third and fourth fingers to compress the sternum.
5. Compress the sternum approximately ½ to 1 inch.
6. Perform chest compressions at least 100 times per minute.

Note: CPR for infants and children is described in detail in Chapters 6 and 8. To review these techniques, see these chapters.

Suctioning

Airways that are blocked by secretions, vomitus, or blood should be cleared initially by turning the patient on the side and using gloved fingers to scoop

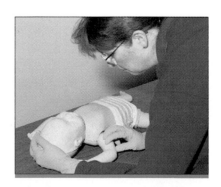

Fig. 15.6 The brachial pulse site is the best place to take a pulse in children.

out as much of the substance as possible. You can use suctioning to remove the foreign substances that cannot be removed with your gloved fingers. Suctioning to open a blocked airway can be a lifesaving procedure. The procedure used for infants and children is generally the same as for adults, with the following exceptions:

1. Use a tonsil sucker to suction the mouth. Do not insert the tip any farther than you can see.
2. Use a flexible catheter to suction the nose of a child; set the suction on low or medium.
3. Use a bulb syringe to suction the nose of an infant. Remember that an infant can only breathe through the nose.
4. Never suction for more than 5 seconds at one time.
5. Try to ventilate and reoxygenate the patient before repeating the suctioning.

For a complete description of the steps of suctioning, review the material presented in Chapter 6.

Airway Adjuncts

Oral airways are used to maintain an open airway once you have opened the patient's airway by manual means. Use the following steps to insert an oral airway in a child or an infant:

1. Select the proper sized oral airway by measuring from the patient's earlobe to the corner of the mouth.
2. Open the patient's mouth with one hand using the jaw-thrust technique.
3. Depress the patient's tongue with two or three stacked tongue blades. Press the tongue forward and away from the roof of the mouth.
4. Slide the airway into place by following the anatomic curve of the roof of the patient's mouth.
5. Be gentle. Children and infants have fragile structures in their mouths.

First responders usually do not use nasal airways for children. If you have questions about the use of nasal airways in pediatric patients, check with your medical director.

Partial Airway Obstruction

Airway obstruction can usually be relieved by placing the child on his or her back (supine), tilting the head, and lifting the chin (Figure 15.7) in the usual manner (the head-tilt/chin-lift technique).

═══ SPECIAL NEEDS

You must be careful not to overextend the neck. In infants and some small children, the overextension may actually obstruct the airway because of the flexibility of the child's neck. Smaller children may breathe easier if the neck is held in a neutral position rather than overextended. To maintain the neutral position, you can use your hands to support the shoulders.

Blockage of the airway by an aspirated foreign object (small toy, piece of candy, or balloon) is an especially common problem in young children, particularly in those children who are crawling. If the foreign object is only par-

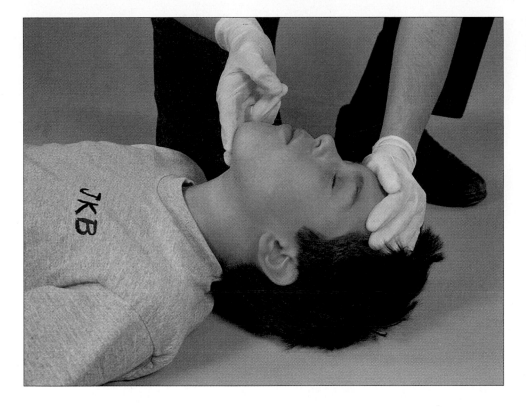

Fig. 15.7 Head-tilt/chin-lift technique.

tially blocking the airway, the child will probably be able to pass some air around the object. If the object is clearly visible in the mouth and can be removed easily, do so.

However, if the object cannot be seen, or if you do not think it can be removed easily, you should not attempt to remove it as long as the child can still breathe air around the object. If you try to remove an object that is partially blocking the airway and it moves to completely block the airway, then you have created an extremely serious situation.

CAUTION

The American Heart Association specifically states that "blind" finger sweeps should not be performed on infants and children because it might result in moving the object and completely blocking the airway.

Children with a partial airway obstruction should be transported promptly to the hospital. You should talk constantly to a child with a partially obstructed airway about what you are doing. Talking also comforts the child and reduces the terror of having something "stuck in the throat."

Consider transporting this patient in the arms of the mother in order to provide psychological support to both the mother and the child. Use the mother's presence to reassure and calm the child. Judge each situation carefully. You may find that not all mothers or fathers are capable of handling such a serious situation. However, most of the time, when the parents realize the seriousness of the situation, they are able to redirect their emotions and work with you to reassure and calm the child.

If you have oxygen available and are trained in its use, administer it by gently placing an oxygen mask over the child's mouth and nose. Don't try to

- Transportation to an appropriate medical facility
- Prompt transportation to an appropriate medical facility
- Rapid transportation to an appropriate medical facility

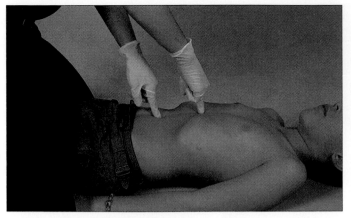

A. Locate the xiphoid process and navel.

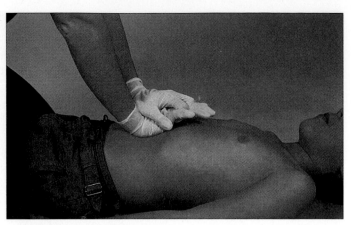

B. Perform abdominal thrust.

Fig. 15.8 Performing abdominal thrust in a child.

get an airtight seal on the mask; hold it 1 or 2 inches away from the child's face. If you tell the child what you are doing with the oxygen and how it will make it easier to breathe, you may be able to calm and relax the child.

Carefully monitor this critical situation to ensure that the partial obstruction does not become a complete obstruction!

Complete Airway Obstruction in Children

This is a serious emergency because no air is able to pass the foreign object and you have only a few minutes to act before permanent brain damage occurs. The abdominal-thrust maneuver (Figure 15.8) is the best technique for providing enough energy to expel most foreign objects that are completely blocking a child's airway.

Airway Obstruction in a Conscious Child

The steps for relieving an airway obstruction in a conscious child (1 to 8 years old) are the same as for an adult patient except you should not perform blind finger sweeps. Instead perform the tongue-jaw lift, look down into the airway, and use your fingers to sweep the airway only if you can actually see the obstruction.

The 1993 American Heart Association skill performance sheet titled "Child Foreign Body Airway Obstruction—Conscious" is included for your review and practice (Figure 15.9).

Airway Obstruction in an Unconscious Child

The steps for relieving a complete airway obstruction in an unconscious child are almost the same as those for an unconscious adult patient. The only difference is that with a child you should perform a finger sweep only if you can see the object that is obstructing the airway. Because the child's airway is so much smaller than an adult's, it is important that you do not push the foreign object farther down into the child's airway. If you are alone, you should attempt to remove the foreign body obstruction for 1 minute before stopping to activate the EMS system.

The 1993 American Heart Association skill performance sheet titled "Child Foreign Body Airway Obstruction—Unconscious" is included for your review and practice (Figure 15.10).

WE'RE FIGHTING FOR YOUR LIFE
American Heart Association

SKILL AND PERFORMANCE SHEET

CHILD FOREIGN BODY AIRWAY OBSTRUCTION—CONSCIOUS

Student Name _____ Date _____

Performance Guidelines	Performed
1. Ask "Are you choking?"	
2. Give abdominal thrusts.	
3. Repeat thrusts until effective or victim becomes unconscious.	
Child Foreign Body Airway Obstruction—Victim Becomes Unconscious	
4. If second rescuer is available, have him or her activate the EMS system.	
5. Perform a tongue-jaw lift, and if you see the object, perform a finger sweep to remove it.	
6. Open airway and try to ventilate; if obstructed, reposition head and try to ventilate again.	
7. Give up to five abdominal thrusts.	
8. Repeat steps 5 through 7 until effective.*	
9. If airway obstruction is not relieved after about 1 minute, activate the EMS system.	

* If victim is breathing or resumes effective breathing, place in recovery position.

Comments _____

Instructor_____

Circle one: Complete Needs more practice

Complete Airway Obstruction in Infants

An infant is very fragile. Infants' airway structures are very small, and they are more easily injured than those of an adult. If you suspect an airway obstruction, assess the baby to determine if there is any air exchange. If the baby is crying, the airway is not completely obstructed. Ask the person who was with the infant what was happening when the baby stopped breathing. This person may have seen the baby put a foreign body into the mouth. If there is no movement of air from the baby's mouth and nose, suspect that the airway is

Fig. 15.10 1993 AHA Skill Performance Sheet "Child Foreign Body Airway Obstruction—Unconscious"

SKILL AND PERFORMANCE SHEET

CHILD FOREIGN BODY AIRWAY OBSTRUCTION—UNCONSCIOUS

Student Name _____ Date _____

Performance Guidelines	Performed
1. Establish unresponsiveness. If second rescuer is available, have him or her activate the EMS system.	
2. Open airway, check breathing (look, listen, and feel), try to ventilate; if obstructed, reposition head and try to ventilate again.	
3. Give up to five abdominal thrusts.	
4. Perform a tongue-jaw lift and if you see the object, perform a finger sweep to remove it.	
5. Try to ventilate; if still obstructed reposition the head and try to ventilate again.	
6. Repeat steps 3 through 5 until effective.*	
7. If airway is obstruction is not relieved after about 1 minute, activate the EMS system.	

* If victim is breathing or resumes effective breathing, place in recovery position.

Comments _____

Instructor_____

Circle one: Complete Needs more practice

Chest thrust maneuver A series of manual thrusts to the chest to relieve upper airway obstruction; used in the treatment of infants, pregnant women, or extremely obese people.

obstructed. To relieve an airway obstruction in an infant, use a combination of back blows and the **chest thrust maneuver.** You must have a good grasp of the infant in order to alternate the back blows and the chest thrusts (Figure 15.11).

Airway Obstruction in a Conscious Infant

To assist a conscious infant who has a complete airway obstruction, you must proceed with the following steps:

1. Assess the infant's airway and breathing status. Determine that there is no airway exchange.
2. Place the infant in a face down position over one arm and deliver five back blows. This is done by supporting the infant's head and neck with

Fig. 15.11 Administering back blows and chest thrusts in an infant.

A. Administer five back blows.

B. Followed by five chest thrusts.

one hand, placing the infant in a face down position with the head lower than the trunk. Support the infant over your forearm and support your forearm on your thigh. Use the heel of your hand to deliver up to five back blows forcefully between the infant's shoulder blades.

3. Turn the infant face up by supporting the head, sandwiching it between your hands and arms, and turning the infant on the back with the head lower than the trunk.

4. Deliver up to five chest thrusts in the middle of the sternum. Use two fingers to deliver the chest thrusts in a firm manner.

5. Repeat the series of back blows and chest thrusts until the foreign object is expelled or until the infant becomes unconscious.

The 1993 American Heart Association skill performance sheet titled "Infant Foreign Body Airway Obstruction—Conscious" is included for your review and practice (Figure 15.12).

Airway Obstruction in an Unconscious Infant

The sequence of actions needed to relieve an airway obstruction in an unconscious infant is the same sequence of back blows and chest thrusts that you use for a conscious infant. However, the steps that are taken to determine unconsciousness and to determine that an airway obstruction is present are somewhat different.

Review the following sequence until you can carry it out automatically. To assist an unconscious infant who has a complete airway obstruction, you must proceed with the following steps:

1. Determine unresponsiveness by gently shaking the shoulder or by gently tapping the bottom of the foot.

2. Position the infant on a firm, hard surface and support the head and neck.

3. Open the airway using the head-tilt/chin-lift technique. Be careful not to tilt the infant's head too far back.

WE'RE FIGHTING FOR YOUR LIFE
American Heart Association

SKILL AND PERFORMANCE SHEET
INFANT FOREIGN BODY AIRWAY OBSTRUCTION—CONSCIOUS

Student Name _____ Date _____

Performance Guidelines	Performed
1. Confirm complete airway obstruction. Check for serious breathing difficulty, ineffective cough, no strong cry.	
2. Give up to 5 back blows and chest thrusts.	
3. Repeat step 2 until effective or victim becomes unconscious.	
Infant Foreign Body Airway Obstruction— Victim Becomes Unconscious	
4. If second rescuer is available, have him or her activate the EMS system.	
5. Perform a tongue-jaw lift, and if you see the object, perform a finger sweep to remove it.	
6. Open airway and try to ventilate; if obstructed, reposition head and try to ventilate again.	
7. Give up to 5 back blows and chest thrusts.	
8. Repeat steps 5 through 7 until effective.*	
9. If airway obstruction is not relieved after about 1 minute, activate the EMS system.	

* If victim is breathing or resumes effective breathing, place in recovery position.

Comments _____

Instructor_____

Circle one: Complete Needs more practice

4. Determine breathlessness by placing your ear close to the infant's mouth and nose. Listen and feel for the infant's breathing.

5. Attempt rescue breathing. If unsuccessful, continue to Step 6.

6. Reposition the airway and reattempt rescue breathing.

Note: Steps 1 through 6 are the same sequence as you use for infant rescue breathing.

SKILL AND PERFORMANCE SHEET

INFANT FOREIGN BODY AIRWAY OBSTRUCTION—UNCONSCIOUS

Student Name _____ Date _____

Performance Guidelines	Performed
1. Establish unresponsiveness. If second rescuer is available, have him or her activate the EMS system.	
2. Open airway, check breathing (look, listen, and feel), try to ventilate; if obstructed, reposition head and try to ventilate again.	
3. Give up to five back blows and five chest thrusts.	
4. Perform a tongue-jaw lift and if you see the object, perform a finger sweep to remove it.	
5. Try to ventilate; if still obstructed, reposition the head and try to ventilate again.	
6. Repeat steps 3 through 5 until effective.*	
7. If airway is obstruction is not relieved after about 1 minute, activate the EMS system.	

* If victim is breathing or resumes effective breathing, place in recovery position.

Comments _____

Instructor_____

Circle one: Complete Needs more practice

7. Deliver up to five back blows using the same technique as you use for a conscious infant.

8. Deliver up to five chest thrusts using the same technique as you use for a conscious infant.

9. Perform tongue-jaw lift and remove any foreign object that you can see.

10. Repeat the sequence of back blows and chest thrusts until the foreign body has been expelled.

The 1993 American Heart Association skill performance sheet titled "Infant Foreign Body Airway Obstruction—Unconscious" is included for your review and practice (Figure 15.13).

Swallowed Objects

If they do not become airway obstructions, small, round objects like marbles, beads, buttons, and coins swallowed by children usually pass uneventfully through the child and are eliminated in a bowel movement. However, sharp or straight objects such as open safety pins, bobby pins, and bones are dangerous. Arrange for transport to an appropriate medical facility because special instruments and techniques are required to locate and remove the object from the stomach and intestinal tract.

Respiratory Distress

Respiratory distress indicates that a child has a serious problem that requires immediate medical attention. Often respiratory distress quickly leads to respiratory failure. You must be able to recognize the following signs of respiratory distress:

1. A respiratory rate of greater than 60 breaths per minute in infants
2. A respiratory rate of greater than 30 to 40 breaths per minute in children
3. Nasal flaring on each breath
4. Retraction of the skin between the ribs and around the neck muscles
5. Stridor, a high-pitched sound on inspiration
6. Cyanosis of the skin
7. Altered mental status
8. Combativeness or restlessness

If any of these signs is present, try to determine the cause if possible. Support the child's respirations by placing the child in a position of comfort, usually a sitting position. Keep the child as calm as possible by letting a parent hold the child if practical. Prepare to administer oxygen if available. Monitor the child's vital signs and arrange for prompt transport to an appropriate medical facility.

Respiratory Failure/Arrest

Respiratory failure is often a worsening of respiratory distress. It can be caused by many of the same factors that cause respiratory distress. Respiratory failure is characterized by the following conditions:

1. A breathing rate of fewer than 10 respirations per minute in a child
2. A breathing rate of fewer than 20 respirations per minute in an infant
3. Limp muscle tone
4. Unresponsiveness
5. Decreased or absent heart rate
6. Weak or absent distal pulses

A child in respiratory failure is on the verge of going into respiratory and cardiac arrest. You must immediately assess the child and take whatever steps are appropriate to support the patient. Support respirations by performing mouth-to-mask ventilations. Administer oxygen if it is available. Begin chest compressions if the heart rate is slow or absent. Arrange for prompt transportation to an appropriate medical facility. Continue to monitor the patient's vital signs and support the airway, breathing, and circulation functions as well as you can.

- Transportation to an appropriate medical facility
- Prompt transportation to an appropriate medical facility
- Rapid transportation to an appropriate medical facility

- Transportation to an appropriate medical facility
- Prompt transportation to an appropriate medical facility
- Rapid transportation to an appropriate medical facility

Circulatory Failure

The most common cause of circulatory failure in children is respiratory failure. Uncorrected respiratory failure in children can lead to circulatory failure, and uncorrected circulatory failure can lead to cardiac arrest. The first lesson to be learned here is to correct respiratory failure before it progresses to circulatory failure. Because it is not always possible to do this, you should learn the signs of circulatory failure and the treatment for it.

The signs and symptoms of circulatory failure are: increased heart rate, pale or bluish skin, and changes in mental status. Your treatment consists of completing the patient assessment sequence, supporting ventilations, administering oxygen if available, and observing for changes in vital signs.

✓ Describe the difference between the respiratory care of an adult and a child.

Sudden Illness and Medical Emergencies

A limited number of illnesses occur suddenly in young children, but they provide most of the medical calls that you will make to treat children. It is important that you be able to determine rapidly the signs, symptoms, and treatment of these key pediatric illnesses:

- Altered mental status
- Respiratory emergencies
 - Asthma
 - Croup
 - Epiglottitis
- Heat illness
- High fever
- Seizures
- Abdominal pain
- Poisoning
- Sudden infant death syndrome (SIDS)

Altered Mental Status

Altered mental status in children can be caused by a variety of conditions, including low blood sugar, poisoning, postseizure state, infection, head trauma, and decreased oxygen levels. Sometimes you will be able to determine the cause of the altered mental status and take steps to correct the problem. For example, a parent may tell you that the child is a diabetic suffering from insulin shock and you may assist in giving sugar to increase the patient's blood sugar. However, you will usually not be able to determine the cause of the altered mental status. In these cases, you should treat the symptoms of the patient.

Complete your patient assessment, paying particular attention to any clues at the scene. Question any bystanders or family about the situation and try to get as much medical history as possible. Pay particular attention to the patient's initial vital signs. Repeat these regularly to monitor the patient for any changes. Calm the patient and the patient's family. Be prepared to support the patient's airway, breathing, and circulation if needed. Place unconscious patients in the recovery position to help keep their airway open and to aid them in handling their secretions.

Respiratory Emergencies

A respiratory problem in an infant or child can range from a minor cold to complete blockage of the airway. The most common respiratory problems in children are caused by colds.

A minor cold can cause breathing difficulties for infants because they breathe primarily through their noses. An infant who has excessive mucus in the nose has much greater difficulty breathing than an older child who breathes through both the nose and mouth. However, in addition to the mucus blockage of the nose caused by colds, you should be able to recognize and treat three more serious conditions frequently found in children: asthma, croup, and epiglottitis.

Asthma

A child who has **asthma** is usually already being treated for the condition by a physician and is taking a prescribed medicine. The parents call for assistance or transport only if the child experiences unusual breathing difficulty.

Asthma can occur at any age. It is caused by a spasm or constriction (narrowing) of the smaller airways in the lungs. Constriction produces a characteristic wheezing sound. Asthma attacks can range from mild to severe and can be caused by many factors, including feathers, animal fur, tobacco smoke, pollen, and even emotional situations.

A child who is having an asthma attack is in obvious respiratory distress. During a severe attack, you can clearly hear the characteristic wheezing on exhalation—even without a stethoscope. The child can inhale air without difficulty but must labor to exhale. The effort to exhale is both frightening and tiring for the child.

A first responder's primary treatment consists of calming and reassuring both parents and the child. Tell them everything possible is being done and that they should try to relax.

Place the child in a sitting position in which breathing is most comfortable. Ask the child to purse his or her lips, as if blowing up a balloon. Tell the child to blow out with force while doing this. Pursed-lip breathing helps in two ways: both parents and the child feel that "something is being done," and this type of breathing relieves some of the internal lung pressures that cause the asthma attack (Figure 15.14).

If a child has asthma medication, help the parent administer it (if this has not already been done). The parents should contact the child's physician for further advice. If the child's physician is not available, arrange for prompt transport to a hospital emergency department.

Croup

Croup is an infection of the upper airway that usually occurs in children from 6 months to 4 years of age. The infection causes swelling in the lower throat

Asthma An acute spasm of the smaller air passages marked by labored breathing and wheezing.

Fig. 15.14 Pursed-lip breathing can help relieve an asthma attack.

- Transportation to an appropriate medical facility
- Prompt transportation to an appropriate medical facility
- Rapid transportation to an appropriate medical facility

Croup Inflammation and narrowing of the air passages in young children causing a barking cough, hoarseness, and a harsh, high-pitched breathing sound.

and compresses (narrows) the airway. Airway compression causes a characteristic hoarse, whooping noise during inhalation and a seal-like barking cough.

Croup occurs often in colder climates (during fall and winter) and is often accompanied by a cold. The child usually has a moderate fever and a croupy noise that has developed over time. The worst attacks of croup usually occur in the middle of the night.

The five main signs of croup are:

- Noisy, whooping inhalations
- Barking seal-like cough
- History of a recent or current cold
- Lack of fright or anxiety
- Willingness to lie down

The last two signs are important because they help you distinguish croup from epiglottitis. Epiglottitis is a more serious condition and is discussed in the next section.

Although croup is frightening for parents, it may not frighten children. As with many childhood emergencies, you must respond to the psychological needs and concerns of the parents as well as the medical needs of the child.

Do not assume that noisy breathing is caused by croup! Look to see if the child is choking on a toy, food, or foreign object caught in the airway.

If the EMS unit is delayed, ask the parents to turn on the hot water in the shower and close the bathroom door. When the bathroom is well steamed, have a parent take the child into the bathroom. This effectively treats the child and reassures the parent. The moist, warm air relaxes the vocal cords and lessens the croupy noise. Contact the child's physician for further instructions or arrange to have the child transported to an appropriate medical facility.

Epiglottitis

The third, and most severe, major respiratory problem is **epiglottitis**. Epiglottitis is a severe inflammation of the epiglottis, the small flap that covers the trachea during swallowing. In this condition, the flap is so inflamed and swollen that air movement into the trachea is completely blocked. Epiglottitis usually occurs in children from 3 to 6 years of age.

At first examination, you may think a child has croup. However, you must be completely familiar with the following signs and symptoms of epiglottitis because, unlike croup, it poses an immediate threat to life.

- The child is usually sitting upright (he or she does not want to lie down).
- The child cannot swallow.
- The child is not coughing.
- The child is drooling (Figure 15.15).
- The child is anxious and frightened (he or she knows that something is seriously wrong).
- The child's chin is thrust forward.

Epiglottitis Severe inflammation and swelling of the epiglottis; a life-threatening situation.

 Focus on Assessment

Fig. 15.15 A key sign of epiglottitis is drooling.

CAUTION

Do not examine a child's throat if you suspect epiglottitis! An examination can cause more swelling and block the airway completely.

- Transportation to an appropriate medical facility
- Prompt transportation to an appropriate medical facility
- Rapid transportation to an appropriate medical facility

If you encounter a child with these signs and symptoms, make the child comfortable, with as little handling as possible. Make arrangements for prompt transport to an appropriate medical facility. You may consider letting a parent hold the child during transport if the emotional attitudes of the child and parent are appropriate.

Remember: The child must have medical attention to ensure an open airway.

There is little you can do in this serious respiratory emergency situation except assist the child in any way possible, keep everyone calm, administer oxygen (if you have it available), and arrange for prompt transport to an appropriate medical facility.

Heat Illnesses

Heat illnesses may range from relatively minor muscle cramps to vomiting, heat exhaustion, and heatstroke.

The most dangerous heat illness in children is heatstroke. Any child who is in a closed, parked car on a hot day or in a poorly ventilated room and who has hot, dry skin may be suffering from heatstroke. This is a serious and potentially fatal condition. Rapid treatment from the first responder is necessary.

First, undress the child. Then, wet the child with water and fan him or her to help lower the temperature quickly. You may use wet sheets (if they are available) to speed up the evaporation and cooling process. Finally, be sure that you have arranged for rapid transport to an appropriate medical facility. (See Chapter 9 for a more detailed description of heatstroke.)

- Transportation to an appropriate medical facility
- Prompt transportation to an appropriate medical facility
- Rapid transportation to an appropriate medical facility

High Fevers

High fevers in children can be caused by many different infections, especially ear and gastrointestinal infections. Fevers are quite common. Because the temperature-regulating mechanism in young children has not fully developed, a very high temperature (104°F to 106°F, or 40°C to 41°C) can develop even with a relatively minor infection.

At other times, a high fever may not develop even though the child is suffering from an overwhelming infection. Temperatures as high as 104°F (40°C) are tolerated well by most children. However, a high fever may require that the child be hospitalized so that the underlying cause can be discovered and treated.

Your first step in treating a child with a high fever is to uncover the child so that body heat can escape. When layers of clothing or blankets retain body heat, body temperature can increase to a level at which the child could begin to have convulsions. About 10 percent of children between 1 and 6 years of age are susceptible to seizures brought on by high fevers.

Focus on Treatment

In attempting to reduce high fever, you are only treating the symptom and not the source. The child must be seen by a physician as soon as possible to determine the cause.

VOICES of EXPERIENCE

Robert P. Pringle, Jr.
BS, NREMT-P
Program Manager of Life Air Rescue
Shreveport, Louisiana

"Having been involved in EMS for 13 years, memories of many of the calls run together. One response, though several years ago, continues to haunt me—we did nothing wrong, nor was the scene extraordinarily bloody, but I remember it as if it was yesterday. Everything worked as it was supposed to, but then again, it did not work.

Having achieved my dream of becoming a flight paramedic, I continued to volunteer as a firefighter and paramedic. One afternoon, my partner and I were dispatched for a "fall." The patient was a 4-year-old child who had fallen and was unconscious. I was not worried; I felt I could handle anything.

The beautiful young boy had been jumping on his bed when he fell against the screen and fell 20 feet onto the wooden deck.

When we arrived, the BLS providers were immobilizing him, taking vital signs, and applying oxygen. The MedSTAR helicopter was 10 minutes away. My partner started an intraosseous line in his lower left leg, while I successfully intubated him. The end-tidal CO_2 detector read positive. He was perfectly packaged, everything flowed perfectly, the call was going like clockwork.

The victim's parents were praying outside the medic unit when the most unforgettable, gruesome thing happened. This precious little boy's head began to swell. In all my years in EMS, I have never seen anything like this. It happened so quickly. Within 5 minutes, his head had become the size of a basketball with more bulging at the temples.

I have never been so happy to see the helicopter arrive. After it lifted off for the 15-minute flight to Children's National Medical Center, the weight of the world was lifted off my shoulders and I broke down and cried. Everything possible had been done. We had treated the patient aggressively and appropriately. It worked, but it didn't—the child died of his injuries the following day.

I have continued to work in EMS. I still fly as a paramedic several days a week and I still love EMS. I will continue to give it the best I've got and let God sort out the rest of it!"

If you encounter a child with a high fever above 104°F (40°C), do the following:

1. Prevent the temperature from getting higher by making certain the child is not wrapped in too much clothing or too many blankets.
2. Attempt to reduce high temperature by undressing the child.
3. Fan the child to cool him or her down.
4. Protect the child during any seizure (do not restrain the child's motion) and make certain that normal breathing resumes after each seizure.

Seizures

Epilepsy A disease manifested by seizures, caused by an abnormal focus of electrical activity in the brain.

Seizures (convulsions) can result from high fever or from disorders such as **epilepsy** (see Chapter 9). Each seizure can vary in intensity from simple, momentary staring spells (without body movements) to generalized seizures in which the entire body stiffens and shakes severely.

Although seizures can be frightening to parents, bystanders, and rescuers, they are not usually dangerous. During a seizure, a child loses consciousness, the eyes roll back, the teeth become clenched, and the body is shaken by severe jerking movements. Often, the child's skin becomes pale or turns blue. Sometimes the child loses bladder and bowel control, soiling clothing. Seizures caused by high fever usually last about 20 seconds.

If a seizure occurs, place the child on a soft surface (sofa, bed, or rug) to protect the child from injury during the seizure. Seizures are frightening for the child's parents, who need your reassurance. If they become too emotional, ask them to leave the room.

Focus on Assessment

Focus on Treatment

Carefully monitor the child's airway during and after the seizure.

First responder treatment of seizures consists of the following steps:

1. Place the patient on the floor or bed to prevent injury.
2. Maintain an adequate airway once the seizure is over.
3. Provide supplemental oxygen after the seizure if it is available and if you are trained to use it.
4. Arrange for prompt transport to an appropriate medical facility.
5. Continue to monitor the patient's vital signs and support the ABCs if necessary.
6. After the seizure is over, cool the patient if the patient has a high fever.

• Transportation to an appropriate medical facility
• **Prompt transportation to an appropriate medical facility**
• Rapid transportation to an appropriate medical facility

Abdominal Pain

Children are susceptible to abdominal pains, which are usually caused by gastrointestinal infections. Prolonged diarrhea or vomiting may also occur and produce severe dehydration. The dehydrated child is lethargic and has dryness of the skin, mouth, and nose. Hospitalization may be required to replace fluids through the veins. Arrange for transport to an appropriate medical facility.

Perhaps the most serious cause of abdominal pain in children is appendicitis. Although it can occur at any age, appendicitis is usually seen in people between the ages of 10 and 25. The pain usually starts in the belly button area of the stomach and is crampy in nature. The pain then moves to the right lower quadrant of the abdomen in a matter of hours and becomes steady and

severe. Usually the child is nauseated and has no appetite. Occasionally, vomiting occurs.

Because there are several potential causes of abdominal pain, including appendicitis, do not try to make a diagnosis in the field. Physicians even have a difficult time diagnosing the cause of abdominal pain. A good rule to follow is to treat every child with a sore or tender abdomen as an emergency and arrange for transport to an appropriate medical facility for an appropriate diagnosis.

Poisoning

Little children are curious and often like to sample the contents of brightly colored bottles or cans thinking they contain something good to eat or drink. However, many of these common household items contain poisonous substances. The two most common types of poisonings in children are caused by ingestion and absorption.

Ingestion

An ingested poison is taken by mouth. You can identify such cases of poisoning by chemical burns, odors, or stains around the mouth. The child may also be suffering from nausea, vomiting, abdominal pain, or diarrhea. Later symptoms may include abnormal or decreased respirations, unconsciousness, or seizures. If you believe a child has ingested a poisonous substance, you should:

1. Try to identify what the child has swallowed, attempt to estimate the amount ingested, and send the bottle or container along with the child to the emergency department.

2. If the child has swallowed tablets from a medicine bottle, gather any spilled tablets and replace them in the bottle so they can be counted. The emergency physician may then be able to determine how many tablets the child has taken.

3. If transportation to an appropriate medical facility is delayed, consider contacting your local poison control center. The poison control center will need to know:
 - Age of the patient
 - Weight of the patient
 - Identification of the poison
 - Estimated quantity of the poison taken

4. The poison control center may direct you to
 a. dilute the poison by giving the child large amounts of water;
 b. administer activated charcoal if it is available and you have been trained in its use (the usual dose for pediatric patients is 12.5 to 25 grams);
 c. induce vomiting using syrup of ipecac if you have been trained in its use and have permission from your medical director or poison control center (the usual dose for pediatric patients is 1 tablespoon).

▼ CAUTION
Do not attempt to give liquids or induce vomiting in an unconscious or partially conscious child because of the danger of aspiration of the vomitus.

5. Monitor the child's breathing and pulse closely. This is a critical step and you must be prepared to give emergency care up to and including rescue breathing and CPR.
6. All children suspected of poisoning by ingestion should be transported to an appropriate medical facility for examination by a physician.

Note: See Chapter 10 for further information on the emergency treatment for various poisons.

Absorption

Poisoning by absorption occurs when a poisonous substance enters the body through the skin. A child suffering from absorption of poison may have localized symptoms, such as skin irritation or burning, or may have systemic signs and symptoms of the poisoning, such as nausea, vomiting, dizziness, and shock. If you believe a child has absorbed a poisonous substance, you should:

1. Ensure that the child is no longer in contact with the poisonous substance.
2. Remove the child's clothing if you think it is contaminated.
3. Brush off any dry chemical. After it has all been brushed off wash the child with water for at least 20 minutes.
4. Wash off any liquid poisons by flushing with water for at least 20 minutes.

SAFETY PRECAUTION
Be careful not to get any chemical onto your skin.

═══ SPECIAL NEEDS

Chemical burns to the eyes cause extreme pain and injury. Gently flush the affected eye or eyes with water for at least 20 minutes. Hold the eye open to allow water to flow over its entire surface. Direct the water from the inner corner of the eye to the outward edge of the eye. After flushing the eyes for 20 minutes, loosely cover both eyes with gauze bandages and arrange for prompt transport to an appropriate medical facility.

5. Try to identify the poison, and send any containers with the child to the emergency department.
6. Monitor the child for any changes in respiration and pulse. Be prepared to administer rescue breathing or CPR if needed.
7. All children suspected of absorption poisonings should be transported to an appropriate medical facility for examination by a physician.

Note: See Chapter 10 for further information on emergency treatment of poisoning.

Sudden Infant Death Syndrome

A condition that is frequently mistaken for child abuse is sudden infant death syndrome (SIDS), also called crib death. It is the sudden and unexpected death of an apparently healthy infant. Such deaths often remain unexplained, even after a complete and thorough autopsy.

SIDS usually occurs in infants between the ages of 3 weeks and 7 months. The babies are usually found dead in their cribs. There is currently no adequate scientific explanation of SIDS. These deaths are not the result of smothering, choking, or strangulation.

You can imagine the shock and grief felt by parents who find their apparently healthy babies dead in bed. Their feelings of remorse and guilt can be greatly relieved by your actions and words.

If the infant is still warm, begin CPR and continue until help arrives (infant CPR is described in Chapter 6). In many cases, the infant has been dead several hours, and the body is cold and lifeless. Do not mistake the large, bruise-like blotches on the baby's body for signs of child abuse. The blotches are caused by the pooling of the baby's blood after death. Sometimes you may find a small amount of bloody foam on the infant's lips.

Know your local guidelines for the management of SIDS. Remember that the parents could do nothing to prevent SIDS. Be compassionate and support the parents during this tragic situation.

Pediatric Trauma

Trauma remains the number one killer of children. Each year, many young lives are lost because of accidental injury, particularly automobile accidents. Treat a child who has been injured just as you would an adult, but remember the following differences:

1. A child cannot communicate symptoms as well as an adult.
2. A child may be shy and overwhelmed by adult rescuers (especially those in uniform), so it is important to develop a good relationship quickly to reduce the child's fear and anxiety
3. You may have to adapt materials and equipment to the child's size.
4. A child does not show signs of shock as early as an adult but can progress into severe shock quickly.

Patterns of Injury

The injuries suffered by children will be related to the type of trauma they experience. Motor vehicle crashes produce different patterns of injuries depending on whether the patient was using a seat belt, whether the patient was strapped in a car seat, or whether an air bag inflated in the crash. Unrestrained patients tend to have more head and neck injuries. Restrained passengers often suffer head injuries, spinal injuries, and abdominal injuries. Children struck while riding a bicycle often have head injuries, spinal injuries, abdominal injuries, and extremity injuries. The use of bicycle helmets greatly reduces the number and severity of head injuries. Pedestrians who are struck by a vehicle often suffer abdominal injuries with internal bleeding, injured thighs, and head injuries. Falls from a height or diving accidents tend to cause head and spinal injuries and extremity injuries. Burns are a major cause of injuries to children. Injuries from sports activities cause a wide variety of injuries depending on the type of sports activity. The patterns of injuries suffered by children depend on the type of activity causing the injury and the child's anatomy. By learning some of the basic patterns of injury, you can anticipate the injuries you may find when carefully examining pediatric patients.

If the child has been hit by a car, look for the common types of injuries shown in Figure 15.16. Major trauma in children usually results in multiple system injuries. No matter what the cause of injury, your first priority is always to check the patient's ABCs. Stop severe bleeding, treat the patient for shock, and proceed with the head-to-toe examination described in Chapter 7 to determine the extent of any other injuries (Figure 15.17).

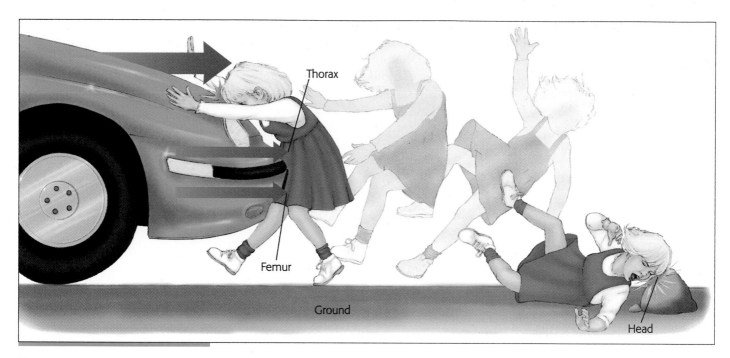

Fig. 15.16 Look for these typical injuries when a child has been hit by a car.

 Focus on Assessment

The head-to-toe examination is a hands-on procedure. A complete examination is especially important because a child cannot always communicate symptoms.

Involve the child in the physical examination as much as possible. Ask the child simple questions. Complete the head-to-toe examination even if the patient is too young to understand what is happening. Then stabilize all injuries you find. Splint suspected fractures, bandage wounds, and immobilize suspected spinal injuries.

Fig. 15.17 Examine every child from head to toe.

If you are dealing with head lacerations, remember that the generous blood supply to the scalp can result in severe bleeding. These wounds can be treated with direct pressure and appropriate bandaging techniques. See Chapter 12 for a review of effective bandaging techniques.

Traumatic Shock in Children

Children show shock symptoms much more slowly than adults, but they progress through the stages of shock quickly. An injured child displaying obvious shock symptoms such as cool, clammy skin, a rapid, weak pulse, or rapid or shallow respirations is already suffering from severe shock. Early recognition and treatment of shock are crucial. Review the signs and symptoms of shock in Chapter 12.

It is important to treat an injured child for shock quickly by controlling external bleeding, elevating the feet and legs, keeping the child warm, and administering oxygen if it is available. Children who show signs of shock should be transported as soon as possible to an emergency department. Seizures are relatively common in children who have sustained a serious head injury. Be prepared to manage this problem by maintaining the airway and protecting the child from further injury.

The greatest dangers to any patient who has suffered trauma are airway obstruction and hemorrhage. The most important things you can do for the injured child are to:

- Open and maintain the airway.
- Control bleeding.
- Arrange for prompt ambulance transport to an appropriate medical facility.

- Transportation to an appropriate medical facility
- Prompt transportation to an appropriate medical facility
- Rapid transportation to an appropriate medical facility

Car Seats and Children

As mandatory child restraint laws begin to have an impact, first responders will find more and more children still strapped into car seats after accidents. First responders should become familiar with child restraint seats and understand how to gain access to children restrained in them.

When a child is found to be properly restrained in a car seat, the child should be left in the car seat until the ambulance arrives (Figure 15.18). In

Fig. 15.18 Leave the child in the car seat if possible.

many cases, a child can be secured in the seat for transport to the hospital. The seat is removed from the vehicle and both the seat and the child are transported together (Figure 15.19).

✓ Describe the differences between adult and child injury patterns.

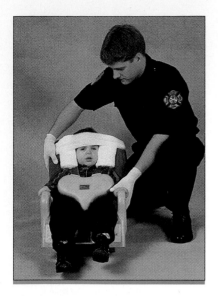

Fig. 15.19 A child can be immobilized in the car seat.

Child Abuse

Child abuse is not limited to any ethnic, social, or economic group or to families with any particular level of education. Suspect child abuse if the child's injuries do not match the story you are told about how the injuries occurred. Child abuse is often masked as an accident.

The abused or battered child will usually have many visible injuries—all at different stages of healing. The child may appear to be withdrawn, fearful, or even hostile, and may be undernourished. Occasionally the child's parents or caretaker will reveal a history of several "accidents" in the past.

Typical signs of child abuse include multiple fractures, bruises (especially those clustered on the torso and buttocks), human bites, burns (particularly cigarette burns and scalds from hot water), or reports of bizarre accidents that do not seem to have a logical explanation (Figure 15.20). Treat the child's injuries and, if you think you are dealing with a case of child abuse, ensure the safety of the child.

Make sure that the child is transported to an appropriate medical facility. If the parents object to having the child examined by a physician, summon law enforcement personnel and explain your concerns to them. The safety of the child is your foremost concern in these situations.

The parents of an abused child need help, and the child may need protection from the parents' future actions. Handle each situation in a nonjudgmental manner. Know whom you need to contact (usually the emergency department staff or law enforcement personnel), and report any instances of suspected child abuse.

Sexual Assault of Children

Sexual abuse is another problem that can occur in children as well as adults. It may occur in both male and female infants, young children, and adolescents. In addition to sexual assault, the child may have been beaten and may have other serious injuries.

When sexual assault is suspected, obtain as much information as possible from the child and any witnesses. However, the child may be hysterical or unwilling to talk, especially if the abuser is a brother or sister, parent, or family friend. A caring approach to these children is very important, and they should be shielded from onlookers.

All victims of sexual assault should be transported to an appropriate medical facility. Sexual assault is a crime, and the first responder should cooperate with law enforcement officials during their investigation.

First Responder Debriefing

As a first responder, you will respond to many calls that involve children. These calls tend to produce strong emotional reactions. At times you may experience a feeling of helplessness when an innocent child is seriously injured or gravely ill. Many of us are reminded of our own children when we see an ill or injured child. We may feel especially helpless when there appears to have been neglect or abuse of a child by adults.

After you have completed your care of the child and transferred the responsibility for care to other EMS personnel, you may need to talk about your frustrations with a counselor or with another member of your department. After a major incident or an especially emotional incident involving children, it may be helpful to set up a critical incident stress debriefing (CISD) session. We cannot change the types of traumatic events we see, but we can use the resources available to us to work through our feelings about these events. By debriefing we can maintain a healthy approach to future calls.

SIGNS and SYMPTOMS

1. *Bruises*
2. *Human bites*
3. *Cigarette burns*
4. *Scalds from hot water*
5. *Bizarre accidents without logical explanation*

Fig. 15.20 Signs and symptoms of child abuse.

CHAPTER REVIEW 15

Summary

This chapter has described the unique illnesses and considerations that you must know about to treat children effectively. Usually, illness or injury in a child causes first responders and other rescue personnel to respond with their best efforts. Children are young and helpless, and they have long lives ahead.

First responders and other rescue personnel frequently undertreat children because they underestimate the severity of the injuries. The factors that make caring for a pediatric patient different from treating an adult patient are covered. Common child illnesses and injuries are covered. The special assessment and treatment considerations are outlined. By learning some special approaches to caring for pediatric patients, you will be able to give more effective care to these patients and will not have to wonder how to treat them.

Treating and handling an ill or injured child can be extremely difficult, and it is almost always an emotional experience. The first responder must approach every child in a calm, professional manner; personal feelings must be kept in check. Although helping ill or injured children may not be easy, it can have great rewards.

Key Terms

Asthma—page 410
Chest-thrust maneuver—page 404
Croup—page 410
Epiglottitis—page 411
Epilepsy—page 414

What Would You Do?

1. You are called to a house for a report of a sick child. When you arrive, you find an 18-month-old child. She is breathing at a rate of 42 times per minute, and her nostrils are flaring with each breath. You note retraction between the ribs and hear a high-pitched sound. What do you think is wrong with this child? What would you do?

2. You are called to a daycare center for the report of a sick child. When you arrive, you find a 2-year-old boy who is not active. As you examine him, you note that he has an increased skin temperature. As you are examining the child, he begins to seize. What would you do?

3. You are called to the scene of an auto accident. You discover a quiet child in a car seat in a car that has been involved in a head-on collision. There is moderate damage to the front of the car. What would you do?

You Should Know

1. The differences in a child's anatomy.
2. The normal rates of respiration and pulse for a child.
3. The differences in performing the following skills on a child:
 a. Opening the airway
 b. Basic life support
 c. Suctioning
 d. Inserting an oral airway
4. How to treat a child and an infant with:
 a. A partial airway obstruction
 b. A complete airway obstruction
 c. Respiratory distress
 d. Respiratory failure
 e. A swallowed object
 f. Circulatory failure
5. How to treat the following illnesses and medical emergencies:
 a. Altered mental status
 b. Asthma
 c. Croup
 d. Epiglottitis
 e. Heat illnesses
 f. High fever
 g. Seizures
 h. Abdominal pain
 i. Poisoning
 j. Sudden infant death syndrome
6. The patterns of pediatric injury.
7. The signs and symptoms of shock in pediatric patients.
8. The steps you should take in caring for a child who has signs of child abuse or sexual assault.
9. The need for first responder critical incident stress debriefing.

You Should Practice

1. Determining the respiratory rate, pulse rate, and body temperature in a child.
2. Performing the following respiratory skills:
 a. Opening the airway
 b. Basic life support
 c. Suctioning
 d. Inserting an oral airway
3. Treating the following conditions:
 a. Partial airway obstruction in children and infants
 b. Complete airway obstruction in children and infants
4. Cooling a child with a high fever.

1.

2.

1. Locate the xiphoid process and navel.
2. Perform abdominal thrust.

1.

2.

1. Administer five back blows
2. Followed by five chest thrusts

1. What are the two key factors that determine whether you should deliver the baby or transport the mother?
 a. The mother "needs to go to the bathroom" and her water has broken.
 b. Crowning and this is her first child.
 c. Contractions less than 3 minutes apart and the hospital is close.
 d. Crowning and contractions less than 3 minutes apart.

2. When caring for the newborn, which of the following factors should you consider?
 a. Newborn babies lose lots of body heat.
 b. Healthy newborn babies do not cry.
 c. Newborn babies can breathe only through their nose.
 d. You can check a newborn baby's pulse at the umbilical cord.

3. Describe your care of a woman who is delivering a baby feet first.

4. Describe the steps in caring for a woman who has suffered a miscarriage.

5. Which of the following actions can decrease the mother's bleeding after she has given birth?
 a. Allowing the baby to nurse
 b. Giving the mother fluids
 c. Elevating the mother's legs
 d. Massaging the uterus

6. In opening the airway of a child, you should take which of the following actions?
 a. Use the jaw-thrust technique for medical and trauma patients.
 b. Flex the neck.
 c. Avoid hyperextending the neck.
 d. Extend the neck as far as possible.

7. Describe the difference between clearing a complete airway obstruction in a child and in an infant.

8. Match the following signs with the illnesses listed.
 ___ Croup a. Wheezing sound
 ___ Epiglottitis b. Barking seal-like
 ___ Asthma cough
 c. Drooling

9. Seizures in children are caused by which of the following conditions?
 a. High fever
 b. Head injury
 c. Poisoning
 d. Hypothermia

10. Describe the signs, symptoms, and treatment of traumatic shock in children.

MODULE

7

EMS OPERATIONS

This module on EMS operations presents information from several different topics that the first responder must know in order to function effectively at the scene of an emergency. The topics covered in this module include phases of an EMS call, air medical considerations, extrication, recognition of hazards at the scene, the role of first responders in multiple-casualty scenes, and triage.

As a first responder, you need to have enough information to perform your role in these emergency situations. However, you should realize that the information presented here is only an introduction to these topics and should not be considered to cover these topics comprehensively. By studying this module, you will gain enough knowledge of these special situations to begin providing care until other EMS providers arrive on the scene.

CHAPTER

16

EMS OPERATIONS

Knowledge and Attitude Objectives *After studying this chapter, you will be expected to:*

1. Explain the medical and nonmedical equipment needed to respond to a call.
2. List the five phases of an emergency call for a first responder.
3. Discuss the role of a first responder in extrication.
4. List the seven steps in the extrication process.
5. List the various methods of gaining access to a patient.
6. Describe the simple extrication procedures that a first responder can perform.
7. List the complex extrication procedures that require specially trained personnel.
8. State the responsibilities of the first responder in incidents where hazardous materials are present.
9. Describe the actions that a first responder should take in hazardous materials incidents before the arrival of specially trained personnel.
10. Define a multiple-casualty incident.
11. Describe the role of a first responder in a multiple-casualty incident.
12. Describe the steps in the START triage system.

Skill Objectives *As a first responder, you should be able to:*

1. Perform simple procedures for gaining access to a wrecked vehicle.
2. Triage a simulated multiple-casualty incident using the START triage system.

EMS operations consist of several steps that a first responder must take to be able to render care to an ill or injured patient. These include being prepared to respond to a call, the safe and timely response to a call, and having the proper equipment to render care. In addition, a first responder needs to be able to perform simple extrication procedures and to be able to assist other responders with patient extrication. Because many first responders work with air medical EMS providers, this chapter covers basic information on how first responders work with them. First responders should also be able to identify simple signs of a hazardous materials incident and be able to prevent injury to themselves and to others in the first minutes of a hazardous materials incident. Because first responders may be dispatched to a multiple-casualty incident, it is important that they understand the purpose of basic triage and be able to perform the steps involved in the START triage system.

Preparation for a Call

You must be prepared for a call as a medical first responder when you are on duty in your primary role as a law enforcement officer, a firefighter, or other worker. This preparation involves understanding your role as a member of the emergency medical system. Your response may be in a fire department vehicle, a law enforcement vehicle, your private vehicle, or on foot in a factory or at a beach. You must be prepared to respond promptly and use the most direct route available. You must have the proper equipment to perform your job. This equipment includes medical equipment in your first responder life support kit, your personal safety equipment, and equipment to safeguard the accident scene. The recommended equipment is listed in Figure 16.1. This equipment must be stocked and maintained on a regular basis according to the schedule specified by your agency.

Response

Response to an emergency call involves five different phases:

- Dispatch
- Response to the scene
- Arrival at the scene
- Transferring the care of the patient to other EMS personnel
- Post run activities

The sequence of actions in an emergency call was covered in Chapter 1, and you may find it helpful to refer to this material.

Dispatch

Your dispatch facility provides a center that citizens can call to request emergency medical care. Most dispatch centers are part of a 9-1-1 dispatch system that is responsible for dispatching fire, police, and EMS. You should understand the operation of the dispatch facility used by your department. Your job will be easier if your dispatcher is trained to obtain needed information from the caller. Dispatchers should also be trained to provide instructions for the caller to perform lifesaving care such as CPR before your arrival.

Suggested Contents of a First Responder Life Support Kit

Patient Examination Equipment	1 flashlight
Personal Safety Equipment	5 sets gloves
	5 face masks
Resuscitation Equipment	1 mouth-to-mask resuscitation device
	1 portable hand-powered suction device
Bandaging and Dressing Equipment	10 gauze-adhesive strips 1"
	10 gauze pads 4" x 4"
	5 gauze pads 5" x 9"
	2 universal trauma dressings 10" x 30"
	1 occlusive dressing for sealing chest wounds
	4 conforming gauze rolls 3" x 5 yd
	4 conforming gauze rolls 4½" x 5 yd
	6 triangular bandages
	1 adhesive tape 2"
	1 burn sheet
Patient Immobilization Equipment	2 (each) cervical collars: small, medium, large
	3 rigid conforming splints (SAM splints) OR
	1 set air splints for arm and leg OR
	2 (each) cardboard splints 18" and 24"
Extrication Equipment	1 spring-loaded center punch
	1 pair heavy leather gloves
Miscellaneous Equipment	2 blankets (disposable)
	2 cold packs
	1 bandage scissors
Other Equipment:	1 set personal protective clothing (helmet, eye protection, turnout coat)
	1 reflective vest
	1 fire extinguisher (5 lb. ABC dry chemical)
	1 Emergency Response Guide book
	6 fusees
	binoculars

Fig. 16.1 Suggested contents of a first responder life support kit.

You may receive your dispatch information by telephone, radio, pager, or written printout. Regardless of how the information is transmitted, you should obtain the following information: the nature of the call, the name and location of the patient, the number of patients, and any special problems. The

dispatch should also obtain a call-back number in case he or she needs to obtain more information from the caller. Unless you have good dispatch information, you will not be able to respond promptly.

Response to the Scene

Your first priority in responding to the scene is to get there quickly and safely. Select the best route for achieving this. Take into consideration the traffic patterns and the time of day. Follow the safety procedures outlined by your department, including the use of safety belts and the proper use of your vehicle warning devices. Above all else, drive so that you are not involved in an accident.

Arrival at the Scene

SAFETY PRECAUTION
Recall the BSI procedures. Do not forget to take appropriate precautions to prevent contamination by the patient's body fluids.

As you arrive at the scene of the accident or medical emergency, remember to place your vehicle in a safe location to minimize the chance of further accidents. Consider the best use of your vehicle warning lights. Remember to overview the scene as outlined in the patient assessment sequence (Chapter 7). Consider the safety of the scene.

Take into account the number of patients and consider the need for additional help if necessary. Begin your actions at the scene according to the patient assessment sequence you learned in Chapter 7. Practice being as efficient and as organized as you can.

Transferring the Care of the Patient to Other EMS Personnel

As more highly trained EMS personnel arrive on the scene, it will be necessary for you to transfer care of the patient to them. Remember to give them a brief report of the situation as you initially observed it and tell them what care you have provided for the patient. Ask them if they have any questions for you. Finally, offer to assist them in their care of the patient.

Post Run Activities

After you have completed your care of the patient and have provided any assistance to other EMS personnel, you may think that you are done with that call. However, never forget that your job is not done until you have completed the paperwork. Documentation is important, as you remember from Chapter 1. In addition to completing paperwork, you must be certain that all your equipment has been cleaned and that needed supplies have been replaced. Once these activities have been completed, you are ready to notify your dispatcher or supervisor that you are ready for another call or to resume your regular duties.

Check ✔ *Point*

✔ Describe the five phases of a response to an EMS incident.

Helicopter Operations

Helicopters are used by EMS systems to reach patients, to move them to medical facilities, or to remove them from inaccessible areas (Figure 16.2). If your EMS system uses a helicopter, obtain and study a copy of the ground operations procedures. As a first responder, you may be responsible for the initial call for assistance to the helicopter service or for set-up and preparation of the landing site in the field.

Know how to contact the helicopter service. Also learn the size and the specific requirements of the field landing zone. Landing zone size and conditions vary, depending on the different types of helicopters that each EMS system uses. As a general guideline, a helicopter requires an open, unobstructed landing area of about 150 feet in diameter. Your organization and the helicopter service should meet to discuss this essential information.

Helicopter Safety Guidelines

In addition to meeting size requirements, the landing zone should be free of loose debris and obstacles. Debris can blow all over the landing zone when the helicopter lands and takes off, causing a hazard for personnel, patients, and bystanders. If a highway or road is used, all traffic must be kept out of the landing zone!

For daytime operations, it may be helpful to use an emergency vehicle to mark the landing zone. Personnel on the ground can also point out the landing zone to the pilot.

SAFETY PRECAUTION

- Do not approach a helicopter until the pilot signals you to do so.
- Mark landing zone with vehicles.
- Be alert for electrical wires when identifying a landing zone.
- Always approach helicopters from the front so that the pilot can see you. Approaching a helicopter from the rear is dangerous because the tail rotor is nearly invisible when spinning.
- Keep low when you approach the helicopter to avoid the spinning main rotor blades. Helicopters are quite noisy, and you may not be able to hear a shouted warning; keep eye contact with the pilot (Figure 16.3).
- Follow the directions of the helicopter crew.

Fig. 16.2 An EMS helicopter.

At night, shining spotlights or vehicle headlights on the landing zone may be helpful. Spotlights should not be pointed directly at the arriving or departing helicopter because they could obstruct the pilot's vision. The corners of the landing zone can be marked with fusees or special strobe lights as long as this does not produce a fire hazard.

Trees and electrical wires pose a special hazard to a helicopter. Report these hazards to the pilot if you can communicate by radio. Electrical wires are particularly dangerous because the helicopter crew cannot easily see them.

Patient Loading into Helicopters

Remember that the helicopter crew may need help carrying equipment to the patient and carrying the patient to the helicopter. Give your patient report to the crew (away from the helicopter's noise) and offer your assistance.

Helicopter stretchers are harder to load into a helicopter than ambulance stretchers into an ambulance. Patients need to be packaged properly and securely. Loose sheets, blankets, or clothing can blow off the stretcher and into the rotor blades, causing severe problems.

The first responder can be of great assistance as ground support during helicopter ambulance operations, provided that proper safety precautions

Fig. 16.3 Approach helicopters from the front so that the pilot can see you.

Danger area

Approach

have been taken. If you will be working with a helicopter ambulance, arrange to have helicopter personnel orient you to their procedures.

Extrication

This section describes simple techniques you can use to access, treat, and extricate patients who are trapped inside wrecked vehicles. In addition to this introduction, many hours of practical exercises are needed to become skilled in the process of **extrication**.

Because it is the most common situation in which first responders use these techniques, an automobile accident is used here to illustrate the various techniques of gaining access and extrication. The ability to think quickly and use the principles and guidelines that are presented here are essential for the first responder.

Extrication Removal from a difficult situation or position; removal of a patient from a wrecked car or other place of entrapment.

A demonstration of the entire extrication operation should be a part of your first responder course. You should be familiar with the equipment, its use, and the hazards involved in the extrication operation. It is essential to know what equipment is available in your community and what steps are needed to summon this equipment.

Although this section focuses on patients trapped in automobiles, many of the same principles apply to other situations in which you must gain access to a patient. Resourcefulness, common sense, and knowledge gained through training are key attributes of the first responder, and they underlie every act of patient care.

The safety of both rescuers and patients is an important consideration during the extrication process. Rescuers should be protected by a helmet with face shield or goggles, gloves, and, if possible, equipment similar to the gear worn by fire fighters (that is, full bunker gear consisting of coat, pants, boots, helmet with face shield, and gloves).

An extrication effort often involves several agencies: law enforcement personnel, the fire department, EMS personnel, and sometimes the utility company, the gas company, and a wrecker operator. Only through prior coordination and practice can rescuers achieve the cooperation and mutual understanding that is needed to carry out an extrication effort safely and smoothly.

As you read this section, keep in mind these basic guidelines regarding your response to the accident scene:

- Know the limitations of your training, equipment, and knowledge.
- Identify any hazards (gasoline, power lines or wires, or hazardous materials).
- Control those hazards for which you are trained and equipped.
- Gain access to the patients.
- Provide patient care and stabilization.
- Move the patients only if absolutely necessary.

A situation in which patients are trapped in an automobile can be complex enough to tax the skills and resources of even the most highly trained and well-equipped EMS system. To ensure the best care, cooperation is required between many different agencies that respond to the accident scene.

The two primary extrication goals of the first responder are to obtain safe access to the patients and to ensure patient stabilization. To achieve these

goals, your role in the process of extrication can be divided into the following seven steps:

1. Conduct an overview of the scene.
2. Stabilize the scene, control any hazards, and stabilize the vehicle.
3. Gain access to patients.
4. Provide initial emergency care.
5. Help disentangle patients.
6. Help prepare patients for removal.
7. Help remove patients.

You will usually only be responsible for the first four steps of the extrication process. However, you will often have to assist other EMS personnel in completing the remaining steps. You cannot give this assistance unless you fully understand what must be done and how it is accomplished.

While you are working to help treat and extricate a patient, it is important that you do not become injured. Think safety! An injured rescuer becomes a second patient. First responders should use appropriate protective clothing and equipment when participating in extrication operations. At a minimum, first responders should have and use a helmet with appropriate eye protection (face shield or goggles) and gloves.

The actions you take as the first trained person on the scene can make the difference between an organized and a disorganized rescue effort, and can even make the difference between life and death! You set the stage, and you have an essential role in the extrication process.

Step One: Overview of the Scene

As soon as the dispatcher tells you of the incident, begin to anticipate and plan for what you are likely to find upon your arrival. You may, for instance, be aware that a certain type of accident occurs at a particular intersection or along a certain stretch of highway. Do not, however, become complacent about responding to the "same old thing." You must plan accordingly.

If the dispatch information is complete, you will know the types of vehicles involved (for example, two cars, a car and motorcycle, a truck and car, or a train and truck) and whether there are injured or trapped people, burning vehicles, or hazardous materials present.

As you approach an accident scene, look over the entire situation (Figure 16.4). Remember that you must locate the patients before you can treat them! Rapidly determine the extent of the accident or incident, try to estimate the number of patients, and try to locate any hazards that may be present. Examine the scene before you exit your vehicle. Get an overview of the entire incident. Then call for whatever assistance you need to manage the accident.

Step Two: Stabilization of the Scene and Any Hazards

It is especially important to keep a sharp lookout for hazards that can result in injury, disability, or death to a patient, yourself, other emergency personnel, or bystanders. Some of the most common hazards found at automobile accident scenes include infectious diseases, traffic, bystanders, spilled gasoline, automobile batteries, downed electrical wires, unstable vehicles, and vehicle fires (Figure 16.5).

Fig. 16.4 As you approach an accident, look over the entire scene.

Infectious Diseases

Many patients involved in motor vehicle accidents will have soft tissue injuries and active bleeding from open wounds or from their mouth or nose. Body substance isolation (BSI) precautions need to be practiced at motor vehicle accident scenes. In cases where there may be sharp glass or metal, you should wear heavy-duty rescue type gloves. Vinyl or latex gloves are needed where sharp objects are not present. If the patient may splatter blood, you should consider using face protection.

Traffic Hazards

First, be sure your vehicle and other emergency vehicles are parked in protective and warning positions around the accident scene. In most situations, place your vehicle in a location that does not obstruct open traffic lanes, but do not hesitate to block traffic to protect you, your patients, and the other rescuers.

Fig. 16.5 How many common hazards can you find?

If other emergency personnel are already on the scene, ask them where you should park your vehicle. Consider the design of your vehicle's warning lights and park so they are used to their best advantage. Do not leave your trunk lid open after you have removed your emergency equipment; the lid may block your warning lights!

Another means of protecting the scene is to ignite **fusees** (red signal flares) or warning flares as soon as possible. Place the flares or fusees up and down the road so oncoming traffic is warned in time to slow down safely. Once these traffic protective measures are taken, survey the scene for other hazards.

Fusee A warning device or flare that burns with a red color; usually used in scene protection at motor vehicle accidents.

⚠ **CAUTION**
Always keep fusees and flares away from flammable liquids.

Bystanders

Keep bystanders away from the scene to minimize the danger to themselves and patients. It is not usually enough to ask everyone to move back. You should give specific directions such as, "Move back to the other side of the road" or "Move back onto the sidewalk." You can also pick out one or two bystanders and ask them to assist you in keeping everyone away from the scene.

Perhaps one of the best techniques is to use a rope or police/fire barrier tape if it is available. People respond appropriately to such "barriers" and usually will not cross them once they are set up.

Spilled Gasoline

Gasoline is often spilled during automobile accidents. Expect to find a fuel spill if an automobile has been hit near the rear, is on its side, or is upside down. If fuel is spilled (or if the car is in a position that suggests it will be), call the fire department to minimize the fire hazard and to clean up any spilled fuel.

If patients are in a car whose fuel is spilled and the fire department has not arrived, consider covering the fuel with dirt. This reduces the amount of vapor coming from the spill, which, in turn, reduces the danger of fire. Fuel vapors tend to stay close to the ground and will travel with the wind. In any event, be sure to call the fire department whenever you suspect a fuel spill.

⚠ **CAUTION**
All sources of ignition such as cigarettes and flares must be kept well away from a fuel spill.

Automobile Batteries

Automobile batteries are hazardous, and you must avoid contact with them. Turn off the automobile's ignition to reduce the possibility of an electrical short circuit. Do not attempt to disconnect the battery because you could be injured by a short circuit, explosion, or contact with battery acid. In a front-end collision, the battery may already be broken open and acid will be leaking.

Downed Electrical Wires

Downed electrical wires may be caused by weather problems or by a vehicle hitting a utility pole. The downed electrical wires may be exploding in arcs of

Fig. 16.6 Be alert for downed electrical wires.

spectacular flashes and sparks, or they also may be quietly draped across the vehicle, fully charged with electricity and capable of causing injury or death to the unwary (Figure 16.6).

Locate the wires but avoid any contact! If a vehicle has a downed wire across it and passengers are trapped inside, immediately instruct them to stay inside the car. Then summon the utility company and fire department. Move bystanders back in all directions, to at least the distance between two power poles.

Do not forget that electrical hazards can come from sources other than wires—traffic light control boxes and underground power feeds. Be sure to check everywhere, including under the vehicles, for electrical hazards.

▼ CAUTION

Treat all downed wires as if they are charged (live) until you receive specific clearance from the electric company. Even if the lights are out along the street where the wires are down, never assume that the wires are dead. Be especially alert for downed wires after a storm that has blown down trees and tree limbs.

The first responder should not attempt to deal with electrical hazards at accident scenes. When you find an automobile in contact with an electric wire, you must take the following steps:

- If the wire is draped over the car, instruct trapped persons to remain inside the car. Any attempt to remove either the wire or the passengers from the car may result in serious injury or death to either the first responder or the passengers.
- Keep all bystanders away from the car.

- Call the utility company for assistance.
- Call the fire department for assistance.

Unstable Vehicles

Assume that every vehicle that has been involved in an accident is unstable, unless you have manually stabilized it. The vehicle may be situated so it could roll down a hill. Or it could be on its side, upside down, or even teetering over the edge of an embankment or bridge. No matter how stable the vehicle appears to be, it may suddenly roll away or topple over. Be sure to check and ensure the stability of every vehicle before you make any attempt to enter it or treat the passengers inside.

Vehicles on Their Wheels
In most cases, vehicle stability can be established by **chocking** the front or back of each wheel with hubcaps or pieces of wood (Figure 16.7) or deflating the tires by safely cutting or pulling the valve stems (Figure 16.8). If wooden blocks or hubcaps are not available, improvise by using materials found at the scene.

Vehicles on Their Sides or Upside Down
A vehicle that is on its side should be considered to be extremely unstable. Fortunately this position is fairly unusual. Stabilizing vehicles on their sides is out of the range of skills and equipment for many first responders and should be left to rescue squads or fire departments. Many fire departments and rescue squads carry **wooden cribbing** and "step-chocks" to deal with this problem.

If you find that you absolutely must enter a vehicle on its side due to a life-threatening situation, do not climb up on the vehicle. Enter through the back of the vehicle by breaking the rear window glass. Bend over or crouch down to stay close to the ground. This keeps the center of gravity of the car as low as possible.

A vehicle that is upside down is usually relatively stable. The primary hazard that occurs with an upside-down vehicle is spilled gasoline, which must be handled by the fire department.

Vehicle Fires

Even though fires happen infrequently at automobile accidents, they are discussed here in depth because they are a cause of great concern among EMS personnel. There are two types of fires related to automobile accidents: impact fires and postimpact fires.

Impact fires are usually caused by the rupture of the gas tank during the collision. The vehicles are usually rapidly engulfed in fire, and it soon becomes impossible to approach them to attempt a rescue. Passengers rescued from fires of this type are usually rescued by bystanders and witnesses to the accident who act immediately to remove them.

Postimpact fires are often caused by electrical short circuits. Prevent postimpact fires by turning off the ignition. Fires caused by electrical shorts usually do not develop into major fires if prompt action is taken. Should one occur, first turn off the ignition. Then extinguish any fire with a portable fire extinguisher. Remove the passengers from the vehicle as soon as possible.

Emergency Actions for Automobile Fires
If you arrive at an accident scene and find that a car is on fire and people are trapped inside, remember the following procedures:

- Use dry chemical or CO_2 fire extinguishers only (Figure 16.9). Most modern extinguishers are dry chemical types that can be used on ordinary

SAFETY PRECAUTION

Even vehicles that are positioned upright on all four wheels should be stabilized.

Chock A piece of wood or metal placed in front of or behind a wheel to prevent vehicle movement.

Wooden cribbing Wooden 2′ × 4′ or 4′ × 4′ boards used for stabilization or bracing.

Fig. 16.7 Chock the wheels.

Fig. 16.8 Deflate the tires to stabilize a vehicle.

A. Check pressure gauge.

B. Release hose.

Fig. 16.9 Use of a dry chemical fire extinguisher.

C. Pull locking pin.

D. Discharge at base of fire.

SAFETY PRECAUTION
Your purpose is to keep the vehicle in the position found. Do not move it! Any movement could cause the vehicle to tip over.

DID YOU KNOW

► According to the Insurance Institute for Highway Safety Statistics, only 1 out of every 1100 automobile accidents results in an automobile fire. Do not mistake hot water vapor from a damaged radiator for smoke from a fire. If the smoke rapidly disappears (10 to 15 feet away from the car), it is probably steam and not smoke from an engine compartment fire.

combustibles, flammable liquids, or electrical fires. Be sure you know what type you carry in your vehicle.

- Use your extinguisher to keep flames out of the passenger compartment. Direct the extinguisher to the base of the fire—not at the passenger compartment.
- Do not worry about discharging the extinguisher onto the passengers. The dry chemical powder is nontoxic.
- Immediately have someone gather other fire extinguishers from the other vehicles on the scene. Do not wait until your extinguisher runs out!

Fig. 16.10 Access the vehicle through the doors.

A. Try all doors first.

B. Try inside and outside handles at the same time.

- Remove patients as quickly as possible. Be careful because they may be injured.
- Move everyone at least 50 feet away from any vehicle that is on fire.

Step Three: Gain Access to Patients

Access through Doors

One of your primary goals is to gain access to patients. Between 85 and 90 percent of all patients can be reached simply by stabilizing the vehicle and then opening a door or rolling down a window. Try all the doors first—even if they appear to be badly damaged. It is not only embarrassing but also a waste of time and energy to open a jammed door with heavy rescue equipment and then watch someone go to another door and open it easily without any equipment.

Attempt to unlock and open the least damaged door first. Remember to check whether the locking mechanism is released. Then try the outside and inside handles at the same time (Figure 16.10).

Access through Windows

If you believe that any passenger's condition is serious enough to require your immediate care (for example, if the passengers are not sitting up and talking), you should attempt to enter the vehicle by breaking a window.

The windshield is not considered a primary access route because it is made of plastic-laminated glass, which can be difficult to break cleanly and remove (Figure 16.11). The side and rear windows are made of **tempered glass,** which breaks into small pieces when hit with a sharp, pointed object (such as a tire iron, spring-loaded center punch, or fire ax). Because these windows break easily into small pieces and do not pose a safety threat, these windows should be the primary access routes.

A spring-loaded center punch (available from many hardware stores) should be carried in your first responder's life support kit (Figure 16.12). It can be used rapidly, takes up little room in the kit, and is nearly always successful in breaking the side and rear windows on the first try.

When you must break a window to open a door or gain access, try to break one that is far from the patient. But if you believe the patient's condition warrants your immediate entry, do not hesitate to break a side or rear window, even if glass will fall onto a patient.

Fig. 16.11 The two types of glass in vehicles: laminated glass and tempered glass.

Tempered glass Safety glass that breaks into small pieces when hit with a sharp, pointed object.

Fig. 16.12 Spring-loaded center punch for breaking tempered glass.

Remember: Always warn trapped car passengers that you are going to break the glass!

Tempered pieces of glass do not usually pose a danger to people trapped in cars. Advise ambulance personnel if a passenger is covered with broken glass so they will notify hospital emergency department personnel. If there is glass on a passenger, pick it off—don't brush it off.

After breaking the window, use your gloved hands to pull the remaining glass out of the window frame so it does not fall onto the passenger or injure the rescuer (Figure 16.13C, D).

If you are using something other than a spring-loaded center punch, always aim at a lower corner of the window. This is so the window frame will help prevent the tool (such as a tire iron, fire ax, or large screwdriver) from sailing into the car and hitting the person inside.

Once you have broken the glass and removed the pieces from the frame, you should again attempt to unlock the door. Do this by releasing the locking mechanism first, and then operating both door handles at the same time. It is often possible to force a jammed locking mechanism by using both the inside

A. Place spring-loaded center punch at the lower corner of the window.

Fig. 16.13 Accessing the vehicle through the window.

B. Press on center punch to break window.

C. Remove the glass to the outside.

D. Enter the vehicle through the rear window.

Fig. 16.14 Check the trunk.

and outside handles at the same time, even in a door that appears to be badly damaged.

If the car is upside down, you may still be able to gain entry, either through the doors or an available window.

Using the simple techniques described and illustrated in this section, you should be able to gain access to nearly all automobile accident victims. If you cannot gain access, you must do what you can to assist the patients. This means stabilizing the vehicle and protecting the scene until the proper equipment arrives.

Remember: Check the trunk. This is especially important in border areas where significant numbers of illegal aliens are transported in automobile trunks to avoid detection (Figure 16.14).

Step Four: Provide Initial Emergency Care

Once you have gained access to passengers, immediately begin initial emergency medical care. Conduct a patient assessment on every patient. Once you have determined the status of each patient, monitor the ABCs, control bleeding, treat shock, stabilize the cervical spine, and provide psychological reassurance. If you have time, you can now perform a patient examination. Figure 16.15 shows you how to perform initial airway management when the patient is in a vehicle.

Leave patients in the vehicle unless it is on fire or they are otherwise in immediate danger. Keep the patients stabilized and immobilized until they are properly packaged and can be removed from the vehicle by other rescuers.

Remember: Access and patient stabilization are the two primary goals of first responders.

Step Five: Help Disentangle Patients

Extrication operates on the principle of "removing the vehicle from around the patient." This process usually requires tools and specialized equipment, such as air chisels, manual or powered hydraulic rescue equipment, and air

Fig. 16.15 Airway management in a vehicle.

A. To open the airway, place one hand under the chin and the other hand on the back of the patient's head.

B. Raise the head to neutral position to open the airway.

Chief Michael Bell
Director, Department of
Fire and Rescue Operations
Toledo, Ohio

"On August 26, 1992, a tanker carrying propane over-turned on the Anthony Wayne Bridge, which separates the east side from the downtown area of the city of Toledo. The Maumee River flows below the bridge, and a large residential area is located on the banks of the east side just under the bridge. The driver had just started up the east side of the bridge when he lost control and overturned. The temperature that day was about 85° with little or no wind. Initial crews responding found a 9000-gallon propane tanker on its side leaking diesel fuel and propane. The Incident Command System was initiated by the first arriving officer. The responding units had monitored the driver for injuries (which were minor) and were in the process of cooling the tanker upon my arrival. After an assessment of the scene was made, I assumed command. Concerns at this incident focused on the safety of the residents and the personnel at this scene. Through the utilization of the Incident Command System, we were able to evacuate an area of one-half mile surrounding the overturned tanker. We were also able to coordinate the appropriate utilization of experts at the scene through the Incident Command System. This allowed for everyone at this incident to know what was going on and when it would happen.

I believe the incident command training received by myself and members of my department played a major role in the outstanding performance of safety personnel at this incident. Through the effective utilization of the Incident Command System, a disaster was avoided and this incident was brought to a successful conclusion sixteen hours after it had begun with no injuries to on-scene personnel or citizens. "

Fig. 16.16 Serious extrication situation requiring teamwork from all responders.

Golden Hour A concept of emergency patient care that attempts to place a trauma patient into definitive medical care within one hour of injury.

bags. In some serious extrication situations, disentanglement can take up to 30 minutes and requires more advanced training than you have received as a first responder (Figure 16.16).

Additionally modern rescue crews work within the concept of the **Golden Hour** when dealing with serious trauma situations. The Golden Hour concept means that the less time spent on the scene with a seriously injured patient, the better. The patient's chances for survival are increased if rescuers are able to take the patient to a trauma center within one hour of the injury.

If you are familiar with the phases of the extrication effort, you may be able to assist the rescue and extrication crews. You can do many things to help, and you should take the time to find out about the rescue and extrication resources in your community. Ask the crews what you can do to assist them; they will probably be delighted to have your help and support.

Step Six: Help Prepare Patients for Removal

As disentanglement proceeds, the patient is prepared (packaged) for removal. Dressings, bandages, and splints are applied and spinal immobilization is accomplished. If you are familiar with what needs to be done and with what the ambulance personnel are doing, you may be able to assist in this effort. For example, because the patient is usually removed on a long backboard, extra trained hands are useful in moving and securing the patient onto the backboard. (See Chapter 5.)

It is important to realize that the route you may have used to gain access to the patient may not be the route by which the patient is removed. The extrication route must be large enough to allow for the safe removal of the packaged patient, whereas the access route may be a relatively small entry hole.

Step Seven: Help Remove Patients

Once packaged, the patient is removed from the automobile and placed onto the stretcher of the transporting ambulance.

Although you are only directly involved in the first four of the seven extrication steps, you should be aware of the entire operation, as your action or inaction can have a vital impact on the entire operation.

Remember that when you arrive on the scene of a vehicle accident with trapped passengers, proceed as follows:

- Call for extrication help.
- Specify the types of vehicles involved.
- Do not stand idly by while waiting for help:
 - Identify and contain hazards.
 - Park your vehicle so that its headlights and warning lights can be used to protect and light the scene.
 - Clear a working area around the accident before you or rescue personnel attempt to stabilize the vehicle(s).
 - Once you gain access to the patients, assess and monitor their conditions.
 - Use your head! Think and use what tools you already have.
 - Remember to try opening the doors first, rather than breaking windows.
 - Above all, keep your cool!

Check Point

✓ List seven hazards you may find at the scene of an emergency and describe what actions you can take to minimize or control each of these hazards.

Hazardous Materials Incidents

Hazardous materials (**HazMat**) incidents involving chemicals occur every day, exposing many people to injury or contamination. During a hazardous materials incident, first responders must protect themselves from injury and contamination.

Remember: A hazardous materials placard indicates a potential problem. Be sure to find the proper response to the problem before beginning patient treatment (Figures 16.17 and 16.18).

The single most important step when handling any hazardous materials incident is to identify the substance(s) involved. Federal law requires that hazardous materials placards be displayed on all vehicles that contain certain quantities of hazardous materials. Manufacturers and transporters should display the appropriate placard, along with a four-digit identification number, for better identification of the hazardous substance. These numbers are used to identify the substance and to obtain emergency information.

The U.S. Department of Transportation publishes the *Emergency Response Guidebook,* which lists the most common hazardous materials, their four-digit identification numbers, and the proper emergency actions to control the scene. It also describes the emergency care of ill or injured patients (Figure 16.19).

Unless you have received training in handling hazardous materials and can take the necessary precautions to protect yourself, you should keep away from the contaminated area, or **hot zone.**

HazMat Hazardous material or chemical.

Hot zone A contaminated area.

Fig. 16.17 Hazardous materials placard.

SAFETY PRECAUTION
Contaminated patients will contaminate unprotected rescuers!

Once the rescuers have been properly protected, triage in hazardous materials incidents has one major function—to identify victims who have sustained an acute injury as a result of exposure to hazardous materials. These patients should be removed from the contaminated area, decontaminated by trained personnel, given any necessary emergency care, and transported to a hospital.

The emergency treatment of patients who have been exposed to hazardous materials is usually aimed at supportive care because there are very few specific antidotes or treatments for most hazardous materials injuries. Because most fatalities and serious injuries sustained in hazardous materials incidents result from breathing problems, you must constantly reevaluate the patient's vital signs, including breathing status, so that a patient whose condition worsens can be moved to a higher triage level.

Hazardous Materials Warning Placards

CLASS 1 EXPLOSIVES 1
EXPLOSIVES
*Enter Division Number 1.1, 1.2, or 1.3 and compatibility group letter, when required. Placard any quantity.

CLASS 1 1.4 EXPLOSIVES 1
EXPLOSIVES 1.4
*Enter compatibility group letter, when required. Placard 454 kg (1,001 lbs) or more.

CLASS 1 1.5 BLASTING AGENTS 1
EXPLOSIVES 1.5
*Enter compatibility group letter, when required. Placard 454 kg (1,001 lbs) or more.

CLASS 1 1.6 EXPLOSIVES 1
EXPLOSIVES 1.6
*Enter compatibility group letter, when required. Placard 454 kg (1,001 lbs) or more.

CLASS 2 OXYGEN 2
OXYGEN
Placard 454 kg (1,001 lbs) or more, gross weight of either compressed gas or refrigerated liquid.

CLASS 2 FLAMMABLE GAS 2
FLAMMABLE GAS
Placard 454 kg (1,001 lbs) or more.

CLASS 2 NON-FLAMMABLE GAS 2
NON-FLAMMABLE GAS
Placard 454 kg (1,001 lbs) or more gross weight.

CLASS 2 POISON GAS 2
POISON GAS
Placard any quantity of Division 2.3 material.

CLASS 3 FLAMMABLE 3
FLAMMABLE
Placard 454 kg (1,001 lbs) or more.

CLASS 3 GASOLINE 3
GASOLINE
May be used in the place of FLAMMABLE on a placard displayed on a cargo tank or a portable tank being used to transport gasoline by highway.

CLASS 3 COMBUSTIBLE 3
COMBUSTIBLE
Placard a combustible liquid when transported in bulk. See §172.504(f)(2)for use of FLAMMABLE placard in place of COMBUSTIBLE placard.

CLASS 3 FUEL OIL 3
FUEL OIL
May be used in place of COMBUSTIBLE on a placard displayed on a cargo tank or portable tank being used to transport by highway fuel oil not classed as a flammable liquid.

CLASS 4 FLAMMABLE SOLID 4
FLAMMABLE SOLID
Placard 454 kg (1,001 lbs) or more.

CLASS 4 SPONTANEOUSLY COMBUSTIBLE 4
SPONTANEOUSLY COMBUSTIBLE
Placard 454 kg (1,001 lbs) or more.

CLASS 4 DANGEROUS WHEN WET 4
DANGEROUS WHEN WET
Placard any quantity of Division 4.3 material.

CLASS 5 OXIDIZER 5.1
OXIDIZER
Placard 454 kg (1,001 lbs) or more.

CLASS 5 ORGANIC PEROXIDE 5.2
ORGANIC PEROXIDE
Placard 454 kg (1,001 lbs) or more.

CLASS 6 HARMFUL STOW AWAY FROM FOODSTUFFS 6
KEEP AWAY FROM FOOD
Placard 454 kg (1,001 lbs) or more.

CLASS 6 POISON 6
POISON
Placard any quantity of 6.1, PGI, inhalation hazard only. Placard 454 kg (1,001 lbs) or more of PGI or II, other than PGI inhalation hazard.

CLASS 7 RADIOACTIVE 7
RADIOACTIVE
Placard any quantity of packages bearing the RADIOACTIVE III label. Certain low specific activity radioactive materials in "exclusive use" will not bear the label, but RADIOACTIVE placard is required.

CLASS 8 CORROSIVE 8
CORROSIVE
Placard 454 kg (1,001 lbs) or more.

CLASS 9 9
MISCELLANEOUS
Not required for domestic transportation. Placard 454 kg (1,001 lbs) or more gross weight of a material which presents a hazard during transport, but is not included in any other hazard class.

DANGEROUS
Placard 454 kg (1,001 lbs) gross weight of two or more categories of hazardous materials listed in Table 2. A freight container, unit load device, motor vehicle, or rail car which contain non-bulk packagings with two or more categories of hazardous materials that require placards specified in Table 2 may be placarded with a DANGEROUS placard instead of the separate placarding specified for each of the materials in Table 2. However, when 2,268 kg (5,000 lbs) or more of one category of material is loaded at one facility, the placard specified in Table 2 must be applied.

SUBSIDIARY RISK PLACARD
CORROSIVE
Class numbers do not appear on subsidiary risk placard.

CLASS 9 1993 RESIDUE 3
RAIL
Placard empty tank cars for residue of material last contained.

Required background for placards on rail shipments of certain explosives and poisons. Also required for highway route-controlled quantities of radioactive materials (see §§172.507 and 172.510).

UN or NA Identification Numbers
MUST BE DISPLAYED ON TANK CARS, CARGO TANKS, PORTABLE TANKS AND OTHER BULK PACKAGINGS
PLACARDS OR ORANGE PANELS → 1090
1090 and FLAMMABLE 3
Appropriate Placard must be used.
1090 3 FLAMMABLE 3 1017 2 1993 3

Response begins with identification!

Fig. 16.18 Hazardous materials placard.

Fig. 16.19 Emergency Response Guide book.

1996 NORTH AMERICAN EMERGENCY RESPONSE GUIDEBOOK

A GUIDEBOOK FOR FIRST RESPONDERS DURING THE INITIAL PHASE OF A HAZARDOUS MATERIALS/DANGEROUS GOODS INCIDENT

Multiple-Casualty Incidents

As a first responder, you are often faced with situations in which more than one person is sick or injured. These situations may range from a serious auto-mobile accident with three or four injured people to an explosion in a building with dozens of injured people. How do you determine whom to treat first?

You must first be able to recognize the situation as a **multiple-casualty incident** or mass-casualty incident and understand that your method of operation must now be very different from the way you routinely handle other emergency medical calls. During some multiple-casualty incidents, the first responder may be on the scene 15 to 20 minutes before assistance arrives, and it may be 45 to 60 minutes before enough rescue resources are available.

Multiple-casualty incident An accident or situation involving more patients than you can handle with the initial resources available.

There is no easy formula for deciding when to shift from normal operations into the techniques of the multiple- or mass-casualty incident. Experience is a key factor, but it cannot be taught in the classroom. Simulations provide realistic situations, but the factors are many and variable. The severity of the accident, access routes, available resources, response times, levels of emergency training, and overall experience of the EMS system all play a role.

The first responder's goal is to provide the greatest medical benefit for the greatest number of people and to match patients' medical needs with correct treatment and transportation. To accomplish this goal, you must be able to identify those most in need of treatment and those who can wait.

The sorting of patients into groups according to their need for treatment is called **triage**. Triage is a French word that has come to mean **casualty sorting** in the emergency care field. The purpose of casualty sorting is to determine which patients should be treated in what order so that the most good can be done for the most people.

Triage The sorting of patients into groups according to the severity of their injuries; used to determine priorities for treatment and transport.

Casualty sorting The sorting of patients for treatment and transportation.

Casualty Sorting: Creating Order Out of Chaos

The ideal casualty sorting system should be simple, rapid, and rely on the skills and knowledge first responders already have. It should not rely on a specific diagnosis for categorization—it is meant to provide the basis for a system of rapid, lifesaving actions.

By using a casualty sorting system, you are focusing your activities in the middle of a chaotic and confusing environment. You must identify and separate patients rapidly, according to the severity of their injuries and their need for treatment.

The Visual Survey: The Eye Sees It All

Even while you are responding to the scene of the reported incident, you should be preparing yourself mentally for what you may find (Figure 16.20). Perhaps you've responded to other accidents at the same location. Where will additional help come from? How long will it take for help to arrive?

Fig. 16.20 An incident requiring triage.

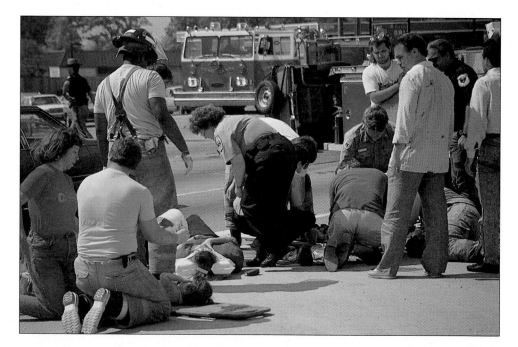

Stay Calm

Upon arriving at the scene of a major incident, you should first try to stay calm, look around, and get an overview of the scene. This visual survey gives you an initial impression of the overall situation, including the potential number of patients involved and, possibly, even the severity of their injuries. For example, you have been dispatched to a commercial bus accident and are the first on the scene. Make a visual assessment of the entire accident scene. Force yourself to stay as calm as possible. The visual survey should enable you to estimate initially the amount and type of help needed to handle the situation.

Your Initial Radio Report—Creating a Verbal Image

The initial radio report is often the most important radio message of a disaster because it sets the emotional and operational stage for everything that follows. As you prepare to key the microphone for that first vital report, use clear language, be concise, be calm, and do not shout into the microphone.

You are trying to give the communications center a concise verbal picture of the scene. The key points to communicate are:

- Location of the incident
- Type of incident
- Any hazards
- Approximate number of victims
- Type of assistance required

Be as specific with your requests as possible. Field experience has shown that a good rule of thumb initially, in multiple- or mass-casualty situations, is to request 1 ambulance for every 5 patients. For example, for 35 patients, request 7 ambulances; for 23 patients, request 5 ambulances; and so forth.

Focus on Treatment

After taking several deep breaths (to give your mind time to catch up with your eyes and to try to calm your voice), you might give the following radio report: "This is a major accident involving a truck and a commercial bus on Highway 233, about 2½ miles west of Route 510. There are approximately 35 victims. There are people trapped. Repeat: This is a major accident. I am requesting the fire department, rescue squad, and seven ambulances at this time. Dispatch additional police units to assist."

CAUTION

Recent studies show that one of the most common and fatal errors made in multiple-casualty incidents is failure to provide adequate traffic control at the emergency scene. Immediately after radioing for help, establish a plan for traffic control. Determine the perimeters to exclude all nonemergency vehicles. Establish a one-way route for emergency traffic coming into the scene and a *separate* one-way route for traffic leaving the scene. Make adequate room for emergency vehicles that need to be close to the scene. Vehicles and personnel that are not needed at a given time must be kept in a staging area. This process should only take a couple of minutes.

Sorting the Patients

It is important not to become involved with the treatment of the first or second patient with whom you come in contact. Remember that your job is to get to each patient as quickly as possible, conduct a rapid assessment, and assign patients to broad categories based on their need for treatment.

You cannot stop during this survey, except to correct airway and severe bleeding problems quickly. Your job is to sort (triage) the patients. Other rescuers will provide follow-up treatment.

The START System: It Really Works!

START system A system of casualty sorting using Simple Triage And Rapid Treatment.

Although many variations of triage systems are used in different communities, the **START system** is one triage plan that is simple to remember and implement. You need to learn the specific role that you have in the triage plan for your community.

The Simple Triage And Rapid Treatment (START) system was developed to allow first responders to triage multiple victims in 60 seconds or less, based on three primary observations: breathing, circulation, and mental status (BCM).

The START system is designed to help rescuers find the most seriously injured patients. As more rescue personnel arrive on the scene, the patients will be re-triaged for further evaluation, treatment, stabilization, and transportation. This system also allows first responders to open blocked airways and stop severe bleeding quickly.

Triage Tagging: To Tell Others What You've Found

Patients are tagged for easy recognition by other rescuers arriving on the scene. Tagging is done using a variety of methods determined by your local EMS system. Colored surveyor's tape or colored paper tags are used.

The Four Colors of Triage The START system consists of four levels of triage and uses color codes for each level (Figures 16.21 and 16.22). The levels are as follows:

- Priority One (red tag): Immediate care/life threatening.
- Priority Two (yellow tag): Urgent care/can delay up to 1 hour.
- Priority Three (green tag): Delayed care/can delay up to 3 hours.
- Priority Four (gray or black tag): Patient is dead/no care required.

The First Step in START: Get Up and Walk!

The first step in START is to tell all the people who can get up and walk to move to a specific area. If patients can get up and walk, they rarely have life-threatening injuries.

To make the situation more manageable, those victims who can walk are asked to move away from the immediate rescue scene to a specific designated safe area. These patients are now designated as Priority Three (green tag/delayed care). If a patient complains of pain on attempting to walk or move, do not force him or her to move. The patients who are left in the rescue scene are the ones on whom you must now concentrate.

The Second Step in START: Begin Where You Stand

Begin the second step of START by moving from where you stand. Move in an orderly and systematic manner through the remaining victims, stopping at

Fig. 16.21 Triage tags.

Fig. 16.22 Triage tape.

each person for a quick assessment and tagging. The stop at each patient should never take more than one minute.

Your job is to find and tag the Priority One patients—those who require immediate attention. Examine each patient, correct life-threatening airway and breathing problems, tag the patient with a red tag, and *move on!*

Focus on Treatment

How to Evaluate Patients Using BCM

The START system is based on three observations: BCM—breathing, circulation, and mental status. Each patient must be evaluated quickly, in a systematic manner, starting with breathing.

Breathing: It All Starts Here If the patient is breathing, you need to determine the breathing rate. Patients with breathing rates greater than 30 per minute are tagged Priority One (red tags). These patients are showing one of the primary signs of shock and need immediate care.

If the patient is breathing and the breathing rate is less than 30 per minute, move on to the circulation and mental status observations in order to complete your 60-second survey.

If the patient is not breathing, quickly clear the mouth of foreign matter. Use a head-tilt technique to open the airway. In this type of multiple- or mass-casualty situation, you may have to ignore the usual cervical spine guidelines when you are opening airways during the triage process.

The treatment of cervical spine injuries in multiple- or mass-casualty situations is different from anything that you've been taught before. This is the only time in emergency care when there may not be time to properly stabilize every injured patient's spine.

Focus on Treatment

Open the airway, position the patient to maintain the airway, and—if the patient breathes—tag the patient Priority One (red tag). Patients who need help maintaining an open airway are Priority One (red tags). If you are in doubt as to the patient's ability to breathe (Figure 16.23), tag the patient as

Fig. 16.23 Use START to sort patients into appropriate groups for treatment.

B = Breathing?
C = Circulation?
M = Mental Status?

RED YELLOW GREEN RIP

Priority One (red tag). If the patient is not breathing and does not start to breathe with simple airway maneuvers, tag the patient Priority Four (gray/black tag).

Circulation: Is Oxygen Getting Around?

The second step of the BCM series of triage tests is circulation of the patient. The best field method for checking circulation (to see if the heart is able to circulate blood adequately) is to check the carotid pulse.

The carotid pulse is close to the heart. It is large and easily felt in the neck. To check the carotid pulse, place your index and middle fingers on the larynx and slide your fingers into the groove between the larynx and the muscles at the side of the neck. You must keep your fingers there for 5 to 10 seconds to check for a pulse and its rate. (See Chapter 7.) If the carotid pulse is weak or irregular, tag the patient Priority One (red tag). If the carotid pulse is strong, move on to the mental status observation, the third step of the BCM series.

Treat patients with a weak carotid pulse for shock by elevating the legs to return as much blood as possible to the brain, lungs, and heart. Then try to stop any severe bleeding. Do not spend time controlling the bleeding yourself. Get the patient to assist or ask one of the walking Priority Three (green tag) patients to help. These patients are often eager to assist with emergency treatment.

If the pulse is absent, the patient is tagged with a Priority Four (gray/black tag).

Mental Status: Open Your Eyes!

The last step of the BCM series of triage tests is the mental status of the patient. This observation is done on patients who have adequate breathing and adequate circulation.

Test the patient's mental status by determining if the patient is responsive to verbal stimuli. Tell the patient to follow a simple command: "Open your eyes," "Close your eyes," "Squeeze my hand." Patients who can follow these simple commands and have adequate breathing and adequate circulation are tagged Priority Two (yellow tag). According to the AVPU scale, which is described in Chapter 7, such patients are considered to be "alert" and "responsive" to verbal stimuli.

A patient who is unresponsive and cannot follow this type of simple command is tagged Priority One (red tag). (These patients are "unresponsive" to verbal stimuli, according to the AVPU scale.)

START Is Used to Find Priority One Patients

The START system is designed to help rescuers find the most seriously injured patients. As more rescue personnel arrive on the scene, the patients will be re-triaged for further evaluation, treatment, stabilization, and transportation.

Remember that injured patients do not stay in the same condition. The process of shock may continue and some conditions will become more serious as time goes by. As time and resources permit, go back and recheck the condition of Priority Two and Priority Three patients to catch changes in condition that may require upgrading to Priority One (red tag) attention (Figure 16.24).

Fig. 16.24 START algorithm.

Working at a Multiple- or Mass-Casualty Incident

You may or may not be the first person to arrive on the scene of a multiple- or mass-casualty incident. If other rescuers are already at the scene when you arrive, be sure to report to the incident commander before going to work. Many events are happening at the same time, and the incident commander will know where your help and skills can best be used. By virtue of training and local protocols, the incident commander is that person who is in charge of the rescue operation. An effective incident command system must be agreed upon and integrated between fire, law enforcement, and emergency medical

services personnel. You should learn the incident command system (ICS) that is used in your community.

In addition to initially sizing up an incident, clearly and accurately reporting the situation, and conducting the initial START triage, the first responder will probably also be called on to participate in many other ways during multiple- and mass-casualty incidents.

As more highly trained rescue and emergency personnel arrive on the scene, accurately report your findings to the person in charge by using a format similar to that used in the initial arrival report. Note the following information:

- Approximate number of patients
- Number of patients that you have triaged into the four levels
- Additional assistance required
- Other important information

After you have reported this information, you may be assigned to use your skills and knowledge to provide patient care, traffic control, fire protection, or patient movement. You may also be assigned to provide emergency care to patients, to help move patients, or to assist with ambulance or helicopter transportation.

In every situation involving casualty sorting, the goal is to find, stabilize, and move Priority One patients first.

Check ✔ Point

✔ Describe your role as the first person arriving on the scene of a multiple-casualty incident.

C H A P T E R
R E V I E W 16

Summary

This chapter has covered EMS operations. As a first responder, you need to understand what equipment you need to carry with you on an emergency call. The chapter covers the five phases of an emergency response and the seven steps of extrication. You should be able to perform the first four steps of extrication and assist other rescuers with steps five through seven. Because you may be the first trained person on the scene of an incident involving hazardous materials, it is important for you to understand your role during the first few minutes of a hazardous materials incident.

You should also understand the role of a first responder during the first few minutes of a multiple-casualty incident. The START system of triage is a simple system for you to use to provide initial triage at a multiple-casualty incident. By learning these simple but important skills involving EMS operations, you can become an effective and life-saving member of the EMS system in your community.

Key Terms

Casualty sorting—page 452

Chocking—page 442

Extrication—page 437

Fusee—page 440

Golden Hour—page 448

HazMat—page 449

Hot zone—page 449

Multiple-casualty incident—page 451

START system—page 454

Tempered glass—page 444

Triage—page 452

Wooden cribbing—page 442

What Would You Do?

1. You are dispatched to the scene of a one-car accident. Upon your arrival, you find the car has cut off an electrical pole and has wires across it. The car is blocking two lanes of traffic. A large crowd is gathering. What would you do?

2. You are dispatched to an intersection where a school bus with 23 sixth graders has collided with an overnight package delivery truck. Many of the children are complaining of pains in various parts of their bodies. Five of the students and the truck driver appear to be unconscious. What would you do?

You Should Know

1. What medical and nonmedical equipment a first responder needs.
2. The five phases of an emergency call.
3. The role of a first responder in extrication.
4. The seven steps involved in extrication.
5. Simple means for gaining access to a patient.
6. Simple extrication procedures that a first responder can perform.
7. Complex extrication procedures that require specially trained personnel.
8. The responsibilities of the first responder in incidents involving hazardous materials.
9. The actions that first responders should take in hazardous materials before the arrival of specially trained personnel.
10. The definition of a multiple-casualty incident.
11. The role of a first responder in a multiple-casualty incident.
12. The steps in the START triage system.

You Should Practice

1. Performing simple procedures for gaining access to a patient in a wrecked vehicle.
2. Using the START system during simulated multiple- or mass-casualty incidents.

1.

2.

1. To open the airway, place one hand under the chin and the other hand on the back of a patient's head.
2. Raise the head to neutral position to open the airway.

1. List and describe the five phases of an EMS call.

2. You should approach an air medical helicopter
 1. From the rear
 2. From the front
 3. When signaled by the pilot
 4. Not until the rotor stops

 a. 1 and 4
 b. 4
 c. 1, 2, and 3
 d. 2 and 3

3. Place the following steps of extrication in the order they should be performed.
 ___ a. Help disentangle patients.
 ___ b. Help remove patients.
 ___ c. Help prepare patients for removal.
 ___ d. Stabilize the scene.
 ___ e. Gain access to patients.
 ___ f. Conduct an overview of the scene.
 ___ g. Provide initial care.

4. What steps can you take to control the following hazards?
 a. Infectious diseases
 b. Traffic hazards
 c. Bystanders
 d. Spilled gasoline
 e. Automobile batteries
 f. Downed electrical wires
 g. Unstable vehicles
 h. Vehicle fires

5. Your first step for gaining access to a patient in a car is through the windows.
 a. True
 b. False

6. In a hazardous materials incident, the "hot zone"
 a. Should be protected by an approved placard
 b. Is an area you should stay out of if you are not trained
 c. Is the area contaminated by the hazardous material
 d. Requires special clothing for entry
 e. All of the above

7. In the START triage system, START stands for

 S _____

 T _____

 A _____

 R _____

 T _____

8. Place the following steps of the START triage system in the proper order:
 ___ a. Circulation
 ___ b. Mental status
 ___ c. Breathing

9. The START triage system consists of four levels. Match the following:

___ Priority Four (gray or black tag)

___ Priority Three (green tag)

___ Priority Two (yellow tag)

___ Priority One (red tag)

a. Immediate care/life threatening

b. Urgent care/can delay up to 1 hour

c. Patient dead/no care required

d. Delayed care/ can delay up to 3 hours

10. Place patients with the following conditions in the proper START priority category:

a. Breathing rate more than 30 times per minute

b. Patient not breathing

c. Weak or irregular cardiac pulse

d. Alert patient with skin laceration

e. Patient unresponsive with pulse and breathing

9. C = Priority four (gray or black); D = Priority three (green); B = Priority two (yellow); A = Priority one (red); b. Priority four (gray or black); c. Priority one (red); d. Priority two (yellow); e. Priority one (red). **10.** a. Priority one (red);

464 Self Test 7

8

SUPPLEMENTAL SKILLS

This module covers supplemental skills that will be useful to you as a first responder. Chapter 17 discusses special patients who are sometimes more challenging to communicate with. These patients include elderly patients, patients who are visually or hearing impaired, and developmentally disabled patients. As a first responder, you will also encounter special rescue situations (Chapter 18). It is important to learn simple rescue techniques that you can perform with little or no equipment. It is also important to know what you *cannot* do without endangering yourself or the patient.

Some first responder service agencies include additional skills that are not part of the regular first responder course. Chapter 19 covers the following skills: blood pressure measurement, oxygen administration, and automated early defibrillation. Your service may choose to teach you one or more of these skills. It is important that you receive adequate instruction in these skills and have the approval of your medical director before using them.

Special Patients
and Considerations

CHAPTER 18
Special Rescue Situations

CHAPTER 19
Supplemental Skills

SPECIAL PATIENTS AND CONSIDERATIONS

Knowledge and Attitude Objectives *After studying this chapter, you will be expected to:*

1. Describe the approach you should use when dealing with elderly patients.
2. Describe the approach you should use when dealing with hearing-impaired patients.
3. Describe the approach you should use when dealing with visually impaired patients.
4. Describe the approach you should use when dealing with non–English-speaking patients.
5. Describe the approach you should use when dealing with developmentally disabled patients.
6. Describe the approach you should use when dealing with patients displaying disruptive behavior.

Skill Objectives *After studying this chapter, you should be able to:*

1. Communicate with elderly patients.
2. Communicate with hearing-impaired patients.
3. Communicate with visually impaired patients.
4. Communicate with non–English-speaking patients.
5. Communicate with developmentally disabled patients.
6. Communicate with patients displaying disruptive behavior.

As a first responder, you will encounter patients who have special needs and deserve special consideration. These patients include elderly patients, patients who are visually or hearing impaired, and developmentally disabled patients. By better understanding these impairments and learning some simple communications techniques, you will be able to work with these people more effectively when they become your patients.

Elderly Patients

Of course, not all elderly patients are disabled. Deal with each patient as an individual, not as a member of some arbitrary group defined by age (Figure 17.1).

The following disabilities may occur with age:

Fig. 17.1 Deal with every patient as an individual.

- Loss or impairment of hearing
- Loss or impairment of sight
- Slowed movements
- Fractures
- Senility
- Loss of bowel and bladder control

Loss or Impairment of Hearing

Be sure an elderly patient can hear and understand what you say. Speak slowly and clearly. If you think the patient has difficulty hearing, do not shout. Speak directly into the patient's ear, or try to maintain eye contact by talking while facing the patient because many elderly patients read lips to help compensate for hearing loss.

Loss or Impairment of Sight

If an elderly patient wears eyeglasses, keep them with the patient if at all possible. Search the bedroom, the automobile, and elsewhere to try to find the glasses! The patient may be severely handicapped without his or her glasses, and finding them will greatly relieve the patient's anxiety. Imagine how you would feel if you were in an emergency situation and could not see.

Slowed Movements

When you are assisting elderly patients, it is important to remember that a person's movements get slower with age. A helping hand or supporting arm is often all that is necessary. Most elderly patients are afraid of falling, and your support helps them overcome this fear.

Fractures

Osteoporosis Abnormal brittleness of the bones in older people caused by loss of calcium; affected bones fracture easily.

Fractures occur often in the elderly because, as we age, our bones become quite brittle. The condition that causes this problem is called **osteoporosis**. Fractures of the wrist, spine, and hip are particularly common.

Hip fractures usually result from a fall and occur mostly in elderly women. Patients may have suffered a minor stroke, heart attack, or confusion, or they may not have seen an obstacle before the fall.

The injured leg is usually (but not always) shortened when it is compared with the other leg. The toes of the injured leg are pointed outward (**externally rotated**), and there may be so much pain that the patient cannot move the leg. Every elderly patient who complains of pain after a fall must be x-rayed for possible fractures.

Splint the patient as described in Chapter 13 and arrange for prompt transport to an appropriate medical facility.

Externally rotated Rotated outward, as in a fractured hip.

Senility

Old age sometimes brings senility. This can include the loss of short-term and/or long-term memory, confusion, inability to follow directions, and even hostile behavior. Despite your best efforts to help some elderly patients, effective communication and interaction may be impossible. Senile patients are a challenge for even the most highly trained medical personnel. You must remain calm and keep talking with them. Remember that the patient needs help, and you are there to provide it (Figure 17.2).

Elderly people often wear more clothing than other people, even during the middle of the summer. The presence of these extra clothes may present the first responder with a reason to do a less-than-complete physical examination. Resist the urge and conduct a complete head-to-toe examination.

Loss of Bowel and Bladder Control

The loss of bowel and bladder control occurs frequently in the elderly. This situation can be distressing and embarrassing to both you and the patient. Do not let this problem interfere with appropriate patient care.

Additional Considerations for Elderly Patients

If the elderly patient is at home and needs to be taken to a hospital, gather all medications and send them to the hospital with the patient.

Fig. 17.2 Treat elderly patients with consideration and respect.

Often the elderly patient's spouse needs your attention, too. Watching a loved one become injured or seriously ill and then be taken away in an ambulance is a frightening experience. The first responder should take a few minutes to speak with the patient's spouse or family, telling them what is being done and why such action is being taken.

Hearing-Impaired or Deaf Persons

One of the major challenges that first responders face is communicating with a deaf person. Most people have few skills for dealing with deaf persons and feel uncomfortable when asked to do so.

A patient of any age may be unable to hear you for a variety of reasons: **hereditary deafness,** long-term deafness caused by ear infections or injury, or **temporary deafness** caused by an explosion. A patient who has been deaf for a long time has developed skills to help compensate for the deafness. A patient who is temporarily deaf (such as from an explosion) does not have such skills.

In either case, your job is to address the medical needs of the patient. Ask, "Can you hear me?" A patient who is used to being deaf will probably respond by pointing at his/her ear and shaking his/her head to indicate deafness.

The temporarily deaf person needs help to reduce panic caused by not being able to hear. Point at your ear and shake your head to indicate that you think the patient is deaf, or write out the question, "Can you hear?" on a piece of paper and show it to the patient.

Once you have determined that the patient is deaf, use alternative means to communicate. A patient with long-term deafness may attempt to communicate with you by signing (using the hands and fingers to communicate). Because many deaf people cannot read lips, your best methods of communication, if you cannot sign, are writing and using gestures.

As you examine the patient for injury or pain, use your own body to show the patient how to indicate whether there is pain in a particular location. Touch a place on your body and make a face to indicate pain. Then look at the patient and repeat the procedure on the patient's body. Most people will understand what you are trying to do.

Keep the deaf patient informed by making gestures to indicate that certain things are happening (for example, when the ambulance is arriving). As with any person you are treating, touching is an important part of communication and reassurance. Hold the patient's hand so that he or she knows you are there to help.

When working with deaf patients:

- Face the patient when you speak so he or she can see your lips and facial expressions.
- Identify yourself by showing the patient your patch or badge.
- Touch the patient; a deaf patient needs human contact even more than a hearing patient.
- Speak slowly and distinctly; do not shout.
- Watch the patient's face for expressions of understanding or uncertainty.
- Repeat or rephrase your comments into clear, simple language.
- If all this fails, write down your comments and offer paper and pencil to the patient to write the answer.

Hereditary deafness Deafness present at birth.

Temporary deafness Deafness that is usually caused by an explosion or loud noise; hearing usually returns after a short time.

VOICES *of* EXPERIENCE

"**W**orking in the backcountry, I have had to adapt my skills and knowledge to meet a variety of unpredictable situations. I have found that, with the delay from the time of the injury to the contact of EMS, concise and accurate communication is vital for us to be able to reach and treat patients in remote settings.

In one incident in New Hampshire's White Mountain National Forest, I was sent with a radio to assess and treat a patient who, according to the reporting party, had "snapped his femur clear in two," eight rugged miles into the Pemigewasset Wilderness. Meanwhile a rescue team was being assembled.

It was well past dark and raining when I reached the patient, who, fortunately, was over two miles closer than had been reported, in great pain, but able to walk, and with no fracture at all. Had we committed twenty to thirty rescuers on that terrain in those conditions, we would probably have had several more injured or hypothermic patients to deal with in addition to our original patient.

As the first people on the scene, we must be able to accurately assess the situation and allocate our resources efficiently. We must be able to communicate that information effectively to the outside world, to the people who will take over our patient's care."

Bryan Yeaton
EMT, S.O.L.O. Instructor
Conway, New Hampshire

- Some people are both deaf and blind. Due to this double loss of sensation, these patients may be difficult to treat. Therefore, the first responder must be extremely patient and use touch as a way of communicating.

Children and the Deaf

If the patient is a hearing child of deaf parents, be sure to communicate to the parents the child's condition and how you are helping. They have a right to know what is being done and are probably even more upset than hearing parents would be because of their deafness. Like all other parents in similar circumstances, deaf parents must give their consent for you to treat their child.

Take care when a deaf patient has a hearing child. Unless the child is obviously mature and capable, resist the urge to use the child as an interpreter. Young children cannot understand medical terminology, and misinterpretation can have very serious results. The first responder must attempt in every way possible to communicate directly with a deaf patient.

If the patient is a deaf child of hearing parents, be sure to ask the parents to assist you in communicating with the child.

Focus on Assessment

Do a complete patient assessment on every patient, whether or not they can communicate with you.

Visually Impaired or Blind Patients

During the patient assessment, as you approach and introduce yourself to the patient, look for signs that the patient may be blind (Figure 17.3). If you think the patient is blind, ask, "Can you see?"

From the time of your first contact with the patient, use your touch, voice, and ears to communicate. Talk with a blind patient more than you would with a sighted one so he or she knows what is happening. Tell them what is happening, identify noises, and describe the situation and surroundings.

Find out what the patient's name is and use it throughout your examination and treatment. Touch the patient to provide psychological support. This is even more important for patients who cannot see.

If the patient has a guide dog, let the patient direct the dog or tell you how to handle the dog. Remember that guide dogs are usually not aggressive and that the blind person and the dog are a unique team and depend on each other. You must try to keep them together.

If a blind patient must be moved and can walk, ask the patient to hold onto your elbow and stand slightly to your side and rear. Tell the patient about obstructions, steps, and curbs as you lead the way.

Remember: Always lead a blind patient—never push!

Fig. 17.3 Blind patients may have a seeing-eye dog.

Non–English-Speaking Patients

Although a patient may only speak a language other than English and you cannot understand each other, you are still responsible for treating him or her. In many ways, the techniques used for a non–English-speaking patient are the same as those used for a deaf patient. Determine how much English the patient speaks. Seek out a family member or friend to be your interpreter.

Your questions can be supplemented by using hand gestures, finger pointing, and facial expressions. If your jurisdiction has a large non–English-speaking population, you should make a serious attempt to become familiar with the language(s) spoken, particularly if this language is used in your daily work.

Developmentally Disabled Patients

Developmentally disabled patients can be difficult to communicate with. Ask the family about the patient's typical level of communication. Speak slowly, using short sentences and simple words. A developmentally disabled patient often needs to have statements repeated several times before understanding what is required.

Again, offer support by taking time to touch your patients. Developmentally disabled patients should be handled with extra care to minimize their fear and confusion. Many of the techniques that are useful when treating children will be useful with developmentally disabled patients.

Persons Displaying Disruptive Behavior

Disruptive behavior is behavior that presents a danger to the patient or others, or that causes a delay in treatment. Eventually every first responder will find a person who challenges his or her skills in patient communication.

In managing any patient who is exhibiting disruptive behavior, take the following steps:

1. Assess the situation. Try to determine the cause of the patient's disruptive behavior.
2. Protect the patient and yourself.
3. Do not take your eyes off the patient or turn your back.
4. If the patient has a weapon, stay clear and wait for law enforcement personnel—no matter how badly injured the patient seems to be.
5. As soon as your personal safety has been assured, carry out the appropriate emergency medical care.

There may be times when a patient simply cannot be approached; the person will not allow anyone to approach, despite all efforts to help. Sometimes family or friends of the disruptive patient insist that the person be taken to the hospital. However, most first responders (who are not law enforcement personnel) cannot take the patient to the hospital against his or her wishes.

Frightened, agitated, drugged, or disruptive patients may be capable of causing serious injury to the first responder, bystanders, or themselves. It is best to wait for additional assistance in these cases.

Summary

This chapter has described special considerations and skills needed when working with elderly patients, hearing-impaired patients, visually impaired patients, non–English-speaking patients, developmentally disabled patients, and patients displaying disruptive behavior.

Elderly people often need specific instructions and more time to understand what is being done for them. They may move more slowly and need more help in moving than other patients.

Deaf patients may be able to read your lips. If not, you must write your questions and instructions. Blind patients need special instructions because they cannot see what you are doing for them.

Non–English-speaking patients present a challenge for you. By using bystanders or family as translators, you can often communicate with these patients. Developmentally disabled patients can often understand you if you speak slowly and use simple words. Patients displaying disruptive behavior will often react to your calm approach. You need to keep your safety in mind when dealing with these patients.

Key Terms

Externally rotated—page 471

Hereditary deafness—page 472

Osteoporosis—page 470

Temporary deafness—page 472

 What Would You Do?

1. You are called to a residence and are greeted at the door by a 58-year-old woman. As you introduce yourself, you believe that the woman does not understand you. What would you do?
2. You are called to a residence and are greeted at the door by a 5-year-old child who appears frightened and upset. The child tells you that her mother is very sick and cannot hear anything. What would you do?

You Should Know

1. The approach you should use when dealing with elderly patients.
2. The approach you should use when dealing with hearing-impaired patients.
3. The approach you should use when dealing with visually impaired patients.
4. The approach you should use when dealing with non–English-speaking patients.
5. The approach you should use when dealing with developmentally disabled patients.
6. The approach you should use when dealing with patients displaying disruptive behavior.

You Should Practice

1. Communicating with elderly patients.
2. Communicating with hearing-impaired patients.
3. Communicating with visually impaired patients.
4. Communicating with non–English-speaking patients.
5. Communicating with developmentally disabled patients.
6. Communicating with patients displaying disruptive behavior.

SPECIAL RESCUE SITUATIONS

Knowledge and Attitude Objectives

After studying this chapter, you will be expected to:

1. Describe the steps you can take in assisting with a water rescue.
2. Describe the initial treatment of a patient in the water.
3. Describe the steps you can take in assisting with an ice rescue.
4. Describe your role in assisting with a confined space rescue.

Skill Objectives

After studying this chapter, you should be able to:

1. Assist with a water rescue.
2. Provide initial treatment for a patient in the water.
3. Assist with an ice rescue.
4. Assist with a confined space rescue.

This chapter covers special rescue situations. These situations are life threatening to the rescuer and to the victim. Your first objective is to maintain your personal safety. In addition, there are basic rescue procedures you can perform without endangering yourself or the victim. This chapter addresses water rescue, ice rescue, and confined space rescue, and it provides you with guidelines for dealing with them.

Water and Ice Rescue

You may encounter situations in which a person is in the water and needs to be rescued. The person may be fatigued, have suffered a diving injury, or have fallen through the ice in the winter. It is not possible in a book of this scope to teach you the skills needed by a certified lifesaver. It is, however, possible to describe some simple techniques by which you can accomplish a water or ice rescue without endangering your own safety.

Water Rescue

Your first impulse upon seeing a person struggling in the water may be to jump in to assist. This action may not result in a successful rescue and can endanger your own life. If you are faced with a water rescue situation, remember the steps listed here and illustrated in Figure 18.1.

Reach-throw-row-go A four-step reminder of the sequence of actions that should be taken in water rescue situations.

1. Reach
2. Throw
3. Row
4. Go

Using the first three steps, even a rescuer who cannot swim can sometimes rescue a struggling person while remaining on land.

Reach
Use any readily available object to reach the threatened person. If the victim is close to shore, a towel, pole, oar, or paddle may be long enough. If you are at a swimming pool, a specially designed pole may be available for this purpose. Use it.

Throw
If the person is too far out to be reached, throw something. At a swimming pool, dock, or supervised beach, a **flotation device** (such as a ring buoy) may be available. If a life buoy is available, throw it to the person in distress.

Flotation device A life ring, life buoy, or other floating device used in water rescue.

If no buoy is handy, then improvise. Throw a rope, plastic milk jug, or Styrofoam™ cooler. Even a spare tire from a car can support several people in the water. Think before you act!

Note: If you are using something like a plastic milk jug or picnic jug, fill the container with about 1 inch of water to add to its weight when throwing to the victim.

Row
If you cannot reach the person by throwing something that floats and a small boat or canoe is available, row out to the drowning person. It is important that you know how to operate or propel the craft properly. Protect yourself by putting on an approved personal flotation device.

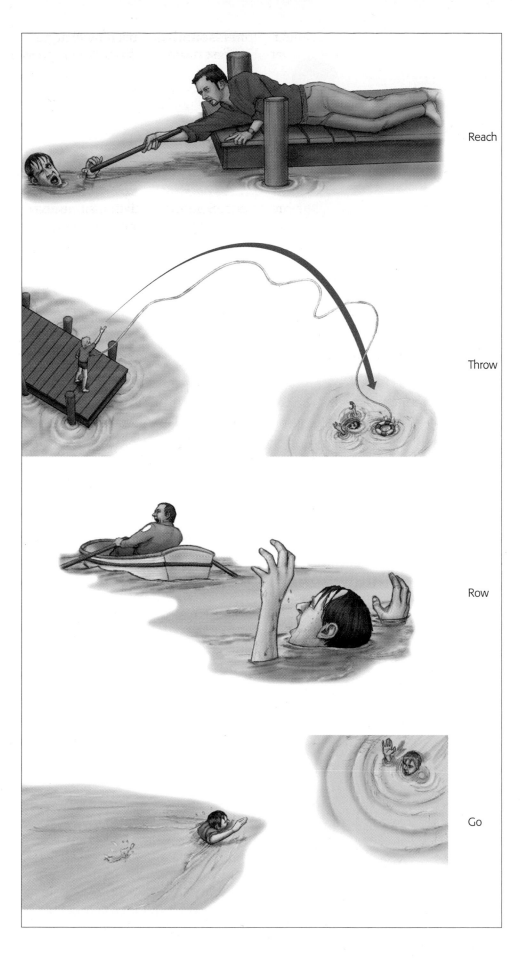

Fig. 18.1 Water rescue rules: reach, throw, row, go.

Reach

Throw

Row

Go

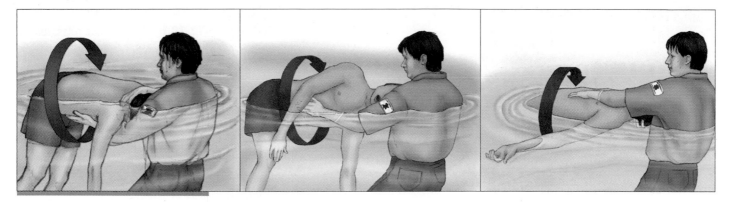

Fig. 18.2 Turning a patient in the water.

Go

As a last resort, you may have to go into the water to save the victim. Enter the water only if you are a capable swimmer and trained in lifesaving techniques. Remove encumbering clothing before entering the water. Take a flotation device with you if one is available.

Riptide An unusually strong surface current flowing outward from a seashore that can carry swimmers "out to sea."

▼ **CAUTION**

Currents in streams or strong currents (riptides) at ocean beaches can pull both victim and rescuer rapidly away from shore. In an area below a dam, rapids, or waterfall, deadly currents may be present. An untrained rescuer should never attempt to enter the water under these conditions. To do so will probably result in both people needing rescue.

Initial Treatment of a Person in the Water

If you must remove a patient from the water, your primary concerns are airway, breathing, circulation, and stabilization of spinal cord injuries.

Turn patients who are face down in the water face up. Support the back and neck with one hand and use the other hand to turn the patient face up, constantly stabilizing the neck. Keep the head in the neutral position (Figure 18.2).

To open the airway, use the jaw-thrust technique. Do not hyperextend the neck because of the high risk of associated spinal cord injuries.

Look, listen, and feel for signs of breathing. If the patient is not breathing, start rescue breathing while the patient is still in the water (Figure 18.3). Ventilation will be much easier if the rescuer can stand on the bottom.

If the patient has suffered cardiac arrest, quickly stabilize the head and neck and remove the patient from the water. Place the patient on a hard surface before you begin CPR (see Chapter 8).

Treat a patient who is unconscious in the water as if a spinal cord injury were present. Also assume the presence of spinal cord injury if a conscious patient in the water complains of numbness or tingling in the arms or legs, inability to move the extremities, or neck pain. Support the patient in the water

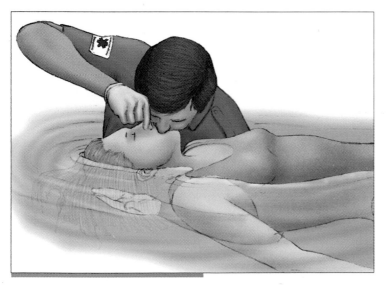

Fig. 18.3 Begin rescue breathing in the water.

with a backboard, which should be floated under the patient (Figure 18.4).

Strap the patient to a backboard, stabilize the head and neck, and remove the patient from the water. If no backboard is available, a chaise lounge, door, or piece of plywood can be used to provide rigid support under the patient. If no rigid device is available and the patient must be removed from the water before EMS personnel arrive, six people's hands can be used to lift and support the patient (Figure 18.5).

Remember: One rescuer should give the commands to lift, move, and set the patient down.

Fig. 18.4 Apply the backboard while the patient is still in the water.

Ice Rescue

The same basic water rescue rules apply: reach, throw, row, go. Reach the victim with anything that will extend your natural span of reach, such as a ladder, a tree branch, or a backboard (Figure 18.6). Next, throw a flotation device, rope, or anything that floats to pull in the victim. Third, row or propel a small boat to the victim. Use a toboggan to get across the ice; it will spread your weight over a wider area and reduce your chances of falling through the ice. Be sure that a rope is secured to the boat or toboggan. Finally, if you must go, tie a rope around your waist, lie on your stomach and proceed across the ice. Spreading your weight over a wider area reduces your chances of falling through the ice.

Fig. 18.5 In emergency situations, a patient can be removed from the water using six people.

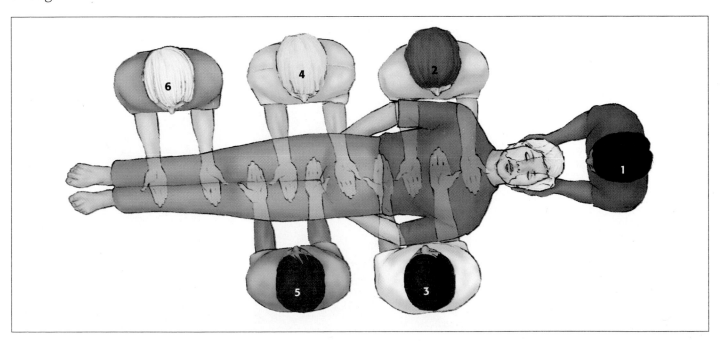

Fig. 18.6 Ice rescue. The ladder distributes the rescuer's weight over a larger area, making it less likely that he or she will also fall into the water.

Fig. 18.7 Confined spaces may have insufficient oxygen to support life without self-contained breathing apparatus.

Confined Space Rescue

Confined spaces are structures that are designed to keep something in or out. Confined spaces may be below the ground, at ground level, or elevated. Below-ground confined spaces include manholes, below-ground utility vaults, storage tanks, old mines, cisterns, and wells. Ground-level confined spaces include industrial tanks and farm storage silos. Above-ground-level confined spaces include water towers and storage tanks (Figure 18.7).

Rescue situations involving confined spaces have two deadly hazards. The first hazard is respiratory. There may be insufficient oxygen to support life, or a poisonous gas may be present. Rescuers must never enter a confined space without approved respiratory protection. Anyone entering a confined space without proper respiratory protection stands a high chance of becoming a second victim.

The second hazard is the danger of collapse. Some confined space rescues require shoring the area before rescuers can safely enter. Confined space rescue requires a specially trained team. Call for additional assistance as soon as you determine there is a confined space situation.

CHAPTER
REVIEW 18

Summary

Ice, water, and confined space rescue are special situations that require extensive skills and special training. It is important to help the victims, but not at the expense of your own safety. In water and ice rescue situations, there are some simple steps you can take to help the victim without endangering yourself. In confined space rescue, your primary goals are to call for additional assistance and to prevent other people from becoming victims.

Key Terms

Flotation device—
page 480

Reach-throw-row-go—
page 480

Riptide—page 482

? What Would You Do?

1. As you are returning from another call, you are flagged down by a young teenager who tells you his friend has fallen into the canal. What would you do?
2. You are dispatched for the report of a man who has collapsed from a heart attack. As you arrive on the scene, you are told that a man was working in the bottom of a tank and collapsed. What would you do?

You Should Know

1. The steps you can take in assisting with a water rescue.
2. The initial treatment of a patient in the water.
3. The steps you can take in assisting with an ice rescue.
4. Your role in assisting with a confined space rescue.

You Should Practice

1. Assisting with a water rescue.
2. Providing initial treatment for a patient in the water.
3. Assisting with an ice rescue.
4. Assisting with a confined space rescue.

CHAPTER

19

SUPPLEMENTAL SKILLS

Knowledge and Attitude Objectives *After completing this chapter, you will be expected to:*

1. Describe how to measure blood pressure by palpation.
2. Describe how to measure blood pressure by auscultation.
3. Describe the indications for the use of supplemental oxygen.
4. Describe the equipment used to administer oxygen.
5. Describe the safety considerations and hazards of oxygen administration.
6. Explain the benefit of automated external defibrillation in the cardiac chain of survival.
7. Describe the indications for the use of automated external defibrillation.
8. Describe the steps in using automated external defibrillation.

Skill Objectives *After completing this chapter, you should be able to:*

1. Measure blood pressure by palpation.
2. Measure blood pressure by auscultation.
3. Assemble the equipment used to administer oxygen.
4. Administer supplemental oxygen using a nasal cannula and a non-rebreathing mask.
5. Perform automated external defibrillation.

In some EMS systems, first responders use supplemental skills to enhance the care they give their patients. These skills include taking blood pressure, administering supplemental oxygen, and performing automatic defibrillation. The topics covered in this chapter are not required by the national curriculum, but they may be adopted by some states or first responder systems. Even if these skills are not used by your system, the information contained in this chapter will help you to assist other EMS personnel in providing care for patients.

Blood Pressure

Blood pressure is one way to measure the condition of a patient's circulatory system. High blood pressure may indicate that the patient is susceptible to a stroke. Low blood pressure generally indicates one of various types of shock. (See Chapter 12.)

The blood pressure measurement consists of a reading of two numbers (for example, 120 over 80 millimeters of mercury). These numbers represent the pressures found in the arteries during the contraction and relaxation of the heart.

The upper number (120 in the blood pressure of 120/80) is called the **systolic pressure.** This measures the force exerted on the walls of the arteries during the contraction of the heart.

The bottom number (80 in the blood pressure of 120/80) is known as the **diastolic pressure.** It represents the arterial pressure during the relaxation phase of the heart.

Normal Blood Pressure

Blood pressure ranges vary greatly. Excitement or stress may raise a patient's blood pressure. **Hypertension** (high blood pressure) exists when the blood pressure is greater than 146/96 after repeated examinations over several weeks. Hypertension is a serious medical condition that requires treatment by a physician.

Hypotension (severe low blood pressure) exists when systolic pressure (the first of the two measurements) falls to 90 or below. A patient with this condition is usually in serious trouble. Treatment of shock should be started immediately if the patient is also experiencing other signs of shock (for example, cold, clammy, and pale skin, or dizziness).

Taking Blood Pressure by Palpation

To take a patient's blood pressure by **palpation,** apply the blood pressure cuff on an uninjured (or less injured) arm (Figure 19.1). The cuff should be placed on the upper arm with the arrow over the brachial artery, located on the inside of the arm. The bottom of the cuff should be 1 to 2 inches above the elbow.

There are different sizes of blood pressure cuffs for adults, children, and infants. Narrow cuffs are for taking children's blood pressures, and extra-large cuffs are for obese adults. Cuffs that are too small may give falsely high readings, and cuffs that are too large may give falsely low readings.

Place the indicator dial in a position where you can easily see the movement of the indicator needle. Turn the control knob on the blood pressure

Systolic pressure The measurement of blood pressure exerted against the walls of the arteries during contraction of the heart.

Diastolic pressure The measurement of pressure exerted against the walls of the arteries while the left ventricle of the heart is at rest.

Hypertension High blood pressure.

Hypotension Lowered blood pressure.

Palpation To examine by touch.

Fig. 19.1 Blood pressure cuff and stethoscope.

inflator bulb clockwise to close the valve. With the fingers of your other hand, locate the radial pulse at the patient's wrist. Slowly pump up the blood pressure cuff until the radial pulse disappears. Continue to pump up the cuff for another 30 mm (millimeters) beyond the disappearing point of the radial pulse.

Slowly release the pressure in the cuff by turning the valve counterclockwise (Figure 19.2). Continue to feel for the radial pulse, and when you first feel the pulse return, carefully note the position of the indicator needle on the dial. This number is the systolic pressure.

When blood pressure is taken by palpation, it is not possible to obtain a diastolic pressure. The results of this method of taking blood pressure should be reported as "the blood pressure by palpation is 90."

Fig. 19.2 Slowly release pressure by turning the valve counterclockwise.

Taking Blood Pressure by Auscultation

When taking blood pressure by **auscultation**, apply the blood pressure cuff in the same manner and position as in the palpation method. Once the cuff has been applied, locate the brachial artery pulse in the crease of the elbow.

Put the earpieces of the stethoscope in your ears with the earpieces pointing forward. Place the diaphragm of the stethoscope over the site of the brachial pulse. Using your index and middle fingers, hold the diaphragm snugly against the patient's arm. Do not use your thumb! If you use your thumb, you may hear your own heartbeat in the stethoscope.

Listening with the stethoscope, inflate the blood pressure cuff and wait for the sound of the brachial pulse to disappear. Note the pressure on the dial.

Continue to inflate the cuff for another 30 mm over the pressure at which the brachial pulse disappeared. Then slowly release air from the cuff by opening the control valve. The pressure should be released slowly and smoothly at about 2 to 4 mm per second. Carefully watch the indicator needle and listen for the return of the pulse. Note the pressure reading when the sound of the pulse returns. This is the systolic pressure.

As the cuff pressure continues to fall (at 2 to 4 mm per second), listen for the moment when the pulse disappears. The number at which you can no longer hear the pulse is the diastolic pressure.

Blood pressure taken by auscultation (Figure 19.3) is reported as systolic pressure over diastolic pressure (the larger number over the smaller number) and is always given in even numbers (for example, 120 over 84, 90 over 40, or 186 over 98).

To become skilled in taking blood pressures, take every opportunity to practice on as many healthy, uninjured people as possible. Try to take blood pressures of both children and elderly patients; do not spend all your practice time with young, healthy adults. This practice will help prepare you to measure the blood pressure of a seriously ill or injured patient.

Auscultation Listening to sounds with a stethoscope.

Fig. 19.3 Taking blood pressure by auscultation.

Oxygen Administration

Under normal conditions your body uses the oxygen that is contained in the air. Your body operates efficiently using the 21 percent of oxygen that is contained in the air.

After a traumatic injury, there is sufficient blood loss to reduce the amount of oxygen that can be delivered to the cells of the body. This results in shock. It is beneficial to administer supplemental oxygen to patients showing

signs and symptoms of shock. Supplemental oxygen increases the amount of oxygen delivered to the cells of the body and often makes a positive difference in the patient's outcome.

Patients who have suffered a heart attack or stroke or patients who have a chronic heart or lung disease may be unable to get sufficient oxygen from room air. These patients will also benefit from receiving supplemental oxygen.

The skill of administering oxygen is not taught to all first responders; however, it can be beneficial in areas where EMS response may be delayed. By learning this skill, you will be able to assist other members of the EMS team. You should administer oxygen only after receiving proper training and with the approval of your medical director.

Oxygen Equipment

The equipment used to administer oxygen (Figure 19.4) consists of three main parts:

1. Oxygen cylinder
2. Pressure regulator/flowmeter
3. Nasal cannula or face mask

Oxygen Cylinders

Oxygen is compressed to 2,000 pounds per square inch (psi) and stored in portable cylinders. The portable oxygen cylinders used by most EMS systems are either D or E size. Oxygen cylinders must be marked with a green color and be labeled as medical oxygen. Depending on the flow rate, each cylinder lasts for at least 20 minutes. A valve at the top of the oxygen cylinder allows you to control the flow of oxygen from the cylinder.

Pressure Regulator/Flowmeter

Because the oxygen in the cylinder is under a pressure of up to 2,000 psi, it is necessary to reduce the pressure down to about 50 psi. This is done by the use of a pressure regulator. The regulator and the **flowmeter** are incorporated into a single unit that is attached to the outlet of the oxygen cylinder. Once the pressure has been reduced, the flowmeter can be adjusted to deliver oxy-

Flowmeter A device on oxygen cylinders used to control and measure the flow of oxygen.

Fig. 19.4 Setting up oxygen equipment.

gen at a rate of 2 to 15 liters per minute (lpm). The flowmeter allows you to select the amount of oxygen delivered to the patient. Patients with different medical conditions require different amounts of oxygen. A gasket placed between the cylinder and the pressure regulator/flowmeter ensures a tight seal and maintains high pressures inside the cylinder (Figure 19.5).

Nasal Cannulas and Face Masks

These devices are placed on the patient's face to administer supplemental oxygen through the patient's mouth or nose. **Nasal cannulas** have two small holes, which fit into the patient's nostrils. Nasal cannulas are used to deliver medium concentrations of oxygen (35 percent to 50 percent). **Face masks** are placed over the patient's face to deliver oxygen through the patient's mouth and nostrils. Nonrebreathing masks are most commonly used by first responders. They deliver high concentrations of oxygen (up to 90 percent). These two oxygen delivery devices are discussed more fully in the section on administering supplemental oxygen.

Nasal cannula A clear plastic tube used to deliver oxygen that fits onto the patient's nose.

Face mask A clear plastic mask used for oxygen administration that covers the mouth and nose.

Safety Considerations

Oxygen does not burn or explode by itself. However, it actively supports combustion and can turn a small spark or flame into a serious fire. Because oxygen supports combustion, all sparks, heat, flames, and oily substances must be kept away from oxygen equipment. Smoking should never be permitted around oxygen equipment.

A second hazard of oxygen equipment is the pressurized cylinders. The high pressure in an oxygen cylinder can cause an explosion if the cylinder is damaged. If the shut-off valve at the top of the cylinder is damaged, the cylinder can act as a rocket. Oxygen cylinders should be kept inside sturdy carrying cases that protect the cylinder and flow regulator. Handle the cylinder carefully to guard against damage.

SAFETY PRECAUTION
Avoid using oxygen around fire or flames. Keep oxygen cylinders secured to avoid the danger of explosion.

Administering Supplemental Oxygen

To administer supplemental oxygen, place the regulator/flowmeter over the stem of the oxygen cylinder. Be sure that the pins on the pin indexing system

Fig. 19.5 Proper position of the regulator on a valve stem with pins in view.

Fig. 19.6 A valve stem with pin-index holes.

line up correctly (Figure 19.6). Be sure to check for the mandatory gasket. Tighten the securing screw firmly by hand. With the special key or wrench provided, turn the cylinder valve two more turns counterclockwise to allow oxygen from the cylinder to enter the regulator/flowmeter.

Check the gauge on the pressure regulator/flowmeter to see how much oxygen pressure remains in the cylinder. If the cylinder contains less than 500 psi, the amount of oxygen in the cylinder is too low for emergency use and should be replaced with a full (2,000 psi) cylinder.

To administer oxygen, you will need to adjust the flowmeter to deliver the desired liter per minute flow of oxygen. The lpm flow depends on the patient's condition and on whether you choose a mask or a nasal cannula. When the oxygen flow begins, place the face mask or nasal cannula onto the patient's head.

Nasal Cannula

A nasal cannula is a simple oxygen delivery device. It consists of two small prongs that fit into the patient's nostrils and a strap that holds the cannula on the patient's face. A cannula delivers 2 to 8 liters per minute of oxygen. It can supply 35 percent to 50 percent oxygen to the patient. This is a low flow of oxygen. Low flows of oxygen are used for fairly stable patients such as patients who may have suffered a slight stroke, patients with slight chest pain, or patients with mild shortness of breath (Figure 19.7).

To use the oxygen cannula, first adjust the liter flow to 2 to 8 liters per minute and then apply the cannula to the patient. The cannula should fit snugly but should not be tight.

Nonrebreathing Mask

A nonrebreathing mask consists of connecting tubing, a reservoir bag, one-way valves, and a face piece. It is used to deliver high flows of oxygen, 8 to 15 liters per minute. A nonrebreathing face mask can deliver concentrations of oxygen as high as 90 percent. This mask works by storing oxygen in the reservoir bag. When the patient inhales, oxygen is drawn from the reservoir bag. When the patient exhales, air is exhausted through the one-way valves on the side of the mask.

Nonrebreathing face masks should be used for patients requiring higher flows of oxygen. These include patients experiencing serious shortness of breath, severe chest pain, carbon monoxide poisoning, and congestive heart failure (CHF). Patients who are showing signs and symptoms of shock should also be treated with high-flow oxygen from a nonrebreathing face mask (Figure 19.8).

To use a nonrebreathing mask, first adjust the oxygen flow to 8 to 15 liters per minute to inflate the reservoir bag before putting it on the patient.

Fig. 19.7 (left) A nasal cannula.

Fig. 19.8 (right) A nonrebreathing mask.

Once the bag has been inflated, place the mask over the patient's face. Adjust the straps to secure a snug fit. Adjust the liter flow to keep the bag at least partially inflated while the patient inhales.

Hazards of Supplemental Oxygen

Although oxygen does not burn or explode by itself, it actively supports combustion. When using supplemental oxygen, be sure there are no flames or sparks close to the oxygen. Smoking must be prohibited wherever oxygen is being used.

When administering supplemental oxygen, be sure the oxygen cylinder will not fall and damage the cylinder valve. The use of carrying cases or protective cages helps protect the cylinder.

Oxygen can be life saving, but it must be used carefully in order to be safe. Although the preceding information provides a basic outline for the set-up of oxygen equipment, further classwork and practical training must be conducted before you administer oxygen in emergency situations.

Early Defibrillation by First Responders

More than 50 percent of all out-of-hospital cardiac arrest patients have been found to have a heart electrical rhythm called **ventricular fibrillation.** This condition, "V-fib," as it is called, is the rapid, disorganized, and ineffective vibration of the heart. An electric shock can be applied to the heart to defibrillate it and reorganize the vibrations into effective heartbeats.

The American Heart Association's chain of survival recognizes the importance of early cardiac defibrillation and advanced life support. This chain includes the early recognition of cardiac arrest and access to EMS, early citizen CPR, early defibrillation by first responders or other EMS providers, and early advanced care. A patient in cardiac arrest stands the greatest chance for survival when early defibrillation is available. The cardiac chain of survival is shown in Figure 19.9.

The first responder is often the first emergency care provider to reach a patient who has collapsed in cardiac arrest. The first responder can start CPR and try to keep the patient's brain and heart supplied with oxygen. In many EMS systems, that is all the first responder can do. This can be lifesaving care if advanced life support is available quickly with the prompt response of paramedics.

Ventricular fibrillation An uncoordinated muscular quivering of the heart; the most common abnormal rhythm causing cardiac arrest.

Fig. 19.9 Cardiac chain of survival.

Early access

Early CPR

Early defibrillation

Early advanced care

Fig. 19.10 An automated external defibrillator.

In more and more EMS systems, first responders are equipped with **automated external defibrillators (AEDs).** These machines accurately identify ventricular fibrillation and advise you to deliver a defibrillating shock if needed. Such equipment allows the first responder to combine effective CPR with early defibrillation of the patient's heart to restore an organized beat (Figure 19.10).

AEDs may be appropriate for your community if you work to strengthen all links of the cardiac chain of survival. The links of the cardiac chain of survival include:

- Citizens are trained to quickly access the EMS system.
- Many citizens are trained to perform CPR.
- Early automated defibrillation is available from first responders.
- Advanced life support is available within 10 minutes.
- Hospital personnel are prepared to give prompt cardiac care.

Performing Automated External Defibrillation

If you arrive on the scene before an AED is available, check the patient for responsiveness, airway, breathing, and circulation (Figure 19.11A). If the patient is unresponsive, is not breathing, and has no pulse, you should begin CPR, as outlined in Chapters 6, 7, and 8 (Figure 19.11B). If you are by yourself and are trained in using an AED, first assess the patient's ABCs. If the patient is in cardiac arrest, begin the AED procedure before starting CPR.

Once the AED is brought to the scene, it is quickly attached to the patient (Figure 19.11C). Stop CPR and remove your hands from the patient before you turn on the defibrillator (Figure 19.11D). No one should touch the patient once the machine has been turned on. The machine analyzes for a shockable rhythm (Figure 19.11E). If a shockable rhythm is found, the machine quickly recommends defibrillation (Figure 19.11F). You should first say, "Clear the patient" and ensure that no one is touching the patient before you press the "shock" button on the defibrillator.

After the first shock is delivered, immediately press the "analyze" button on the defibrillator. The defibrillator then analyzes the heart rhythm again. If

A. Check ABCs—look, listen, feel.

B. If patient is pulseless and not breathing, begin CPR.

Fig. 19.11 The procedure for automated external defibrillation.

C. Apply adhesive electrode pads and connect to defibrillator.

D. Turn defibrillator on.

E. Allow machine to analyze rhythm.

F. Determine if shock is indicated by the defibrillator. If shock is indicated, defibrillate the patient.

Early Defibrillation by First Responders 495

a shockable rhythm is found, the machine charges and recommends a second defibrillation. The first responder should then press the "shock" button a second time.

This procedure of "analyze" and "shock" should be repeated a total of three times. These three shocks are called "stacked shocks." Some machines automatically analyze and recommend shocks three times. After the third shock is delivered, some machines time a 60-second interval. After this interval has passed, the AED recommends that you check the patient or push the "analyze" button again and perform a second set of three countershocks.

If the AED advises no shock, check the pulse. If the pulse is present, check the breathing. Support ventilations if necessary. After the one-minute interval if no pulse is present, resume CPR for one minute, and repeat two sets of three shocks. Once advanced life support personnel arrive at the scene, they will assume control and responsibility for the patient's care.

AED machines vary in their operation. You need to learn how to use your specific AED. Practice until you can perform the procedure quickly and safely. You must have the training required by your medical director in order to practice this procedure. Because the recommended guidelines for performing AED change, you should always follow the most current American Heart Association guidelines.

CHAPTER
REVIEW 19

Summary

This chapter covers the information necessary to measure blood pressure by palpation and auscultation, the administration of oxygen by face mask and nasal cannula, and the procedure for performing automated external defibrillation. Depending on the role of the first responder in your EMS system, you may need a special class to practice any or all of these skills.

Key Terms

Auscultation—
page 489

Automated external
defibrillator
(AED)—
page 494

Diastolic pressure—
page 488

Face mask—
page 491

Flowmeter—
page 490

Hypertension—
page 488

Hypotension—
page 488

Nasal cannula—
page 491

Palpation—
page 488

Systolic pressure—
page 488

Ventricular
fibrillation—
page 493

 What Would You Do?

1. You are dispatched alone to the scene of a man down. Your assessment reveals a 70-year-old man in cardiac arrest. You are trained in automatic external defibrillation. What would you do?

You Should Know

1. How to measure blood pressure by palpation.
2. How to measure blood pressure by auscultation.
3. The indications for the use of supplemental oxygen.
4. What equipment is used to administer oxygen.
5. The safety considerations and hazards of oxygen administration.
6. The benefit of automated external defibrillation in the cardiac chain of survival.
7. The indications for the use of automated external defibrillation.
8. The steps in using automated external defibrillation.

You Should Practice

1. Measuring blood pressure by palpation.
2. Measuring blood pressure by auscultation.
3. Assembling the equipment used to administer oxygen.
4. Administering supplemental oxygen using a nasal cannula and a nonrebreathing mask.
5. Performing automated external defibrillation.

1. Check ABCs–look, listen, feel.
2. If patient is pulseless and not breathing, begin CPR.
3. Apply adhesive electrode pads and connect to defibrillator.
4. Turn defibrillator on.
5. Allow machine to analyze rhythm.
6. Determine if shock is indicated by the defibrillator. If shock is indicated, defibrillate the patient.

1.

2.

3.

4.

5.

6.

1. Disabilities that may occur in elderly patients include *all but*

 a. Loss of sight
 b. Senility
 c. Croup
 d. Slowed movements
 e. Fractures

2. Describe an accident scene that may result in temporary deafness.

3. Which of the following steps should *not* be taken when managing a patient exhibiting disruptive behavior?

 a. Take your eyes off the patient.
 b. Protect yourself.
 c. Assess the situation.
 d. Carry out appropriate emergency care.

4. Place the following water rescue actions in the proper order. Describe how to perform each action.

 ___ a. Row
 ___ b. Go
 ___ c. Reach
 ___ d. Throw

5. Describe the steps you can safely take to assist in an ice rescue.

6. Name the two deadly hazards of confined-space rescue.

7. List the steps for taking blood pressure by auscultation.

8. Indicate which oxygen administration device would be appropriate for the following conditions.

 ___ a. Slight chest pain
 ___ b. Severe chest pain
 ___ c. Mild shortness of breath
 ___ d. Carbon monoxide poisoning
 ___ e. Shock

 1. Nasal cannula
 2. Non-rebreathing mask

9. List two safety considerations in the administration of supplemental oxygen.

10. Describe three conditions necessary for the use of an AED.

Answers: 1. c. **2.** An explosion with a very high noise level. **3.** a. **4.** 3 = a; 4 = b; 1 = c; 2 = d. **5.** Reach—with a ladder, a tree branch or a backboard; Throw—a rope or a flotation device; Row—a small boat; Go—use a device to spread your weight such as a toboggan, or lie on your stomach. **6.** 1. Respiratory hazard = a lack of oxygen or the presence of a poisonous gas; 2. Danger of collapse. **7.** 1. Apply cuff over brachial artery; 2. Place stethoscope earpieces in ears, and diaphragm over the site of the brachial artery; 3. Inflate blood pressure cuff to 30 mm above the point where the sound of the brachial pulse disappears; 4. Slowly release pressure (2 to 4 mm per second); 5. The point at which you heard the first sound is the systolic pressure; 6. The point at which the sound disappears is the diastolic pressure. **8.** a = 1; b = 2; c = 1; d = 2; e = 2. **9.** 1. Be sure cylinder is secured so it will not fall; 2. Avoid heat, flames, and sparks. **10.** Unresponsive, no breathing, no pulse.

Additional Photo Credits

Module Opener 1
© Spencer Grant, Liaison International

Chapter Opener 1
© Kenneth Murray, Photo Researchers, Inc.
p. 7 © Spencer Grant, The Picture Cube;
p.11 © Bob Daemmrich, Stock Boston

Chapter Opener 2
© Craig Jackson, In the Dark Photography
p. 22 © Bill Brett, The Boston Globe;
p. 32 © Mark E. Gibson, MCMXCIII

Chapter Opener 3
© Bob Daemmrich, The Image Works
p. 43 © James Shaffer, PhotoEdit;
p. 45 © Hiroyuki Matsumoto, Tony Stone Images

Chapter Opener 4
© Lori Adamski Peek, Tony Stone Images

Chapter Opener 5
© Lt. Luis Fernandez, Metro-Dade Fire Rescue

Module Opener 2
© Craig Jackson, In the Dark Photography

Chapter Opener 6
© Craig Jackson, In the Dark Photography

Module Opener 3
© Craig Jackson, In the Dark Photography

Chapter Opener 7
© Craig Jackson, In the Dark Photography

Module Opener 4
© Craig Jackson, In the Dark Photography

Chapter Opener 8
© C.C. Buncan, Medical Images, Inc.

Module Opener 5
© Spencer Grant, Photo Researchers, Inc.

Chapter Opener 9
© Craig Jackson, In the Dark Photography

Chapter Opener 10
© David J. Sames, Stock Boston
p. 256 © Martin Rogers, Tony Stone Worldwide
p. 257 © Howard Paul

Chapter Opener 11
© Craig Jackson, In the Dark Photography

Chapter Opener 12
© Craig Jackson, In the Dark Photography
p. 291 © 1991 Jones and Bartlett Trauma Slide Kit

Chapter Opener 13
© Craig Jackson, In the Dark Photography

Module Opener 6
© Craig Jackson, In the Dark Photography

Chapter Opener 14
Steve Ferry, P & F Communications

Chapter Opener 15
© Byron Rhodes, Code Red

Module Opener 7
© Andy Sacks, Tony Stone Images

Chapter Opener 16
© Craig Jackson, In the Dark Photography
p. 435 © Matthew McVay, Tony Stone Worldwide;
p. 450 © U.S. Department of Transportation;
p. 451 © U.S. Department of Transportation;
p. 452 © J. Higgins, Unicorn Stock Photos

Module Opener 8
© Ed Lallo, Liaison International

Chapter Opener 17
© Tim Davis, Photo Researchers, Inc.
p. 473 © Lawrence Migdale, Photo Researchers, Inc.

Chapter Opener 18
© Michael Gallacher, Liaison International
p. 484 © Jim Riddle, Unicorn Stock Photos; © Michael Siluk, The Picture Cube, Inc. © Aneal Vohra, The Picture Cube, Inc.

Chapter Opener 19
American Academy of Orthopaedic Surgeons

Additional photo research: Sue Howard

Quick Emergency Index